St Ives

1883 -1993

Portrait of an Art Colony

Marion Whybrow

Introduction
by David Brown

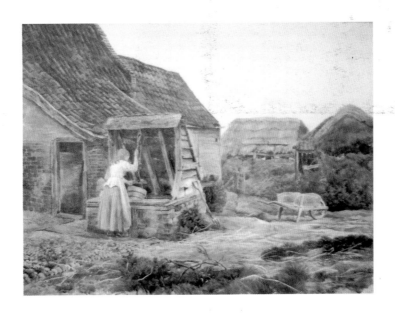

Antique Collectors' Club

*I do not personally think it would be going too far to say that
it would seem unimaginable that any genuine creative artist
could visit Cornwall and fail to be profoundly influenced.'*

Denys Val Baker

British Library Cataloguing-in-Publication Data
A catalogue record for this book is available from the British Library

Printed in England by
The Antique Collectors' Club Ltd., Woodbridge, Suffolk, IP12 1DS
on Consort Royal Satin from The Donside Paper Company, Aberdeen, Scotland

Contents

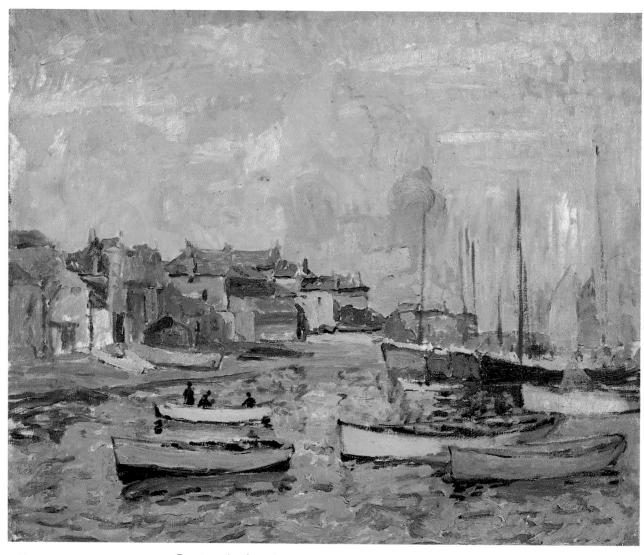

Boats at Anchor, Late Afternoon, *John A Park, c.1905. Oil on canvas, 19in. x 23½ in. Montpelier Studio.*

Boats Before Smeatons Pier and Lighthouse, *R Hayley Lever, c.1905. Oil on canvas, 10½ in. x 13in. The Crow Studio.*

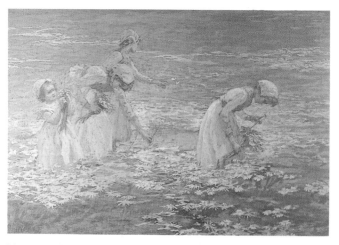

Marguerites, *W H Y Titcomb, 1895. Titcomb Family.*

Foreword

The unique appeal of St Ives and the mysterious magnetic forces operating in Penwith are well known to artists and writers who, throughout the last hundred years, have attempted to explain the extraordinary power that attracts creative people to West Cornwall.

Before the turn of the century St Ives had an art colony to equal Newlyn in status and was greater in number. It has been dismissed as a colony of itinerant artists. However, this applied to most colonies when painters travelled in pursuit of an art education and experience.

St Ives was unique in establishing an 'Artists Club' in a small town. Buildings not only require organisation, membership and committees, but they also depend upon a stable population. The colony of St Ives had these advantages, as well as a continuous flow of visiting painters. It is astounding, given these circumstances, that its history has not been fully appreciated and recorded.

During the second half of the nineteenth century artists were travelling extensively in Europe and setting up colonies in rural areas. Painting in the open air developed and a romantic attachment to the countryside and its people. Their simple way of life appealed to artists and formed a counter to the industrialisation of towns. What caused the sudden insurge of artists in the 1880s to Newlyn and St Ives?

View of St Ives, *Helene Schjerfbeck, 1887. Oil on panel, 33in. x 42in. Carl Appelberg.*

Most of the painters had visited the colonies of Pont Aven and Concarneau in Brittany and their counterparts were discovered in the two Cornish harbours. News spread to painters who were searching for the ideal, where all the desired elements come together. The introduction of rail travel undoubtedly encouraged the artists to explore once remote areas. St Ives had all the features common to the rural communities chosen by other groups, an untouched way of life, studio accommodation, a marine environment and the quality of 'the light' about which so much has been written.

The final section of the book needs another introduction. After completing the first stage the publisher said, "Yes, fine. Now go away and bring it up-to-date." After I had recovered from this shock I set about the enormous task of researching and writing about an even more celebrated group of artists in the same small town.

St Ives artists underwent a sea change as far as art is concerned. The painters that descended on the art colony at the beginning of the Second World War brought with them radical ideas, a rethinking and different approach to art. They added a new dimension to purely visual representations of beautiful scenery. They invested their paintings with a feeling for place, a spirituality, a power of looking at land/seascape from the inside.

Cornwall exerted its magic and they extracted the essence of their experiences processed through the mind and imagination. They employed more than skill, technique and ability in their art. Their influences out-reached St Ives and the town once more became a magnet for the 'creative', who wished to drink from the same font and further their own ideas.

This middle period of art activity from the thirties to the sixties is the reason for the establishment of the Tate Gallery in Cornwall. These artists made history and produced enough work for the world to be interested in coming to St Ives.

For the contemporary artists – they are here and working – many in various abstract styles and others more figuratively. It is important to note, for the moment, that the art colony continues as vigorously as ever. Only time and the space of years can assess their contribution.

Marion Whybrow

Acknowledgements

Special thanks to my husband Terry and daughters Kim and Tracey for their encouragement and belief. My grateful thanks for the Caroline L. Kemp Scholarship Award. Many thanks to the people of St Ives, the majority in their eighties and nineties, who gave me much useful information of a personal kind relating to the artists in St Ives and let me take photographs of their paintings:
Catherine Bowtell; Mrs Cann; Mrs Care; Mr Couch; Eileen Cross; Cathy Cullen; Treve Curnow; Sarah Escott; Mr & Mrs Farrant; Ellen Haggett; Joan Hain; Ned Hart; Susan Hosking; Miriam Kemp; Mr & Mrs Knight; Mr & Mrs R Laity; Miss Vivien Noye; Sylvia Pardoe; Marion Pearce; George Pearce; Charles Pearce; Mrs Proudfoot; Sylvia Sirrett; Jim Smith; Brian Stevens; Tillie Thomas; Mr & Mrs T Tonkin; Winifrede Willis.

My thanks to relatives and friends of the artists who talked, wrote letters and provided information and photographs and to those who did not wish to be identified:
June Atlee; Martin Val Baker; Flora Berriman; Marguerite Bottge – Switzerland; Sir Alan Bowness; Stephen A Bucknall – Gwent; Graeme Bucknall – Australia; Robina Craze; Magdalen Evans – London; Wilhelmina Barns-Graham; Nikolas Halliday – Surrey; Elizabeth Hawkins; Dave Harre – New Zealand; Jean & Malcolm Haylett; Edna Hirth; Horace Kennedy; Elizabeth Lamorna-Birch – Lamorna; David Leach – Devon; Hope Smith (Lindner) – Surrey; Alice Moore; Robin & Marnie Nance; Phoebe Proctor; Veronica Pattenden – New Zealand; Margaret Reed; Mary Schofield; Hyman Segal; C N Snider – USA; Dorcie Sykes; Alison & Henry Symons; Joan Temby; Roger N H Whitehouse – Isle of Mull; Prof J M A Whitehouse – Winchester; Frances Wilcock – New Zealand; Mary Williams.

Others who provided information/photos/articles etc.:
Friends at St Ives Library; Penzance (private) Library – Morrab Gardens; Local Studies Library – Redruth; British Museum Library; Dr Todd Gray – Institute of Cornish Studies; Dr Myrna Harris – Institute of Cornish Studies; Professor Charles Thomas – Cornish Studies University of Exeter; Professor Malcolm Todd – University of Exeter; Michael Tooby – Tate Gallery St Ives; Mr Baker – Carbis Bay Hotel; Hazel Berriman – Truro Gallery & Museum; Toni Carver, St. Ives Printing & Publishing; Art Institute of Chicago; David & Tina Wilkinson – The Book Gallery; Patricia Bishop; Sam Bennetts; Del Casdagli; John Charles Clark; Stanley Cock – St Ives Museum; Roy Conn; Bob Devereux; Kate Dinn, Falmouth Art Gallery; H C (Gillie) Gilbert – Wills Lane Gallery; Vic & Helen Harris, Broad Street Gallery; Jonathan Holmes – Penlee House Museum; Michael Hunt – New Craftsman; D Jackson; Father John – St Johns In The Fields; KAKM Alaska TV; Harding & Dee Laity; Rachel Levine; Sheila Marlborough; David & Sarah Lay, Auctioneers – Penzance; Mirror & The Lamp Bookshop – St Ives; Colin & Celia Orchard; Ray Petty; Robert A Poynton; James Presswood; Primitive Methodist Chapel, Fore Street; Roy Ray – St Ives School of Painting; Diana & Alan Shears – Shears Fine Art; Roger Shuttlewood; Annie Smith; Leon Suddaby Fine Art; Angela Verren Taunt; Sarah Watson – New Craftsman; Joan West & Vivian Eddy – Crow Studio; Mary Whitnall – Oxford; St Ives Printing & Publishing Co for assistance with film, processing, photocopying and loan of archive collection of newspapers; Waddington Galleries.

Thanks to all contemporary artists who are represented in this book.

The author and publisher would like to thank the following for permission to use quotations:
Adams & Dart; Martin Val Baker; Terence Dalton Ltd; Garland Publishing; Chapman & Hall Ltd; Faber & Faber Ltd; Museum Press; Chatto & Windus Ltd; Hogarth Press (Estate of Virginia Woolf); Oxford University Press; Headland Printing; Wm Heinemann Ltd; Ivor Nicholson & Watson; Wm Kimber Ltd; Constable & Co; Greening Publications; Methuen & Co Ltd; Macmillan London Ltd; J.M. Dent & Son Ltd; Tabb House Ltd; Society of Authors; Octopus Publishing Group Library; Peter, Fraser & Dunlop; Collins Publishers; Random Century Group; Thames & Hudson.

Introduction

Artists started to visit Cornwall in large numbers in the 1880s, part of a movement originating in France when painters wanted to leave large towns and work in the countryside where they formed artists colonies, first in the village of Barbizon, near Paris, and later in Brittany. Foreign artists working in France returned to their own countries and formed artist colonies in, among other places, Denmark, Germany, Russia, Hungary, England, Scotland and the USA. The movement was at its height in the 1880s when colonies formed in Cornwall, near Land's End, in Newlyn on the south coast and in St Ives on the north.

Whereas Newlyn attracted almost exclusively British artists, St Ives, where a hotel opened in 1878, a year after the railway reached the town, was much more cosmopolitan. Some of the artists in St Ives had worked in Brittany and the move of a few of them may have been spurred on by an outbreak of infectious disease there described by one American painter in a letter home. Painters in St Ives were reported in 1898 as having come from the USA, Canada, Australia, France, Germany, Austria, Denmark, Norway, Sweden and Finland, as well as from other parts of Britain. Their work was exhibited widely: in London and other British cities, in Paris, Munich, Berlin, as well as in America, Canada, Australia and New Zealand.

Turner had visited St Ives in 1811 and one of the earliest to come in the 1880s was Whistler, who spent some months in the town early in 1884, accompanied by Walter Sickert and Mortimer Menpes. In 1890 a Japanese painter visited St Ives and the local newspaper reported that when he set up his easel by the harbour and started work local children threw stones at him and shouted, telling him to go away: this was because he was painting on a Sunday, not because he was Japanese.

Artists in Newlyn painted mainly figure compositions and few landscapes, whereas in St Ives, with its more open landscape, artists made many views of the harbour and elsewhere. The popularity of St Ives with artists led to many cottages and sail-lofts being converted into studios and at one time there were more than a hundred; now there are far fewer. In 1887, a surprisingly early date which tells us much about the speed with which the art colony and its reputation developed, James Lanham, a general merchant who sold artists' materials, opened some rooms above his shop as an art gallery, which continued until about 1970. There is a story, which may be apocryphal, that Lanham started to sell artists' oil paint at Whistler's suggestion.

St Ives was especially popular with American and Scandinavian artists and two of the best known were Hélène Schjerfbeck from Finland, whose *View of St Ives*, 1887, is one of the most beautiful landscapes of St Ives ever painted (see page 7), and the Swedish painter and etcher of buxom girls, Anders Zorn, whose *Fisherman St Ives*, 1888 (Musée des Beaux Arts de Pau, France) shows a fisherman and a woman standing by a wall overlooking the harbour. An English painter, W H Y Titcomb, depicted a chapel congregation in *Primitive Methodists*, c. 1888 (Dudley Art Gallery). (See the pioneering study of art colonies in Europe and America, including St Ives and Newlyn, *The Good and Simple Life* by Michael Jacobs, Oxford, 1985.)

Foreign artists stopped coming in numbers from about 1900 but many British painters continued to do so and founded the Society of Artists in 1927 and held exhibitions in one of the largest Porthmeor studios.

An old retired fisherman, Alfred Wallis (1855-1942) started to paint, untutored, in about 1925 'for company' following the death of his wife. In the 1890s, when working as a rag-and-bone man, he had blotted his copybook when he became involved with the old Cornish practice of stealing from wrecks. Two boys stole brass from a wreck on Porthmeor Beach and sold it to Wallis. The boys were each fined £5, couldn't pay and spent a month in Bodmin Prison; Wallis was fined £20, a large sum at that time, but paid up. Wallis painted on irregular pieces of cardboard or wood, using ships' or

household paint applied in a direct and lively way, pictures of ships, remembered from his youth, in shallow pictorial space. He was one of the few to paint Godrevy lighthouse in St Ives Bay. He was a Modernist but didn't realise it and was to be 'discovered' by Christopher Wood and Ben Nicholson in 1928 on a day visit to St Ives and was to be influential on their painting.

Nicholson and Barbara Hepworth moved to St Ives just before the outbreak of War in 1939 at the invitation of Adrian Stokes, writer and painter, and his wife Margaret Mellis, also a painter. Naum Gabo and his wife followed a couple of weeks or so later. Thus three members of the international Constructivist Movement came to be living in a small and remote Cornish fishing port 300 miles from London. Before Stokes and Mellis moved to St Ives in April 1939 in the expectation of heavy wartime bombing, which seemed increasingly likely, they had looked for a house in East Anglia but failed to find one. If they had moved, say, to Southwold, then the art history of Britain would have been rather different. Gabo, Nicholson and Hepworth would probably have spent the war years in Southwold and there would have been no St Ives School of Modernists as we now know it.

Soon after he arrived in St Ives, Nicholson gave Peter Lanyon, a Cornishman born in the town, lessons in drawing and painting which changed his style towards abstraction. After his return from war service Lanyon was to be influenced much more profoundly, and long lastingly, by Gabo's work.

Nicholson seems to have been very hard-up after he arrived in St Ives. When he and his family left Stokes' house in December 1939 to move into their own accommodation, Stokes and Mellis lent them furniture and paid the rent. Then, in 1940, Nicholson advertised in the local paper offering lessons in drawing and painting but it is doubtful whether there were any takers. At one time Nicholson thought of taking a job in an aircraft factory but nothing came of the idea. Most of the 'traditional' artists in St Ives were hostile or indifferent to Gabo, Nicholson and Hepworth, but one artist, Borlase Smart, a landscape painter and author of *Techniques of Seascape Painting*, wanted to extend a welcome to the new artists. Smart asked Barns-Graham to introduce him to Nicholson, the result was that Nicholson, Hepworth and Miriam Gabo, a painter, joined the St Ives Society of Artists and exhibited with them. Gabo declined the invitation on the grounds that he never joined groups. Nicholson and Hepworth also exhibited with Borlase Smart in his studio on 'Show Day', the one day in March when studios opened to the public both from within and outside the town.

Nicholson was to stay in St Ives until 1958 and Hepworth until her death in 1975. The work of both in the later 1930s had been uncompromisingly geometrically abstract; but in Cornwall the landscape of West Penwith became reflected in their work: Nicholson began to include figurative elements in his paintings, harbours, houses and hills and his abstracts included the colours of the local terrain. Hepworth's sculpture began to have references to rocks worn by the sea and to prehistoric standing stones.

The Gabos, Stokes and Mellis left St Ives in 1946 but there were other arrivals. Wilhelmina Barns-Graham, who had studied at the Edinburgh College of Art in the 1930s with Mellis (and with Norman Reid, a future Director of the Tate Gallery), had arrived in 1940 and in 1945 Bryan Wynter went to live in an isolated house above Zennor. Dr John Wells, who met Nicholson in 1928 and studied art at evening classes while a medical student in London, spent the war years in general practice in the Scillies, gave up medicine for art in 1945 and settled in Newlyn, but maintained close links with Nicholson and Gabo while they remained in St Ives.

Terry Frost came to St Ives in 1946 to study at the St Ives School of Painting and was later at the Camberwell School of Art. Patrick Heron, who had lived for some years as a child in West Cornwall, worked at the Leach Pottery 1944-45 and spent each summer 1946-55 in St Ives in rented accommodation by the harbour, moving permanently to Eagle's Nest, Zennor, in 1956.

The audience for 'advanced' art in the town was growing and in 1945 Endell

Mitchell, brother of the future sculptor Denis Mitchell, started to hold exhibitions in the saloon bar of the Castle Inn, Fore Street, of which he was landlord. The exhibitions continued until 1951 when he left the town and artists' work shown included that of Barns-Graham, Wells, Frost, Lanyon, Nicholson (lino cuts), Sven Berlin and Denis Mitchell. Also in 1945 the St Ives Society of Artists moved into larger premises in the deconsecrated Mariners' Church near the harbour. In 1947 a local bookseller, G R Downing, started to have exhibitions at the back of his shop in Fore Street; mainly showing work by those artists who had shown at the Castle Inn, with the addition of Barbara Hepworth. Many of the catalogues for these shows were printed by the fine craftsman, Guido Morris, at the Latin Press which he had moved from London to St Ives at the end of 1945. Also in 1947, a group of younger 'advanced' artists exhibited as 'The Crypt Group' in the crypt of the Mariners' Chapel and the furniture makers, Robin and Dicon Nance, started to show art, including an exhibition of work by Peter Lanyon, in their shop. The same year, 1947, Borlase Smart was elected President of the St Ives Society of Artists, succeeding that fine and still underestimated painter Dod Procter. In his speech Smart referred to the shortage of studios in the town, far fewer than the one hundred or so in the 1890s. There could have been one more; in the 1930s a painter living in St Ives, Helen Knapping, bequeathed her studio and money for its maintenance to the Royal Society of British Artists, to be occupied by a deserving artist from Devon or Cornwall. The RBA disgracefully soon sold the studio and it was never occupied by a deserving West Country artist.

In 1947 Smart died and a memorial fund was established to buy the Porthmeor Studios; this aim was achieved with the help of a loan from the Arts Council to be paid back out of rents. Art in St Ives owed a lot to Borlase Smart who had a generosity of spirit lacking in many of the other artists and who welcomed the 'advanced' artists and encouraged them to exhibit with the 'traditional' artists. He was forward-looking and in 1944 took up the suggestion of the Mayor, that the Council should buy a large house with extensive grounds as a town art gallery to show St Ives art from the 1880s to the present day, with the grounds to be a public park which the town badly needed. The suggestion was not adopted. Marion Whybrow has discovered that a proposal by the Mayor of St Ives in 1919 to build an art gallery and museum as a war memorial was also supported by Borlase Smart and likewise came to nothing.

Early in 1949 tensions in the Society of Artists came to a head and some of the 'traditional' artists, including Dorothea Sharp, were afraid that the introduction of a jury for exhibitions might result in some members not necessarily having at least one work in a show. At an extraordinary general meeting on 5th January, all the 'advanced' artists and a few 'traditional' ones resigned and three days later nineteen people founded 'The Penwith Society of Arts in Cornwall'. It was agreed that the Society would be founded 'as a tribute to the late Borlase Smart'. Herbert Read was elected President. Other artists were invited to join, among them John Tunnard, who declined. The Constructivist artist Marlow Moss, who had studied in Paris with Leger and was much influenced by Mondrian, lived in Penwith but was not invited to join the new Society because of opposition from Nicholson and Hepworth (information from the late Denis Mitchell). The Penwith Society, unlike the St Ives Society of Artists, included craftsmen among the members, including Leach, Robin and Dicon Nance, Guido Morris and the embroiderer, Alice Moore. Tension soon arose in the Penwith Society when Hepworth proposed a rule, which was passed, that members had to classify themselves under one of three groups: Group A – roughly traditional/ figurative; Group B – modern/abstract and Group C – craftsmen, each group having its own jury. This division into groups irritated some and within a year six members had resigned as they thought this categorization disturbed the unity and harmony of the Society. Lanyon was one of those who resigned and he did not rejoin the Society after the rule was rescinded in 1957. He wrote many letters to local newspapers on the subject. Lanyon considered that Nicholson and Hepworth were dominating the Penwith Society which, in his view, was becoming a society of abstract artists lacking the tolerance shown by Borlase Smart. Lanyon did acknowledge that artists in St Ives

had benefited from Nicholson and Hepworth, learning from their professionalism, for example, attention to detail in framing and keeping accurate records.

The St Ives 'advanced' artists were probably at their zenith from the early 1950s to the early 1960s. Some were to be markedly influenced by the paintings of the American Abstract Expressionists shown at the Tate Gallery's exhibitions of American art in 1956 and 1959. In the early 1960s, the attention of the avant-garde art public moved to Pop Art and Hard-Edged Abstraction.

I have mentioned two of my favourite St Ives characters, Alfred Wallis and Borlase Smart. Another is James Uren White who, in 1889, founded and edited the first St Ives newspaper, *The St Ives Weekly Summary, Visitors' List and Advertiser*, which from the start regularly gave much information on art activities in the town, as did its rival, *The Western Echo*, founded in 1899 and edited for its entire existence by W J Jacobs, until it was taken over by *The St Ives Times* (founded when it took over *The Summary* in 1910) in 1954 to form the present newspaper, *The St Ives Times and Echo*, which continues the tradition of extensive coverage of art. These newspapers are a mine of information on art matters in St Ives over more than a hundred years. Another great source of information was the local historian and curator of St Ives Museum, Cyril Noall (1919-1984), who published much on local history in *The St Ives Times and Echo* and who bequeathed his papers to the Royal Institution of Cornwall in Truro.

In this book Marion Whybrow gives an account of the art world of St Ives over more than a century. She weaves her story around the St Ives Arts Club, founded informally in 1888 in the studio of painter Louis Grier, and formally in 1890 when permanent premises were found quickly, which the Club has occupied to the present day. Ladies were soon admitted to membership and were quick with their suggestions for improvements. Mary Campbell and Marianne Stokes found 'the present lighting trying to the eyes and unbecoming to the complexion'. I am sure that their grievance was soon righted.

Golf seems to have been popular with the painters and several became president of the local Golf Club, among them that specialist in moonlit views over the sea, Julius Olsson. Arthur Meade, President of the Arts Club in 1902, always wore plus fours and liked to depict cattle and sheep in his pictures and his paintings of the golf course were well stocked with sheep.

Early this century various artists presented examples of their work to the Council. In 1968 the Council decided to get rid of fifteen of these pictures by auction in Penzance. There was no notification to the press or public. The auction went ahead despite protests and the paintings were sold for very low prices. Why couldn't these paintings have been placed in the town museum? The St Ives Museum near the harbour, founded in 1925, which owns some St Ives paintings, deserves to be much better known.

The Arts Club used to have a fine library with long runs of old art magazines such as *Colour, The Art Journal*, and *The Magazine of Art*, all rarities, which were sold at auction for derisory sums in 1979 to pay for repairs to the premises.

Marion Whybrow suggests some of the richness of the complex activities occurring during the past century in the St Ives art world. It is a fascinating story, written at an opportune moment with the opening of the new Tate Gallery St Ives.

Borlase Smart was forward-looking and would surely have applauded the initiative which, fuelled by local support and an active local committee which formed a steering group, led to the realisation of the Tate Gallery St Ives, opened in June 1993, a fine piece of architecture of which the town and Cornwall can be proud. There is, perhaps, a shortage of wall space for hanging pictures and some visitors may find that the stained glass near the entrance evokes the feeling of entering a mausoleum or memorial chapel. The new gallery attracts large numbers of visitors, some 180,000 in the first eight months. So far the gallery has shown only St Ives Modernist painting and sculpture by a few artists, restricted largely to work produced since Gabo, Nicholson and Hepworth settled in St Ives in 1939. The sole exceptions have been a few paintings by Wallis and a solitary picture by Adrian Stokes of West Penwith moorland, 1937. Nothing yet is shown to suggest that artists had been working in St Ives in large

An Evening on the Seine, *Adrian Stokes, 1927. Watercolour, 14¼ in. x 19¼ in. Private Collection.*

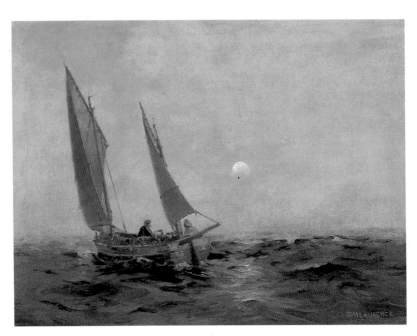

Cornish Lugger, *Sydney Mortimer Laurence.*
Oil on canvas, 16½ in. x 22½ in. Braarud Fine
Art, USA.

Yellow and Blue Laced, *Terry Frost, 1993.*
Painted collage paper/leather/canvas. Sims
Gallery.

Passing Over, *Wilhelmina Barns-Graham, 1982-86. Oil on canvas, 36in. x 48in. The Government Collection, London.*

Red and White Gloxinia with Peppers, *Bryan Pearce, 1988. Oil on board, 24in. x 20in. Mary Pearce.*

Figure and Bird, *Roger Hilton, 1963. Oil on canvas, 46in. x 70in. Private Collection.*

Gabo and his fellow artists arrived in 1939. Perhaps in the future the gallery will show earlier art in more traditional idioms made from 1884. If it doesn't there might be a risk that it will project an arrogant or patronising image, as if showing anything other than Modernist art would be too dangerous.

The Tate St Ives is a specialised gallery with special needs which at present the London Tate's collection cannot provide completely. I hope that it will search out and acquire suitable works by early St Ives artists, including crafts, not only ceramics but also furniture by the Nances, fine printing by Guido Morris and embroidery by Alice Moore. At present the Tate does not collect crafts but the Trustees make their own rules, so I hope this will change. Perhaps it should also consider showing paintings by Dod Procter RA, who was a member of the Penwith Society and by Marlow Moss, a Constructivist artist who lived in West Penwith; her work is in the Tate's permanent collection.

Visitors to the St Ives Tate who come from far and wide will, I hope, be able to visit a gallery from which they will leave with more than memories of a fine building with splendid views of the rooftops of the town, the Island and the sea from the cafeteria. They should also have seen a panorama of St Ives art and crafts over a hundred years which would appeal to a wide public, not just the cognoscenti of Modernism alone, something which Borlase Smart dreamed of in vain.

DAVID BROWN
23 February 1994
(Assistant Keeper of the Modern Collection, Tate Gallery, London, 1974-85)

A Prophesy Fulfilled

The Art Colony of St Ives was founded in the great 'Plein-Air' Movement of the nineteenth century and hundreds of internationally renowned painters have lived and worked here. As a direct result West Cornwall is today one of the few places where the daily work of an artist is considered a normal occupation.

Although in sheer scale, productivity and internationalism the Plein-Air Movement outstrips any other nineteenth century arts endeavour, it remains the worst researched, most poorly documented and least understood by art historians of the twentieth century. Except, perhaps, within the microcosm of St Ives, where a particular vision, circumstances and the community's consistently high expectations of its artists have allowed Marion Whybrow to investigate, in fine detail, the remarkable saga of this, the greatest of all the art colonies.

Marion's excellent book has two primary sources. The records of the St Ives Arts Club, founded in 1890, of which she is a past president and the archives of the town's weekly newspapers.

Until February lst, 1957 the tiny fishing port, former mining town and holiday resort of St Ives (population then around 9000) had managed to support two weekly newspapers. They were *The Western Echo,* founded in 1899 by Mr William J Jacobs and *The St Ives Times,* founded in 1910 by Mr Martin Cock. These two newspapers merged in 1957 to become *The St Ives Times and Echo,* but the *St Ives Times* had a 'spiritual' predecessor.

The first newspaper to appear in St Ives was founded in 1889 by a Cornish journalist of extraordinary vision, James Uren White, who came from the village of Madron near Penzance. Mr White's little newspaper was entitled *The St Ives Weekly Summary, Visitors' List and Advertiser,* which he printed at his stationers and printing works in Fore Street. To the uninitiated this will seem a quaint title bearing all the hallmarks of a Victorian curiosity.

The first edition of *The St Ives Times and Echo* in 1957 contained an article by the St Ives historian Cyril Noall entitled 'About Ourselves', which told the already remarkable story of St Ives' weekly newspapers. Cyril wrote: 'The weekly Visitors' List formed an important feature of the old Weekly Summary; but precisely what useful function it was supposed to serve is very difficult to say. Certainly, it is now quite devoid of interest.'

J U White had chosen to introduce 'The Summary' to his readership with some lines of doggerel verse which started:

'This year the pictures in th' Academy
By artists who last Summer made St Ives
Their happy hunting ground and rendezvous,
Must help materially to swell the ranks
Of cultured folk who come down year by year ...'

This first verse seemed of little interest to Cyril who quoted a later verse which seemed to make White's intentions clearer.

'As St Ives becomes more popular,
So year by year does the demand increase
For some authentic List of Visitors,
Together with a Local Summary
Of useful information and the like ...'

Cyril Noall ended with another quotation of White's which he quite rightly considered an apt ending for his excellent piece which, after all, was about newspapers and not art:

'A newspaper is valuable today; valueless tomorrow; and in 100 years 100 times more valuable than it has ever been before. From newspapers, history is written.'

The visitors, the cultured folk, now so obviously referred to in White's verses were the artists who came to St Ives from the art colonies of the 'Plein-air' Movement. These had been established between 1840 and 1889 all over Europe and the eastern United States. St Ives had by 1886 become a cosmopolitan centre for artistic, literary and intellectual activity.

The Academy of which he wrote was no less august an institution than the Royal Academy in London and he was well aware that these people made news and hence – history. Curiously, in 1957, Cyril Noall rather missed James Uren White's point although he certainly made up for it by March of that year when his article 'The Art Colony at St Ives' appeared in the newspaper.

In the early 1980s, Dr David Brown, then Assistant Keeper of the Modern Collection at the Tate Gallery, London, began to research his catalogue for the gallery's St Ives 1939-64 exhibition, shown at Millbank in 1985. As show time drew nearer my work at the St Ives Printing and Publishing Company was continuously interrupted by frantic requests from David at the Tate for photocopies of art articles that had appeared in the St Ives newspapers, back to the very first edition of James Uren White's unique chronicle.

After a Private Preview Party at the Tate, before the Private View of David's outstanding exhibition, away from painters, potters, sculptors and glitterati David invited his Tate assistants, helpers and myself back to supper at his 'Palazzio.' Here amid the congratulations of colleagues he solemnly raised his glass and proposed a toast to James Uren White whose intentions were now abundantly clear.

In the aftermath of the exhibition David Brown came down to St Ives and made a complete study of yesterday's 'valueless' newspapers for the Tate archive. Now many thousands of times more valuable as history was being written from them in under 100 years! He was presented with an art record completely unprecedented anywhere in the British press. In West Cornwall neither *The Western Echo* nor *The Cornishman*, a weekly newspaper based in Penzance, had chosen to chronicle the achievements of the artists consistently or to the same degree. David has since written that he would like to nominate James Uren White and Cyril Noall for 'secular sainthood.'

In 1910 James Uren White sold 'The St Ives Weekly Summary' title to *The Cornishman* but he sold his press and type to Martin Cock! Consequently when *The St Ives Times* appeared a few months later, Martin Cock's newspaper looked remarkably similar to Mr White's. 'The Summary' merged seamlessly into the body of *The Cornishman* within the decade while White was to edit *The St Ives Times* during the Great War.

Martin Cock, like James Lanham, had become involved with artists on several levels and was the logical keeper of White's 'art colony chronicles'. James Lanham retired in 1911 but his business came under the direction of Martin Cock. In 1951 the late Martin Cock's family decided to sell *The St Ives Times* to my parents, John and Virginia Carver.

At the time my parents founded the St Ives Printing and Publishing Company, expressly to purchase *The St Ives Times*, my father was drama critic on *The Coventry Evening Telegraph*. I expect it was the dramatic vistas of the town together with the ever present 'cultured folk' that attracted him to St Ives although, like most journalists, his principal ambition was simply to run his own newspaper. John edited *The St Ives Times* until the merger of 1957 when the business aspects overwhelmed his editorial role and his brother Geoffrey arrived to edit the new title.

Both my father and uncle had entered into journalism through the offices of the *Birmingham Mail* and could boast substantial careers in provincial journalism before arriving in St Ives. They already knew St Ives to be a place that attracted artists and were aware of the value of artists as: 'the town's chief publicity agents,' but initially the historical reasons why were not fully understood. On a daily basis only the community news concerns the editor of a 'local' and he has little time to reflect upon the recordings of his predecessors.

Geoffrey Carver's lead story in that first edition of *The St Ives Times & Echo* was headlined 'St Ives Could Become a World Art Centre.' The article reported painter Ben Nicholson's views on receiving a $10,000 award from the Guggenheim Foundation in New York for his abstract oil painting 'Val d'Orcia'.

Erymanthos, *Ben Nicholson,
1966. Carved relief, 47¾in. x
73in. Angela Verren Taunt and
Waddington Galleries.*

I rather suspect that had Martin Cock still been alive Mr Nicholson would not have
got such a generous headline. In all probability the reader's attention would have
been drawn to the long and illustrious history of St Ives art by 'again' appearing in the
headline.

This was to be a vintage year for the St Ives 'modern' artists who were later known
as the 'St Ives School'. They 'came of age' to international acclaim and as the painter
and critic, Patrick Heron, said St Ives became 'the only place that is not a capital city
or great metropolis to lend its name to an internationally renowned movement in
twentieth century art.'

Newly arrived in St Ives, Geoff had not yet had time to digest the archives of his
inheritance and in this same edition Cyril Noall missed the primary significance of
J U White's verse. An entirely forgivable lapse because the extent of the tiny town's
history is staggering. Cyril's own knowledge was enormous, covering fantastic histories of
the mining, shipping and fishing industries, buildings, wrecks and local families. These
subjects had provided him with a lifetime's work, of which the Art Colony was but a part.

Harbour, *John Wells, 1949-50.
Montpelier Studio.*

January 1: 1983: 11, *Patrick Heron. Gouache on paper, 23in. x 31in. Montpelier Studio.*

My own special historical interest is that of West Cornwall's mountaineers and sea-cliff climbing. I mention this to illustrate the wealth of history in such a small area and to demonstrate the intricacy of the subject. An example is that of Sir Leslie Stephen, father of the Bloomsbury Group painter Vanessa Bell and the novelist Virginia Woolf, who in 1858 recorded the area's first rock climb at Gurnards Head. Sir Leslie Stephen was also a founder member of the St Ives Arts Club and president elect in 1891.

Stephen's friend John Westlake, a prominent international jurist, was among the first to be made an honorary member of the Arts Club and his wife Alice was a painter. The Westlakes owned Eagle's Nest, now the home of painter Patrick Heron, on the Zennor road – later the house was sold to Will Arnold-Forster. Westlake's nephew, Arthur Westlake Andrews, surpassed Stephen in rock-climbing and became known as the 'Father of Cornish (hence British) sea-cliff climbing.'

Living at Tregerthen, Andrews maintained a close friendship with Arnold-Forster, as apparently did Virginia Woolf who recorded in her diary, March 30, 1922: 'Visited Arnold-Forster's at Eagle's Nest ... Endless varieties of nice elderly men to be seen there, come for the climbing.' Such snippets from the climbing history serve to demonstrate a curiously small world as the same individuals crop up in different spheres of the area's past.

Since my school days, when I became enmeshed both in the climbing and art histories of St Ives, the sheer magic of the historical processes at work here have proved a source of endless fascination. It was many years before I realised that Sir Leslie Stephen, Golden Age alpinist, literary critic and editor of the *Dictionary of National Biography* was also the father of Virginia Woolf. Years again before I realised that these people had been as familiar with my home as I was. Yet, they are the few.

The many, you have to meet in Marion's remarkable book as she shows you the extraordinary nature of the St Ives Art Colony. Marion's access to the Arts Club Records and the St Ives newspapers has allowed her to tell a truly amazing story. She has chosen to tell it in the prescribed manner of James Uren White, by documenting his 'visitors' and this would have pleased him; his prophesy fulfilled!

TONI CARVER
January 1993
Editor – The St Ives Times & Echo

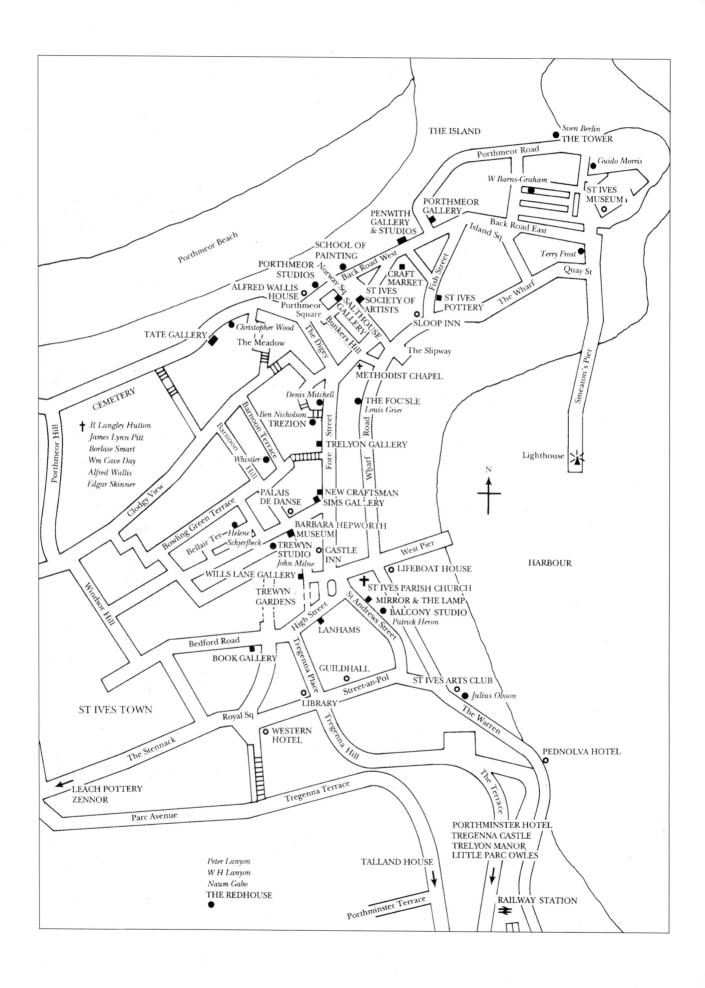

THE ISLAND

THE TOWER
Sven Berlin

Porthmeor Road

Guido Morris

W Barns-Graham

ST IVES
MUSEUM

PENWITH
GALLERY
& STUDIOS

PORTHMEOR
GALLERY

Back Road East

Island Sq

Porthmeor Beach

SCHOOL OF
PAINTING

Back Road West

Terry Frost

Quay St

PORTHMEOR
STUDIOS

Norway Sq

CRAFT
MARKET

Fish Street

The Wharf

ALFRED WALLIS
HOUSE

ST IVES
SOCIETY OF
ARTISTS

ST IVES
POTTERY

Porthmeor
Square

SALTHOUSE
GALLERY

SLOOP INN

TATE GALLERY

Christopher Wood

The Meadow

The Digey

Bunkers Hill

The Slipway

METHODIST CHAPEL

Smeaton's Pier

CEMETERY

✝ R Langley Hutton
James Lynn Pitt
Borlase Smart
Wm Cave Day
Alfred Wallis
Edgar Skinner

Barnoon Terrace

Denis Mitchell

Ben Nicholson
TREZION

THE FOC'SLE
Louis Grier

Fore Street

TRELYON GALLERY

Wharf Road

Lighthouse

N

Porthmeor Hill

Clodgy View

Barnoon Hill

Whistler

PALAIS
DE DANSE

NEW CRAFTSMAN
SIMS GALLERY

HARBOUR

Bowling Green Terrace

Bellair Ter

Helene
Schjerfbeck

BARBARA HEPWORTH
MUSEUM

TREWYN
STUDIO
John Milne

CASTLE
INN

West Pier

Windsor Hill

WILLS LANE GALLERY

TREWYN
GARDENS

LIFEBOAT HOUSE

✝ ST IVES PARISH CHURCH

MIRROR & THE LAMP

BALCONY STUDIO
Patrick Heron

High Street

St Andrews Street

Bedford Road

LANHAMS

BOOK GALLERY

GUILDHALL

Tregenna Place

Street-an-Pol

ST IVES ARTS CLUB

Julius Olsson

ST IVES TOWN

LIBRARY

Royal Sq

Tregenna Hill

The Warren

PEDNOLVA HOTEL

The Stennack

WESTERN
HOTEL

The Terrace

LEACH POTTERY
ZENNOR

Tregenna Terrace

Parc Avenue

PORTHMINSTER HOTEL
TREGENNA CASTLE
TRELYON MANOR
LITTLE PARC OWLES

Peter Lanyon
W H Lanyon
Naum Gabo
THE REDHOUSE

TALLAND HOUSE

RAILWAY STATION

Porthminster Terrace

The Arts Colony of St Ives
1883-1930

St Ives was already a thriving arts colony when its first artists' club was founded in 1890. Artists travelled extensively on the Continent in their quest for experience and the development of plein air painting that gripped the colonies of Europe. There they met with other painters, and no doubt word was spread about St Ives by the earlier arrivals, who had set up their easels for a few weeks and then departed back to city life. The Hon. Duff Tollemache, marine painter, had a summer studio in Downalong and his companions included at various times such Royal Academicians as the architectural painter Sir Lawrence Alma Tadema, landscape and coastal artists Sir Ernest Waterlow, Henry Moore, James C Hook, and Herbert Marshall, R Weir Allan and the French marine painter Emile Vernier.

By the 1880s the numbers of artists coming to St. Ives increased. Louis Grier arrived in 1884 and the painter Walter Jevons registered at the Tregenna Castle Hotel in 1886. W H Y Titcomb was resident in 1887 and there followed in the next two years William Eadie, Julius Olsson, E W Blomefield, Adrian and Marianne Stokes, Sydney Mortimer and Alexandrina Laurence.

Henry Harewood Robinson and his wife Maria came from France in 1885, after seeing a painting of St. Ives. In his article St Ives as an Art Centre Robinson reports, 'Old sail lofts and cottages were sought out, and turned into studios, and large skylights appeared everywhere among the grey roofs of the old town; by the enterprise of the townspeople new studios were built, some of imposing size, and St. Ives took its place as a world-known centre of art work.'[1] Robinson also noted the arrival of Anders Zorn and Mr and Mrs Gronvold.

Living in St Ives in 1889 were Allan Deacon at 6 Bellair Terrace, Henry Detmold at No 7, Helene Schjerfbeck and Maria Wiik at No 8. Folliott Stokes resided at 5 Bowling Green Terrace and Percy Northcote at 26. The Terrace housed the Griers, Blomefield, Stokes, Dyer and Lillingston. The Sydney Lawrences were at Ayr House and Leslie and Julia Stephen at Talland House. The American painter Alexander Harrison was booked in at the Tregenna Castle Hotel.

Edward Simmons, an American painter, noted in his autobiography, 'When I went to St Ives it was unknown as an art colony. Whistler had been there two years before (1883/84) but Robinson was the sole representative of the clan upon my arrival. When I left, five years later, there was an Art Club of one hundred members.'[2] Other Americans were the painters Emma and Frank Chadwick, Abbot Thayer who lived at 5 Bellair Terrace in 1894, and Mr and Mrs Howard Russell Butler who arrived from New York in 1895 and lodged at 1 Carrack Dhu.

Simmons was a founder member of the Club which provided a permanent gathering place for the painters to return to from their travels and seek the company of like minds, to exchange opinions on the state of the art and to entertain visiting artists. It proved a haven for educated men and women, mostly painters and writers, who had forsaken their sophisticated life style for a beautiful but cultural backwater.

The attractions of St Ives were numerous and provided food for the painter's brush and the writer's pen. The harsh working life of the fisherfolk with the allure of boats and harbours, the clusters of independent minded men and women who lived in the town, and the gigantic seas and moors of the peninsula provided a diversity of romance and reality to a hypnotic degree for people who could observe from the safe divide of a different class and culture. They did not rely on painting for a living and most were supported by a private income which enabled them to travel and have the freedom to pursue a painting career.

In 1889 the first local newspaper made its appearance in the town, the St Ives Weekly Summary and Visitors List made its report on the artists that same year — 'St Ives Painters are now returning to their studios, fresh from their triumphs at the various great picture shows, Royal Academy, Salon, and other well known exhibitions. Amongst those who are already at work are Mr and Mrs Adrian Stokes, Mr and Mrs Harewood Robinson, Mr and Mrs E E Simmons, Messrs W Eadie, Louis Grier, W H Y Titcomb, E W Blomefield and Julius Olsson.'

The Cornishman newspaper, well used to reporting on the activities of the Newlyn artists, commented on the marine pictures of Louis Grier on Show Day, March 1889 — 'He seems perfectly at home in depicting every mood of the Cornish seas and surely he loves a fishing boat as clearly as a Cornishman loves a pasty. In his studio are eight broad canvases showing sea and sky and cliff in many varieties of mood and weather.' He first exhibited work at the Royal Academy in 1887. The newspaper also printed an excerpt from The Daily Telegraph for May 1889 — 'We see that amongst the newcomers of distinction at the 19th Century Art Society are mentioned the names of L M Grier and Julius Olsson. They are building up what may one of these days be known as the St Ives School.'

Louis Grier and Julius Olsson were prominent among the early artists. They set up one of the first schools of painting in St Ives which attracted students internationally. Grier began painting en plein air before the colony existed. He is quoted as disclaiming all connection with 'the establishment over the way, the School of Newlyn.' The two colonies were separated both by distance and their painting styles.

Olsson won recognition for his marine paintings of the Cornish coast in stormy weather and revelled in large canvases. He was a keen sportsman and daring yachtsman. He was described by Folliott Stokes in an article for The Studio as 'a big man with a big heart, who

The Lighthouse, *Julius Olsson.*

paints big pictures with big brushes in a big studio.' The advertisement for their school appeared in the *St Ives Weekly Summary.* 'Two young artists, Mr Louis Grier and Mr Julius Olsson, are announcing the opening in St Ives, Cornwall of a School of Landscape and Marine Painting. The main idea of this School is to give students an opportunity of studying out of door effects, and therefore the work of students will, weather permitting, be carried on actually in the open air, and will only be taken into the studio when atmospheric conditions render open air painting impossible.'

Charles Lewis Hind, art critic and journalist, commented that a painter must be something of an athlete, and hardy, to carry a six-foot canvas around the hills morning after morning in the nipping air of daybreak. There are various stories of canvases tied to boulders or to the masts of boats to prevent them sailing off into the wind. Painters were fortunate in St Ives in that many studios fronted the sea with large opening windows. Olsson had a studio overlooking Porthmeor on the Atlantic coast with its huge seas, and Grier's studio viewed the quieter seas of the harbour with its picturesque fishing boats and the busy fish market. They shared the facilities of both with their students.

Notable Artists

The most notable of artists to visit St Ives was Turner in 1811 and again in 1813. Another visitor was Whistler, who came to St Ives to prepare a series of pictures for an exhibition in Bond Street. Lewis Hind made comment that St Ives had grown enormously since Whistler made a little watercolour of the view before the Malakoff was built. A biographer records Whistler's visit to St Ives, when he stayed at No 1 or 14 Barnoon Terrace with his two students Mortimer Menpes and Walter Sickert in the winter of 1883/84. 'They were up at six because he (Whistler) wanted an early start, yet patiently waited to eat breakfast until he made his entrance and rang the bell. They prepared his panels, mixed his paints, cleaned his brushes. And they saw Whistler begin to experiment in new, less demanding techniques, and learn from them. He was painting on 9 inch or 7 inch panels, which were easy to carry and upon which he painted a minimum of

brush strokes to achieve the essentials of a scene.'[3]

Sickert had previously visited St Ives as a player in actor/manager Henry Irving's troupe and was well known and liked by the local fishermen, much to the chagrin of the master, Whistler.

A writer member of the colony, Greville Matheson, whose friends the Pennells lived in Hampstead, noted in his diary that he had dined with Joseph Pennell one evening at the Cheshire Cheese, his other guest being Whistler. Whistler was then an old man and at first he felt rather frightened, because he had heard so much of his caustic tongue, but on that occasion he was charming. Elizabeth and Joseph Pennell, American writers, jointly wrote a biography of Whistler.

The Swedish artist, Anders Zorn, visited the town in 1887 and painted 'The Fish Market, St Ives' depicting the shore and the haul of giant cod lying there. In the background some boats are seen on the calm water. A buxom woman stands in the foreground; it is the same model as is seen in one of his very earliest oil paintings. The following year his first successful oil painting, 'Fisherman of St Ives', won a medal for Zorn and was purchased by the French State. In the Louvre hangs a painting by Zorn of St Ives harbour in twilight.

Edward Simmons noted, 'Anders Zorn and his wife, who was the daughter of a wealthy merchant of Stockholm, came over from Spain to St Ives. He was known principally as a water-colourist before this, but had painted portraits of some of the Royal families of Europe, and was patronized by the King of Sweden. Zorn had a disposition of sweetness and light... He was a man with a great hypnotic quality.'[4]

One of Finland's foremost painters, Helene Schjerfbeck, spent a summer painting in St Ives in 1889 attending classes run by Adrian Stokes. This same year she was awarded a bronze medal in the Paris Exhibition. She shared accommodation with her painter friend Maria Wiik. Both women had studied at Finnish schools of art and at Professor Becker's private academy. They continued their studies in Paris, Brittany and Italy.

On a previous visit Schjerfbeck had a studio in the house of Harewood and Maria Robinson, with a towerlike attic from which she could view the town and sea. She was a close friend of Marianne Stokes and shared with her the secret of her engagement to a young unidentified painter, whose parents discouraged the association because Helene Schjerfbeck was lame. However, she wrote to Marianne saying that marriage would have spoilt the course of her painting career.

In 1993 a Schjerfbeck painting was bought in a house sale, along with a Henry Detmold, for just over £100. These were the only two paintings in the house. An interesting question arose — could Henry Detmold have been the English painter to whom she was engaged? In 1889 the artists lived next door to each other in Bellair Terrace, St Ives. Detmold was described by Forbes as a fussy man always lecturing those who fell short of his values and Helene, being lame, would not have measured

The Convalescent, *Helene Schjerfbeck.*

up to his exacting standards of perfection.

The Finnish Broadcasting Company completed a filmed version of Schjerfbeck's life in 1991 having previously visited St Ives to trace and film locations for some of her paintings. In 1992 an exhibition of her work toured the States.

In 1892 Mrs Holman Hunt and party are recorded in the Visitors List of the local paper as staying at 5 The Terrace. Holman Hunt had first visited Cornwall in 1860 with the painter Val Prinsep (a relative of Julia Stephen of Talland House), the poet Alfred Lord Tennyson and Francis Palgrave who the year before published his *Golden Treasury of English Verse.*

The painter Philip Wilson Steer arrived in 1900 from London together with Frank Coles and Professor Frederick Brown, who taught at the Slade School from 1892-1918 and was a founder member of the New English Art Club. They were the invited guests of fellow artists Augusta and Moffat Lindner at their house Chy-an-Porth. 1903 saw the arrival of Mrs and Miss Sackville-West, who lodged at Terrace House. The writer George Meredith visited the same year and many times resided at Talland House, the guest of Leslie Stephen, and one of the original 'Sunday Tramps'.

Oswald Sickert, painter and father of Walter Sickert visited St Ives and stayed at 1 Bellair Terrace. In 1897, Bernard Sickert, painter and brother of the more famous Walter, was brought as a guest to the Arts Club by Julius Olsson. Walter Sickert's other connection with the town was in later years when his pupil was Garlic Barnes of St Ives.

Europe

Artists were establishing colonies in Scandinavia, Europe and America and travelled extensively between colonies, gaining experience of working en plein air amidst their fellow artists. France attracted the greatest number of colonies with Paris as a central pivot.

The British artists generally stayed at Pont Aven. Adrian

Stokes and Marianne Preindlsberger met there in 1884 and married the same year. Marianne painted her first Salon picture in Brittany called 'Reflection' and exhibited at the Royal Academy in 1885.

It was in Pont Aven that Elizabeth Adela Armstrong (Mrs Forbes) made her first tentative efforts towards working for the exhibitions. Her watercolour paintings at the Royal Academy were exhibited and sold on the opening day. In August 1889 she was awarded a second class medal for a watercolour drawing at the Paris Exhibition. She describes her artist companions in Pont Aven as, 'A lively picturesquely-clad, Bohemian group of men and women... A cosmopolitan crowd gathered of an evening at the long table d'hôte at the Hôtel des Voyageurs. Some of the men had already made their mark at the Salon and at the English Royal Academy.'[5]

The French and American artists stayed in Concarneau. Alexander Harrison, the marine painter, Frank Chadwick, Howard Russell Butler and Bastien Lepage were there at the same time. Simmons notes, 'Bastien was the first in importance in the Concarneau set, being almost the father of the Realistic Movement. He was a quiet, well bred person, swift at repartee, and could write as corking a letter to the press as Whistler. Bastien was one of the most lovable men I ever met, bright, smiling, with a certain undercurrent of sadness — the mark of tuberculosis was upon him then... Poor Bas. He was gone the following year.'[6] He died at the age of 36.

Jules Bastien Lepage first came to the attention of the public and critics with a painting of his grandfather which was exhibited at the Paris Salon in 1874. Bastien Lepage had more influence on the Newlyners and their genre paintings of the fishermen and their lifestyle than the mainly landscape and marine artists of the St Ives group.

St Ives and Newlyn were the equivalent of the Continent's Concarneau and Pont Aven, both being 10 miles apart and offering the same attractions of cheap accommodation, studios, sea and landscape and with an agreeable local population and the Celtic connection. St Ives attracted the marine and coastal painters and the

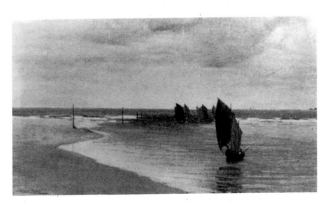

The Harbour Bar, *Adrian Stokes.*

landscape artist interested in wild and rugged moorland scenery.

Artist and writer Frank Lewis Emanuel who was one of the founder members of the Arts Club wrote an article for *The Studio* in 1894 which, in its content, applied equally to St Ives and Newlyn. 'You cannot possibly do better than choose Concarneau in Brittany as a pitch for your easel. Whether you intend to paint marines, landscapes, interiors, or figures, that is the place for you; If you want, on the other hand to laze away a month or two, Concarneau affords you every facility for so doing. You may reckon on finding pleasant artist companions both English and foreign in the town and at the village of Pont Aven l0 miles off... Lodgings, studios, artist materials and a well known art connoisseur and photographer are all to be found in the town, not to mention scores of little Bretons who beg to carry ones apparatus.'[7]

After touring Europe it was said of the artists in Cornwall that many returned from their painting trips to Italy and France with the Impressionist palette of light and colour. In fact few showed any European influences. There was a likeness in the subject of nocturns, but most of the paintings and painters were cast in the traditional English mould, their main aim was to hang in the Royal Academy. Europe's Impressionists, Post Impressionists, innovators and avant garde made little impact on this group of artists.

One expedition of painters to Paris in 1899 included Norman Wilkinson, Hugh Percy Heard and Guy Kortright. They found a studio in the Rue Boissonarde, furnishing it with a bed each, three chairs, a table and shared living costs. They also shared models for their study of the figure. The Latin Quarter of Paris drew art students from all over the world and it was certainly on the itinerary of most serious painters.

Artists were quick to share their experiences of good places to work. 'Mr and Mrs Eastlake, who have wandered about and found subjects at all sorts of out-of-the-way places in England and abroad, seem to have found their inspiration of late at Volendam. Mrs Eastlake (M A Bell)

is best known in England by her pastels; and her studies of Dutch child life have already met with much success in England and America. Mr Eastlake is well known for landscape.'[8]

Gwilt Jolley, whose wife had just given birth to a daughter at 5 Bowling Green Terrace, was preparing to escort a 'small class of ladies and gentlemen for plein air painting in the Riviera.'

The Gathering of Artists
In the first few years painters gathered in each other's studios for social events and discussions. They felt the need to find regular premises where they could meet, socialise, entertain and further the artistic activities of the group. Louis Grier gives his account of those early 'gatherings'.

'In the autumn of l888 a few good men and true met together in my studio, commonly known as The Foc'sle, to discuss the advisability of forming an Arts Club in our little fishing town, and over the pipe of peace and a little of the dew of Bonnie Scotland, we decided to start an institution to be called The St Ives Arts Club. After a few meetings some judged it rather slow ... one member bolder than the rest, dropped a bolt from the blue by proposing the introduction of lady members ... The following Saturday we mustered over sixty members of both sexes. This time we had a piano on the spot, and as we boasted some members possessing considerable vocal and instrumental talent, things began to "Hum" a little more. The light charade was indulged in (much to the detriment of The Foc'sle draperies).'[9]

Having formed the Club it became a popular meeting place and too small to contain its members and very soon Grier found it inconvenient. In 1888 Louis Grier was preparing his painting 'The Night Watch', which measured 7ft x 6 ft, for the Royal Academy. In those days artists worked on rather large canvases and he was no longer able to maintain the attractions of entertaining a growing number of artist friends in a room which at the same time served as his studio, where he worshipped the 'Goddess of Art'. The Foc'sle was off the harbour, and he wrote of the experiences of the painters when they met: 'On fine nights the large doors at the end of the studio would be opened, and then we had a series of nocturnes that would have merited the artistic appreciation of Mr Whistler.'[10]

In this rather pedantic statement there sounds a note of irony quite unlike his usual light hearted banter. It is possible Grier met Whistler when they were both in St Ives in 1884 and perhaps received some critical comment from that quarter, which Grier did not altogether appreciate. It was said Whistler could brook no rivalry and his jealousy extended to the most petty details. Mortimer Menpes in his book, *Whistler As I Knew Him*, confirmed that they would often meet other artists when out sketching, who could not understand Whistler's preference for small working panels while they worked out of doors on large canvases.

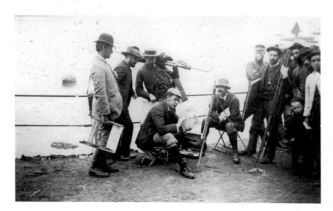

Artists and onlookers, c.1900. Cornish Studies Library.

Louis Grier, 1888. W.H. Lanyon.

Norman Wilkinson, painter of sea and ships, said it was mainly in St Ives where he learned his painting craft, at one time joining Louis Grier's summer painting class where they sketched a lot, and he felt that was the best way to learn to paint, and had 'a great deal of fun.'

Artists and local people
The building of the branch line to St Ives in 1877 undoubtedly made the town more accessible to tourists and certainly to the artists, who arrived in increasing numbers. *The Western Echo* commented on the type of visitors who were expected in the town, 'It is upon these visitors, the majority of whom belong to the wealthy class, that St Ives mainly depends for the support of its inhabitants.'

With the influx of the artists local people were able to provide accommodation on an all year round basis. Although the artists were of a different social class the Cornish were by no means intimidated by this seemingly well-to-do and educated gentry and the newcomers were expected to abide by local customs. Louis Grier was probably the first, and one of many, who nearly suffered the fate of being thrown into the harbour, easel and all, when the fishermen caught him attempting to paint on a Sunday.

Grier is still remembered by three St Ives people who were children at the time. "He was the artist best known

locally. He wore Oxford bags and had a great fondness for the Sloop Inn." "He always wore knicker-bockers and a big plaid or black cape." "He was always rather tipsy but always perfectly mannered." Such were some of the genuine friendships that were formed between artists and local people that the youngest son of one of the Stevens family was named 'Louis Monro Grier' Stevens. To celebrate another friendship with an artist a son is called 'John Douglas' Care.

Frank Lewis Emanuel was scathing of the Sunday observance which prevented artists working and said local people were known to enter private studios and destroy works intended for exhibitions, despite the fact that the rent the artist paid allowed a fisherman and his family 'to live rent free.' Many St Ives residents still remember those early days. Miss Sarah Escott recalls the divisions in which the people of St Ives lived according to their trade or profession:

"Generally St Ives was split into three groups. The fishermen lived in Downalong, the tinners in the Stennack and the gentry at Upalong. There wasn't any resentment from the fisherfolk when the artists came amongst them and rented their lofts. By then the days of huge catches were over. I think the local people tolerated the artists because they thought if they were prepared to live in the same conditions as themselves, they couldn't be too bad. Many of them lived and worked in their studios."

Writer Robert H Sherrard, wrote in the *The Table* — 'Apart from the towns people and the fishermen of Downalong the little town divides itself into Upalong, that is to say the houses on the slopes — the fashionable folk — and Downalong, the houses round the port, the democratic quarter; there is a large colony of artists here, attracted to the natural beauties of the place.'[11]

It seems certain that so large a group of people descending on a town, bringing their wealth and needs

Louis Grier's Studio, The Foc'sle, on the Wharf. The Studio *1895.*

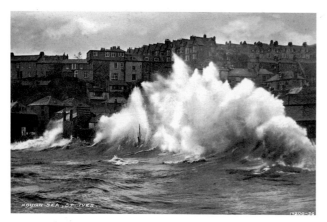

Storm and high tide, St Ives, postcard, 1938.

with them, played a significant role in refloating the economy of a town whose mining and fishing industries were fast disappearing. The townsfolk supplied services to the artists, from studios, models, shops, accommodation, housekeepers, maids, cooks and every form of necessary requirement for living.

It is certainly true that many artists exchanged local services for paintings. The son of a dentist, who was practising in St Ives from 1904-14, has a painting by John Noble Barlow which he believes may have been bartered for a full set of dentures. It speaks well of the relationship between the two large disparate communities that they could barter goods for paintings.

Local people remember John Park, who was always hard up. He would exchange a painting for the price of a drink saying, 'I can always paint another picture.' There are probably more Park paintings in St Ives than any other artist. His landscapes and sea paintings were widely printed as postcards. St Ives has probably a larger collection of paintings distributed among its local population than any other town of similar size.

Treve Curnow, son of a master baker in the town said, "My father owned many paintings. He used to take them in payment for provisions and services he provided, and Arnesby Brown and John Park used to stay with an aunt of mine in St Andrews Street, before John Park married. The aunts had rooms for the artists. There were three aunts and their mother — third house up from the bottom. Before Pednolva Walk was built the sea came right up. Every time we had a bad north easterly storm with a following wind the sea would come down the chimney and put the fire out."

An early photograph, printed as a postcard, showing the sea as described, was found among the papers of German artist Franz Muller-Gossen who was painting in St Ives at the turn of the century and who made frequent visits to Cornwall thereafter. His daughter's translation from the German reads, 'Behind the big wave are many studios. The foam is going over them and the sea water going down the chimneys is making the fires go out.' The Arts Club is seen at the far left. The Studios and The Bell Inn are masked by the wave.

Frank Emanuel recounts the same experience in the house in which he lodged, 'I have personally known the

spray come down a chimney and extinguish my fire in a room of what was once the smuggling Bell Inn, but latterly has been a studio, part of which formed the setting for Bramley's Hopeless Dawn.'[12] Frank Richards claims in 1895 that the picture was painted in Bramley's old studio in Newlyn. It is possible he used both studios. The painting was purchased by the Chantrey Bequest in 1888.

Artists also lodged with Mrs Rowe, two doors up from the Arts Club in The Warren. They took rooms in the newer houses in the town, Bellair Terrace, Bowling Green Terrace, Carrack Dhu and Talland Road. They rented the houses on The Terrace and Barnoon, and after establishing themselves for a number of years some had houses built, like St Ia on Treloyhan Hill and Belyars Croft, which now both serve as hotels. The house Chy-an-Porth was considerably enlarged.

The Sloop Inn

The artists drank with the fishermen at the local Sloop Inn. Town records show that the inn has been in

The Sloop Inn.

existence for 400 years. Some of the rafters are ships' timbers. It has been the favourite haunt of artists and has been photographed and painted hundreds of times. It is said that nearly every artist visiting or living in Cornwall has turned up at The Sloop. Treve Curnow commented, "The majority of the artists used to meet the fishermen in the Sloop. They got on alright together."

The Sloop lies in the lea of St Ives Harbour. Here Alfred Munnings, Louis Grier, Julius Olsson, Alfred East, Noble Barlow, Lowell Dyer and other painters held regular sessions in the round room — according to the writer Denys Val Baker. When the landlord, Mr William Baragwanath, died the artists sent flowers and were present at the funeral. Billy, as he was familiarly called, was a general favourite with the artists, as is testified by the fact that the walls of the Sloop are adorned with oil paintings. The Sloop was the especial favourite of Louis Grier and many of his paintings hung there in the early years.

The Rogers family hosted the Sloop Inn for nearly a century. After his uncle's long service, Phil Rogers' term as landlord lasted for 35 years and the same good relationship of fishermen, artists and landlord continued, with the traditional collection of paintings. Subsequent landlords were equally friendly with the artists and one could visit the Sloop to find local people and painters standing alongside their portrait or caricature; or paintings by artists that had been exchanged for their worth in pints of beer — John Park was one such beneficiary. "In the Snug there were about 20 or 30 pictures by John Park taken in payment."

Harry Rountree, a New Zealander, was a caricaturist who made his name in Fleet Street and carried on his profession in St Ives. A plaque to his memory has been placed on Smeatons Pier. When Rountree died Phil Rogers asked Hyman Segal to refurbish the inn with portraits and caricatures of the local population of fishermen and artists. His work still enlivens the rooms in the old pub and causes comment.

William Henry Bartlett's paintings were of genre

Phil Rogers, landlord of the Sloop Inn, by Hyman Segal.

subjects, often with a strong pastoral or marine element. He travelled widely and his work shows the influence of the Barbizon painters. In an article for the *Art Journal*, he quoted an old fisherman as saying the visiting artists who came every summer provided food for conversation as well as for the eye.

Swimming was a great sport in St Ives among the local people and every year championship races took place. The town turned out to watch the Regatta with its great sporting events, with awards and medals to be won. Virginia Woolf describes the carnival atmosphere of the harbour with its decorated sailing boats, brass bands and flags, which she witnessed as a child from the Malakoff before the heyday of holidaymakers. The Mayor was invited to present the prizes and in 1892 the Vice President of the St Ives Swimming and Sailing Association, Leslie Stephen, was called upon to present a bronze medal of the Royal Humane Society to fisherman Humphrey Ninnes for rescuing a man from drowning. In moving a vote of thanks the Mayor, Mr Hain, expressed the hope that Mr Leslie Stephen would consider himself a native of St Ives for many years to come.

Are you Ready, *W H Bartlett, c.1900*. The Studio.

Formation of the Arts Club – First Decade

On the 1st August 1890 a meeting was held at the Western Hotel to discuss forming an official Artists Club. It was to be entitled 'The St. Ives Arts Club'. The plaque commemorating the formation of the Club is dated 12th December 1890, whereas the Minute book starts on August 1st.

Seven men were elected to form the Arts Club committee. The first president was Adrian Stokes, with Eardley W Blomefield, William Eadie, C G Morris, Edward E Simmons, W H Y Titcomb and H Harewood Robinson. All but one committee member had hung in the Royal Academy. They were also members of painting societies and exhibited widely in other galleries and other countries.

On the 4th August a letter of invitation was sent to people whom the committee felt were eligible to become members. 'I am directed by the Committee to express to you their hope that you will become a member. A large and convenient Club Room, overlooking the Bay, will, it is expected, be ready to receive the Club in a few weeks. In the meantime temporary rooms will be taken.' The letter is signed H Harewood Robinson, Hon.Sec.

On the 8th August 1890 a General Meeting was held in Edward Simmons' studio in St Andrews Street. At this meeting a letter was read from Mr Leslie Stephen from Talland House on behalf of himself and Mrs Stephen,

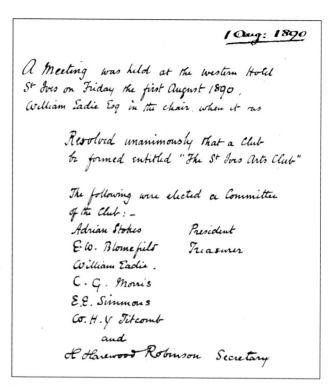

First page of the Minutes of St Ives Arts Club dated 1 Aug. 1890.

accepting the invitation to membership.

A list of members who were present on this occasion was noted. Messrs. Adrian Stokes (in the Chair) Wm Eadie, Folliott Stokes, Edward Docker, Davis, John Chadwick Lomax, Eardley W Blomefield, H Harewood Robinson, Emanuel P Fox, Bosch Reitz, Edward E Simmons, E Wyly Grier, George W Jevons, Dr Charles Grier, Thomas C Gotch, Charles G Morris, Frederick H Bertram, Arthur G Bell, George Roller, Henry Bishop, Henry E Detmold, William H Y Titcomb. Mesdames Annie Eadie, Maria Robinson, Mina Grier, Pansy Rainey, Mrs F Stokes, Caroline Gotch, M J Rogers, Edith C Hayes, Harriet M Ford, Mary Cameron.

Louis Reginald James Monro Grier

Grier is noted as the founder member of the Club since it was in his studio, The Foc'sle, where the first meetings of the painters took place.

He was born in Melbourne, Australia, of Irish parents. After rejecting a banking career he voyaged around the world in pursuit of painting experience. He exhibited at the principal European galleries and the RA.

His most famous painting 'The Night Watch', showing Godrevy lighthouse, Hayle Towans and points of light from the fishing fleet with seine boats in the foreground, was owned in 1920 by Treve Holman of Camborne.

Grier was an active member of the Arts Club for over 30 years and, rather surprisingly, never took the office of president although he served as secretary and librarian on the committee. He is commemorated in the Club by his painting 'Moonlight St Ives Bay', a photograph by W H Lanyon, and his palette.

By the 1st September 1890 the members were holding

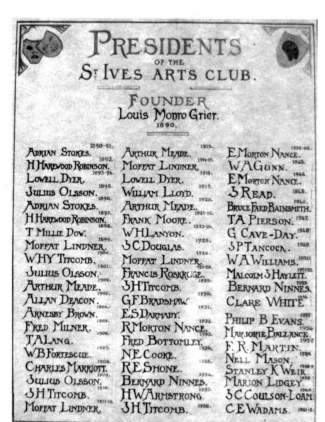

First list of Presidents of the St Ives Arts Club.

their meetings in the new Club Room, 'with quaint Dutch-like roof with here and there a skylight and a swinging window.' Louis Grier describes the view: 'Once more we are in view of the glorious bay and in sound of the cry of the hovering gull, and under our feet comes the roar of the ground-sea as it struggles with the rocks at the base and rushes madly up the granite walls of our foundation. It is a very marine spot indeed.'[13]

John Jenkyn leased to the Club the top floor of his premises in The Warren. He erected a steep wooden staircase inside the front door and provided a fire escape ladder on Westcotts Quay. He used the ground floor as a carpenter's workshop. Susan Hosking said "Morton Nance told me the top floor was fixed up as a place for smoking fish before the Arts Club took over. An eccentric old chap had the place. He made a windmill on the top." This was Charles Eathorne, who owned the property from 1856.

Over a period of two days the committee made plans and inspected the work of refurbishing the new Club room. Furniture was ordered from Lanham's in the High Street and the landlord had been instructed to provide a large window overlooking the Bay, and a skylight 11ft. x 6ft. on the east side of the building between the dormer windows.

R H Sherrard wrote, 'The artists, with whom associate the few literary people who live here, have a Club, which is over a carpenters shop, looks like a barn, the walls being of tarred wood. Inside, however, it is a very comfortable place, with magnificent views of the sea — an ideal artists Club I should say.'

Rules of the Club

Rules were drawn up and printed after the first committee meeting. 'Only Professional Painters, Engravers, Sculptors, Architects, Authors and Musicians, resident in or visiting St Ives and their wives, husbands and relations, shall be eligible for membership.'

All did not progress smoothly at the beginning. There were no women on the Committee, although most of the men's wives were painters, and many of the members were women. They made their comments and objections

Arts Club 1882, before Wharf Road was built. St Ives Museum.

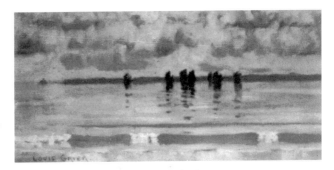

Moonlight St Ives Bay, *Louis Grier.*

through letters, general meetings and the Suggestions Book. On the 5th August 1890, at a committee meeting held in Mr Robinson's studio in St Andrew's Street, he as secretary recorded: 'The Secretary read a letter which Miss Cameron had addressed to the Committee suggesting that, as no woman was on the Committee nor were any invited to be present at the meeting on the first inst: those ladies who were eligible as members of the Club should have an opportunity of seeing and commenting on the rules before they were officially made public.'

Miss Mary Cameron was a lady to be reckoned with. She was a painter and writer and struggled to earn her own living. She arrived from Ireland and rented a studio. She wrote articles about art and in the summer sailed to Brittany with the fishermen and rented a studio there for the season.

It seems Miss Cameron was successful in getting some recognition for women. The amended rules provided that the evenings of Tuesday and Thursday should be reserved for the exclusive use of ladies. The evenings of Monday, Wednesday and Friday were for the exclusive use of gentlemen. At other times the Club was open to all members.

At the very beginning members made use of a Suggestions Book to voice their opinions, ideas for improvements, dissatisfactions and amusing remarks to the committee. Comfort was clearly in the minds of some members:

'That cushions be provided for the Gridiron chairs'
Signed — Melicent S Grose, E W Rouncefield, Mary Cameron, Terrick Williams, G W Bertram.
'That framed photos of members pictures be accepted as a suitable form of decoration for this barn.'
Louis Grier and 14 others
'That in lighting the new Club the eyesight of the members shall be considered, and also their appearance be spared. The present lighting arrangement being as trying to the eyes as unbecoming to the complexion.'
Signed Mary Cameron and Marianne Stokes

Whatever problems arose at the beginning there was great satisfaction for the painters in establishing a permanent base as an artists Club. Mrs Susan Hosking, as a child, lived in the oldest house opposite, where the

water wheel was still grinding corn for the town. She remembers the painters: "After the Arts Club started the artists were all round us. I knew them all as a child. Herbert Lanyon would always come in, especially when we were having a pasty. You couldn't go anywhere without seeing a painter with his easel in the early days. They liked to paint out of doors." Charles Pearce gives his account: "In those days the artists went around with their easels and it wasn't unusual to see the artists painting the view of the harbour from the Arts Club."

Artists and Studios

Artists were now coming to St Ives in increasing numbers. Most joined the Arts Club. Elizabeth and Stanhope Forbes, although mainly concerned with Newlyn, where they set up a school of painting, were signed into the Visitors Book by Harewood Robinson in August 1890. The colonies of Newlyn and St Ives were closely concerned in each other's affairs and in the early days Elizabeth had a studio in St Ives where she much preferred to work.

The St Ives Weekly Summary quotes from an article in the *Westminster Gazette*, which gives an interesting glimpse of the painters as they lived their lives in the town. 'The artists are chiefly in evidence in the morning. You may meet them in the narrow ancient streets. You may see the men of the painter colony, stalwart figures in tweed suits and knicker-bockers, and the women (amongst them a Rossetti face crowned by a Tam o' Shanter cap) — you may see them diving into dark archways and up rough wooden steps to their studios, great wooden sheds hung with brown sails or fishing nets instead of tapestry.'

'Some of these studios are built close to the seashore, looking upon the long Atlantic rollers foaming upon yellow sands — a rare opportunity for a sea painter to study wild weather and raging seas comfortably from his own windows. You may lunch with the artists at a simple restaurant which bears as its sign a palette and brushes; or, if you are lucky enough to get an introduction, you may spend an evening at their Club, which meets in a room above a carpenter's workshop, in a queer, Dutch-looking wooden building, black with tar.'[14]

Grier, whose studio was practically on the beach in the harbour, before Wharf Road was built, said he had a bedroom attached and often slept there because he made a speciality of painting moonlight effects and it was necessary for him to be in his studio at night. His wife also stayed there and cooked meals. According to one old resident of St Ives: "The fishermen's joke about Louis Grier was that when he took a boat out on the water to paint the sunset he couldn't row out far enough to keep up with the sun as it went down."

Adrian and Marianne Stokes drew forth the comment in the local press, 'Since their marriage, Mr and Mrs Stokes have travelled a great deal, as the various scenes of their pictures have shown; but for the last six years they have lived and painted principally at St Ives.'

Lynn Pitt's White Studio was above Porthmeor beach. Across the narrow road by the gas works, now the site of the new St Ives Tate Gallery, was Bird Field where many other studios stood. The local man often visited Herbert Lanyon and John Park who shared The Attic studio in St Andrews Street. "You could be sitting talking to Lanyon and Park and there would be rats running along the rafters over your head."

In 1902 the *Western Echo* reported that five new artists' studios were 'erected' at Porthmeor based on the proportions of neighbouring sail lofts. The first occupants were all Arts Club members, Messrs. Fox, Adams, Brooke, Douglas and Lindner. The studios were described as 'very commodious, with good approach and all of them with a northern aspect and splendid sea view.' Although the Porthmeor studios were reported as 'new' they were probably conversions from sail lofts and thought to have been built around 1850 as part of a group of lofts extending the length of Porthmeor beach.

Folliott Stokes, painter and writer, commented on the early days of the arts colony. 'There is another product besides fish for which St Ives is famous, and that is pictures. A large colony of artists is resident in the town, and their studios, numbering over fifty, are to be found in all sorts of unexpected places. Many famous pictures have been painted in old St Ives. Two, bought for the nation from the Chantrey Bequest, now hang in the Tate Gallery. Several have won medals at the Paris Salon; while there is hardly a large town in England that has not procured one or more for its permanent collection.'[15]

The Model Class

In 1891 drawing classes were established. Louis Grier wrote: 'We have a model twice a week, and it is no cheery place for the idler then, as there is little to disturb the monotony of silence save the grating of charcoal.'

Suggestions Book :
'That the Committee look to the arrangements for drawing nights and appoint responsible "massiers"! Tonight, no massier, no model, no anything! — also that one retiring massier gives notice that his

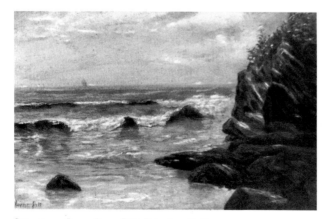

Seascape, *James Lynn Pitt. Private collection.*

time has expired, that someone else may take on the work.' Julius Olsson

'That a book be kept at the Club in which members be requested to enter names and addresses of models, whether male or female, light or dark etc.' Sarah Whitehouse, Frank L Emanuel, G Rosenberg, Wm Eadie, B C Collier, C L Greenfield, C W Bartlett.

Louis Grier recalls. 'One model night a youth with diminutive plaintive face under a very large Tam 'o Shanter was perched on the throne, when suddenly the roar of the sea was for a moment drowned by the crack of the lifeboat rocket. That youth (minus his pay, for which he never returned) did the spread-eagle downstairs, and was outside our front door before anyone could say Jack Robinson.' Many hands were needed to help launch the lifeboat in the early years and nothing would stop the crew from attending the call.

An amusing entry in the Suggestions Book reads :

'That a separate book be supplied exclusively for Mr Louis Reginald James Monro Grier's signature' Bertram, Morris, Detmold, Wolfenden, Lanyon, Emanuel, Fox, Lomax, Browne, and including — Louis Grier

St Ives and Newlyn

St Ives chose a building for its centre of excellence and no very dominant figure emerges from among the company of painters as a leader, unless it was to some extent the marine painter Julius Olsson, who opened a painting school in 1895, four years before the Forbes School. Adrian Stokes, whose work had been bought by the Chantrey Bequest in 1888, the first president of the Arts Club, was obviously a figure of importance. Moffat Lindner was also a prominent figure, being resident in the town for many years, several times president of the Arts Club and the longest serving president of St Ives Society of Artists.

The Newlyn and St Ives colonies were established about the same time. The Newlyners centred around Stanhope Forbes. He became a resident in Newlyn in 1884 and

Three figures in a studio, photo by W H Lanyon, c.1890. A. Lanyon.

began painting en plein air. In 1885 his 'Fish Sale on a Cornish Beach', painted on the sands at Newlyn and using the fisherfolk as his models, drew acclaim from critics and artists at the Royal Academy. In 1899 he and Elizabeth opened their School of Painting, which provided a focal point for the artists.

In an article in *The Cornish Magazine* of 1898 Forbes writes — 'Cornwall has indeed been fortunate in attracting the artists of other lands. I remember finding in a house at St Ives where I was calling, four painters of four different nationalities. In that town Zorn, the well-known Swedish artist, painted his first oil picture.' He goes on to say, 'Nothing could be more cordial than the relations between the art settlements in Cornwall, which, found so close together, are yet so distinct in character and diverse in their aim. It is curious how a few miles can affect the style of a body of workers.'[16]

On 15th August 1889, Elizabeth and Stanhope Forbes were married at St Peter's Church, Newlyn. 'The bride was dressed in cream-coloured satin, trimmed with point lace. She wore a tiny bonnet laden with white flowers, and carried a beautiful bouquet of lilies-of-the-valley, white roses and maidenhair-fern.'

Artists attending the wedding were a good mixture of St Ives and Newlyn painters: Mr and Mrs Adrian Stokes, Mr and Mrs Simmons, Mr and Mrs Eadie, Mr and Mrs Robinson, Mr and Mrs Fortescue, Mr and Mrs Walter Langley, Mr Frank and Miss Bramley, Messrs Frank Bourdillon, Chevalier Taylor, Fred Millard and H S Tuke.

Stanhope Forbes was appropriately showing 'The Health of the Bride' in the Royal Academy. 'I painted a wedding feast ... when I saw it hanging in the fine gallery which Sir Henry Tate has given to the nation, I could only remember the good luck it brought me.'

The paintings from the West Country to the RA. and other exhibitions in London were invariably termed, 'The Newlyn School,' but in an excerpt from *The Cornishman* of 1889 it is stated, 'I had learned at St Ives, what was afterwards confirmed at Newlyn, that the title which has been generally accorded to this group of painters is a misnomer... let us, therefore, for the future

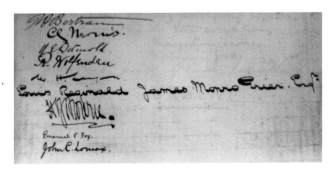

Signature of Louis Reginald James Monro Grier.

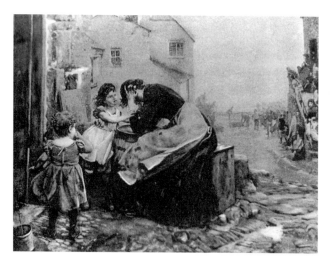

Twixt Life and Death, T C Gotch, showing Fish Street, St Ives. The Studio, c.1900.

speak of The Cornish School'. *The Sunday Times* commented that the St Ives painters had made great advances in the last few seasons, their work was prominently hung at the leading galleries and if they were distinguishable from the Newlyners in their choice of subject this was not to their disadvantage.

Painters commonly termed 'Newlyners' also lived in St Ives at some time during their painting career. Henry Detmold lived at 7 Bellair Terrace. Thomas Cooper Gotch and his wife Caroline lived at 9 Bellair Terrace. All three were present at a General Meeting of the Club on 8th August 1890, held in Simmons' studio in St Andrew's Street.

Frank Lewis Emanuel pointed out in an article that the St Ives coast was sufficiently attractive to induce those who annually go abroad and spend their wealth in foreign Rivieras to patronise Cornwall. He stated that many more painters had worked their way to fame in St Ives than the better known Newlyn.

Harold Begbie, writing in *The Morning Post*, complained that such was the power of advertising that all the world had heard of the Newlyn School whilst few were aware of the existence of the colony in the old world town of St Ives. 'The Newlyn School has been written about; the St Ives School has not. Newlyn paints interiors, St Ives nature. The men of St Ives are all devoted to ocean, plain and rolling down. They work to catch the effect of sunlight on sea. They are outdoor men, and it is in keeping with their aims that whenever an hour is snatched from the canvas it is devoted to the sea-blown golf links.'

This observation is further substantiated in the local press on Show Day. 'At Newlyn you mostly see figure paintings. At St Ives you see a dozen marine or landscape studies for every painting for which a human being has served as a model. The studios were invaded by hundreds of visitors and the great majority found much to praise and little to dislike.'

In general the two colonies were distinguisable for their different subject matter but W H Y Titcomb and the Robinsons in particular produced work in which the figure played a prominent part.

Two critics of this period were Charles Lewis Hind and Alice Meynell.

Charles Lewis Hind

Art critic, writer, and friend of the painters, Lewis Hind was first editor of *The Studio* 1893, editor *Pall Mall Budget* 1893-95 and of *The Academy* 1896-1903. He wrote many books on art and art criticism and two volumes on *Landscape Painting*. He writes from personal knowledge of the painters and gives a further insight into the early days of the two colonies.

'If the colony at Newlyn is better known than the colony at St Ives, it is because the pictures of those who paint the drama of life catch the public eye more swiftly than the works of the men who mirror the moods of Nature.'

'For beauty of environment, Newlyn cannot be compared to St Ives, and if Newlyn is the possessor of an art gallery, with periodical exhibitions, St Ives has its Club, and a Bohemian camaraderie that the sister colony lacks. Gala night is Saturday, when the painters, men and women, foregather to talk art and life, to skim papers and

Charles Lewis Hind, writer and critic.

Alice Meynell, writer and critic, watercolour, Adrian Stokes. From The Slender Tree *by June Badeni. Tabb House.*

magazines, to sing glees, and to show their skill in acting. Saturdays everybody makes a point of being present at the Club.'

'At Newlyn the artists are mostly veterans, men who have won their spurs. At St Ives some of the strongest wielders of the brush are broad shouldered, alert, sanguine, bright-eyed young men who are strenuously working their way to the front.'[17] It was also said of the St Ives painters they were followers of Constable, with hints of Bastien Lepage, Whistler, Sargent and the Glasgow School.

Alice Meynell

Alice Meynell, poet, writer, art critic and President of the Society of Women Journalists in 1897, was thought by Stanhope Forbes to have first used the term 'Newlyn School'. In an article for the *Art Journal* she comments, 'The Newlyn painters differ essentially from the rest of the English painters, and they differ from one another accidentally, by all the charming accidents of their individual character. It is in spite of these latter distinctions that their separateness from the majority has been recognised by a name. They are all "Newlyners." And seeing some Newlyners abide at St Ives and some at

Lelant and that one dwells in a boat in Falmouth, their nickname is assuredly given them in acknowledgement of something they have in common.'[18]

Cricket and other Sports

Social and sporting activities were an important element in the life of the artists. In spring 1889 *The St Ives Weekly Summary* reported — 'Archery, lawn tennis and cricket are now in full swing. One of our American artists, Mr Dyer, leaves for New York next week and will be absent about three months. An art exhibition is open in our midst. The weather is delightful and visitors are arriving from all parts.'

July 1889. A new cricket club was formed with Adrian Stokes as Captain and William Eadie, Secretary. One of the first matches played was Town and Visitors V. Artists. This match resulted in a victory for the artists. Artist players — F Bourdillon, F Stokes, A C Taylor, E W Grier, H Detmold, E W Blomefield, E E Simmons, W Eadie, A Stokes. The artists scored 37 runs over the town's 19.

Frank Richards reported on the cricketing achievements of the St Ives and Newlyn artists in 1895. 'By the way for lighter entertainment on a hot summers day, we indulge in cricket. Newlyn Versus St Ives is the match of the year, generally terminating in victory for the home team over their friendly opponents. Bramley is our Captain, and with Forbes, Langley, Taylor, Harris, Rheam, Blackburne, Da Costa, myself and with Gotch and Mackenzie as Umpire and Scorer, and Fred Hall, Caricaturist, we make up not so bad a team. Playing the match first at home, the return at St Ives succeeding always in gaining a good days rest from our work and a good days fun.'

'Adrian Stokes was our opponents most formidable man at St Ives; backed by Wyly, Grier, W H Y Titcomb and Simmons, all of whom were most energetic and good cricketers, and more often than not did all of the work for their side ... We Newlyners used always to be looked upon by our opponents at St Ives as a body of men

An artists' cricket team (unidentified). Cornish Studies Library.

following in the wake of a funeral, yet when on the cricket field I think there is little trace of such a melancholy spirit in us.'[19]

Stokes was also instrumental in founding a golfing club. A meeting was held at Lelant in 1889 to consider the possibility of forming a golf club with links on the Towans. It was agreed that the six gentlemen present at the meeting should constitute themselves a Golf Club to be called the West Cornwall Golf Club. Adrian Stokes was one of those six. A year later a visiting player on the links was Arthur Conan Doyle, whose stories of Sherlock Holmes were being published in *The Strand Magazine*.

W H Y Titcomb was referee in the Lawn Tennis Club Tournament at Higher Tregenna. Other artist players were Blomefield, Dyer, J Titcomb, Farina, Morris, Wynne, Lamarque and Sydney Laurence. Lady players were the Misses Whitehouse, Wynne, K Horn and Rieu. Also noted as players were Gerald Duckworth, George Duckworth and Miss Stella Duckworth. These were the older half brothers and sister of Virginia (Woolf) and Vanessa (Bell) Stephen, all of whom were staying at their summer residence, Talland House.

At Ayr House in July 1889 Mrs Alexandrina and Sydney Mortimer Laurence, recently arrived from New York, gave their first 'at home.' A pleasant afternoon was enjoyed by their numerous guests and the old English sport of archery was indulged in and 'thoroughly appreciated.'

The St Ives and Newlyn artists were great entertainers but St Ives took the advantage of having their own club room in which to play host. Louis Grier said that at times they had even indulged in 'the dissipation of a masquerade' and on such occasions some of their friendly rivals from Newlyn had honoured them by their presence and provided much of the entertainment. The Newlyn artists included the Forbes, Walter Langley, the Garstin family, S H Gardiner, Lamorna Birch and others.

A Carnival Masquerade became a yearly event and took place a month before the spring Show Day. Dancing was kept up till a late hour and excellent music provided.

A Gleam Before the Gloaming, *Alfred East.*

The event of 1889 was reported in the local paper and the characters described. From a list of 70 names a few are selected, Mrs Edward Hain, Carmen; Mrs Dyer, Snake Charmer; Mrs Stanhope Forbes, 'Green Tea' (based on Mrs Vesta Simmons story); Miss K Boase, Desdemona; Miss K West, Kate Greenaway; Miss Whitehouse, Moonlight; Miss Rosenberg, My Great Aunt.

And some of the men, Bosch-Reitz, Venetian Noble; Dr Nicholls, Garibaldi; Julius Olsson, Venetian Gondolier; Lowell Dyer, Astrologer; Louis Grier, Turk; Stanhope Forbes, Blue Beard; Arnesby Brown (blue) Dixon (pink) twin babies; Adrian Stokes, Barrister; S.M. Laurence, Breton Peasant Girl; R S Read, Bush Ranger. A masquerade ball became a tradition in St Ives and was carried on for many years, becoming known as The Arts Ball in later years.

Tea Talks and Dinners

The Club established a series of weekly lectures when a speaker was invited to take tea with the president and members before proceeding to entertain or to educate.

A minute of 1900 reads: 'During the winter months several interesting papers were read before the members of the Club. The first paper being read by Norman Garstin upon the subject Is Science Inimical to Art? This was followed by a paper by Mr Feeney and afterwards by Folliott Stokes upon the same subject.' Another lecture featured English songs of the 16th and 17th centuries by Harewood Robinson with musical illustrations by members. Alfred East gave a talk on An Artist's Visit to Japan, which was illustrated with lantern slides shown by Rupert Vallentin.

Before the founding of the Arts Club the artists had already established the tradition of 'dinners' to celebrate major events in a painter's life. A menu card dated 1888 reads, 'Complimentary Supper to Adrian Stokes given by his artist friends of St Ives and Lelant.' A facsimile of the painting 'Uplands and Sky' which had been purchased by the Chantrey Bequest, and a photograph of Stokes were reproduced on the menu along with the signatures of 20 artists. All except two of the painters, W H Borrow and Philip Norman, were members of the Club.

Dinners were the special province of the men and ladies were not invited. A dinner was given in the Club room to Arnesby Brown in celebration of his success at the Royal Academy and the purchase of his picture 'Morning' in 1901 by the Chantrey Bequest. Another celebratory dinner was held in 1903 to mark his election as an ARA. He was made an R.A. in 1915.

Treve Curnow remembers — "Father was a master baker and confectioner. We used to do the catering for the Arts Club. On President's night we provided a running buffet. The things we made were out of this world, game pies, fish pies, vols-au-vent, various sandwiches and salads, meringues, iced puddings, French and Genoese pastries, Venetian jellies and creams. They really went to town. The cost was one guinea per head."

Acceptance of the artists was complete when their worth

Men Must Fight and Women Must Work, *Frank L Emanuel.*

Japan but often returned to St Ives and the Arts Club, where there was great friendly rivalry between Hemy and East on their reputations as raconteurs. East was still visiting the Club when he was knighted in 1910.

In 1889, the director of the Fine Art Society, Marcus Huish, sent Alfred East to Japan to record in pictures the life and landscape of the country. Sixteen of these paintings were exhibited in 1991 at the Fine Art Society in Bond Street 'British Artists in Meiji, Japan 1880-1900' as part of the celebrations of Japan week.

Collections of his work are held in the major cities of Europe and USA, also in the Alfred East Art Gallery, Kettering, his home town in Northamptonshire. His work was said to avoid realistic trivialities and sought qualities of decorative expressionism which gave significance to open air and space. East was often to be found working on six-foot canvases in the open in St Ives.

In 1913 Sir Alfred was elected a member of the Royal Academy but died the same year. Lady East wrote to the Club thanking them for the wreath sent to her husband's funeral. *The St Ives Times* described him as a man of kindly nature, appreciator of other men's work and always ready to help younger artists. They had lived at 5 The Terrace.

Frank Lewis Emanuel was another early member. In 1892 he was staying at Albany House, St Ives with his parents. He studied at University College, London, the Slade School and Juliens in Paris. He was special artist with the *Manchester Guardian* and also wrote for the *Architectural Review.* He was known as a painter, etcher, designer, teacher and writer and chief examiner for the Royal Drawing Society. His brother Walter wrote articles for *Punch.* In 1912 the Chantrey Bequest bought for the nation his painting 'A Kensington Interior', which is in the Tate Gallery. Most of his paintings were burnt in a fire at his home in later life.

Terrick Williams studied briefly at the Westminster School of Art. His source of influence was Impressionism

was recognised at official functions. It was now customary to toast 'The artists of St Ives.' At the Mayoral Banquet held at Porthminster Hotel in 1899 the retiring Mayor was Mr Edward Hain MP. Among his guests were members of the Arts Club, R S Read, who was also a director in the Hain Shipping Line, and artists H Robinson, T M Dow, M Lindner, A Meade, J Olsson, E G Fuller, and T A Lang. W H Y Titcomb replied to the toast on behalf of the artists.

Among the early members of the colony was Sir Frank Brangwyn who was born in Bruges. He was a painter, etcher and mural painter. He worked under William Morris at the age of 15 and afterwards went to sea. It is interesting to note that when Brangwyn was asked by his biographer whether he sold any of his works, he said — 'Yes — the local doctor bought from me, which helped me along. The doctor, who was called Grier had two brothers; both of them clever artists, one was well known in Canada; the other well known in St Ives.' They were Wyly and Louis Grier. The brother referred to was Dr Charles W M Grier of Mevagissey. Brangwyn continues, 'I'm afraid I wasted a lot of my time going along with the fishermen. When I look back and think of the work I might have done there, oh dear me! ... I often returned to Cornwall for painting excursions.'[20] The Chantrey Bequest bought his work 'A Poulterer's Shop' in 1916.

Sir Alfred East was a frequent visitor to the town. He travelled widely on the Continent, to North Africa and

Breton Fisherwomen, *Terrick Williams. David Lay.*

Visitors to Studios on Show Day. E. Cross.

and his inspiration Brittany and the Cornish Coast. He worked in Mousehole, Brixham, Mevagissey and St Ives and travelled widely in Europe. He portrayed the fleeting effects of light and shade in tonal colours. His work 'A By-Path', was first shown at the Academy in 1888. As president of the Royal Institute of Painters in Watercolour he is remembered for gaining equal rights and full membership for women painters.

Show Days

Show Day was a yearly event and took place in March on one day only. Whatever the weather, its popularity attracted large crowds of visitors and townspeople to view the paintings of resident artists, whose studios would be open to the public, and the pictures shown destined for the Royal Academy, Paris Salon and other major exhibitions in the UK and Europe. The Arts Club printed 300 Show Day lists of exhibitors and played host to visiting painters, providing teas for artists and their guests. Invitations were sent to the Newlyn and Falmouth artists, Lord St Levan, the Bolitho family at Penzance, Roger Tyringham, Dr Boase and many notable people in the County.

Various exhibitions of paintings would be held independently throughout the year in artists' studios, The Piazza, Porthmeor, St Andrew's Street, Tregenna Hill, Back Road West and The Harbour, being those most frequently mentioned, as well as those organised by Lanhams Galleries.

Lewis Hind wrote that there were 70 or 80 studios occupied during the winter months. 'More pictures are painted in Cornwall in the course of the year than in any county. The great centres are Newlyn, St Ives and Falmouth, and the votes of the Cornish contingent, it is said, can turn the scale in an election at the Royal Academy.' He also described the scene on Show Day.

'When the skipper of the tramp steamer that sought shelter at St Ives on picture Show Day came ashore he must have exclaimed as he paced the steep and narrow streets, shiver my timbers — or whatever expression modern mariners employ — it's a bank holiday! All day the population swarmed and gazed. In the huddle of

studios that are packed away on the Porthmeor shore, against whose granite foundation walls the Atlantic breakers dash, one could move neither backwards nor forwards. Fishermen and painters stood like sculpture figures on the open staircases that shoot this way, that way and upwards from the ground. In every studio you were jostled by a wide-eyed crowd of gazers. The Cornish are a silent race, remarks were infrequent; but I heard one old Cornish dame say of a broadly painted, slap-and-dash seascape; "It looks likelier, my dear, the further you go away from it." That old dame had the root of the matter in her.'[21]

Show Days created great public interest. The Great Western Railway ran extra trains to cater for all the visitors to the studios in the fishermen's quarter of Downalong. Miss Tillie Thomas, aged 90, said, "I remember as a child going to all the studios on Show Day where the artists showed all their season's work. We would go with the school." Miss Sarah Escott explained, "It used to be the custom before sending the paintings to the Royal Academy that the artists opened their studios for the entire town to come and view. We traipsed up and down steps, in lofts over fish cellars. It was amazing that they could live and paint such beautiful pictures in quite primitive conditions."

The Royal Academy

The peak of achievement for artists after their Show Day was for their pictures to be hung in the Royal Academy. This was their main aim, followed closely by the Paris Salon and other important galleries in London and the provinces. Lewis Hind was at the Academy writing as art critic for the *Art Journal* and *The Academy*. Press Day at the Royal Academy meant that writers and critics had their own viewing day and etiquette dictated that members of the Academy should not be present in order to allow the paintings to speak for themselves.

There was much dissatisfaction concerning the amount of hanging space available at Burlington House but in spite of the odds against being hung in the Academy the submissions from St Ives were very high. At the turn of

Judging the Pictures at the Royal Academy, 1894. Black and White Handbook.

the century roughly 12,000 pictures were sent from all over the country and only 2000 accepted. An article in the *Western Morning News* complained that half the space was earmarked in advance for the works of Academicians and Associates and the space left was sufficient to hang only two or three hundred pictures, most of them being above the line. 'The outsiders, with the exception of those in immediate running for Academic honours, generally confined their contributions to small examples, knowing that their size would be their greatest recommendation to the Hanging Comittee.'

'Such a state of things practically stops the production of ambitious work, and its effects are and must continue to be highly detrimental to British art. In France, The Salon, which fulfils the same purpose as the English Royal Academy, contains five times the amount of hanging space, and this is supplemented by another exhibition, nearly as large, for works rejected by the latter. Is it too much to ask that the RA organise a second exhibition in which the best of 13,000 rejected works could be shown?'[22]

St Ives artists enjoyed great success in getting their pictures hung. In 1896 it was reported 'The old town by the Cornish sea is represented in every room in Burlington House. We cannot doubt that St Ives will now be more firmly established than ever as the most successful and popular Art resort in the West of England.' The following year 30 members of the colony had their work hung.

After the Royal Academy Summer Exhibition there was a general movement of artists to Italy, France and London but sufficient numbers remained to sustain the Arts Club, and at the same time there were many visiting painters.

'Now that the bustle and excitement of Academy time are well over St Ives appears almost deserted by its artist population. The jolly little fraternity which met nearly every evening at the cosy Arts Club, to discuss the day's doings and each other's pictures, has nearly entirely disappeared. Among those who remain, Will E Osborn has stayed on to complete a charming picture of twilight.'[23]

In spite of the comings and goings of its resident artists St Ives was still full of artists in the summer; principally art students from London and Paris, who often came to study with Grier and Olsson for marine paintings, and to the school run by Algernon and Gertrude Talmage. Individual painters each had a number of students. The artists were attracted by the idealised view of the town and its growing reputation as an artists' colony.

The Chantrey Bequest

The donor, Sir Francis Chantrey RA, left money in his will for the purchase of works of art to establish a national collection. Paintings and sculpture bought under the terms of the Chantrey Bequest from the Royal Academy were presented to the Tate Gallery for the nation. Purchases required the following conditions — A recommending committee consisted of three represent-atives of the RA and two from the Tate. A selection of

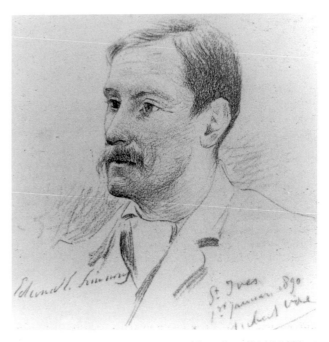

Edward E Simmons, American painter. Magazine of Art, *1890.*

works was submitted to the Council of the RA who made the final decision to purchase. The Tate also selected works to submit to the Council but there was much criticism of this 'in house' selection. The Tate from time to time would suggest works by living or deceased artists which they regarded as desirable acquisitions.

Criticism of the Chantrey Fund selection methods eventually erupted into a national scandal when it became apparent that the Academy Council had amassed a large collection of works from fellow academicians and given them a permanent home in the Tate, to the alleged detriment of British Art. Questions were asked in Parliament, the matter raised in The House of Lords and a Select Committee appointed to investigate. The chief complaint was that the works were not of the highest standard. Changes were made after the Select Committee reported its findings in August 1904.

'Owing to MacColl's attack on the administration of the Chantrey Bequest, exhibitions other than the Academy were now visited, for the purpose of the Bequest, by members of the Royal Academy Council.'[24] An associate was elected to serve to represent the younger artists. George Clausen, who was on the Council for the Chantrey Bequest, widened its scope by visiting the New English Art Club, of which he was one of the founders, looking for work to purchase for the nation and for Australia.

Edward E Simmons v. Royal Academy 1890

The Weekly Summary's round-up of The Studios of March 1890 says of Mr Simmons' painting 'John Anderson, My Jo, John' — 'we find it difficult at first to speak. A picture, with two full-length figures, without a face!.' The subject showed a fisherman, with his head turned away from the viewer, as he stoops to kiss his wife. 'That this bold departure from received canons will provoke criticism there can be no doubt.'[25]

The painting certainly provoked some action. It was hung in the Royal Academy but Simmons complained that the picture had been wrongly marked 'sold.' He asked for an explanation. Receiving no admission of fault from the President of the Royal Academy and the Hanging Committee, he consulted his legal adviser. It was forecast in St Ives that if the action came to Court it would be one of the great events of the season.

In Simmons' own account of the battle with the Royal Academy, the picture is named differently although it is obviously the same one. 'The next year I took courage and sent another canvas to the Academy — this time an inoffensive thing of an old man kissing his wife goodbye — which I called Darby and Joan. Through some mistake, it was marked "sold" in the book. Some of my friends seeing this telegraphed me congratulations, I being away down in Cornwall.'

'It was customary to notify the artist as soon as a sale was consummated and, as I heard nothing, I wrote to the secretary and asked him to confirm it. He answered that the picture was not sold. All through that exhibition my picture was hung and marked "sold," thereby preventing anyone else from buying it, and this in spite of the fact that I wrote to protest about it three times. Then I did a terrible thing! I issued a writ against the Royal Academy! British honor was sullied, British institutions had been assailed. Never before had anyone dared to invoke the law against that august and distinguished body — the Royal Academy! My final letter ran something like this, "Dear Sir — In my country, when dealing with gentlemen, I get an answer. In dealing with you, I do not. I appeal to the law".'[26]

An article in August reported — 'The Council of the Royal Academy of Arts has made to Mr Edward Boase, as solicitor to Mr Edward E Simmons, the American artist now residing at St Ives, ample apology for having at the recent Academy exhibition wrongly marked his picture, John Anderson, My Jo, John, as sold. Mr Simmons has accepted the apology, and the matter is now, so far as Mr Simmons is concerned, at an end. The thanks of the artist world are undoubtedly due to Mr Simmons for the plucky stand he has taken in the matter, and he may be congratulated on having practically elicited from the Council of the Academy an admission of their legal obligation to exercise proper care in the registration of the sales of pictures entrusted to them by artists, an obligation which they have up to the present been very careful to ignore.'[27] Simmons said he received a large parchment apology from the Trustees of the Academy.

Although the Royal Academy was still the most prestigious institution and dominated the art world many painters were already seeking alternative galleries with a more enlightened attitude to the artists and more modern works, but it needed an outsider, the American Simmons, to offer an open challenge to the supreme authority of the RA. He was described as a witty conversationalist and something of a Bohemian who was equally at home in sophisticated Paris, the wildlife backwoods of America or on the quiet shores of Cornwall.

Nearly 45 years later, Adrian Stokes created a storm at the Royal Academy when he interrupted the speech of the Prime Minister, MacDonald, at the RA Banquet saying, 'Why not say something about the exhibition.' He justified his interjection by complaining that every year the paintings were ignored by speakers and artists treated as if they were not worthy of consideration. Fortunately the remark created laughter and the The Prince of Wales, who was present, was reported to be much amused.

New English Art Club

The founding of the The New English Art Club in 1886 was proposed by William Henry Bartlett, who with Fred Brown, Henry Scott Tuke, T C Gotch, and W J Laidlay, as their first Chairman, and other English painters who had studied in Paris, felt their work to be out of sympathy with many of the paintings that were being accepted for exhibitions.

The New English Art Club engendered a feeling of progress and opposition to the conservatism of the established societies, especially the Royal Academy. There were 81 pictures hung in the first exhibition, which was held in The Marlborough Gallery — all exhibitors voting for the paintings. The painters had joined an egalitarian society where 'members possess no privileges, work is judged and accepted on its merits without personal bias.'

Early NEA members were T Millie Dow, Arthur George Bell, Henry Detmold, Emanuel P Fox, Alfred Hartley, Adrian and Marianne Stokes, Alfred East, Julius Olsson, W H Y Titcomb and Moffat Lindner.

Some years later the New English Art Club still held its title of New Gallery and in an article for *The Standard* it is stated, 'The banal, the entirely stupid, the merely popular is, for the most part avoided. The New Gallery gives an opening now and then to painters who do not go to the Academy at all, and a few young artists of great promise — here and there perhaps of genius — prefer certain and courteous hospitality to the chance of competition at Burlington House.'[28] Complementing galleries and societies, which exhibited their work, the painters gathered together in various artists' clubs where they met for social occasions. That an Arts Club was formed in St Ives was certainly because most of the artists belonged to clubs in London such as the St John's Wood Arts Club, Chelsea Arts Club and the Dover Street Arts Club. In the reception hall of the latter hang two of the members' paintings, Julius Olsson and Adrian Stokes, both works escaped the bomb when the building was severely damaged in the second world war, but many historic documents and membership books were lost. Nevertheless, the members lists of 1889 and 1892 contained the names of 20 members of St Ives Arts Club.

James Lanham Gallery

Lanham's played a major role in the life of the artists' colonies of St Ives and Newlyn. They exhibited their work in the gallery, bought their materials, rented their houses

and studios and, very importantly, this was the source for framing their pictures for sending to the Royal Academy and other galleries.

James Lanham was a man of some enterprise, he started business in the High Street in 1869 with a general merchants store. He later included a stock of artists' materials. The story of how this came about was told by Miss Agatha Johnson, who in turn heard it from the painter, Arthur White.

"Whistler used to visit the shop, sit on the counter and talk to James Lanham. One day he said to him, 'I have to send all the way to Cambridge for my paints, why don't you start selling paints?'" This advice was apparently taken up and Lanham's are still selling artists' materials today. Whistler also predicted that one day St Ives would be recognised as a great artists' colony.

Lanham travelled once a week to the Newlyn studios and the Stanhope Forbes School of Painting with a supply of paints and artists' materials. Sir Alfred Munnings, painter of horses, wrote in his autobiography, 'I see myself with a thirty-by-twenty-five-inch canvas — beautiful canvas from Lanham's with a surface on which any artist would have loved to paint'. Laura Knight had first introduced him to these canvases. Another canvas was prepared for a picture of a black and white cow. 'Painted on another of Lanham's canvases, this time with an absorbent, china-clay priming... a tribute to the canvases prepared in those days at St Ives.'[29]

Mr Lanham, having premises of a reasonable size, decided to extend his activities in the artistic field and open a gallery for his painter friends in West Cornwall. There are two conflicting dates for the opening of the gallery.

W Badcock in *Historical Sketch of St Ives* 1896 wrote, 'In the year 1887 a small gallery for the exhibition of works by members of the community was, at the insistence of the artists, opened by Mr Lanham. It has since been enlarged and improved. Pictures are selected and hung by a Committee of Artists chosen by the Exhibitors from amongst themselves.'

August 1889, *The Cornishman*. 'A new art exhibition for the West of England has sprung into existence, and the quaintly attractive town of St Ives bids fair to become a centre, where the celebrated artists at St Ives, Nelwyn, and other parts of West Cornwall will group together their works for the benefit of the public and themselves until the nucleus will expand and obtain a widespread and favourable reputation. The credit of originating this idea is due to James Lanham, the well known importer of artists materials and he has borne the entire expense of tastefully decorating a room over his extensive warehouse, where the paintings are set off by a back-ground similar to that in vogue in all great exhibitions.'

The Hanging Committee

The first hanging committee consisted of Adrian Stokes, Simmons, Robinson and Louis Grier, who let it be known that the exhibition was small but good and that no amateur or mediocre professional artists need apply as sufficient numbers of good painters were willing to contribute.

Among those exhibiting at Lanham's were Simmons, whose 'St Ives Bay By Moonlight' was hung in the RA in 1889. He showed 'Off The Island' and 'The Abandoned Clearing'. His wife Vesta showed 'Sketch at Evening' and Miss Elizabeth Adela Armstrong (Forbes) 'Three Blind Mice'. Two sketches by J D Mackenzie. Other painters were Frank Bramley, whose picture 'Saved', was purchased in 1889 for the Chantrey Bequest for £640, Harewood Robinson and wife Maria. Wyly Grier showed 'Evensong' — his picture, 'Bereft', was hung in the RA This was painted in the woods by Knills Steeple.

The list continues, Louis Grier, Marianne Stokes, Blomefield, Alexandrina Laurence, Olsson, Detmold, 'Evening In a Cornish Village', Sydney Laurence, 'Ebb Tide', and Eadie, whose picture at the RA was 'The Interior of St Ives Parish Church'. Other artists who promised works were Percy Craft, whose picture 'Heva' was hung in the RA, C G Morris, Frank Brangwyn, Chevallier Taylor and Tuke, who took the Chantrey prize in 1889 for 'All Hands To The Pumps'.

It was important for St Ives painters to have a gallery in the town because, apart from the artists' studios, this was the only place where the public could view pictures, and painters exhibit their work all the year round.

Extract from *The Artist* 1894: 'The selections and hanging are on purely artistic lines, the commercial element, which is usually the prevailing one in small exhibitions, being entirely avoided. And though the good curator and business manager, Mr Lanham, sometimes appears dismayed at the number of pictures rejected each month, yet the sales have been very good.'

An article in *St Ives Weekly Summary* of 1896 from the *Westminster Gazette* quotes, 'An enterprising tradesman — beyond doubt, has set up an excellent shop, where can be bought the choicest French and English colours and canvases, and — strangest feature of all in a far-west fishing town — a permanent picture gallery. Here the artists show their works — such of them as safely pass the ordeal of the hanging committee.'

The Hanging Committee for Lanham's Gallery was always in the hands of painters from the Arts Club. They were responsible for the selection and display of work and James Lanham was entirely happy with this arrangement since it attracted artists of a professional standing — the very same who bought canvases, paints and who required framing services and needed their paintings transported to galleries throughout the country. In April 1897 Noble Barlow, Louis Grier, Lowell Dyer, Harewood Robinson and W H Y Titcomb insisted on two rule changes:

'It was resolved that members of the Committee should not vote on the works of their pupils'
'Exhibitors may not have works on sale in any other Public Gallery or Shop in St Ives.'

Packing Pictures for the RA at Lanham's. E Cross.

The Committee consisted of 6 members, elected every 6 months. Only artists were entitled to vote. Others who served on the Committee were — A Stokes, Dow, Olsson, Talmage, Arnesby Brown, Lindner, F Stokes, D Davies and Elmer Schofield.

The Weekly Summary published an advertisement for Lanham's: 'West Cornwall Gallery of Fine Arts, James Lanham's High Street, Paintings by artists resident in St Ives, Newlyn and West Cornwall.' Lanham's also dealt with studio lettings. An advertisement of 1892 reads — 'To be Let, Mr Wyly Grier's magnificent studio overlooking Porthmeor Beach.' James Lanham also acted as agent for some of the painters. '1897. Exhibition of pictures and sketches by Sydney H Carr at his studio, Porthmeor — apply to Mr Lanham to view.'

James Lanham

Lanham made himself familiar with the work of local artists and if a visitor expressed a desire for a particular type of painting, he would know which studio and which artist could fulfil that requirement. In a recent house sale in St Ives a painting by William Wendt was discovered. It was exhibited at the Royal Academy in 1899 and the wording on the picture reads, 'To my friend James Lanham.' Wendt was born in Germany but lived in America. Several of his works are in the Chicago Museum. Doubtless Mr Lanham received many pictures from his artist friends.

A painting by Sydney Mortimer Laurence, now in Alaska, still retains its original framer's metal tag, 'James Lanham, artists colourman, St. Ives, Cornwall.' The picture is of boats at Falmouth.

James and Lucy Lanham liked to play host. The Retreat, their Georgian house in Street-an-Pol, was the venue for many a musical evening and artists were both visitors and entertainers. When Mrs Lanham died in 1899, among the resident artists who attended the funeral were Mrs Chadwick, Julius Olsson, William Wendt and Gardner Symons. The house was eventually demolished to make way for the Guildhall, despite the attempt by the artists to preserve it as an architectural feature.

Virginia Woolf included Lanham's in her book, *Moments of Being* — '...in retrospect, probably nothing that we had as children was quite so important to us as our summer in Cornwall. To go away to the end of England; to have our own house, our own garden — to have that bay, that sea, ... to hear the waves breaking that first night behind the yellow blind; to sail in the lugger; to dig in the sands; to scramble over the rocks ... to have a great dish of Cornish cream ... to go down to the town and buy penny boxes of tintacks or whatever it might be at Lanham's: Mrs. Lanham wore false curls all round her face: the servants said Mr Lanham had married her "from an advertisement." I could fill pages remembering one thing after another that made the summer at St Ives the best beginning to a life conceivable. When they took Talland House, my father and mother gave me, at any rate, something I think invaluable.'[30]

1890

Adrian Stokes, first President of the Arts Club:
Stokes was a landscape, portrait, genre, historical and literary painter. He was educated at the Liverpool Institute, studied at the Royal Academy Schools and in Paris under Dagnan Bouveret. He first exhibited at the RA in 1876 and in 1888 the Chantrey Bequest purchased his painting 'Uplands and Sky' for the nation. In 1903 'Autumn in the Mountains' was bought for £300 for the Tate. In 1889 he was awarded medals at the Paris Exhibition and Chicago World Fair. He was elected an RA in 1919.

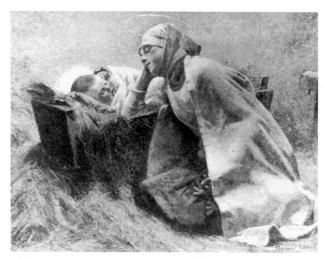

Light of Light, *Marianne Stokes.* Magazine of Art, *1890.*

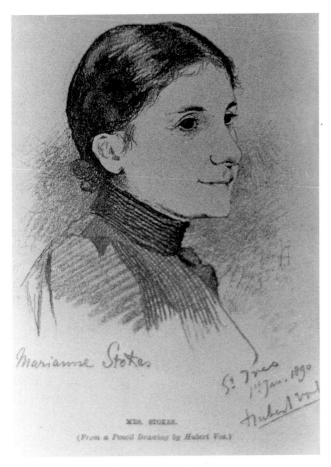

Marianne Stokes, 1890. Magazine of Art.

'The Convalescent' was painted in St Ives by her friend, Helene Schjerfbeck.

The Stokes lived at Lelant and also 15 The Terrace, St Ives, and had a studio in Virgin Street, which was later burnt down. They made frequent trips to Austria and travelled extensively in France, Spain and Italy. During the First World War the Stokes were interned in Austria, along with John Singer Sargent, who was travelling with them at the time. They turned this to good account and settled down in the village of Colfuschg where they continued to paint.

1890 was a good year for the Stokes family. Both Adrian and Marianne had paintings accepted and hung in the Royal Academy. One of his was 'Off St Ives'. Her painting 'Hail Mary' was then shown in Chicago, where it gained a medal in the British section.

W H Y Titcomb's picture 'Gossip', was accepted in 1890 along with 'Primitive Methodists', which had won a medal at the Paris Salon. Captain Dick Harry, aged 85, was the central figure in 'Primitive Methodists at Prayer', and when he died in October 1890 Titcomb attended the funeral. Old Captain Veal sits on a bench with his back to

The artist and writer on Cornish subjects, Folliott Stokes, was a cousin and the architect and one time president of the R.I.B.A., Leonard Stokes, who designed Chelsea Town Hall, was his brother. There were two other brothers with successful careers but only Leonard visited the Arts Club.

Marianne Stokes was born in Graz, Austria. A portrait, genre and biblical painter, she studied under Lindenschmidt in Munich and spent ten months studying in Paris with the artists Raphael Colin and Gustave Courtois, as well as en plein air with the painters in Brittany. Her early work shows the influence of the pre-Raphaelites and Bastien Lepage.

In 1885 the Walker Art Gallery purchased her painting 'A Parting'. It was a realistic painting of a child with a calf and was described as 'an avant garde choice' for the period. It was first shown in the Paris Salon in 1884, signed Marianne Preindlsberger, where it received an honourable mention. After her marriage to Adrian this same year she countersigned with her married name. The first picture Marianne showed at the New English Art Club was 'Polishing Pans' in 1887. It was also exhibited at the Walker Art Gallery and is in their collection. In 1888 a painting done in St Ives 'Mending the Sail' was exhibited at the NEA. Another painting 'The Red Dress' may also have been painted in 1888 since the same model of a child sitting in the same chair in the same year called

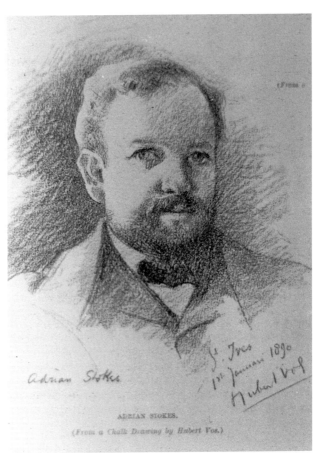

Adrian Stokes, 1890. Magazine of Art.

Primitive Methodists *1889, W H Y Titcomb. Primitive Chapel, St Ives.*

the spectator. Louis Grier posed as the minister. A writer for *The Magazine of Art* of 1890 stated, 'The Cornish School are very much in evidence at the Academy.'

A painting by Sydney Laurence was shown at the Royal Society of British Artists in 1890. It is described, 'L'Epave represents the skeleton of a large ship stranded on a desolate shore. This is the most surprising work of the kind in the collection and certainly one of the best. The

sunshine on the wide stretch of sand modified by moist mist, the more brilliant gleam on the distant sea and the deep but luminous shadows are rendered with subtle skill.' The wreck is on Porthkidney sands. St Ives is seen in the distance. This painting was owned by a 95 year old member of the club, Harry Nankervis. It was bought from the artist by his uncle, who was a sea captain. After his death it was sold at auction and went to America.

KAKM Alaska Public Television, with director Eric Wallace and producer Rachel King, visited St Ives in October 1989 to make a filmed biography of the life of Sydney Mortimer Laurence. The extensive wardrobe of the club was made freely available and the valuable collection of Victorian and Edwardian costumes were worn by seventeen members of the club who acted as extras. Simon Ough, a junior member, played the part of Sydney as a boy on an old timber masted sailing ship at Dartmouth. Filming also took place at the Arts Club with a reconstruction of the model class and in the Victorian conservatory at Treloyhan and in the cobbled streets of St Ives.

In 1991 the film *Laurence of Alaska* won two Emmy Awards. These were presented to Eric Wallace for directing and Kim Daehnke for photography.

In 1889 Sydney Mortimer Laurence and Alexandrina, both painters, were married in New York and came to St Ives the same year. Ten years after their marriage Sydney Laurence and Mrs (Alexandrina Dupre) seemed to be living apart. Sydney was advertising in the local paper for a studio from his address at Albany Terrace and Alexandrina for a good general servant from her address at Zareba, Treloyhan Hill.

Sydney settled in Alaska and Alexandrina stayed in England. There were two sons from the marriage, one born in St Ives and the other in Kent. Mrs Laurence visited the Arts Club in 1912 as a guest of Daisy Whitehouse, giving an address in Coventry, and again in 1916 with Sarah Whitehouse.

Wreck on Porthkidney Beach, *Sydney M Laurence. H Nankervis.*

Arts Club members in TV film 1989 with actor David Schneider. KAKM, Anchorage

Laurence painted boats, coastal scenes and landscapes but is identified as Alaska's primary painter of Mount McKinley, one of the highest mountains in the world. At one time he spent several months in a cabin, which he built himself by the mountain, making an easel out of his dog sled. The journey had taken him four months to accomplish. He completed 40 sketches during his lone sojourn with Mount McKinley. Much of his work is now in the Anchorage Museum.

Sir Leslie Stephen and Talland House

In April 1891 Leslie Stephen was elected President, but he did not fulfil his term of office. His name is not written on the roll of honour of past Presidents. The reason for his not taking up the appointment was noted in the local paper, 'The health of Mr Leslie Stephen is steadily improving.' He suffered a serious breakdown in 1889, which recurred in 1891 causing him to resign his editorship of the *Dictionary of National Biography,* which he had worked on since 1882, after which Sidney Lee took over as sole editor. However he was sufficiently recovered to resume his literary interests by 1894 when he presided at the Annual Dinner of the Society of Authors in London.

The Stephen family occupied Talland House as a summer residence from 1882-94. The writer Virginia Stephen (Woolf) and painter Vanessa Stephen (Bell) spent much of their childhood at St Ives and it is likely that they visited the Arts Club with their father.

Stephen's portrait was painted in St Ives by Bosch-Reitz. It is the only time the artist showed at the Royal Academy. *The Spectator* made particular note: 'There is one other capital portrait in the Gallery and one that is likely to be passed over because the name of the artist is unfamiliar, and his work is carefully concealed in the farthest corner upstairs; it is a head of Mr Leslie Stephen by Mr Bosch-Reitz. It is pleasant to record this association of Art and Literature in the persons of Mr Bosch-Reitz, the popular St Ives artist, and his subject, Mr Leslie Stephen, who from long residence may almost be claimed a St Ives man.'

Leslie Stephen was among the first rank of Victorian 'Golden Age' mountaineers, and the first climber to record this activity in Cornwall. In 1858, the year he joined the Alpine Club and ascended Monte Rosa in Switzerland, he also recorded a rock climb 'gangling and prehensile' at Gurnard's Head, giving the now popular sport of sea cliff climbing a starting date. He was president of the Alpine Club from 1865-68 and the editor of the *Alpine Journal* from 1868-71.

Walking was another major interest. He had formed a society of Sunday walkers, 'The Tramps' in 1879 which continued until 1884, consisting of many of Stephen's eminent contemporaries. Among his achievements was a walk from Cambridge to London, some 50 miles in 12 hours. In 1890 the writer Edmund Gosse and his wife Nellie were staying at the Tregenna Castle. He writes, 'We went to St Ives to be near Leslie Stephen, with whom I took immense walks of a wholly speechless character. He and I went to the wrestling at Redruth I remember.'[31]

Lane in St Ives, *Sydney Mortimer Laurence, 1891. M.Reed.*

Stephen's children regularly took walks with him in West Penwith. He had first discovered Talland House when on a walking tour in Cornwall in 1881. Walking was important to Virginia, especially when she came to Cornwall. Mrs Proudfoot, local resident remembered, "In 1908 Miss Stephen lodged with my mother at Trevose House. She came to St Ives on her own. She went walking on the moors. She was a bit of an eccentric." (she was joined a week later by Vanessa and Clive Bell). Virginia describes the visit of 1908 in a letter to Lytton Strachey. '22 April 1908, Trevose House, Draycott Terrace... I have a sitting room, which is the dining room, and it has a side-board, with a cruet and a silver biscuit box. I write at the dining table, having lifted a corner of the table cloth, and pushed away several small silver pots of flowers.'[32] She wrote to Lytton that she was going to walk to Trencrom. This is a hilltop in St Ives from which St Michael's Mount and Penzance can be viewed on one side and Godrevy lighthouse and the Bay of St Ives on the other. Memories and the love she held for St Ives are evident in Virginia Woolf's novels, especially *To The Lighthouse,* which gives an insight into the characters of her mother and father. Godrevy lighthouse could be seen from the children's nursery at Talland House, from Porthminster Beach on which she played and from the Arts Club window.

Mrs Julia Stephen's concern was for the poor and sick in

St Ives. Her attention had been called to several cases of distress in the town and she raised subscriptions to engage a nurse to serve the poor in cases of accident and sickness. In 1892 she wrote a letter to the Editor of the local paper: 'The want of a certificated nurse for the sick poor of St Ives has long been felt. At Penzance, Marazion and Newlyn such nurses are worked with success and a committee of ladies is now formed in St Ives which undertakes to superintend the working of a nurse should funds be procured. The patients are required to pay nothing for the care they receive and all are nursed irrespective of creed or position'

After her death in 1895 the Julia Prinsep Stephen Nursing Association was set up in St Ives in her memory, with a donation of £200 from Leslie Stephen. *The Western Echo* reports in 1901, '2248 visits have been made to 66 patients during the last 12 months ... the poor have always the first claim in the nurse's services without charge.' The first President of the St Ives Nursing Association was Miss Stella Duckworth, daughter of Mrs Stephen's first marriage. The Committee were Mesdames E Hain of Treloyhan, T B Bolitho and R S Read. Mrs Florence Millie Dow and Vanessa Stephen joined the committee at a later date, although by this time the Stephen family had moved permanently to London and the painter Millie Dow and his family occupied Talland House.

After Julia's death Leslie Stephen lamented the loss of the family summers, 'all of which were passed in Cornwall at St Ives. There we bought the lease of Talland House: a small but roomy house, with a garden of an acre or two all up and down hill, with quaint little terraces divided by hedges of escallonia, a grape-house and kitchen-garden and a so-called orchard beyond. Every corner of the house and garden is full of memories.'[33]

There is a story in the Dow family of Thomas Millie Dow's visit to Talland to negotiate the lease of the house and of Leslie Stephen putting his finger to his lips, saying 'shush', lifting a floorboard and whistling; several rats emerged from below the floor, which he fed with some cheese, then suddenly clapping his hands they disappeared from sight. This obviously didn't deter the Dows from taking the house.

1891

Adrian Stokes, President

With the illness of the elected candidate Leslie Stephen, Stokes served another year as president. Marianne and Adrian Stokes were among 12 St Ives painters whose work was accepted at the Royal Academy. *The Times'* comment for this exhibition was that if one were to select a single picture from the rooms, it would be the 'Edelweiss' of Mrs Adrian Stokes, a picture in which a delicate symbolism was happily interwoven with modern and realistic feeling. The painting was purchased by the Prince Regent of Bavaria.

The Arts Club yearly membership was between 70 and 80. Bill Williams, (husband of Mary Williams the novelist) described the building in earlier times: 'The entrance to the club-room was up a very steep flight of stairs, a glorified ladder, so to speak, with a rope serving as a handrail. Underneath was a carpenter's shop with its usual pile of wood shavings. The illumination in the club-room was by oil lamps and candles.'

Suggestions Book:
'That a rope be provided for the stairway' (This was signed by lady members, for whom it would be difficult and dangerous to climb stairs in their long clothes)
Alexandrina Laurence, Annie Bruce Eadie, Alice E.Gillington, Anna Dyer
Someone has then added —
'P.S. And at the end of the rope a piano!'
Signed — Wm Eadie, A Conquest, W H Lanyon, E W Blomefield, A J Warne-Browne, S M Laurence, C Latham, C L Greenfield, H H Robinson.
'That a thing to hold a candle should be placed on the writing table — the beer bottle is of course useful but not decorative.'
Louis Grier
'That a jar of ink be supplied together with a few respectable pen nibs for the use of members.' W H Lanyon

Storm of 1891

Shortly after this entry there was a question of whether the club could continue when the building was nearly demolished by a storm during which a tremendous sea came rolling into the Bay followed by a gale force north-easterly wind. The tide was at its highest and the sea dashed right over the houses in The Warren. The gale continued during the night and on Friday morning it was discovered that a corner of the building of John Jenkyn's carpenter's shop had been washed away. A considerable quantity of wood had been smashed to matchwood. It was feared that unless the weather moderated the next high tide would sweep away the carpenter's shop together with the upper floor, the rendezvous of the St Ives Arts Club.

Arts Club with giant wave, 1991. Leon Suddaby.

Fishergirl at St Ives, *H Harewood Robinson. Queens Hotel, Penzance.*

from drowning. He was taken to his home and Dr Nicholls was quickly in attendance.'

> Suggestions Book:
> 'There is a decided feeling that the roof should be put in proper repair, at the present moment 8.35pm, the rain is entering into a tin vessel, the draughts are also liable to cause bad colds and other unpleasant illnesses.' H J Hebblethwaite and 22 other signatures.

1892

Henry Harewood Robinson, President
Robinson had been studying in France in 1884 and he and his wife Maria D Webb, also a painter, were among the early arrivals. He was the first secretary of the club and performed these duties for nine years. He gave many concerts in St Ives for charitable purposes, arranging songs and conducting the orchestra.

Maria was born in Northern Ireland but migrated to Dublin. She studied art at the Atelier Julien in Paris. In

Village Children, *Maria Robinson. Mr and Mrs Farrant.*

Louis Grier gave his personal account of the storm: 'We were going through a period of stiffish weather, I announced the interesting fact to my landlady at breakfast that while dressing I had seen a considerable portion of the Arts Club washing round the island head on an excursion up the English Channel. My eyesight had not failed me on that occasion, and a little later on we had a string of painters, clad in sea-boots, sou'westers and oil skins, handing the club furniture through the town to a neighbouring studio for greater safety, as we found the sea had removed a corner of the roof and carried away about a quarter of the foundation, so there was every chance of the whole structure coming down by the run. Carting about odds and ends of furniture is good enough in decent weather, but dodging green seas, as they come sweeping up the alley ways, with rows of hanging lamps swung on poles across one's shoulders, is no joke.'[34]

It was during one such high tide that a boy and girl, children of Matthew Stevens of The Warren, were playing on Pedn-Olva rocks when the boy was swept into the sea. The local paper reported, 'Happily the accident was observed by Mr E W Blomefield from his studio, and he at once rushed into the water and rescued the little fellow

Lowell Dyer in his studio, St Ives 1909. W.G. Batchelor.

Stephen and Miss Stella Duckworth, daughter by her first marriage, were in the audience.

In 1892 Louis Grier travelled back to Australia to exhibit in his native country, being disillusioned with the Royal Academy in rejecting his painting 'The Night Watch' in 1890, which was reported at the time to be one of the 'masterpieces' of the season. A report on the exhibition in Melbourne suggests that his work was much appreciated.

'The best one-man show of pictures yet seen in Melbourne is that of Mr Louis Grier in the old Athenaeum Club rooms. The works shown are mostly seascapes, all painted with a breadth and freedom as free as the atmosphere the artist renders so faithfully. Having decided on a subject and scheme of colour, he works it out boldly and with broad brush, thumb, or palette knife, utterly disregarding all conventionalities and going simply for broad and truthful effect. 'The Night Watch', is also exhibited, which shows Cornish fishermen on a tranquil summer night with a seine net of pilchards.'

Grier showed 61 paintings at the exhibition in Melbourne. However, in October 1892 he was back in St Ives. W Wyly Grier, brother of Louis, was shortly to move to Toronto, Canada.

1893/94
Lowell Dyer, President

Dyer was an American painter, and said to be one of the wits of the community. Horace Kennedy, a grandson of Millie Dow, said Dyer was a great buddy of his grand-parents. He and his wife, Annie, lived in Dow's studio at Talland Side, which had been converted into a house. Dyer is said to have painted an angel and was so thrilled when it was praised that from then on he painted nothing but angels. He was nicknamed the Boston Swedenborgian because he painted angels combining Swedenborg with

1883 she made her debut at the Paris Salon with her picture 'A Breton Farm' painted in Pont Aven. She divided her time between Paris, Brittany and Dublin.

Maria Robinson's painting 'Too Late' was hung in the Royal Academy in 1892 after its debut on Easter Monday when at an entertainment stage-managed by Folliott Stokes it was presented as a tableaux at the Public Hall depicting the five foolish virgins. Also hanging in the RA was her painting 'A Volunteer for the Lifeboat' which measured 5ft. 6in. x 3ft. 9in. and showed a crowded beach scene at St Ives with a mother trying to persuade her young son not to join the lifeboat crew in the emergency call-out. This painting is now owned by the City of Salford Art Gallery.

In the General Election of 1892 Mr T Bedford Bolitho M.P. visited St Ives to address a meeting at the Public Hall. It was presided over by Leslie Stephen, who said he was very glad to have a share with his fellow townsmen in discharging an important political duty. Mrs Julia

Members of St Ives Arts Club 1895. Back left: Bernard Walke (or his brother), Guy Kortright, Wm. Lloyd; front: Fred Milner, Folliott Stokes, Will Ashton, M H Norsworthy.

Saturday Night at the Arts Club, 1895. Standing: Alexander, John Bromley, H Robinson; left: Louis Grier, Maria Robinson, Helen Colter Ludby, unknown man, Lily Kirkpatrick, Daisy and Sarah Whitehouse, Lowell Dyer.

Botticelli. That is the romantic version, the truth (told by his great niece from Pennsylvania on a recent visit) seems to be that his father, Oliver Dyer, who was a reporter on the staff of several New York newspapers, was a Swedenborgian minister in Mount Vernon, New York.

In 1899 his picture 'An Angel' was described as 'an exceedingly interesting and clever study in flat tones. The figure is carrying a cluster of Annunciation lilies.' On Show Day 1919 he was showing a painting called 'A Florentine Angel'. In 1921 Dyer exhibited three decorative panels of angels 'painted in the manner of the late primitives.' He lived in St Ives from 1889 to his death in 1939.

Suggestions Book:
'That one of the Ladies Nights be in future open to all members of the Club and be principally devoted to music.' Signed W H Lanyon, Louis Grier, Pansie A Rainey, F H Bertram, A Stokes.
'That one of the Mens Nights be in future open to all members of the club and be devoted to drawing.' L Grier, A Stokes

Obviously the separation of the sexes was not popular or satisfactory and club nights were soon open to all members. The second photograph of 1895, taken by John Christian Douglas, shows a good camaraderie between the men and women of the Arts Club. All are painters.

1895

Julius Olsson, President
Kathleen Olsson, his wife, was also a painter. He was born in Islington, London and in 1890 at the age of 26 he settled in St Ives, where he lived on and off for 20 years. He played an active part in local affairs and was a Justice of the Peace. In 1911 the Chantrey Bequest bought his 'Moonlit Shore' for the Tate Gallery. He was elected a Royal Academician in 1920. He was highly regarded among marine artists for his pure sea paintings. Olsson tried to show the varying colours of the sea, gained from

his wide experience of painting the subject, seeing in the waves 'all the colours of the opal' and he was most upset when the art critic for the *Evening News*, Paul Konody, described his paintings as 'Neapolitan ices.' 'Damn it, what, what?' he would protest whenever the subject arose.

Mr and Mrs Olsson had a house built, St Eia, which is now a hotel. Many of the Arts and Crafts features of the building remain in spite of considerable alterations. Olsson had a large studio adjoining the house, as well as No 5 Porthmeor studios. Although he moved away from St Ives he often returned as a visitor. At one time he lodged at Trevose House on Draycott Terrace and occupied the room over the garden.

From the vantage point of his studio on Porthmeor Beach Julius Olsson painted many of his seascape studies. One such painting is described in the local paper. 'Clodgy Point from the Westward is a grand bit of coast scenery, painted when Nature is in her sternest mood — in a heavy gale. It depicts the rocky headland standing

Julius Olsson with his painting Seascape.

Julius Olsson in his Porthmeor Studio. A.Lanyon.

defiantly out into the storm-swept sea. Against the iron-bound coast the great waves are breaking in magnificent fury, whilst overhead, the angry lowering clouds — full of wild weather — are racing across the darkening sky. It is a picture strong in composition, and so intense in its truth that it must, we feel, bring to Mr Olsson great success.'

'The other marine pictures are Sea, Sun and Shadow, Evening Sunlight, and the largest work of all A Study of Porthmeor. Here we have Mr Olsson quite at home. In his vigour of treatment — his strength of purpose — and his breadth of design — he is all in his glory, when he shows us Porthmeor with its towering seas and its surf-swept beach.'

Lilian Faull, who lived at Ayr Cottage, bought a painting from the artist. 'I was given a cheque for £10 with which I purchased one of Julius Olsson's pictures — an oil of St Ives Bay. But for father's help I could not have bought it.'

A Julius Olsson painting given as a wedding present to Mr and Mrs W H Y Titcomb was cleaned and restored by Mrs Cogan, daughter of the Titcombs, who gave it to the Arts Club. There is a third generation of the Titcomb family who is a member, so spanning the 100 years of the club.

At Christmas 1895 a party was held in Julius Olsson's Porthmeor studio when the comedy 'Our Boys' was performed. This performance was repeated by club artists the same year, with proceeds in aid of the fire brigade, for their prompt action in dealing with the fire which broke out in Arthur Meade's studio in Back Road. The fire was discovered by a neighbour and firemen were quickly on the scene and passed out Meade's partly-finished canvases, but not before they were much blistered with the heat and damaged by water.

Alterations to Club Rules

The club was gaining in popularity and the rules were being tightened. In 1895 it was resolved that no election shall be valid unless 12 votes be given for the candidate. It was a secret ballot and members dropped their vote, which was a black or white ball, through a hole in the top of a ballot box.

Honorary membership was conferred on persons of eminence in literature, the arts and sciences or the learned professions. Mr John Westlake QC., DCL, Professor of International Law in the University of Cambridge, was elected an Honorary Member. John Westlake was born at Lostwithiel. He and his wife, Alice, had a summer residence at Eagles Nest, Zennor. He was a founder member of the Institute of International Law and published a treatise on the subject. They died in Chelsea and have a headstone in Zennor Churchyard.

Grier or Gossen?

It has always been fondly imagined that the man smoking a pipe in the photograph of 1895 has been correctly identified as Grier. However in 1990 a visitor to the club was decidedly of the opinion that it was her father, Franz Muller-Gossen, who was in St Ives at that time. She offered such evidence as the ring on the finger on the right hand in the German tradition, ears peculiar to her family, and the mourning black arm-band worn for her grandfather who died in 1895.

No reference to his work has been found in the local paper of the period but recently some of his paintings have appeared in auctions. The Catholic Church in St Ives had one of his works in their collection and there is a painting at the Queen's Hotel, Penzance. His daughter, Marguerite Bottge, says he was a quiet and reserved man and did not seek the limelight. Louis Grier, on the other hand, with his amusing remarks in the Suggestions Book, his articles and poem looks the likelier personality to be stretched out comfortably at ease smoking his pipe.

Franz Muller-Gossen was expected to succeed his father in his loom-making business but showed a determined interest in painting. His father admitted defeat when, at the age of 15, his painting was accepted for exhibition. He studied for three years in Dusseldorf under Professor Ducker and in 1889, at the age of 18, he made his first trip round the world, after which he continued his studies with Stanhope Forbes at Newlyn and with Julius Olsson.

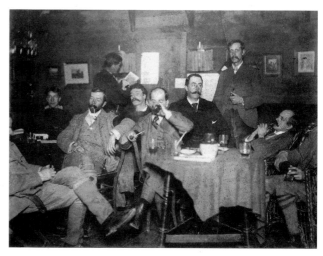

A Saturday night Arts Club, 1895. Left: F W Brooke; back: Alexander; standing: M A Jameson, J Bromley; left facing: L Grier, W E Osborn, J H Titcomb, C G Morris, W H Y Titcomb, W Jevon's legs.

Franz Muller-Gossen in his studio, Munich, 1902. M. Bottge.

Palette of Franz Muller-Gossen, 1890.

Between 1890 and 1899 he lived in Penzance, St Ives and Sennen. In 1892 he married Maria Selzle in the Catholic church at Penzance and two of his four children, a son and daughter, were born in Cornwall. He was a close friend of Charles Napier Hemy.

One of the artist's palettes dated 1890 was given to the club by his daughter in 1990 and reads 'From Cornwall's Coast' showing views mostly in St Ives of Porthmeor, French crabbers in the Bay, Tregenna woods, the island and the Longships lighthouse at Land's End. He often painted pictures on his palettes when the wood cracked at its weakest point.

The Empress and Emperor Wilhelm II paid an official visit to Franz Muller-Gossen's studio in Germany in 1902 and purchased 9 paintings. The artist was appointed marine painter to the Kaiser and when he bought a new boat the artist travelled with him to paint it under sail. Many of Gossen's paintings are in the possession of the European aristocracy. In 1905 he was back in Cornwall teaching painting in Penzance.

He travelled widely, gaining painting experience in France, Italy, Holland, Australia, Japan and the USA. His main interest was in painting the sea and boats and his love of Cornwall was a source of great happiness. During 1914-16 he was interned on the Isle of Man. He settled in Geneva with his wife in 1925, where she died. In 1929 he married Swiss-born Frieda Borner and had one daughter. He did not return to Germany after 1933 because of political events but continued regular visits to Cornwall. He left St. Ives again during the Munich crisis of 1938 and died in Lausanne in 1946.

1896
Adrian Stokes, President
In 1896 William Badcock published his *Historical Sketch of St Ives and District,* and in the chapter 'Modern History', he wrote — 'The large colony of artists resident in our midst have done very much to make widely known the charms of this district by the exhibition of their pictures on the walls of the Royal Academy and elsewhere. It has been said that St Ives cannot be exhausted from an artistic point of view. If that is so, we may hope to have the painters with us for many years to come.'[35] This prediction has certainly proved correct.

Churches and Chapels
The artists have contributed their art and design to the benefit of local churches and chapels from the earliest times to the present. One of the early visitors to the club was the Rev Griffin, who became a member. He was Parish Priest of St John's in the Fields, St Ives. His appeal for contributions for fund-raising for his church in 1896 resulted in a sale of paintings donated by the artists. 'Poppies', Miss Cooper; 'A Weird Cornfield', W H Y Titcomb; 'Evening — Fishing Boats Becalmed', Mrs E L Greenfield; 'The Foresand — Night', Miss Cogill; 'Gerran's Bay', G W Jevons; 'Loud-sounding — Clodgy', P B Northcote; 'Among The Daffodils', Mrs Titcomb; 'Glare and Glow', Will E Osborn; 'A Golden Coast', J C Douglas; 'A Summer Shore', S H Carr; 'Still Life', Miss Gertrude Rowe; 'Chrysanthemums', Mrs S M Laurence.

The Rev Griffin also commissioned William Eadie, who was a sidesman of the church, to paint the Twelve Apostles on panels for the choir stalls. The sitters were Captain Harry, retired Master Mariner and Mayor of St Ives, Lt. Hackman RN, C L Williams, Station Master, S H Carr, local artist, Percy Simpson, sidesman, Rev. R Griffin, Vicar, John Eadie, the artist's son, Wm Eadie, the artist, Lt.Hackman's son and three local fishermen (not named) were St Peter, St Andrew and St Bartholomew. In the redesign of the church in the 1980s they now form a Memorial Corner.

A new oak altar and reredos were designed by the painter, W B Fortescue and Miss W K M Coode (who was a designer of ornamental art). Other connections with church and club resulted in a stained glass window above the central altar designed by the painter Thomas Millie Dow. The decorative motif of stained glass pleased his sense of colour and design. The window was dedicated by his wife Florence, in 1903, to the memory of her father William Cox.

In 1924 Titcomb presented three large drawings to the Primitive Methodist Chapel in Fore Street, where they still hang today. They were studies for the paintings 'Piloting Her Home', 'The Sunday School Class' and 'Primitive Methodists'. The latter painting is in the collection of the Dudley Art Gallery, but a smaller version exists in St Ives Museum.

The Catholic Church at one time owned a collection of paintings by St Ives artists including John Park, Arthur White, Franz Muller-Gossen, Marianne Stokes, Jean du

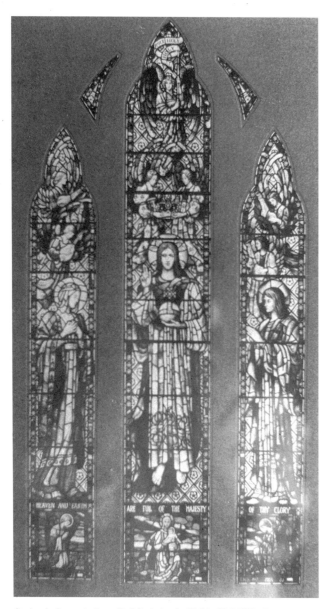

Stained glass window, St John's in the Fields. T. Millie Dow.

Apostles, *section of panels of choir stalls by William Eadie. St John's in the Fields.*

Maurier (sister of the novelist Daphne), E E Rice, Agnes Drey and others. A statue of the Patron Saint, St Ia, was carved in wood by Faust Lang. These paintings were on view in the hall below the church and were the especial pride of Father Delaney.

St Ives Parish Church has carvings in wood of the 12 Stations of the Cross by Wharton, son of woodcarver Faust Lang. The white stone carving of the Madonna and Child in the Lady Chapel is the work of Dame Barbara Hepworth. She also designed the Christmas Rose candlesticks. The sculptor, Paul Mount, fashioned the altar candlesticks and flower pedestal in the Lady Chapel. The embroidered figure of St Ia was made by Alice Moore. A pot by William Marshall was given by Henry Gilbert of Wills Lane Gallery. The Island Chapel contains floor tiles by Bernard Leach and in Truro Cathedral the altarpiece, in the form of a triptych, was painted by Anne Fearon Walke.

Mr and Mrs Eadie were early arrivals in 1888. He was one of the first members of the Committee. Described as a domestic painter, a tale of a family portrait is told by Lilian Faull: 'It was decided we were all to have our portraits painted in oils by William Eadie, an artist who was living in Halsetown. Willie was painted wearing a white sailor suit and I wore a pink frock and pinafore, while Henry was dressed in a plaid frock and pinafore and shown eating grapes from a bunch which he held. Those grapes drew us time after time to our sittings and I have been told the final reward was grapes for all of us.'

'Mr Eadie had a flair for painting antiques and always incorporated a piece of antique furniture in whatever interior he produced. Each of us is shown seated on a Chippendale chair. I am shown wearing black button boots, which I never wore. I think the artist must have used his daughter's feet for his model. In those days the artists were coming to St Ives and they were always short of money and I have no doubt our portraits were painted to offset business debts.'[36]

1897

Henry Harewood Robinson, President

Serving on the committee with Robinson were J Elgar Russell, W H Y Titcomb, Treasurer, Millie Dow, Lowell Dyer, Adrian Stokes and Julius Olsson.

During 1897 Edmund G Fuller held an exhibition of paintings in his Porthmeor Studio. 120 pictures were on view throughout the summer months. He published a set of pen and ink sketches, which comprised 'Old Houses', 'The Wharf', 'The Beach', 'Herring Fleet', and 'Old Houses Skidden Hill'. Treve Curnow describes Edmund Fuller as a little fellow, very dapper. "He always wore a green-coloured suit of tweed. He wore a cap and always a bow tie and carried a walking stick. His shoes were brown brogues, highly polished."

Miss Sarah Escott remembers Edmund Fuller and his wife. "He was an artist who was never wrapped up in himself, like some of the others. He always said hello and I was only a child. I had to leave school to look after my mother, who was mentally deranged. Someone had to be with her all the time. I remember Mrs Fuller came to the door and said, 'My husband hasn't seen you out with your dog and he wondered what was wrong.' I told her I

was looking after my mother and I hadn't been out for three months. 'I will send my maid over one evening and she will sit with your mother,' she said. That was wonderful for me. I was only 12 years old. So the maid came over and the only place to go was to Mr Hill's silent cinema on Barnoon Hill. Every week after that the maid came round to sit with my mother. It was a very kind act."

Celebration and Discord

St Ives celebrated the Diamond Jubilee of the Queen with a dance at the Porthminster Hotel. Over 160 invitations were issued — mainly to the members of the Art Colony and the evening closed at 3am.

The year 1897 ended on a note of discord. At the Town Council election in November the artists were accused of rushing into the crowd 'brandishing their sticks.' Harewood Robinson refutes this: 'There was no rushing of artists, no brandishing of sticks by artists, no clearing of the way by artists; for the very good reason that there were no artists to rush, to brandish, or to clear. I have made an exhaustive inquiry, and I find that there was not one artist in the Market place after eight o'clock on the night of the election.'[37] He went on to say that most of the artists received kindness and assistance from the fishermen and they had no desire other than to live amicably among them, so there was no reason why there should not be good feeling between them.

The good feeling is expressed the following year when the artists are described as 'guests who represent much of our National artistic talent. The artists of St. Ives appear to be a colony of ladies and gentlemen wedded to their profession, living a happy Bohemian life, but whose influence upon the local community nevertheless is clearly becoming more apparent — developing more liberal opinions upon men and things and broader views of the modern condition of social life.'

Modern views and liberal opinions were not part of the Methodist social life which dominated the local population and some years were to pass before a broader outlook reached into Cornwall.

Gowna Rock, St Ives, *Edmund G Fuller.*

Tulips, *Thomas Millie Dow.*

1898

Thomas Millie Dow, President

His strong point was his flower paintings. He also featured Italian landscapes and allegorical pictures. His style was decorative and his output slow. He studied in Paris and visited America, spending some time with his friend, Abbot Thayer, the portrait painter who, while visiting the Dow family in St Ives, painted a portrait of Mary, the youngest daughter. He exhibited in Scotland, where he was born, and was one of the 'Glasgow Boys'. He was a member of the New English Art Club.

Norman Garstin described Dow's distinction in painting as an 'absorbing passion for all things beautiful and dainty and tender, for colours that dwell together in harmony.' Susie Hosking recalls. "Millie Dow painted me and gave me an orange. It was a portrait. I used to go up to Talland on Saturday mornings. It was about 1907 when I was six. I don't know what happened to the portrait." In 1908 William Strang stayed with the Dows and painted portraits of Thomas and Florence.

Dow married Florence Pilcher, who had also studied as a painter. She had been shipped out to India in 1882 with the "fishing fleet" which means that women were sent out to 'angle' for a husband. She met and married Pilcher, who died when Florence returned to Scotland to have her second child. There was great opposition from the Pilcher family to Thomas Millie Dow, who was

Talland House with Italian servant, c.1910. A and H Symons.

considered a penniless artist, thrown out by his father for refusing to join the family firm. However, undeterred, Thomas declared that now he had met Florence he would never let her go. He had actually inherited a small legacy which gave him the opportunity to give up his legal studies and set out for Paris to study art.

The couple were married and came to Cornwall because he was in poor health. Their first visit was in 1889 when they stayed at Tregenna Castle Hotel. They lived at two other houses before acquiring Talland House, one was said to be haunted and the other full of rats. The Dows made frequent trips to Italy and brought Italian servants back with them. There are still relatives of the Italians in the town. The Dows employed St Ives people as gardeners and coachmen. An Italian housekeeper married to a fisherman was employed at Talland for 30 years.

The garden at Talland house was large, with croquet lawns, stables, greenhouses and a pond, as well as Dow's studio. Thomas Millie Dow was a keen gardener. He entered the Chrysanthemum Society Show winning first prize for a pot plant and first prize for a table decoration. He also gained first and second prizes in the fruit section. T M Dow died in 1919 and is buried in Zennor.

Mary Rosamunde, daughter of Florence and Thomas Dow, married George Kennedy, son of painter Charles Napier Kennedy in St John's in the Fields in 1913. George was an architect, whose buildings can still be seen in St Ives. Little Parc Owles in Carbis Bay is his most renowned. April Cottage in Talland Road and an Italianate barn at Tremedda Farm, Zennor, were built for the Dow family. One of his first designs was a country cottage for Lytton Strachey. He also designed the Arts Theatre in Cambridge and the war memorial in Zennor.

George Kennedy asked Leonard Woolf to employ his nephew, Richard, in the early years of the Woolf's publishing company. His employment with the Woolfs resulted in a book of his reminiscences and illustrations of Virginia and Leonard called, *A Boy At The Hogarth Press*. 'Shortly after my mother and I returned from our holiday in St Ives a letter came from Leonard Woolf asking me to call on him. I was elated that I had got the job.'[38]

Hope Pilcher, daughter of Florence's first marriage, had a son whose wife, Rosamunde Pilcher, wrote in 1987 the best selling St Ives-based novel *The Shell Seekers,* which was also made into a film. She was born in Lelant and many of her books are centred on St Ives.

1899
Moffat Peter Lindner, President

He produced landscape and marine paintings, mainly watercolours, portraying many scenes of Venice, Etaples and Holland. His style was closer to Impressionism than many of his contemporaries. Lindner wrote, 'pure transparent colour appeals to me most.' He was sensitive to the differences in light and atmosphere say, of Holland, Venice and St Ives.

During the period when Whistler was president of the Royal Society of British Artists, Lindner was the only artist elected to membership. They remained friends and Whistler sent for Lindner a few days before he died. 'Whistler was a charming man to his friends, but implacable to those he did not like', he observed. Among his other friends were Walter Sickert and Philip Wilson Steer.

Lindner was a member of the New English Art Club. Augusta Baird-Smith, his wife, was also a painter. She was the daughter of F M Smith RA. Mr and Mrs Lindner lived with their daughter Hope at Chy-an-Porth, The Terrace. The original house dated from 1876 and Lindner built an extension larger than the first house. He brought craftsmen over from Italy to design an Italian garden.

A painting by Moffat Lindner exhibited at the Royal Academy in 1900 was priced at £100. From a piece of writing in Lindner's own hand found recently by his grandson, headed Chy-an-Porth but undated, he writes: 'It was not till I was about 22 that I resolved to cut the mercantile business under my father and take to art as a profession. I realized that good drawing was essential and went to the Slade School for a term or two. But I soon tired of that and began making elaborate studies from nature. My first water-colour hung at the RA was in the 1880s; a farmyard

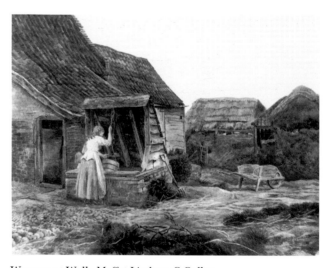

Woman at Well, *Moffat Lindner. C Cullen.*

with a girl at the well — every tile and stone was copied from nature and it took me over six weeks to do.'[39]

The painting of a woman at the well was sold from Chy-an-Porth and bought by a St Ives family and remains in their house today. Hope Lindner sold the painting because it was unlike the Impressionist technique of his later work and was therefore not typical of his style.

Lindner was a generous donor to any project concerning art and artists. He owned Porthmeor Studios and held them in trust for the painters. In 1901, when he was Captain of the West Cornwall Golf Club, he loaned them £150 to pay for the extension to the dining-room.

Lindner was 97 when he died and was remembered by Marion and George Pearce, who subsequently bought his house, as an old man sitting in the window in a high backed chair looking out over St Ives Bay.

1900

William Holt Yates Titcomb, President

Titcomb was born in Cambridge in 1858. He studied art at the South Kensington Schools under Professor Herkomer at Bushey and at Paris and Antwerp. His paintings of the Newlyn type, portraying Cornish fisherfolk, were compared favourably with Stanhope Forbes. Titcomb's wife Jessie (née Morison) was also a painter. She studied at the Slade and painted child studies. They married in 1892 in St Ives and moved to Windy Parc, Ayr Lane in 1896. An example of the work of Jessie Ada Titcomb is shown in a painting set in the garden of their home which features her son and daughter (centre) Frank and Loveday. A local lady, Mrs Miriam Kemp (née Hart) now aged 95 sat for Mr Titcomb for 6p an hour. "It was a lot of money in those days. My mother and brother also sat for him. We went to the Porthmeor Studios."

The painting of two figures at a window is unsigned but the model resembles the character used in Titcomb's

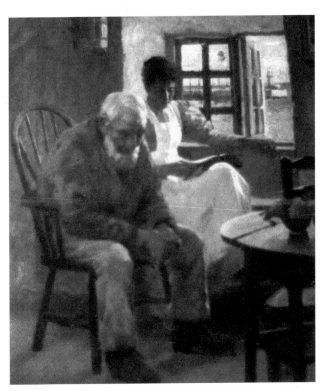

Two Figures by a Window, unsigned, attributed to W H Y Titcomb. Private Collection

painting 'Primitive Methodists'. The view through the window shows Smeatons Pier painted from a house in St Andrews Street, St Ives and the writer believes it is the work of Titcomb.

His style changed in later years, becoming more impressionistic. His exhibition of watercolours and drawings at the Walker Galleries, New Bond Street in 1925 were of landscapes of France and Italy. A large proportion of the 89 drawings were of Venice. Titcomb's work was described as nicely balanced between formal and atmospheric interests showing a gift for suggesting detail that precludes exact definition.

A Boer War Artist

In January 1900 Sydney Mortimer Laurence was engaged as a war artist and the local paper gives extracts from his correspondence.

'A St Ives Artist Off to the War. Mr S M Laurence, a well-known member of the St Ives Art Colony has been engaged by 'Black and White' to go to the front as one of its special war artists. Mr Laurence sailed in the Union liner 'Moor' from Southampton on Saturday.'

Extract from a letter from Laurence, February. 'I started for the front at 4.30am to see if anything was on. I got as far as Mada Camp, which is the extreme outpost. I then went on to Cole's Cop, a hill 1,500 feet high, overlooking the Boer lines. To get there I had to cross a plain of four miles, and got over all right, although others were not so lucky. Cole's Cop must be climbed on foot, or rather on hands and feet, and very hard work I found it after 19 miles in the saddle.'

Painting by Jessie Ada Titcomb c.1905. 'Frank and Loveday' (centre) Titcomb.

Extract from letter by Laurence, March. Rensburg Camp. 'All the morning there had been guns going off somewhere, and just then there seemed to be an unusual amount of things in the air, which I thought were cock-chafers until I saw one of them go clean through a big cactus. Then I knew what they were! I stopped — turned round in a circle and then did a sort of Wild West Show! — laid down on the horse's back, put my arms round his neck, kicked with my heels, and went straight for the hills! For the rest of the way I kept under cover, when I had lunch, that is a drink of hot water and a biscuit.'[40]

St Ives Weekly Summary, May 5, 1900. 'That the many friends of Mr Laurence, who went to South Africa as one of the special artists of 'Black and White,' will regret to hear that he is returning on the sick-list, having had an attack of enteric fever.' Laurence left England in 1902, never to return.

A fatality of the Boer War was Hugh Blackden, a private of the Imperial Yeomanry. A promising marine and landscape painter who delighted audiences at the Arts Club with his playing of the mandolin.

1901 – The Second Decade
Julius Olsson, 2nd time President
Into the second decade the Arts Club was firmly established. Very few professional artists remained outside its influence. Although described as Bohemian, the artists' colony was respectable, middle class, educated and well-to-do. There are no accounts of artists taking drugs, living with mistresses, starving in attics or awaiting a rich patron. Although generally their studio conditions were primitive, they were ideal working spaces, light, airy and large.

Olsson attracted a large number of students who wished to study sea painting. He was the colony's foremost exponent of marine studies and also very much involved in the town and sporting activities. He was Captain of West Cornwall Golf Club in 1905.

Show Day for this year in St. Ives was compared very

Arthur Meade in his studio before his visitors arrive, 1926.

favourably with the Newlyn exhibits in the local press, the writer stating that although there was nothing to equal Mr Forbes' 'Goodbye', there were a larger number of canvases of more than ordinary merit.

Cricket, St Ives v Artists
The artists had retained their initial enthusiasm for the game of cricket from the time Adrian Stokes formed the first Artists' Eleven in 1889. Cricket was the mutual meeting ground over which the St Ives and Newlyn artists fought their battles, leaving room for amiability in the more common field of painting. It also provided a level upon which the artists could mix socially with the townsfolk.

'The St Ives Cricket Club are anticipating a good season. Town v Artists. St Ives team — A Lanham, A Trewin, A S Wilton, F Nicholls, H Escott, J Hosking, H Hosking, A Trueman, E O'Donnell, Docton Thomas, W Cogar, W H Bennets.'

'The Artists' Eleven will comprise — W H Y Titcomb, E G Fuller, R H Lever, T A Lang, F Stokes, A Talmage, F Milner, J W Ashton, Julius Olsson, T H Danby, J Uren.' Deacon, Douglas and Rheam were on standby.

'The first match for the season was played at Higher Tregenna on Saturday, when the Club was opposed by an Artists' Eleven, captained by W H Y Titcomb, and a very good account they gave of themselves. The (cricket) Club however, after an interesting but not very exciting game, won by 15 runs.'[41]

The year before the Australian artist, Richard Hayley Lever, who came to St Ives to study under Julius Olsson, won the cricket bat donated by Mr W Trewhella JP for the highest batting average. At a Cricket Club dinner in 1909

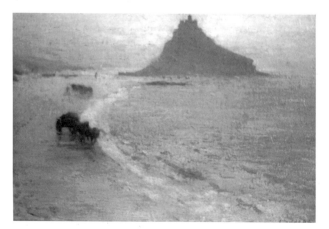
St Michael's Mount, *Arthur Meade.*

the toast was proposed by Hayley Lever, 'The Town of St. Ives'. He also presented one of his oil paintings to Mr Dyke for the highest average score of the season. The Australian artists Ashton and Lever were the stalwarts of the Artists' Eleven, with Julius Olsson replacing Adrian Stokes as the all-round sportsman.

1902

Arthur Meade, President

He usually included cattle and sheep in his pictures. Several of Arthur Meade's paintings are owned by the Porthminster Hotel. He painted a portrait of the Reverend Tyacke, which hangs in the clubhouse of The West Cornwall Golf Club, of which he was a one-time scratch golfer. He won the Bolitho cup three times, the Club Challenge Cup five times and in 1904 the Hain Challenge Cup. In 1919 he was Captain of the Golf Club. Several of his paintings are of the Golf links when sheep grazed on the grounds.

Arthur Meade has been described as a small, well-built man who always wore plus fours. The Meades lived at Godrevy House, Trelyon Hill. In 1922 the local press reported the death of Emma Lane, who was, for fifty years, faithful friend and servant in Mrs. Meade's family. The Meade's spent 30 to 40 years in St Ives and were buried in Zennor churchyard.

In a Minute of 1902 the President, Julius Olsson, was in the chair and spoke of the loss to the art colony by the death of a valued artist, Miss Lily Kirkpatrick. Lily Kirkpatrick was a painter from Ireland. She showed at the RA on three occasions. Always in delicate health, she was looked after by an older sister. They had lived at 15 The Terrace, 2 Bowling Green and Carbis Bay. Lily had been a great friend of the writer, Edith Ellis. In 1901 the friends visited the Arts Club to enjoy the Christmas festivities for the last time. Their signatures appear together in the Visitors Book.

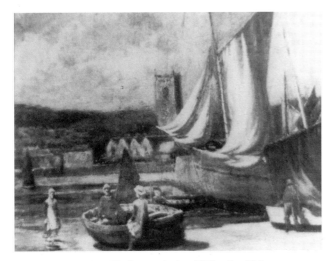

Children at St Ives Harbour, *Arthur White. David Lay.*

Painting, *John Noble Barlow. L. Suddaby.*

Suggestions Book:
'White should be made to buck up with the papers. The Studio comes out on the 15th of each month. Today is the 19th, it is not here yet. Algernon Talmage, Percy Heard.'

In 1902 John Noble Barlow, one of the oldest of the art colony, was awarded a silver medal at the Paris Exposition. He studied art in New York and on the Continent. His tendency was to express himself on large canvases, especially when dealing with landscapes and sky subjects. A painting destined for the Paris Salon 'The Spirit of the Night' measured 9ft. x 5ft. 6in. In 1909 his painting 'The Estuary' was the largest landscape at Burlington House. Others included 'Moonrise' 1894, 'One Summer's Night' and 'Lelant, Cornwall' in 1898, 'The Return of the Boats' and 'St Ives, Early Morning' in 1902 and 'Autumn' in 1916. He was said to be influenced by Corot.

One of his pupils was Garstin Cox, of Camborne. He was on the panel of the Cornwall Polytechnic Society and President of the Carnegie Art Gallery, Torquay. He had two sons and lived in Skidden Hill from 1893 until his death in 1917. As well as a good attendance of St Ives artists at the funeral, Lamorna Birch and R Hughes came over from Newlyn. A special exhibition and sale of his pictures was held in Porthmeor studios and Lanham's Gallery. The exhibition was arranged to give Barlow's friends a last opportunity to see, or buy, his work and the paintings not sold were sent to London.

Landscape and marine painter Arthur White came to the town in 1902. In 1909 he advertised for pupils at 4 Tre-Pol-Pen, Street-an-Pol: 'Painting in oil and watercolour, marine, landscape, figure, etc.' He was nicknamed Arthur Church White or Tower White because he was always painting the Parish Church.

Sylvia Pardoe, his housekeeper, was with him for seven years. "It was in 1946, after I had finished doing war work in Yorkshire. I was about 30. Dorcie Sykes asked me to come and look after him. It was somewhere for me to live and I had plenty of freedom. He was nearly 80. He couldn't cope on his own. He spent most of his day in the studio at Fern Glen, The Stennack."

"At one time he had a studio at Tregenna Hill. He was a good musician and was organist at the Catholic Church for 25 years, although he was a member of the Wesley

Arthur White, c.1950.

Chapel. His middle name was Moorwood but he never used that name. In his last year he sent work to the Royal Academy. It was rejected by the RA. He was so upset he had a stroke and died. He was 88. His niece and her son came down and sold his paintings cheaply at the local pub."

"Mr White said to me, 'I wonder sometimes if I have made a success of my life and my work.' In the end he couldn't paint because his eyesight went. He didn't marry." Charles Pearce described him. "He was a very tall man. He reminded me of Bernard Shaw. Hair thick and white. He wore leggings, a cap, and had a beard."

Arthur White and John Guthrie Sykes, from Newlyn, were great pals. They studied at the Sheffield School of Art together. Dorcie Sykes, daughter, also a painter said, "Arthur White had a school of painting in Yorkshire. He said his pupils must learn to draw before they picked up a paint brush."

1903
Allan Deacon, President
This year he was also Captain of West Cornwall Golf Club. He studied in Paris and painted mainly portraits, nine of which were hung in the Royal Academy. After his

term as president he served as secretary for four years and was on the Hanging Committee for Lanham's Gallery. He was a player in the artists' cricket team in 1901 and in 1912 was given a complimentary dinner for services to the Club. Deacon was still in St Ives in 1921 when he lost a quantity of paintings in a studio fire, after which the building was demolished.

It was decided the Club should have a bar to sell drinks, members helping themselves and placing either money or debit notes in a box. 'Mr Olsson's kind offer to look after the bar for three months was accepted with thanks.' Unfortunately the bar soon recorded a loss, which Mr Pazolt reported after only ten days running. The remains of two shillings worth of whisky and soda was sold off and the bar discontinued, but the fame of Julius Olsson's 'punch bowl' was created and he continued to brew this special concoction at every suitable event.

Suggestions Book:
'July 1903. 3.30pm. The heat is almost unbearable. All the windows were closed when I entered. I have no thermometer but am certain it would register more than 90 degrees. The ink gives off a thin bluish steam and even the quill pens are curling up.' Folliott Stokes

Walter Elmer Schofield was born in Philadelphia of English parents. He arrived in St Ives in 1903. He studied art at the Pennysylvania Academy of Fine Arts and Julien's, Paris. In 1909 he spent some time in France sharing accommodation with Julius Olsson and American painter George Oberteuffer. Schofield found it necessary to travel abroad frequently in pursuit of different scenes to paint and to establish contact with museums and galleries. He was particularly known for his paintings of snow scenes.

He was awarded the Carnegie Gold Medal whilst in St Ives and a one thousand dollar prize at the National Arts Club of New York. Another American, Gardner Symons,

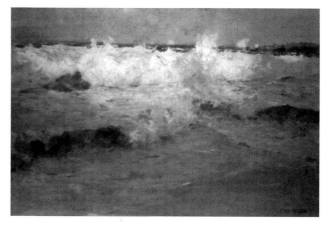

Sea Painting, *Julius Olsson, c.1892.*

Walter Elmer Schofield by W.H. Lanyon.

was a friend from the early years in St Ives. They showed together in several exhibitions in the States.

Schofield joined as a private in the British Army. It was through Olsson that he gained his commission. He was stationed at Pendennis Castle under Philip Chellew, who was known as a real tartar. In 1918 he retired from the army with the rank of Major. He died in Cornwall in 1944 and was buried in Lelant but his body was removed to America, St James the Less Church, Philadelphia after the war.

Schofield was a friend of W Herbert Lanyon. Their children Sydney Schofield and Mary Lanyon married in 1940 and lived at Godolphin, an Elizabethan manor house in Cornwall. Elmer and Murielle Schofield spent their last years at Godolphin. Mary now hopes that the National Trust will take over responsibility for her beloved house.

1904

Sir John Alfred Arnesby Brown, President

His free style of landscape painting brought him early success. Three paintings were purchased by the Chantrey Bequest, 'Morning' 1901, and 'Silver Morning' 1910, which was exhibited at the RA and described as a masterpiece of landscape with cattle solidly moving under a great soaring sky. Landscape was the major theme in his work. 'The Line of the Plough' was purchased in 1919. He was knighted in 1939 for his contribution to British art.

'A year after Arnesby Brown entered the Bushey School he exhibited a picture called A Cornish Pasture at the Royal Academy, which was the result of his first visit to St Ives, in which place he has spent every winter since. To most people he is best known as a painter of landscape

and cattle but is by no means an artist of only one direction. He has produced several memorable paintings of the sea and several pastorals in which the human figure is prominent, and he has scored many successes with portraits.'[42]

Mia Arnesby Brown, his wife, painted figures and portraits. She painted a portrait of a daughter of the novelist and writer Charles Marriott. The Arnesby Browns shared a Piazza studio, but spent much of their life in Norfolk.

Arnesby Brown's brother Eric studied painting at the Nottingham School of Art and in Cornwall. He visited the Club in 1904 and 1905 as a guest of Arnesby and left St Ives in 1909 for Canada. He became Director of the National Gallery of Canada, after which he did very little painting.

Along with his fellow artists Arnesby Brown was a keen golfer and in a contest for the monthly medal played on Lelant Towans, the West Cornwall Golf Club, he tied for first place with two others.

There were several reports and happenings in the colony in Brown's term of office. This year saw the loss of Henry Harewood Robinson, JP at the age of 54. He trained as a Barrister and was one of the earliest members of the Art Colony. Maria Robinson was made an Honorary Member of the Arts Club as a token of the esteem in which her husband was held.

He died at his house, Bellyars Croft. As the cortege passed the West Cornwall Golf Club the flag was lowered to half mast. He was one of their earliest members. Interment was at Lelant. Eight Arts Club artists acted as bearers and these were Louis Grier, Allan Deacon, Arthur Meade, Lowell Dyer, W H Y Titcomb, Folliott Stokes, Julius Olsson and Walter Jevons. Many others attended the service, including T A Lang, W B Fortescue, Stanhope Forbes, F W Brooke, Moulton Foweraker, Beale Adams, J M Bromley, J C Douglas, Phyllis Bottome, Mrs Havelock

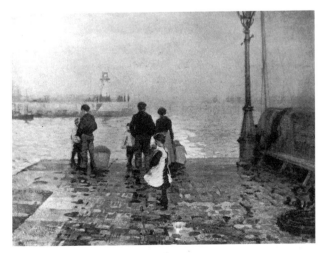

Two Piers, St Ives, *1908. J A Arnesby Brown.*

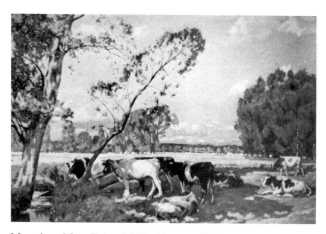

Morning After Rain, *1923. Algernon Talmage.*

Ellis, Bernard Walke, and other friends. In 1920, after
the death of Maria, the house which the Robinsons had
built, Belyars Croft, with adjoining studio became an
hotel.

At Lanhydrock, a National Trust house near Bodmin, is
a full length figure painting by Robinson. It hangs in the
music room and was recently given as a gift to the Trust.
It is called 'Girl with Violin' and is more in the romantic
style of the Pre-Raphaelites, rather than the Bastien
Lepage type chunky figure of his 'Fisher Girl at St Ives'.

Students and Art Schools

Many students and hopeful young painters came to study
or to meet the painters whose names were at that time
well known in the art world. In 1904 a promising 16 year
old artist, Brian Hatton, came to Cornwall to meet the
artists of Newlyn and St Ives. In Newlyn he met Norman
Garstin, Sherwood Hunter and Stanhope Forbes. Living
at Hendra's Hotel in Carbis Bay was the painter
Girdlestone who introduced the boy to the artists. Olsson
impressed him as 'one of the best at seascapes.
Girdlestone told me he works at an awful rate. He has
before now painted a 6 foot canvas in 12 hours and with a
few finishing touches when dry, was ready to be hung on
the line at the Royal Academy.'

Brian considered his best drawings were of animals and
he was anxiously awaiting the return of Alfred East and
Arnesby Brown from the Academy, who painted animals,
and from whom he hoped for a word of encouragement.
However, Arthur Meade told the boy he should come to
St Ives as, 'a good many artists would be only too glad to
have me put animals in their landscapes.'

Other painters he met were Louis Grier, Algernon
Talmage, Stuart Hobkirk and John Bromley. He also met
the painter Russell Dowson who invited him to lunch on
mutton chops; 'very nice old boy, has his studio in a back
alley somewhere by some shops by some cottages round
some corners somewhere by the market place which is
somewhere by the church. I hope I shall find it.'[43] Brian
spent an afternoon in Dowson's studio watching him
work in oils and watercolours.

Hatton, whom the painter George F Watts predicted
would be a great artist, was awarded a bronze medal and
gold star by the Royal Drawing Society at the age of eight.

He studied at the South Kensington Schools and Juliens,
Paris. He died in Egypt in 1916 while serving in the
Worcestershire Yeomanry. His family dedicated an art
gallery as a memorial to him in his home town of
Hereford.

John Park studied with Olsson and Talmage. Both
helped Park, who was one of the poorest of their
students, by not charging him for tuition. He earned
extra money by painting portraits, collecting payment on
a weekly basis to provide an income.

The Studio magazine of 1904 carried advertising for
several schools of painting. They all promoted marine,
figure and landscape painting from nature en plein air.
Noble Barlow and Beale Adams also advertised for
students. Foweraker's sketching and painting expedition
to Spain, 'mainly out of doors,' was to include two
months in Malaga, a month at Cordoba and a month in
Granada. Talmage provided an outdoor figure class in a
private orchard during the summer (probably at Talland
House). Louis Grier's and Talmage's classes were
advertising 'for students adopting painting as a
profession.'

A three part Cornish painter was Algernon Talmage, his
mother and his father's mother both belonging to old
Cornish families. He studied painting at West London
School of Art and with Professor Herkomer at Bushey
and gained medals at Hors Concours, Paris Salon and
won two prizes at Pittsburg International. His paintings
were described as essentially open air. He joined Julius
Olsson at his School of Landscape and Sea Painting and
became principal; later running his own school with his
wife Gertrude who was also a painter. He was said to
impress upon his pupils the importance of open-air study
and the love of truth that it engendered. His work
featured etching and the study of landscape. Talmage
had injured his right hand in a gun accident and painted
with his left.

He was an official war artist in France for the Canadian
Government and art adviser for the Australian
Government. He was also a keen sportsman. Gertrude
and Algernon lived at 14 Draycott Terrace. Mrs
Proudfoot remembers them also staying with her family
at Trevose House. They would spend six months in their
drawing room flat. "Gertrude (known as Fanny) would go
through a pound of strawberries without turning a hair.
She would say to mother 'Algernon has been a naughty
boy, he's in Paris.'" The Talmage's also lived at Westcotts
Quay.

Charles Marriott described Talmage as one of the most
talented and certainly the most popular of the St Ives
painters; a most attractive personality, modest and slightly
reserved but always ready to do a kind action for a friend.
It was Talmage who told Marriott the story of the fish cart
being driven up Skidden Hill. The horse, finding the
load too much, stopped in his tracks. The driver, after
calling the horse all the insulting names he could think
of shouted, 'You Pygmalion artist!' — the worst insult he
could think of — and the horse fairly bolted up the hill.

The Titcomb Drawings

The Primitive Methodist Chapel in Fore Street owns three large Titcomb drawings and one of them was the subject of an enquiry in 1904. In a letter addressed from Barnoon House, W H Y Titcomb attempts to explain the reason for his painting 'Piloting Her Home' which was on exhibition at the Laing Art Gallery, Newcastle. The curator had received many requests for information.

Titcomb explained that he was present when the old woman in the picture was apparently in the last throes of a death scene. He had come to say goodbye to Mrs Rouncefield before leaving for a year's visit to Italy and found the daughter of the house crying by the bedside and the old lady waving her arms and talking to Jesus 'as only Methodists can'. Suddenly the door burst open and five fishermen came in to pray for the safe deliverance of the dying woman. Titcomb said he knelt to pray with the family and was struck by the beauty of the scene and the contrast between the frail old lady in ecstasy at death's door and the bronzed fishermen.

Returning from Italy a year later Titcomb again visited the house. To his surprise he found the old woman recovered and aged 85. He persuaded the family to let him paint the scene he had witnessed and reconstructed the interior of the cottage in his studio and furnished it as a bedroom. The scene was enacted several times and in all there were 40 sittings before the picture was complete.

The painting was exhibited at the Royal Academy and on the Continent. One letter from a woman in Australia said her conversion to Methodism was solely on the impression the painting had made on her. The three drawings were presented to the Methodist Chapel by Titcomb in 1924.

Rev Bernard Walke

Walke lived at Ayr Cottage. Lilian Faull remembers being taken into the house while still in the occupation of St Ives curate Bernard Walke and his mother and brother. He was highly thought of and something of this regard is reported in the press in 1904.

'A Runaway Pony. The Rev. N B Walke pluckily caught hold of the bridle of a spirited and frightened run away pony which had dashed up Fore Street and was careering towards the Digey where the street was full of children going to their midday meal. At considerable personal risk Mr Walke managed to pull him up and avoid serious accident to the children.' Walke is better known for his work at St Hilary Church near Marazion but was assistant priest at the Parish Church of St Ives, until his removal by the Bishop of Truro. The painter Sydney Carr sent letters to the local paper and the Bishop of Truro, protesting against Walke's dismissal. Other letters were from the fishermen asking for his retention in the borough.

'In losing him the fishermen will lose not only a pastor but a friend; and it will take a man of more than ordinary tact and ability to recover the ground lost by his departure.' The Bishop of Truro writes regretting the decision, 'I have had interviews and correspondence with the decision,

your Vicar and Mr Walke. Their main difficulty is their inability to work together. Neither attaches blame to the other. I do not think it advisable for him to continue in St Ives.'[44]

Bernard Walke was married to the painter, Annie Fearon, sister of the painter Hilda Fearon. Through the sisters' associations he was in contact with the artists and St Hilary church near Marazion is the recipient of many of their paintings. He wrote the book *20 Years at St Hilary*, and was author of the Nativity Plays broadcast on BBC in which local villagers and children played all the roles. Filson Young, who visited the Arts Club on several occasions, was the BBC producer responsible for bringing the plays to the public.

Australians Return Home

In 1904 Will Ashton held an 'at home' in his studio on the harbour, where he said goodbye to friends and exhibited about 50 oil paintings of seine boats and several marine and landscape paintings. During his stay it was said he made himself popular with both artists and fishermen. He went home to Adelaide to hold a one-man show of his work and sailed on the *Britannia* at the end of the year. He was often painting in Paris but returned frequently to St Ives. In the local press he was noted as 'a valuable member of the artists cricket team.'

Hayley Lever, who could wield a cricket bat as well as he could control a paintbrush, also returned to Australia, but the following year the newspaper noted his return and commented, 'Hayley Lever has just returned from an Australian voyage and will be in England for a few years to complete his studies. He is accepted in all the leading shows in London, Paris and America.'[45]

Lever was a landscape and marine painter. His studio was on the top floor over Lanham's gallery. He came to St Ives to study under Julius Olsson and was introduced as a visitor to the Arts Club by fellow Australian Louis Grier. He married Aida Gale at St Ives Parish Church in 1900. An article on Show Day 1908 reported 'Mr Hayley Lever the well-known Australian artist (who for the seventh consecutive year has been successful in getting his work accepted by the Paris Salon) again pays graceful homage to St Ives — its bay and harbour — which he has the ability to present in an unconventional manner. His largest canvas 'Landing Fish St Ives', deals with the life of the harbour in a decisive and convincing style. His other paintings 'Fishing Times St Ives Harbour', 'The Bay at Eventide' and 'The First of the Night' are all works of considerable interest. Lever also exhibits a typical French scene 'After a Shower'.'[46]

In 1912 Mr and Mrs Lever emigrated to America with their American friend Ernest Lawson. One of Lever's last paintings in Cornwall is dated 'St Ives Harbour 1912'. He made his last appearances at the Arts Club on the 1st April. His work attracted much attention in the USA. In 1913 a painting, 'The Port of St Ives', was purchased by the Sydney National Art Gallery for 200 guineas. The picture was exhibited at the New Salon, Paris, and Walker

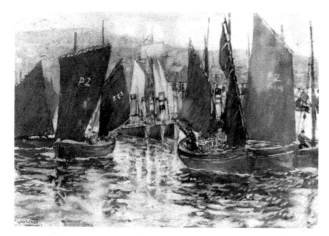

St Ives Harbour, *1912, Hayley Lever. Eve Mock.*

Art Gallery, Liverpool. That year three canvases were hung in the New York National Academy, of which he was made a life member. He was invited by the Carnegie Institute to act as juror for the spring exhibition, the largest international show in the world. Canvases of St Ives hang in 11 galleries in the U.S.A. and three in Australia.

A former New York Attorney, the owner of some of Lever's canvases and a great connoisseur of art, was spending a season at the Tregenna Castle Hotel. Writing to a friend in America he commented, 'As I look out over this beautiful harbour of St Ives, I am thrilled and I am reminded of Lever's pictures ... Speaking to him (Hayley Lever) a few days since about St Ives he said, "I really worked there. I did not quite realise then how much my future depended upon those days when I studied diligently from morning till night. Here in America I work, of course, but one cannot get the solitude for reflection and concentration and therein lies the beauty of those quaint old world villages." '[47]

In 1985 the Previti Gallery of New York held a retrospective exhibition of Lever's work. He was probably best known for his scenes around the harbour. He was an admirer of the vigorous colours of Vincent Van Gogh, although like many of the St Ives artists, he ignored movements and trends.

A most valuable and surprising discovery of the work of Hayley Lever occurred in St Ives in 1991. Sixty-one canvases were found in a studio loft of a property that was undergoing renovations. The oil paintings were unframed and stacked one upon the other, thick with the dust and grime of 80 years. Only when one or two were cleaned were they revealed to be the work of one artist, Hayley Lever. The subjects varied from Cornish seascapes to French landscapes, all beautifully painted in rich and vibrant colours, which had lost none of their brilliance. The mystery of how and why the work was stored and forgotten has not been solved.

Fellow Australian Sidney Long introduced Lever and Barlow to Albers, a Sydney art dealer, who was interested in securing some of their work for exhibition in Australia. Long was a painter and etcher and visited Lever in St Ives. In 1912 Long was living at 195 Ladbroke Grove in

rather poor circumstances and a letter to Adolph Albers reminds him that it is 10 weeks between letters and he has spent money on art materials from his scant stock and asks for an immediate cable by return.

'I can't possible hang out till March on the amount I have, as you suggest, particularly as Mrs Long is ill and I am under extra expense. I have forwarded by this mail 6 small water colours and shall endeavour to send some larger stuff in a few weeks. Amongst this lot are some that I have had in an exhibition at St Ives. There are three very good ones at the Baillie Gallery which I shall send later on. At present they are in pawn as I can't bring them away till I pay for the frames and I don't care to part with the money until some more comes forward... I am always very careful only to show my best stuff when I am on the spot.'

In a letter from St Ives in March 1912 Lever says he is sending 6 paintings in oil on canvas 14in. x10in. to Adolph Albers. He tells Albers he was a leading member of the RBA for three or four years and a member of the ROI. 'However I resigned after thanking them for the honour. I made up my mind to keep away of (sic) being a member of societies for a time. I have been studying over this way and working for 12 years. This year I was specially invited to send a work to the Venice International. I am one of the 40 artists picked from England. I'm also asked to send a large canvas to Pittsburgh USA to be placed on the line without a jury.'[48]

1905
Fred Milner, President

Milner painted mostly landscapes in oil and watercolour and worked on mezzotint. Many of his landscapes were painted in the Cotswolds. He lived at Zareba, Trelyon Hill, with his wife Sophia and was resident in the town for about 40 years. He exhibited 60 pictures at the Royal Academy and was active on the committee of Lanham's gallery. Milner's paintings of Corfe Castle (his favourite subject) were said to be so prolific that they were called

River Scene, *Fred Milner. Private Collection.*

'Milner's Corfe Drops.' He even painted two miniatures of Corfe Castle for Mary Lanyon's dolls house.

In 1905 Virginia Stephen, with Vanessa and the two brothers Adrian and Thoby, made a sentimental journey to St Ives to recall the pleasures of their childhood at Talland House, which they relinquished after the death of their mother in 1895. They also visited several people living in Primrose Valley who had served the Stephen household. There was Mrs Daniels who did their washing and the couple who managed the bathing tents on Portminster Beach, Jinny Berryman, the farmer's daughter who used to bring chickens and help in the house and Mr and Mrs Pascoe who recalled many tales of the Stephen's childhood years at Talland House.

Suggestions Book:
'That the librarian order a supply of writing paper.'
'That a piano be procured for the season.'
'That the stove should be lighted in the afternoon during the winter months. Guy Kortright.'

1906

T Albert Lang, President
Lang was one of the first members of The West Cornwall Golf Club and Captain from 1896-1900 and again in 1909; he was a scratch player. It is not known what professional occupation he pursued to entitle him to be a member of the Arts Club.

A proposition by Allan Deacon and Charles Marriott that actors be added to the list of persons eligible for membership of the Club, was defeated by an amendment by Arnesby Brown, and Louis Grier. Two years previously St Ives was favoured with a visit from Sir Henry Irving and his troupe of players who toured Cornwall. Irving, actor/manager, spent his boyhood in Halsetown, two miles outside St Ives. Actors were not proposed again until the twenties.

After the meeting songs, tableaux and charades continued till midnight. The entertainment's committee for the evening were Lang, Russell, Marriott, Kortright, with Lowell Dyer 'unanimously appointed Punch maker for the evening.'

Several events were reported in the local press in 1906. Mr and Mrs A M Foweraker called for a constable to eject their servant. He arrived but declined to do so. The Fowerakers then, 'carried her into the garden,' where her boxes had been put out. It appears that the couple arrived home one Sunday afternoon and could not gain admittance to the house because the servant did not think it her duty to answer the door when the housemaid was out. Mr Foweraker eventually had to climb through a window in their house at Hawks Point. She was paid a month's wages and dismissed.

Moulton Foweraker was a flower and landscape painter. He was a member of the Royal Society of British Artists but on one occasion when he submitted a painting for

Fred Milner by W H Lanyon. A Lanyon.

exhibition in their show it arrived too late to be included in the catalogue and the president of the RBA sent it on the Royal Academy, where it was accepted and hung in the large gallery. This is the only time his work was exhibited at the RA.

Dame Clara Butt (singer) and party drew a crowded audience at St John's Hall, Penzance, including a large contingent of listeners from St Ives. Mrs Butt visited the Club as a guest of Julius Olsson in 1891 and 1894. A local lady, Winifred Mary Proudfoot, remembers Mrs Butt staying at her childhood home, Trevose House, on Draycott Terrace in 1906. Mrs Proudfoot also remembers Julius Olsson lodging in their garden room after letting his home, St Eia, to the Lloyds. Adrian Stokes also stayed at Trevose House.

Donations of books were made from the estate of Sir Leslie Stephen to the St Ives Free Library. Artists who contributed books were Louis Grier, Lowell Dyer, S H Carr, James Davis, T M Dow, Miss Whitehouse and W Brooke (formerly of Ayr Cottage) who gave 18 valuable volumes of *Illustrated Magazine of Art.*

At St Ives Mayoral Banquet Councillor Chellew gave the toast, 'St Ives Arts Colony.' He said its members had served the Borough both on the bench and in the Council. He congratulated Louis Grier on his election as Member of the Royal Society of British Artists. Mr Milner acknowledged the compliments on behalf of the artists.

The Old Forge, *W B Fortescue. Private Collection.*

1907
William Banks Fortescue, President
He lived in St Ives for nearly 30 years and was buried in Zennor churchyard. He studied abroad but the character of his work was influenced by his Cornish associations. A major retrospective of his work was held in Plymouth in 1924. His painting 'The Old Forge' is owned by a St Ives resident, who remembers the forge. The pony in the picture is the one Fortescue rode around the countryside with an easel on his back. A similar painting, 'Village Smithy' was hung at the Royal Academy in 1905.

St Ives Artist's Bad Luck
On this occasion it seems the two main products of the town, fish and paintings, were despatched to London in the same railway carriage. The local paper reported 'That large section of the community who take an interest in Art, and particularly those who visit the St Ives studios on the occasion of the annual show of pictures, preparatory to the latter being despatched to the Royal Academy and other exhibitions, will regret to hear of the ill-fortune which has befallen Mr Julius Olsson.'

This year he exhibited a seapiece entitled 'The Moonlit Bay', which had attracted admiration on Show Day and was generally considered to be 'one of the finest products of this artist's brush'. With other pictures, the canvas was despatched to London for the Royal Academy, who informed Olsson that the picture had been irreparably damaged in transit. A barrel of fish had been placed near the package containing the picture, and the oil from the fish had seeped into the canvas with disastrous results. It was thought to be beyond repair but was worked on by Olsson and hung on the line at the Royal Academy; no doubt giving an authentic waft of sea air in Burlington House.

1908
Charles Marriott, President
Marriott was born in Bristol in 1869. Before coming to St Ives he lived in Lamorna at Flagstaff Cottage, subsequently owned and lived in by Lamorna Birch until his death and by his daughter, Elizabeth (Mornie) Kerr, until her recent death.

Marriott writes, 'The year I happened to be president of the Arts Club, and gave the presidential party, (Compton) Mackenzie wrote for me a brilliant parody of Maeterlinck, *The Princess Migraine.* Mackenzie and Fay were frequently in St Ives plotting mischief with our two girls, who were about the same age as Fay.'[49] The three girls took part in the play.

As president, Charles Marriott wrote an article for the *Daily Mail:* 'At the present moment, of the eighty odd studios in this little town of St Ives there is not a single one to let. Cornwall is becoming more and more emphatically the centre of English art, and this winter marks the highest point the development has yet reached.'

'Painters are a sociable race, and where one settles others are likely to follow... In the summer the painters go away to Norfolk, Hampshire, France, Spain, or Holland and Morocco, but with the end of autumn they come flocking back to St.Ives, Newlyn, Falmouth, Polperro and Sennen and set about their work for the spring exhibitions.'

'It is in St Ives that one finds that best illustration of the artistic colony. Somehow the place seems less under the influence of a tradition and more artistically alive than Newlyn, and the extraordinarily wide range of methods pursued there makes it extremely difficult to select individual painters for particular mention.'[50]

During the year three ladies from the Lyceum Club visited the Arts Club. They were Miss Hardy, Miss Vernon and Miss Edelston. The Lyceum Club in Piccadilly was the centre for women connected with literature, art and the sciences and was established in 1904 with Constance Smedley as its first secretary.

A painter who spent most of his adult life in St Ives was John Anthony Park. He specialised in marine and landscape painting and was more of an Impressionist than most St Ives artists. His first three submissions to the

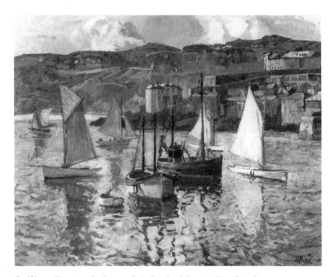

Sailing Boats, St Ives, *J A Park. Montpelier Studio.*

John Park with young friend in St Ives, c.1909. Private Collection.

RA were rejected. These paintings were subsequently bought by a manufacturer who was visiting St Ives at the time. The following year three of Park's paintings were hung at the Academy. His 'Snow Falls on Exmoor' was bought by the Chantrey Bequest in 1940.

He was a popular man with both the local people and the artists, very fond of children, although he and his wife had none of their own. One local lady said her mother looked after a painter called Wilson, who was a friend of Park. "She cooked dinner for him and stayed by his bedside when he was dying. John Park gave mother a drawing for taking care of his friend."

Park was a longstanding member of the Arts Club but on one occasion he nearly lost his membership by turning up drunk. He served on the committee in 1924 and was asked to take the office of President in 1932 but wrote refusing the post. He lived at many addresses in St Ives. He once owned the middle cottage on the harbour beach. One of his studios, now demolished, was close by the Sloop Inn. Another was 10 Porthmeor studios where he and his wife Peggy lived and worked. In 1948 Park relinquished this studio to Hyman Segal. According to Segal, one of Park's favourite places to paint was on the steps outside Rose Lodge studio on the wharf, then owned by Segal.

An exhibition in the Adelphi, London 1925, of John Park oil paintings was named The Two Rivieras — his 30 pictures showing the French Riviera and St Ives. His work is described: 'It is the singing quality of his drawing and colour harmonies which lifts his slightest picture above the common ruck and makes him the true artistic historian of the Cornish fisher folks. There is a beautiful suite of fishing pictures showing the fleet beaching the silver treasures in the dim dawnlit harbour. The light in

these little sketches is wonderfully rendered, elusive and semi-opaque, and hardly distinguishable from the darker masses of the waves.'

It was said by more than one person that Park's name was put forward for election to the Academy but he was turned down by the 'stuffed shirts' who weren't prepared to consider frequenters of pubs.

1909
Julius Olsson, 3rd time President
Olsson was still very active in St Ives, attracting many visiting painters who regarded him as a leading marine artist. His work was accepted and hung in the major art galleries and he was a member of many art societies. The Royal Academy exhibited 175 of his paintings during his lifetime.

It was in 1909 that Alfred Charles Bailey arrived from Brighton. He stayed for 10 years and studied under Louis Grier. He was a landscape watercolour painter and exhibited at the Goupil Gallery, Redfern and Twenty One Galleries. He had the Atlantic Studio in St Ives and Mincarlo in Carbis Bay.

The owner of the painting 'Harbour Cottages' said his mother won it in a Masonic Whist Drive. He remembers the artist, Bailey, as a very tall man.

Harbour Cottages, St Ives, *A C Bailey. Private Collection.*

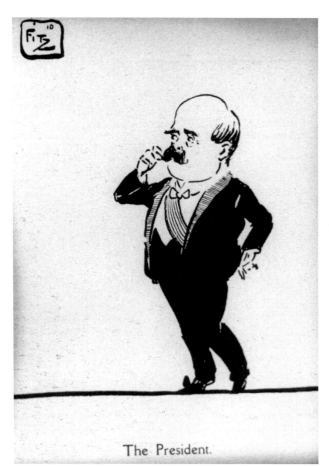

The President.

Caricature of John Titcomb, 'The President 1910' by H G Fitzherbert.

An exhibition of some of his work called for the following comment: 'A C Bailey may be said to represent the younger School of painting in St Ives, and there is strong individuality in all his watercolours. They comprise 'A Village in France', 'On the Thames at Greenwich', 'A French Chateau', 'The Fair, Hastings, Summer Time' and one or two others. Mr Bailey's impressionism gives excellent results and he is to be congratulated.'

1910

John Henry Titcomb, President
The younger brother of W H Y Titcomb was a landscape painter. He had studied at the Slade School but his work is not so well known as that of his brother William. John Titcomb was a longstanding member of the Club, serving as secretary and president on several occasions.

At the Mayoral Banquet in 1910, Julius Olsson, JP said, 'St Ives owes in no small degree a debt of gratitude to the local artists for what they have done to advertise the town.'

Advertising in *The Studio* magazine of 1910 were Alfred Hartley and Norman Garstin, who were together conducting classes for drawing and painting from life during the winter months in St Ives. Mary McCrossan was also advertising for pupils to take lessons in watercolour and oil painting (landscape, sea and boats) from her Piazza Studio.

Women Artists and the R A Schools

There was a large number of women artists in St Ives but details of most of them are sketchy. They are often mentioned if their husbands also happened to be painters. Their paintings were hung in the RA and exhibited in the major galleries but they were not recognised as being equal with men. The responsibilities of managing house, husband and family, and the difficulties inherent in being a wife, inevitably meant that their output of paintings was less. With this division of duties they were unlikely to be taken seriously and indeed, who could take that portion of the population seriously who could not be trusted with the responsibility of voting for a Member of Parliament.

In an interview with Harriet Ford, Marianne Stokes, who studied art in Paris and Munich, related the experiences that fell to all women who undertook any form of study or education. 'The chances for effective training for women in Munich at that time were few. There were no schools open to them. All they could do was to take a studio, two or three girls together, and ask some artist to visit them. Generally, on the professor's part it was not altogether serious. He came, he praised, he pointed out a superficial fault or two, he went away. For the rest the student wrestled with technical problems by herself. For the quick witted earnest minded girl the feeling of being treated with a somewhat perfunctory gentleness and condescension, not too much being demanded of her, added insult to injury.'[51] Harriet Ford, also a painter, was in St Ives with Marianne Stokes and the article was published in the *Magazine of Art,* but no amount of articles or protests could change the status for women.

Augusta Baird Smith was a landscape and flower painter. She came to St Ives to study under Julius Olsson and was introduced to the art colony and signed into the Club by Olsson in 1896. She met and married Moffat Lindner. Hope Lindner, her daughter, said of her mother that she was a good artist but somewhat overshadowed by her father and his successes and growing reputation.

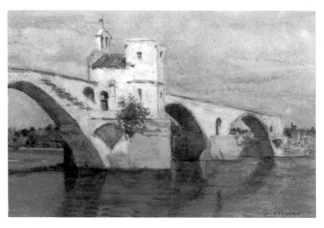

Old Bridge Avignon, *J Titcomb.*

However Moffat Lindner stated, "My wife, who also paints, has been a great help to me. I think a lot of her criticism — in fact, I consult her in everything."

When Philip Wilson Steer, who was a friend of the Lindners, visited St Ives in 1900, he painted a portrait of Augusta, which was shown at the New English Art Club the following year. Marianne Stokes also painted Augusta's portrait.

The reforms at the Royal Academy Schools, although they led to a broadening of studies for women, also meant cutting down their numbers by the implication that they wouldn't be equal to the demands of study from the nude. 'The first advantage will be the exclusion of the ordinary run of the lady students, as only the best of them will be equal to the new and more painter-like list. For those of them who succeed in the preliminary examination the new regulation — that of permitting them to study flesh painting from the semi-nude is a boon. It is inconceivable that this ban under which they

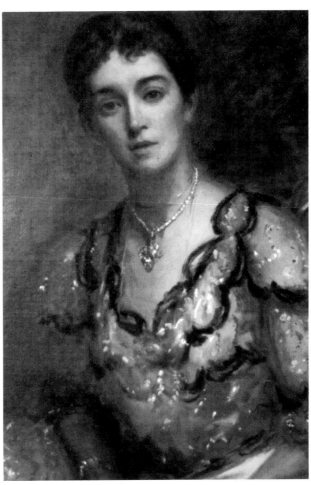

Augusta Lindner, *1900, Philip Wilson Steer. Nikolas Halliday.*

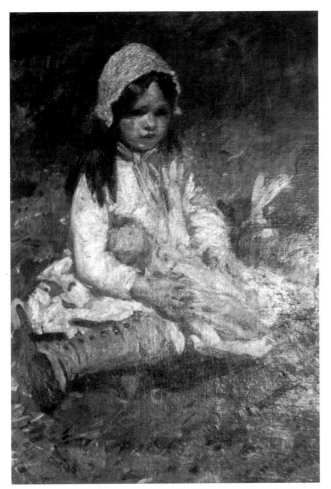

Elizabeth Birch, aged 10, *Laura Knight, signed 'to my dear friend Elizabeth'. E. Kerr.*

have laboured hitherto should have been permitted to handicap them so hopelessly and so unfairly.'[52] In spite of the strong supportive words, most art societies, clubs, exhibitions and galleries discriminated against women painters.

In a discussion on whether the female had the mental capacity to attain the skill of a Michelangelo Laura Knight said, 'Michelangelo had no baby's bottle or teapot hanging round his neck. Now that womenkind are no longer born to hold a needle in one hand and a scrubbing brush in the other, what great things may not happen?'[53]

Dame Laura Knight lived for several years in Cornwall. Her Cornish paintings often included children in a landscape. Whilst living in Lamorna she scandalised the neighbours by painting nude women out of doors. None of the local girls would pose naked so she brought models from London, who thought nothing of undressing in the open and posing naked on the rocks and afterwards rushing into the sea for a swim.

'In the autumn of 1927 I was elected Associate of the Royal Academy. Only one other woman had had that honour since its foundation in 1768 — Mrs Anna Swynnerton who became an ARA in 1922. It was she that broke down the prejudice against women members.

Unfortunately this very fine artist did not live long enough to attain her RA.'[54] She was in fact 89 when she died in 1933, long enough one would have thought.

Anna Louisa Swynnerton studied at the Manchester School of Art. She painted allegorical, symbolic subjects and portraits. She was born in Kersal near Manchester and with her artist friend, Susan Isabel Dacre, founded the Manchester Society of Women Painters. Three of the 60 paintings which were exhibited in the RA were bought by the Chantrey Bequest in 1924, 1929 and 1930. In 1923 the Manchester City Art Gallery showed a major exhibition of her work and they now have 16 of her paintings in their collection. She was married to Joseph Swynnerton, sculptor.

Laura Knight was elected a full member of the Royal Academy in 1930 after being made a Dame. 'Spring' and 'The Gypsy' were bought by the Chantrey Bequest. She was president of the Society of Women Artists from 1932-67. In 1965 Dame Laura was the first female artist to be honoured with a retrospective exhibition of her work at the Royal Academy. She and Elizabeth Forbes were two of the few women painters whose work gained equal recognition with their artist husbands.

Another woman painter, Elizabeth Thompson (Lady Butler), sister of Alice Meynell, who wrote articles on the Newlyn School in the early years, was nominated for membership of the RA but rejected on the grounds of her sex. Her painting 'The Roll Call' exhibited at the RA in 1874, was so popular that a policeman had to control the crowds. The work showed the aftermath of a battle, a unique subject for a woman artist.

In spite of her title, the privileges this would bring, and the male oriented scope of her paintings it was considered that the exhibition of women's pictures in the gallery was sufficient acknowledgement of a painting's worth and this was their sole privilege. A woman may now be included in the government of the institution, although women's work is still largely under-represented in galleries and their presence on committees rather sparse.

The founding of the Society of Female Artists helped change the status of women in the painting world, although it must be said this was a very slow progression. It actively promoted work of professional standard and gave confidence and encouragement to women to exhibit their work.

The Walker Art Gallery has one of the largest collections of work by female artists, acquired between the years of the Liverpool Autumn Exhibitions 1871-1938. Of these 53 works, 6 were by women who at some time in their lives had studied at St Ives. Two were by Marianne Stokes, the others were by Mary McCrossan, Lucy Kemp-Welch, Teresa Norah Copnall and Elizabeth Adela Forbes. Other works by women working in St Ives were added later, Laura Knight, Anne Falkner, Frances Hodgkins and Sandra Blow.

Dinners

These were still exclusive to the men in the artistic world. The regal repasts were provided by Curnows. In 1905 W

H Y Titcomb was treated to 'a dinner' on leaving St Ives. Mrs Titcomb is not named as being present. The guest list reads, 'Louis Grier, Chairman and Allan Deacon Vice-Chairman and in addition to the guests of the evening the following were present Messrs. Hind, Marriott, Talmage, Adams, White, Barlow, Browne, J H Titcomb, Stuart, Elphinstone, Foweraker, Olsson, Chadwick, Douglas, Fuller, Dow, Russell, Keasbey, Lanyon, Schofield and Thomas.'

In 1906 a dinner was given in the Club to a team of golfing artists from London. Twenty-four were seated. Arthur Meade was captain of the home team. The next day a social evening, at which the women were allowed to attend, was provided in honour of the London artists — it is not stated which was the successful team.

The members were already beginning to feel the restraints of their one room and a Minute records that Elgar Russell gave the Club first offer of his cottage, which was next door, and used as an extension to the building on several occasions. However, the offer was soon withdrawn as Russell had decided to stay in St Ives.

In 1907 a farewell dinner was given to Elmer Schofield, on one of his frequent trips to America, by his fellow artists at the Western Hotel. Julius Olsson presided and was supported by Lowell Dyer, Allan Deacon, Hayley Lever and Fred Milner.

Responding to the toast of his health Mr Schofield remarked that he very much regretted leaving St Ives and his many friends. During the evening Mr Dyer gave one of his characteristic humorous speeches and a song. Mr A M Foweraker also contributed three songs, and Messrs. Olsson, Milner, Lever, Douglas, Meade and Lanyon helped to brighten the evening with songs and instrumental selections.

When Schofield sailed for America he left behind his wife Muriel and two sons Seymour and Sydney at 16 The Terrace. He wrote one of his frequent notes from on board ship, 'Dearest Wife, We are rapidly nearing New York and should land about Wednesday am.'

On the departure of Charles Marriott 20 men sat down to a farewell dinner at the Club, with Julius Olsson in the chair. Within sight of The Bay he had written his first successful novel *The House on the Sands,* also *The Remnant,* and *Women and the West.* The local paper noted his departure, 'Charles Marriott, the well known novelist, with Mrs Marriott and family left St Ives this week for their new home in London, with the best of good wishes from numerous friends. Much regret is expressed at the departure from the neighbourhood of this talented and distinguished writer.'

Leonard Spray, who wrote the book *As I was Going to St Ives* and was on the staff of the *Daily Telegraph* recalls, 'In the streets of the town Marriott's quick moving figure, hatless and clad always in the roughest of corduroys, often attracted attention. Now alas! he does no longer, for Mr Marriott deserted St Ives, after a residence of several years, for journalist London, and now haunts Fleet Street in much more conventional garb.'[55] Spray

died in 1962 at the age of 79. He had drowned and was found below the cliffs at Clodgy Point. It was believed he had taken his own life. He had worked on the *Cornish Telegraph* and *Western Morning News* before moving to Fleet Street. He retired to St Ives in 1952.

Photography and Posters

A resident of St Ives remarked, "Photography was a big thing in St Ives. There was Edward Ashton, who had the chemist shop. He was a keen photographer. At 10 Parc Avenue was John Christian Douglas, Herbert Lanyon, L E Comley, Mr Trevorrow and John Cooper who lived at the end house in Windsor Terrace. I remember when I was passing a horse and cart in Street-an-Pol seeing several large boxes of photographic plates being removed from offices next to The Retreat. I asked what was happening to them. The carter said he was taking them to the dump. What history must be lost."

Douglas was interested in photographing people. He is responsible for the three photos 'Saturday Night at the Arts Club 1895'. Although the figures look entirely relaxed Douglas posed his subjects to look natural, so this was probably a carefully arranged scenario, made to look as though someone suddenly popped up with a camera.

Comley owned a draper's and footwear stores. He recorded on camera the St Ives of the turn of the century

William Herbert Lanyon (self portrait). Andrew Lanyon.

and many of his photographs are preserved by his nephew, H C Gilbert of Wills Lane Gallery. The work of these early photographers can be seen in Andrew Lanyon's book *A St Ives Album*. Ashton's work was largely of boats and fishermen. A woman photographer was Georgina Bainsmith, who was also a sculptor, but no records of her work survive.

In later years the photographer Marcus Adams and son Gilbert lived in The Digey. Marcus had photographed the Royal children and published books on his art with a foreword by Patrick Lichfield. During an attic clearance a trunk containing hundreds of photos by Gilbert and Marcus Adams, with cameras and diaries, was discovered. These items were sent to London for sale at Sotherby's but later a stop was put on the sale whilst an investigation took place to establish ownership. The Adams' were informed of the discovery of this material but it was adjudged to be the property of the person who bought the lot in the house clearance and they had to buy back items such as the diaries, which would have caused embarrassment to themselves and their various famous sitters.

William Herbert Lanyon lived with his wife at The Red House where Peter (St Ives painter) and Mary were born. He was a musician, composer, painter and especially renowned for his photographic studies. His grandson Andrew is photographer, artist and writer.

In 1902 Herbert Lanyon gave a lecture on Music and Religion in the Wesley hall. The lecture occupied an hour and 40 minutes. He advocated that musical societies should be open to all comers with no restrictions as to social standing or monetary qualifications. His set of ten pianoforte pieces of original compositions was published in five parts.

Mary Schofield, daughter of W H Lanyon, gave this writer a published piece of music by her father dated 1908

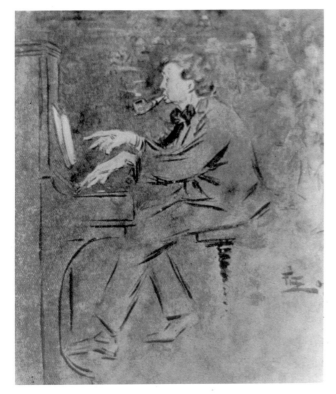

W.H. Lanyon at the Arts Club, *caricature by H G Fitzherbert, c.1910.*

H G Fitzherbert by W H Lanyon. Andrew Lanyon.

executed specimens of the photographers art, by Mr Herbert Lanyon of the Attic Studio, St Andrews Street. It is a striking advertisement and should be the means of considerably increasing the already large and influential connection of this talented artist.'

The railways played a major role in the development of the poster. Their advertising showed the train's ability to get people to the attractions of seaside resorts. There were many colourful railway posters designed for the Great Western Region by St Ives artists in later years and postcards of the town by John Park.

A poster designed by Borlase Smart in 1922 was purchased by the Great Western Railway with a view to reproduction. The design, 50in. x 40in., was called 'The Cornish Riviera for Golden Sands and Sunshine'. Herbert Truman also produced posters and postcards. He won £50 for the design of a poster for the Great Western Railway. The poster showed a view of St Ives looking through a narrow gap to the harbour.

The London Midland and Scottish Railway, through Norman Wilkinson, commissioned several members of the Royal Academy to design posters of places and industries on their line including Arnesby Brown, Julius Olsson, Adrian Stokes, Algernon Talmage, Stanhope Forbes and George Clausen. Frank Brangwyn designed for the London North Eastern Railway. At a later date Terence Cuneo designed for the National Railway Museum.

Writers

Cornwall has attracted large numbers of writers to its shores and many of them have found their way to the Arts Club. Denys Val Baker, the writer who edited and published *The Cornish Review,* was a member in later years and it is likely he made use of the Club's library, when it had its full complement of art magazines, in noting the painters and writers who were in Cornwall in the earliest years of the arts colony. Charles Marriott was the only writer, apart from Leslie Stephen, and T Albert Lang, to become president during this early period. The others were all painters.

Marriott spent seven years in St Ives, during which time his son Basil was born at his house on The Terrace. He also had two daughters, Dulcie and Vivien. A number of writers visited Charles Marriott. Hugh Walpole brought the manuscript of his first novel *The Wooden Horse* for Marriott to read, who said: 'In all essentials it is a very good piece of work, and whatever defects there are noted are merely due to inexperience.' The Marriotts entertained, among others, the writers W H Hudson, Dr and Mrs Havelock Ellis, Ranger Gull, Annie and Bernard Walke, Mrs Alfred Sidgwick and the literary editor Samuel Jeyes.

Another of these writers was Sir Compton Mackenzie. Mackenzie in his autobiography says, 'Charles Marriott put me up for the Arts Club in St Ives, and during that autumn I would sometimes bicycle over and take a long walk with him. Marriott dressed in corduroy breeches

called 'Mexican Dance' and dedicated to Charles Marriott, the writer. Herbert Lanyon was sure to have played it on the departure of Charles Marriott from St Ives in 1908. Marriott said that besides being a first rate photographer, Lanyon was a brilliant pianist but he had been limited in his achievements as a musician because of an injury to his hand.

Mary Schofield said there was a very interesting mix of society in St Ives. "The relationship between the fishermen and the artists was very close. My father said it was lovely." Mrs Miriam Kemp (née Hart), aged 95, said Herbert Lanyon was well liked in the town. Her brother worked on the railway and she remembers his having an accident at work and Lanyon arranging and paying for him to be treated at a London hospital, where he stayed for several weeks.

Charles Pearce remembers Lanyon, "He was a prominent member of the arts colony. His wife was the daughter of one of the best known engineering names in Camborne and Redruth — a very pleasant lady. He smoked a Sherlock Holmes pipe. He was a good photographer and specialised in portraits."

It is likely that Herbert Lanyon's photographs were some of the first adverts for the railway. 'That the latest addition to the advertisements at St Ives Railway Station is a fine mahogany case containing several artistic and well

and jacket. He had been a photographer and dispenser before he wrote *The Column* and by now he was disheartened by his inability to repeat the success of his first book. Nevertheless, he continued to write novels until he became art critic of *The Times*.'[56]

Susie Hosking says she remembers seeing a pantomime written by Mackenzie at the Drill Hall. "The hall had been a Methodist Chapel and had a gallery. We held all our dances and political meetings there."

Mackenzie lived at Riviere House in Hayle, a Georgian house on three floors looking onto the Hayle Estuary with the Towans behind. It had once belonged to a copper baron and had a copper roof. Mackenzie's first two novels were written at Riviere House where his wife, Faith, would play Beethoven Sonatas, Schubert and Chopin piano music for three hours at a time, to enable him to concentrate on his writing.

The second novel *Carnival* ensured Mackenzie's continued success. It was filmed in Cornwall. *Whiskey Galore* was filmed in Scotland but inspired by his stay in Cornwall. Many of his books were turned into stage plays. Walpole, staying with the Marriotts at St Ives, called at 'Riviere' with his manuscript of *The Wooden Horse* and asked Mackenzie's opinion of the book. Charles Marriott and E M Forster had praised it, but Mackenzie told him he was not really a novelist. Mackenzie was then rather upset when Walpole's novel was published in l909, before his own first novel *The Passionate Elopement*.

Talland House, so Mackenzie notes, 'was the home of Leslie Stephen and was the gathering place for all sorts of interesting persons... He was an editor, and used to get his friends to look over some of the manuscripts submitted to him before he gave his final opinion... he knew many notables, and was the biographer of most of them. He entertained such men as Edmund Gosse, the critic and brother-in-law of Alma Tadema, the famous painter.'[57]

In 1891 Leslie Stephen was presented with some silver plate by 83 writers subscribing to the *Dictionary of National Biography*, on which he had worked since 1882. In his speech of thanks he said that much of the work in compiling the dictionary had been done in St Ives. He was knighted for this work in l902.

A new local magazine entitled *The West Country Arts Review* appeared in 1896. Its contributors were chiefly artists resident in the West and the subjects were painting, sculpture, architecture, music and literature. The first articles were written by Adrian Stokes, H Robinson, Folliott Stokes and the Editor was Carl Olsson, possibly a relative of Julius Olsson. Since the magazine appeared to be in-house it is likely that they formed part of the Club library but all efforts to trace copies have failed.

The novel *Portalone* by Ranger Gull, which came out in 1904, was a work of fiction based on fact, and tells the tale of two fishermen serving six months in prison for throwing an artist in the harbour and trying to prevent him reaching safety until rescued by his fellow artists. It

Charles Marriott by W H Lanyon. Andrew Lanyon.

was said, at the time, that the characters of the artists were easily recognised. The accounts of artists being thrown into the harbour are so numerous as to make it almost a traditional St Ives practice. There are other events in the novel which have been substantiated. Certainly the character of the chief protagonist, on the author's admission, was based on Folliott Stokes, and the painter of angels, 'which no one ever bought' was Lowell Dyer.

In l908 William Henry Hudson published his book *The Land's End*, a naturalist's impressions of West Cornwall. Hudson was born in America but became a British subject in 1900. Whilst in St Ives Hudson lived at 2 Seaview Terrace. He complained of the cruel practice of netting birds by the boys of the town. It was borne upon him quite forcibly by the local population that when the fishing community came upon hard times they supplemented their diet by this means.

In Hudson's travels in West Penwith he recalls finding a lady artist out in the hills under a big umbrella painting a squalid-looking farm house. 'She was one of a colony of forty or fifty artists in the small town close by (St Ives), but the first one I had seen out in that wild place in wet weather. I was told that the artists of this one colony alone turn out about a thousand landscapes a year.'[58]

After Hudson's death in l922 Will Arnold-Forster, who lived at Eagles Nest, had these words of tribute to his memory carved on a rock face on Zennor Hill, 'W H Hudson often came here.'

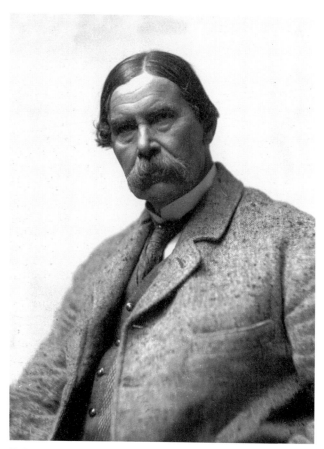

Folliott Stokes by W H Lanyon. Andrew Lanyon

Granny Griggs at Zennor

The tiny village of Zennor, four miles from St Ives, has attracted artists and writers throughout this century. In Hudson's many travels around the peninsula he stayed at Zennor in lodgings called Granny Griggs' house. Her visitors book, in which many famous names appear, is now in the possession of Mrs Griggs' grand-daughter, a relative of the Dows. Hudson was one of the first guests. Arnesby Brown visited Zennor many times from 1897 through to 1909. He wrote in the visitors book, 'One of Mrs Griggs first visitors — always sorry to leave — always delightfully comfortable.' Frank Russell Butler in 1909 wrote that he was extremely happy and comfortable and sketched himself smiling and smoking a pipe. William Parkyn at the same date wrote, 'If you want a good tea at Zennor come to Mrs Griggs.' George L Kennedy the architect stayed in 1910. Another artist, F R Fitzgerald, lodged there with his wife in 1913 and drew a sketch of boats in the visitors book.

Painter and writer Alan Gardner Folliott Stokes stopped off at Granny Griggs in the course of writing his book *St Ives to Land's End*, which was published in 1908. In the chapter 'St Ives to Zennor', he wrote, 'We will now get a glass of milk at the house opposite the church. It belongs to Mrs Griggs, who lets lodgings. One can always get tea here, and comfortable permanent quarters, provided her rooms are vacant.'[59] J C Douglas, who illustrated the book with photographs, stayed with Mrs Griggs in 1908.

Stokes and Douglas collaborated on another book published in the twenties, *The Cornish Coast and Moors*, with additional photographs by Alex Begbie. A reviewer for the *St Ives Times* wrote: 'The author is less concerned with history and architecture of the Duchy than with its natural scenery. He has seen all the places of which he tells us; has climbed the cliffs; traced the rivers and explored the moors; and has drawn joy from the contemplation of them all.' A subsequent book was called *From Land's End to the Lizard*. He was also author of a novel, *A Moorland Princess*, described as a romance of West Cornwall. The local paper reports: 'Mr. Folliott Stokes, the popular author and artist, has returned to St Ives after a delightful tour through Russia, Turkey, Italy and other countries.'

In 1903 Folliott Stokes wrote an article in the *Playgoer* making a plea for a Cornish theatre. In support of this he says: 'England contains no more romantic, emotional and pleasure-loving people than the Cornish ... In the middle ages miracle plays were a great feature in Cornish life, and were acted there after they had died out in other parts of England.'[60]

He felt sure Sir Henry Irving, actor/manager, who had spent his boyhood in Halsetown near St Ives, if appealed to would support the project. However, Irving died in 1905 and in 1990 Cornwall is still without a theatre — apart from the unique open-air theatre, The Minack, and various small theatres in the county.

Alfred J Munnings chose a location near Zennor village for the scene of one of his paintings, although he lived chiefly in Lamorna. 'I had arranged lodgings with Mrs Griggs and had her front parlour, whilst Ned had a bedroom, and fed in the kitchen with the landlady — all this for the vast sum of one guinea for myself and fifteen shillings a week for Ned. In those days, before motor traffic brought sightseers and countless visitors to Cornwall, lodgings were cheap; farm butter and clotted cream were in abundance.'

'The morning after our arrival, the humble Ned, to the surprise of Mrs Griggs, appeared in white cord breeches and top boots, and at about 9.30 am, riding Grey Tick, with a mackintosh to hide his scarlet coat, he came towards me up the hill where I was already planted with easel, canvas and box. This was a start.'

'All these Cornish people were used to artists. It was the home of artists, and everybody understood their ways. Perhaps it was the artists who helped to popularise that end of Cornwall and brought increasing crowds to the West.'

'For five weeks Ned and I lodged with Mrs Griggs and I worked every day seeing more scenes to paint; grey rocks, brown heather; great sows lying in the mud at the end of the village street; little pigs, middle-sized pigs; fowls; crows; and stone walls. Alas! There is no time in life to paint everything. This picture, thirty-six by forty inches, painted on that same spot of Ned riding up the hill with his hounds, was exhibited at the Academy.'[61] The painting was bought some time later for 250 guineas.

Three of Munnings' paintings were bought by the Chantrey Bequest.

Alfred Munnings wrote in the visitors book, 'Wonderful!!! woman Mrs Griggs,' with sketches of himself at table and sitting comfortably in an armchair smoking his pipe.

Munnings met the American painter P Dougherty near Zennor. He was coming away from the cliffs where he had been painting a seascape and with him was his chauffeur carrying his equipment. At the side of the road was his waiting car. He was staying at a hotel in St Ives.

Ranger Gull, the novelist who also wrote under the pseudonym Guy Thorne, wrote 25 novels and spent some time in St Ives. He died of influenza in London in 1923. As Guy Thorne he wrote the controversial book *When It Was Dark*. His entry in Mrs Griggs' visitors book reads: 'I have just returned to Zennor after an absence of 8 years. Before that time I often used to visit the delightful village. My wife and I always stayed with Mrs Griggs — who always made us completely happy and comfortable. My brother and many of his Oxford friends stayed with her also — all of us have the happiest memories. I am here again on almost the last night of 1911 and it is with great pleasure and interest that I see once more the village and the rooms where part of *When It Was Dark* was written.'[62]

Charles Pearce recalls, "I was only a boy but I remember a chap who had been working on one of the London papers had a great success with a book he published. It was called *When It Was Dark*. He gave up his job and joined the fraternity at St Ives. He pulled to pieces the bible in this book. That was why it created a fuss. The book was quoted in the daily papers. There was a woman preacher in St Ives well known for her preaching. The chapel was filled with locals, fishermen, miners, everybody. This chap would not be allowed in a shop in town. This man denigrated the very thing they believed in, their faith. He had to leave the town."

The book caused a storm in Cornwall and this added to its sales appeal, 'which thanks to widespread pulpit advertising would be the first best seller in a big way.'

Compton Mackenzie recalls his memories of Ranger Gull. 'When he went to live in Cornwall he made a habit of concealing bottles of whisky all over the moors so that on country walks he could boast he was never more than a quarter of a mile away from refreshment.'[63]

Granny Griggs was still looking after the artists in later years when J M Bromley and family from Holly Hill, Hampstead, lodged there in 1929. Edward Sackville West, giving his address, Knole, Sevenoaks, Kent was there in 1930. Alice H Nicholson and Emily Allnutt stayed in September 1933 and Borlase Smart in 1934.

In 1909 an advert appeared in the local press 'Artistically furnished cottage at 12/6d per week, plate, linen and service optional, south aspect. Letters to Mrs Havelock Ellis, Carbis Bay.' Havelock and Edith Mary Ellis had a house in Carbis Bay. Among the tenants of their cottages, which Edith furnished for letting, were Henry Bishop, ARA, writers Mr and Mrs Alfred

Sidgewick, Edward Verrall Lucas, novelist and authority on Charles Lamb, whose biography he wrote in 1905, and Somerset Maugham, novelist and short story writer.

Havelock was described as tall and bearded, very silent and shy. Edith, by contrast, was the picture of feminism, very round and bustling, with a quick temper. In 1897 the Ellises lived at The Cot near Hawkes Point, where she wrote her first novel *Kit's Woman*, in 1898.

In 1909 Edith's novel *Atonement* was published and considered the most important book from the pen of Mrs Havelock Ellis...'the story of a young girl who comes to London from her quiet home in Cornwall, and is plunged into the midst of all the new movements... the reader will be able to detect many well-known people under a thin disguise in her pages.'[64]

Havelock Ellis was a president of the World League for Sexual Reform and published several volumes of *Studies in the Psychology of Sex*. Mrs. Ellis gave a series of lectures in England and America. Her subject concerned women's suffrage and her husband's psychological theories on sex. Edward Simmons gives an insight into her character, 'There came to Concarneau a young girl, wide eyed, eager, temperamental, thirsting for a knowledge of life, but knowing about as much of it as the bird just out of

Alfred J Munnings, self portrait at Mrs Griggs' guesthouse, Zennor. A Symons.

the egg. She was alone and studying art ... Not long after she announced her wedding with none other than the well-known writer, Havelock Ellis.'

'Some years after, I visited the Ellises in England. This one-time childish wife had developed into a charming woman and strange to say, a full-fledged raiser of blooded stock. She it was who tended the wants of the baby bulls and colts, was in at the births and deaths of the animals, while Havelock sat by the warmth of his very delightful fire-place smoking his pipe and probably mulling over the psychological effect of all this on the feminine mind.'[65] Edward Simmons says he held the head of a baby calf, while she slipped a dose of oil down its throat, and was quite oblivious of the fact that he ruined a new pair of white flannel trousers.'

Edith managed her farming activities at the Count House, Carbis Bay, where they lived for 12 years. It was once the property of the local mine, and afterwards the family home of Bernard Leach. In 1906 her book *My Cornish Neighbours,* was published as a series of stories and anecdotes written in the vernacular. She wrote eight books and several plays, two of which were performed in America while she was lecturing and touring there in 1914.

A Friendship

Havelock Ellis wrote that Edith's great friend was the painter Lily Kirkpatrick. 'Lily was a St Ives artist who lived with an older sister, by whom she was jealously tended and guarded, in a little home of refined culture. She had studied in Paris without, however, being touched by the Bohemian life of the Latin Quarter, and as the sisters had private means she was not dependent on her art for a living.'[66]

Such was the depth of their friendship that when Lily died in 1902 Edith purchased the neighbouring plot in Lelant church as a grave for herself, though she gave it up on moving to London. When she was troubled she would stand by the grave and talk to Lily. Before their move to London Havelock Ellis wrote about his wife, 'On New Year's Eve, the last of her life, she was able to carry out a still more old standing custom, associated in her mind with the beloved Lily, whose fascinating personality had once played a leading part in it. This was the annual entertainment of the St Ives Artists Club.'[67] Edith died in 1916 at Maida Vale, London.

In 1907 Lewis Hind's book *Days in Cornwall,* was published and dedicated to Charles Marriott with the inscription, 'To Charles Marriott, Companion on many walks — past and to come.' Mrs. Vesta Simmons, wife of the American painter published a novel entitled *Men and Women.*

Suggestions Book:
'To prevent the use of unparliamentary language, would suggest that decent pens be provided.'
'That a supply of writing paper be obtained. Quality to be left to the Hon. Sec. George Sherriff'

The Library

From the very beginnings of the Club it was clear that the committee intended setting up a library. It was proposed: 'That the Nineteenth Century be added to the magazines taken.' These magazines included *Punch, The Studio, Magazine of Art, The Year's Art, Colour,* London newspapers, *St Ives Weekly Summary* and as many art magazines as could be afforded at this early stage.

It was proposed by Julius Olsson and Adrian Stokes: 'That the best thanks of the Club be given to Mr F Sargent for his present of Grave's Dictionary of Artists.' Mr Feeney and Mr Grier also gave books. Mr Maybridge presented a book of his work on Animal Locomotion. A library of works of reference relating to the arts was bought.

In 1900 the Club purchased Mr Feeney's *Encyclopaedia Britannica* for the sum of £10 — half the purchase price. These volumes were offered for sale in the 1940s but, not surprisingly, were considered too old. They were offered again to Lane's in 1979 and were not taken up for the same reason. They have sat upon the shelves in the Club library for 90 years.

Suggestions Book:
'That the Club purchase a good atlas — say The Times atlas P M Feeney, H H Robinson'
'That the Club purchase a good English Dictionary. L Grier, H H Robinson'

Lewis Hind and Miss Whitehouse also gave books to the library — the titles are not named. Mrs Coventry Patmore (wife of the poet) presented three books of colour reproduction of the works of Velazquez, Turner and Greuze. The secretary wrote a letter of thanks and she was subsequently elected to membership. Alfred East wrote promising a copy of his book *Landscape Painting in Oil Colour* which was published in 1908. Edgar Skinner gave a volume of drawings by Harry Furniss who had worked as political caricaturist and illustrator on the staff of *Punch.* In later years Borlase Smart's book *The Technique of Seascape Painting* 1946 and Leonard Richmond and Littlejohns's book *The Art of Painting in Pastel,* were bought for the library and a book of Brangwyn's was presented by Dr W Best in 1944.

When the office of Librarian was established Louis Grier took up the appointment. There was by now a fairly extensive range of books and magazines and it was decided to have *Punch* and *The Studio* bound. Grier, as one of the first artists to be elected to the Local Council, was also concerned with the Free Library (to which Leslie Stephen contributed 21 volumes of books). In 1906 William Brooke donated 18 volumes of the *Illustrated Magazine of Art* to the public library but Grier complained that, with the exception of the chairman and himself, there was absolutely no one taking an interest in the public library. However, the Arts Club library continued to flourish.

To The Lighthouse

It was resolved that the librarian, by order of the

committee, should sell by auction, excepting *Punch, The Studio* and *The Athenaeum*, the following papers — *The Sphere, Ladies Field, Graphic, Country Life, Academy.* 'The money thus acquired to be used for the purchase of valuable books for the library.' This decision was overturned at a General Meeting in 1912 on a proposal by Louis Grier and Herbert Babbage, 'that the papers be sent to the lighthouse.' Thereafter all out of date periodicals were taken to the lighthouse and the Seamen's Mission. In Virginia Woolf's novel *To The Lighthouse* the children talk of rowing to the lighthouse to deliver magazines — can the idea have originated from this practice at the Arts Club?

Committees through the years were faithful in continuing to build an art reference library. In 1919 the librarian reported that new shelving had been installed to provide for the growing numbers of books. Mrs R S Read donated three books to the library in memory of her brother, Robert Langley Hutton, who died in 1919 at the early age of 36. John Titcomb proposed that the books be inscribed, 'In memory of Langley Hutton.'

Depletion of the Library

During many years the arts library reference collection of magazines and books was faithfully stored, as was intended by the early artists, and was a valuable resource for researchers, journalists and art historians. The art magazines, dating from 1890, held the history of St Ives and Newlyn artists' colonies, as well as an insight into Pont Aven, Concarneau, the Scandinavian and American colonies. Biographies of painters, illustrations and articles written by members of the art colony detailing events of an historic nature were also plentiful.

According to one art historian, who made use of the library in the late 1970s, it was the finest complete collection of art magazines in the West Country and contained volumes of *The Artist, Colour, Art Journal, The Studio, Century Magazine, Royal Academy Pictures, Magazine of Art, Punch, Century Magazine* and *Harpers* magazine.

In 1950 it is recorded that there were 720 volumes in the library on art, literature and drama, but mostly related to art. One volume would constitute a year's collection of a magazine. It is even more surprising, given the amount of material to be found in one place, and the number of writers and journalists who were members of the Arts Club, that none thought to produce a book on the early artists' colonies.

It is probable that small sales of books took place over the years but unfortunately, in 1979, it was decided to auction the remainder of all the art magazines in a misguided effort to raise money for repairs to the building. The committee at that time obviously ignorant or uncaring that it was disposing of the last remnants of its written history.

The auctioneer's catalogue listed 125 bound volumes of *The Studio,* others unbound, and a variety of several art magazines and books, as well as a collection of *Punch.* Also sold was Morton Nance's *Pottery and Porcelain of*

Mr Prout, Arts Club Librarian, showing volumes of art magazines.

Nantgarw and Swansea, a book of specialist interest to collectors of such pottery, which had been presented to the Club in 1943.

Lanham's Gallery

At a meeting of exhibiting members in 1905 it was proposed by Lindner and Dyer to, 'get the rules and regulations affecting Lanhams Committee printed.' The newly elected Gallery Committee were — W E Schofield, Louis Grier, Beale Adams, Lowell Dyer and Fred Milner. By the end of the year it was reported 'that the Committee had broken down for the months of August, and September and that Mr Lanham had hung the Gallery during those months to please himself.'

The 'please himself' arrangement of paintings by Mr Lanham drew a disapproving comment from the artists. Some had complained of overlapping of paintings shown in Lanham's window.

> 'We, the undersigned, think it is most unbecoming in members of this Club to allow their pictures to be exhibited in shop windows.'
> Signed — Adrian Stokes, Louis Grier, C G Morris, Will E Osborn, W Dickson, Charles H Eastlake, J C Lomax, Arthur Meade, Bosch Reitz, Edward T Lingwood, G Walter Jevons, Algernon M Talmage, John Noble Barlow.

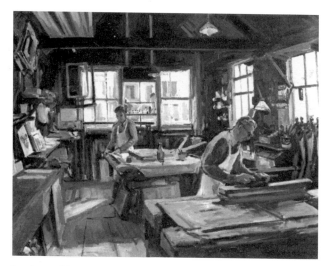

Lanhams Picture Framing Workshop, *Leonard Fuller. David Lay.*

The Prynne Family

Thomas Tonkin Prynne was responsible for framing and sending paintings to more than 36 Royal Academy shows and many other exhibitions. He worked at Lanham's for 50 years. His father before him left school at 14 and also spent 50 years at Lanham's.

An article in *St Ives Times* mentions a foreman who had perfected a system of stretching canvases and had served the firm for 39 years. 'You may trust a quarter of a century's experience in the firm.'

A local resident said, "Charles Prynne and his son Tonkin did all the framing and packing for the artists at Lanhams. They had quite a lot of paintings given them by the artists. The son-in-law (Jim Smith) took over and they worked for Lanhams for 125 years between them."

Jim Smith said, "We were all involved in packing and framing," Jim said, "I joined my wife's father at Lanhams in 1954. There was a room set aside for packing cases. We sent everything by rail. After Show Day, when the artists opened their studios to the public, we would receive as many as 150 pictures for despatch to London. A complete railway carriage would be hired. Leonard Fuller painted a picture of the two of us in the workshop. It was a fine painting. I went to see Mrs Fuller to purchase it but unfortunately it was exhibited in a show and was sold. I don't know who bought the picture." This painting appeared in David Lay's auction in February 1991.

1911 – The Third Decade

John Henry Titcomb, President

Into the third decade the numbers of people joining the colony rose considerably, with folk making all sorts of claims to being painters, writers, musicians and other artists in order to be included as members of the Arts Club. It provided a meeting place for like minds and offered a venue for socialising, entertainment, meetings and discussions. There were no Cubists, Futurists or other influences from the continent to disturb the steady flow of landscape and marine paintings, which were a feature of the St Ives artists' colony.

At a committee meeting a discussion took place on the re-establishment of the professional qualification for members and students. Julius Olsson said that this had now become desirable and determined efforts were put into effect to promote the 'professional' standing of the Club. When Florence Canning applied for membership she received a letter from the secretary requiring her to provide information on where she had studied and exhibited.

Florence Canning was elected a member on her record as a painter and teacher. It was important for artists to establish that their work was accepted for exhibitions or that they were members of art societies. J C Uren was turned down because he was practising as a borough surveyor, although in the period up to 1900 he was a member.

Suggestions Book:
'London Art Journal, Art Chronicle, The American Art News and French and German Arts Papers — these magazines would greatly add to the already valuable collection which the Club has in its possession.' Hayley Lever and 14 other signatures

Moffat Lindner, *1943, Leonard Fuller.*

'The following members beg to urge the committee to take steps to remedy the bad ventilation of the Club Room — To replace the stove with a new one on account of the poisonous fumes given off by the present heating apparatus thereby causing a vitiated atmosphere — signed Charles D Tracy, Louis Sargent, Claude Barry, M Evergood Blashki.' 21 other signatories described themselves as victims and martyrs.

1912
Moffat Peter Lindner, President

On 12 January, a complimentary dinner was given to Mr Olsson in honour of the purchase of his picture *Moonlit Shore*, by the Chantrey Bequest. There were 24 members present (male) and 11 guests. (cost 5/9d per head). Olsson sent the following letter to the President from the Chy-an-Drea Hotel, St Ives on the 13th January 1912.

'My dear Lindner,
Before leaving St Ives today I should like to express to you as President of the Club, to your committee and members, my heartiest thanks for the reception given me last night and which will always remain as one of my happiest memories. Always yours truly, Julius Olsson'

A complimentary dinner was given to Alan Deacon in recognition of his services to the Club. There were 23 members present and 2 guests. Cost 6/6d per head. A gentlemen's supper which had been arranged was postponed 'owing to Curnow refusing to cater at 1/6d per head.'

At an informal meeting of exhibiting artists the president decided to alter Show Day because the railway could not guarantee the delivery of the pictures on time. Claude Barry, as treasurer, felt he had been slighted

Skidden Hill, St Ives, *1910, Claude Francis Barry. Carbis Bay Hotel.*

because he had not been informed of the change. Lindner assured Mr Barry that all he did was to agree a new date and make arrangements for printing the lists and preparing the tea. The necessity arose through the coal strike and in the circumstances was quite justifiable. However, at the next meeting Claude Barry tendered his resignation. The painters Louis Sargent and William Fortescue followed as treasurers in quick succession.

Sir Claude Francis Barry was elected to the RBA in 1912. He was the eldest son of Sir Edward Barry of Ockwell's Manor, heir to the baronetcy and educated at Harrow. He shared a studio in Tregenna Hill with Mrs Doris Barry, who exhibited needlework pictures in silk. She was a member of the Society of Women Artists. Mrs Barry is said to have sold all her husband's paintings when he left for Italy in 1913 — with his mistress.

The Barrys also exhibited their work in St Leonard's Studio, Back Road West in 1920, where he sold paintings and etchings classed as a series of 10 souvenirs of St Ives. Barry rejoined the Club in 1940 when he again returned to the town. Many of his works are scenes of Windsor Castle and district, where he lived for some years. One such work is in Belyars Croft Hotel, where he stayed whilst in St Ives. Two large paintings of Skidden Hill are exhibited in the Carbis Bay Hotel and Treloyhan Manor.

At the age of 19 Garstin Cox had his first picture hung in the RA. A report of May 1912 notes his success: 'Academy pictures. Mr Garstin Cox, of St Ives, a pupil of Noble Barlow a well-known local artist, has achieved the height of his ambition by getting his first picture accepted and hung in a prominent place in this year's Royal Academy. The painting depicts one of Mr Cox's clever landscape scenes of Lamorna Valley and is entitled The Coming of Spring. As we have previously foreshadowed, Mr. Cox, who was born at Camborne is a rising artist of no mean ability.'[68] This painting was reproduced as a print by a firm of art publishers.

In 1919 Cox presented a canvas to St Dunstan's Academy. His work was described as translations of morning sunlight in the West Country. A picture (not named) and

Kynance Cove at Sunset, *1928, Garstin Cox. David Lay.*

Buildings before Wharf Road was built, showing Louis Grier's studio, centre.

hung in this year's Academy was purchased for the Johannesburg Art Gallery. The painting sold for £80. In 1920 three pictures painted out of doors by the River Fal were sent to the RA. *The Cornish Post* reports: 'Moonrise on the Fal is perhaps the more arresting and original picture.' These three paintings were said to illustrate the artist's range of inspiration as well as his interpretive ability.

In 1923 Garstin Cox painted a picture, 'Cliff Mining in Cornwall', which showed the precipitous situation of the Botallack mines and the conditions and danger under which the miners worked. Cox died at the early age of 41.

1913
Arthur Meade, President

In 1913 Georgina Bainsmith, sculptor, living at Barnoon Terrace, stood as a candidate in St Ives' municipal elections. Edgar Skinner, painter, of Salubrious House, also stood. Both were defeated. Much as the artists may have been accepted as people who lived and worked in the town, the Cornish were self-governing, and none but a Cornishman and a native born St Ives person, could determine how their town should be run, whatever one's claim to fame, family background or social standing.
Telegraph to Julius Olsson

> 'Heartiest congratulations from St Ives Arts Club 21.3.1914.'

The telegraph was followed by a letter.

> 'Last night at the Arts Club a unanimous vote of congratulation was given you on your election to the Associateship of the Royal Academy. I know your friends everywhere will be delighted at this honour, but none more so than the St Ives Art Colony, with which you have been so closely associated for so many years. All here send you and Mrs Olsson best wishes. Robert Langley Hutton, Hon. Sec.'

Olsson telegraphed,

> 'Many thanks to all members for kind thoughts of me.'

A letter followed, written from on board *RMS Mauritania*.

> 'Dear Hutton,
> Please thank the members of the St Ives Arts Club for their kind vote of congrats: which is much appreciated by an old member of the Club.
> Sincerely, Julius Olsson.'

An Artist's Lament

An advertisement of May, 1916, in *St Ives Times* under properties for sale was Lot 2. 'All that Artist's Studio, facing the Harbour, and in the occupation of Mr Louis Grier as tenant.' The sale was to take place in June at the Public Hall but the day before the sale an unsigned poem was printed in the *St Ives Times*. It is known that Louis Grier had occupied this studio, certainly since 1888, and very likely before then so it must be assumed that this is his poem of lament.

THE ARTIST'S LAMENT
What have I done that I should lose
The eerie where I woo the muse,
The place of all, which I should choose
 My studio?
The home of all my pots and pans,
The place I lay my deepest plans,
Where I think out my can'ts and cans
 My studio.
The place of warming pans galore
Which I had bought before the war,
They're not for sale, they're only for
 My studio
For thirty years I've laboured there,
And planned and thought and torn my hair
It is my only private lair
 My studio
The landlord, so the bills have said,
Has sold the place above my head
He might as well have sold my bed.
 O! Studio.
How hard it is you can't believe,
I wish I could get a reprieve,
It really breaks my heart to leave
 My studio.
Now I must gird my loins and find
Another place in which to bind,
The fleeting sketches in my mind,
 A studio.[69]

However, it is noted in the report of Artists Show Day 1919, the Foc'sle studio of Mr Louis Grier is visited. Probably the landlord and he came to some arrangement — as a result of the poem?

The War 1914-1918
Moffat Peter Lindner, President

Throughout the war years the same president with more or less the same committee continued in office with a depleted membership among the men. Lindner was very much concerned with keeping the Arts Club as a going concern and preserving its primary aims as an artists' club.

However the war was beginning to restrict activities. Money was being redirected to the war effort. £100 was invested in the War Loan and it was resolved that £25 could be withdrawn from time to time for the benefit of any war funds, the Serbian Fund, St Ives War Depot, Navy and Flying Corps Funds.

Louis Grier placed one of his pictures at the disposal of a relief fund for the widows of drowned fishermen. The original illustrations by Messrs. Chadwick, Milner, and Verbeck, which appeared in the Christmas number of *St Ives Times* for 1914, were offered for auction to the highest bidder for the Tobacco Fund for the troops. In aid of the Lifeboat several local artists painted posters, which were later sold for the benefit of the Society. Charles Simpson and Moulton Foweraker presented two pictures for sale for the Red Cross. St Ives artists visited the neighbouring colony of Newlyn on Show Day to see the pictures of Laura and Harold Knight, Stanhope Forbes, R M Hughes, Norman Garstin and daughter Alethea, Charles Simpson, Harold Harvey, T C Gotch and Walter Langley before despatch to the RA. Acceptance of paintings at the RA for 1914 were 15 from St Ives and 14 from Newlyn.

In this year a number of American painters arrived in the town. Gardner Symons, P Dougherty and H B Snell, who brought 20 pupils with him. A J Lyons and Professor Miller were expected from Paris. Before the war the number of artists living in St Ives was numbered at over 100.

Artist Volunteers

'March 12, 1915. A letter was read respecting the formation of a Volunteer Training Corps in St Ives for home defence. Some 18 members of the Club joined.' At the first meeting of St Ives Volunteer Training Corps Louis Grier was anxious to know when they would be taken for a real route march, say 10 or 15 miles.

In these early years of the war the newspaper carried various reports of the artists. Edmund Fuller left the town for work in munitions, and H G Fitzherbert, artist and cartoonist, was made up to Lieutenant in the 1st Devon Yeomanry. He was also awarded the Military Cross for conspicuous bravery in the field. U R Douglas, son of Mr and Mrs Douglas, passed his examination for entrance to the Royal Military College at Sandhurst and Guy Kortright became a Captain in the 21st Monmouthshire Regiment. W S Parkyn ARCA, ARWA, offered to paint and present to the St Ives Town Council a picture of any battleship or cruiser they selected. The Mayor and Corporation chose *HMS Albion,* in which so many St Ives men served.

The son of the sculptor Georgina Bainsmith was reported wounded in action but William Alexander Forbes, only son of Stanhope Forbes died on active service. A memorial was later placed in Sancreed Church. Expressions of sympathy were extended to Mr and Mrs W H Y Titcomb in the loss of their son Francis Holt Yates Titcomb, who was accidentally killed while flying. Both young men were only 19 years of age.

Julius Olsson was congratulated as one of 50 artists selected in connection with the Canadian War Memorial Fund to paint pictures at the front, battlefields, roads of France, towns etc.

Frank Moore, artist, living at Pedn-Olva house, Draycott Terrace, protested at the remarks made by Edward Daniel at the Drill Hill. He drew particular attention to him and indicated that he ought to join the Cornwall Light Infantry.

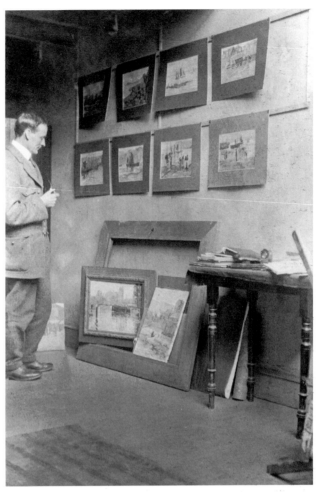

H I Babbage in St Ives Studio, 1912. Frances Wilcock.

Moore pointed out that he was not only over the required military age, but also unfit, and felt this did not help recruitment but was also in the worst possible taste. An apology was made by Mr Daniel. Later in the war Moore was appointed 2nd Lieutenant of the East Surrey Regiment. Four members died on active service.

Lindner announced that he had applied for a plot of land, which could be worked by various members of the Club. Two plots were duly allocated by the Borough Surveyor at Nanjivey. Nine members gathered to begin work on the land. In the autumn the results of the work on the allotment were given by the treasurer and considered to be satisfactory. Thanks were expressed to Edgar Skinner for his great help in superintending the cultivation of the plots on the Club's behalf.

On 25th October 1916 a letter of sympathy on behalf of St Ives Arts Club was written to Mrs Amelia Babbage on the death of her son, Herbert Ivan Babbage, the marine and landscape painter. The *St Ives Times* recorded 'Mr H I Babbage, well known in St Ives as one of the art fraternity, has died whilst on active service as a result of an operation. He was in St Ives at the outbreak of the war and enlisted as a private in the Devon and Cornwall Light Infantry. Mr Babbage was a native of New Zealand and was travelling in pursuit of his art, but stayed in St Ives for

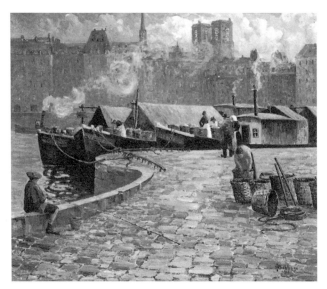

Bateaux Des Pommes, Paris, *H I Babbage. V Pattenden.*

some time before the war. He was greatly respected by a number of friends.'[70]

Two sisters, Veronica Pattenden and Frances Wilcock (née Babbage), relatives from New Zealand, visited the Arts Club in 1988 and 1989 on a pilgrimage to the places where their uncle had lived and painted during his stay in England. Two of his paintings were exhibited in the RA. Most of his work is with the family in New Zealand but a small painting of St Ives Harbour dated 1912 shows his style. This picture was sent back to St Ives from New Zealand by his nieces, after nearly 80 years. It is interesting to note that a relative, Charles Babbage, invented the first computer. In 1991 his bi-centenary was celebrated in Totnes, Devon where he was born.

In 1914, probably just before he joined the army and his last exhibition, H I Babbage opened his studio in Porthmeor Square showing a selection of his work from Holland, Italy and Switzerland, many of which were snow studies. Also on view were paintings of local interest.

The painting 'Bateaux Des Pommes', was exhibited in the RA in 1908 and bequeathed in Babbage's will. 'The RA picture Bateaux Des Pommes now in my mother's home I wish to be given to the Wanganui Art Gallery. I wish the above distribution to be made by my uncle Alfred Adrian, 40 Elsworthy Road, London NW signed Private H Ivan Babbage, 24 Co. R.D.C. The Camp, Edwardsville, Treharris, Glam. 18 September 1916'. He died a month later.

Restriction on Sketching — Artists Object
At a meeting at which Alderman T Uren, the Mayor, was present, the matter under discussion was the new sketching prohibition order issued by the military authorities. The secretary was instructed to write to Lieutenant General Sir Pitcairn Campbell pointing out that this restriction was inconvenient to those who adhered to the philosophy of en plein air.

Three artists signed a joint letter addressed to the Editor of the *St Ives Times* in 1915. 'The winter will soon be upon us and unless something is done to rescind the order relative to sketching and painting out of doors, we may reckon that ninety-nine percent of our usual winter visitors will go elsewhere. The artists will suffer, both through the restriction, and the loss of pupils, the lodging house keepers through the lack of their winter lodgers, and the tradesmen and town generally through the loss of customers.'

'Yet the remedy is both simple and obvious, and we believe would recommend itself to the naval and military authorities, viz: That the Mayor should offer to take upon himself the responsibility of granting permits within the Parish of St Ives. A petition to this effect, signed by nearly every citizen would impress the authorities with the importance of this matter to St Ives.'

'Now in St Ives we have a number of resident British artists and others who have been in the habit of frequenting our town year after year to whom restriction means serious loss of income. We think it little short of ridiculous that these men and women should be prevented from pursuing their vocation. Signed Thomas Millie Dow, Julius Olsson and Moffat Lindner'[71] Petition forms were made available and the Mayor promised his full co-operation in the scheme.

In the House of Commons the Under Secretary for War was asked whether he had been able to make arrangements with the Admiralty for painters in Cornwall under proper regulations to carry on their out-of-door painting. Mr Tennant said it was now only necessary to apply for permission to the local naval or military authority who had been delegated to grant permits in suitable cases. However not all could be exempt and because of the restrictions on painting and sketching in the open more sketching classes were arranged at the Arts Club.

Writers
During 1914/15 there were several writers at the Club writing war novels. Frank Barrett's novels were particularly popular on the Continent and translated into French. A production of *Mistress Wilful* was playing at the

St Ives Harbour, *1912, Herbert Ivan Babbage.*

Strand Theatre, London, based on the novel by Rolf Bennett, *The Adventures of Lieutenant Lawless RN*. Arthur Machen, master of the supernatural, wrote a book of short stories *The Bowmen and other Legends of the War*, which related to the sighting of angels. It was in the *London Evening News* that his story first appeared and was accepted by many as fact. Harold Begbie drew inspiration for his novel *On the Side of the Angels*, from the reports of angels appearing to the troops at Mons.

During 1916/17 D H Lawrence stayed at the Tinners Arms and later at Higher Tregarthen, where he wrote his novel *Women In Love*. Having a German wife and an untimely habit of singing German folk songs, neither endeared him to local people or the military. Lawrence and Frieda came under suspicion of spying and were ordered out of the county. Their experiences in West Penwith form the basis for the chapter entitled 'The Nightmare' in Lawrence's novel *Kangaroo*.

The Lawrence's literary friends, the New Zealand short story writer Katherine Mansfield with John Middleton Murry, author and editor, lived in the cottage next door, where Katherine wrote in the tower room named by Lawrence, Katherine's Tower. Lawrence had persuaded them to join him and Frieda in Zennor, where he was sure they could share common ideals. However, after a few months living so close the friends parted on bad terms. Katherine and Murry found Sunnyside cottage in Mylor on the south coast of Cornwall.

A relative of the Dows, who lived near the Lawrences, remarked that they weren't too keen on Lawrence but Frieda was very nice and always laughing and Katherine Mansfield was lovely. Another local resident from Zennor said the four friends ate together and her aunt used to cook them a midday meal. One morning on going into the kitchen she found Lawrence and Frieda arguing. He shouted at her, 'You will wear the red stockings!' These red stockings, when they appeared in the town of St Ives 'marked them out as foreigners'.

Also living in Zennor at Bosigran was Cecil Gray the musician and for a time Hilda Dolittle the poet, who came to live with him there in 1918. She was married to Richard Aldington but had an illegitimate child by Gray, who offered to marry her. Aldington wrote from the 'front' that he was willing to take care of her and the baby. She refused both offers. During the war Gray was fined £20 for showing a light in his window.

Gift of a Portrait
At a Council meeting in 1916 the following letter was read from W B Fortescue of Trelyon. 'It occurred to me some little time ago that it would be a fitting tribute to the admirable way in which our Mayor Mr Uren has discharged the duties of his office during a lengthy period of particularly arduous times, if his portrait could be added to those of former Mayors which hang in your Council Chamber. I thought that I should like to paint a portrait with this end in view, and upon my asking the Mayor, he kindly consented to give me the necessary sittings, and the

portrait is now completed. If it meets with the approval of your Council and they would accept it from me as a gift, given in the spirit in which it was under-taken, I should feel very pleased.'[72] Alderman Daniel moved and Councillor Ninnis seconded that Mr Fortescue's gracious offer be accepted, with the best thanks of the corporation.

It is interesting to note that the sale of Hain Shipping Lines to P and O took place in 1917 and that £10 shares sold for £80. This obviously affected a great many people in the town. Apparently the ordinary seamen and fishing families in St Ives also had shares in the Company. It is noted that R S Read, who was a director, and Edward Hain donated £500 each from the sale of their shares for the building of Tehidy TB hospital.

1918
Lowell Dyer, President
The Club continued its efforts for the war fund. A concert arranged by Madam Solly was given at the Arts Club in aid of the Artists Benevolent Institution, which was founded 100 years ago. It was said that many artists were badly hit on account of the war and no urgent or genuine appeal for help was ever refused. Moffat Lindner was appointed steward for collection of funds and he was congratulated on the large amount he had acquired for his fellow artists and for the able manner in which he had filled the post of president during the war years.

The War Years and Women
Meetings in favour of extending the franchise to women were held on the Malakoff and Porthminster Beach, with speakers coming from London to address a large and sympathetic audience. In 1912 Keir Hardy, speaking on the subject in Penzance, had said he knew of no reason which justified a man having a vote that did not equally justify women having one. In 1910 a meeting of the National Union of Women's Suffrage Societies was held in the Central Hall, St Ives.

Mrs Augusta Lindner, who was a suffragette, held meetings at Chy-an-Porth when the organiser of the women's suffrage movement addressed a gathering of about 50 ladies. In 1915 Mrs Lindner was president of the NUWSS, but the stress in this part of the world was on change by constitutional methods. 'Service to Others' was the dictum of the Cornwall Branch, which effectively stopped any form of action. This service was soon to be put into operation in the war years.

However, some form of direct action was proposed by Mrs Edith Havelock Ellis on her lecture tour in America. She suggested a 'love strike'. 'In Cornwall my home, I asked an old farmer what he thought of this plan. He replied, '"Good gracious, women would get the vote within a fortnight."' In 1916 Edith Ellis's death was reported. She was described as, 'one of the greatest feminists in England ... she worked always for greater freedom for women.'[73]

One act of defiance was recorded when Mrs Lily Girdlestone was fined 50 shillings for failing to fill in a

Laura Knight at work in St Ives, *Sarah E. Whitehouse.*

registration form. She said she objected firstly because she was opposed to any war and secondly because, not having a vote, she was not a citizen.

Laura Knight recorded her wartime experience. 'In 1915 the first restrictions against painting any part of the coastline came into force. At St Ives, where we went to work for a while, when painting some children playing in the harbour, I put a dab or two to represent the sea horizon; I knew that even to draw a perfectly straight line there might be interpreted as a sinister act. The official who came to examine what I was doing asked, "What are those spots of paint?" I told him, and he said, "How am I to know they don't mean something?" After that I confined my studies to boys swimming, looking straight down on them.'[74] Any breach of the restrictions on painting out of doors could have meant imprisonment for an unfortunate painter so discovered.

Laura Knight painted a portrait of Daphne Pearson, who served in the Women's Air Force during the second world war and was the first woman to win a medal. She was incidentally a member of the Arts Club in 1936.

At the start of the First World War a Ladies Committee was set up. Miss Whitehouse of Lyndon, Talland Road, put an advert in the paper requesting magazines, novels and suitable literature be brought to the *St Ives Times* for distribution to the territorials. A Sewing Party was organised and in the first year they sent parcels of flannel shirts, waistcoats, mufflers, mittens, helmets and socks to the Duke of Cornwall's Light Infantry at the Front. Other parcels were sent to English, Belgian and French Red Cross.

Two pictures presented by Miss Whitehouse and Elgar Russell were sold at the Café Chantant for 15/6d and £1.12.6d respectively on behalf of the First Aid Nursing Yeomanry Corps at Calais. It was advertised that Miss Whitehouse would be in her studio, 3 St Andrew's Street, morning and afternoon and would be pleased to give the proceeds of any picture sold to the Depot Funds.

The RSPCA set up a fund for sick and wounded horses. It was the only fund authorised by the British Army Council to help alleviate the suffering of horses in wartime. Prints by Lucy Kemp-Welch, recognised as one of England's greatest painters of horses, and president of the Society of Animal Painters, were offered for sale to provide shelter and treatment for sick horses. Lucy Kemp-Welch studied under Professor Herkomer and took over the running of the Bushey School in 1907 until 1926. Two paintings were purchased under the Chantrey Bequest 'Colt Hunting in the New Forest' in 1897 and 'Forward the Guns' in 1917. Her painting 'Low Tide St Ives' was purchased by the Walker Art Gallery in 1923 and was exhibited there in 1988 at a major show of paintings by women artists called Women's Works.

At Lelant parish church hall Her Highness the Ranee of Sarawak, who was living in Lelant, gave an address on the work of the Blue Cross Fund for horses and dogs in the war and the work of Our Dumb Friends League showing lantern slides of animals' devotion and involvement.

Mrs Lindner arranged drawing room sales at her home, Chy-an-Porth, for the benefit of Dr Barnardo's, and Miss Shakerley, who was headmistress and owner of a grammar school in the town, provided free education for many Belgian refugee children.

Four women working in the ladies party were the four Misses Whitehouse. Sarah Elizabeth (Lizzie) 1854-1933, Mary Jane (Jeannie) 1855-1933, Louise Caroline (Louie) 1856-1932 and Frances Charlotte (Daisy) 1863-1957. Sarah and Daisy were the painters and Louie did a little sketching. They lived with their mother Sarah in St Ives over a number of years. She died in 1900 and is buried in Barnoon cemetery. Their brother, a painter and architect, set up the Hyde Park Fine Art Gallery at 30 St George's Place, London, and reproduced paintings by 'Autotype method.'

None of the sisters married but spent time together travelling to Italy, and painting their way through Europe. When they returned to St Ives they lived at various locations in the town, The Warren, 24 The Terrace, 4 Draycott Terrace, and Balcony Studio, 3 St Andrews Street. Finally they bought a house, 'Lyndon' in Talland Road, which has since been renamed. Another of their studios was in St Peter's Street. Daisy and Sarah Whitehouse are seen in the Arts Club photograph of 1895.

At the unveiling of the centenary celebration plaque on

Three Misses Whitehouse. Prof M Whitehouse.

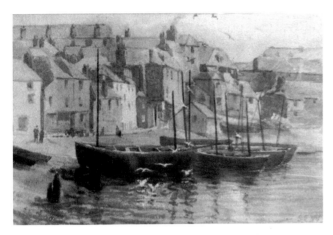
St Ives Harbour, *1895, Sarah Whitehouse. R Whitehouse.*

the Arts Club in 1990 Roger Whitehouse, nephew of the four Misses Whitehouse, and his wife Jocelyn, travelled down from the Isle of Mull to help span the 100 years from his aunts' joining the Arts Club in 1890 to his presence in 1990.

Sarah's signature first appears in the Suggestions Book in 1891 supporting Louis Grier's request that 'framed photos of members pictures be accepted as a suitable form of decoration for this barn.' In her handwriting 1892 is the request that a book be kept at the club with a list of models, a description of their appearance, and their address. She appeared to be an active member of the model group.

She seemed to have more of a commitment to a painting career than her sisters. In 1893 she was awarded the bronze medal for painting by the Académie Deleclude for an oil picture 'Bo Peep' which was shown at the RA. She showed 'An Interior' in 1894 and that same year was invited to exhibit at Birmingham. In 1895 she was elected a member of the 91 Art Club and in 1897 was awarded first prize of £40 for her picture 'Interior and Figure' in Mellins Art Competition. She also exhibited in Liverpool, Manchester and Leeds. In 1901 a large oil painting 'In Praise of Love' was reproduced as an autotype, a copy of which was purchased by HM Queen Alexandra.

A New Zealand artist who spent the war years in St Ives was Frances Hodgkins, figure, landscape and still life painter. She came to England when she was 20. After teaching at Colarossi's in Paris, the first woman to teach there, she opened a watercolour school in France for women students.

In 1914 she joined the Arts Club. Her studio was at 7 Porthmeor next to Moffat Lindner's. Hope Lindner said her father let her have it rent free because she was quite poor. "He liked her work and bought several of her paintings, which I sold back to New Zealand."

Her work was often considered ahead of her time and was not easily understood or appreciated by the general public. A critic described her work in 1915 as 'undoubtedly clever and shows wonderful handling of watercolour, but to the popular taste it would appear a little wild, candidly, we do not understand it.'

In 1916 Frances gained a distinction at the International and Portrait Society's exhibition and was attracting favourable attention from the critics at the RA. *St Ives Times* of 1919 comments, 'Her work is reminiscent of one or two of the French masters. Her pictures of child life are original in expression and full of the quality of dignified impressionism. Two drawings of Polperro will call for comment from those who cannot find any interest outside elaborate details.'

She spent some time in Manchester after leaving St Ives and also travelled abroad. One would imagine her work would not have sat easily with the traditional painters in Cornwall. In 1955 Patrick Heron wrote that she was probably the best woman painter ever to work permanently in England. 'Undoubtedly Frances Hodgkins was in certain respects an inspired artist.'

In 1916 Frances painted a portrait group of Mr and Mrs Lindner and their daughter, Hope. Criticism of this portrait group by Myfanwy Evans notes, 'There are awkwardnesses, especially about the placing of Mrs Lindner, the arrangement of the figures is far simpler than in earlier pictures.'[75] This 'awkwardness' is explained by Hope Lindner who said the painting was to include only her father and herself but, "at that moment mummy came along and stopped to talk to daddy and Frances quickly sketched her into the picture."

A close friend of the New Zealand painter Herbert Ivan Babbage was Edith Marion Collier. Both were born in Wanganui. Edith was one of 6 students of Frances Hodgkins when she was teaching in St Ives in 1914/15. The influence of her teacher in the use of colour is apparent in her work of this period. Edith visited St Ives again in 1920 and 1921.

On her return to New Zealand she gave up serious painting, receiving little support for her somewhat 'difficult' work and having much of it destroyed by her

Moffat Lindner, Augusta and daughter Hope, *1916, Frances Hodgkins. N Halliday.*

photograph, the portrait is obviously of her sister, Georgina.

Georgina Bainsmith, sculptor, was the sister of Mabel Douglas. She was described as 'going around with long flowing scarves.' These were the daughters of Sarah and Samuel Bucknall who emigrated to Australia in 1850s. The mother and two daughters returned to England.

Mrs Georgina Bainsmith RSA, sculptor, painter and photographer, was elected a Fellow of the North British Academy but is not listed in dictionaries of artists. She was also elected a member of the Honorary Council to represent Cornwall. Her sculpture gained a diploma from the Royal Britannic Society; she had also won medals and diplomas and other valuable awards. In 1906 she made a sculptured head of the novelist Fergus Hume during his stay in St Ives.

At a dinner for West Country Week Georgina was chosen as an artist featuring the South West. In 1919 she stood for Cornwall County Council, withdrawing her name when she discovered that Dr Nicholls was standing, however he persuaded her that women should exercise their right to do so. Georgina wrote letters urging other women to take their place in society because, 'one gentleman has very grave doubts that a women (in this case it is I) could sit on the County Council if elected.'

father. Edith was gathered into a domestic situation with large numbers of nieces and nephews and ill relatives. However, retrospective exhibitions of her work were held in New Zealand in 1927 and 1955 and finally the 'glowing future for this quiet and retiring pupil', predicted by Frances Hodgkins, was coming to fruition in New Zealand 25 years after her death.

Mabel Maude Douglas (née Bucknall) was a portrait painter who later turned to painting miniature portraits. She and John Christian Douglas, painter and photographer, lived at 10 Parc Avenue, St Ives. Mabel lived until well into her nineties. The local reporter noted her work, 'The fascinating art of miniature painting is not neglected in St Ives. We have a very able exponent of this branch of the painters craft in Mrs Douglas. It just happens that she has at present in her studio three beautiful little portraits, all of which have been exhibited in the RA. One a charming study in pale blue of Miss Chadwick, an excellent likeness of Kitty Hain in a large picture hat, and the third a portrait study of a girl in red with a 15th century head dress, which is an exceptionally pleasing piece of miniature painting. Besides these Mrs Douglas kindly showed me a very dainty portrait study in greys of Mrs Bertram and other work now in progress.' Mabel Douglas also painted miniatures on ivory. She painted a miniature for Mary Lanyon's dolls house.

In David Lay's auction house in 1991 the writer came upon a large and beautiful portrait of a woman by M Bucknall. No one knew of this painter but she was of course Mabel Bucknall and this painting was done before she married John Christian Douglas in 1897 and before her miniature work. On close examination with the

Georgina Bainsmith (née Bucknall) aged 22 and Mabel Maude Bucknall aged 19. Dated 1881.

Miniature of John Christian Douglas, *Mabel Douglas.*

She was obviously a capable woman and stood as a candidate in the municipal elections on several occasions, always attracting a large vote but always defeated. Georgina died in 1937 and was buried in Barnoon cemetery with her mother, who died in 1923.

1918 Equal Status

At the Annual General Meeting, a resolution to the effect that lady members should be eligible to rank equal with men for all positions in the Club was not submitted. The president explained that under Rule 2 there was nothing to prevent the ladies being elected. At that meeting, as though to admit the inequalities of 18 years, Miss Cameron was elected librarian, the first woman to hold office. There continued to be two separate committees with the ladies acting as the working party responsible for the Club's comforts, and major decisions taken by the men. The following year Miss Cameron's job went to A C Bailey. In spite of the reassurances that women ranked equal with men, it wasn't until the 1950s that the first woman was elected to the committee.

Peace Celebrations

The artists entered into a friendly competition to produce a Presentation Card for Peace Celebration Day, to be handed to those who had served in HM Forces during the war. Cards were sent in by Mrs Barrett, Miss Cook, Edmund Fuller, Borlase Smart, Miss Ballance and Robert Morton Nance. After careful scrutiny, in which 33 entries were considered, Borlase Smart's card was chosen. At Gala Day in July 1919 servicemen and women were presented with Smart's illuminated address of thanks by the Mayor Captain John Hain. Lanyon was responsible for the carnival parade.

In connection with the peace celebrations a meeting of all artists in St Ives was held to elect 6 to serve on the Peace Celebration Committee. The following were elected, Lowell Dyer, W Herbert Lanyon, Morton Nance, Miss Nelly Cook, Miss Barrett and P Yabsley.

It was discussed and agreed that a memorial tablet should be dedicated to those members who had died in the service of their country. Alfred Hartley submitted a design for the memorial and it was proposed by Moffat Lindner and by Dr MacVie that the design be accepted. However, at a later meeting 'Aumonier's' working drawing (which was received by post) was considered too difficult to carry out. William Aumonier was an architectural sculptor who had designed over 100 war memorials; so Alfred Hartley's sketch was rejected in favour of a new design by Borlase Smart. Edmund G Fuller was asked to make the memorial in copper. The finished design was mounted on a backboard by Lanhams.

'Dedicated to the memory of the above members of the Saint Ives Arts Club who gave their lives in the great war 1914-1918.' H I Babbage, W T Hichens, H M Norsworthy, E R Taylor

Babbage is mentioned previously. There is no trace of Hichens or Taylor as artists but their names are inscribed on the public war memorial in St Ives along with Babbage. Harold Milford Norsworthy's name is not listed

Memorial to Arts Club members, designed by Borlase Smart and made by Edmund Fuller.

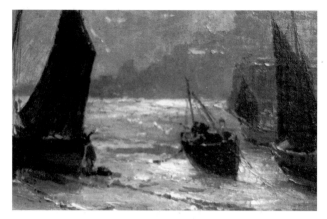

Boats at St Ives Harbour, *William Cave Day.*

on the war memorial. He had perhaps left St Ives when he enlisted. He was in London in 1908 and 1912 and in Liverpool in 1911. He hung twice in the RA and was killed in action in 1917. He is among the group of artists photographed by Douglas at the Club in 1895.

In getting back to a pre-war norm the allotments were given up but economies still had to be made. The writer, Frank Barrett, was concerned by the coal shortages and suggested that windmills be erected on high ground above Clodgy to provide electricity for the town.

1919

William Alexander Charles Lloyd, President

Lloyd was a musician, as was his wife, Constance, and son George. Mrs Proudfoot remembers the family when she was a girl living at Draycott Terrace. "They took over St Eia from Julius Olsson. They were musicians and had a practising room. He often played the picolo. He called his wife Primrose. They had an estate in Northumberland and my mother had the key to St Eia when they went away. Then they went to live in Zennor."

At Zennor the family took an active interest in the Waywide Museum. At various times in the thirties William served as assistant director, treasurer and secretary. Constance Lloyd was the museum's curator in 1938.

George Lloyd wrote the music for an opera, *Iernin,* based on the Cornish legend of the Nine Maidens, turned to stone for dancing on Sunday. The libretto was written by his father William.

In 1921 an exhibition of paintings was held at St Eia on Show Day as a memorial exhibition to Mrs Frances Lloyd, mother of William. Her last named work was entitled 'The All Pervading Light', a mother and child study. Frances Lloyd had studied in Paris and with Stanhope Forbes. She was the daughter of William Powell, the American painter.

William Cave Day joined the art colony in 1919. He studied in Paris under Benjamin Constant and Jules Lefebre for painting, and M Chapu for modelling. Also under Professor Herkomer at Bushey. Formerly of Knaresborough, he exhibited in Yorkshire and other leading provincial galleries.

He died in 1924 and a memorial exhibition was held at the Municipal Art Gallery, Plymouth. 'Some clever oil paintings and watercolours from Cave Day are among the 80 or so pictures which form the Memorial Exhibition. He followed landscape painting under various masters. The district of Knaresborough provided ample scope for his talents for a considerable period and the work he produced there was not confined to one particular groove. Rarely has work of a better quality reached Plymouth from the St Ives and Newlyn Schools of Painting. While adopting the same broad principle of brush work of lavish colour as his brother artists of St Ives, Cave Day exercises very considerable restraint and extreme care in subduing the non essentials.'

One artist whose name and paintings are virtually unknown is Louis Augustus Sargent. He married Katharine Evelyn Clayton, painter of flowers and fruit. His family was of French extraction, his father and several of his forbears were artists and engravers in France, and one of them, Charles Sargent, an inventor of international reputation.

At the age of 14 he was studying at the local school of art, having been awarded a £40 scholarship. This, with his other artistic work, helped him to be self-supporting. He studied at the RA Schools. He came to St Ives in 1908 and had a Porthmeor studio. Although St Ives was his home for 50 years he also worked in the South of France. His paintings were admired in the United States where he exhibited at the Carnegie Institute. Landscape was his subject and oil his medium. An article by Folliott Stokes, The Paintings of Louis Sargent, appeared in *The Studio* in 1919. 'At 17 he exhibited his first pictures in London galleries. Since then he has principally exhibited at the International Society, of which he is a member, the New English Art Club, and the National Portrait Society. His animal books are well known for their truth and artistry. In landscape it is the untrodden paths that call him. In portraiture the character and spiritual essence.'[76] Four of the paintings he exhibited at the NEA were of Cornwall. He also exhibited at Basle, Zurich, Geneva, and at the Venice and Pittsburg International Exhibitions.

Downas Cove, *L A Sargent.* The Studio, *1919.*

In 1911 he painted a portrait of the artist's daughter Mary Dow. In 1919 *The Western Morning News* reported of Louis Sargent that he appeared to be the only artist down West who realised the individuality of the Cornish coast and its characteristic colouring. 'Such colour as Mr Sargent shows really does exist if one only looks for it. Each picture is a harmony of beautiful colour passages. The artist is to be congratulated on producing an object lesson to those who see Nature as a monochrome.' He died at his home Tallandside in 1965, a few weeks before his 80th birthday.

Show Day 1919

After the war St Ives artists immediately re-established their traditions. 'With the return of Peace the Arts once more resume their sway, and compel attention. On Thursday the artists reverted to their pre-war custom of a Show Day, and opened their studios to the public. The fact that it was "early closing" allowed large numbers of townspeople to avail themselves of the opportunity of seeing the pictures.' The Arts Club mounted a show of work to augment exhibitions held in the studios.

A letter to *St Ives Times* from a visitor complained about the bad behaviour of children at exhibitions. Borlase Smart, from his Ocean Wave Studio, replied, 'I had scores of young children in my studio. They showed an intelligent interest in what they saw, especially if any work on view contained "local interest." I always make it a practice to endeavour to interest the children in the various pictures, and anything I feel may appeal to them, I give them a little talk on it. I have invariably found them very attentive listeners, and that they appreciate such consideration is shown by their general behaviour.'[77]

Several of Borlase Smart's drawings of Plymouth's old buildings and architectural features were bought for the Imperial War Museum. He presented to the Museum 21 drawings of the Western Front which he executed in

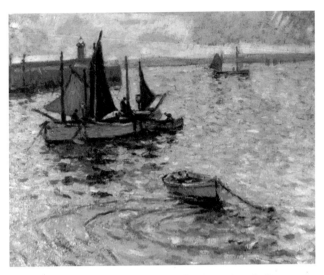

The Harbour, St Ives, *Robert Langley Hutton. Ealing Gallery.*

1916. He also recorded old buildings of St Ives in a series of drawings with bold outlines of charcoal completed with washes of watercolour. Some of his drawings were reproduced in the *Architectural Review*, 1920 — 'The Warren', 'St Andrew's Street', 'Norway Lane', 'Down-Along', 'The Harbour' and 'Hicks Court'. In the article, written by Frank Emanuel on St Ives, he states, 'Borlase Smart is one of the few members of the art colony who have ever set themselves to record the architectural features of the picturesque old town.'

In 1919 the funeral service took place of Robert Langley Hutton at St Ives Parish Church. He was buried in Barnoon cemetery. Hutton's health had broken down in Burma where he contracted tuberculosis. He came to St Ives in 1909 in the hope of improving his health and was accompanied by his three sisters. He was inspired to paint in the company of so many artists and though largely self-taught, was described as a gifted landscape artist having exhibited in London and municipal galleries.

Among relatives and friends who attended were many artists, J C Douglas, L Dyer, M Lindner, L Grier, A C Bailey, W B Fortescue, E Skinner, Arthur White, W H Lanyon, A Meade, A Bodilly, A Yabsley. Wreaths were sent from the Arts Club, Miss Cameron, Nina Weir Lewis and Helen Weir, Claude Barry, Mrs T Millie Dow, the Misses Whitehouse, Bertha Cockeram and Doris, Mary, Laura and Margaret Epps, Sir Herbert Thirkell White and Rolf Bennett.

Herbert Lanyon held an exhibition of Langley's sketches and paintings in his own Attic Studio on Show Day. The collection of his work is largely held by the family and the influences of artists such as Moffat Lindner and Julius Olsson are clearly shown in his techniques and seascapes. He worked from the Harbour Studio.

Art Gallery for St Ives

It was suggested by Captain John Hain, former Mayor of St Ives, that a War Memorial should take the form of an Art Gallery. There was always a desire among the painters to have a gallery to equal that of Newlyn, which was built

Borlase Smart, pen and ink drawing of St Ives from the Malakoff with Arts Club in foreground.

St Ives Harbour, *G Turland Goosey. David Lay.*

by the benefactor Passmore Edwards. A letter in support of this idea was written by Captain Borlase Smart.

'Such an idea should be fostered by the Art Colony and would no doubt find favour with the inhabitants of the Old Town, and it is the Old Town that after all has provided subjects for some of the greatest pictures of modern art. Considering the great painters St Ives has produced or inspired, no doubt those who remain to us and others would be only too pleased to give of their best to further such an effort and help to make the permanent collection a bye-word. In the event of a gallery materialising it should be insisted that only the very first-class work be admitted in the case of a special show of local art. A suitable site in every way (being central) would be the enclosed ground, bottom of High Street. The running expenses of such an institution would be easily paid for by a small charge of admission during, say special exhibitions.'[78]

A more cynical reply to Captain John Hain's suggestion was printed under an assumed name.

'Dear Sir,

The suggestion of the ex Mayor that the artists of St Ives should gratuitously offer their works to the town is excellent but he omitted to further suggest that all public officials should work without salary, that the masons, carpenters, plumbers etc. employed in the new art gallery should also work without wages. Why single out the artists?

Yours sincerely, Whole Hogger.'[79]

The war memorial took on a more conventional form in the shape of a cross designed as a gift to the town by architect and painter George Turland Goosey, and the 'enclosed ground' became a memorial garden, the design of which was the work of Arnold Forster.

Coming from America to live, George Turland Goosey retired as an architect and decided to further his interest in painting. It was said he grew tired of building palaces for millionaires in America. 'He lives in a little studio perched on the rocks, where he paints and draws in black and white, so close to the sea that in the winter-time the foam dashes against the walls of his home.'

'In New York City he has left behind him giant buildings of his design, the famous Friars Club, the theatrical centre of America's capital, county home for Otto Kahn, and seven Roman Catholic churches are but a few. He left them to paint and to etch. These are his love, not that insatiable pursuit of money which makes us old before our time. There he is, whiling the hours away, just doing the things he likes best — and happy. He and Rolf Bennett, the author, sit at the window, listening to the cries of the gulls and the music of the waves, smoking Dustman's Delight, a mixture of their own concoction.'[80]

At some point G Turland Goosey dropped his last name because of some association with a wartime song. His later paintings are signed George Turland. He is not listed in any dictionary of British artists.

1920

Arthur Meade, President

Under the direction of their president the artists were very much to the fore and in favour of preserving the character and buildings of old St Ives and conserving the natural beauty of Cornwall and its ancient sites. A Minute states, 'It was resolved to support the movement for the conservation of places of Historic Interest and to invite the secretary of the National Trust to lecture in the Club room, and that influential persons of the neighbourhood be asked to attend the lecture.'

Charles Walter Simpson School of Painting

Simpson was born in Camberley. He studied animal painting under Lucy Kemp-Welch at Bushey and landscape painting under Noble Barlow but was largely self-taught. He came to Cornwall in 1905 and to St Ives in 1916.

Charles and Ruth Simpson started a School of Painting in St Ives in 1920. An advertisement appeared in the *St Ives Times* — 'Charles Simpson RI, RBA and Mrs Ruth Simpson are holding classes during the winter. The subjects include portrait painting in oils (models daily) sketching in watercolour. Study of animal and bird life. The Shore

Charles Simpson outside his harbour studio, St Ives.

Studio.' This school was conducted in the Piazza Studios from 1920 to 1924. In the year of setting up their painting school Charles Simpson received a gold medal and diploma for a large moorland landscape which he exhibited at the International Exhibition San Francisco.

Ruth Alison studied at the Stanhope Forbes School in 1911/12. She met Charles in Newlyn and they were married in 1913. Ruth tutored in portrait painting. In l920 she painted a portrait of Rollo Peters, an American artist and author of New Art (this painting appeared in the David Lay Auction catalogue in 1991). After the Shore Studio the Simpsons lived at Loyalty Cottage, now renamed, near Clodgy. Leonora Simpson, their daughter, said, "They had lovely dances and parties at the house and studios and people from Newlyn came over. My father was very musical." Ruth Simpson died in 1964 at Stanley House, Alverton.

Charles Pearce says he met Charles Simpson soon after the First World War when there were many people moving into the town. "I noticed this newcomer. We were allowed to keep our uniforms provided we took off all badges and buttons. I saw him with an officer's jacket on. It was obvious to me he was saving on clothing. He was wearing a pair of shorts as well. That was Simpson." He was said to travel everywhere on his motorcycle into the countryside, with a great canvas tied to his back, to study the domestic habits of the birds, which he was so fond of painting. He painted not only as an artist but as an ardent naturalist.

In 1923 Charles Simpson exhibited a series of 22 pictures painted from the steps of his studio. They depicted the working day of the fishermen — 'Girls Awaiting the Gurries', 'Packers In Oilskins', 'Loading the Carts' etc., showing the whole process in the different stages of the landing and packing of fish.

Death of Louis Grier
Meeting of November 6th l920: 'Major Lloyd made a touching reference to the late Louis Grier. He said Mr Grier had started the first St Ives Arts Club in his own studio and was the founder of the present Arts Club.'

The artists' colony on the Cornish Riviera, l92l with Mr and Mrs Charles Simpson and Mr and Mrs Sidgwick.

The boat Ebenezer and harbour fishermen, *1918, Charles Simpson. Private Collection.*

Miss Agatha Johnson said, "Women didn't go to funerals in those days but, as a young girl, I remember my father telling me about Louis Grier's funeral at Lelant. There was a lark singing in the churchyard and this little bird followed after the people as though it knew that a nice man had died. It stood on the gate post and sang all through the service. He was a charming man, a gentle man and a very good artist."

Suggestions Book:
'That the Committee shall take steps to acquire the palette of the late Louis Grier and have it hung on the Club room wall.' Signed G T Goosey, Frank Moore, R Borlase Smart, J S Yabsley, A C Bailey

Mrs Grier was elected an honorary member. John Titcomb suggested that a photograph of Louis Grier should be hung in the Club and Herbert Lanyon agreed to make an enlargement from an existing photograph, which now hangs on the stairs. In 1922 Mrs Grier presented her husband's palette to the Club and in 1946 two of his paintings were given to the town.

Further gifts were received from Moffat Lindner who offered the Club a fine print of a picture by Velasquez, which he obtained in Madrid and Borlase Smart gave a Medici print. These and Edgar Skinner's gift of a scarce edition of Phil May's drawings were received with thanks by the Committee. Phil May was a black and white artist/illustrator who worked for *Punch*. Several of his works are in the Tate Gallery.

James Lynn Pitt's studio above Porthmeor beach. C Bowtell.

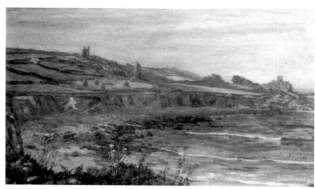

Clodgy, showing old mine workings and haystacks, *James Lynn Pitt. T Tonkin.*

In 1920 James Lynn Pitt returned from his family home in Clifton, where he had been recovering from an illness to find his studio had been broken into. Lynn Pitt's studio was a wooden chalet on the cliffs overlooking Porthmeor Beach. Arthur White visited the studio with the police to see the damage, which he assessed at £60.

Roy Laity often visited Pitt at the White Studio. "The thing I remember is a picture he was sending to the RA. It was called 'Paradise'. There was a castle, rivers, boats, a ruined church and figures with transparent wings. One day when he was away a boy climbed up from the beach and painted in a few of his own ideas on the canvas, but it was put right and sent off as usual". His last known work was a miniature for the Queen's dolls house.

He was one of the few painters who regularly opened his studio to the public exhibiting oils and watercolours. Pupils attended on three afternoons a week. His work was largely composed of seascapes off Porthmeor, as seen from his studio.

The Council, needing the site of Pitt's studio for road widening, served a notice to quit. This notice brought to light the power behind the crippled 'Owld Pitt' as he was known locally. According to Mary Quick, barristers of the highest authority descended on St Ives to fight his case and it was discovered that Mr Pitt was related to two

distinguished Prime Ministers. The Council hastily withdrew.

The chalet was eventually demolished in a storm and his paints and brushes were found by Roy Laity scattered over Barnoon field. He had at one time sent in plans to erect a more permanent building. This was eventually rejected by the Council as the building had not commenced within 12 months of presentation of the plans.

According to Mr Couch, another local man, Lynn Pitt came to St Ives with his manservant to look after him, as he was crippled and in a wheelchair. One of his sisters lived in Norway Square and two others lived at Clifton. Lynn Pitt's name was discovered on an ornate gravestone in Porthmeor cemetery. Later two of his paintings were found buried under some papers in the Arts Club library and several others are owned by townsfolk. Since his signature is Lynn Pitt most people were under the impression that the paintings were by a woman.

Lynn Pitt died in 1922. The Arts Club sent a wreath on his death. The painter, Arthur White, a particular friend, being noted as a chief mourner. His headstone is a palette with brushes with the inscription — 'In ever loving memory of our dear brother James Lynn Pitt ARWA of the old colony of St Ives artists and of Clifton, who passed quietly away at the White Studio, November 11th 1922. The fight is o'er, the battle won.' Additionally — 'Also his sister Fannie Elizabeth Pitt, who passed away August 22nd 1937.'

The following words accompanied a floral tribute on Remembrance Sunday in 1930. 'In kindly remembrance of Mr Babbage, valued friend of the late James Lynn Pitt ARWA, late of White Studio.' This may explain the mystery to the Babbage family of the gravestone erected, by someone unknown, to their uncle who died during the First World War and was buried in Wales. Was Lynn Pitt's family responsible for this tribute to his friend?

In 1922 Francis Algernon Spenlove Spenlove at the Tregenna Hill Studios offered 'Lessons and criticism in the art of modern portrait, figure painting and still life.' He was also known as Francis Raymond and signed some of his work in that name. He gave lessons to the young Terence Cuneo. He exhibited for only about 10 years and worked mostly in landscape and figure paintings. In 1920 he shared an exhibition with Marcella Smith at No 3 Porthmeor Studios.

Palette of Louis Grier (founder) on the chimney breast of the Arts Club.

In the early thirties Francis gave up painting altogether and set up as a flower grower and market gardener and remained as such for the rest of his life. In the Second World War he was responsible for employing conscientious objectors at his horticultural centre at Madron, Hamilton Jenkin was one of these people.

Francis was the son of Frank Spenlove Spenlove. Frank was the better known painter and was awarded a gold medal at the Paris Salon. He was principal of The Yellow Door School of Painting in Victoria Street, London. His work is in the collection of their majesties the King and Queen and the French Government.

The war changed many attitudes, gave greater freedom to men and women to express their points of view, but in the community of St Ives little had changed, especially with regard to Sunday observances.

The religious fervour of the local fishermen, which often led to bloodshed if an attempt was made to land fish on a Sunday, was related in an article by Frank Emanuel. 'They will use force to prevent an artist or a visitor from sketching or painting on Sunday. Should one unaccustomed to the practices venture out with a notebook, if only to sketch some little detail in a quiet spot, busybodies will soon be heard shouting out "No sketchin' allowed on Sundays," and if he persist they will molest him. There is no need to dwell on the subject, but it seemed necessary to warn sketchers of this odd eccentricity of the good folk of St Ives — lest they might chance to find out by bitter experience the peculiar sensitive sanctity of the saints of St Ives.'[81]

Francis Spenlove sketching on Porthminster beach with his wife as model.

Children

Children were always involved in the Arts Club. Childhood memories are recalled by artists' children and the local children of St Ives, who are now all grand-parents. It is more than likely that Virginia (Woolf) and Vanessa (Bell) as children visited the Club with their father, Leslie Stephen, who was a member and friend of most of the writers and painters. It is possible the young Rupert Brooke also visited; 'The family went to St Ives for

Headstone — James Lynn Pitt.

a holiday. There also were Sir Leslie Stephen and his family and Rupert played with Virginia on the beach.'[82]

Talland House

The Stephens, Virginia, Vanessa, Thoby and Adrian stayed at Carbis Bay in 1905 and in a letter Virginia writes, 'We go to tea with the people who now own Talland. They are a delightful pair of artists, with a family of the age we used to be.'[83]

Thomas Millie Dow and family had taken over Talland House. Mrs Florence Dow served on the Committee of the Nursing Association, envisaged by Mrs Julia Stephen and set up after her death. Mr Dow was elected Chairman of the NSPCC.

Horas Kennedy: "I was brought up in Talland House, my grandfather's house, Thomas Millie Dow. I remember as a small child being taken out to tea by my Kennedy grandmother to play with Poppy and Vivien, daughters of Dorelia by Augustus John. They lived in Ayr. My grandmother was a Slade student. We used to have Christmas parties at the Arts Club. I remember too Henry Lamb coming. He painted a family group of my mother (Mary Dow) and father (George Kennedy) and us four children. Later we used to visit Commander Bradshaw and his wife in their Porthmeor studio and change there after swimming."

The children of local families who worked for the Dows

Thomas Millie Dow, Florence and children, Elsie, Hope and Mary. A Symons.

of my sister and I in the garden. John Douglas was a marvellous photographer too. Folliott Stokes was a painter and writer. He put tuppence down my dress under my chin and I remember it got caught in the elastic round my knickers. In the carpenter's shop under the Arts Club we used to pinch the shavings and stick them under our hats for curls."

Peter and Mary were the children of W H Lanyon. Mary recalls her childhood. "I remember the first time I went to the Arts Club. I was about four and Peter three years old. There was a wooden ladder which took you upstairs. It was a fancy dress party. When we reached the top floor I remember I was enchanted. Mrs Frank Moore came to greet us dressed in red and all around her glowed lights from the oil lamps. We lived at the Red House and grew up with the Kennedys."

"I remember after some storm damage at the club, Eleanor Leach, Dicon Nance and Peter and I and a whole group of us young ones cleaned up. The boys had some beer and soaked some bread in it and threw it to the gulls. They were swooping around very clumsily. I thought the boys were dreadful."

At one time Herbert Lanyon had his studio in Parc Avenue adjoining the steps. Mary says, "It was in this house that the Christmas goose had been left on the table to be carved and Jimmy Limpots came through the window and pinched it off the table."

As mentioned earlier, Mary Schofield had miniature pictures painted by the artists especially for her dolls' house. Three are by Fred Milner, two of his favourite subject, Corfe Castle, inscribed, 'To the Lanyons of Great Red House, Christmas;' an etching by Francis Roskrudge,

also spent much of their time at Talland House, playing in the house and garden with the extended families of the Dows and Kennedys. They were brought up alongside them and were laughed at by other local children for wearing 'posh clothes.'

The Parties
In 1905 Mrs Titcomb applied to the Committee for permission to hold a children's party. This was granted; reluctantly, it seems from the Minute. 'That the action of the Committee must not be taken as a precedent, that any future request shall be judged by the Committee entirely on its merits and circumstances of the moment.' About 20 children were entertained and despite the Committee's 'considerable discussion' of the matter this did set the precedent for many children's parties.

Mrs Miriam Kemp (née Hart) said, "The Titcombs were more like friends of the family. They wanted to take me to Italy with them, but mother wouldn't let me go. We used to live at the Fishermen's Co-op on the Wharf. My brother used to take the Titcomb children out for donkey rides. They used to sit in a basket each side of the donkey." The Titcombs lived at Windy Parc, where their two children were born. The grand-daughter of W H Y Titcomb was taken to the Club as a child and is still a member.

As a child living in The Warren, Susie Hosking remembers the artists. "Herbert Lanyon took a photograph

Titcomb children Frank and Loveday with Humphrey Hart on Porthminster beach, c.1903 (photo probably by W H Lanyon).

90

Susie (Hosking) and Grace Geen, c.1907, photographed by W H Lanyon. S Hosking.

Peter and Mary Lanyon photographed by W H Lanyon. M Schofield.

own furniture workshop on The Wharf, St Ives, and the two Leach boys, David and Michael, after working some time with their father, Bernard Leach, became potters in their own right and set up their own individual potteries.

Robin Nance continued, "The Cuneos lived in the Copper Kettle. Terry's father was an illustrator and his mother was a painter. He became famous for painting the Queen's portrait, which was hung in the Royal Academy. As a young boy he used to ride on the footplate to St Erth when there were steam trains."

two Fitzherberts, 'Bruges 1925' and 'Clodgy'; Bernard Ninnes, watercolour; Mabel Douglas, 'Child and Cat' and John Park writes on his, 'For Miss Mary Lanyon's house, with his blessings.'

Robin and Phoebe Nance remember the children's parties. "There was the Nance/Leach corner. It was just a simple room full of children. The two families did everything together, including playing cricket on the beach. We were all children of painters and writers. There were fancy dress parties — the Leach family were terrific dressers-up." In 1934 the Leach family won the fancy dress competition as the Loch Ness Monster.

It is not surprising that the two families were joined in marriage. Bernard Leach's daughter Eleanor married Dicon Nance. They lived at The Count House, Carbis Bay. It was the Leach family house where the children spent their childhood, after leaving The Old Bakehouse at St Ives. The Count House had formerly been the home of Havelock and Edith Ellis.

In 1933 the brothers Robin and Dicon Nance set up their

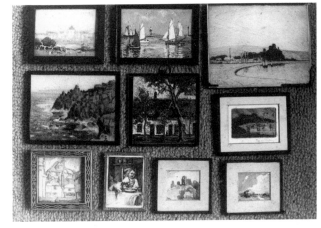

Miniature paintings for Mary Schofield's dolls' house.

Margaret and John Reed, 1923, photographed by W H Lanyon. Margaret Reed.

Drama
In 1909 *Cinderella* was performed at the Drill Hall with Vivien Marriott playing Cinderella. Charles Marriott played a mender of toys, with Edward Hain junior, playing a dandy. Other actors were Miss Irene Carr, Horace Taylor, Mrs Bodilly. It was stage-managed by Bromley. Fortescue played the piano in a small orchestra. The entertainment provided funds for the Church Restoration Fund.

In 1917 'children of members of St Ives Arts Club performed *Little Red Riding Hood* by Frank Barrett, author and dramatist, for the St Dunstan's Home.' Mary Reed wrote and produced many Christmas plays for the children and they were well schooled in the various forms of stage craft. Mary's daughter Margaret joined the club as a child and remains a member. Her grandfather was Greville Matheson, who wrote for the *St Ives Times*.

Margaret recalls, "The Leach, Schofields, Lanyons, Patrick Heron, the Dows and Reeds were pupils at a Dame School in St Ives. Later some of the children went to boarding school. The Cuneos lived at the Copper Kettle with their two boys. Bernard Leach let us have a wheel and clay at the pottery. We lived in adjoining gardens divided by the Stennack stream and had a secret place over the stream. John Park allowed us to paint in his studio. We didn't realise how lucky we were to have the use of a pottery and a painter's studio."

Patrick Heron remembers as a child that his parents'

house, Ocean Breezes, backed onto the house where John Park lived at Bowling Green and that Park bought him a set of French oil pastels.

Margaret remembers the coffins in the carpenter's shop below the club, before they bought the upper floor in 1928. Her brother fell down the steep ladder, which was the only access to the club, and had to be taken to the doctor's surgery.

Hope Lindner said David and Michael Leach were her contemporaries in childhood. She remembers that dancing classes were held for the young ones and recalls the pantomimes, with scenery painted by the artists, and costumes which were well designed and skilfully made and won many prizes. This follows on the tradition of Compton Mackenzie's pantomimes written for his sister Fay and the Marriott children.

In 1929 a sketch written for children by Terry Cuneo and produced by Mrs Cuneo involved Robin and Dicon Nance, Michael and David Leach, Peter Lanyon, Terry and Desmond Cuneo and Michael Darmady. Kathleen Frazier, who was later employed as a musician at the BBC, played the piano. This in-house production was called *Blood and Sawdust*.

In 1937 Peter Lanyon, as a young man of 19, was still involved with the Club and the secretary was asked to express the thanks of the committee for his work in painting the stage back-cloth for a play.

Lanham's Gallery
James Lanham and the artists were still proving mutually beneficial. All the now recognised painters of the St Ives and Newlyn Schools exhibited with Lanham's during the early years and it has to be recorded that Lanham's played an important role, not previously commented on by writers of the Art Colonies.

The goodwill built up over many years between Lanham's and the artists continued but problems arose and had to be resolved. A general proposal commended — 'The Committee are of opinion that the holding of auction sales of pictures is not only undignified but detrimental to the best interests of art and artists and trust that members of the Arts Club, and other artists, will signify their disapproval of such methods by signing this notice. Also in the Committee's opinion, artists should only exhibit their pictures publicly in St Ives at Lanham's Gallery. Moffat Lindner, President.' It is not known who signed the notice and who in fact was auctioning paintings.

The hanging and auctioning of paintings continued to be a problem and it was proposed at the Annual General meeting that, 'The rule with regard to the hanging at the St Ives Art Gallery that exhibitors may not have works on sale at any other public gallery or shop in St Ives — be strictly enforced.'

An autumn exhibition at Lanham's included the work of Nora Hartley, Daisy Whitehouse, Garstin Cox, Alice Nicholson, Foweraker, Olsson, Parkyn, Milner, Fortescue, Ida Sawyer, Grier, Meade, Fitzherbert, Louis Sargent and A N Walton.

Lanham's was holding monthly shows and exhibited a wide range of works. Olsson, newly appointed ARA, showed three seascapes, Hutton a study of waves, Meade a portrait, Barlow a landscape, Caroline Jackson group portraits, J.Titcomb fishing, Lindner Venetian paintings, Hartley a study of Dartmoor, Bertha Cockeram watercolours, Moore etchings, Hartley aquatints, Grier nocturnes, Pauline Hewitt a sketch of Porthmeor, Babbage sketches, Arthur Beaumont a canvas of Whitby. Several Newlyn names appeared among the familiar group, Lamorna Birch, Ernest Procter and others.

When reporting on Show Day in St Ives the writer protested against the practice of importing Newlyn work for exhibition in Lanham's, 'which should rightly be given up to St Ives artists only.' Lanham's Gallery remained open throughout the war years although little was reported for the years 1915 and 1916.

In 1917 revival of interest occurred, 'The Lanham Gallery (in future to be called the St Ives Art Gallery) is much to be congratulated on having secured the help of the Arts Club Committee for the hanging of its summer exhibition. The result is eminently satisfactory and the exhibition as a whole attains a high level. The gallery, which has been redecorated and re-hung, now presents a most attractive appearance. No picture lover should fail to pay the gallery a visit.'

There were 120 paintings by Cornish artists on show at the Plymouth gallery and the *Western Morning News* reported, 'The majority of pictures now on view come from the studios of Newlyn and St Ives.' They were packed and forwarded by James Lanham Gallery.

The enthusiasm continued into 1918 when advertisements appeared in the local paper. 'St Ives Art Gallery (under the direction of Committee appointed by St Ives Arts Club) visitors will be interested to know there is a large and representative exhibition of oil paintings and watercolour drawings by eminent local artists.' At a meeting of 20 exhibitors the following were elected to the Hanging Committee — Arthur Meade, Moffat Lindner, Frederick Beaumont, Claude Barry, R L Hutton and Fred Milner.

In 1919 Lanham's was sold to Martin Cock, who carried on the name and the art gallery and, since *St Ives Times* was run by the same proprietor, the Arts Club decided to have all their printing done by the firm. Martin Cock was born at Pelynt, Cornwall in 1880, he was the founder and editor of the *St Ives Times* for 30 years.

Problems arose with Lanham's in 1919 after exhibitors had made representations to the committee concerning the way pictures were shown in Lanham's window. The following letter was sent —

'Dear Mr Cock,
 At a meeting of the exhibitors of the Lanhams Gallery it was unanimously resolved to ask the President and Committee of the St Ives Arts Club to write to you with regard to the manner in which paintings and drawings are exhibited in the windows of Messrs. Lanham Ltd. They are of the opinion that the way they are now shown, crowded together and over-lapping, is undignified and against the interest of the artists and yourself, both commercially and artistically. The Committee assures you of its good will and readiness to help you in any way and would be pleased to meet you and talk the matter over thoroughly.
 Yours sincerely, W B Fortescue Hon.Sec.'

As with most disputes with Lanham's, agreements were reached and problems solved to everyone's satisfaction, except that Lanham's Gallery increased in size, with only one gallery being under the direction of the Arts Club and two others for smaller exhibitions.

An advertisement announced — 'Miss Ruth Davenport, formerly of Oxford Street, London, is making a small exhibition of art needlework at James Lanhams. Miss Davenport, who designs her own work holds several South Kensington certificates and is prepared to accept juvenile or adult pupils. Commissions executed at the shortest possible notice.'

'Miss Marcella Smith ARBA advises people to apply to Lanhams to see her recent work at 3 Porthmeor Studios.' Marcella Smith and Dorothea Sharp managed Lanham's Galleries together many years later.

August/September 1919. Exhibition of paintings by Ruth and Charles Simpson. He showed paintings, in and around St Ives, coastal scenes, figure and animal subjects and of special interest was a 7ft canvas entitled 'End of the Holidays' showing a man and girl walking along the edge of the sea. Mrs Ruth Simpson showed her dexterity in an exhibition of portraits. For the first time in Lanham's show the name Mrs E S Sargent, the wife of Frederick Sargent, is noted. Captain Borlase Smart showed a collection of drawings, 'From Vimy to the Somme'. In July he exhibited drawings of old St Ives. This was to be the first of a series.

The Newlyn Gallery

Lanham's became the sole agents for Newlyn Art Copperware. The gallery at Newlyn was closed for a period of time and caused much exasperation among the artists. The local paper commented in 1920: 'The Passmore-Edwards Gallery at Newlyn has once more hung pictures on its walls and flung open its doors. The writer is informed that this revival is due less to the awakening of energy and conscience on the part of the Committee than to the enterprise of Messrs. Lanham of St Ives. If this is so, it reflects great credit on the firm; but one is tempted to enquire what would have happened — or would not have happened — if Messrs. Lanham had been less adventurous. A closed gallery in a district claiming to be pasturage of breeding ground of art is an anomaly hard to explain.'

1921 – The Fourth Decade

Forty years on from its foundation, the artists' colony of St Ives was still flourishing. It was said to be the largest colony, out-Chelseaing even Chelsea and the rivalry of St

Visiting the studios — newspaper cutting.

Ives and Newlyn continued into the fourth decade.

The St Ives artists were an acceptable part of the town and secure within the community. Many achieved considerable success during their lifetime, selling and exhibiting their work at the Academy, Paris Salon and provincial galleries.

However, the work of St Ives and Newlyn early painters suffered a decline and was largely forgotten for half a century. During the loss of status of the St Ives artists, their European counterparts, ignored and misunderstood during their lifetime, made art history internationally.

The young moderns, who would eventually strike St Ives, were still some years away. When they arrived a new development of art forms in painting, sculpture and pottery revived the artists' colony and once more St Ives became recognised on an international scale.

St Ives v The Newlyn School
Charles Marriott, art critic, 14 years after having left St Ives, gives his opinions on the artists colonies in 1922.

'The peculiarities of the Newlyn School are that it is not a school, and that most of it is at St Ives. The last I can say with certainty, because I lived for several years at St Ives ... the only thing in Newlyn which can be called a "school" is the school of painting conducted by Mr. Stanhope Forbes, RA.'

'My first acquaintance with Newlyn, via Lamorna, was exactly twenty-one years ago, and by that time anything like a school had ceased to exist, and the drift across to St Ives was in full progress. Between the two places there was a gay interchange of compliments; at Newlyn they said that the St Ives artists were always talking about each other, and at St Ives they said that the Newlyn artists were always talking about themselves.'

'Not unnaturally, the St Ives contribution to painting is more colourful than that of Newlyn. St Ives was a broadening and brightening of the stream which set out from Newlyn... my own impression is that the so-called Newlyn School was a gathering of artists for company and the advantages of light, rather than a definite movement with a permanent influence on British art.'[84]

Charles Marriott was correct in stating that the early artists had no permanent influence on British art, but at the time they did influence their students, admirers and art collectors, and many a painting lies buried in a public gallery's permanent collection.

In 1922 the Plymouth gallery, which was currently showing an exhibition of work from artists of St Ives and Newlyn, drew forth the comment that it was well known in the art world that the Newlyn and St Ives schools of painting were not Cornishmen born, but artists who had been attracted to the Duchy by its quaint fishing villages and brilliant colouring, as well as the exceptional facilities afforded for working out of doors.

The Studios
Visitors to St Ives in 1922 were commenting on further conversions of sail lofts and fish cellars to studios and to the extensive use of buildings refurbished to meet the demands of the artists and visits to the studios had become something of an institution.

'The fish-odoriferous town of St Ives is a veritable gem of beauty and inexhaustible in its attractions to artists. Whistler, struck with its charms, is said to have sketched it, and certainly many have done it since. Now there are some 200 studios tucked away in many an odd corner of the place, forming a little colony of the artistic world.'

'The rent of a studio runs to about £20 a year — or less if shared. Some must cost very little, especially those converted from the attics of some tumble-down old house, and reached by worn old stairways from the road. The possessors of these are to be envied, for the attic is the ideal home of arts and in this case possesses an uninterrupted view of the harbour.'[85]

Undoubtedly a record number of visitors from all parts of the county visited the colony. A hope had been expressed for some years that Show Day should be confined to pictures which were actually being sent to the

Royal Academy and other spring exhibitions by the professional artists and an official list giving the studios in the most convenient order to make the day less of a strain on the public.

The good relationship which had built up between the local people and the incoming artists continued through the years. When it was pointed out that Show Day would clash with the opening of the Primitive Methodist Sunday School the Club decided to alter its date.

'This pleasant act shows the good spirit existing between the art colony and the fishermen, which undoubtedly the latter will much appreciate. The only problem is that many shop assistants will be deterred from visiting the studios, but as business is not particularly brisk at present, there is no doubt that employers would meet the situation by giving the employees an hour off in time to visit the studios. Further, it is far better for the many visitors who come to the town on Show Day to find business premises and restaurants open.'[86]

Because of the crush of people on Show Day it was suggested that the artists should be a little more generous in the opening times of studios as people coming from long distances couldn't possibly visit them all in the time allowed. It was also considered that children should be accompanied by adults because visitors complained that it was impossible to view the pictures through the swarms of children.

Sylvia Sirrett remembers a childhood experience, "I was taken round the studios on Show Day as a child. I tipped a painting over. It was Yabsley's. Fortunately it wasn't damaged, but I was taken outside and given a talking to."

Letters were sent to headmasters of schools requesting that parties of children, accompanied by their teachers, should visit the studios between 11am and 1pm. Stanhope Forbes was informed that Show Day had been fixed for March 19th and requested the date of the Newlyn Show.

A letter from the headmaster, Charles H Bray, from the National School appeared in the *St Ives Times*. 'I would express through your columns my sincere thanks to the artists of St Ives who invited our senior school children to visit the studios on the morning of Show Day. Such visits have a very high educational value and the courtesy shown to us by the artists is greatly appreciated by the teachers and the scholars. We cordially return their invitation and usually welcome a visit to the school.'[87]

1922

Frank Moore, President

Captain Frank Moore, born in Watford in 1876, was an etcher and watercolour painter. He studied at Highgate School and University College, London. Collections of his work are in Africa, India, USA, France, Australia and New Zealand. He held exhibitions of etchings and drypoints at the Beach Studio on the Harbour, covering landscape, seascape and figure work, inspired by the scenery in and around St Ives. Mrs Moore was principally known for her embroidery. They lived at 1 Draycott Terrace.

Planting Broccoli, *William Banks Fortescue.*

Visit of Mr Asquith

The visit of the Rt Hon H H Asquith to St Ives in 1922, was seen as a great encouragement to those people trying to preserve the cobbled streets and cottages surrounding the harbour. The ex-Prime Minister said he hoped the Town Council, though progressive, would not destroy the old world buildings and spoil the attractiveness of the town. Foremost among those interested in preserving the traditional ambience of the old quarter were the artists.

Martin Cock closed the High Street Galleries for half-an-hour to the public while he had the honour of showing Mr Asquith many examples of St Ives art. He toured a few studios, choosing to visit Alfred Hartley, an old friend of Mr Asquith, Borlase Smart, and the St Ives School of Painting at The Shore Studio, run by Charles and Ruth Simpson.

Request for Miniatures

The famous 'Fairy Queen's Palace' made by Sir Neville and his wife and designed by Sir Edwin Lutyens held miniature paintings by several St Ives artists, including Moffat Lindner, Borlase Smart, Marcella Smith, Alfred Hartley, W S Parkyn and Edmund Fuller. Princess Louise asked each one to submit specimens of their typical work, giving a size of 1½ ins. x 1in. Also contributing were Lynn Pitt who sent 'The Island, St.Ives', W Cave Day 'Spring', with sheep and lambs coming down a wooded fell and W B Fortescue a watercolour painting 'Planting Broccoli'.

Members of the committee met to proceed together to lay a laurel wreath at the War Memorial on unveiling day. They were President Captain Frank Moore, Rolf Bennett, W Herbert Lanyon, Norman Cooke, G Turland Goosey, Fred Milner, R Borlase Smart and John Titcomb.

Alfred Hartley, etcher, by W H Lanyon. A Lanyon.

1923/1924

William Herbert Lanyon, President

At a General Meeting Herbert Lanyon said that in times past it had been rather easy for so-called painters and authors to get into the Club. It was high time that these rules should be strengthened, having regard to the nature of the Club, its traditions and its already swollen membership, which had risen to 200. It was further decided that only members elected on their professional qualifications should serve on the committee.

In 1923 the New Print Society was formed with Alfred Hartley as its principal. There were 9 etchers and five working in colour printing, woodcuts and lithographs. Their first exhibition was held at Lanham's Art Gallery. There were 65 works on view. The exhibitors were Alfred and Nora Hartley, Miss Marjorie Balance, Miss D Cooke, Miss Frances Ewan, Edmund Fuller, Bernard Leach, Fred Milner, Frank Moore, Francis Roskruge, Charles Simpson, Miss Bliss Smith, Miss E M Walters and Miss D Webb.

The exhibition received favourable comment. 'It speaks volumes for the quality of the colony when one sees such a high standard of work produced in a collective show, which one would see at the more important galleries in London.'

Hartley specialised in etching and had a studio at Piazza. He studied at the Royal College and Westminster Schools of Art. An etching, 'A Wessex Valley', which was awarded a prize for the best colour etching at the Print Makers' Society of California in 1922, was purchased for Los Angeles Museum.

Nora Hartley was also a painter and they lived in St Ives over a long period. Agatha Johnson remembers them. "Alfred Hartley and his wife lived in this house, 7 Bellair Terrace. They each had a bedroom with an adjoining door. These are the rooms and here's the door. He was a great etcher and had a studio in the Digey. He had infantile paralysis and walked with difficulty. Mrs Hartley used to do portraits of children."

He exhibited regularly at Lanham's, who held a one-man show for him in 1920. The *St Ives Times* reported on the exhibition and a particular painting. 'The one that strikes the visitor is St Ives under snow, a simple view of an old world town and a dominating church tower under a mantle of soft snow.'

1925

John Christian Douglas, President

He was familiarly known as Jack Douglas and was both a painter and photographer. His photographs illustrate

John Christian Douglas by W H Lanyon. A Lanyon.

many books of old Cornwall. He married the painter Mabel Bucknall in 1897. He died in 1938 aged 78.

W L Wyllie RA visited the Arts Club in 1925. Greville Matheson writes, 'I wrote to Wyllie, whom I had known for many years, congratulating him when he was made a full RA. It was a great pleasure to me when he was staying for some weeks in St Ives, to take him round to a number of the studios, where naturally he had a very warm welcome.' Wyllie visited again in 1930. He came to England to present an address to Her Royal Highness Princess Louise in honour of the 50th Jubilee Anniversary of the Royal Canadian Academy, of which he was President.

At the Annual General Meeting of November 1925 it was proposed that the secretary write to past presidents, or their relatives, and invite them to present, or lend, small examples of their work. This is probably when the Club acquired its collection of paintings.

George Turland Goosey moved that the Club seek affiliation with the Chelsea Arts Club. The president supported the proposal and a letter was sent to the secretary. There is no evidence to show that the link was made with the Chelsea Arts Club, although several artists were members of both Clubs, such as Arnesby Brown, Alfred East, Julius Olsson and Fred Milner. Terrick Williams and Algernon Talmage served as Chairmen in the twenties. It was said that in summertime Chelsea migrated to Cornwall. St Ives in particular was noted as the Cornish Chelsea and also known as Cornish Bloomsbury.

1926
Moffat Peter Lindner, President
In taking the chair as president Moffat Lindner expressed his pleasure at once more taking office. The first time he had been so honoured was 25 years before. It came as a sort of wedding present, as he had just been married. He could therefore regard this year as a Silver

The Copper Kettle (Pop Short, John Park, reaching, Leonard Richmond's back, facing David Cox, far right, Willie Barns Graham, far left). M Val Baker.

Wedding present. He said the spirit of the Club had not changed in all those years and he would do his best to preserve its traditions.

It was during the presidency of Moffat Lindner that Treve Curnow, young son of master baker/confectioner Curnow, who had just finished his catering apprenticeship, was asked to make and decorate the cake for President's Night. "A special cake for a special occasion. My father said it had to be a work of art. This particular time I started after everybody had left the bakery so I could concentrate. Just as I was putting the finishing touches to it it fell over, so I had to start all over again. We always made wedding cakes which were left to mature so I took one of these, marzipanned and iced it, and spent the whole of that night finishing the cake, but it was ready for the next day."

1927/28
Captain Francis John Roskruge, President
A retired Captain in the Royal Navy DSO, OBE and Justice of the Peace. He was born at St Keverne, Cornwall in 1871 and educated at Truro. He was chiefly concerned with etching.

Hugh and Elizabeth Gresty came to St Ives in 1927. Ship Aground just off the harbour was their first home and he had a Porthmeor Studio. "He and his wife used to climb down the ladder from the studio and rush across the beach into the sea," so remembers Edna Hirth. "Hugh and Arthur Hayward shared a locker at the Arts Club where they kept their bottles of wine. They also shared a studio, next to the Copper Kettle, which was owned by Pop Short. The cafe was full of paintings by artists who paid in kind. Pop Short was a good friend of the painters and a real character. He would loan money to the artists."

"Hugh painted with the same action as Cézanne — came forward, made a stroke with the brush, stood back to look, and then made another stroke. He listened to classical music all the time he was painting."

The Gresty's eventually moved to Mincarlo at Carbis Bay. Another friend, Joan Temby, said, "Hugh served in the First World War and suffered the effects of gassing for the rest of his life. He was a modest, quiet man, who

Boats in the Bay, *Moffat Linder. Arts Club.*

Arthur Hayward painting outside the Arts Club in 1923.

Hugh Gresty in his studio Mincarlo, Carbis Bay.

avoided the limelight and liked a few close friends." He is buried in Lelant Churchyard. His tombstone bears the inscription, 'An eye for beauty and a heart for a friend.' In his will Hugh Gresty left two paintings to the Tate Gallery, two to the Walker Art Gallery, Liverpool, and one to the St Ives Corporation called 'Cornish Idyll — The Quarry, Clodgy, St Ives' 2ft. xl8ins.

Arthur Hayward School of Painting
Hayward gained a Middleton Scholarship and was awarded a bronze medal for design. In St Ives he set up his own School of Painting at 4 Porthmeor Studios, with personal instruction in drawing, painting, life, still-life and landscape. He was also known for his portrait and figure paintings. Hayward also had the Shore Studio on the harbour after the Simpsons and lived at Treventh, St Ives for some years. The Warrington Art Gallery purchased 'The Village of Paul' for their collection.

Mrs Jennet Knight recounted her story of how she became the subject of a painting by Arthur Hayward. "I was at the Palais de Danse at the Arts Ball and I won first prize. Arthur Hayward asked if he could paint me in the dress I was wearing. He said it wasn't me he wanted to paint but to see if he could capture the colours and sweep of the dress. It measured 17 yards around the bottom and the dress had been designed and made by my relative Clair Knight. He owned a dress shop called the Vanity Box in St Ives. He also designed dresses for the Ranee of Sarawak and her lady companion who lived in Lelant."

Mrs Knight believes the painting had been sold from the Royal Academy. "Arthur Hayward started the painting in his Porthmeor studio and then continued from his house in Porthminster Terrace. He promised me a copy of the picture but about that time his son was killed and we never heard from him." Several years later Mrs Knight saw a print of the painting in Knights in Fore Street, under the brand name 'Twilfit,' corset makers. She wrote to the firm, who were pleased to hear from her and sent several copies.

In an interview on Radio Cornwall in 1988, Denis Mitchell, the sculptor, remembered when Hayward set up his easel for painting on a Sunday and St Ives folk threw him and his dog into the harbour. In talking of his days at St Ives Denis recalled the artist Frederick Bottomley. 'He was a jolly man who loved children. He studied at the Slade, painted landscapes with figures and lived at

The Striped Shirt, Hugh Gresty, *watercolour. Mr and Mrs Temby.*

Salubrious House. His later work became very colourful. He worked in a studio on the quay and had a notice in his window, which was larger than the window frame so part of the writing was concealed. The notice read, "Paintings by red Bottom".' Denis Mitchell was a member of the Arts Club in 1965. In 1969 Denis, painter and sculptor, and Bill Picard the potter, gave a talk at the Club about their work.

1929
John Henry Titcomb, President
A letter was read from the St Ives Society of Artists thanking the Arts Club for the use of a room for their committee and stating that in future their meetings would take place in the Porthmeor Gallery. The Society now finally established their independence of the Club.

1930
George Fagan Bradshaw, President
Lieutenant Commander Bradshaw RN, specialised in painting ships. He occupied The Ship Studio in Norway Lane and was tutor at the School of Painting run by Charles and Ruth Simpson. He married a pupil of the school, Kathleen Marion Slater from Salisbury, Rhodesia, who was given away by her uncle Sir Francis Dundas Couchman. Mrs Bradshaw made painted lampshades for Heal's. She wore big black hats and Liberty print dresses. In 1929 Bradshaw painted the Crest of the Borough of St Ives on the proscenium arch of the Scala theatre and decorated the walls with 17th century galleons and nautical scenes. (This is now Boots the Chemist.)

James Laity and Son, White Hart Stores, St Ives, who imported tea from China, had a painting in the shop window of the 'Cutty Sark the fastest Tea Clipper', which was painted by Bradshaw. He also painted pictures of Chinese Junks on their large tea canisters. These were later sold at Christie's.

Roy Laity said, "We used to supply everybody with coffee, tea and food. I took over the shop from dad and I used to deliver to the houses and studios of the painters.

Laity's Shop with Tea Canisters, *Leonard Fuller. R Laity.*

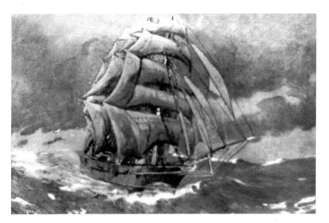

The Cutty Sark, *George Fagan Bradshaw. Roy Laity.*

Father had hundreds of pictures exchanged for goods. He also had a museum. Herbert Truman painted a picture of dad's antique shop. It was made into large and small postcards for sale."

Women Painters
An observation of the women painters was made in an article in the *St Ives Times* for 1930 by D I Sedding. 'Out at a door, beneath a low arch, a woman sings at a tub. On the low benches the mariners loll and smoke; interspersed with grave-eyed matrons, who rock their babies and gaze with strange indifference at the women with the brush. These stand at their easels and paint, oblivious to their surroundings.'

'Many a morning, as you wander through the narrow alleys of Down-along, you may meet a figure dressed almost as casually as the fisherfolk hastening along, a canvas tucked under her arm. You turn to your companion and whisper: "That is the brilliant M. whose pictures hang in the Academy" or that plainly dressed elderly woman who goes in to make her purchases at the butcher's with a crowd of less gifted housewives, you recognise as one of the foremost water colour artists of the day.'[88]

Miss Vera Bodilly was one such female artist. She won a scholarship to the Royal Academy Schools at the same time as Rex Whistler was rejected. Adrian Stokes and Frank Brangwyn, formerly of St Ives, were on the RA selection board at this time.

Vera and her mother, known for their needlework, made raffia bags, purses and baskets, silk bags with designs in fine gold thread, scarves with Egyptian decoration, necklaces and needlework pictures.

'Mrs. Arthur and Miss Bodilly are holding a most artistic exhibition of art needlework at the Malakoff Studio. It speaks volumes for what we may describe as the pioneering quality of originality, which is the keynote of the display.'[89]

An article in the local paper revealed something of how Dorothea Sharp set about painting her pictures of childhood. 'Walking along the sand the other day I met Mrs Blakeney Ward, President of the Society of Women Artists, who paints the portraits of fashionable London. Armed with her palette and paint-box, she was revelling in the glories of Cornwall. "Have you seen my Vice-

Esther Borough Johnson painting on the harbour, 1923.

President?" she asked me, and directed me to the studio of Dorothea Sharp, who specialises in pictures of children.'

'I found her painting on the Porthmeor beach, surrounded by children, mostly the daughters of fishermen, for these are her chief sitters. How they love to dress up in the pretty frocks from the children's wardrobe she always carries about with her!'[90]

Charlotte Blakeney Ward was president of the Society of Women Artists from 1923-31 and Dorothea Sharp was acting president. The Society of Women Artists was founded in 1855 under the title Society of Female Artists, renamed Society of Lady Artists in 1873 and in 1899 acquired its present title.

Dorothea Sharp, who studied art in London and Paris, was a landscape, figure and flower painter but is known mostly for her paintings of children on the beach. Before starting out to work she loaded her palette, obviating the need to carry several tubes of paint. She placed colour boldly with a full brush and treated her figures with loving care, remembering this advice from Sir David Murray in her student days. Her work appeared in *Studio, Colour, Homes and Gardens* and other pictorials.

In her book *The Studies Book of Oil Painting* she noted the differing methods of artists, some who placed colour, subject or drawing first, personally she rated colour as important as drawing but stated that a badly designed picture cannot be redeemed by good drawing or good colour.

The art critic P G Konody in the *Sunday Observer* of 1922 wrote, (somewhat patronisingly) 'Miss Dorothea Sharp struggles bravely and not unsuccessfully with the 'plein air' problem in a number of pictures devoted to the happy life of holiday makers enjoying sunshine and seabreeze on the sandy beach, or among the boulders of the rocky coast.'[91]

Dorothea died at her home in London in 1955. Her last picture was a huge flower painting to hang over the fireplace in the Empress of Britain.

A friend of Dorothea, Marcella Smith, studied art in the USA and Paris. She was a seascape, landscape and flower painter. Her technique of painting was described as suggestive of freedom and purpose and a full brush, with some work so coated with impasto as to resemble a relief. When she returned from her studies in America she stayed in St Ives with her aunts, who were nurses and lived in Seaview Terrace.

P G Konody wrote — 'The ports and harbours of the Cornish coast are Miss Marcella Smith's happy hunting ground. She commands a delightfully delicate scale of greens and blues and greys and is particularly successful in the suggestion of sea mist. Although distinctly modern her subtle insight into the values of diffused light and the decorative quality are among the predominating characteristics that should be noted.'[92] Her book *Flower Painting in Watercolour* was published in 1955.

Marcella designed hats for the races, the Henley Regatta and other great social occasions and was establised in London as well as in Cornwall. Mrs Sirrett of St Ives remarked, "Marcella Smith wore beautiful hats. They were of straw and she made rampant raffia flowers to decorate them. She used to send them up to London and they sold very well." She lived at 1 Piazza Studio.

Beatrice Pauline Hewitt, Pauline, as she was known, was a teacher of painting and her own work was of landscape and portraits in oils. She studied at the Slade School under Augustus John and Sir William Orpen and in Paris. She exhibited at the International Fair, London 1919 and in 1928 won a prize for the best picture executed entirely with Rembrandt oil colours with a landscape painting of Hayle. She signed her work with a monogram of a circle enclosing her initials. She occupied St Peters Street studio, the Balcony Studio in St Andrews Street and lived also at 7 Carthew Terrace.

In 1956 the death was recorded of Pauline Hewitt aged 83. She was a leading member of the art colony for over 40 years. As well as painting the Cornish landscape many of her subjects were of France and Italy. She died in a nursing home in Surrey.

Cornish Holiday, *1935, Dorothea Sharp. David Lay.*

West country women were exhibiting in a London showing of women artists at the Suffolk St Galleries, where the Women's International Art Club was holding its 26th Annual exhibition. Mrs Eleanor Hughes of St Buryan showed 'Autumn', Miss C K Carlyon of Exeter exhibited two pictures, Miss E M Bruford of Liskeard a charming child study and Mrs Mary Grylls of Lelant 'Primroses' and a study 'By The Wharf, St Ives'.

A New Zealand landscape painter, Margaret Stoddart, first appeared in the club as the guest of Louis Grier in 1898. 'My studies commenced in Cornwall,' said Miss Stoddart. 'I went to St Ives, which at that time was practically a colony of earnest workers. There I joined one of Lasar's classes.' (This is the only reference found to Lasar, who was an American and had an art school in Paris.) 'He was one of the first exponents of post impressionism, and he used to try and make us understand his weird ideas. One of his notions was to send us out, to see sunlight, on grey days.'

'Miss Stoddart, who has just returned to New Zealand, is a good artist and a modest woman. She has exhibited at the Paris Salon 15 times. A portfolio of sketches she brought with her to Sydney were mostly colourful impressions of Papeete, where she heard many interesting stories of the artist Gauguin.'[93]

Her pictures were illustrated and commented upon in *La Revue Moderne des Arts,* in Paris. The galleries of Christchurch and Wellington purchased several watercolours and a painting exhibited at the Wembley Exhibition was sold.

After some years she went to live in Paris where her work was accepted at the Salon and exhibited yearly. When she returned to New Zealand she was amused when she received her varnishing ticket from the Salon, as the answer to attend was demanded within a week.

In 1928 Sunday was still faithfully kept as a holy day. A report in *St Ives Times* quotes an article in the *Daily Mirror.* 'Nor are members of the enormous colony of artists expected to work on the seventh day. A lady, not knowing this, set up her easel in one of the grey alleys. Out

Pauline Hewitt showing paintings Tents on the Beach *and* Packing Herrings, *1928.*

popped a resident warning her to desist. "And you're lucky to have me telling you so politely," she said. "If you were further up the alley they'd say it with a bucket of water." A dramatic scene in a novel of the period gives an account of a woman artist being pursued by a crowd of angry chapel goers intent on seizing and destroying a painting she was carrying under her arm.

Frank Emanuel confirms this, 'I have known of inoffensive lady artists' work destroyed by native women on week-days on some idiotic charge, and destroyed, moreover, with impunity.'[94]

American Women

A New Yorker, Helen Stuart Weir, lived in a studio overlooking the harbour, and outside she could hear the fishermen auctioning their catch. 'She puts flowers and vases together with relish of rich harmony.' She was described as a distinctive landscape and still life painter who also sculpted. She was a member of the Society of Women Artists and Vice President from 1934-36. Helen often exhibited with her daughter, the painter Nina Weir-Lewis, who lived at Rose Lodge Studio and whose subjects were landscape, figure and still life.

Children at St Ives Harbour, *Pauline Hewitt. David Lay.*

Tulips, *Helen Stuart Weir. H Segal.*

Two American women who were in St Ives over a number of years were Hanna Rion and Theresa Rion Abell, her daughter. Theresa was a dancer, and singer of Negro songs and a popular entertainer. She toured with a musical comedy company. She had also written on the subject of twilight sleep. In 1918 Theresa married Captain Charles Bernard Trewhella, who lost an arm in the war. He was the son of Mr and Mrs Trewella of Trewyn. The bridegroom was a descendant of two of the oldest St Ives families, his mother being formerly a Miss Rosewall. Both branches of the family could be traced back several centuries. Theresa died young in a nursing home in Woking in 1927 but was buried at Zennor.

In 1921 Hanna Rion, the mother, married the Rev. Dr Apheus Baker Hervey in Maine, USA. Throughout the First World War Hanna was in England where she established 11 maternity hospitals. She also nursed for 18 months and was appointed matron at a maternity hospital in London. Mrs Hervey contributed articles to several English and American magazines. She was author, composer and painter and was born in South Carolina. Her third marriage was to Frank Verbeck, writer and illustrator and orginator of the 'Teddy Bear'.

Miss Euphemia Charlton Fortune, another American painter, was described in a Show Day article in *St Ives Times* in 1922 as, 'one of the new artists in the colony whose work is likely to stimulate those around her with a deeper sense of regard for painting in the open-air. Her canvases radiate vitality of outlook and her vigorous technique but searching tonalities, offer a lesson in expression to more timid members half afraid of their own powers.'

Women's Peace Pilgrimage

Women were politically active in the years leading up to their finally achieving the vote. The fact of being able to organise a 'pilgrimage' in an area so distant from the hub of politics is proof of this. The women met on the promenade in Penzance, from there to walk through Cornwall to Plymouth for the train to London. They were to meet up with similar pilgrimages from other parts of the country for a great demonstration at Hyde Park.

'Sir — The Peace Pilgrimage of women that will be starting from Penzance on Whit Tuesday is a matter of national as well as local interest. Much support is already promised, in Penzance, Hayle, Camborne, Redruth and Truro, for the object of the demonstration, which is to support the principles of arbitration in international disputes: it is hoped that St Ives will not be behind in showing its sympathy with the cause of peace.'

'Those who began to organise this great demonstration many months ago, include women of every belief and every political party and are indeed representative of the women of this country.'

The letter ends — 'May I ask anyone who is interested to get in touch with Mrs Morton Nance, Chylasson, Carbis Bay, or Miss Paynter, 9 The Terrace, St Ives or Mrs Arnold Forster, Zennor.

Yours very truly, K Arnold Forster'[95]

Mr and Mrs Arnold Forster were visitors at the Arts Club over the years. Mrs Forster was made a JP in 1928 and two years later appointed a County Magistrate. She died in 1938 aged 51 whilst visiting a sick friend at the isolated cottage known as The Carn on the Zennor Moors. One of the mourners at Zennor was Mr Sackville West. Virginia Woolf was a friend of Katherine 'Ka' (née Cox). She and Leonard had visited them at Eagle's Nest in 1921 on one of their frequent trips to Cornwall. In a letter Virginia wrote — 'Ka and Will sit among the rocks in Mrs Westlake's stone mansion, rather windblown, but sublime, observing hail storms miles out to sea, and the descent of the sun.'[96]

Writers

In December 1924 Greville Matheson proposed 'that members of the Operatic and Dramatic professions should be admitted as members.' Some 24 years previously this had been proposed by the writer Charles Marriott and turned down.

Greville Ewing Matheson lived at Boskerris Vean, Carbis Bay. He was a prolific writer, a valued member of the colony and contributor to the columns of the *St Ives Times* with the pseudonym MA Honest. He was called upon to act as editor on various occasions.

He was described as a man with an exceptionally brilliant brain, and most versatile. He loved acting and was a member of the newly formed St Ives Dramatic Society. He retired as passenger manager of the Union Castle Line and started the publicity department, the first of its kind in the shipping world. He had charge of the ships' libraries and prepared all their brochures.

He published several books of verse, one of which, *Crooked Streets,* was about St Ives with a foreword by Hilaire Belloc. Margaret Kennedy wrote to Matheson from London thanking him for her copy of the book. 'It must give pleasure to a great many people who have learnt to love St Ives. I showed it to Tillie Thomas, my little maid from Down-Along, and it drew from her a quite surprisingly passionate burst of homesickness. I think you would have been interested and touched if you had heard her. I often long for St Ives, now that the summer has come.'[97] Edmund Fuller designed the library for Boskerris Vean and a book plate, which shows Matheson sitting in a chair in his library surrounded by his 10,000 books.

A book published in 1924 which caused a stir among respectable circles was *The Constant Nymph* by Margaret Kennedy. It was produced as a play at the New Theatre in 1926 with Noel Coward as Lewis Dodd and subsequently played by John Gielgud. The play had its premier on the Arts Club stage. *St Ives Times* of 1929 carried an advert for the film — 'Scala Theatre — Ivor Novello as Lewis Dodd in *The Constant Nymph.*'

The book apparently caused concern in St Ives. Sylvia Sirrett explained. "Margaret Kennedy was living in Primrose Valley. She was a relation of the Talland House people. There was great gossip when that novel came out. We as children were playing on the beach — our mothers were talking about it, and saying, how did she know about such things?"

Margaret Kennedy was still receiving furious letters from women all over the world about *The Constant Nymph* when her new novel *Red Sky At Morning* was published. The writers of these letters said that the character of Tessa desecrated modern girlhood. A woman who lived in Rome wrote to Miss Kennedy, 'I have just seen your photograph in a magazine and I am no longer surprised that anyone with as ugly a face as yours should write a book like *The Constant Nymph.* I cast the book into the Tiber.'

Kennedy's first novel, *The Ladies of Lyndon,* was published in 1923. As a first novel this book was overlooked because of the dramatic impact of the second novel.

Eileen Cross, painter, told of meeting Mrs Kennedy on the beach. "Margaret Kennedy moved to London but they came down on holiday and had the tent next to us. I remember something she said to her husband on Porthminster Beach — our daughters met and were playing together. He came out of the bathing hut with his bathing suit on and his socks. She said, 'How chaste dear,' and it struck me as very funny at the time."

The play *The Monkey's Paw* by William Wymark Jacobs, was performed on the Arts Club stage in April 1927. The writer visited the Club in March and April that same year. He was on vacation and was brought as the guest of Hamilton Jenkin, who married Jacobs' daughter. (The play was performed again in 1989.) This was not the first visit of Jacobs. He had delayed returning to his home on

Book plate by Edmund Fuller of Greville Matheson's library.

another occasion to see his play, *The Bo'sun's Mate* performed at the Palais de Danse. Greville Matheson, who was in the cast of *The Monkey's Paw* in 1927, wrote of Jacobs, 'He occasionally comes to stay and he and I spend many mornings on the quay, visiting this or that studio for a smoke and a talk, and perhaps paying a visit to the two hundred year old "Sloop" for an aperitif.'[98] Jacobs' widow died in St Ives in 1945 by taking an overdose of tablets.

In 1928 the writer A K Hamilton Jenkin, broadcast a series of talks on Cornish miners and mining. He had first tried out these lectures on his friends at the Arts Club in their Tea Talks. His book *The Cornish Miner,* was published in 1927 and in the 1930s followed *Cornish Seafarers, Cornwall and the Cornish, Cornish Homes and Customs, Story of Cornwall* and *News from Cornwall.* In his books Jenkin explored all aspects of mines and miners in their life, character, beliefs, customs and humour and the Celtic remnants of speech. He was a founder member of the Cornish Gorsedd and was made a Bard with the title of Lef Stenoryon (voice of the tinners). He was also a President of the Royal Institution of Cornwall.

Outside St Ives Guildhall. Left to right: Charles Murrish, Hamilton Jenkin, Kingston Curnow, Mayor, R Morton Nance and G R Downing, who owned a bookshop. Susie Hosking.

On a more personal note Miss Sarah Escott remembers the man in his early days at St Ives. "Hamilton Jenkin used to come to country dancing classes with Margaret Kennedy and her brother. They were all very tall. The dances were taught by Flo Welsh and held in the old junior school at the Stennack. Hamilton Jenkin was the only person I have ever known who couldn't skip. He danced in carpet slippers."

Crosbie Garstin was the writer son of the painter Norman Garstin. Alethea, Crosbie's sister, was also a painter. In 1929 Crosbie appeared at the Scala Theatre, St Ives, playing Sandy Tyrell in Noel Coward's *Hay Fever*. He was a member of the Penzance Players and performed with them at the Arts Club at which he and his wife were frequent visitors. Crosbie gave a Tea Talk on 'Adventures in Africa' in 1930.

Greville Matheson wrote of the tragic event in 1930 in relation to Garstin. 'A few years ago I was talking to Crosbie Garstin — the author of the *Penhale Trilogy* and other books one Saturday night at the Arts Club, after the usual play — it was actually Presidents Night — and I asked him how his new book was getting on. "Finished it last night," he replied joyfully, "and tomorrow I'm going for a short holiday round the Cornish coast with a friend who's got a small yacht." Two or three days later we were all shocked to hear that he had been drowned.'[99] He drowned off Salcombe while making for the yacht in a small dinghy. Two companions were rescued. He lived at Lamorna and all his novels were influenced by and related to Cornwall.

Phantom Party
A Phantom Party took place at Mrs Ashton's garden at Hawke's Point. Invitations were issued and stern orders given to members that everyone must appear dressed in white. An article by Matheson in *St Ives Times* 1924 describes the scene.

'It was a perfect summer night, warm but with a pleasant breeze — the artists and their guests began to assemble. Having only arrived from London on the previous evening I was content with a pair of flannel trousers, and a painter's linen jacket.'

'At one end of the tiny lawn by the side of the railway a small stage had been erected with an immense Japanese umbrella for canopy, and here songs were sung and stories were told from time to time. On the grass, to the music of a small band, we danced. How we danced in those days, we who are now battered veterans, to whom fox-trotting for a whole evening — or two rounds of golf a day — do not appeal now-a-days.'

'I remember that one well-known artist, who later betook himself to Alaska, (Sydney Mortimer Laurence) or some other God forsaken country, in search of more gold than pictures produced, was deputed to mix the fruit salad in a mighty bowl, while another, still justly famous in St Ives for his brews, (Julius Olsson or Lowell Dyer) was responsible for the punch, which accompanied the stand-up supper.'

'In the semi-darkness, under the starry sky ghosts danced gaily or went wandering along the path of the little mysterious garden, or found their way through the white gate on to the green cliffs. Some, crossing the railway line explored the leafy labyrinths of the famous nut-grove. Wayfarers making for home may well have been startled as they came along the cliff path.'

'And as a glorious ending, when the sun was coming up and even the most energetic dancers were wearying, some of the madder ones found their way down to the rocks below Hawke's Point, and with the wind and rising sun to welcome them bathed in the chilly sea. We were indeed younger then.'[100]

Christmas Number — St Ives Times 1925
Greville Matheson was asked to edit the Christmas number and wrote to all his friends and acquaintances who had lived in or visited St Ives for their memories of the town.
Charles Marriott — author of *The House on the Sands*
'I think it is of the winter months that I retain the most characteristic impression. There comes back to me the memory of a shining place when most other places are dull.'
Mrs Alfred Sidgwick — author of *None Go By*
'It is nineteen years since we spent a summer in one of Mrs Havelock Ellis' cottages near the Knill monument and first got to know St Ives. I think of Charles Marriott's phrase about it 'lying like a lizard on the water,' and then I think of its ancient winding streets and the old harbour. One of its attractions is its independent life.'
Margaret Kennedy — author of *The Constant Nymph*
'I am extremely grateful to the *St Ives Times* for this opportunity of greeting all the friends in the town which gave me a home for several happy years. I send my love to Down-along and Up-along and the Arts Club and the Dramatic Society and the Folk Dancers, and to all the little boys who sang carols down my letter box for seven years in succession.'
Stanhope A Forbes RA Newlyn

'Christmas Greetings to St Ives and may it continue to extend hospitality to the members of my profession, for there are none who love it and appreciate its charm and beauty better than the likes of we.'
Charles Lewis Hind — author of *Days In Cornwall*

'St Ives was my first love — stars in the sky, stars in the sea, the blue shimmer all around, and Godrevy shining out beyond the bay. Ah! those days, those walks, those friends!'
Havelock Ellis — author of *Impressions and Comments*

'I can only say that I lived at Carbis Bay during a quarter of a century, until the death of my wife, and there is no part of it which contains for me so many memories or is so deeply impressed on my mind.'
Terrick Williams RA

'My first visit to St Ives was in 1890 and I have been there many times since, often staying for three or four months. In those days it was truly an artists' resort.'
Julius Olsson RA, JP

'There is no place in England of the size of St Ives that has had such a marked influence on the progress of British art during the last 40 years. It has been visited by so many people, distinguished in art and literature. One of my earliest recollections was dining with Sir Leslie Stephen at Talland House, about 35 years ago. St Ives materially helped me in my art and I am grateful for it. The first comparative success I had amongst painters was with a picture I painted overlooking Carbis bay, which is now in the Tate Gallery. My happiest memories of the place are in the harbour, whence I navigated a floating coffin which I called a yacht. I take this opportunity of wishing all my friends, and not least the good fisher folk who assisted me afloat and ashore. Happy days.'[101]

St Ives Society of Artists

At a meeting in 1926, of 40 artists, George Bradshaw and Herbert Truman proposed that a society of artists should be formed to further the interest of artists, and painting, in the colony and to endeavour to raise the standard of work exhibited in Lanham's Gallery, still the only gallery in St Ives. Bernard Leach said they could commence by having a gallery where the standard would compare with London exhibitions and they wanted a place where they could meet and talk about their work. Moffat Lindner pointed out that the St Ives Colony always had a diversity of work to discuss, 'We did not agree with the ideas of the Newlyn School because they all adopted the same style of painting.' 'Lowell Dyer proposed and Alfred Hartley seconded that a St Ives Society of Artists should be formed.'

A committee of working artists was elected to look into problems affecting artists. Lindner acted as Chairman, others were Bradshaw, Spenlove, Milner, Park, Pauline Hewitt and Nora Hartley. This committee reported its findings and it was agreed that the New Society should not in any way be connected with the Arts Club, although it was proposed by Milner and Douglas 'that the St Ives Society of Artists be invited to make use of the Arts Club

Room for holding their periodical meetings during the remainder of the year.' The Society took over the election of hanging committees for Lanham's Galleries — a job which had been the responsibility of the Club since the 1890s. One of their new duties was, if asked, to visit the studios of artists who so desired, to give useful criticism and advice.

St Ives Society of Artists was formed in 1927 *en bloc* from the members of the Arts Club with Moffat Lindner as its first President. He still remained a member of the Club having first served as president in 1899, 1911/12, through the war years 1914/17 and again in 1926. He was President of the St Ives Society of Artists for 19 years. He bought the Porthmeor Studios to secure them as galleries in which the Society could exhibit their work.

Retrospective Exhibition May 1927

The new St Ives Society of Artists began preparations for a retrospective exhibition of work by former artists of the colony with a letter to the *St Ives Times*. 'The St Ives Society of Artists are arranging a retrospective exhibition of the works of artists who have painted in St Ives in the past. It is proposed to hold the exhibition during the month of May at Messrs Lanhams Galleries. The joint secretaries would be very glad to hear from residents who own and are willing to lend good examples of the work of artists who have been in this neighbourhood during past years. The exhibition will not be commercial in any sense, none of the pictures will be for sale. The greatest care will be taken of all loaned pictures and they will be insured against damage. Yours truly, G F Bradshaw, Joint Secretary SSA.'[102]

Nearly all the artists of importance who had lived in the town were represented. A brochure was issued to hotels, Great Western Railway, etc. which contained a brief history of St Ives as an art centre.

Forty-one paintings were exhibited and it is interesting to note the names, especially such people as Helene

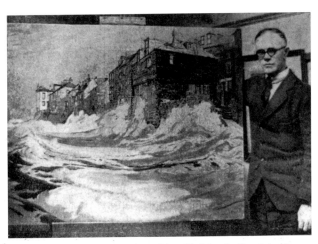

Borlase Smart with his painting of Arts Club for the Royal Academy.

105

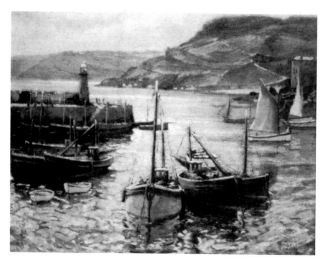

St Ives, *Herbert Truman. Ellen Haggett.*

Schjerfbeck, who last visited the town in 1889. Her painting showed a small boy tending a fire on the beach. All the exhibitors had been, or still were, members of the Arts Club or, as in the case of Helene Schjerfbeck, met at Louis Grier's studio in 1888.

Frances Hodgkins' painting was a portrait of Mr and Mrs Moffat Lindner with daughter Hope, Elmer Schofield's work included a snow scene, Gardner Symons portrayed a wet day. Others were Julius Olsson, Adrian Stokes and Marianne Stokes, Will E Osborn, Henry Bishop, Noble Barlow, Millie Dow, Lowell Dyer (angel), Terrick Williams, Louis Grier, Edmund Fuller, W H Y Titcomb, Charles Simpson, E Charlton Fortune, Algernon Talmage, H E Detmold, C G Morris, W B Fortescue, M A Bell (Mrs. Eastlake), Moffat Lindner, Arnesby Brown, Langley Hutton, Arthur Meade, Louis Sargent, Borlase Smart, Fred Milner and John Park.

After the success of the retrospective show the first exhibition of the Society elicited this comment, 'The summer exhibition of works by members of St Ives and Newlyn art colonies, which opened at Lanhams Galleries is one of the most interesting collections that has been shown in the galleries for some time. The standard of the pictures exhibited is of the highest and they are well hung.'

At the Annual General Meeting of St Ives Society of Artists in 1928 the new committee elected were Moffat Lindner, President; Capt F J Roskruge, Treasurer; A Cochrane, Secretary; A C Bailey, Librarian; Arthur Hayward, John Park, Francis Spenlove and W H Truman with Martin Cock, representing the Associate members.

St Ives Society of Artists acquired No 4 Porthmeor studios for their first gallery, which was enlarged in 1933 by encompassing No 5 studio next door. Distinguished artists were invited to become honorary members — Messrs Adrian Stokes, Arnesby Brown, Julius Olsson, Algernon Talmage and Stanhope Forbes, all accepted.

A successful summer exhibition in 1928 held in the Porthmeor Gallery showed pictures from St Ives and Newlyn. At the opening Julius Olsson RA addressed the assembly. He was introduced by Moffat Lindner, who said Julius Olsson was known to most of the members and it

was his studio, which he had occupied for 25 years, that they now used as a gallery.

The second summer exhibition was held in August at the Society's new gallery. 107 works were shown in oil, watercolour, drawings and black and white. Lowell Dyer exhibited 'Angel with Daffodil'. 'Adoring Angel', which he showed in a later exhibition, was said to be a canvas which might well decorate a church of the Renaissance. Francis Roskruge exhibited three etchings of local subjects. Herbert Truman showed Egyptian studies. He lived in Egypt for 15 years and was inspired by drawings on the tombs. He now lived at Trezion, off Fore Street, where his daughter was born.

The Winter Exhibition in December was the last of the season in a successful year of the St Ives Society. Over 120 pictures were shown 'and a very high quality of work maintained.' The Society was beginning to realise success in their venture.

The Summer Exhibition of 1929 included Royal Academicians Arnesby Brown, Julius Olsson, Adrian Stokes and Stanhope Forbes. There were 100 works on view by members of the Arts Club. The 1930 spring exhibition was opened by Terrick Williams and there were several changing exhibitions through the seasons of the year. Continuing their series of lectures, Bernard Leach gave a talk on *The Training of an Eastern Artist.*

Lanham's Gallery

In January 1921 the Newlyn, Passmore Edwards Gallery closed its doors for the winter and a correspondent

Moffat Lindner and Julius Olsson at the opening of the St Ives Society of Artists Exhibition, Porthmeor in 1928.

pointed out, 'one turns with high expectation to the galleries of Messrs Lanham at St Ives. Here one has the only place in the West country where may be found, at all seasons, a representative collection of recent art.'

'The greater part of the work is produced in the studios of St Ives, and though brushes and paint are more in evidence here than elsewhere in Cornwall, it would be greatly to everyone's advantage if more of the pictures came from Newlyn and Lamorna. This is a point that we commend to the serious attention of that remarkably efficient director Mr Martin Cock.'[103]

The Newlyn galleries opened again in May. Norman Garstin expressed his concern that there were only 15 artists in the Newlyn School and it was necessary to have public support if exhibitions did not become a thing of the past.

Lanham's continued to expand and encompass the various needs of the artists. An advertisement of the time read, 'Two gentlemen artists are prepared to take two gentlemen pupils for sketching and yachting tour on the Norfolk Broads, apply James Lanham.'

On Show Day 1922 Gallery 3 was reserved for an exhibition of Bernard Leach's pottery and etchings. Helen Stuart Weir and Nina Weir-Lewis shared gallery space in a summer show of flowers and still-life subjects. Lanyon held an exhibition of photographic portraiture and a special commemorative exhibition celebrated the work of the late James Lynn Pitt. The Print Society formed by Alfred Hartley held their members exhibition of etchings and woodcuts, among which Mr Matsubayashi showed a study of Japanese medlars. An exhibition of Original Drawings of Old St Ives was the work of Francis Spenlove.

D I Sedding wrote — 'There is always an exhibition of the artists work in the town and the pictures on view are changed every month. The Hanging Committee, in its broad mindedness, shows many pictures of the new school, which, perhaps speaking charitably, need an acquired taste to appreciate fully. Here also, however, we may view the grand paintings of Milner, delicate seas of Grier, and the thick coated canvases of that moorland master Folliott Stokes. Then there are paintings by Marcella Smith and other women artists. The gallery is a continuation of a shop and, returning from the contemplation to the sublime, we pass the counters stocked with wines and spirits, and old warming pans!'[104]

In 1927 showing alongside the first exhibition of the St Ives Society of Artists was the work of J S Yabsley, whose oil paintings included 'Eagle's Nest', 'Gigs in the Harbour' and a portrait. He was also showing at the Atlantic studio with A C Bailey. An August exhibition featured the work of Ernest Procter, who showed the head of a Burmese peasant, Harold Harvey had several works on view including 'Seaweed'. S H Gardiner from Lamorna exhibited 'Lamorna Stream'.

In 1928 a report on Lanham's exhibition noted, 'On the easel in the front gallery is a beautiful work, the best in the exhibition. It is an oil painting of Mullion Cove by G

Lanham's in the thirties. Jeanette Orum.

Turland Goosey. The wonderful blues and greens of the sea, so often seen around the Cornish Coast, are treated in a bold manner, but those who know Cornwall know how true these colours are.' The August exhibition showed the work of Frances Ewan, one of four being 'St Ives Harbour — Low Tide'. John Park exhibited five paintings. Francis Roskruge exhibited several aquatints. W H Truman and Hurst Balmford were among the new names.

1929 Diamond Jubilee of Lanham's

Through 40 of the 60 years Lanham's served as a show case for art in St Ives as well as a store of essentials for an artist's palette.

'The Galleries in the High Street have just been re-hung with work from the various studios of the Art Colony, and the result is an attractive exhibition. Pictures of the neighbourhood are to be found throughout the world. No poster advertising St Ives as a beauty spot and health resort could have done what the artists have proved by their pictures for the last half-century ... It is just as well that the town of St Ives realises this important fact and what it owes to the Art Colony and their artistic endeavours.'

'On view in Lanhams are 3 large works by Rolf Jonsson, a Swedish artist who studied art in Cornwall. All are bold in treatment. There is a delicate pastel by Arnold Forster. P McMahon shows several clever water colours. Alfred Cochrane's surface rendering of still life objects is clever and interesting. Bailey has chosen his subjects from Holland and Italy. Yabsley shows an oil of St John's Church. Penbeagle Farm has a clever sky effect. For unique decorative works one must visit Donald Angier's studio. Miss Helen Seddon's flower studies are full of brightness. Her water colours of foreign scenes are worthy of inspection.'[105]

The Christmas exhibition of 1930 included painters from Newlyn. Works were received from Stanhope Forbes, Mrs M C Forbes, T C Gotch, Lamorna Birch, Harold Harvey and Geoffrey Garnier. Leading members of St Ives also showed, Julius Olsson, Arthur Meade, Fred Milner, Herbert Truman, Daisy Whitehouse, John Park, Reginald Turvey, J H Titcomb, Fred Bottomley, as well as 28 other St Ivesians and a few outsiders, among whom were Garstin Cox and A C Hambly. Dorothea Sharp and Marcella Smith took over the running of Lanham's gallery for a number of years.

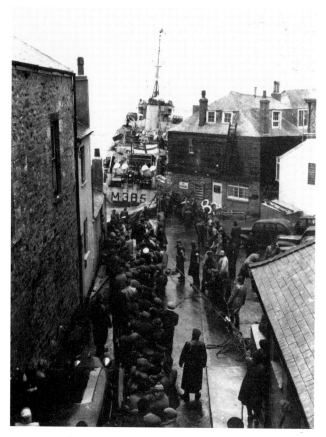

The Arts Club nearly swept away by H M S Wave, *1952. Penzance Private Library.*

The Building

The building has been the major factor in the Arts Club celebrating its Centenary Year. It has kept the members working together for something they own. It has housed endeavours in painting, writing, drama and music and provided St Ives with a small theatre which is appreciated by visitors and a loyal circle of supporters and members.

In 1928 a meeting was called to discuss the possibility of the Club buying the building, which had now been put on the market. After some discussion Moffat Lindner, W Herbert Lanyon, E S Darmady and Colonel Findlay volunteered to make an offer of £600 for the Club Building and if successful in obtaining it, to offer it at the same price to the Club.

It was agreed that there was no other building in St Ives suitable and no other convenient site available, and a new building would exceed £600. The committee therefore recommended that the building should be bought at this figure, the site alone being worth the price. The four

members who bought the building were elected as trustees.

The lower part of the building, consisting of stone and brick work, was in sound condition, the upper part of wood, not so good but the committee were satisfied that no heavy repairs would be required within a reasonable period in the future.

It was agreed to co-opt the architect Mr Turland Goosey on to the sub-committee and invite him to prepare plans. He recommended as a priority, strengthening the floor of the room above, concreting the ground floor and rebuilding the staircase. Electric lighting was also to be installed. Also a better entrance, an emergency exit, two lavatories, cloakrooms, kitchen and pantry, additional room below, and extra windows. The architect was to obtain permission from the Borough Council for the erection of an outside iron staircase as a fire escape.

An extract from a document drawn up by Chellews, solicitors, reads:
'The Club Building with the Workshop underneath has been purchased as from the 29th September 1928. The Club will thus own its own Club house and the valuable site on which it stands. If at any time the Club ceases necessitating the sale of the building the balance of money left will be devoted to such kindred Societies as the Club will previously nominate.'[106]

One of the most dramatic moments in the history of the building was in 1952, when *HMS Wave* dragged her anchor in St Ives Bay and failed to hear the warning rockets fired by the coastguards. She came to rest alongside the Arts Club and the crew were rescued by breeches buoy with St Ives people forming a human chain to effect the rescue.

The legacy of those early artists is the Arts Club building, without which it is unlikely that the Club would have reached its centenary. In spite of the frequent financial crises, and storm damage to the sea wall and roof, the building is regarded as a most valuable asset, not the least of its values is that it provided a home for the first artists' colony.

In its centenary year major and vital building works to the sea wall and ground floor were carried out by builders Roy and Robin Timms. They discovered below the floor the old cobbled slipway of Westcotts Quay and fish cellar complete with millions of fish scales. Part of that floor has been left uncovered to reveal some of the building's history. To ensure the continuation of the Arts Club into the next century the membership sought Charity status. This took effect on 12th December 1990 under the title 'St Ives (Cornwall) Arts Club Society,' exactly 100 years from its foundation.

The New Era
1930-1993

Introduction to a New Era

From the thirties several painters in Cornwall were turning to abstraction, John Tunnard and John Armstrong both showed a tendency to a surrealist element in their work, as did Ithell Colquhoun, but they were isolated among a group of traditionalists. Surrealism did not accord with the philosophies of the later arrivals in the peninsula, the constructivists.

The Modern Movement developed gradually in St Ives, gaining little impetus, and with opposition and disapproval from an established artists' community that had gained its reputation from faithful pictures of sea and landscapes. Abstract art did not have its roots in the immediate past generation of painters in Cornwall, rather it was implanted with the influx of a group of artists from 1939 onwards. This first group, which included Adrian Stokes, Margaret Mellis, Ben Nicholson and Barbara Hepworth, was influenced by the Europeans.

Nicholson had a long association with the wide range of French art in Paris which he and Winifred, his first wife, visited in the twenties on their way to and from their Swiss home, to take in the recent exhibitions of Matisse, admire the works of Cézanne, and to renew their interest in the simple classical works of Italy's Piero della Francesca and Giotto.

In the early thirties Nicholson and Hepworth, recently married, were living in Hampstead. They visited Paris and met the artists Brancusi, Picasso, Braque, Mondrian and Arp and were familiar with the Modern Movement in Europe. After the enforced closure of the Bauhaus in Germany in 1933, it was a natural progression that the architects of the Bauhaus, Walter Gropius, Eric Mendelsohn, Arno Goldfinger, the designer Marcel Breuer, Naum Gabo, Lazlo Moholy-Nagy, exponents of the International Movement in art, architecture and design, should escape the rising tide of war in Europe and join them in Hampstead, London.

Winifred Nicholson had travelled across France by train with Piet Mondrian in 1938, accompanying him to London on her way to Cumbria. Ben Nicholson found him a studio at 60 Parkhill Road, Hampstead, which Mondrian immediately painted white replicating his Paris studio. Gabo described this studio as a Mondrian in space, white, with geometrical shapes of colour on the wall.

This community of artists also included the sculptor Henry Moore and architects Leslie Martin and Maxwell Fry. Fry completed his Hampstead Sun House in the early thirties and Wells Coates designed Lawn Road Flats, Hampstead, which housed Gropius, Mendelsohn and Breuer. Berthold Lubetkin had arrived in 1931 and helped form the Tecton group which had built High Point flats at Highgate. These were buildings in the International Style and Ben Nicholson's white reliefs of this period reflect the clean dynamic structures of modern architecture. 'The white reliefs were intended to hang on the white walls of modernist houses.'

Another important Hampstead resident was the writer on art Herbert Read, who had written *Art Now* in the thirties as a survey of modern painting and sculpture. In 1934 he edited *Unit One,* a manifesto for the organisation of the Modern Movement in English Architecture, Painting and Sculpture, founded by Paul Nash to coincide with an exhibition held at the Mayor Galleries, in which Nicholson, Hepworth, Moore, Nash and the newly arrived architects took part. Read, on looking back to this era in Hampstead, described it as a period of international significance.

H S Ede, assistant curator at the Tate Gallery, bought One Elm Row in Hampstead and lived there from 1928-38. Ivon Hitchens had a studio in Primrose Hill, a 10 minute walk away, which he occupied until 1940, when it was bombed.

An Artists' Refuge was set up by the German painter, Fred Uhlman, at 47 Downshire Hill, Hampstead, offering accommodation to painters fleeing from the Nazis. Two such distinguished guests were Oskar Kokoschka and Kurt Schwitters. Committee rooms and offices were provided to deal with any problems they might have.

The presence of these artists, architects, writers and sculptors in London forwarded the development of the avant garde. Under the sponsorship of the art magazine *Axis* Nicolette Gray, in 1936, organised 'Abstract Concrete' an exhibition of Abstract painting, Sculpture and Construction, in which the Hampstead artists were prominent. Nicholson showed his white reliefs alongside the work of Mondrian, Leger, Miro and other European modernists. In this same year an International Surrealist exhibition was shown in London, whose concepts were supported by writers, psychologists, and poets. The exhibition was organised by Roland Penrose, who also lived at Downshire Hill, and the introduction to the catalogue was written by Herbert Read.

These were two opposing forces of the avant garde motivated by different ideas and philosophies. The constructivists favoured order, harmony and clarity and encouraged artists to see art in relation to their environment. The surrealists, at their exhibition, organised events to shock and create sensation and free the imagination.

In 1937 the magazine *Circle, An International Survey of Constructive Art* was produced, which was edited by Gabo assisted by Ben Nicholson and Leslie Martin. It accompanied an exhibition, Constructive Art, held at the London Gallery and showed work of some of the contributors to *Circle.* It was not designed to be the Constructivist Manifesto but contained a collection of essays invited from architects, designers and artists outlining their approach to their work. It brought

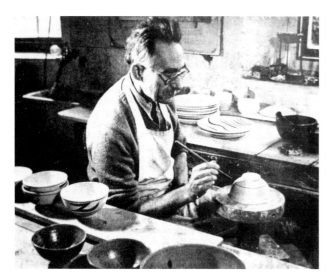
Bernard Leach working in his pottery.

The Leach Pottery

Bernard Leach was born in Hong Kong in 1887. He was educated at Beaumont College, Windsor, and studied at The Slade under Henry Tonks and the London School of Art where he learnt etching with Frank Brangwyn. He returned to Japan to teach etching and studied the craft of pottery in Japan and China.

In the 1920s Leach returned to Britain, bringing with him his friend the potter Shoji Hamada. Together they set up a pottery to marry the various techniques and ideas of East and West. They built a Japanese three-chambered climbing kiln which was wood-fired. It was the first of its kind built in the West. When fully packed it contained about 500 pieces. The pottery was built by the Stennack river and in the early years used local clays, china and fire clay from Towednack and red and blue plastic clays from St Erth. A replacement kiln was constructed by Matsubayashi two years later and was used, alongside an oil-fired kiln installed by David Leach in 1937, until the 1970s.

Although the pottery was envisaged as curing some of the unemployment problems of the area, a report from the *West Briton* caused some alarm when the word 'industrial' described the establishment of the pottery. Bernard Leach wrote to the *St Ives Times* to allay local fears.

'Sir: As there seem to be various rumours in the town that the pottery which we are now building below Penbeagle Farm is to be a large industrial concern, employing local labour, I shall be glad of the opportunity of briefly stating the facts in order to prevent any sense of disappointment which might otherwise arise.'

together a wide cross-section of abstract painters and sculptors in England who aligned themselves with the ideas of the European artists, designers and architects.

Leading up to the outbreak of war the Hampstead group dispersed. Many of the Europeans emigrated to America. Stokes and Mellis migrated to St Ives and invited Nicholson and Hepworth to join them in their house, Little Parc Owles, at Carbis Bay, and shortly afterwards Gabo and his wife Miriam arrived. Surprisingly these sophisticated artists, who fled London, were taking note of the primitive paintings of an untutored and semi-literate old man in St Ives, Alfred Wallis, whom Nicholson, accompanied by Christopher Wood, had first met in 1928. His paintings were dismissed by the local population and beneath the notice of legitimate artists working close at hand.

At the same time, this progressive 6 were experimenting with form, line, colour and spatial relationships and finding their own paths, while England was cut off from Europe, the great art influence of the Western world. There was a holding of breath during the war years which afterwards was released in a great wave of energy, ideas, hope and progression, leading to a regeneration of the modern art movement.

Artistic life in America became enriched by the flood of European émigrés escaping to the safety of the United States. These fugitives took with them the seeds of modern art and effectively transferred the course of development from Europe to America, which was to reveal itself in the late 1950s.

Meanwhile in the small remote town in Cornwall Ben Nicholson and Barbara Hepworth, were putting down roots that would have far-reaching effects. St Ives, with its scenery painters and its methodist local population, was to be the catalyst for change in the international world of art — but for the moment life carried on as normal.

However, nearly 20 years before the arrival of those who would revolutionise painting and sculpture in the County, the potter Bernard Leach had established a pottery which created studio design ceramics. He became a leader in the world of potters.

Leach Tiles on Edgar Skinner's Grave.

'The works are to be of a private nature and on quite a small scale. For the first year or two, at least, we shall not employ more than the occasional odd labour of one or two men. How the work will develop later on remains to be seen. Our object is to turn out genuine handicrafts of quality rather than machine craft in quantity.'

'The former is difficult to find now in England, as it has been driven out by modern industry and applied science. In the Cornish pitcher, made at the Lake Pottery at Truro, it is still possible to see something of the spirit of the old English pottery, but the ware is a very simple one and unsuited to many modern purposes. I have long been studying pottery in the Far East, where the traditions of old craftsmanship and beauty have not yet been driven out, and the various kinds of earthenware, stoneware and porcelain, which my Japanese friend and assistant, Mr Hamada and I will make, will be an attempt to combine the fine old craft of both East and West to our present needs.'

'With many thanks for the courtesy of your page. Yours truly, Bernard Leach'

The Partnership

Hamada was artist-craftsman, assistant and chemist. He made pots stamped with his seal. Leach designed and produced three-quarters of the work with his own seal. The pottery made Raku earthenware, Korean stoneware with a variety of textures and colours, and brown and cream Galena slip-ware of the old Devonian and Staffordshire pottery — the backbone of English pottery.

Most of the pots made by Leach were for practical use, vases, bowls, mugs, jars, dishes, etc. He was very much concerned with the philosophy learned in the East; the quality of hand-crafted pottery and the use of natural materials with simplicity of design.

In 1922 Edgar Skinner took over as business manager and assistant craftsman. He came to St Ives as an artist in 1907. He died at Chy-an-Creet in 1925 and was buried in Barnoon cemetery. His grave is decorated with tiles from the Leach pottery, showing views of St Ives and with the inscription 'He went through life with outstretched hand of help.'

Many craftsman potters visited the Leach pottery and afterwards the names of some of them are recorded in the Visitors Book of St Ives Arts Club. Leach, Hamada and Skinner were all members. H R H Prince Chu-gli of China visited the club in 1921 and was a probable visitor to the pottery. Mr Kawaski came from Tokyo in 1922. Matsubayashi was brought by Bernard Leach and Michael Cardew came in 1923 with Morton Nance. Michael Cardew set up his own pottery after a three year study period at the Leach. The Wenford Bridge pottery at Bodmin continues with Seth Cardew, his son.

As well as reporting on the successes of the Leach Pottery in exhibitions in Britain and Japan the *St Ives Times* of 1927 also noted its continuing validity in St Ives.

'Afternoons at the Leach Pottery has provided people with a unique opportunity of decorating their own pots

Bernard Leach by Hyman Segal.

and then watching them glazed and fired. This experience has been keenly appreciated. Next year to meet this growing interest in comfort, teas of a good home-made character will be provided in the pottery cottage now being built. The furnishings of the new room will be by some of the best living English craftsmen and women, selected with a view to showing a combination of the interior work which is good and yet not very costly.'

The two sons of Leach, David and Michael, both trained as potters and in 1955 they went their independent ways and set up their own potteries. In 1956 Bernard married American potter, Janet Darnell, and that year she took over the management of the pottery.

The Apprentices

In later years Bill Marshall was responsible for the work of apprentices. He also acted as foreman and assistant to Bernard Leach, especially in the throwing of large pots. Michael Cardew was the first apprentice potter and Katherine Pleydell-Bouverie. Scott Marshall, who trained with the sons David and Michael Leach, was the last of a long line of apprentices. Most went on to develop their own successful potteries. Fellow potters like Alan Brough of Newlyn, along with many others, worked alongside Bernard Leach because they considered him the highest authority in the craft. Others, like Anthony Richards, visited the Leach Pottery to join in the endless discussions on the art of Korean pottery and the philosophies of the Eastern world.

Young potters practising in Cornwall today talk of the influence of a classical training gained at the Leach which gave them a good grounding from preparing clay to the techniques of throwing, glazing, firing and working in the Show Room. Bernard Leach could look at the pots on a shelf and tell which of his apprentices had made it, seeing in a pot the character of the person coming through. This is a development he looked for in his apprentices.

Abstract Composition *1946, Sven Berlin. Belgrave Gallery.*

The New Arrivals

The arrival of artists, who were to change the face of art in St Ives, are featured more or less in the year in which they arrived. In 1938 Sven Berlin came to the town. He had followed a successful career as an Adagio dancer for about 10 years and then decided to become a painter. He was a student at Beckenham School of Art and was tutored by Arthur Hambly at Redruth Art School. After his move to St Ives he began adding sculpture to his list of accomplishments for which, as a large and powerfully-built man, he was particularly fitted.

Berlin's studio was above Porthgwidden Beach, known as Sven's Tower. He stayed 15 years in the town, finally moving because the Council built public lavatories next to his studio and on his outdoor working space. The derelict studio still stands. Although Berlin painted some abstract pictures in the early years, he veers to the romantic in both his paintings and sculpture. Berlin is also a writer of articles, poetry and novels.

Another arrival was the painter George Lambourn. His paintings ranged from symbolic figures representing suffering to Cornish landscapes and coastal subjects. He was born in London and studied at Goldsmith's College and the Royal Academy Schools 1921-26. He first came to Cornwall in 1938. During the war he worked with the Friends Ambulance Unit in France and organised the decoration of the 8th Army canteens and theatres in Africa and Italy. His first one-man exhibitions were at the Matthiessen Gallery in 1936 and 1938. In 1949 he returned to St Clements Hall in Mousehole where he and his family lived until 1970, after which he moved to St

Just. His last exhibition was at the Newlyn Gallery in 1977.

Robert Borlase Smart studied seascape painting with Julius Olsson at St Ives in 1913. He was an oil painter of seascapes, watercolourist and etcher of architectural subjects. He served in the Artists Rifles Machine Gun Corps during the First World War when he formed a friendship with Leonard Fuller. They decided to come to St Ives to paint after the war. In 1919 Smart returned to the town and became secretary of the Arts Club.

In his earlier career he was art critic for the *Western Morning News* in Plymouth 1902-13. He was one of the most respected of St Ives artists and although he was a committed representational painter he could appreciate and respect the ideas and creativity in abstract art and tried to bring co-operation and harmony to the two differing artists groups.

The portrait, figure and still life painter, Leonard John Fuller, finally achieved his ambition to live in St Ives after a delay of nearly 20 years. He taught at St John's Wood

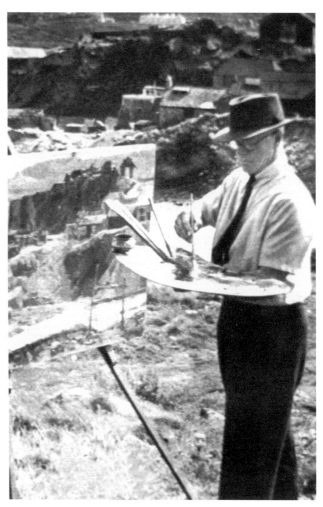

Borlase Smart, painting at St Ives.

Lady Margaret Tangye, *Leonard Fuller. David Lay.*

included John Singer Sargent, George Clausen and Sir William Orpen.

St Ives School of Painting

The Fullers established the St Ives School of Painting as a base for an academic approach to painting. They opened the school in 1938 to meet the need for a centralised school of art to cater for the artists community in St Ives and for the many students and visiting artists. Pupils received a very scholarly style of training. The old idea of artists having their own group of students was no longer operational.

The stated aims of the school were 'To assist the many resident and visiting students in attaining the requisite proficiency to enable them to express themselves adequately in the various mediums; especially to enable them to combine their studies in landscape with figure and portrait work, carried on simultaneously.'

Terry Frost said, "We young painters used to go to the painting school, it was the cheapest way we could get a model. There was Peter Lanyon and Sven Berlin. We were some of the early pupils who went along to draw."

School of Art 1922-32 and at Dulwich College until 1938. He was an academic painter of great integrity, and an understanding teacher.

Leonard lived with his wife, Marjorie Mostyn, on the Wharf in St Ives. She was an accomplished painter of portraits, children, interiors and still-life and daughter of artist Tom Mostyn. In 1915 she was awarded the British Institute Scholarship and silver and bronze medals for life and composition. Her tutors at the RA Schools

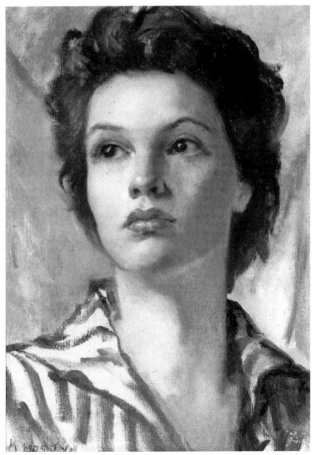

Portrait of Sue Lucas, *Marjorie Mostyn. David Lay.*

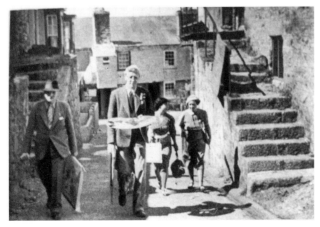

Leonard Fuller with students.

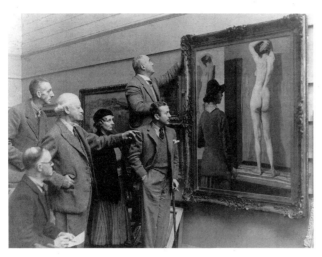

St Ives Winter Exhibition 1937, Porthmeor Gallery. Painting by Dame Laura Knight Self Portrait and Model. *Borlase Smart (seated), J. Millar-Watt, Moffat Lindner (President, pointing), Shearer Armstrong, Bernard Ninnes (front picture), Commander George Fagan Bradshaw.*

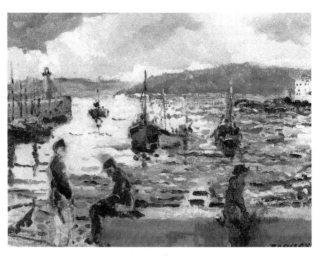

St Ives Harbour, *John Barclay. David Lay.*

The traditional painters held great sway in St Ives, being quietly dominant since the founding of the Arts Club in 1890 and St Ives Society of Artists in 1927. They were hugely popular with the public. Mrs Care, who lived in the Dolls House next to the Porthmeor Studios, knew the early painters and was also familiar with the incoming group. "The artists were very interesting to meet. There was Bradshaw, Nicholson, Smart, Park, Shearer Armstrong, Frances Ewan and Lucy Walsh. Mrs Walsh used to talk to me. She used to see me cleaning my brass and said, 'Mrs Care you need a holiday.' She left me £1,000 in her will." Show Day in St Ives and the submission of paintings to the Royal Academy was still the most important event in the artists' calendar. In 1938 the number of pictures exhibited by St Ives artists at the RA totalled 80. Forty-eight of these were hung on the line. However, the art critic Charles Marriott, wrote in Denys Val Baker's *Cornish Review*, 'I have a notion that,

even in their abstractions, the later recruits to the colony, such as Ben Nicholson, get nearer to the peculiar magic of West Cornwall than did the painters of my day.'

Helping to teach at the school of painting was John Rankine Barclay who had served in France during the 1914-18 war with the Highland Light Infantry and won the Military Cross and Bar. He lived in St Ives from 1935. He produced woodcuts and illustrated books and established a reputation as a decorative and mural painter. He was commissioned to paint a giant mural to decorate the club room of Wembley Stadium. It was through his painted murals at St Ives Bay Hotel that Barclay received his commission. In 1938, the tercentenary of the Granting of the Charter for St Ives, Barclay painted three murals for Curnows Restaurant. The proprietor was then Mayor and this important historical event was re-enacted on the Island with the dignitaries of the town in period costume and mounted on horseback. Mr Curnow gave these celebratory murals to the town museum.

The War Years 1939 — 1945

In 1939 Adrian Stokes and Margaret Mellis were playing host at Little Parc Owles to Nicholson and Hepworth with their triplets Paul, Rachel and Sarah. They stayed for about four months then lived at Dunluce before finding a more permanent house, Chy-an-Kerris, overlooking Carbis Bay. Nicholson had the privilege of using Stokes' studio and was immediately at work.

Stokes was not related to the first Adrian Stokes (1854-1935). He studied history, philosophy, politics and economics at Magdalen College, Oxford 1920-23. He began painting seriously in 1938, when he arrived in St Ives, after taking art at the newly opened Euston Road School. He married Margaret Mellis and their son was born in Carbis Bay. The marriage broke up in 1946 and he married Margaret's sister soon after. He wrote a selection of books on art and artists and wrote poetry. He became a Trustee of the Tate Gallery 1960-67.

Mellis was born of Scottish parents in China. She came to Britain when a year old. With a two year travelling scholarship from Edinburgh College of Art she studied in

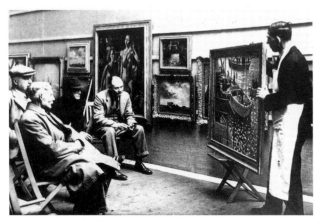

The Hanging Committee T Maidment, G Bradshaw, B Smart, L Fuller and Tonkin Prynne. H Segal.

Fields near St Ives, *Adrian Stokes.*

Margaret Mellis with son Telfer at Little Parc Owles, A. Angus.

Paris and travelled to Spain and Italy. Afterwards awarded Fellowship at Edinburgh College of Art 1935-37. In 1938 she attended Euston Road School, where she may have met Adrian.

Moving to Cornwall had an effect on her work as a painter. She started making constructions, working on collage and relief carving. The first of these were abstract collages of paper and card, moving on to wood and stone. She also made slate reliefs. She left Cornwall in 1946 and married Francis Davison, known mostly for his

Sinking Boats, *Margaret Mellis, 1989. Found and painted wood.*

colourful torn paper collages. They lived in the South of France 1948-50. A Margaret Mellis retrospective exhibition 1940-87, 'Constructions in Wood and Paintings', was held at the Redfern Gallery in 1987.

Hepworth and Nicholson were unable to persuade Piet Mondrian, with whom they were closely associated in their London studios, to join them in rural Cornwall. He did not like the countryside, preferring city life, and had often complained of the number of trees in Hampstead. In 1940 Mondrian wrote to Winifred Nicholson to say he had arrived in New York. He said London had become too dangerous. The windows of his room had been shattered by a bomb while he lay in bed and it made him feel that in such circumstances art was too difficult in London.

Nicholson's first one man show was at the Adelphi Gallery, London in 1922. He attended the Slade School for a year in 1910 and then spent three years travelling and painting in Europe. He joined the Seven and Five Society in 1924, becoming President in 1926 and exhibited regularly with them until their demise in 1935, which was partly the fault of Nicholson for demanding that the exhibition should be totally abstract.

During the war Nicholson became the senior figure

Monolith Carnac 5, *relief, Ben Nicholson, 1969. Waddington Galleries.*

among a group of abstract and avant garde artists painting in Cornwall. He composed a series of still-life objects, overlapping or grouped, or seen as outlines in the foreground of landscape or harbour, related to a post-Cubist period. Much of his drawing work features St Ives and Cumberland.

Not surprisingly, Barbara Hepworth was heavily engaged with her triplets for the first few years after arriving in Cornwall, although having a nanny to help care for the children. However, her real working time was at night. She would draw and develop ideas associated with the crystal, which for her was an expression of spatial feeling and a continuation of her interest in abstract sculpture begun in her London studio, but Cornwall was beginning to exert its influence.

Hammacher comments, 'It is not easy to put one's finger on the difference between the late London work (1937-39) and the early St Ives work (1940-43).

Nevertheless the difference is there... In London the holes were still fairly small in relation to the volume and the mass. Sometimes they were a complete penetration, sometimes merely a hollow.' After 1943 Hammacher observed that the forms were broken and open with the introduction of cords and colour to add further depth and dimension, and the oval shape was beginning to replace the circle. 'She put into her work emotions drawn from nature, which were neither mystical nor romantic but based on her actual observation and experience of the Cornish landscape.'[1]

Hepworth carved in wood and stone, but particularly loved to carve in wood. At Leeds School of Art Henry Moore was a fellow student. She married John Skeaping the sculptor in 1925 and lived in Hampstead. They had one son, Paul. She met Nicholson in 1931 and joined the Seven and Five Society that same year. They were married in 1934.

Cornwall became Hepworth's permanent home. She

Barbara Hepworth's Sculpture Garden at St Ives.

Lomnica 1964, *Peter Lanyon. S. Lanyon.*

another person working with similar ideas as himself. Stokes asked Nicholson to tutor Lanyon and they spent several months working together in Lanyon's studio at the Redhouse in St Ives. Twice a week he set up objects and they created shapes and spaces, drawing around them, changing the images and experimenting with form. It was an exciting time for Peter having spent 18 months at Penzance School of Art perfecting academic drawings and four months at the Euston Road school, which he only remembered for two particular tutors, Victor Pasmore and William Coldstream, who both visited Adrian Stokes in St Ives.

The young Peter Lanyon had previous experience of working with Borlase Smart, his first painting tutor. They would go out to the cliffs and he would make Peter observe and draw the rocks, taking into account their weight, age, and the battering from the sea.

In later years Lanyon said his paintings were influenced by cubism and the constructivism of Naum Gabo and Ben

bought Trewyn Studio and gardens in St Ives in 1949 and lived at Trewyn permanently after her divorce from Nicholson in 1951.

Naum Gabo moved to Faerystones in Carbis Bay with his wife in 1939 to be near the Stokes and Nicholsons. He first visited England in 1935 and settled in London after his marriage to Miriam Israels, a painter. St Thomas's Hospital in London commissioned him to design a fountain. In Cornwall he was concerned with making linear constructions in space, with lightness and movement in his three-dimensional forms.

Gabo was born in Russia. His brother was Antoine Pevsner, sculptor and painter. He changed his name in 1915 when he began making constructions. He lived in Paris, Copenhagen and Oslo. From 1917-22 he was in Moscow with his brother, Kandinsky and other artists. He designed sets and costumes for Diaghilev.

Gabo lived in Berlin for 10 years where he came into contact with the De Stijl group, Klee, and various artists at the Bauhaus. He produced transparent sculptures in perspex at the same time as Laszlo Moholy-Nagy, who taught by experimentation at the Bauhaus.

Peter Lanyon, the only Cornishman of the young moderns, was introduced to the circle and admired Nicholson's white reliefs and couldn't believe there was

Construction for Painting, St Just, *Peter Lanyon. S. Lanyon.*

White, Black and Blue, *1950, Marlow Moss.*

Nicholson. His concern was not to make pure shape or colour on a surface but to charge every work with information from the world in which he lived. He described his paintings as a journey from St Ives to St Just. Lanyon often made constructions as a prelude to his paintings. He regarded them as experiments in space to help define content and space.

Lanyon visited Gabo and saw a perspex construction. This was in line with his own ideas and he found Gabo's work exciting. 'He was trying to define space, and space after all has no quality ... it isn't solid, and I felt the means he used were absolutely ideal for this, he was creating forms in space itself, and he was using space like sculptors use stone. I don't think I had ever seen an object which was so obviously right in every way, and full of poetry.'[2] Gabo had an influence on all those he came into contact with in those vital few years when he was in Cornwall. It was said that the spiralling spaces of Gabo were caught from watching the Atlantic rollers curve and fall on Porthmeor beach.

Oskar Kokoschka was travelling in England between 1937-48 and in 1939 spent 9 months painting at Polperro. The Surrealist, Max Ernst, visited Roland Penrose in Cornwall. Adrian Heath attended the Stanhope Forbes School of Painting in Newlyn for 6 months.

Stanley Spencer, whose work often depicted present day biblical scenes in Cookham where he lived, exhibited in the 1939 and 1940 exhibitions of the St Ives Society of Artists. He had first stayed for 6 weeks in the town in 1937 on his marriage to Patricia Preece his second wife, who was accompanied by her friend Dorothy Hepworth. He lived in the middle of the three cottages on the harbour beach, the two women elsewhere. One local woman recalls Stanley Spencer coming into her sister's shop. "He bought his wife a dress and then asked if the shop had an attic. I took him up to see the view but he didn't use it. I

watched him painting the view of the harbour from the Malakoff. He painted it from the top of the steps."

In 1940 Wilhelmina Barns-Graham arrived, having spent a year travelling in France, Italy, Switzerland and Spain on a post graduate scholarship. She stayed with Margaret Mellis with whom she had studied at Edinburgh College of Art. She immediately liked Cornwall and Borlase Smart found her a studio at No 3 Porthmeor. This was normally occupied by Commander Bradshaw, a painter of sea and ships, who was away serving in the Navy. She later occupied a purpose-built studio complex at Barnaloft.

Barns-Graham was one of a few women painting in an exploratory manner, feeling her way more and more towards abstraction. She married the writer, David Lewis, in 1949. They divorced in 1963. She gained a travelling award from the Italian Government and worked in Tuscany, Calabria and Sicily in 1955, afterwards returning to teach for a year at Leeds School of Art. She shares her painting time between her native Scotland and St Ives.

During the war, Shearer Armstrong, artist and wife of an army major, was officer in charge of air raid wardens in Carbis Bay. Nicholson and Gabo served under her direction. Bernard Leach, Stokes, Fuller, Mitchell and Smart joined the Home Guard. In 1941 Edward Bouverie-Hoyton, principal of Penzance School of Art, set up a pottery department and Leach was the first potter to teach there. Graham Sutherland, staying with Bouverie-Hoyton and his wife Inez, visited Geevor tin mine at Pendeen to make sketches of miners at work for the War Artists Advisory Committee. He worked small scale and on the spot to capture the immediacy of the moment in swift line and textured drawings.

Peter Lanyon joined the Air Force as a flight mechanic and while he was away Gabo made use of his studio at the Red House. At first Gabo was worried because he found it difficult to work and was distressed because as a foreigner he could not venture anywhere without asking permission, or informing the authorities. He felt the answer to his problems was to leave for America. The anxieties of the war which constricted his ability to work were released with a turning point in the course of the war in 1942.

An exhibition at the London Museum in 1942, New Movements in Art, included the work of Wells, Nicholson, Lanyon, Gabo, Mellis and Mondrian. Gabo expressed surprise at the warm reaction to his piece 'Spiral Theme' which he had made in St Ives. The public had seemed unsympathetic to work on the same theme that he had exhibited previously.

In 1941 Marlow Sewell Moss came to live in Penzance. She had first visited Cornwall in 1919. In 1927 she visited Paris where she met Mondrian, and her work was very influenced by his geometric style and the predominance of primary colours. She also studied under Leger and Ozenfant and painted non-figurative compositions and constructed relief panels. She was a founder member of Abstraction-Creation in Paris, which sought to bring

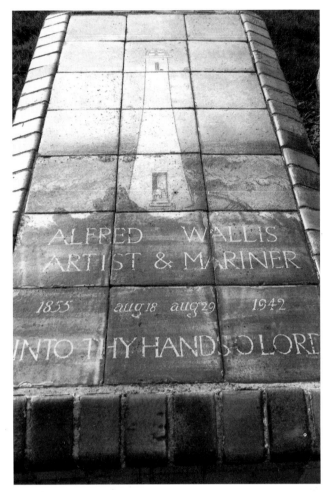

Leach tiles on gravestone of Alfred Wallis.

together the variants of modern art. Nicholson and Hepworth joined while they were in Paris in 1933. The entire output of her work up to 1940 was destroyed during the war. She studied architecture, which led to constructive sculpture. In the later years of her life she had two solo shows at the Hanover Gallery in London 1953 and 58. She remained in Cornwall until her death in 1958. An exhibition of her work was shown at Hanover Galerie, Zurich in 1973.

1942 Death of Alfred Wallis

In 1942 Alfred Wallis died in Madron workhouse. He had been taken there just over a year previously when neighbours reported that he could not look after himself. He was ill and neglected, largely through his distrust of relatives and neighbours from whom he refused help. Stokes and Nicholson visited Wallis in the home and took him small comforts and painting materials. After the discovery of Wallis by Ben Nicholson and Christopher Wood in 1928, Nicholson became a collector of his work and introduced other artists and people of influence to his quality of innocence and unthinking vitality in the naïve paintings which he so admired. Although Jim Ede of the Tate Gallery never met Wallis he also bought work, which was parcelled up by Wallis in brown paper and

string and posted to him. The painter Alethea Garstin was helpful to Wallis in assisting with wrapping and posting parcels of paintings. In 1966 Ede presented his house, known as Kettle's Yard, along with his collection of art treasures to the University of Cambridge, among these were 100 works by Wallis. In 1940 Nicholson took Margaret Gardiner on a visit to Wallis's cottage and, as well as a gift of a painting, Wallis advised her to pay more attention to the Bible.

At the funeral of Wallis in Barnoon cemetery Adrian Stokes stopped proceedings when he realised that Wallis was being buried in a pauper's grave. This was one of the main fears of the old man in his lifetime and he had saved £20 towards a grave. A few days later a new grave was dug and Wallis buried in ground reserved for folk who could pay for a plot. Among those attending the funeral were Stokes, Mellis, Nicholson, the Gabos, Leach and the writer Manning-Sanders. The wording on a floral tribute from Miriam and Naum Gabo bore the words 'In homage to the artist on whom nature has bestowed the rarest of gifts, not to know that he is one.' The words from Hepworth and Nicholson read 'To a great artist.' Mellis and Stokes wrote 'A tribute to an extraordinary artist' and from Berlin 'To a great painter from Helga and Sven.'

Stokes was also able to persuade the authorities not to burn Wallis' paintings, which were lying around amid the debris of the cottage. When Stokes arrived home to Little Parc Owles with his rescued paintings he left them in the garage, took off all his clothes and ran naked for the bathroom. It apparently took some time before the Stokes finally rid themselves of all the fleas which accompanied the pictures.

Later Bernard Leach made a ceramic tiled plaque for the grave. A figure is entering a lighthouse and it reads 'Alfred Wallis Artist and Mariner.' The following year articles about Wallis were published simultaneously in *Horizon* by Sven Berlin and Ben Nicholson.

Wallis went to sea as a cabin boy at the age of 9. He joined the fishing boats at Penzance where he met and married Susan Ward. Susan was 21 years older than Alfred and already had 17 children but only five survived.

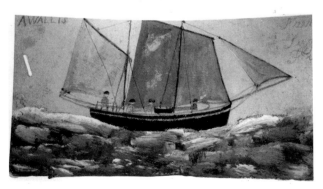

Boat, *Alfred Wallis. H C Gilbert.*

Alice Moore, 1986.

They had two children of their own but both died in infancy. In 1890 they moved to St Ives and Wallis carried on a business as a scrap merchant on the harbour living at 4 Bethesda Hill at this time.

When the couple retired they occupied the cottage at 3 Back Road West. Soon after the death of his wife in 1922 Wallis took up painting because he was lonely and to pass the time. He produced paintings on odd scraps of paper and torn card, remembering and painting scenes of his experiences of boats, the sea, harbour and Godrevy lighthouse, which he brought from its three miles distance, to stand beside the two lighthouses on the quay at St Ives. But for the fortunate discovery by Nicholson and Wood he would have died in obscurity along with other naïve and untutored painters in Cornwall.

Moffat Lindner's 90th Birthday
The St Ives Society's President, Moffat Lindner, celebrated his 90th birthday at the Porthmeor Gallery, when the Spring Exhibition was opened by Miss Margaret Kennedy, author and playwright.

In thanking Miss Kennedy, Borlase Smart asked her to present to the Mayor two watercolour paintings to be hung in the Guildhall. The pictures, painted by Moffat Lindner, had been purchased by the Society and presented to the town to mark the occasion of their President's birthday and long service to the Society. Lindner expressed himself deeply touched and said, 'I am happy to hear that my pictures will have a permanent home in the Guildhall of the town where I have spent so many happy years.' These paintings are not on show but are believed stored at the Town Museum. Lindner remained President until he resigned in 1946 at the age of 94. He died at the age of 97 at his home Chy-an-Porth.

Nearing the end of the war, history repeated itself. The Mayor of St Ives stressed the need for a museum and art gallery to house paintings owned by St Ives Council and

to act as a fitting war memorial. It was just after the First World War that this suggestion was first put to the town. The advice was not acted upon in either case.

At this time Treloyhan Manor, the home of the Hain family, was up for sale and Borlase Smart urged the Council to call a public meeting to persuade the people of the town that the building and extensive grounds be bought by public subscription, thus providing a park, museum and art gallery. This proposal was lost by 14 votes to 9. Smart himself then decided to call a public meeting on the matter but was prevented from doing so because the site was under offer.

The building was in a state of dilapidation after the occupation by the Downs School evacuated there for the war years. Marion and George Pearce, both ex-Mayors of St Ives, Marion's father, Jacobs and J M Nicholls bought the Manor between them to prevent it falling into the hands of developers. They spent considerable sums of money refurbishing the building and sold it to the buyer they thought would preserve its character, which was the Methodist movement who use it for their seminars and holiday accommodation.

The only wartime threat to the town was the dropping of two bombs, one on the gasworks and the other on the Leach Pottery. Jimmy Read of Trevone in the Bellyars had a distinct memory of the Leach bomb. "We were at the Arts Club having a show as usual. The building swayed. I was a member of the Local Defence Force and I thought it was my duty to get my arms and go on parade. Bullets sprayed all over the roof as I got to the front door. A bomb had dropped on the Leach Pottery and hit the house next to the pottery. Part of the house was shattered."

Alice Moore joined the Arts Club during the war. She moved with her parents from Penzance to Carbis Bay and finally lived in a double fronted cottage at Tyringham Row, Lelant. She was born in Honolulu in 1909 and studied at the Royal College of Needlework, South Kensington. Her work was of very fine stitching, often with silver and gold threads. Examples are in the public library and St Ia Church.

In 1942 Wilhelmina Barns-Graham joined the Arts Club. She acted in plays with the wife of artist William A Gunn. "It was more of an Arts Club in those days. Saturday we had a short play and then everyone danced. Proper ballroom dancing. We used to go in evening dress. People dressed up even during the war. It had a lovely cosmopolitan atmosphere."

Sven Berlin was a member of the Arts Club in the forties. On one occasion he signed himself in as the visitor of Alfred Wallis, and on another as himself signing in Wallis as the visitor. At this time he was writing a biography of Alfred Wallis and was very involved with the man and his work and possibly felt interchangeable with the character of Wallis.

Also in the early forties Adrian Stokes and Margaret Mellis came as guests of Elizabeth Leach. Patrick Heron, whose father Tom Heron was a member in the twenties, visited as

the guest of Muriel Leach, when he was working at the Leach pottery. Ben Nicholson made several visits, the first in 1947 with the painter Dorcie Sykes from Newlyn.

After five or 6 years of residence the young moderns had not yet begun to make their mark in the town. Lanham's were still mounting exhibitions and in the Autumn show of 1944 the traditional names were still in the majority, W Todd Brown, Medora Heather Bent, Dorothea Sharp, John Park, Pauline Hewitt, Bernard Ninnes, Leonard Richmond, Dorothy A Lawrenson, Constance Bradshaw, Fred Bottomley, R C Weatherby, L E Walsh, Joza Belohorsky, Edith Boyle Mitchell, Marcella Smith, Harry Rountree, Emily E Rice, W A Gunn, W Barns-Graham, Agnes E Drey, Frances Ewan, H F Waring, Misome Peile, Hilda K Jillard and Dorothy Bayley.

The poet, W Sydney Graham, with his wife Nessie, arrived in Cornwall in 1944. They lived in several areas, Mevagissey, Marazion, Gurnard's Head and finally at Madron. Graham is well remembered for poems he wrote as memorials for several of his artist friends, for Peter Lanyon *The Thermal Stair, Lines on Roger Hilton's Watch, Dear Bryan Wynter* and *The Voyages of Alfred Wallis.* These are all included in the Tate Gallery catalogue St Ives 1939-64. He also wrote poems for Tony O'Malley, *Tony as the Owl* and another, *Master Cat and Master Me.* Graham was well integrated in the community, acted as an extra coastguard in bad weather and had worked on the fishing boats at Mevagissey. He wrote a poem based on these experiences, *The Night Fishing,* which he read to an audience at the Penwith Gallery in 1957.

1945

Peter Lanyon returned from military service and in 1946 he married Sheila St John Browne. They had 6 children. Sven Berlin was invalided out of the army and returned to St Ives. He was a conscientious objector at the outbreak of the war and worked in Adrian Stokes' market garden before eventually joining the forces. Guido Morris arrived from London to set up his printing press near Sven's Tower. Heron left for London having served his final year as a conscientious objector working at the Leach Pottery.

Those successful at the Royal Academy this year were Charles Pears, Dod Procter, J Riddle, Dorothea Sharp, Charles Simpson, Borlase Smart, Marcella Smith, A J Munnings, Lamorna Birch, Midge Bruford, A J W Burgess, Miss P E T Fisher, E Charlesworth, B Fleetwood-Walker, Stanhope Forbes, Leonard Fuller, S H Gardiner, Alethea Garstin, Gertrude Harvey, Mrs E L Kerr, Faust Lang, Laura Knight, Harold Knight, T J Maidment, Margery Mostyn, John Park, Miss Mary Watt, R C Weatherby and Miss Denise Williams.

The modern painters did not aspire to become Royal Academicians. The reliance on paintings being accepted in the RA in the promotion of an artist's work and name, gave way to the emergence of the commercial galleries, who fostered individual painters.

In November of 1945 Ben Nicholson showed paintings

Tony O'Malley with Nessie Graham, 1986.

and reliefs at the Lefevre Gallery, New Bond Street, London. More than half the works were sold but an extract from *The Spectator* on the show reported, 'A good Ben Nicholson is unto itself a true and perfect creation. No one else can do it. It is of great value as a discipline for other painters; it is an expression of impeccable taste, exquisite balance, subtle design and elegant conception. The only reason it is not great art is because it lacks humanity.'[3] The art critic, Paul Hodin, on the other hand recognised in Nicholson's relief compositions a new humanism, serene harmony, and a new spiritual order.

The Mariners Church

St Ives Society of Artists moved from Porthmeor Gallery to the deconsecrated Mariners Church in Norway Square. The building was designed for the use of fishermen and built in 1902, but native people were Methodists and did not appreciate over large and imposing buildings. All their own simple chapels fitted in correctly with the environment, so the church fell into disuse after only 20 years. The move was largely brought about by the efforts of Borlase Smart when he was secretary of the Society and a loan of £2800 for the purchase of the freehold was negotiated with the church authorities. The final instalment was paid in 1968.

Five years after the opening of the new gallery a commemorative exhibition was held of the paintings of Stanhope Forbes, the recognised leader of the early Newlyn School of painters, who died in 1947.

Smart was anxious for Nicholson and Hepworth to exhibit with the St Ives Society of Artists and through an introduction by Barns-Graham, who described Smart to Nicholson as an 'enthusiast' this was arranged. Smart persuaded the moderns to exhibit in the show and Hepworth's sculpture, Nicholson's abstracts and other artists working in a new mode were shown together at the altar end of the building. Those artists given space 'around the font' were Miriam Gabo, Margaret Mellis, John Wells, Sven Berlin, Barns-Graham and Peter Lanyon. Smart allowed Nicholson and Hepworth to exhibit paintings in his Porthmeor studio on Show Day.

Peter Lanyon in a letter of August 1945 to the *St Ives Times* states, 'A new exhibition of the St Ives Society of Artists has undoubtedly aroused great interest both because of the gallery and the unorthodox willingness of the members to mix so many points of view. I feel that the artists of St Ives

Penbeagle Farm, St Ives, *Denis Mitchell.*

are making an attempt to revive themselves and become a more positive part of the community.'[4]

The Castle Inn

Another exhibiting venue for the work of the moderns was held in the Castle Inn run by Denis Mitchell's brother, Endell, and included work by Barns-Graham, Berlin, Drey, Frost, Haughton, Lanyon, Mitchell and Wells. A Dutch painter, Eddy Kalma, held his first one-man show at the Castle in 1954. The centrepiece of his exhibition was a 4ft. wide canvas which he called 'Cornish Mood', a composite of Cornish harbours. He studied art at the Amsterdam Academy and came to St Ives to paint because the town suited his temperament. Also lined up for exhibitions at the Castle were Peile, Barclay, Segal, Worsdell, and Olive Dexter, daughter of Leonard Richmond.

Denis Mitchell spent most of his childhood years at Swansea. He had always longed to be an artist and at the age of 17 worked in a commercial art studio. In the thirties he and his brother Endell moved to Halsetown, at the request of an aunt, to convert two old cottages into one. They also turned one and a half acres of garden into a field of marketable produce and kept chickens.

Mitchell met Jane Stevens in St Ives and they were married at Towednack Church in 1939. During the war he worked as a miner at Pendeen which helped him 'in handling tools and in manipulating loads.' He spent two years as a fisherman from 1946-48. In between all these jobs Denis found time to paint.

Through his friendship with Bernard Leach he was introduced to Barbara Hepworth and worked for her for the next 10 years, becoming her chief assistant. In 1959 Mitchell decided to strike out on his own as a sculptor. In 1969 he was offered his first solo show with Margery Parr at King's Road, Chelsea, with an introduction in the catalogue by Patrick Heron. Denis also produced slate reliefs and carvings in wood.

The painter, John Wells, offered Mitchell a fine studio space next to his own and in 1969 Jane and Denis bought a house, La Pietra, in Newlyn. His chief assistant is Tommy Rowe, Cornishman, sculptor and part-time fisherman. Their working relationship spans many years.

Although Denis Mitchell lives in Newlyn he is chiefly associated with St Ives.

Although living in Newlyn, John Wells' work and friendships have always been St Ives inspired. In 1928 he visited his cousin in Feock and at the home of Rene and Marcus Brumwell met Ben and Winifred Nicholson. He retained these friendships and thereafter made frequent trips to Cornwall. Before turning to painting he lived in Sussex and studied to be a doctor, qualifying from University College Hospital in 1930. He worked in a hospital for 6 years and from 1936 to his retirement in 1945 as a general practitioner in St Mary's, Isles of Scilly. During his medical studies he was attending evening classes at St Martin's School of Art.

In 1945 he bought Anchor Studio from Mrs Forbes, once the centre of the Stanhope Forbes School of Painting at Newlyn, where some 17 years previously he had spent a month as a pupil of Forbes. Some time later he bought an old board school. His already established friendships with Nicholson, Hepworth and Gabo helped in making his final commitment to painting. He never forgot his experiences of travelling between islands on the Isles of Scilly and many of his earlier constructions and paintings reflect the tenuous relationships between these parcels of land.

Another arrival in 1945 was Bryan Wynter who, during the war, worked on the land in Oxford as a conscientious objector. In 1947 he began showing with the Redfern Gallery over a period of ten years. He had visited West Penwith on many occasions and eventually moved to the Carn, Zennor, an isolated cottage on the moors above the village and married Susan Lethbridge. He painted his first abstract works in 1956 when he felt a certain freedom and optimism after giving up teaching. This new series of paintings was on a larger scale and gained him a place alongside other of his contemporaries working in abstraction. He married Monica Harman in 1959 and this same year exhibited at Waddington Galleries. Patrick Heron wrote of the remarkable depth achieved in

Cornish Farm, *1952, Bryan Wynter.*

Wynter's non-figurative paintings, which he described as a series of beaded curtains, 'all evocative of an almost unmeasurable depth of recessive space, into and behind the surface of the canvas'.

From 1960 as well as painting he made three dimensional and kinetic works. In 1965 his kinetic sculptures IMOOS 'Images Moving Out Onto Space' were exhibited at Waddington galleries and sold. All 6 of the works were brought together at Tate Gallery St Ives in 1994 creating great public interest in these moving sculptures of colour and light reflecting images.

But Wynter considered himself primarily as a painter. His paintings were a response to the landscape and its physical properties, the movement of water, the growth of plants and hedges, stones and walls, are all contained in his paintings without direct reference to the landscape. In 1964 he moved to St Buryan. He died a year before a retrospective exhibition at the Hayward Gallery, for which Alan Bowness wrote the introduction to the catalogue.

Arthur Caddick's book of verse *Broadsides from Bohemia* was dedicated to the painter Bryan Wynter and reads, 'To my dear friend Bryan Wynter, and to the memories of creative carousels we shared with such splendid others in St Ives long, long ago.'

1946

At the beginning of 1946 St Ives Society of Artists had a touring exhibition of 90 paintings which had visited Sunderland, Gateshead, Carlisle, Darlington and Swindon. It was reported that 15,000 people had visited the Sunderland Gallery during the 27 days of the show. Borlase Smart had stayed in the town for a week acting as a guide lecturer which included an illustrated talk '100 Years of Cornish Painting'. Four pictures (unnamed) were purchased for Swindon's future art gallery.

Increasing numbers of artists visited or came to live in Cornwall in the next few years. Charles Breaker, George Lambourn, Marjorie Mort and Albert Reuss came to live

Tucking Mill Chapel, *Tom Early.*

in Mousehole. Patrick Heron and William Scott stayed near by. Peter Potworowski rented a cottage at Sancreed and held his first exhibition at the Redfern Gallery.

Tom Early, born in South China in 1914, had Cornish connections on his mother's side going back many years. He lived at Falmouth, Newquay and Redruth as well as St Ives. He studied medicine and practised during the war but illness forced him to give up in 1946, after which he took up painting, with the encouragement of Ben Nicholson. His work is greatly influenced by the Cornish countryside and particularly by the deserted mines and industries, rather than by the coast.

Robin and Dicon Nance re-established their furniture workshop on the Quay. Adrian Ryan moved from Padstow to Mousehole, returned to London, and came back to Mousehole where he lived from 1959-65. Barns-Graham met David Haughton and the Scottish painters Robert Colquhoun and Robert MacBryde in Cornwall and the Scottish poet George Barker.

Barbara Tribe, Australian sculptor, with her potter husband, converted an old chapel to home and studio at Sheffield, a village near Penzance. John Armstrong gravitated to Lamorna, as did Ithell Colquhoun for a short period. Alex Mackenzie moved to Newlyn and the poet Arthur Caddick to Nancledra.

The Crypt Group

In 1946 there was increasing tension in the St Ives Society of Artists between the traditional and modern painters and the latter were offered space below the church. They became known as The Crypt Group. Before any exhibitions could take place they had to paint the walls and get it into a fit state for hanging work. The first exhibition was opened by Borlase Smart, ever the go-between and peace maker. The founder members of the Crypt Group were Peter Lanyon, Sven Berlin, John Wells and Bryan Wynter. Guido Morris printed the catalogues.

Red and Black Streams, *1973, Bryan Wynter. M. Wynter.*

Terry Frost in his studio, 1984.

The venue below the Mariners Church proved satisfactory for three years. Other exhibitors in the Crypt included Barns-Graham, David Haughton, Patrick Heron, Kit Barker, Adrian Ryan and Guido Morris.

At the autumn Crypt Group exhibition Borlase Smart replied to criticism he had received for encouraging 'these alleged modern ideas.' He said he admired all forms of art, and referred to the fact that the work of many old masters had not been appreciated until long after they had died. 'In this exhibition young artists have on view works of exceptional merit. They have just returned from the services and brought back new ideas which they are endeavouring to carry out in artistic works.'[5] The painters referred to were Lanyon, Berlin, Wells and Wynter.

Hilda K Jillard, whom David Cox described as a bold painter, 'almost an experimentalist' exhibited in 1948. One of the last exhibitions to be held in the Crypt was reviewed by an unnamed writer in the *St Ives Times*. 'For some time a group of young painters of differing outlook and training but holding a common sympathy towards the modern movement in their painting has been seeking fresh inspiration from Cornwall.' Some of the works drew comment, 'Kit Barker looked too much at Braque.' 'W Barns-Graham paints without compromise or fuss.' 'Patrick Heron is so incoherently dazzling that his undigested similitudes, in spite of catalogue titles, are neither here nor there.' Of Bryan Wynter it was said, 'A pity that Picasso hovers too near his oil paintings.' David Haughton was described as 'a fine draughtsman with Cubist bias,' while Sven Berlin's sculpture 'echoes archaic thought' and John Wells shows 'a contrast in poise.'[6]

A memorial exhibition of the work of the New Zealand painter, Frances Hodgkins, was held at the Crypt Gallery. This was brought about with the help of the Arts Council. She came to Europe in 1900 and spent some years in St Ives. She had exhibited with the London Group and the Seven and Five Society. She died at Corfe Castle in 1947.

Miss June Opie, a New Zealander whose family came from St Agnes, North Cornwall, gave a lecture illustrated by slides on Frances Hodgkins in 1969, for which she won a Royal Society of Arts medal. Miss Opie also made a documentary for radio with conversations about the painter with artists Henry Moore, Barbara Hepworth, Ben Nicholson, John Piper, Graham Sutherland and others.

This year saw the departure of Margaret Mellis and Adrian Stokes from Cornwall. Naum Gabo failed to arrange any exhibitions of his work in London or the North and his hopes for the world being renewed by visions of constructive art were never realised in England. He left for America. In 1947 he wrote to John Wells that life was hectic and that he had been lecturing and hoped to settle in Connecticut, where he had found a house and studio and could work towards his exhibition at the Museum of Modern Art in January 1948. He urged Wells to produce as many works as he was able and said that he expected much from him and Peter Lanyon.

In 1946 Terry Frost moved to St Ives and studied at the School of Painting under Leonard Fuller. He had spent the previous year at evening classes at Birmingham Art College. From 1947-49 he was in London at the Camberwell School of Art and returned to St Ives in 1950 where he worked as assistant to Barbara Hepworth for two years and acquired No 4 Porthmeor Studios. In 1952 for a period of two years he began teaching drawing at Bath Academy of Art.

Frost's subject matter is related to sensations evoked by movement of boats, water in the harbour, lines and rigging, colour and shape and translating these experiences into bold statements in paint. He advises that looking for something to inspire you is an escape from taking action. The only way of seeing is to work. 'The beauty of abstract art is that if it feels right in my head and eye and big toe, then I know I have got something. You get the feel of the landscape through your feet. You have to be intimate with it. The thing is to discover something while you are actually wandering around. I used to walk along Porthmeor Beach before starting work in the morning, and for 25 years I walked along the quay in St Ives.'

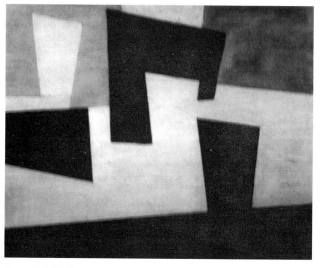

Grey with Yellow, *Adrian Heath. Belgrave Gallery.*

Adrian Heath had served with the RAF and was a prisoner of war in Germany where he met Terry Frost. He visited Frost at 12 Quay Street, St Ives after the war and met Nicholson and other painters during a few months stay. Back in London he held a series of exhibitions in his studio in Fitzroy Street for abstract artists and helped organise the first post-war Abstract Art exhibition at the AIA Gallery. He held his first one-man exhibition at the Redfern Gallery and in the same year published *Abstract Art: Its Origin and Meaning*.

His earlier works of portraits and landscapes derived from his academic training at the Slade but his study of Cubism allowed a release from tradition. He changed his methods of work through the years, becoming painterly and in a later period he made a great many studies before committing the final work to canvas. "I strive for something both monumental and mysterious."

William Scott associated with artists in Cornwall, and visited St Ives on many occasions. He married a fellow student of the Academy Schools, Mary Lucas, in 1937 and from that year until 1939 he organised summer painting schools at Pont-Aven. He spent the summer of 1946 in Cornwall, painting mainly in Mousehole and this same year was appointed Senior Painting Master at Bath Academy of Art, Corsham.

The simplified shapes and forms of cups, bowls and saucepans became his distinctive style. He visited New York in 1953 to meet a dealer who was interested in his work and met Jackson Pollock, de Kooning, Rothko and Frans Kline and admired their work. In 1954 he exhibited at the Martha Jackson Gallery, New York and continued showing there until the seventies. He finished teaching at Corsham in 1956 to concentrate on painting. Awarded first prize at the second John Moore's Liverpool Exhibition 1959. He held several one-man exhibitions in Europe and the States.

William Todd-Brown also arrived in 1946 but he was at the end of his career. He was a landscape and decorative painter. He had studied for five years at the Slade under Professors Steer and Tonks, where he gained a scholarship and prizes for head and figure painting. He assisted Professor Gerald Moira in mural decoration work in many important buildings such as Lloyds and the Central Criminal Courts. He was in charge of women artists who decorated the first Wembley Exhibition restaurants. From 1922 onwards for 18 years he was Principal of the Reigate and Redhill School of Arts and Crafts.

Historic Events

Perhaps the most historic event, and one cannot imagine it ever being excelled, was the exhibition arranged by Borlase Smart, with the support of the Arts Council. The paintings were shown in No 5 Porthmeor Studios. Works exhibited were from Thomas Gainsborough, Sir Anthony Van Dyck, J M W Turner, Sir John Everett Millais, Sir Henry Raeburn, Richard Wilson, Sir Joshua Reynolds, Walter Richard Sickert, Wilson Steer, Sir Peter Lely,

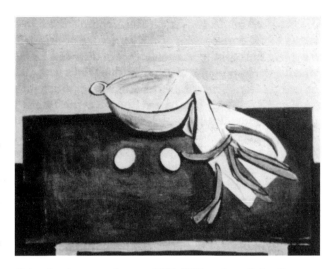

Colander, beans and eggs, *1948, William Scott. Robert Scott.*

George Stubbs, John Sell Cotman and many other famous painters, not named. The exhibition lasted three weeks.

A momentous event for 1946 that celebrated a return to peaceful conditions was an exhibition at the Tate of the painter Georges Braque. His pictures recorded his work during the years of the war and brought into being 'a new development in an immensely powerful art.' Heron writes of Braque's objects in a painting, 'Each unit, is both itself and an infinite number of variations on itself.' These variations of objects in space and from different viewpoints was also explored by Heron. He wrote 'In this great master of modern painting we find the most powerful fusion so far made of the abstract and the representational — two aspects of art which, isolated, either from the other, can only impoverish the painting of our time.'[7]

1947

Patrick Heron rented a cottage known as Balcony Studio, overlooking the harbour, once occupied at separate times by Pauline Hewitt and Dorothea Sharp. Here he produced a series of pictures influenced by Braque and the objects immediately in the room and seen through the window to the harbour.

'I may swivel my head momentarily away from the open window, with its prospect of the Bay, and for two seconds may absorb visual realities of a very different order: the reddish outline of a near chair cutting up and across the white of a piece of the wall... and this momentarily perceived and registered, becomes an integral part of my apprehension of the reality that surrounds me at this particular moment.' He noted that his sudden consciousness of the interior of the room intruding upon his contemplation of the Bay would be registered upon the canvas.

Heron visited Braque in his studio two years later and was aware of the jug, a familiar object of his paintings, as also were guitars, plants and chairs, tables and everyday inanimate things, which Braque imbued with life. Heron's own work was to be influenced for a number of years by his admiration for Braque.

Patrick Heron, 1986.

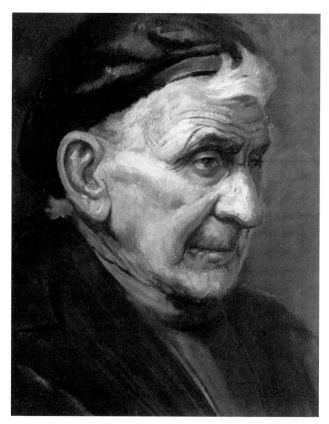

Jimmy Limpotts, *Hyman Segal.*

In St Ives Harry Greville Irwin, who had Down-under-Studio at Porthmeor Road, committed suicide. He was born in 1893 and studied at Juliens, Paris in 1924 and the Academie des Beaux Arts, Brussels in 1926. He was a landscape and figure painter. Mrs Keeley, who managed St Christopher's restaurant next door, had taken him breakfast. Later, not seeing him around, she entered his bedroom and found he had shot himself.

Mary Williams remembered the cafe. "We used to go to St Christopher's on Porthmeor Beach for breakfast. All the artists were there. The Keeleys ran it. They collected paintings from those who couldn't pay. Sven Berlin, Bryan Wynter, Guido Morris, Wilhelmina Barns-Graham — all went there. In the evening we would go down to the harbour in evening dress. The Breton fishermen would walk along the quay in their coloured smocks and clogs. They occasionally had a fight with the local fishermen. There were masses of boats in the harbour. There was a magic in St Ives then."

Hyman Segal arrived in St Ives with a kit-bag of drawings from his army duty in Africa working in the Intelligence Service. He was soon set up in the Crypt with 100 drawings on view. Segal said "Borlase Smart came in, had a quick look and went out again. I thought, well that's it, but he returned with the press and a photographer. Very few people in St Ives had seen coloured faces in those days so they created quite a sensation." Through Borlase Smart Segal obtained John Park's studio, number 10 Porthmeor, where he has been ever since.

Segal gave up a successful career to move to Cornwall, going first to St Agnes and Porthtowan before St Ives. His Russian Jewish parents fled the pogroms in Russia and came to England. At 12 he won a scholarship to St

Martin's School of Art where he showed a talent for design. He won a further scholarship and several design competitions. He opened Segal's Studio in London and worked as a freelance commercial artist. He was commissioned by Vogue, Shell Mex, Courtaulds, Rolls Royce and Decca, among others.

In Cornwall he became an art therapist at Trehidy Sanatorium and was supported by M Peile, S Armstrong and P Lanyon. This eventually became his sole responsibility, a post which he held for 20 years. His other great interest was the RSPCA, of which he was a

Black Cliff, Hayle Towans, *Misome Peile.*

member for 30 years and chairman for 18, so he was well on hand to direct activities when the ship, the *Torrey Canyon*, spilt her cargo of oil in St Ives Bay.

Cornish artist, Marion Grace Hocken, was born in Zennor. She studied at Redruth School of Art and Brighton School of Art and had exhibited in South Africa, the Royal Academy, Paris Salon and provincial galleries. She was a botanist and fellow of the Zoological Society. Her painting 'The Hollow Men' created a storm of protest in St Ives in 1957. It was a symbolist painting depicting the decline into materialism of St Ives and its inhabitants and a laxity of values. At about this time she decided to live in seclusion in Carbis Bay.

Misome Peile held her first solo exhibition at Ocean Wave Studio, which was the culmination of 7 years of study and experiment. The paintings were landscapes and portraits, many of which were of the American commandos when they were stationed in St Ives. She also worked on programmes and theatre design.

Peile came to Cornwall as a traditional painter and gradually changed over to abstraction. At one time she

Zennor, *David Haughton.*

gave up drawing for three years to concentrate on the painted surface. She also wrote reviews of exhibitions. In 1952 she became chairman of Penwith Society and was an Associate of the Society of Women Artists. She moved to Malta in 1969 where she spent the rest of her life. In 1973 she shared an exhibition with Denis Mitchell at the National Museum in Valletta and in 1985 a small show of her work at Newlyn Gallery paid tribute to her life-time of painting and her love of Cornwall.

In 1947 David Haughton moved to the village of Nancledra, near St Ives. He was briefly a member of St Ives Society of Artists but resigned to join the newly established Penwith Society in 1949. He left Cornwall in 1951 to teach at the Central School of Arts but returned to St Just each year, bringing with him a party of students to work in the area that inspired his own work.

Haughton wrote that a turning point in his painting career occurred when he discovered St Just. He was fascinated by the strings of miners' cottages and derelict mine buildings, and they became the subject of his work at this period. One of his pupils, Noel Betowski, was so influenced both by Haughton's subject matter and West Penwith that he eventually left London to live as a painter in Cornwall. The Newlyn Gallery held an exhibition of Haughton's work in 1979. In 1980 he lost many of his paintings in a fire.

The painter David Bomberg was camping with his family in Trendrine, near the village of Zennor in 1947 and some of the landscape paintings done at that time were considered to be among his finest. He was brought up in London's East End but managed to attend evening classes at the Central School of Art and with Walter Sickert at Westminster School. He won several awards at the Slade, although he was later rejected by the Slade as a tutor. His fellow students were Christopher Nevinson and Stanley Spencer. He also studied history of art in Roger Fry's classes.

He was a founder member of the London Group in 1913 and that same year travelled to Paris with Jacob Epstein. He said drawing provided the basis for his compositions. He held his first solo show at the Chenil Gallery, London in 1914 and showed with the Vorticists

The Hollow Men, *Marion Grace Hocken.*

Trendrine, *1947, David Bomberg.*

in 1915. He lectured in Brasenose College, Oxford in 1921 and travelled to Switzerland to see Ben Nicholson 1922.

Between 1934-53 Bomberg taught part-time at a Polytechnic in London, where two of his students were Frank Auerbach and Leon Kossoff. He opposed an academic approach to art, encouraging his students to become involved in the subject. His students continued to be his disciples for a time and exhibited with Bomberg in London. In 1988 the Tate Gallery showed 200 paintings and drawings of his work.

Charles Breaker moved to Newlyn where he bought Gernick Field House and Studio with Newlyn harbour spread out below. He, Eric Hiller and Marjorie Mort ran the Newlyn Holiday Sketching Group for 15 years. The Newlyn Gallery held an exhibition of the paintings of Marjorie Mort to mark her 80th birthday — 'Fifty Years of Painting 1935-1985'.

George Downing Bookshop and Gallery

George Downing, a Cornishman, opened a bookshop at 28 Fore Street and allowed an area to be used for gallery space for the largely controversial painters. Posters were designed and printed by Guido Morris. A variety of work was shown including Lanyon, Heron, Mitchell, Hepworth, Nicholson, Peile, Wells, Wynter, Morris, Barns-Graham, Frost, Garlick Barnes, Kit Barker, Marion Grace Hocken and the embroidery of Alice Moore.

An exhibition by Patrick Heron drew forth a receptive, or sympathetic understanding of the new work. 'One gets a shock at what appears to be great splashes of colour without form or design but after sitting watching them quietly and reflectively one begins to feel their qualities of gaiety, freedom and courage, and to understand the sensitive nature of his work.'[8]

Also showing at Downing's was the work of Francis Cargeeg, an artist craftsman in hand beaten copper. Twenty-one examples of his work were on show, pots, bowls and trays 'with intricate and delicate designs.' He was interested in the ancient Celtic artists and their work with hammered sheet-bronze, who achieved remarkable embossed designs known as repoussé. He was a Bard of the Cornish Gorsedd.

Other two-man exhibitions were by John Wells and David Haughton; Denis Mitchell and Tom Early; Barns-Graham showed with M Staniland Roberts, a miniaturist; Sven Berlin and Hugh E Ridge; Bernard Ninnes and David Leach. Barbara Hepworth said of David Leach's exhibition of pots, 'the art of the potter creates form for its own sake as well as form with a function and embraces colour and texture. By using these cups, jugs and bowls one would get not only aesthetic pleasure but bring into daily life the vital beauty of objects which were a joy to hold.'

St Ives Society and Death of Borlase Smart

Borlase Smart was elected President of St Ives Society of Artists succeeding Dod Procter RA. It was reported that at the beginning of the war they printed 600 catalogues, they now printed 6000. The number of modern painters showing in the St Ives Society increased to 17 and tensions increased in the uneasy alliance between the traditional and modern artists. Regular visitors to St Ives expected to find only the familiar, the easily understood, the immediately appreciated, land and seascape paintings for which the town was rightly famous. It proved a shock to both visitors and local painters and an affront to the native inhabitants when the abstract artists set up their paintings and talked their philosophies.

In 1947 Borlase Smart died of a heart attack. Leonard Fuller, writing in the *St Ives Times,* mourned the loss of his life-long friend and spoke for the arts community. 'His tremendous energy, his absolute integrity in artistic matters have won for him a place that can never adequately be filled. He always showed the broadest sympathy with the younger artists and in him they have lost a most valued friend.'[9] He is buried in Porthmeor cemetery not far from the grave of Alfred Wallis.

Cornish Cliffs, *Borlase Smart. David Lay.*

Smart was a great supporter of artists, whether figurative or abstract, and tried to encourage the younger painters in their endeavours to express themselves in whichever way they chose. He interested himself in the efforts of school children and encouraged them to paint and appreciate art. His book *The Technique of Seascape Painting* was published in 1934 and reprinted in 1964.

Two local ladies recalled fond memories. Catherine Bowtell said, "Borlase Smart used to come to the schools in St Ives and choose pictures to display in the studios on Show Day. I had mine hung in Moffat Lindner's Porthmeor Studio. We were very pleased if we were chosen. That's why I have always been interested in art and enjoy painting."

Sylvia Sirrett remembered her mother's connection, "The Smart's lived in The Cabin and during a great storm they were washed out. Borlase Smart had a heart attack some time previously. He was brought over to our house in a blanket. Mother went and tackled the after-effects of the water and he gave mother a painting in appreciation of her help."

Smart showed a great interest in preserving the old quarters of St Ives. He proposed that a letter be sent to the Town Council suggesting that two members of the Society of Artists be available to advise on new building plans so that the character of the old town be retained as far as possible. He served as a Town Councillor for three years. In the newly designed garden of Norway Square a garden seat was placed in memory of Borlase Smart.

1948
Lindner's Legacy

The Porthmeor Studios, owned by Moffat Lindner and kept by him in trust for artists, were offered for sale for £6,000, on the understanding they would be kept as

Seabird, *1950, John Tunnard.*

studios. These 13 studios were bought by the Borlase Smart Memorial Trust Fund, which was set up as a tribute to him. Its aim was to buy and manage the Porthmeor Studios for the benefit of future artists, and to further safeguard this precious commodity and ensure their use by bona fide artists. The Arts Council stepped in with an interest-free loan of £4,500 and the sum of £2,036 was raised by the new Trust Fund. Lindner's legacy to the art colony is undoubtedly the saving of the Porthmeor studios which, without his beneficent custody, would have drastically reduced the artists' ability to live and paint in St Ives. The conversion of the Piazza studios to new artists' flats and studios effectively out-priced their pockets.

William Gear, an early abstract painter, fellow Scot and friend of Alan Davie, spent some time in the summer painting in St Ives. He studied in Paris with Leger in the thirties and after the war returned to France, but was back in England by 1950 and the following year was awarded a Festival of Britain purchase prize. In 1964 he became head of fine art at Birmingham.

John Tunnard joined the staff of Penzance School of Art and taught design from 1948-65. He had studied at the Royal College of Art 1919-23 where he met and married fellow student Mary Robertson. He was a textile designer and she collaborated with him in the design and production of hand blocked materials. He took up painting full time in 1928 and joined the London Group. He taught part-time at the Central School of Art and Design.

In 1930 the Tunnards settled in Cadgwith, a small village on the Lizard peninsula, where he served as a coastguard. In 1933 he had a show at the Redfern Gallery and showed mostly Cornish landscape and coastal scenes. In 1939 Peggy Guggenheim gave him an exhibition of his non-representational pictures. In 1942 he held an exhibition of his work at Arno Goldfinger's house in Hampstead on behalf of the Aid To Russia Fund. (This architect's house is now the subject of discussion by the National Trust.) After the war the Tunnards moved to Morvah and in 1952 to Lamorna valley, where he took over Laura Knight's old studio.

Summer Afternoon, *William Gear. Austin/Desmond.*

Loki, *1948, Ithell Colquhoun. David Lay.*

He was a jazz musician and set up a small jazz band at Cadgwith. He had an abiding love of nature, of birds, bones, animals and insects, which were often part of his design for paintings. His work often showed a dream-like quality with Surrealist elements.

During the 1930s, Ithell Colquhoun, a member of the Surrealist Movement, lived in Paris and London. She held her first London exhibition at the Fine Art Society in 1936. She was a leading member of the British Surrealists and exhibited with the most distinguished of them at the Mayor Gallery from 1939. Her influences were Salvador Dali and later Kurt Schwitters in her use of collage.

She moved permanently to Mousehole where she continued to explore, in painting and writing, poetry and novels, all aspects of the Surrealist movement. She wrote *The Living Stones, Cornwall* in 1957. A major exhibition of her work, Paintings Drawings and Collages 1936-76 was held at Newlyn Orion Gallery in 1977.

Shearer Armstrong made her home in St Ives for 60 years. She and her husband bought two old cottages in 1921, one of which she used as a studio. This was Rose Cottage in Carbis Bay. She had studied at the Slade and with Algernon Talmage. She was known largely as a flower and portrait painter in oils and watercolour and an illustrator in black and white. In later years she changed her style to more abstract work and was exhibiting these newer paintings in her Porthmeor studio in the early 1980s, when she also showed the work of her young nephew. She had a studio at 1 Piazza before these were demolished. After her death the auction of her paintings also included pictures by Nicholson, Heron, Wallis and Pearce.

Writers

Writers have always been associated with the artists and during the late forties several arrived in Cornwall. Norman Levine came to St Ives in the summer of 1946 when he was 25, after graduating from McGill University in Montreal. His first book of poems *The Tightrope Walker* was the first book printed by Guido Morris in 1950, with a drawing by Sven Berlin as its frontispiece. Levine has written novels and non-fiction but he is known mainly for his short stories and in all of them St Ives figures prominently. *From a Seaside Town*, his second novel published in 1970, is entirely set in St Ives and the town itself is the main character. The painters' influence on his work can be seen in the way he uses images in his writing. In 1972 the BBC made a film, 'Norman Levine's St Ives'.

Levine's most recent fine art book, *The Beat and the Still*, published in 1990, is exclusively of St Ives, with paintings by the Canadian artist Ron Bolt. It is in the collection of the Victoria and Albert Museum.

Yorkshire-born Arthur Caddick took up residence in a holiday chalet on the sea at St Michael's Mount before moving to Windswept Cottage at Nancledra, a house owned by the Electric Power Company, by whom Caddick was employed to safeguard the working of a generator which serviced the pumps at Geevor Mine. He received a small income and time to write poetry and articles from his confinement in the cottage. His poems were often satirical comments on life around him.

Shearer Armstrong in her studio at St Ives.

Caddick read law at Oxford but was a practising poet and writer. In 1954 the United States post office impounded a manuscript of a novel by Caddick on the grounds that it was indecent. The novel, *Two Can Sleep Cheaper,* dealt with the loves, hopes and rivalries of artists living in an imaginary colony in Cornwall, Trebogus-on-Sea. Caddick said "Actually it is a highly moral book." He believed his novel was a victim of the McCarthy hunt for subversive literature. He lived in Windswept Cottage with his wife Peggy and five children from 1945-81.

Writer and art critic David Lewis came to West Penwith from London in 1947, living at Tregerthen, near Zennor, in one of a group of cottages below Eagles Nest, once occupied by the New Zealand writer Katherine Mansfield and John Middleton Murray during 1917. Next door is the cottage in which D H Lawrence lived with his German wife Frieda and where he wrote *Women in Love,* the sequel to his much maligned novel *The Rainbow.*

Lewis was curator of the Penwith Society from 1951-54. He wrote art criticism for several periodicals and left St Ives to study architecture at Leeds in 1956. He was married to the painter Barns-Graham for 14 years. From Lewis's knowledge of the area and friendship with the artists in St Ives, he wrote the introduction for the Tate Gallery 1985 Exhibition catalogue 'St Ives 1939-64 25 Years of Painting, Sculpture and Pottery'.

An important writer moving into St Ives in 1948 was Denys Val Baker. He rented a cottage on Trencrom Hill with his second wife Jess Val Baker, who became a potter. Their next house was in Penzance, on to Sennen Cove, St Hilary vicarage and back to St Ives and St Christopher's, a house facing on to Porthmeor beach and the Atlantic ocean, from where the first of his autobiographies was written, in 1963, *The Seas In The Kitchen.*

The family's voyages on their vessel *Sanu,* which was moored in St Ives harbour, are recorded in several volumes. He wrote various collections of short stories, for which he was an acknowledged master. In 1959 the popular and informative book *Britain's Art Colony by the Sea* appeared and in 1950, *Paintings from Cornwall.* He also produced and edited a literary magazine *The Cornish Review.*

In 1948 Sven Berlin published his book *Alfred Wallis Primitive.* He became interested in Wallis from seeing Stokes' collection of Wallis paintings. He never managed to meet the man but while working on the land in West Penwith and living on Zennor moor he began talking to the local people and gathering information about Wallis from relatives and neighbours. He began the writing whilst serving in the army. The book was reprinted in 1992 with an updated foreword by Sven Berlin.

Another arrival was Yorkshire-born Frank Halliday. He studied at Kings College, Cambridge and was Head of English at Cheltenham College for 20 years before moving to St Ives in 1948 to devote his time to writing. He wrote 8 books on Shakespeare and as many on Cornwall, including *A History of Cornwall,* of which the noted Cornish historian A L Rowse wrote, 'He gives a more compelling account of the story of the little land than anyone so far.' His biography of Thomas Hardy was published in 1972. He also wrote poetry and about poetry. He was a great walker, a lover of music, painting and sculpture. The Hallidays were great friends of Barbara Hepworth and this is noted in her *Pictorial Autobiography,* 'This book is dedicated to Frank Halliday and his wife Nancibel, who have given me friendship, love and courage for two decades.'

Several poets arrived around the late forties, John Heath-Stubbs and David Wright, with whom David Lewis shared his cottage at Tregerthen. George Barker came with his wife Ilse who was both novelist and poet. George was brother of the painter Kit Barker. These poets were named by Sven Berlin The Moor Poets, so called because they lived at various times in cottages on the moors above Zennor.

Guido Morris issued under the title Crescendo Poetry Series a number of poetry books printed and published by the Latin Press in 1951. One of these was by Arthur Caddick, *The Speech of Phantoms* containing 19 poems. *Aphrodite's Garland* was a booklet of five ancient love poems translated by Heath-Stubbs. *The Lost Flowers* and *Songs at High Noon* were by Morris himself. Others were by Douglas Brean Newton, Nigel Heseltine, Bernard Bergonzi and David Wright.

Newlyn-born Frank Ruhrmund prefers to be known as a poet but has been teacher, journalist, playwright, theatre critic and short story writer. He has produced plays for theatre companies and at the Minack, Cornwall's famous open-air theatre on the cliffs at Porthcurno. He currently writes on art and artists.

1949

The Penwith Society of Arts in Cornwall

Carrying on the tradition of reporting art matters in the local press, the editor of the *St Ives Times* February issue stated, 'We have been requested by Mr David Cox to publish the following.' David Cox was secretary of the Society of Artists.

'At an extraordinary general meeting of the St Ives Society of Artists on Saturday, called by ten members, a split, which has been threatened for some years took place, broadly between the more progressive and the conservative element. As a result seventeen members of the SISA have resigned.'[10]

At a subsequent meeting held at the Castle Inn, St Ives, these resignees and others founded the Penwith Society of Arts and Crafts in Cornwall. As with the St Ives Society, which was formed from a branch of the Arts Club, likewise the Penwith society was formed from a branch of St Ives Society, leaving the main body intact.

The breakaway group dedicated their achievement of this new development as a tribute to Borlase Smart. The founder members numbered 19, Shearer Armstrong, Wilhelmina Barns-Graham, Sven Berlin, David Cox, Agnes Drey, Leonard Fuller, Isobel Heath, Barbara Hepworth, Marion Grace Hocken, Peter Lanyon, Bernard

Figures in a Landscape, *Bernard Ninnes, c.1930.*

Leach, Denis Mitchell, Guido Morris, Marjorie Mostyn, Dicon Nance, Robin Nance, Ben Nicholson, Hyman Segal and John Wells. Herbert Read was invited to be President. Other artists elected to membership were, Garlick Barnes, Dorothy Bayley, Alec Carne, George Downing, Tom Early, W Arnold Forster, David Haughton, Mary Jewels, Miss A K Jillard, David Leach, Jeanne du Maurier, Alice Moore, Misome Peile, R G Perry, Dod Procter RA, M A H Sefton (Fish), Barbara Tribe and Bryan Wynter. John Tunnard declined to be a member.

In May the Penwith Society acquired the public hall in the centre of St Ives for its new gallery at 18 Fore Street. Its total membership, written into the introduction to the first exhibition in 1949, was to remain constant at 40 artists and 10 craftsmen. It was written of the Society, 'It is entirely opposed to exclusiveness and antagonism.' Unfortunately, history was to prove that the Penwith, from its beginnings to the present day, has always been both exclusive and antagonistic.

The first exhibition featured 100 items in paintings, embroidery, pottery, sculpture and furniture. It was opened by the writer Phyllis Bottome. She lived at Red Willows St Ives with her Cornish-born husband Captain Ernan Forbes Dennis. Her book, *The Mortal Storm,* published in 1937 dealt with the rise of National Socialism in Germany. She wrote novels and a biography of the Viennese psychologist Alfred Alder. In 1947 came the first volume of her autobiography *Search for a Soul.* The final volume, which would have covered her years in St Ives, was never written. In 1955 her book *Not In Our Stars* was dedicated 'To our beloved friends David Lewis and Wilhelmina Barns-Graham.' Her last public appearance was a television interview on her 80th birthday.

The Penwith Society exhibition was reviewed in *St Ives Times.* 'The first exhibition of the Penwith Society of Arts in Cornwall is an event of more than local importance because of the sheer quality of the work... with the pictures hang printing and needlework, beneath them perhaps a jug by David Leach or an elm chair by Dicon Nance or an oak trestle table by Robin Nance on which is a porcelain tea set by Bernard Leach. 'Two Figures' in elm wood are by Barbara Hepworth. These figures pierced and hollowed and the splayed apertures painted

white are a spiritual and aesthetic revelation and so intensely moving that it is difficult to write about them. 'Pendour' and 'Two Forms' relate to Cornwall.' David Cox's painting 'The Red Blouse' was described as 'Matthew Smith-like for its colour.' (Sir Matthew Smith visited Cornwall in the 1920s, staying at St Austell and was noted for his use of bold, vibrant colours in the style of the Fauves. Charles Ginner also visited in this period and painted St Just in Penwith in 1923.) Hyman Segal's work was distinctive for its 'economy of line.' Sven Berlin's drawings for sculpture were 'powerful.' John Wells' 'Landscape Under Moors' 'shows a feeling for space.' Ben Nicholson's paintings were 'imaginative interpretations of space.' 'Nicholson's expression is geometrical, that of Peter Lanyon is curvilinear. The latter is a young artist of rare promise, one who has completely identified himself with the Cornish landscape as in Portreath and West Penwith.'[11] The work of Borlase Smart, Alfred Wallis, Bryan Wynter, Dod Procter, David Haughton, Alice Moore and Leonard Fuller was also shown.

For August the Penwith Society arranged a lecture on The Main Tendencies of Modern Art by Dr Paul Hodin, Czech doctor of philosophy and art, who said, 'The public does not always understand contemporary art, they are taught to read, to write, to draw, to sing but nobody has ever taught them how to look at a picture.'

In September an exhibition was held as a memorial to Borlase Smart, which was afterwards shown in Plymouth Art Gallery. Nicholson was given the tenancy of Smart's studio No 5 Porthmeor, this allowed him to work on larger paintings. He occupied the studio until 1958 when it was taken over by Patrick Heron.

In spite of the success of their first exhibition, tensions in the new Society were soon to be realised with the difficulties of trying to select, without bias, the work of abstract and representational artists. At a general meeting there was dissension among the membership of the Penwith Society when a clause was proposed by Barbara Hepworth to group work in A B or C depending on whether it was abstract or traditional or fell in the category of craft. The proposal was carried.

The newly formed Penwith group were not only finding disruptions within their own society but were under constant attack from the one from which they had just broken away. Alfred J Munnings, who had just finished his term of office as president of the Royal Academy, was elected president of St Ives Society of Artists following the death of Borlase Smart. After Munnings' public verbal abuse of the work of Matisse, and on modern art in general, it was feared, because of the close association of Munnings with St Ives, that the public would be inclined to accept his authority on art matters instead of relying on their own judgement. Bernard Leach pointed out that the break with the Society had taken place before the controversy at the Tate and was not a matter of personalities but of principles.

What began as a divide between two different forms of art continued as a disruptive element for some years.

Gradually the moderns and traditional artists were separated into two, the Penwith Society of Arts for the first group and the St Ives Society for the second. This is largely the position as it remains today. The Newlyn Society of Artists spans both fields.

At the end of 1949 Peter Lanyon held his first London exhibition at the Redfern Gallery. It was reviewed by Patrick Heron for the *New Statesman and Nation* who walked into the gallery and, 'recognised this white gleam of clear grey light which Lanyon's near abstract painting gives off — it is the light of St Ives, of a peninsula seven-eighths surrounded by ocean, where the sky has a soft white radiance that must come from the reflection of light off the huge surrounding mirror of the Atlantic.' [12] He noted that his landscapes had originality and vitality. A painting by Lanyon played a sort of hide-and-seek with visual reality. He felt that if the artist could cultivate sensation as well as imagination he would produce something of exceptional interest.

A painting by Leonard Fuller was presented to the art gallery at Penlee House, where the handing-over ceremony took place. The painting was a portrait of Herbert Thomas who was 50 years editor of the *Cornishman* and thereby a great supporter of the arts. Two paintings by Moffat Peter Lindner, who died in 1949, were bequeathed to St Ives Town Council.

Bernard Ninnes was not a member of the more progressive Penwith Society but his later pictures were distinguished by their bold use of line and colour. He was elected RBA in 1933 and ROI the following year. In 1939 the Bournemouth Russell Cotes Gallery bought a painting 'Street in Spain' for their permanent collection. Ninnes was foremost among those painters connected with efforts to preserve the ancient buildings and fishermen's cottages in the locality. He was Vice President of St Ives Society for many years and President of the Arts Club. He lived at Hayeswood, Burthallan Lane.

German-born Paul Feiler visited Cornwall with his first wife June Miles, also a painter. He was interned in Canada from 1939 but returned to England in 1941 and taught art in Eastbourne and Oxford until 1946. From the 1950s his work became more abstract. Tonal colours and the scale of shapes and their relationship to each

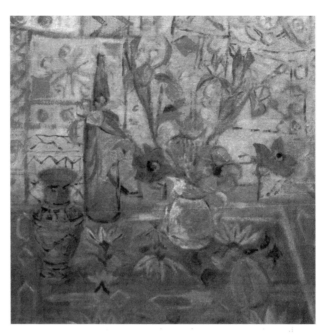

Still Life, *June Miles. New Craftsman.*

other has been crucial to Feiler's application of the paint as expression of his view of the world. In 1953 his first solo show was held at the Redfern Gallery, London, where he exhibited for the next five years. He was head of painting 1963-75 at West of England College of Art. He now lives with his second wife, the painter Catherine Armitage, in a converted chapel at Paul, near Newlyn. He held a major retrospective at Austin Desmond, Bloomsbury in 1990.

Living in St Just, June Miles is now married to the sculptor Paul Mount, where they each have a studio attached to their cottage. June studied at the Slade and West of England Colleges of Art and taught for 10 years at the Bristol Polytechnic. She paints flowers and still life and the houses of Southern France where she and her husband spend some working time each year. She is also a sensitive painter of portraits.

The Fifties
The New Ruling Operates

In 1950 when the new ruling of the Penwith Society, segregating artists into A, B and C began to operate, Hyman Segal, David Cox, Sven Berlin and Isobel Heath resigned. At the first annual meeting Guido Morris said it was sad that four of the 19 members had resigned because the committee had created an artifical division between artists. He had attended the meeting as representative of the resignees and asked that the ruling be looked at to see whether it was at fault. Arnold Forster proposed that the four members should be asked to rejoin.

The first letter to appear in the *St Ives Times* on this subject was from Hyman Segal, he stated 'The division of the Society into various groupings is quite contrary to the spirit in which it was founded. Had these terms been mentioned when the Society was first formed, they would have been laughed to scorn.' [13]

David Cox, a Cornishman born at Falmouth who had

Cornish Landscape, *Paul Feiler, 1950.*

Turning Forms, *reinforced concrete, 8ft x 7ft, Barbara Hepworth, 1951.*

studied art in London and abroad and was secretary of the Penwith Society, had recently left St Ives, but he wrote supporting the view that the Society was founded as a tribute to Borlase Smart on the principle that modern and traditional artists could work together. The rule was a contradiction of these ideals. Isobel Heath noted that 8 members had voted against the ruling of placing members in categories. Denys Val Baker pleaded for a little more sympathy for the members and a little less regard for the rule. Peter Lanyon and Guido Morris also resigned. Lanyon wrote 'After attempting to institute right of appeal against committee rulings and being ruled out-of-order, I too resigned.'

Barns-Graham viewed the rulings differently. She said it was to safeguard the abstract artists' work. It was so despised as to be totally overruled by a majority of artists who only recognised figurative elements in a painting. "It was necessary to introduce that rule at that time."

Remarkable for so new a venture, the Penwith Society was awarded an annual grant towards their expenses by the Arts Council and public bodies showed interest in the work. Paintings by J Coburn Witherop and David Haughton were purchased by Derbyshire Education Committee. Paintings by John Wells and Marion Grace Hocken were bought by Hertfordshire Education Committee as well as additional works by Barbara Hepworth and W Barns-Graham. Another painting by Barns-Graham was purchased by the Arts Council.

Review By Patrick Heron

In July Patrick Heron, in reviewing the shows at the new gallery, stated that each exhibition had been enhanced by the paintings of Ben Nicholson, sculpture by Barbara Hepworth and pottery by Bernard Leach. 'One might claim that this society thus numbers among its members the most distinguished painter, sculptor and potter working in England today.' In discussing the work and progress of John Wells he wrote, 'I think he is certainly the most important abstract painter of his generation in Britain today.' Of Barns-Graham's series of glacier paintings he says she has achieved 'that marriage between abstraction and figuration which has been characteristic of the main tradition in European painting in our time.' Of Bryan Wynter's paintings he observes that his work derives from Cubism but he evokes the world of the Cornish moors and their inanimate inhabitants. He 'might well be considered to be our most distinguished landscape painter since Graham Sutherland.' Of Margaret Mellis' painting 'Still Life with Round Table' and Francis Davison's 'Lemons at Night' Heron states 'Matisse is as evident in the intense yellows and scarlets of the first as Braque is in the structure and the blues of the second. Two other painters in sympathy with this full-blooded and French use of colour are Kate Nicholson in 'Fish on Slab' and Mary Jewels.' Of the more traditional painters he pronounced them 'all competent and deft executants.' [14]

Denys Val Baker writes in protest at the large statements made by Heron and says that Heron set out consciously or unconsciously 'to give an entirely misleading impression of the importance of the Penwith Society.' He felt his words were calculated to sustain a myth about the Society's national, and even international importance. In his final paragraph Val Baker says of the Penwith Society, 'What has been somewhat lacking from its make-up has been a true humility.'

Perhaps some of Heron's statements about individual artists were prophetic or sound judgements and Val Baker's words find truth today in his ironic remark that there are artists of equal standing who only lack 'the unique qualification of membership of the Penwith Society' !

Show Days

Show Days gradually incorporated more work of the moderns. Tom Early showed black and white drawings of the City of London in the same studio where Mitchell exhibited his first carvings and paintings. Hepworth exhibited 'Concave Large and Small Form' in elm. Nicholson and Barns-Graham's studios were open. Lanyon, Wells, B Leach and D Leach showed work in Robin Nance's workshop on the harbour where ladderback chairs in oak and ash stood beside a modern oak sideboard. Guido Morris at the Latin Press displayed printing and brush drawings, while at Sven's Tower, Berlin was chipping away at his model for a large piece, 'Praying Man'. He also showed a sculpture, 'Mother and Child', in alabaster.

Assistants for Hepworth

Barbara Hepworth enlisted the help of Wells and Frost as two extra assistants in helping to carve 'Contrapuntal Forms'. She had been invited to represent British sculpture in the British Pavilion in Venice for the International Biennale. Two rooms were allocated to display 40 sculptures with drawings and paintings. Misome Peile visited the studio at Trewyn at 11 o'clock at night to view a selection of the work, '.. the moonlight shone on a huge tarpaulin covering sculpture looming up in the garden. Inside and upstairs, on the bare boards stood a number of carvings in wood and stone. Whether the shape was purely abstract or easily read as a figure or group, the effect of tension, delicacy and strength was tremendous.' [15]

The work of Barbara Hepworth, 'Bicentric Form' was the first to be bought by the Tate Gallery. Hammacher noted in this 1949 period of her work a partial return to the figure 'the human image begins to exert a pressure on the abstract element, one which it can hardly bear with.' He felt the figure played too important a role. In the fifties, he says, 'she retrieved herself' from this influence.

1951

Festival of Britain

Sixty paintings were commissioned by the Arts Council as their contribution to the Festival of Britain. The only brief was that they should be large works. From Cornwall Peter Lanyon showed 'Porthleven', Patrick Heron 'Christmas Eve', Ben Nicholson 'Curved Panel', John Tunnard 'The Return' and Bryan Wynter 'Blue Landscape', Barbara Hepworth 'Turning Forms'. William Scott and William Gear also exhibited. Nicholson and Tunnard were commissioned to design murals for restaurants on the South Bank and Victor Pasmore designed a tile mosaic 'The Waterfall' for the Regatta Restaurant. The exhibition of paintings toured Britain and helped promote the artists in the public eye. Nicholson's painting was later given a home at London Airport in 1957. It measured 7ft. x16ft.

The St Ives Festival of Music and the Arts accompanied the Festival of Britain, with Michael Tippett, Cornish-born composer and conductor, Peter Pears and Benjamin Britten. It was organised chiefly by Barbara Hepworth and Priaulx Rainier, who shared the musical direction. They allocated jobs to the artists and Barns-Graham recalls that Denis Mitchell and herself found themselves as barman and waitress at the Arts Club. This was the start of St Ives Festivals.

At this time Heals of Tottenham Court Road had an exhibition space, the Mansard Gallery, and reaping benefit from Festival Year Denis Mitchell and Tom Early organised a show 'Fifteen Artists and Craftsmen from Around St Ives'. The catalogue was printed by Guido Morris and the exhibitors were Ben Nicholson, Hepworth, Lanyon, Heron, Wells, Berlin, Peile, Wynter, Barns-Graham, Leach, Wallis, Frost, Early, Mitchell and Guido Morris.

Lovers in the South Seas, *Patrick Hayman. Wills Lane Gallery.*

The Penwith Society and St Ives Society ran their own competitions for painting, sculpture and pottery. The judges were Philip James, Director of the Arts Council, John Rothenstein, Director of the Tate Gallery and Alderman Gerald J Cock JP, all trustees of the Porthmeor studios. The winners for the Penwith were W Barns-Graham with her painting 'Cornish Landscape, Porthleven'. Barbara Hepworth for her sculpture 'Rock Form'. Each was awarded a prize of £75. Bernard Leach won the crafts section for a lidded pot. His reward was £45. For the St Ives Society Bernard Ninnes' painting of Nancledra and John Park's 'Symphony in Grey St Ives Harbour' were awarded prizes. Each of the works was presented to the town.

Hepworth's sculpture 'Rock Form' was damaged when it was moved from the Council Chamber at the Guildhall to the library some time later. The piece was worth £1000 and weighed several hundredweights. Barbara Hepworth was upset and said the damage could have been avoided if she had been informed and would have arranged for experts to handle the move. She repaired the damaged piece and returned it to its setting in the public library.

This year Nicholson exhibited at Durlacher Brothers, New York and there followed a retrospective at Philips Gallery, Washington. Several paintings were purchased for the National Art Gallery, New South Wales, the National Gallery at Melbourne and the Toronto Gallery.

Patrick Hayman exhibited his paintings at Robin Nance's workshop. A review of the exhibition was written by Lanyon who made the same statement as was made about his own work, 'his direction is not yet decided'. In an exhibition the following year Lionel Miskin referred to the similarities in Hayman's work to Munch and Rouault in the 'psychological use of colour' but at the same time described him as an 'original and inventive painter; a colourist of great subtlety.'

Hayman at the age of 20 went to New Zealand where he began painting. He returned to England in 1947 when he married and moved to Mevagissey and then to St Ives. He painted figures and landscapes in strong colours, which often contained a mystery. His Cornish landscapes are dark, often threatening. He lived in London and St Ives. He founded and edited *The Painter and Sculptor,* a magazine specialising in figurative art which ran from

The Artist's Model, *Isobel Atterbury Heath. David Lay.*

In 1951 Lowndes lived at Tremedda Farm, Zennor, the home of the Dow family for 9 years. After his marriage the couple bought a house in St Ives and lived there until 1964, after which he went to live in Halsetown just outside St Ives and had a studio built in his garden. In 1970 he moved to Gloucester, but made frequent trips to Cornwall. An exhibition of 54 of his paintings 1948-78 was held at the Penwith Gallery in 1979. His friend Norman Levine wrote in the catalogue 'He was attracted by the ordinary, the every day, and he tried to show that the lives of ordinary people should have some dignity.'

Among exhibitors at the Penwith Society was the work of the potter Michael Cardew, from the Wenford Bridge pottery near Bodmin, Warren and Alix Mackenzie from St Paul, Minnesota, working at the Leach Pottery, Bernard and David Leach and Kenneth Quick.

The Penwith Exhibition was reviewed by David Lewis, who remarked that 'the Penwith Society after only two years had reached stalemate.' Lanyon, in a protest to the *St Ives Times,* said Lewis was the armchair footballer instructing the initiated how to shoot goals. This was strangely defensive from someone who had resigned. Several letters on the subject were received until the editor decided that the issue was 'closed.'

1958-64. He also wrote and illustrated his own poetry. His last book *Painted Poems* was published in 1988.

Another poet/painter was Isobel Atterbury Heath. After studying at Colarossi's, Montparnasse, Paris she attended the St Ives School of Painting with Leonard Fuller. During the war, 1939-45, she was an artist for the Ministry of Information, making drawings of factory workers and painting incidents of war. She married Dr Marc Prati, Italian political correspondent and lived at Bosun's Nest, near Clodgy. Her concern was to prevent further building development in that area. She often spent days out on the moors on painting expeditions driving and living in a dilapidated van.

Alan Lowndes left school at 14 and was apprenticed to a decorator. He attended evening classes in Stockport 1945-48 and began painting full time. He was largely self-taught and painted in thick impasto the scenery surrounding him, as well as portraits, interiors and street scenes. He shared a studio with Michael Broido and had the use of Linden Holman's Piazza studio.

Alan Lowndes with his boat, St Ives Harbour. Peter Kinnear.

1952

In the severe storms of this year great banks of sand built up on Porthmeor beach and engulfed several studios. Workmen were sent to shore up ceilings which were collapsing under the weight of sand on the roofs. The fronts of some studios gave way under pressure and 10 tons of sand had invaded Bradshaw's studio. The *St Ives Times* launched an appeal for 'The Porthmeor Sand Fund.' The Arts Council gave £50 and there were many contributions from the town. On completion of the work 18,000 tons of sand had been removed from the beach to prevent a recurrence of the problem. Every spring in present years mountains of sand pile up in front of the buildings and have to be spread by a bulldozer.

Clare White, whose own work was shown in Rose Lodge Studio, reviewed the spring exhibition of the St Ives and Penwith Societies. Nicholson showed some of his white reliefs at the Penwith and Mary Chamot, assistant keeper of the Tate and art critic, lectured on 'Leonardo da Vinci and Modern Art'. John Park became acting president of St Ives Society but left the same year to live in Brixham. He lived in St Ives for 50 years.

Several artists died this year, George Cave Day, Francis John Roskruge, Florence Ellen Dow, John Titcomb, W Arnold Forster and Philip Maurice Hill, who lived at The Chimneys in Porthmeor Square. He was educated at King's College School and Balliol College, Oxford; the eldest son of Sir Maurice Hill, a judge. He exhibited at the RA, the Paris Salon and Royal Scottish Academy. He arrived in St Ives in 1948.

At the Lefevre gallery in London an exhibition of the work of Barbara Hepworth included 15 sculptures and 35 drawings. She had exhibited at this gallery in 1946 when the Queen spent 40 minutes at the show. This new work was also the subject of a film shot in St Ives during the summer. The film was screened at the National Film Theatre on the South Bank. Music for the film was

Abstract in White, Black, Brown and Ochre, *collage, Victor Pasmore, 1950.*

composed by Barbara Hepworth's friend in St Ives, Priaulx Rainier of Tregenna Studio, who some years later was commissioned by the BBC to write a new work for the cello. This new cello concerto was played by a 19 year old cellist, Jacqueline Dupré, in its first performance at the Albert Hall in 1963.

In October of this year Nicholson won $2000 as a first prize in the Carnegie Pittsburgh International Exhibition of oil painters. Twenty-four nations were represented by 270 artists. Also in this month a painting by Julius Olsson was formally received on behalf of St Ives by Mayor Alderman T Bryant. The painting was the gift of Helen Stuart Weir, former president of the Society of Women Artists.

Terry Frost held his first one-man exhibition at Leicester Galleries, London and began teaching life drawing at the Bath Academy of Art, Corsham from 1952-54. Peter Lanyon was awarded a travelling scholarship which entitled him to four months' study in Italy. John Milne returned from Greece and setting aside his own sculpture, became an assistant to Hepworth.

Victor Pasmore, painter and relief maker, painted in his spare time until he was noticed by Kenneth Clark who helped finance his career. He studied the Expressionists and experimented with Fauvism, turning eventually to the realism of the Euston Road School, of which he was a founder member in 1937 with Claude Rogers and William Coldstream. The building which housed the school of painting, 314 Euston Road, was demolished and although the school existed for only three years, it was sufficient to make history.

By 1949 Pasmore's solo show at the Redfern Gallery was totally abstract. In the early fifties he spent some time in St Ives meeting Nicholson, Frost and Heron, who had a great influence on him. He became a leading member of the Constructivists. Many of his works were inspired by

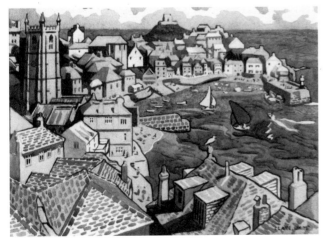

St Ives with Arts Club, *Clare White.*

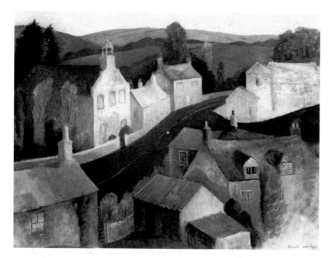

The Chapel, Lelant, *Billie Waters. David Lay.*

the spiral movements of the waves on Porthmeor beach, of which he made many drawings. He taught at Camberwell School of Art 1943-49 and the Central School 1949-54. He became Director of painting at the University of Newcastle-upon-Tyne 1954-61.

Moving to St Just-in-Penwith Michael Seward Snow soon became acquainted with Ben Nicholson, Denis Mitchell and Terry Frost. He was invited to exhibit with the Penwith Society and in 1954 was elected secretary, serving first with Misome Peile as chairman and then Denis Mitchell. He benefitted from a wide association with many artists and frequent studio visits. In 1960 Snow leased Nicholson's house in St Ives, after he moved to Switzerland, and wrote and visited him regularly.

Snow was commissioned to provide sculptures in three schools, one in Penzance, and exhibited paintings, reliefs, constructions and jewellery in the West Country, London and Manchester. He made annual journeys abroad over 30 years and was familiar with modern works, medieval and prehistoric art.

Nicholson and Mondrian were important to Snow's early explorations. 'Mondrian provided me with the first powerful demonstration of painting being used to create sensations rather than illustrate them. My interest in Nicholson's white reliefs and the sort of thinking and feeling responsible for them are directly related to works which use landscape elements. He had the same interest in the paintings as a real object, which is in sympathy with the value I place upon the event being the painting itself.'

1953

In an international sculpture competition with the theme of 'The Unknown Political Prisoner' Hepworth shared a second prize of £750 with Naum Gabo, a Frenchman, and an Italian. Barbara Tribe also entered the competition. The winning abstract model of wire by Reginald Butler was smashed by a member of the public at the exhibition in the Tate Gallery. In 1954 Butler, as guest artist, was invited to exhibit one of his works at the Penwith Gallery. The work was a 6ft high group of statuary, which was first shown in public in the gardens of the Festival of Britain on the Thames South Bank. Also showing was a construction in

mild steel called 'Girl and Boy', which was sent by the Arts Council as the first of a series of major works which the Penwith Society proposed to exhibit.

Barbara Hepworth's son, Paul Skeaping, from her first marriage, was killed in a flying accident in Thailand while serving with the RAF. Two years later the Bishop of Truro dedicated a sculpture, 'Madonna and Child', carved by Hepworth in granite in memory of her son, which was presented to St Ives Parish Church.

Heron arranged an exhibition at the Hanover Gallery, 'Space In Colour', and wrote the introduction to the catalogue. He regarded colour as powerful a medium to convey spatial expression as drawing. He pointed out the impossibility of juxtaposing colours on a surface without creating the illusion of recession and its opposite. Other artists sharing the exhibition and an interest in colour, and mostly related to Cornwall, were A Davie, T Frost, R Hilton, P Lanyon, V Pasmore, William Scott, Ivon Hitchens, Keith Vaughan and William Johnstone.

Peter Lanyon was elected a member of the Newlyn Society of Artists and became Chairman in 1961, at which time he was made a Bard of the Cornish Gorsedd for services to Cornish art and lectured for a year at Falmouth School of Art. From 1960-64 he was visiting lecturer at West of England College of Art, Bristol.

The first woman to be elected Mayor of St Ives was Mrs Marion Pearce, aunt of the painter Bryan Pearce. She expressed her pleasure at being elected and also that her first official function was the opening of the Penwith Society's Coronation Exhibition. As part of the programme Sir Herbert Read gave a lecture on 'The

Leaflight, *1989, Michael Seward Snow. Bob Berry .*

Fundamental Conflict in Contemporary Art'. A L Rowse, the noted historian, lectured on Tudor Cornwall.

Prince Chula Chakabongse of Thailand, of whom Barbara Tribe sculpted a portrait, opened the St Ives Society exhibition. The Princess of Thailand exhibited work and opened the show in the 1955 exhibition. Roger Leigh became an assistant to Barbara Hepworth and was joined the following year by Brian Wall. Bryan Pearce started to draw and paint. Sven Berlin and Guido Morris left St Ives.

1954

At the Arts Ball held at the Porthminster Hotel a huge picture frame was provided in which parties of two or more could pose and represent a famous painting. The Arts Ball, a survivor from earlier days, flourished for a few years before being revived again some time later.

Peter Lanyon won The Critics Prize for 1954. The prize was initiated in 1953 by the British section of the International Association of Art Critics and awarded to a painter or sculptor in Great Britain who had yet to achieve an established reputation. Of the paintings shown it was said 'At first glance, the paintings seem near abstract, but they are founded on the landscape of the country round St Ives.'

At the Whitechapel Art Gallery Hepworth showed a comprehensive exhibition of sculpture and drawings covering the years 1927-54. New sculptures created in the past two years were among 198 exhibits. 'Pastoral' in Serravezza marble and 'Monolith-Empyrean' in blue corrib limestone 9ft. 6in. high were two of these new pieces. The latter was also shown outside the Festival Hall.

Lawrence Alloway produced a book, *Nine Abstract Artists*, choosing to feature mostly the work of artists who had been connected with St Ives. These were Robert Adams, sculptor, and the painters Frost, Scott, Hilton, Pasmore and Heath. His subsequent critical attacks on the St Ives School were therefore surprising and were damaging to the extent that, for a time, the artists were excluded from many exhibitions of modern painters. The other artists were Mary and Kenneth Martin and Anthony Hill.

The death occurred of Tom Heath Robinson at St Michael's hospital in Hayle, aged 84. He was born in London, the son of an engraver and was the eldest of four brothers, three of whom were artists, the most famous being W Heath Robinson the cartoonist. Tom Heath Robinson came from Pinner to St Ives in 1942. He illustrated books of fiction and history and was an expert on historical costume. He and two of his brothers were responsible for an illustrated version of Hans Andersen's *Fairy Tales*.

The Penwith Society decided to widen their scope and introduce Associate Membership and to use the gallery during the winter months for small group shows and to introduce a more informal and intimate atmosphere. It was proposed to hold discussions and debates and similar activities. They hoped to establish links with other galleries in America and Europe for the exchange of exhibitions, information and possibly artists' studios.

Portrait of Cardinal Heenan with Father Delaney and artist Malcolm Haylett.

John Forrester lived in St Ives for five years and had an exhibition at Downing's Bookshop. The work was described as modern with a dynamic arrangement of colours and forms with a grouping of obtuse angles on different planes, which were impressions of landscapes and seascapes. He came to St Ives because it was the home of Nicholson and Hepworth and he was influenced by their abstract art. He also made constructions which were based on architecture and in this field he was an advisor and design consultant. He was included in a mixed exhibition at Whitechapel Art Gallery in 1955 and had a one-man show at Gimpel Fils the same year. He later moved to Paris and Italy.

Billie Waters spent five years at Newlyn 1926-31 where she studied under Ernest Procter and Harold Harvey. In 1928 she first exhibited at the RA and had her first solo show at Leicester Galleries in 1933. She travelled in France and Italy and in 1934 was commissioned to design a mural for the Knightsbridge Grill. She experimented briefly with abstract art when she was influenced by Nicholson but is better known as a representational painter.

Malcolm Haylett came to St Ives and built up a reputation as a portrait painter, to which it was said he brought a touch of genius. He confessed that his favourite subject was his own wife Jean. He taught painting, design and display art at Redruth School of Art.

Haylett was appointed designer of the Grand Hall at Olympia for the Daily Mail Ideal Home Exhibition for 1953/54. His subject was chosen in competition with other British designers. He was responsible for remodelling several shops and window displays in St Ives and it was his design for the Picnic Box cafe, which brought his work to the notice of the organisers of the exhibition. His other commissions were redesigning the interiors of a big London store and a chain of public houses in Devon and Cornwall.

Peter Lanyon in his studio at Little Parc Owls, 1955.

Jean Haylett studied at Higginbottom School of Art, Ashton-under-Lyne. She paints abstracts and still life and makes use of collage in her work. In particular, her designs for flowers and birds are made up from silk and a variety of objects and materials from nature. She worked from a studio at Westcott's Quay for some years.

The Copper Kettle Exhibition

In May an exhibition of contemporary craft pottery was shown at the Copper Kettle, a favourite meeting place and restaurant on the Wharf. It was opened by Lady St Levan who said that she found pottery fascinating, combining as it did the functional as well as the artistic. The show was organised by Mr and Mrs Mayfield who thanked Ivor Short, the owner of the restaurant, for putting the premises at their disposal and William Redgrave for the loan of paintings.

Potteries representing Sweden were Gustavesberg's Fabriker and Porslinsfabriker. The Poole Pottery showed two-tone eggshell glaze tableware. Joseph Bourne and Sons included specimens of hand-made work. Studio works were by William Newland who taught at the Central School of Art, Nicholas Vergette who studied at Chelsea School of Art, Pamela Nash who was inspired by Africa and the South Seas, Joe Lester from the Isle of Wight who specialised in underglaze colours and William Freeth who produced sculptural shapes of a functional character. The Milton Head Pottery at Brixham produced work from their group of 10 potters, who were all under 30 years of age. The Rye Pottery showed studio pieces in tin glaze.

Two young men from the Leach Pottery, both born and educated in St Ives, qualified as established members of the team of craftsmen. They were William Marshall and Kenneth Quick who started their apprenticeship at the age of 15. They were now doing creative work of their own designs having mastered all the processes of the art of the potter. Some of their pots were exhibited at the Copper Kettle.

1955
Peter Lanyon at Plymouth Exhibition

Lady Nancy Astor opened a one-man show of the work of Peter Lanyon at Plymouth City Art Gallery. In his opening remarks Lanyon said 'If it hadn't been for Borlase Smart I should never have started painting at all.' By way of explaining his work he also quoted from the catalogue 'This painting is abstract, but not non-figurative; it is dominated by a rhythm that is organic rather than geometric; it is evocative of place, but it is not illusionistic; not in any sense an orthodox presentation of landscape.' In reply Lady Astor said 'While the paintings themselves have done nothing to me, the artist's speech has done a great deal. For the first time I can see there is something going on inside. I recognise sincerity and vision when I see them and Mr Lanyon is a man of very great sincerity.'

A letter to the local press after a report on the exhibition at Plymouth stated 'I have often wondered why Peter Lanyon's pictures are hardly, if ever, exhibited in our own galleries. Nor as far as I know, are any of his works on the walls of any public building. He is a native of St Ives and he lives in St Ives. He has long been recognised by connoisseurs as one of the most promising of young British painters.'

In reply to this letter Lanyon said 'I share his concern,

Birds, *Jean Haylett.*

but I must remind him that I was brought up in St Ives with such artists as Milner, Grier, Park, Schofield, Borlase Smart and many others and I share with them a respect for tradition. When paintings by these artists have adequate hanging space in a town museum such as Borlase Smart envisaged I would be proud to join their company. My own isolation has been voluntary and arises from my refusal to accept the idea that modern art is apart from traditional art.'[16] He referred to St Ives as his workshop, the finished product for export only and because of his disapproval of the way art societies were structured he was not free to be an artist in his own town.

Lanyon had established a reputation, exhibited in a mixed exhibition in New York and in 1957 secured a solo show there. He became associated in America with Kline, Motherwell, Gottlieb and in particular Rothko.

In St Ives Lanyon, Redgrave and Frost founded St Peter's Loft School of Painting, which developed to meet the demands of students for a more modern approach to painting. As well as the founders, Karl Weschke and Anthony Benjamin taught at the school. Tony O'Malley attended as a student in its first years on a painting holiday, where he first met Bryan Wynter. Included in the curriculum were courses on painting, sculpture, pottery and printing and on two days a week a model was employed. The School was a sail loft, now the print room of the Penwith Gallery in Back Road West. It ran until 1960.

Nicholson Retrospective at the Tate
In May the Tate Gallery held a retrospective exhibition of the work of Nicholson, which included 90 paintings and drawings. These were first seen at the Venice Biennale and galleries in Amsterdam, Brussels, Zurich and Paris. The Tate Show was considered 'a rare honour for a living artist.' Other artists so honoured were Graham Sutherland, Sir Matthew Smith, Jacob Epstein and Henri Matisse. A celebratory party was held at the Fore Street Gallery and Denis Mitchell, the Penwith's Chairman, said it marked a high point of public recognition for one of Britain's leading contemporary artists. The Tate bought three of the works 'White Relief' 1935, 'Painting' 1937 and 'Vertical Seconds' 1953. This brought their collection up to 7.

This exhibition was the subject of discussion by four critics on a BBC programme. The panel generally agreed that whether one accepted or rejected abstract painting, there was no question of its integrity.

'The puritan and the poet unite in Nicholson's brand of abstraction. He often uses only the most elementary symbols such as a jug or a cup; or at times merely an arabesque flourish, as a linear basis for his play of colour. A recession of planes is a frequent substitute for the world of appearances.' 'Being a creator of extreme sensitivity and quite unusual aesthetic sensibility, he makes far stricter demands on us than Rigaud, or Rodin or Mulready.' [17] Another major retrospective for Nicholson was held at the Tate in 1969. At the same time

a book on his work was published by Thames and Hudson with an introduction by John Russell, the art critic of the *Sunday Times*.

Changes
During the period of 1955-57 changes were again taking place in St Ives. In June '55 at the Penwith show a sculpture of Vaughan Williams by Sir Jacob Epstein was prominently displayed. The sculpture was on loan from the Arts Council and was one of the few representational works in the gallery. A reviewer wrote 'For good or ill, the Penwith Society has apparently decided that its mission is to exemplify the abstract. Abstract compositions, paintings and drawings, many of them conveying only the most tenuous connection with the visible world, hang on the walls... abstract sculptures and carvings hold the floor.'

Denis Mitchell was chairman of the Penwith from 1955-57. It was said that during this particularly difficult time he was the most diplomatic, sensitive and considerate chairman. His wisdom and sense of fairness and great good humour helped steer a safe path through the troubles that arose during this period. Acting secretary Michael Snow said, 'he was held in such general affection, he changed discord into (relative) harmony on many occasions.'

In spite of the meteoric rise of the Penwith Society and the deposition of traditional painting, that had held sway in St Ives for over 60 years, the St Ives Society of Artists was still strong. 130 members held an exhibition in the Milne Gallery of the Medici Society in Grafton Street. A London correspondent pointed out that the Society had members all over the country. The Editor of the *St Ives Times* remarked 'I rather think he under-estimates the number (of artists) in our midst.' The same mistake is made today, when St Ives can still boast of being one of the largest colonies of artists in the British Isles.

The newly elected President of the Society was Claude Muncaster, a painter of marine subjects, with particular reference to sailing ships. He was also an etcher and illustrator and painted landscapes and townscapes with fine attention to detail. He published a book, *Landscape and Marine Painting*, in 1958. His work is represented in the Tate. He was commissioned by George VI to paint watercolours of the royal residences.

There was a great falling away of artists sending paintings to show at the Royal Academy. Exhibiting this year was W Redgrave's 'Model In Blue Skirt', said to be suggestive of the Henry Moore school. In the watercolour section J Merriott of Polperro showed 'The Barge Builders' and Dod Procter of Newlyn's picture was a floral study 'Rose and Blackcurrant'.

The Scottish Arts Council mounted an exhibition to tour Scotland, Seven Scottish Painters. It included the works of Robert Colquhoun, Alan Davie, Charles McCall, Robert MacBride, William Wilson, Scottie Wilson and Wilhelmina Barns-Graham as the only woman.

Four St Ives artists were represented in the centenary

Painted Relief, *1969, Alexander Mackenzie. Belgrave Gallery.*

exhibition of the Society of Women Artists in London. They were Margery Mostyn, Misome Peile, Laura Roberts and Isobel Heath.

Nicholson and Hepworth had both established international reputations and no longer needed the Penwith Society to promote or exhibit their work. However, Hepworth retained her interest in the gallery. Nicholson resigned in 1957 and the following year left St Ives.

It was proposed by Hepworth and Wall that the Society should move to 36 Fore Street, a premises with a shop front. The committee voted against a proposal which meant less hanging space in a smaller gallery, but in spite of this rejection, the move took place. There was some resentment at this somehow overturned committee decision — after which Hepworth acquired 18 Fore Street.

When Dr Paul Hodin opened a Summer Show he remarked in his speech that for reasons unknown to him the exhibition was about half the size of former ones and he thought the accommodation inadequate. He felt the arts contributed much to the town and Cornwall County Council and the St Ives Town Council should create a public fund to support the arts.

Joseph Paul Hodin was the first Director of Studies at the Institute of Contemporary Arts and President of the British Section of the International Association of Art Critics. In 1954 he won first prize for art criticism at the Venice Biennale. He wrote critical studies on Stokes, Lanyon, Wells, Heron, Janet Leach and others.

Other painters began to appear on the scene. Some of the new names exhibiting in the Penwith were Alexander Mackenzie, whose 'Landscape' was described as 'brooding vitality expressed in sombre greens and blacks.' Trevor Bell challenged the imagination 'through the mystery of windows and the life behind them.' Kate Nicholson's paintings were 'stimulating and strongly individual, harmonious in colour and design.' 'Figure' by Karl Weschke 'held power and a subtle, sinister quality. The dark red tones tinged with green emphases this.' Clifford Fishwick's 'Fishing Boats Newlyn' was 'modern in treatment.' 'Red, Black on White' by Brian Wall was 'startling in design and cold in feeling.'

Alexander Mackenzie taught art in Penzance 1951-64 and lived in Newlyn. He was appointed Head of Fine Art at Plymouth College of Art 1964-84 and painted in his spare time. He came back to live in Penzance in 1988. His paintings exploit his love of landscape. His works are aesthetically elegant. Lines and torn edges play an important part in the tonal qualities of his compositions.

John Halkes wrote, 'Mackenzie's paintings are not overtly descriptive neither are they totally abstract. His understanding of geography and geology is as important as his aesthetic judgement. The line of a rock fault is tellingly simplified to give the sensation of a hill-side. On the surface the subtleties of lichen colours and cloud shadows are worked. A sharp movement of line suggests stone walls or sheep paths.'

Painter, printmaker and sculptor Anthony Benjamin, with his wife Stella, bought Sven Berlin's cottage at Cripplesease, near St Ives in 1955 and he began painting abstracts based on the landscape around the cottage, as well as growing flowers. The year before he was vice president of the Young Contemporaries in London. In 1958 he gained a French Government award to study

The Night Sailing, *Trevor Bell.*

with S W Hayter at Atelier 17 in Paris, after which he returned briefly to Cornwall. In 1960 he received an award to study in Italy from the Italian Government. In 1977 he was granted an Arts Council Major Award. He has held several teaching posts both in Britain and Canada. His later and best known works are minimalist sculptures and etched and engraved glass murals, paintings and wallhangings with an absence of colour.

Terry Frost met Trevor Bell at Leeds College of Art where he taught from 1947-52 and directed him to St Ives. Bell arrived with his wife on a motorcycle and rented a cottage at Tregerthen, Zennor, next door to Karl Weschke. He shared studio space with Brian Wall, the sculptor, at the Seamen's Mission, now St Ives Museum. Later he moved to a house in Nancledra, which was eventually bought by Roger Hilton. His works reflected the structure of waves and fields and were abstract based. He painted industrial landscapes and the Cornish coast. In 1958 he held a solo show at Waddington's and in 1959 he toured in an Arts Council show Six Young Painters.

Anthony Benjamin, 1959.

He left St Ives in 1960. He became Gregory Fellow at Leeds University and taught briefly at Ravensbourne, Bradford and Winchester Schools of Art. He is now living and teaching in America.

Karl Weschke arrived via Holland at a prisoner of war camp in Britain. He decided to remain in England and studied at St Martin's School of Art in 1949. He travelled to Spain and Sweden and after meeting Bryan Wynter in London moved to a cottage at Tregerthen. He met Francis Bacon in Cornwall in 1959 and bought a cottage at Cape Cornwall near St Just in 1960, where he still lives and works. He was granted Arts Council Major Award in

The Fire-Eater, *Karl Weschke, 1984-86. Redfern Gallery.*

Painting, *1959, Anthony Benjamin.*

Carbis Bay and Godrevy, *Kate Nicholson. P E C Smith.*

1976 and South West Arts Major Award 1978. He was a John Moore's prizewinner in 1978.

Weschke paints aspects of living which he gives permanency by his paintings. He tries to retain the immediacy of vision of the first artists who painted about life. Experiences, or happenings, are portrayed in his paintings.

Clifford Fishwick was for 25 years principal of Exeter College of Art from 1948. He combined a career as teacher and painter and formed close associations with St Ives artists, Lanyon, Feiler and Bell. His work in the 1950s showed similarities with William Scott and Kenneth Armitage, who were influencing other West Country artists in their respective roles as heads of painting and sculpture at Corsham. Austin/Desmond Fine Art exhibited Fishwick's work 'Painting Around the Fitfties', a period in which he was preoccupied with harbour scenes and fishermen at work.

A childhood visitor to St Ives with her parents was Kate Nicholson, daughter of Ben and Winifred Nicholson. She was born at her mother's home in Cumbria and studied at Bath Academy of Art 1949-54. She taught at Totnes High School 1954-56 and afterwards moved to St Ives. Her first solo show was at Waddington Galleries in 1959. In the 60s and 70s she painted in Greece with her mother, exploring movement in colour. She lived between Cumbria and St Ives, until her mother's death. There was a close relationship between mother and daughter.

Kate Nicholson said her father disliked fuss and pretension and remembered his beautifully sculptured abstract lines, but she always tried to be different and to look at the real thing rather than transcribe thoughts and ideas into paintings.

Ben Nicholson's first wife Winifred, née Roberts, who also used the name Dacre, was born in Cumberland, the grand-daughter of the 9th Earl of Carlisle. She studied at Byam Shaw School of Art, London. She married Ben in 1920. They spent several winters at Lugano in the Italian Swiss Alps and travelled in Europe meeting up with many of the avant-garde artists such as Brancusi, Helion, Arp, Hartung, Kandinsky, Giacometti and Mondrian.

Jim Ede decribed Winifred, when he knew her in the 1920s, as a leader not only in painting but in life. Three children were born 1927-31, Jake, Kate and Andrew. Her permanent home became Banks Head in Cumberland. In 1928 Ben, Winifred and Christopher Wood visited Cornwall, staying at a cottage in Feock near the Brumwells. Athough they divorced shortly after Winifred retained a lifelong friendship and correspondence with Ben.

Winifred was always interested in light and its relation to colour. An early interest in exploring prismatic colour remained throughout her life. Kate Nicholson recalls that her mother loved white and bright light and found it particularly satisfying to paint white damask tablecloths and silver domestic ware, which were so beautiful and luminescent.

In 1987 the Tate Gallery held an exhibition of the paintings by Winifred Nicholson 1893-1981, which showed works featuring St Ives.

Native of Mousehole, Jack Pender, returned to his village in 1956, where generations of his family lived. He studied at Penzance School of Art 1938-39. After war service in the Duke of Cornwall's Light Infantry he studied at Athens School of Art for a year. On his return he attended Exeter School of Art 1946-49 and the West of England College, Bristol 1949-50.

His first solo exhibition was at the Arnolfini Gallery, Bristol in 1963. He was made a Bard of the Cornish Gorsedd in 1965. He was included in the St Ives exhibition at the Tate Gallery in 1985 and in the collection Celtic Vision which opened in Madrid in 1986 and toured. His first London one-man show was at the Belgrave Gallery in 1990. His work is based on his Cornish environment, the boats and harbour, combining figurative and non-figurative elements. Mousehole harbour is the view from his window and the activity of his native fishing village is the main subject of his painting.

1956
Modern Art in the United States

An event which might be said to have changed the course of art history was the exhibition of American art at the Tate in 1956. Entitled Modern Art in the United States, it attempted to cover the principal directions of abstract art over a period of 40 years. Most of the work was drawn from the collection of The Museum of Modern Art, New York, which they had acquired since the founding of the

Black Punts Waiting, *Jack Pender. Belgrave Gallery.*

144

Museum in 1929. Although the Tate had exhibited American Painting from the Eighteenth Century to the Present Day in 1946, this was the first major exhibition devoted entirely to 20th century paintings and sculpture from the States to be shown in Britain.

One room was devoted to Abstract (Expressionism) and included work by Clifford Still, Ashile Gorky, Franz Kline, Willem de Kooning, Mark Tobey, Robert Motherwell and Jackson Pollock to Abstract (Impressionism) with Mark Rothko and Philip Guston and to (Geometric Abstraction) with Fritz Glarner and Irene Rice Pereira. The works also included those of the Modern Primitives, the Realist Tradition of Fact, Satire and Sentiment to Contemporary Abstract Art and the Romantic Painters.

Patrick Heron, as art critic and London correspondent for the American magazine *Arts,* from 1955-58, was able to bring his critical judgement to bear on the exhibition of American paintings. Moreover he recognised a new move taking place; the influences of abstract art were turning from Europe to America. He heralded the show as 'the most vigorous movement' since the war and commented that English painters would watch New York as eagerly as Paris. For a short time these exciting images from America influenced Heron's own work, but after the 1959 exhibition of American paintings he realised his ideas of asymmetry conflicted with the stricter regime of balance in the American work.

A prime movement in the ascendancy of the American painters occurred in the thirties depression when the American government employed about 5000 artists, who mostly recorded contemporary scenes of poverty and unemployment. Against this backwash of Social Realism paintings the Society of American Abstract Artists organised an exhibition of their work in 1936 and during the forties and fifties abstract art became a dominant force. Leading to the establishment of this position was the opening of a gallery by Peggy Guggenheim in 1942 named Art of This Century. She was the principal supporter of the Surrealist group of painters and the gallery was the centre for the avant garde in New York. Motherwell, Rothko and Still were given one-man shows.

Younger artists had benefitted from an improved art education, provided and influenced by immigrant artists from Europe. Having little tradition to compete with they looked for inspiration within their own environment, the vast expanses of landscape, air and space, the architecture of New York, and the freedom of thought of the country, from which to develop a whole new painting style.

Meanwhile the St Ives painters were following their own lines of progression. Wilhelmina Barns-Graham exhibited 44 works at the Scottish Gallery in Castle Street, Edinburgh. A painting from this exhibition was purchased by the Scottish Arts Council.

Nicholson won a 10,000 dollar Guggenheim award for an abstract oil painting 'Val'd'Orcia'. The picture, which measured 7ft. x 4ft., was placed first among submissions from 19 countries. The award was presented by President Eisenhower at the White House. This same year he also won first prize for painting at the Sao Paulo Biennale. Nicholson had truly arrived in the art world in the fifties and many more awards were to follow. In his later years he returned to making reliefs on a large scale.

Ever vigilant, Peter Lanyon, in another of his broadsides to the Press, complained about an additional grant awarded to the Penwith Society from the Arts Council for educational purposes, while there was no support for 'realism.' He said the Newlyn Society had been unable to obtain a grant but the St Ives Society were financially more fortunate by reason of a clause in the Borlase Smart Memorial Fund 'which permits them to return to the two Porthmeor Studios which they occupied before moving to the Mariners Church.'[18] Continuing their educational programme the Penwith invited a leading architectural historian, John Summerson, to give a lecture on contemporary British architecture.

Barbara Hepworth joined the Arts Club and wrote, 'I look forward to being a member of the St Ives Arts Club next season and I appreciate your offer of the hospitality of the club meanwhile.' Malcolm Haylett produced a programme involving visual and kinetic shows, one such featured a piece of Hepworth sculpture displayed on a revolving platform, with a Denis Mitchell mobile. "Barbara had never seen her work viewed from all angles in movement. She was thrilled. Music was played, with moving lights and Wm Walton music."

1957 Exhibition at the Redfern Gallery

As if in answer to the exhibition of American abstract art at the Tate in 1956 the Redfern Gallery, which had been showing the work of Heron for 10 years and given several solo shows to St Ives artists, mounted an exhibition of abstract painting devoted to British artists in 1957. 'Metavisual Tachiste Abstract' apparently did not get a pleasing reception from either the public or the critics. The title alone one would have thought would be off-putting for the introduction of new ideas to the public.

The exhibition brought together the work of Nicholson, Pasmore, Heron, Wynter, Davie, Scott and Hilton, as painters associated with Cornwall. The following year Heron held a one-man exhibition of his striped paintings, of horizontal and vertical bars of colour, at the Redfern Gallery. Some years later this same series of work was shown at the Museum of Modern Art in Oxford.

Following the Redfern exhibition Sir Herbert Read, President of the Penwith, gave a lecture on Tachism at the Society. Tachism, he explained, was the name the French gave to the latest international movement in painting. He said 'The creative artist must draw images from the deep unconscious levels of his personality.' The lecture was illustrated by slides of the paintings of Wassily Kandinsky, Jackson Pollock, Mark Tobey, Sam Francis, Sandra Blow and others.

Sir Herbert Read was the President of the Institute of Contemporary Arts, member of the British Council Fine Art Committee and a director of a publishing house. His numerous books on art and literary criticism were

Herbert Read in Hampstead, c.1933. Behind is Ben Nicholson's painting Le Petit Provençal.

translated into several languages. He had recently brought out a book of poetry called *Moon's Farm* and continued to write poetry thoughout his life.

Bryan Wynter was invited by the Redfern Gallery to hold a one-man exhibition of 25 oil paintings on large canvases. One of these works was bought by the Arts Council, 'The Mineral World', which measured 5ft. x 4ft. In 1957 Wynter showed three paintings in an international exhibition in Tokyo. Also Wynter and Lanyon represented English painting in Chicago.

A portrait painting by Fuller was bought by the Dean and Chapter of St Paul's Cathedral to hang in the recently built Chapter House. The painting of the Dean W R Matthews was completed in the Dean's House but was on exhibition in Fuller's studio on Show Day.

The Question of Studios

The *St Ives Times and Echo*, in an interview with Nicholson, recorded his belief that St Ives was the most important art centre in Britain after London. He thought it remarkable that a place as small as this town should have attained this distinction and suggested a long-term plan to provide residential studios to attract more artists to St Ives. The BBC followed this up with an interview with Nicholson and Heron and sought the views of various other artists. An American artist, Florence Leo Barlow, said she had been seeking a studio without success and finally bought and restored a house in the Digey. She had studied at Stockholm and New York and had three solo shows in the last five years.

Later in the year a former box factory at Carncrows above Porthgwidden beach was bought by Percy Williams and Sons of Redruth and was being converted into a block of residential artists' studios, which included a house with a pottery workshop and four studios, each with living accommodation. Three of the studios were occupied by Kate Nicholson, Billie Waters and Guy Worsdell. The County Planning Officer arranged for Henry Gilbert, who lived close by at Rock House, to advise on the conversion of the box factory building.

Percy Williams' next project was the Barnaloft flats. The designer was again H C Gilbert. The block overlooked Porthmeor Beach and comprised 10 residential studios, 7 flats, four cottages and a larger residential suite. The site was formerly used for pilchard packing and salting cellars. The building was made to harmonise with its surroundings with the use of granite, vertical slating, tiling and weather boarding. Both projects were awarded diplomas and medals for design.

The finishing touch to complete the Piazza and Barnaloft flats was the erection of a piece of sculpture by Barbara Hepworth in each courtyard. These were the first pieces of sculpture to be displayed in the open air in St Ives. The sculptures were a bronze, 'Two Forms in Echelon', and 'Single Form with Two Hollows', in Roman stone.

In 1966 Miss Octavia Elfrida Saunders bequeathed two cottages in her will to the Arts Council to be occupied by practising artists. One was Seal Cottage in Back Road West and the other 5 Bowling Green.

Porthmeor Studios.

Annual General Meeting of the Penwith Society

At the AGM of the Penwith Society Denis Mitchell, retiring as Chairman, said that the Society was now known everywhere that art was discussed and this was because at the beginning members believed that they were forming a vigorous centre of contemporary work. He welcomed new members Karl Weschke, Janet Leach and Patty Elwood. The new Chairman was Bruce Taylor the potter, J T Roach was elected treasurer and Keith Leonard secretary. Serving on the committee were Mitchell, Bell, Wynter, Mackenzie, Heron and B Leach.

A unique scheme to raise funds for the Penwith Society was devised by members who produced miniature paintings, sculpture and pottery. A tea set was made by Bernard Leach and other ceramics were by Janet Leach and William Marshall. A tiny metal sculpture was designed by Brian Wall and forms in alabaster were made by Elizabeth Andrews. Other sculpture was by Denis Mitchell, Barbara Hepworth, Roger Leigh and Bruce Taylor. Paintings were by Bryan Wynter, Alexander Mackenzie, Robert Brennan, Gwen Leitch, Keith Leonard, Stuart Armstrong, Patrick Heron, Guy Worsdell, William Paynter, Wilhelmina Barns-Graham, Bob Law, Misome Peile. Drawings for sculpture were by John Milne, Lorna Heath and Trevor Bell.

Penlee Park, Penzance, was the venue for an exhibition of sculpture in the open air organised by the London County Council 'Sculpture 1850-1950' and included the work of Henry Moore, Charles Wheeler, Sir Jacob Epstein, Reginald Butler and Barbara Hepworth.

In August Sven Berlin, who had recently left St Ives, received a commission of £1,000 to produce a carving for the entrance hall of an administrative building for the International Synthetic Rubber Company, near Fawley. Berlin was now living in a caravan in the New Forest with his wife Juanita, which he described as his last stop to eternity.

Unveiling of Barbara Hepworth sculpture Single Form with Two Hollows, *1963. H C Gilbert.*

Martyrdom of St Catherine, *1956, Alan Davie.*

Wilhelmina Barns-Graham and Trevor Bell were invited to exhibit at Wakefield's 'Modern Art in Yorkshire'. Bell, a native of Yorkshire, had gained his diploma at the city's art college, while Barns-Graham's connection was her part-time teaching post at Leeds College of Art.

The death was recorded in 1957 of Agnes Drey, who first came to St Ives in 1932. She had been a student of painting in England and France with Frances Hodgkins. Her sympathies were with the modern school. She exhibited regularly with both societies in St Ives as well as Newlyn and with the Women's International in London. During her last illness two portraits, of herself and F Hodgkins, were purchased for a New Zealand gallery. It was said her compositional, colour and movement values, which make a picture, were always present in her work. A close friend was the painter Emily Eleanor Rice who died in 1962 and was buried in the same grave.

Alan Davie regards his paintings as a continuous process, working on several paintings at a time in different stages of completion, in a flowing of the life force. "When I am working, I am aware of a striving, a yearning, the making of many impossible attempts at a kind of transmutation." He is also a professional jazz musician.

He travelled widely in Europe and in 1948 met Peggy Guggenheim, who bought his 'Music of the Autumn Landscape'. Among her collection he admired the paintings of Rothko, Motherwell and Pollock. He travelled to Spain and visited Picasso. In 1950 he had his first one-man show at Gimpel Fils, for which he remained a gallery artist. At an exhibition in New York he was chosen for the Guggenheim International Award. From 1956-59 he was Gregory Fellow at Leeds University. He taught at the Central School of Art for a year. His paintings are mostly brightly coloured and richly patterned with symbols of magic and religion, reflecting his interest in Buddhism, primitive art and mysticism.

He held a solo exhibition at Gimpel Fils, Major Works of the Fifties, in 1987 and showed at Wolf at the Door in Penzance in 1991. He spends part of the year in St Buryan, Cornwall.

Bob Law started concentrating on painting in London

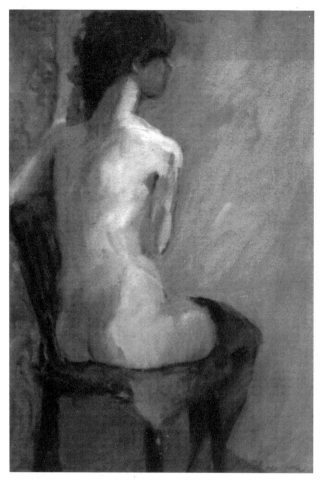

Girl with Red Hair, *1991, Rose Hilton.*

service he taught art at Port Regis Preparatory School and Bryanston School 1946-47. He began producing abstract works in the early fifties and used a limited palette of the primaries and black, white and earth colours. He taught at Central School of Art 1954-56. He won prizes in the John Moore's Exhibitions 1959 and 1963 and showed at the Venice Biennale in 1964.

He became ill and was confined to bed in 1972 and this had a marked effect on his work, reflecting the pain of his illness. He was married to the painter Rose Phipps, who had to give up painting in order to minister to the demands of the invalid. After her husband's death Rose Hilton gradually resumed painting, regaining the confidence and surety of herself as a painter. She had studied at the Royal College from 1954-57 and travelled to Rome on a study scholarship. She had hardly started on her career as a painter when in 1959 she met and married Roger Hilton and brought up her children. Rose Hilton's paintings are of people and the atmosphere created around them in their activity, which is often in pursuit of pleasure. Her colours blend and merge and are always bright.

In 1957 Sandra Blow stayed with Patrick and Delia Heron and rented a cottage at Tregerthan below Eagle's Nest. She returned to London in 1958 but made frequent visits to Cornwall over several years. She studied at St Martins School of Art 1942-46 and the Royal Academy Schools 1946-47. She lived and studied in Italy, Spain and France. Her first solo show was at Gimpel Fils in 1951. She exhibited widely nationally and internationally. Her non-figurative work was large scale and dynamic and included elements of collage of differing materials. She concerned herself with balance, proportion, tension and scale in her work. She taught at the Royal College of Art in 1960. In 1979 she had an exhibition at the Royal Academy. Her painting 'Two Figures' was purchased by the Contemporary Art Society.

In 1957 the novelist Dorothy Richardson died in her 84th year. She first came to Cornwall when she was 40 by invitation of the novelist J D Beresford, who allowed her

in 1956. He moved to the village of Nancledra near St Ives in 1957 and lived in a house later occupied by Hilton. He is a self-taught artist. Law has the idea of his work in his mind's eye before bringing it to fruition. He often engages in serial painting to achieve the quality of work he is forever seeking.

He painted and made pots until 1960. The following year he was awarded a French Government Scholarship to work in Aix-en-Provence and held his first exhibition at the Grabowski Gallery in London in 1962. He taught in several colleges of art in England between 1964-71 and took part in a BBC film 'One Pair of Eyes' in conversation with Tom Stoppard at the Tate Gallery, London.

There was a retrospective exhibition of his work at the Whitechapel Art Gallery in 1978. In a series of works he produced paintings of fields of colour and black and white which are clearly defined by a border and of a minimalist nature.

On the invitation of Patrick and Delia Heron, Roger Hilton spent a few days with them in Cornwall in 1956 and the following year he rented studio space in Newlyn overlooking the harbour, which he used for a few years. He moved permanently to Cornwall, living at Botallack, and became part of the St Ives group.

Hilton studied at the Slade and in Paris. After war

Farmhouse, *1974, Roger Hilton.*

to stay in a cottage he had converted from an old ruined chapel. She wrote a series of 13 novels with the title of *Pilgrimage*. She was married to artist Allan Odle. Both of these writers are now out of print and largely forgotten, but it was Beresford who loaned D H Lawrence his cottage in North Cornwall before his move to Zennor. In 1918 Beresford was sufficiently influential to write to the Royal Literary Fund in support of a request for financial assistance for Lawrence. He wrote that his great misfortune was his refusal to write anything less than his best and his genius appealed to a very small public. Lawrence received £50 from the fund.

1958

The most noted event to start the year was the honour conferred on Barbara Hepworth who was created CBE in the New Year Honours List. She said 'I owe St Ives a tremendous debt: living here has meant a very great deal to my work. It is not just landscape, but the community, the town and everything about the place.'

Another, sadder, event for St Ives was the departure of Ben Nicholson. He lived at Trezion, Salubrious Place, St Ives after his divorce from Hepworth. In 1957 he and his third wife Maria Felicitas Vogler, a doctor of philosophy, photographer and writer, decided to live in Switzerland. At the same time J P Hodin brought out a book on Nicholson, *The Meaning of his Art*.

At the Penwith Society AGM the ruling defining members into a category of A or B (figurative or abstract) was abolished. The Society now consisted of 24 painters, 8 sculptors and 8 craftsmen. The committee were Barns-Graham, S Armstrong, Hepworth, B Leach, R Leigh and Kate Nicholson. The summer exhibition was said to embrace traditional and modern experimental works.

'The strong influence of the environment is in the work of artists living in West Cornwall. In his painting 'Sirens' L Fuller has a richness of quality of paint and depth of feeling for the moods of the coast and in a small wash drawing by T Bell one can feel the calm of the boats in the harbour. P Heron's 'Red Layers with Blue and Yellow' is inspired by the sunset over the sea and in the later work 'Red Sea' the focus is shifted from the impact of the whole to an intense observation of the variations of red in the centre of the sun. There is also an increasing sense of strong colour form in the work of Bryan Wynter and of Barns-Graham, who has been experimenting with the juxtaposition of red, blue and mauve masses in her recent work. J Wells is represented by three small works typical of his fine sensitive use of colour but in this show A Mackenzie is only showing two monotypes which illustrate the basic structure of his paintings. The younger artist Kate Nicholson has developed considerably in the past few months and in her paintings this summer there is a fresh vitality in the introduction of a wider, more adventurous colour range. B Pearce is another young painter and it will be interesting to watch his development. In the sponsored contribution to this show the most outstanding work is provided by Gwen Leitch,

Abstract, *c.1954, Sandra Blow.*

who is gradually absorbing more local atmosphere and Stanley James who has submitted two of a series of Cornish landscapes.'[19]

Exhibiting sculptors were B Wall, J Milne, B Taylor and B Hepworth, with pottery by B Leach and embroidery by A Moore.

At Newlyn the novelist Howard Spring opened an art show of the early Newlyn School, which included works by Elizabeth and Stanhope Forbes, Tuke, Langley, Gotch, Bramley, Tayler, Garstin, Henry Martin, Sherwood Hunter, Harris, Bourdillon and Fred Hall. A selection of the work of Alethea Garstin occupied the newly opened lower gallery.

Two films were made in St Ives in 1958. The first was for the BBC *Tonight* programme which featured Fyfe Robinson asking the question 'Why do artists like to live in St Ives?' Interviews took place with D Mitchell, B Taylor, J Barclay, L Fuller, H Ridge and Harry Symons, the local plumber, who had known many of the painters.

The second film was for the programme *Monitor* and took in the areas of St Ives, Zennor, Newlyn and Mevagissey and again an attempt was made to answer the question 'Why do artists come to Cornwall?' Many artists were interviewed or filmed while at work, including Hepworth, Heron, Lanyon, Wynter, Weschke, Taylor, Wall, Bell, Redgrave, Barns-Graham, K Nicholson, Leach and Stanley James, lithographer. The sculpture of Mitchell, Leigh and Wall was filmed among the rocks on Porthmeor beach. W Sydney Graham wrote some introductory script. Material was also collected for a film on the painter Alfred Wallis with taped interviews of local people which had been collected by GP Dr Roger Slack.

As a continuation of the education programme of the Penwith, Alan Bowness of the Courtauld Institute was invited to give a lecture on Cézanne. He began by quoting Matisse, who said that Cézanne was not an Impressionist painter because he always painted the same picture. Throughout his life Cézanne's chief concern was with figures in landscape. His last picture was 'The Bathers'. Bowness said Cézanne's work naturally led on to Cubism

Gouache No 2, *Patrick Heron. Belgrave Gallery.*

and Tachism, which was one reason why he continued to be an inspiration to painters of the present day.

Bowness has written several books on art history. He married Sarah Nicholson, daughter of Hepworth, and was later to become the Director of the Tate Gallery. He was knighted for his services to art in 1990.

In London at the Drian Gallery an unusual exhibition was taking place. It was unusual by reason of showing four sculptors and two painters. The sculptors were Mitchell, with wood carvings, reliefs and sculptures in plaster for bronze, and Roger Leigh, who previously worked as an architect before moving to Nancledra. Brian Wall's work took the form of rectilinear constructions in steel and coloured plastic. All three sculptors were working as assistants to Hepworth. Bruce Taylor, whose work was shown the previous year in a one-man exhibition, showed new work in plaster, welded metal and bronze. The two painters were M Peile, whose work reflected changing light and atmosphere, and Gwen Leitch, who came from Tasmania in 1954. This was her first London show of work mainly abstracted from landscape.

An American painter visiting St Ives at this time was John Hubbard. He met many of the painters in the town and made return visits for a number of years. Francis Bacon, the English painter whose work was gaining an international reputation, arrived and began painting in number 3 Porthmeor Studios. He was a friend of the writer Norman Levine and was kind to his young family of children, sending Christmas presents and on his visits talking matters of 'profound importance.' At various periods visits were made by other painters from New York, Mark Tobey, Helen Frankenthaler and Larry Rivers, as well as gallery owners and eminent art critics.

In the summer the American painter Mark Rothko paid a visit to St Ives and stayed at Little Parc Owles with Peter Lanyon and his family. He had come to Cornwall hoping to find a chapel to decorate. Lanyon took him to meet his cousin, James Holman, who was chairman of the engineering firm of Holman Brothers of Camborne, and his wife, the actress Linden Travers and Patrick Heron. Linden said, "Rothko was one of the top American painters. He was a charming and quiet man and subsequently when I was in New York I telephoned him.

He was painting in a remote chapel. He said to me, 'Painting is such agony.'"

England and the admiration for his work by enthusiastic English painters was much appreciated by Rothko, and English critics wrote lengthy articles in his praise. His work was well received in his one-man show at the Whitechapel Art Gallery in 1961, held as a consequence of exhibiting with the American painters at the Tate in 1956 and 59.

Rothko donated 9 paintings to the Tate Gallery in 1969, stipulating that they should be shown together in a room on their own. The following May the Rothko room opened to the public, but he had committed suicide three months earlier. After his death William Scott and Paul Feiler wrote a letter to *The Times* in recognition of his vital contribution to landscape painting through colour and light and influence on young English painters.

Bryan Pearce's work was gaining recognition and five of his paintings were accepted for exhibition in Sloane Street. It was stated 'Bryan's talent has unfolded during the past four years while he has been attending Mr Fuller's School of Painting. Mr Fuller has taken a personal interest in Bryan's development as a natural painter and he and other leading members of the colony foresee the possibility of a big future for the pictures of this young man.'

John Wells was awarded the Arts Critics' prize for painting, and the names of Roy Conn and Janet Leach began appearing in reports of exhibitions. Bernard and Janet were married in 1956 and she took over the management of the pottery. Janet had studied pottery for three years in the USA and then for two years in Japan before coming to Cornwall.

On Show Day 45 studios were open to the public. Among those showing work at St Ives School of Painting were two local 12 year old boys, Eric Ward and Stuart Peters, both were to become painters.

Patrick Heron lived in Cornwall as a child. He studied at the Slade School of Art from 1937 for a year and a half. "I didn't want to study perspective, or drawing, or art history. I just went for two days a week and then I walked out." His fellow students were Bryan Wynter and Adrian Ryan. He married Delia Reiss and moved to London in 1945. The years between 1945-58 were spent painting, and in his spare time writing art criticism, along with designing for Cresta Silks, a textile firm created in 1929 by his father Tom Heron. As a boy of 14 he first began to design for Cresta. His reasons for writing on art were a lack of understanding by the majority of critics to what Heron saw as a modern renaissance, and he hoped to promote and gain acceptance for the work of artists to whom most were hostile. He wrote reviews for *New English Weekly, New Statesman and Nation,* and *Arts New York.* He taught at Central School of Art 1953-56.

Heron bought Eagle's Nest, Zennor in 1955 and in 1958 took over Nicholson's Porthmeor studio. The move to Zennor marked a change to total abstraction in Heron's paintings. Following his Taschist paintings, he produced

a series of striped canvases in response to the variety of flowering trees in his garden which is high on a promontory overlooking fields below and the sea beyond.

Bowness wrote *On Patrick Heron's Striped Paintings,* 'One should remember that these striped paintings were the first ever seen anywhere. We are now familiar with the idea from many sources, and in particular from the late pictures of Morris Louis, all done well after Heron's vertical bands.' Ronald Alley, writing in *Studio International* in 1967, 'The Development of a Painter' also claims a first for Heron with his series of striped paintings. 'A picture like "Vertical Light 1957" even anticipates the striped paintings of Morris Louis which were not executed until several years later.'

Gaining a Porthmeor studio stimulated a change to soft rounded abstract shapes and soft cornered rectangles, with colour dominating. His overriding interest was in colour, which he said was the subject and the means, the form and the content. His stained glass window, which he has designed for the Tate Gallery St Ives, reflects his interest in colour.

The permanent move of Patrick Heron to St Ives brought another major influence to the arts community. Heron's collection of essays and articles on art and artists, *The Changing Forms of Art,* was published in book form in 1955.

Penzance-born Margo Maeckelberghe returned to live in a William and Mary house in Cornwall after a period in Gibraltar. As a child Margo knew she wanted to paint and whilst still at school she attended art classes in the evenings at the Penzance Art School under the tutelage

Margo Maeckelberghe in her studio, 1974.

Scilly Blue Round, 1987, Margo Maeckelberghe.

of Bouverie Hoyton. Later he was horrified to learn that she had chosen to attend the Bath Academy of Art at Corsham and not the more sober Slade, at which she had also been offered a place.

Margo said during her three years at Corsham the whole meaning of painting became real and exciting, "William Scott was head of painting, Peter Lanyon was there, Bryan Wynter, Terry Frost and Kenneth Armitage taught sculpture. I admired Scott's ability to simplify." Bath Academy had become a centre for the avant-garde painters.

The land and seascape of Cornwall is the vital force in her painting. She is concerned with space and light and air and the feel of a place. "I don't paint places but try to show the thrust of a wave or the weight of water, or the feel of an approaching storm and the light breaking on the horizon. A painting has to be abstract to harness and structure the way that the land meets the force of another element, the sea."

From 1958-62 Joe Tilson owned a cottage in Nancledra. His landscapes were said to be the landscapes of the modern city. He used materials such as wood, plastics, photographic images, newspapers etc and came nearer to Pop Art than many of his contemporaries. He worked in Italy and Spain for two years and was instructor at St Martin's School of Art 1958-63. He was visiting lecturer at the Slade, University of London and King's College, Oxford and in the School of Visual Art New York in 1966.

He won prizes in John Moore's exhibitions 1957 and 1967 and several European prizes. Exhibited in London, New York, Milan, Rome, Hanover, Berlin and Venice. In

The Shadow Accompanied by her Rope Dancer, *1971, Tony Shiels.*

1976 he held an individual exhibition of his work at the Institute of Contemporary Arts, London. He was commissioned to design murals for the Royal Garden Hotel, London, Heathrow Airport, and Brunel University Library, Middlesex.

Tony 'Doc' Shiels lived in London and briefly in Paris before settling in St Ives. When he arrived in the area his work was influenced by friend and neighbour, Peter Lanyon. "He was very friendly and helpful, a good man. He also liked my work. He, Dick Gilbert and other painters of that era created powerful images of Celtic landscape, by which I was heavily influenced." When Shiels found his own style of painting, his images became more surreal, with strange marine creatures and human oddities. Beween 1979 and 1985 he spent time in Ireland, producing paintings of Irish imagery.

In 1986 he published the first issue of *Nnidnid,* a surrealist magazine. He is variously described as a poet/playwright, Shaman of the Western world and a modern monster hunter. With regard to this a book called *Monstrum A Wizard's Tale* with an introduction by the writer Colin Wilson was published in 1990.

Wallis Exhibition

As part of St Ives Festival an exhibition of the work of Wallis was shown at Studio 36 next to the Penwith premises in Fore Street. It was opened by Albert W Rowe, a relative of Wallis who said he fondly remembered the old man who couldn't stop painting. Wallis had given him 30 to 40 paintings but they had all been burned along with other items from his attic. Bernard Leach, who presided at the show said he would not use the word genius in relation to Wallis, as Sven Berlin had done in his book. Also supporting the festival, which was co-ordinated by Malcolm Haylett, was an exhibition of St Ives sculptors in Trewyn Gardens.

The Tate Gallery benefitted by a gift from Adrian Stokes of two paintings by Alfred Wallis, they were 'Schooner Under Moon' and 'Voyage to Labrador'. These Wallis pictures were the first in their collection. The following year another Wallis, 'St Ives', was presented by Ben Nicholson. The Tate purchased an oil painting by Terry

Frost and drawings by Hepworth and Nicholson. Trustees of the Tate had recently acquired a number of works by artists of the past 100 years, including two of A Stokes and portraits by Sickert painted in the thirties.

1959
St Ives School of Painting

In April the St Ives School of Painting celebrated a Coming of Age party. Leonard Fuller said he had been enticed away from London by his old friend and war comrade, Borlase Smart. He had opened the school in 1938 and over 1,000 pupils had attended, many of them now successful and accomplished artists. The premises had previously been the studio of Arthur Meade and at another time a school of painting run by Job Nixon. At one time a chance call at the School by Leonard Fuller had saved the building and whole block of artists' studios, when firewood stored by the slow burning stove had caught alight. Had the fire taken hold Leonard and Marjorie's studios would have been burned together with the studios beneath belonging to Hyman Segal and John Barclay.

By 1963 the School of Painting was celebrating its Silver Jubilee. Over the 25 years pupils had come from many parts of the world, including USA, Canada, Australia and New Zealand. The main tuition had always been on orthodox lines but all shades of artistic outlook had been welcome. The school had been recognised by the American Embassy after the war and had received several American servicemen as students. Fuller hoped the tradition of providing an outlet for art students in a town known for its art and artists would continue long into the future.

In 1977 Roy Ray took over the school, after the death of Leonard Fuller and at the request of Marjorie Mostyn. He knew the Fullers well from his annual visits to the

Model Miranda Phillips with students at St Ives School of Painting. David Crane.

school in the sixties. The first few years of running the school were difficult, with lack of students and funds. By the early eighties the school was realising success and partly because of this, and the demands of his own painting, Roy Ray invited other painters in their specialist fields to assist with the teaching. He feels this to be one of the school's strongest assets — students are taught by artists in an art colony. These artists are John Charles Clark, Bob Devereux, Stephen Dove, Malcolm Haylett, Kathy McNally, Sheila Oliner, Ken Symonds, Roy Walker and Peter Ward.

Success Outside Cornwall
St Ives artists were enjoying some success outside Cornwall. Another award was winging its way to Hepworth. Her sculpture 'Orpheus' won a major prize of 4,000 dollars at the International Exhibition of Modern Art, Sao Paolo, Brazil. She had sent a selection of work in wood, carvings, stone, bronze and drawings, executed over the past 20 years at her home at Trewyn studio. She was also working towards a solo show in New York later in the year and some 30 sculptures were prepared.

Enjoying her first solo exhibition at Waddington Galleries in Cork Street, was Kate Nicholson. At the Primavera Gallery in Sloane Street, Janet Leach and William Marshall held a combined exhibition of 350 pots.

Guy Worsdell held his first one-man show in the John Whibley Gallery, Baker Street, London. He studied at the Central School of Art under Meninski and was included in the Arts Council exhibition '52 Book Illustrators'. Trevor Bell received a prize for painting at the Paris Biennale des Jeunesses in the form of a scholarship for 6 months residence in France.

In the John Moore's exhibition at the Walker Art Gallery, Liverpool, Patrick Heron won the main prize of £1000 for his abstract work 'Black Painting, Red, Brown and Olive' 1959 and a second prize of £400 was awarded to Peter Lanyon for his abstract painting 'Offshore'.

Representing the figurative painters of St Ives at the Royal Institute of Oil painters, Piccadilly, were Helen Stuart Weir, Bernard Ninnes, Leonard Fuller and Dorothy Alicia Lawrenson.

Future of the Penwith in doubt
A local reporter writing on an exhibition of the Penwith Gallery in 1959 observed that the society appeared to be suffering from the success of a number of its members. This was evidenced by the absence of some and the sparse representation of others. He said that members who had moved into more lucrative fields in London and New York still had a responsibility towards their own gallery and were ungrateful to their Society.

This article accords with a letter sent to professional members of the Society by the Chairman Roger Leigh, which suggests that Leigh was the writer of the article in the paper. In his letter he tries to rally members to greater efforts and interest in the affairs of the Society but also says that perhaps it had run its course and the

internal problems should lead to a revision of the constitution. However, the Penwith still managed to mount an exhibition of 100 works to celebrate its 10th anniversary and the exhibition travelled to Middlesborough, Nottingham, Cirencester, Eastbourne, Norwich, Cardiff and Liverpool Galleries. Later, for unspecified reasons, resignations were received from Bell, Frost, Heron, Hilton, Wynter and Wall and five other members were against the Society continuing.

The New American Painting
In 1959 an exhibition at the Tate Gallery was arranged by the Museum of Modern Art, New York, with the support of the Arts Council of Great Britain for a show called The New American Painting. As in the 1956 exhibition, which introduced painting, sculpture and print making, Sir John Rothenstein was Director of the Tate and Norman Reid, Deputy Director. This collaboration in introducing 20th century American painting to the British public was a confirmation that America had taken over the role of leader in the promotion of modern art. Indeed, from 17 painters showing their work only Gorky, de Kooning, Tworkov and Rothko were born outside the United States. It denoted a change in direction and thinking towards Europe as the fount of development in art movements, to America and American artists.

The other painters were all born in America, W Baziotes, J Brooks, S Francis, A Gottlieb, P Guston, Grace Hartigan, F Kline, R Motherwell, B Newman, J Pollock, T Stamos, C Still and B W Tomlin. Although all the artists were concerned with abstraction the only similarity in the work was in the large size, some as big as mural paintings. 'Despite the high degree of abstraction, the painters insist that they are deeply involved with subject matter or content. The content however is never explicit or obvious even when recognisable forms emerge.' The show travelled to Paris, Zurich, Barcelona, Frankfurt, The Hague, Vienna and Belgrade, stating the dominance of American art in Europe.

Clement Greenberg, the American art critic, visited Patrick Heron at Eagle's Nest and stayed there for several days. He had first met Heron in London in 1954 and on his return to the USA had suggested to Hilton Kramer, editor of *Arts New York,* that he should invite Heron to become the London correspondent. Heron resigned from the post in 1958. Heron formed a two-way introduction of abstract expressionist artists from New York with St Ives Moderns, namely Davie, Frost, Hilton, Lanyon, Scott, Wells, Wynter and himself.

Heron's first enthusiasm for American painting had begun to wane by the sixties and he began to find faults with their way of working, which compared unfavourably with the British painters. In an article in *Studio International* for December 1966 he denigrates a symmetrical mode of working adopted by the Americans: 'This symmetry, or centre-dominated format, has become a vast academic cult, evident even in the best Americans. The British 'middle generation' never fell for this: we

Kodak 1, *1968, Roy Conn.*

never abandoned the belief that painting should resolve asymmetric, unequal, disparate formal ingredients into a state of architectonic harmony which, while remaining asymmetrical, nevertheless constitutes a state of perfect balance, or equilibrium.'[20]

Heron also objected to the self-congratulatory writings of the Americans and their dismissive and sparse comments on British art. Quite a change from the mid-fifties position when writers like Heron drew the attention of the American critics and public to the painters in their midst. Artists such as Davie, Scott and Lanyon had also spread the names of the Americans before their canvases arrived in London.

In asserting the rise of British painters over the Americans, the latter were said to have repeated the formats by which they had arrived and so not advanced towards new ideas. Or there was a total rejection of all that had gone before to conjure something new.

The Sixties
The New Influx of Painters
The 1960s marked another era in St Ives. A new influx of painters arrived, equally ambitious to paint, equally adventurous in exploring ideas, of being part of an artistic community, but not equally financially fortunate. These were mostly people who had sacrificed a wage in order to paint. Theirs was a different background. In the majority the previous group, who formed the avant-garde in modern painting, were already destined to be painters, sculptors and potters. It was just a question of choosing what they wanted to be. They mostly had financial support, even if quite small, but it enabled them to live. The incomers were mostly from a working class background with no family money to act as a safety net and no public school background providing an old boys network.

The first example comes to light through an exhibition

of Michael Dean who came to St Ives and washed dishes through the summer to enable him to paint during the winter. He and Elena Gaputyte, a Lithuanian-born sculptor, held a joint exhibition. A statement to the press explains their aims, 'We want people of St Ives to see our work and to know about our approach to art. We want them to come and discuss our work and argue about it with us if necessary.' Michael Dean was born in Yorkshire and studied art in Newcastle-under-Lyne and Camberwell Schools. One of the largest paintings in the show was 'Abstract Townscape St Ives'. There were also figurative works, and drawings showing their development as artists. Elena Gaputyte had studied and worked in Paris and America and had recently arrived in St Ives. Other artists were Alan Wood in 1959 and in 1960 Tom Pearce, a Welsh sculptor who came to work with Hepworth, and a Canadian sculptor, William Featherstone, who lived in West Penwith for 11 years.

The sixties were noted for the arrival of Pop Art, although it developed during the fifties. It was the art of the ready-made, taking sectors of modern life, the town, mass production, consumer goods and transforming them into a new art vocabulary. Pop Art, especially from America, was a reaction to Abstract Expressionism, a revolt against the narcissistic and inward vision which emanated from those artists. It was also a broadening art form which made art more accessible.

In England it coincided with the rise of the pop scene generally in clothes and the availability of goods, houses and holidays. Pop Art, especially in music, declared the evolution of the new culture of the young generation who threw off the restrictions of a repressive society. Suddenly the young refused to be allocated their 'place' and class imposed boundaries, which had previously existed, were swept away in a social revolution.

In St Ives the incoming painters were little influenced by the new Pop Art and were more closely related to the work of the contemporary painters in the town. Tilson, Shiels and Davie made diversions into Pop Art.

One of the first new arrivals was Roy Conn. He is mainly self-taught as a painter but gained experience by association with many artists, Ben Nicholson in particular. His interest is in flat planes and pure colour areas. Shape and line play an important part in his liking for uncluttered surfaces. He started painting in 1952 and moved to St Ives in 1958 and No 1 Porthmeor Studios. He is often described as an abstract, hard-edge painter but he is also influenced by nature and his work also features representational elements. The sand and sea all around is a source of inspiration. In the last few years his interest has been in photography.

A year later Bob Crossley arrived. His first painting came about through cleaning the brushes of a signwriter. In 1941 he joined the RAF and served in Italy where he was impressed by Morandi and Chirico. He exhibited with the Forces in his first show in Rome. In 1948 he exhibited with Rochdale Art Society, Paris Salon and was elected to Manchester Academy. L S Lowry bought a Crossley

painting from his first London Show at the Reid Gallery in 1960. He had visited Lowry at his home, was shown his recent paintings and asked to name the colour for an object in the work, Crossley did so and Lowry squeezed the colour from a tube and completed the picture. Frost was the first artist who befriended Crossley on his move to St Ives.

In 1987 he held a restrospective of his work at the Penwith Gallery. The 100 works on view recorded an achievement of 45 years of painting from figurative drawings of war-time experiences to abstract landscapes of primary colours with heavily scored brush marks. These later works denote his true obsession with paint.

It was while selecting paintings for his retrospective show that he uncovered drawings and watercolours he made as a wireless operator during the war. The RAF museum at Hendon showed an interest and bought 10 for their permanent collection. "My personal experiences had become historical documents."

By 1959 Gill Watkiss had adopted Cornwall as her home. Her work is so evidently influenced by the south-west wind, which blows constantly across the Atlantic to this peninsula that to live anywhere else would seriously disrupt it. She closely observes the effects of wind and weather on the local community and its people and records their resilience and zest for life. A painter at one with the elements and in sympathy with the landscape and its humanity.

Tony O'Malley made his home in St Ives in 1960. His first visit was on a painting holiday in 1955 to study at St Peter's Loft Studio. He had worked in a bank and on retiring through ill-health he turned to painting full time with the support of his bank pension. He worked also in the Scillies, in the Bahamas and in Ireland. All of these environments are reflected in his paintings, the tonal greys of St Ives, the tawny field patterns of Ireland and the brilliant coloured foliage of the Bahamas. His work became increasingly abstract. In 1981 he was awarded the Douglas Hyde Gold Medal by the Irish Arts Council. In

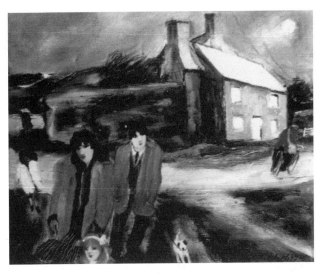

Winter Walkers, *1992, Gill Watkiss.*

1985 his work was included in the Tate Gallery's show St Ives 1939-64. In 1989 he was made an honorary member of the Royal Hibernian Academy in Dublin, the equivalent of a Royal Academician. He left with his wife Jane to live in County Kilkenny, Ireland in 1990.

The Sail Loft Gallery

Gaputyte opened the Sail Loft Gallery, Pier View. Its inaugural exhibition showed the work of Peter Blakeley, Bob Crossley, Derek Guthrie, P Lanyon, A Lowndes, W Redgrave, K Weschke and Gaputyte.

The next show tended towards the figurative. Lowndes showed three landscapes and a figure drawing. Lanyon 'a puzzling little portrait of a girl titled Forget-me-Not' and Derek Guthrie, several seascapes. Patrick Hayman's paintings were 'sensitive and poetic with a tendency to sentimentalise.' There were two 'exotic portraits' by Redgrave and Pender's paintings were local scenes, 'sometimes figurative, otherwise tending to abstraction.' Crossley showed 6 works, 'There is now movement and more abstract interest in his work. His landscapes are now concerned with creating a tension between shapes in depth and the line of the horizon.' K Nicholson's drawing was a 'spiky abstraction and Gaputyte's drawings were described as 'some of the best in the show.' Kasiulis and George Rackus showed prints, Byron Temple and Richard Jenkins, pots, and wood sculpture was by John Milne.

In April 1962 the Sail Loft featured the work of Tony O'Malley. The reviewer stated, 'In this town there have been so many works of dubious modernity whose origins need so many cross references to the fag ends of worn out movements that it is good to see the work of a man who knows what he is doing. The paintings with their savage and sombre colours have the visual conviction of life itself, and all the humanity that the painter can bring to his art. Paint here is used for the real purpose of the medium and not just an alternative to coloured paper, newsprint or hardboard. Whether the subject is an interior, or a wreck on the Wicklow coast or an ancient Celtic origin, the individual aloneness and universality of

Landscape, *1987, Bob Crossley.*

Sculptor's Garden, *1981, Tony O'Malley.*

the artist is indelibly stamped on each work; a quality which is rapidly becoming a rarity.'[21] Following on from O'Malley was the work of Patrick Hayman who showed 60-70 paintings.

Another new gallery, Steps Gallery run by Tony Shiels, opened at 4 Academy Steps, and exhibited work by Barns-Graham, Anthony Benjamin, M Dean, Patrick Dolan, Alan Wood, Robert Brennan, Jeff Harris, J Leach, R Leigh, Gwen Leitch, Roy Conn and Bob Crossley. With Kenneth Coutts-Smith, Shiels put on a surrealist show, 'Exposition of Wonders and Delights'. Shiels said "A lot of local artists went surreal for the occasion. My reasons for mounting such a show had to do with my rapidly changing attitudes towards the rather 'clubby' atmosphere of the colony and its polite styles of painting and sculpture. I wanted to be genuinely subversive."

Side by side with the newcomers the established painters continued their progress, Terry Frost flew to New York for his one-man show at the Bertha Schaefer Gallery, New York. He had returned to St Ives in 1957 to paint full time. In America he met Mark Rothko, Willem de Kooning, Kline, Motherwell and other abstract expressionists and the art critic Clement Greenberg. He exhibited in several cities in the United States during his career.

Frost was now a regular exhibitor with Waddington's in London and had shown work with the British Council's travelling show which visited Leningrad, Moscow, Mexico and Australia. Henry Moore, the sculptor, bought a Frost painting from the Russian exhibition. Terry Frost was also trying his hand at designing in silver for an exhibition of contemporary jewellery held at the Victoria and Albert Museum.

Paintings in oils by two St Ives and two Newlyn artists were purchased by the Plymouth City Art Gallery for their permanent collection. They were L Fuller's 'On The Verandah', Alan Lowndes' Cornish scene of the Digey, 'A Street in St Ives', Mary Jewels' 'Salt Boat' and a Cornish landscape by Michael Canney, Curator of Newlyn Art Gallery, who also organised the exhibition.

In its Annual Report, the Arts Council listed grants of £583 to the Newlyn Society of Artists, which must have satisfied Lanyon's frequent requests for support, and £250 to the Penwith Society.

The Gas Works Site

An interesting article appeared in the *St Ives Times and Echo* in April 1960. 'St Ives Town Council have declined a request from the Penwith Society of Arts asking them to consider providing an art gallery as part of the development of the gas works site at Porthmeor. The Society had indicated that they would have to leave their present gallery in Fore Street in March 1961. The Council confirmed a recommendation from the Housing Department that the Society should be informed that as the gasworks site was purchased for housing purposes, it was not possible to consider their proposal.'

'Another request from the Penwith Society asking if the Council could help with financial assistance and/or land or premises for a new Art Gallery has been referred to the Publicity and Entertainments Committee for consideration and support. The Penwith Society, with adjoining property at 36 Fore Street, owned by Mr and Mrs Bruce Taylor was for sale. The Council told the Society they had no site they could lease or sell but the Council would be prepared to investigate the possibility of assisting them.'

This assistance was soon to become a reality when suitable new premises were found in the building which was formerly St Peter's Loft School in Back Road West, with the addition of the pilchard packing factory below to convert to a gallery and studios, at the cost of £4,300. The purchase was made possible with the aid of a grant of £4,500 from the Calouste Gulbenkian Foundation and a loan of £1,500 from St Ives Council for refurbishment purposes.

It was felt that St Ives' status as a world art centre was recognised by this grant and the Penwith Society patted itself on the back for having established 'a nursery to the avant-garde in painting and sculpture.' It was also claimed they had produced 'more artists of standing and more impact on the art world than any other society in the country.'

Thirty years later this same gas works site was to become the home for St Ives artists' paintings and sculpture in the Tate Gallery of the West.

1961

The New Penwith Gallery

Wounds seemed to be healing with the advent of the new gallery until a letter composed by Mackenzie, Mitchell and Snow was distributed to members and those recently resigned, but also included Lanyon, who had resigned in 1950 and refused to show with the Society, although invited to do so on several occasions.

The letter complained that power in the Society was held by the same few, who refused to relinquish, or share, that power with a younger group, and was the reason for the resignations of Frost, Bell, Heron and Wynter and the continued refusal of Lanyon to be associated with the Society. It was suggested that imaginative steps were needed to promote the Society's progressive nature and that long-serving Committee members should retire and act as advisers, leaving the younger element to run affairs.

A letter from Barbara Hepworth followed saying that she considered it an attack on her ideals and motives and tendered her resignation. She had only put her name forward because of the £4,500 Gulbenkian grant — which sounds as though it was largely through her influence and name that the grant was made.

Following upon this the Chairman, in agreement with the Committee, wrote to her requesting that she remain a member of the Society and the representative on the Civic Trust. Hepworth agreed to both. She was re-elected to the Committee in 1964.

After the major row at the Penwith, their next show produced a number of new names, Patrick Dolan, Tony Shiels, George Rackus, John Peace, Michael Heard, Robert Brennan, Tony O'Malley, Jeffrey Harris, Dorothy Mead, Dick Gilbert, Margo Maeckelberghe, Helen Clarke, Giles Auty, Bob Bourne, Victor Bramley, Patrick Fishwick, Clifford Fishwick, Brian Robinson, Bill Newcombe, Jeremy Le Grice, Jane Furness, Dr M Marx and Scott Marshall.

Tony Shiels was elected to the committee, a step he afterwards regretted as it often involved him in ugly arguments, "In those days many of us became more than a wee bit fed up with the heavy influence of the Hepworth/Leach team. I remember moaning about Barbara to Alan Bowness, who was about to write a catalogue introduction to my early London show. My dealer kicked me under the table. I gave a yelp and Bowness laughed." In spite of the slight on his mother-in-law he still wrote the introduction, calling Shiels a painter to watch.

Later in the year Sir Herbert Read opened the new gallery of the Penwith and congratulated St Ives on their magnificent premises. He described it as one of the most beautiful places for the exhibition of art he had ever seen. He was introduced and welcomed by Dame Barbara, who was one of the exhibitors in the inaugural show. Sir Herbert Read said he assumed there was an organic relationship between the art produced in the region, and the light, landscape, buildings and people.

November's winter show at the Penwith brought forth the comment that the main trends in construction were still based on Cubist tradition as in Breon O'Casey's work, or the elegant collages of Simon Nicholson, 'the only painter who so far is using pure formalism.' Roy Conn was described as getting movement with his flat colour and B Pearce also with a series of early watercolours. It was said that with the notable exception of Bordass's painting 'Black Melancholy' there was no sign of 'a relaxation of the straight line priority.' Lanyon's construction 'Airspace' 'has the spontaneity so lacking in some of the oil paintings.' This is the first time Lanyon had exhibited with the Penwith for many years.

Arnolfini Gallery of Bristol was showing a special exhibition related to Cornwall. It was stated that the dominating source was the Cornish landscape and frequent traces of the influence of Gabo, Nicholson, Hepworth and Wallis were discernible. The artists included Barns-Graham, Michael Broido, Crossley, Leigh, Mackenzie, Mitchell, Simon Nicholson, Tom Pearce, Pender, Shiels and Taylor.

Breon O'Casey, son of the Irish playwright Sean O'Casey, began making an appearance in St Ives as an assistant to Barbara Hepworth and Denis Mitchell between 1959-62. He attended Dartington Hall School in Devon and studied painting for three years at the Anglo-French Art Centre, London. He is painter, weaver and jeweller but considers himself primarily a painter and is happy sharing his time between the three crafts. He designs and makes jewellery in precious metals and held his first solo show at Somerville College, Oxford in 1954. His paintings are in the collection of Kettle's Yard, Cambridge and the V and A. He served as Vice-Chairman of the Penwith Society 1967/68/69.

French-born Minou Steiner came to England from Paris in 1958 and to Cornwall in 1961, where she was attracted by the primordial landscape of West Penwith. It is an influence which pervades her work. Flowers and nature are an important element. Her paintings are explosions of brilliant colour. Her work is exhibited in England and France. She is equally comfortable using a palette knife as a brush and many works have a distinctive texture and

Song, *Breon O'Casey.*

Roses, *Minou Steiner.*

bold colours. She began painting at an early age and is entirely self-taught.

Bryan Pearce, a native-born painter, attended St Ives School of Painting. Very quickly Leonard Fuller realised that he should be left largely to develop his own natural style. His paintings are naïve, but strong in colour and line and are meticulous in their execution. He paints full time and compulsively. He held his first solo show at Newlyn in 1959. As a child Pearce suffered brain damage which affected his mental development. Mary Pearce, his mother, was also a painter but gave up her studio and interest in her own progress to foster Bryan's desire to paint. He uses colour naturally and in ways other painters would find daring. In 1992 he held a major retrospective show at the Penwith Gallery. His paintings convey a sense of peace and contentment.

In the sixties Bryan spent two weeks with his parents at Kettle's Yard, Cambridge with Jim Ede, surrounded by paintings, pottery, sculpture and found objects of nature collected over a lifetime. Ede had become a family friend from the time he first bought two oils and three watercolours in the early days of Bryan's career. He later wrote in the introduction to a catalogue for Bryan's exhibition at Falmouth Art Gallery, 'If anyone is in need of peace, trust and joy, they will find it in the work of Bryan Pearce. He gives with his whole being, totally free of sophistication and totally altruistic; he paints as he breathes. These stones which form a pier, this blue which surrounds a ship, this island and lighthouse, this road, church, window, flowers in their pot, a thousand visual things, are the deep unconscious quality of his interior life.'[22]

1962

Bernard Leach was awarded the CBE in the New Year's Honours list. Leach was on a lecture tour of New Zealand when the news came through. The award marked 50 years as a potter. He was also awarded honorary degrees by Leeds and Exeter Universities.

In February the painter John Park died aged 83. He had left St Ives 7 years previously to live in Brixham but after the death of his wife he returned to his native town of Preston. The Harris Art Gallery at Preston, which owned several of his paintings, held a one-man exhibition of his work as a tribute to him.

A film study of the painter Bryan Pearce was a feature of a 1962 television programme *View*, which aimed to show the artist at work against his environment. The commentary was spoken by the Cornish poet Charles Causley. At the same time Pearce was holding his first

St Ives Parish Church, *Bryan Pearce.*

one-man show in London, where most of the paintings seen in the film were photographed.

Simon Nicholson introduced a programme of films made by the Arts Council at the Penwith Gallery. They featured Hepworth and Pasmore and Leach, 'A Potter's World'. The films were directed by John Read, son of Sir Herbert Read, president of the Society. Continuing the education programme Mary Chamot, assistant keeper of the Tate Gallery responsible for arranging travelling exhibitions, gave an illustrated lecture on modern Russian painting. She spent her early years in Russia and spoke the language fluently. After studying at the Slade and also taking history of art, she then lectured at the National Gallery and the Tate. The spring exhibition of mostly large canvases provided the background for lectures and films.

Fore Street Gallery opened with the stated aim of showing work of the younger artists and to achieve a balance between figurative and abstract art. In the opening show were D Guthrie, M Maeckelberghe, D Gilbert, T O'Malley, Mary Le Grice, Peter McCullough, B Crossley, James Van Hear (Falmouth), Giles Auty and Frank Goodwin (Exeter). Each showed 6 paintings. The owner said 'The gallery is free from the difficulties that often beset societies of artists, who have to hang work to please their members.' During 1965 Roy Conn arranged exhibitions for Liz Rainsford, who owned the gallery, usually four-man shows with the occasional solo. Artists included Helen Dear, John Wells, Denis Mitchell, Robert Brennan, Bob Bourne, Michael Snow, Michael Broido, Patrick Dolan, Breon O'Casey, Brian Illsley, Don Brown, Peter Rainsford, Roger Leigh and Roy Conn.

Self Portrait, *1990, Sven Berlin.*

The Dark Monarch

In 1962 Sven Berlin published his most controversial book, *The Dark Monarch*. The author called the book fantasy but it was considered by others to be about the town and community of St Ives. The writer, also an artist and sculptor, was the main character and many people identified themselves in spite of their fictitious names. Both publisher and Berlin were threatened with court action and the book was withdrawn from the bookshops, but not before it was circulated among the townsfolk.

Surprisingly one of those who carried out the threat, claiming damages and winning his case against Berlin, was the lawyer/poet Arthur Caddick who, as a writer himself, had faced court action for similar misrepresentations. The event caused Berlin financial and personal distress. He was quoted as saying 'I am extremely sorry if I have upset anybody with the book. That was never my intention. Cornwall was my home for 20 years. I know many Cornish people who like the book very much and certainly haven't taken any offence at it. Though I expect the artists colony is being rather sensitive.'

Successes for Barbara Hepworth

From the Whitechapel Art Gallery, the Tate bought a large wood Hepworth sculpture from her exhibition.

This was the fourth piece bought by the Tate. The work was named 'Corinthos', a piece carved in wood from Nigeria with the interior of the form painted white. Other works in the show were in stone and bronze.

The previous year there was a grand opening and champagne was drunk with friends, to celebrate the acquisition by Hepworth of the Palais de Danse for £9,000. It was a huge building opposite Trewyn Studio where she felt she had room to produce large works for architecture. One such large work was her four ton bronze 'Meridian', a work 15ft. high, which was erected the previous year at State House, a new 16 storey office block in High Holborn, London. Another sculpture, 'Winged Figure', was floodlit and on display in the yard. 150 friends, craftsmen and tradesmen gathered to toast its success and send it on its way to London destined for the John Lewis building in Oxford Street. It measured 19ft. 6in. high and was cast in aluminium and steel.

A Hepworth sculpture, 'Single Form Memorial' 1961-62 shown in Battersea Park's London sculpture exhibition, was bought by the London County Council for 6,000 guineas. The piece was bronze and 10ft. high. It was intended for the lake in the park. The original and largest of this version was placed by the United Nations building

Hepworth's Studio. Fallen Images *in white marble with painting* Two Heroes *completed after the death of her son Paul.*

in New York as a memorial to Dag Hammerskjold, who was a great friend of Barbara Hepworth. Another art prize was awarded to Hepworth at the 7th International Art Exhibition in Japan, which opened in Tokyo in 1963. She was one of two British artists to win an award, the other was Gillian Ayres. Previous winners were Graham Sutherland and Henry Moore.

Hepworth was awarded the CBE in the New Year's Honours List of 1965. She received many more honours from Universities. From 1965-72 she was a Trustee of the Tate Gallery. Hepworth offered a bronze work 'Rock Form Porthcurno' to Cornwall County Council for £3,000, its true value being £9,000. She had made this special offer because she wished to be associated with Cornwall and for it to be placed in the new County Hall at Truro. The Council were pleased to accept this part gift.

During celebrations of Dame Barbara's 70th birthday her 6th work on public display, 'Epidaurus', a bronze sculpture, made its appearance at the Malakoff, where the Round Table had created a garden. The sculpture was offered on permanent loan, after the designer of the scheme, Henry Gilbert, had interested Barbara Hepworth in the project. "Come round and choose whatever you like," she said. In 1968 a large bronze, 'Dual Form', was given to the town and stands in a prime position outside the Guildhall, St Ives.

1963

Terry Frost left St Ives with his wife and 6 children, five sons and one daughter, to live in Oxfordshire. 'Frost's 16 years association with the artists colony was of supreme importance to him as an artist. He has been an influence in modern art movements in West Cornwall. He and his wife Kathleen arrived at St Ives when their eldest child Adrian was still a baby and he was grateful to the town and its people for helping him to readjust to a peaceful mode of life. Although the people of Downalong professed not to understand his art, they understood and liked the man. They were keeping on their house in Back Road East, which they had let on a temporary basis to enable them to return in the summer.'[23] In 1964 Frost was awarded a Fellowship in painting at Newcastle University and returned to teaching full-time at Reading University Department Fine Art the following year.

Spring was anticipated with exhibitions at Fore Street Gallery, St Ives Society of Artists and Penwith Gallery. Seventeen St Ives artists, with the help of Phil Rogers of the Sloop Inn, helped to raise funds for the Surf Life Saving Club. Harry Rountree's caricatures of local personalities were temporarily removed from the public bar and replaced by 17 paintings and drawings. The artists taking part were Barns-Graham, Robert Brennan, Conn, Jonathan Coudrill, Peggy Frank, Jeff Harris, Brian and Leslie Illsley, Lanyon, Lowndes, T.O'Malley, Brian Robinson, Cedric Rogers, Vernon Rose, Segal, Jan Thompson and Peter Ward.

A loss for the Leach Pottery was suffered when Kenneth Quick, a 30 year old potter from St Ives, died while on a visit to Japan. He was awarded an educational grant to enable him to travel, study and practice pottery in Japan, initially with Hamada, whose pottery was situated 70 miles from Tokyo. A St Ives man, he worked as a student potter with Bernard Leach, then for five years ran his own pottery in Tregenna Hill. He taught at summer school in Maine, USA then returned to the Leach pottery, when Bernard Leach helped him obtain the award for study in Japan. Mr Quick drowned as the result of a boating accident. A wave had overturned the boat and he and two friends were tossed into the sea. Tributes were paid by Janet and Bernard Leach at the funeral service held in Fore Street Methodist Church. Kenneth Quick had been a founder member of the Trencrom Revellers drama group.

Artists Protest
June of this year saw a letter composed by Patrick Heron supported by Barbara Hepworth, and published in *The Times,* protesting at The Admiralty's plans to use the moorland between St Ives and Zennor for troop landing exercises by helicopter. The letter was signed by 39 distinguished painters, sculptors, musicians, writers and architects. Those connected with the West Country included John Betjeman, Alan Bowness, Frank Halliday, Bernard Leach, Ben Nicholson, Priaulx Rainier, A L Rowse and William Scott. Among others were Sir Wm

Coldstream, Benjamin Britten, Dame Edith Evans and architects Maxwell Fry, Sir Basil Spence and Sir John Summerson. The plan seems not to have been put into effect.

Patrick Heron, a life-long defender of the old town, launched a broadside on the authorities in 1959 for widening the Stennack road leading into St Ives. He had suggested 10 years earlier the banning of traffic into the town during peak periods. He said to demolish the uniquely narrow streets for those who had come expressly to see the places where they once existed, would be like filling in the canals in Venice in order to accommodate the motorists who had come to see the canals.

Another protest led by Dame Barbara Hepworth, Frank E Halliday and James F Holman took court action to prevent the grassed and ancient Island site from being surfaced with tarmac. In 1966 the Council planned to use the whole of the Island for car parking. Levelling work had already begun on the site overlooking Porthmeor Beach but this was halted on the authority of the High Court, which ordered the Borough Council to cease operations. It was claimed the Council were acting illegally in taking over land which was presented to the town in 1907 for use as public space.

After two years of negotiation the Council issued a statement agreeing to limit the amount of ground to be used for car parking on the island. The site was restored and top soil replaced and no further legal action was necessary.

Frank Halliday had rallied support through meetings of the St Ives Trust, of which he was chairman. At a further meeting at the Arts Club 'The Friends of St Ives' was formed to protect and preserve the beauty of the town against development.

In another environmental battle some years later Dame Barbara, Leach and Heron called upon the Environment Minister, Anthony Crosland, to revoke an outline planning permission for the development of a holiday complex at the former clay works on an isolated moorland, Penderleath, near Towednack. Heron stated that it would open the way for other developments on areas of outstanding natural beauty. This action was supported by the Friends of St Ives and also Ben Nicholson, now living in Hampstead, who offered £500 to open a fund to enable Penwith Council to pay the site owner compensation to which he would be entitled if planning permission were revoked. Bernard Leach contributed £100 and the fund-raising was eventually taken over by Peter Laws, Chairman of the Cornwall Branch of the Council for the Protection of Rural England. £2000 was raised. Other bodies fighting the building on the land were the Cornish Building Group, Cornwall Conservation Forum and the Friends of the Earth.

After four years planning permission was revoked on the Penderleath site and the district valuer's report estimated a total of £24,000 should be paid to the owner. This recommendation was sent to the Environment Minister, Michael Heseltine.

1964
The Death of Peter Lanyon

The most momentous event to devastate St Ives in 1964 was the death of Peter Lanyon. He died as the result of a blood clot after a gliding accident. He had taken up gliding in 1959 and this activity had a significant effect upon his work. He described the thermal currents of hot air that he experienced while gliding as a world of activity as complex and demanding as the sea.

Not only was Lanyon a Cornishman and native of the town but he was also one of its foremost artists. Although he was constantly at odds with other local artists he was nevertheless regarded with affection by those who had been his friends in the early years of his painting career. Barbara Hepworth said at his funeral 'He was a unique spirit — a spirit that was perhaps airborne. I don't suppose he knew how much we all thought of him, but we did love and admire him tremendously.' Patrick Heron said he was one of a half dozen British artists whose reputation was truly international. One feature of his art which was constant was the marriage of figuration and abstraction. He was buried in Lelant Parish Church.

The previous year Peter Lanyon had painted a major mural for the Arts Building of the University of Birmingham which was considered by some to be his finest achievement. The mural occupied a complete wall. 'It has no title and the subject is the mingling of landscape and architectural forms, grass, trees and elusive shadows, together with more solid brown and reddish architectural forms.'

Lanyon had also completed a ceramic mural for the Civil Engineering Building of the University of Liverpool. The building was designed by the architect Maxwell Fry, responsible for many buildings in the International Style. The mural was named 'The Conflict of Man with the Tides and Sands', a study of the forces of nature which Lanyon constantly strove to capture in painting and which the University studied in terms of physics and mathematics. The mural was composed of 750 six inch white ceramic tiles and measured 9ft. 10in. x 28ft.

In 1965 South and West Programmes broadcast a tribute to Lanyon under the title *The First of the Cornish Painters*. Those who took part were Dr A L Rowse, a fellow Cornishman, Mark Rothko who spoke his tribute from America, Alan Bowness, art critic and friend, Clifford Ellis, principal of the Film Academy of Art where Lanyon was a visiting lecturer, artists Adrian Stokes, Paul Feiler, Michael Canney and the writer Norman Levine. Others were Dan Rouncefield, a St Ives baker and William Spencer, with whom Lanyon played dominoes. Also in the programme were discussions between Lanyon and some of his contemporaries. To end the tribute W S Graham read his poem written for Peter, *The Thermal Stair*.

An oil painting by Peter Lanyon 'Two Place 1962' was bought from his executors and presented anonymously to the County Council for hanging in the new County Hall building in Truro.

In 1964 the Tate Gallery held an exhibition 'Painting

Random Patterns, *John Charles Clark.*

and Sculpture of a Decade 1954-1964', made up of artists in mid-career and showing sufficient of their work to record their personal development during the decade. It included the major painters and sculptors who had made a name for themselves in St Ives and in their field of art and also European and American artists. The Cornish contingent were Adams, Davie, Frost, Gabo, Heath, Hepworth, Heron, Hilton, Hitchens, Lanyon, McWilliam, Nicholson, Pasmore and Scott.

The New Generation
Some of the new arrivals in St Ives began showing at the Penwith and other galleries and so marked the beginning of changes and renewal. What is certain is that most of the incomers were either trying to combine a serious painting commitment with a full-time or part-time job, were teaching art or had taken the plunge and given up their jobs, cutting their expenses to a minimum, and were supporting themselves and families by some means or other, or were risking all to paint, and perhaps crippling their creativity with worries over income.

Some were part-time graphic designers, postmen, supplied bed and breakfast in the season, worked in cafes in summer to support themselves in the winter when they could paint, or lived on small pensions. Others relied on a partner working to provide the necessities until they could establish themselves as painters, both within the community of St Ives and to succeed in holding exhibitions outside the county.

John Charles Clark was one of the next wave of newcomers in 1965. He describes his painting as conceptual with formal and symbolic content and is far removed from the formal training of Camberwell, and the London College of Printing where he studied. Athough he feels words limit the flexibility of art for both artist and viewer he describes starting his work as a dialogue with canvas and paint. His early influences were the Kinetic Movement and American hard edge abstraction, but he states there is now no dominant influence. He was an award winner in Sainsbury's Images for Today competition in 1982. He first visited St Ives in

1964 and had tea with Barbara Hepworth and talked sculpture. He also met Bernard Leach, Roy Conn, Marie Yates, Dick Gilbert and many other artists. He became Chairman of the Penwith Society in the early 1990s following on from Roy Walker, but resigned in 1992.

Although painter Pat Algar had been in St Ives since 1964, she kept a low profile and did not mix with the artists' circles nor seek to exhibit her work in local galleries. Her first solo was offered by Porthmeor Gallery, St Ives in 1992 when other painters suddenly became aware of her work.

She studied at Wimbledon College of Art for five years where she gained her National Diploma in Art and Design and won a place at the Royal Academy Schools to study for a further three years. She was awarded a silver medal for her painting and gained the Royal Academy Schools Certificate in 1959. Her paintings are intimate interior studies with figures and include mirrors, chairs and fruit and convey a contented domesticity, a quietness and calm. Colours are often muted and tonal with a textural quality.

1965
This was a good year for the Penwith Society under its new chairman, John Crowther, an architect from Truro, with vice-chairman Alexander Mackenzie. The committee were R Leigh, J Leach, B Hepworth, J Pender, K Nicholson, D Guthrie, M Peile and B Taylor.

In the first Penwith Society show of the season a sculpture by Henry Moore, 'Locking Piece', which weighed nearly half a ton, had been hauled through the streets from the Wharf by trolley and the willing arms of several artists. The lorry had been unable to reach the

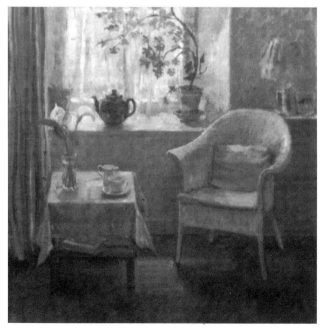

Interior, *Pat Algar.*

gallery because of road works.

In a later show works by Epstein and Moore formed part of the most impressive exhibition of modern sculpture in the Penwith Gallery. There were 52 exhibits, amongst which were Epstein's maquette for 'Madonna and Child' and Moore's 'Seated Figure Against a Curved Wall'; Reg Butler's 'Bronze Torsos'; Kenneth Armitage's 'Figure Lying on its Side' and Hepworth's 'Icon 1957'. Other exhibitors were Brian Wall and Denis Mitchell. The sculpture formed part of the Arts Council's collection which had been built up since 1946.

For the autumn Penwith show John Crowther invited 40 distinguished guests from the art world to a reception before the autumn exhibition was opened by the art critic Dr J P Hodin. Guests included J J Sweeney from Houston, Texas, Professor A M Hammacher from Holland, Professor G C Argan from Rome, Professor Gregor Paulsson from Sweden and G S Whittet, editor of *Studio International*. On show were 8 pots by the Japanese artist potter Shoji Hamada, 12 Bernard Leach pots, as well as those by Janet Leach, Denis Lane, Benny Siroto, Marie Crowther and William Marshall. Barbara Hepworth's 'Sea Form Atlantic' shared the sculpture courtyard with Roger Leigh's 'Diamond Discharge' and Denis Mitchell's bronze 'Porthcressa'. Paul Mount, a newly elected member, showed four pieces of sculpture. The drawings and paintings section covered a wide range of styles and included works by J Harris, A Mackenzie, B Pearce, Barns-Graham, K Nicholson, B O'Casey, R Conn, D Gilbert, T O'Malley, J Pender, M Maeckelberghe, J Wells and Don Brown.

1966

Roy Walker moved to St Ives in 1966. He describes his work as brushy, fluid, abstract painting based on residual

Storm Bird, 1988, Roy Walker.

Robert Culwick in his studio, 1985.

memory of the Penwith area and the elements of wind, storm and sea. He uses a variety of materials and techniques and enjoys making constructions. He studied in Kent and Central School of Art, London. He launched into full-time painting in 1972. "This was frankly a frightening move as I had a wife and three children to support and yet I knew it was the right time." He has always had full encouragement and help from his wife Peggy. This first year he received moral support from Tony O'Malley, Douglas Portway, Hyman Segal and Breon O'Casey. His first solo show was held at Camel Gallery, Wadebridge in 1973.

His interest in etching led him to direct the Print Workshop at the Penwith and later that year he was allocated No 2 Porthmeor Studio. His use of steel for etching came about through his experience of working in the car industry. In 1975 his life as a working artist was featured in a BBC film. He taught etching and printmaking at Plymouth College of Art and Design and was one time Chairman of the Penwith Society. In 1991 he held a major solo show at the Annexe Gallery, City Hall, Truro.

1967

In 1967 Robert Culwick moved to St Ives. He believes that a painting should speak for itself, the spectator bringing his own experience to the work to discover what the painting is saying. "The word which comes to mind to sum up my paintings is 'silence'. There are levels of awareness to be penetrated which the word cannot approach, but which paintings can."

Texture is important in his work. Shapes develop when colour is applied and are kept very simple to allow the colour, as an emotive language, to be read and felt. His paintings are images from the subconscious imagination. His work is minimalist and his colour tones resemble those of Mark Rothko's dark range of depth and quiet reflection.

A student from Falmouth School of Art, Colin Freebury came to St Ives in 1967. Colour plays a major role in his

Douglas Portway in his studio, 1983.

work in the way it is applied. He enjoys the spontaneity of painting, which often produces a thick complexity of colour. Also important is the precision in cutting out coloured canvas shapes to be applied to the main background colour. "What helps is that you can move these relief forms around until you achieve the desired effect."

His work is purely visual and not representative. He experiments with colours and forms, laying pieces out like a giant jigsaw puzzle, which he can select and discard to the purpose of his design. Some of his more recent work carries paint in heavy impasto with a multicolour ground.

South African born Douglas Portway studied at Witwatersrand University and the School of Art 1941-42 and taught painting there until 1945. He began as a figurative painter but turned to abstracttion. In the USA in 1952 he saw an exhibition of the Abstract Expressionists and was bowled over by the vigour and freshness of Kline, Motherwell and in particular Rothko. These paintings opened up a new world of possibilities. Portway lived and worked in Spain, The Netherlands, Germany and London between 1956-67. His first solo exhibition was at the Drian Gallery, London 1959. He won the gold medal at the 1971 European Prize for Painting Exhibition at Ostend, Belgium. He occupied a Porthmeor studio in St Ives and lived at Salubrious House. He visited France regularly to paint. He died in 1993 after an illness.

Kathleen Watkins was appointed curator of the Penwith Gallery and is still serving in this capacity.

1968

In April of this year, with the support of the Arts Council, an exhibition of the work of Alfred Wallis was held at the Penwith Gallery. Jim Ede of Kettle's Yard, Cambridge contributed the largest loan of paintings. A portrait of Susan Wallis was loaned by Mr Care of Back Road West, who owned the cottage in which Wallis had lived. The catalogue was prepared by Alan Bowness and the show was afterwards exhibited at the Tate Gallery in London. At an auction at Sotheby's a Wallis painting, 'A Large House', done in pencil and oil on the back of a GWR poster, was sold for £110. Other Wallis paintings fetched £220 and £100. They were bought by the Crane Kalman Gallery.

A few years later St Ives Old Cornwall Society, through a request by its President Stanley Cock, appealed for donations towards the cost of a commemorative plaque to be placed on Alfred Wallis's cottage in Back Road West. David Leach, the potter, offered to make it at cost price. The following year, 1974, Patrick Heron officiated at the unveiling and Dr Roger Slack afterwards gave a talk, played recorded memories, and showed slides of Wallis paintings to a large audience at the Penwith Gallery.

A film of Wallis, *In the Wake of the Wind-Ships* was made by and shown on BBC South West in 1975 and '76. The film was reported as showing many paintings never before seen by the public and it was estimated that Wallis had painted 4000 pictures in the 17 years before he died.

Sale of Paintings

Part of the heritage of St Ives was disposed of by St Ives Town Council at an auction sale of paintings which took place in Penzance. Fifteen works, mostly large canvases,

Red Haired Girl, 1991, Colin Freebury.

had been presented to the people of St Ives by artists who had lived in the town during the early part of the century. While the sale was proceeding Mrs Lilian Hollow stood up and challenged the right of the auctioneer to sell the paintings. Her protest was ignored and she felt obliged to bid for a painting which her father, William Faull, a Mayor of St Ives in 1902 had presented to the town. The painting was 'The Cottage Supper' by William Eadie, for which she paid £45. Some time later Mrs Hollow applied for reimbursement of this money from the Council, but her claim was unsuccessful.

Leonard Fuller and Hugh Ridge had both tried to stop the sale. Fuller sought the advice of solicitors to see if legal action could be taken. Ridge had offered to restore some of the works. Both men protested that irrespective of their value, or their period or their school, an important question of principal was involved, no one could forecast how future generations would value the pictures.

The other paintings sold were 'Sunset On A Cornish Beach' by Julius Olsson £60; 'The Blue School — Mending Day' by W H Y Titcomb £30; 'Moorland Scene with Sheep and Rainstorm' by Louis Grier £20; 'Corfe Castle' by Fred Milner £37; 'Autumn Ploughing' by Arthur Meade £27; 'The Enchanted Wood' by T M Dow £24; 'Water Mill In Sussex' by J M Bromley £26; 'Cows in a Moonlit Stream' by A M Talmage £11; 'Dutch Boats' by M Lindner £11; 'Evening' by Greville Morris £15; 'The Cellist' by Harewood Robinson £12; 'Mans Head' by J M Bromley £10; 'Nuns Preparing Dressing' by S Whitehouse £9; 'Flora Dance' by G Moira was unsold. Letters of protest regarding the sale, and lack of notification to the press and people of St Ives, were received from M J Cock of Lanham's, Kathleen Bradshaw, Cyril Noall, Alan Lowndes and many other local people.

At the same time as one part of the heritage was being disposed of another part was being celebrated. Barbara

Alfred Wallis' cottage, Back Road West.

Hepworth, Ben Nicholson and Bernard Leach were granted the Freedom of the Borough of St Ives in recognition of their international contribution to the arts. Nicholson was unable to attend the official investiture because he was in Switzerland but exhibitions of the three artists, in sculpture, painting and pottery were held throughout the town.

H C Gilbert was responsible for the arrangement of the exhibition in the Guildhall, which was opened by Sir Norman Reid, Director of the Tate Gallery. Other shows were held at the library, Trewyn Gardens, the Leach Pottery, the Penwith Gallery and an outdoor exhibition of sculpture in the Parish churchyard. Dame Barbara was also made a Bard of the Cornish Gorsedd.

1969
Re-Birth of the Penwith Gallery
Sir Norman Reid, who succeeded Sir Herbert Read as President of the Penwith Society, opened the Spring Exhibition and praised Henry Gilbert for the newly designed gallery which included an outdoor sculpture courtyard, separated by glass sliding doors from the reception area and new entrance. A second small gallery was formed from the old committee rooms. Bernard Leach said, "We owe Mr Gilbert a great deal for what he has contributed to art in what used to be a fishing village."

Barbara Hepworth, Mayor Jory and Bernard Leach, Freedom of the Borough of St Ives, 1968. Wills Lane Gallery.

Newly designed Penwith Gallery.

Opening the Winter Exhibition was the Minister for Arts, Jennie Lee, who was on a general visit to Cornwall. She was welcomed by Norman Reid, the President and Marcus Brumwell, Chairman. In 1972 the Penwith Society launched its most ambitious project, to acquire 6 cottages in Back Road West, and to open four sculpture studios and four painting studios. They also hoped to establish an art museum to display the work of important artists connected with the town. This gallery was formed from a pilchard packing factory and was a separate venture under the title Penwith Galleries Limited. Dame Barbara guaranteed the purchase price for the block of buildings in which the museum envisaged housing a permanent collection of paintings associated with St Ives. Penwith Galleries Limited acquired charitable status.

The other dilapidated properties were all adjoining the Penwith Gallery and consisted of a garage, fish cellars and net lofts and cottages which required renovation. The County Council offered financial support, Barbara Hepworth contributed £8,000 and a grant was received from the Gulbenkian Foundation and other grant aid bodies. Sir Norman Reid described the Penwith Gallery as 'one of the best galleries in England.' He congratulated Henry Gilbert on the design of the buildings.

A further venture was the opening of printmaking studios with etching presses for the use of artists making etchings and silk screen prints. Roy Walker was in charge of the print workshop. In 1973 a portfolio of lithographs of 12 artists was launched to raise funds for the newly acquired properties of the Penwith Galleries. Artists in the collection were Robert Adams, Alan Davie, Merlyn Evans, Duncan Grant, Barbara Hepworth, Peter Lanyon, Bernard Leach, F E McWilliam, Henry Moore, Ben Nicholson, John Piper and Michael Rothenstein. The lithographs were printed, not at the Penwith studios, but in Curwen Studio, London. An edition of 90 copies was published. The Penwith Portfolio of 12 prints cost £880.

Wills Lane Gallery

Marjorie Parr, who owned an antique showroom in King's Road, Chelsea, in which she also exhibited one-man shows of St Ives artists, opened the Cornwall branch of her business at Wills Lane. She continued her interests in both furniture and modern paintings, sculpture and pottery and showed these to effect in domestic settings. In previous years she had dealt in antiques in Oxford and in Portobello Road market, London. In her King's Road gallery the abstract painter Guy Worsdell had held his first one-man exhibition.

Wills Lane was taken over for a few years by Reg Singh. After he moved to the Beaux Arts Gallery in Bath, Henry Gilbert (Gillie) took over and exhibited modern sculpture and paintings showing the work of Heron, Hilton, Mackenzie, the Nicholsons, Barns-Graham, Weschke, Wells, Frost, Wallis, Pearce and Sumray as well as the newer arrivals, Betowski, Whybrow, Brenda King, Jacqueline Real and Emanuel. He showed the sculptors, Mitchell, Mount and Max Barratt. He favoured the work of one potter, William Marshall.

Gillie was particularly helpful and encouraging to the sculptor Max Barratt and persuaded him to try working

Gillie at Wills Lane Gallery.

166

with slate. After many mishaps he managed to conquer the difficult handling of the material and produce some fine pieces.

Londoner Maurice Sumray studied art with his twin brother Harman. He won a scholarship to Goldsmith's College, London. Maurice and his wife Pat used to visit Cornwall, staying with Moreen Moss, a painter from Mevagissey. Maurice gave up painting for 20 years and restarted after moving to St Ives in 1968. "I didn't like the idea of living in an artists colony, but on a visit my wife Pat saw St Christopher's, which was up for sale. I offered Denys Val Baker, who owned it, a ridiculous price — thinking he would refuse — and he accepted!"

When he started painting again it was as though he had never stopped. There were the same images of 20 years ago. His subjects are groups of figures, often with a circus background. He works on each painting for over a year, using small sable brushes on large canvases. "I think it's a subconscious attempt not to produce a lot of pictures because I'm a one image man." Although he is not a narrative painter his paintings are concerned with social comment. He shows one aspect of people, the reflected images of loneliness. His figures, often mounted on a ladder, form a tableau of people looking out of the canvas with vacant stares.

His most recent, unfinished painting, 'The Crowning of Creir' is so named to confound the historians looking for connections with the ancient world. "It's just a made-up name," laughed Maurice. In 1987 the Gillian Jason Gallery selected Sumray's work to show at the International Art Exhibition in Chicago.

Canadian-born Jane O'Malley travelled extensively in Europe before settling in St Ives. Her work reflects the inspiration of her visits to the Bahamas, Ireland and the Scillies with her husband Tony O'Malley. These were essentially working holidays where most of the luggage

Maurice Sumray with his painting, The Crowning of Creir, *1992.*

was painting materials. They shared a Porthmeor studio and lived at Seal Cottage. Both premises overlooked Porthmeor Beach.

Many of Jane's paintings are of still-life set up on a window sill with the sea as background. Her subjects are always of an intimate nature and part of the daily life of her surroundings. "In exploring my still-life themes I become absorbed in an awareness of colour, line and space in both the objects themselves and the spaces between." Her eye absorbs the tonal changes inherent in the change of the seasons. She is equally at home with shades of blue, grey and white as seen in sunlight, as in more temperate moods when the sky and colours are sombre.

She came to live in St Ives in 1969 and studied at the St Ives School of Painting. In 1990 she and Tony went to live in a cottage they had bought in County Kilkenny, Ireland.

The Seventies

Although momentous events took place in the mid-seventies, with the deaths of several major artists, there were few reports of exhibitions taking place in St Ives, or elsewhere, and certainly little was noted on the activities of the newer painters now living and working in the town. They had yet to estabish a significant presence, and were

Still Life Night St Martins 1, *1987, Jane O'Malley.*

Divided Landscape, *1972, George Dannatt.*

possibly intimidated by painters, potters and sculptors who had achieved world-wide recognition for their art.

George Dannatt began showing paintings in the Penwith Gallery and thereafter showed regularly for about 12 years. He began a close association with the St Ives painters when he first visited Cornwall in 1963. Frost, Mackenzie, Mitchell and Wells were his mentors. Of Cornwall's influence he wrote, 'The circles in a landscape, the predominance of small areas of brilliant red, the age-old markings on stones and in field patterns of which I am ever aware are always there.' In 1969 he retired from his profession as a surveyor to concentrate on painting and music. He lives in Wiltshire. The Newlyn Gallery, in 1981, gave him a retrospective exhibition of work from 1960.

In 1970 Jim Ede of Kettle's Yard, which he had recently handed over to the keeping of Cambridge University, was asked to write a personal note on how Kettle's Yard was formed. This was to coincide with the large extension, designed by Sir Leslie Martin. Ede, who had studied painting under Stanhope Forbes in 1910, wrote of his meeting with Ben and Winifred Nicholson in the early twenties when he was assistant at the Tate Gallery. They opened his eyes to the world of contemporary art and he was one of Nicholson's first buyers, noting that Kettle's Yard had 44 works by him. Other artists collected and

associated with St Ives were Gabo, Hepworth, Feiler, Hilton, Bryan Illsley, Leach, Kate and Simon Nicholson, Scott, Pearce, Wood and Wallis.

Ede described his 'living space' as he liked to call it, 'Kettle's Yard is in no way meant to be an art gallery or museum, nor is it simply a collection of works of art reflecting my taste or the taste of a given period. It is, rather, a continuing way of life.' He added, 'There should be a Kettle's Yard in every university.'

In 1990 Jim, Harold Stanley Ede, died in Edinburgh at the age of 94. In 1984 he published *A Way of Life,* a book with photographs and his own personal philosophy and motivation for his collection of found and made objects in the creation of Kettle's Yard.

Ede had also devoted much of his life in promoting the sculpture of Henri Gaudier Brzeska, believing him to be one of the greatest sculptors of the early 20th century. He wrote a life of the artist published in 1930, followed by *Savage Messiah,* based on the letters between Henri and his wife Sophie, which was the source for a Ken Russell film of the same name. In a letter to the author dated 1987 Jim Ede said he had fond memories of his visits to St Ives but one connection with an unhappy nature was some time in the sixties, when he sent 30 drawings of Gaudier, on approval, to a resident of St Ives, whose name he had forgotten. These drawings were never returned and this had been a concern to him ever since. It was reported to him many years later that the recipient of the drawings said, 'We are keeping them until he (Jim Ede) dies and then take them to London for sale.' He never remembered or discovered who had the drawings and was upset because he wished to leave them to the village where Gaudier was born.

Known primarily as an illustrator, Michael Foreman is the author and illustrator of more than 100 books, many as the result of travels to distant parts of the world, but St Ives is of prime importance as a source of inspiration. "These travels reinforce my feeling for the uniqueness of St Ives,

Detail from Michael Foreman's book cover, Jack's Fantastic Voyage.

sea, weather, landscape, myths and legends, the ever changing light — and above all, the Cornish people."

He held his first solo show at the Queenswood Gallery, London in 1960 and won the Gimpel Fils prize for a young painter in 1962. He has won numerous awards for illustration and was twice winner of the Francis Williams prize awarded by the V and A, and twice winner of the Kate Greenaway medal for an artist who had produced the most distinguished work in the illustration of children's books.

Foreman began visiting St Ives in the early sixties and bought his first house in 1970. He used to rent a cottage, near the Hiltons, in Nancledra from the painter Joe Tilson, as did Peter Blake. Eventually he settled in Trezion, the house once owned by Nicholson, whose work he particularly likes, but regrets he never managed to meet him.

In 1986 Michael Foreman collaborated with the writer Eric Quayle and they produced a book, *The Magic Ointment* a collection of Cornish Legends, which has been translated into other languages. His most recent award was the Smarties Book Prize Trophy with his book *War Game* which tells the story of four friends who joined up to fight in France in 1914, based on the life experiences of his four uncles who all died in that War.

Eric Quayle is a bibliophile, and a writer. His unique collection numbers 12,000 books, many first edition and rare books. While researching the journey of R M Ballantyne to St Just for material for his children's story *Deep Down — A Tale of a Cornish Mine*, Eric Quayle discovered and bought the house Carn Cobba, on a Cornish cliff in Zennor.

Quayle started a collection of 3000 children's books in the mid 1950s when he discovered the first printed children's book in a secondhand bookshop in London. It was a German woodcut book produced in 1580. He had been to school in Germany and was able to decipher the title page, which was re-produced in his collectors' book. In 1970 his *Collectors' Book of Children's Books* was published

Eric Quayle at Zennor, 1989.

by Studio Vista, which followed his *Collectors' Book of Books*. He produced *The Collectors' Book of Detective Fiction* and *The Collectors' Book of Boys' Stories*. In 1979 he married his second wife, Sachiko Kitahara of Tokyo and they have a son and twin daughters. In 1984 he featured in the BBC series Antiques at Home with Michael Newman.

Novelist Mary Williams, at one time among the first 100 names on the Public Lending Rights list, sets her scenes in Cornwall or Wales, the counties which evoke mystery and strangeness and affect the characters in her novels. She is a master of the ghost story. Mary's own story equals any of those she has imagined. Her first fiancé was killed in a road accident in Wales. His mother was mourning the loss of a son killed in the war and this son was driving through the night, with Mary at his side, to comfort her. The road was steep and dark and the car skidded and overturned. Mary was unhurt but she spent the next few hours cradling her fiancé in her arms until he died. Her first marriage ended in divorce. She then married Bill Williams in St Ives and after his death she became Mrs Lewis.

In the seventies she produced several collections of ghost stories with her publisher William Kimber, *The Dark Land, Chill Company, They Walk at Twilight* and several novels, produced in a prolific period of writing. She also wrote a 'Woman's Diary' for the *St Ives Times*, regularly contributed the Christmas Story, and wrote books for children.

1973

Kathy McNally's Irish parentage forges the links she feels with the Cornish countryside, its moods, light, and the expanse of land and sea. She is a painter of landscape and figures. "When I look at things I think of them as sculptural forms." Her figures are strong powerful images.

She uses colour to describe landscape and in life drawing her medium is often charcoal. She responds to

Kathy McNally against a background of her work.

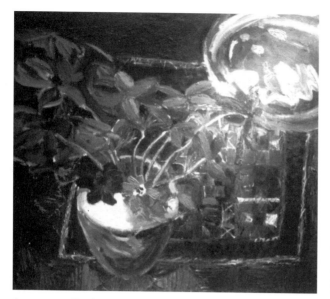

Anemones, *Pauline Liu Devereux.*

what feels right, whether it is a figure, a building or landscape and deals with basic elements, often paring back until her final drawings show how she has explored the subject.

Although Pauline Liu Devereux is primarily a painter she took a post-graduate degree course in embroidery at Manchester. Her first solo shows were held in Holland where she exhibited paintings and embroidery. Liberty of London and Seibu in Japan sold her embroidery. "My work has become more free, expressive and larger. I am interested in the paint, colour and composition, that's why I prefer painting still-life. I am not an analyst and I do not tell stories in my work." She came to St Ives in 1973. She married Roy Liu and has two sons. She married Bob Devereux in 1992.

1974

Roy Ray claims to have no formal art training but he found inspiration and opportunities for painting on visits to St Ives. His paintings are non-figurative and he makes collages and constructions, with which he seeks to evoke the special qualities of the Penwith peninsula, exploring nature's muted colours, windswept moors and evidence of man's past. It was on a flying trip over the peninsula that he saw Penwith's prehistoric settlements and this emphasised his feeling for the landscape he wanted to paint and portray.

Frank Ruhrmund, writer and art critic wrote, 'Although he finds much of his inspiration in the prehistoric relics of an unknown Cornwall, he remains essentially an artist of today.'

Roy has drawn and painted all his life but two years after coming to live in St Ives he made his serious commitment to painting. He enjoys the physical aspects of his work, the making of different textured papers and assembling these into creative collage and expressing his feeling for the way early man shaped his environment.

He has taken part in many art discussions on radio and the School of Painting has been the subject of several television programmes. He has given slide lectures on the art history of St Ives at the Tate Gallery in London and to many art societies and colleges.

St Ives born Anthony Frost explored graphics, pottery, sculpture and finally settled for painting. Further study took him to Cardiff School of Art for a fine art degree. In 1974 he returned to Cornwall and lives in Morvah, between St Ives and St Just, with his wife Linda and two sons. He commutes daily to his studio in Penzance where he paints to a background of music. In 1990 he designed an album cover and back-drop for a rock group, The Fall, for their world tour.

In 1974 his father Terry Frost retired from teaching to paint full-time and bought a house in Newlyn. Like his father, Anthony is a great colourist.

Anthony allows intuition, energy, inspiration and spontaneity full rein when he is painting. His colours are strong vibrant primaries laid on in random soft-edged squares, triangles and odd shapes. Often layered on the canvas are extra pieces of canvas, wood, rope, paper, and fragments of any interesting material to hand, which appear random in paying no attention to the confines of a frame.

He works on several paintings at a time, enjoying the pure pleasure in pushing paint around and leaving behind the educated side of his studies which taught him to analyse, criticise and intellectualise the activity of painting. He said, "I like my paintings to be colour and shape. They're to do with space, speed, rhythm and movement. It's like creating your own language."

1975

This proved a momentous year for the art colony when three of its foremost artists died. Bryan Wynter died of a heart attack at West Cornwall Hospital aged 59. During a

Trencrom, *1984, Roy Ray.*

What a Gas it was to Paint This, *1990, Anthony Frost. Bob Berry.*

Anthony and Terry Frost.

was said to be grief stricken. He designed a bronze 6ft. high sculpture 'Megalith' in her memory, which the Town Council allowed to be sited in Trewyn Public Gardens.

Three years later John Milne also died tragically, from alcohol and barbiturate poisoning. He had made previous attempts on his life but at the time of his death he was reaping some success from his work as a sculptor.

previous spell in hospital he had shared a ward with Tony O'Malley, who had also suffered a heart attack. He had lived in Cornwall for 30 years. His close friend, Patrick Heron, wrote in an introduction to an exhibition of Wynter's at the New Art Centre, Sloane Street in 1981, 'Writing in the past I devoted the greater part of my analysis, always, to the spatial realities his canvases evoked. Perhaps this was because it was in their spatial organisation that they came closest to overlapping my own pictorial interests and practice over the years... Finally, analysis fails. All we have to do is to savour the remarkable quality of these beautiful paintings.'

Roger Hilton died after a long painful illness. He was bedridden for the final months of his life and cared for by his wife Rose. They had lived at Botallack Moor, St Just for the last 10 years. During the long night hours of his illness he wrote 'Night Letters' to his wife, each page liberally covered with drawings of the female form. These pages were published in 1980 in book form. He regarded his writing as something to do between pictures, but increasingly both writing and sketching became more difficult and the deterioration is evidenced towards the end of the book. David Brown commented that Hilton could paint and write equally well with either hand.

The last tragic death occurred in May when Dame Barbara Hepworth died in a fire at her home. The fire started in her bedroom and was believed to be caused by a burning cigarette which she had been smoking when the night nurse looked in to say goodnight. All attempts made by several neighbours to reach her through the smoke and flames were to no avail. The town was shocked by such a tragedy and her near neighbour, the sculptor John Milne,

Abstract, *Roger Hilton, 1974. David Lay.*

171

Scilly Whites, *Susan Bradbury.*

Jug with Red Sun, *Brenda King.*

He was 47 years of age and had lived in St Ives since 1952 when he became an assistant to Barbara Hepworth and bought the house known as Trewyn, adjoining her garden. In 1977 J P Hodin wrote a book in tribute to his sculpture, *The Life and Work of John Milne,* and in that same year he held successful exhibitions in the States.

Brenda and Jeremy King both studied at Lancaster College of Art. Brenda went on to the Royal College and Jeremy to teacher training at London University Institute of Education. Brenda paints landscape and still-life and combinations of both in brilliant colours. She favours objects on a window sill with a background of harbour or sea or townscape. Her work is small scale and detailed. She is also a lithographer, working for French and Japanese distributors.

Jeremy left teaching in 1967 to take up painting and lithography full time and is commissioned by Christie's Contemporary Arts to create limited edition lithographs. He has also made lithographs for the National Trust. His first one-man show in the USA was held in Ohio in 1984. He has also exhibited in Japan. The Kings moved from Falmouth and bought a house in St Ives in 1985.

After studying art at Lancaster College Susan Bradbury completed her degree in painting at Falmouth School of Art and Design. Her main source of inspiration is the Cornish landscape near her home in St Ives and her garden is often her subject matter. She paints out of doors, in all weathers. She strives for immediacy in her painting and the challenge of working from nature. She is a colourist and her work is mainly abstract, painted in acrylic and watercolour. Susan and her architect husband Mike live in a cottage which was once the home of Bernard Leach and before that of the writers Edith Mary and Havelock Ellis.

1976

This year the Barbara Hepworth Museum opened to the public, with the lower ground floor given over to memorabilia, the first floor to works for an interior and in the garden various large works were displayed among the foliage and flowers. Her workshops have remained untouched since her death.

Sir Norman Reid, Director of the Tate Gallery, performed the opening ceremony and Sir John Summerson, Dame Barbara's brother-in-law, made the opening speech. He said it was her wish that the house and garden, together with all the works of art, should be given to the nation. The house and spaces in which she worked were a fitting memorial.

Dame Barbara achieved international acclaim as a sculptor. She shared her work ethics and commitment to her art with those who worked as her assistants, many of whom became sculptors in their own right. Her longest association was with Denis Mitchell, who became her chief assistant and worked with her for 10 years before setting up on his own in 1959. The painters Terry Frost and John Wells stayed one to two years. Others, who were craftsmen and sculptors living in Cornwall, were John Milne, Roger Leigh, Brian Wall, Keith Leonard, Michael Broido, Tommy Rowe, Breon O'Casey and Dicon Nance.

Charleston, *Jeremy King.*

Barbara Hepworth Museum.

Daisy Chain, *Jill Chandler.*

In April the realisation of another dream of Hepworth's came about. The new extension to the Penwith Gallery was opened by Sir Norman Reid. It was remembered that Dame Barbara had helped to obtain a Gulbenkian grant for the purchase of the old buildings, which had been transformed into a new gallery for the display of a collection of work of artists associated with St Ives. The Chairman, Marcus Brumwell, had been responsible for a five year period of fund raising for the project and had achieved the sum of £80,000.

As well as a main gallery there were five bays for sculpture and pottery. Henry Gilbert, the designer, had ensured the use of traditional materials in the conversion. The following year the first director of Penwith Galleries was appointed, with the necessary financial support from the Arts Council. Hugh Scrutton had served as director of the National Galleries of Scotland, director of the Walker Art Gallery, Liverpool, and Whitechapel Gallery in London.

Jill Chandler followed a lifelong ambition to live in St Ives and arrived in 1976 from Mevagissey. She had studied at Falmouth School of Art and was fortunate to remember Peter Lanyon at the college, who she said was a very good teacher. Her inspiration also embraces the primitive landscape, standing stones and cliff formations which are given human form and the human condition. "Truth and not prettiness is what I am seeking."

Shape, mass and form are important elements in her work, with tonal values and natural colour. Her work is sombre and quiet, catching the ancient vibrations of the area. She draws as though sculpting or carving and these drawings have the power of sculpture and the monumental presence of stone or wood.

The newly arrived Trelyon Gallery in Fore Street was opened by Kathryn and Robert Floyd, where paintings and jewellery are displayed. Kathryn studied at Newport College of Art and Design before obtaining a degree in Three-Dimensional Design at Wolverhampton Polytechnic. She first opened an enamelling workshop in the Sloop Craft Market.

Robert Floyd obtained a degree in fine art, and travelled to Italy and Australia on painting expeditions. He was a prize winner in the International Artists in Watercolour 1981. Henry Gilbert offered him a solo show at Wills Lane Gallery where he exhibited paintings of mainly life-size surfing activities, which explored striking images with a sense of movement. The Floyds moved to St Ives 1976. Robert works in a Porthmeor Studio.

Companions, *1991, Kathryn Floyd.*

Horse's Head (from the East Pediment, Parthenon), 1990, Robert Floyd.

Someone who knew from childhood that she wanted to be a painter is Morwenna Thistlethwaite. It was while she was living in the north of Scotland at the age of 14 that she met Borlase Smart who told her she should go to Cornwall when she was 17 to the St Ives School of Painting. However, it was as a mature student of 23 that she finally studied at Birmingham and Leamington Colleges of Art.

Morwenna's paintings are quiet and still. "I like a painting to be slightly mysterious. I also aim to have a total unity in the painting, with perfect balance." There is often a door or window in her pictures, or a series of rooms or paths down which figures in her paintings are escaping. Generations of her family were born in St Ives, which is why she returned to her roots in 1976.

1977
Miss Mary Ethel Hodgkins, who died in St Ives at the age of 93, left in her will paintings by Ben Nicholson and three

sculptures by Barbara Hepworth to the Tate Gallery. Also included were paintings by Wilhelmina Barns-Graham, Terry Frost, Patrick Hayman, Alexander Mackenzie, John Wells and Denis Mitchell. An earlier benefactor living in St Ives was Helen Margaret Knapping, herself a painter, who in 1935 bequeathed her estate to the Trustees of the National Gallery. Other benefactors were the Tate and the National Gallery of Wales.

Bernard Leach
Bernard Leach celebrated his 90th birthday with several hundred guests at the Penwith Gallery. The following year two of his books were published, *Beyond East and West* and *The Art of Bernard Leach*. His first book of note was published in 1944, *A Potter's Book*. He produced many books and with failing eyesight in 1974 dictated on to a cassette. On Leach's 91st birthday his great friend Shoji Hamada died. He was in his eighties and the last time he had visited St Ives to see Bernard was in 1973. His son, Atsuya, was a guest potter at the Leach pottery for two

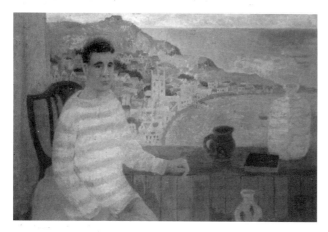

Paul Vibert with view of St Ives Harbour, *Morwenna Thistlethwaite*.

Janet Leach, 1985.

years. Leach died in his 92nd year and is buried at Longstone cemetery, Carbis Bay.

Alice Moore talked of Bernard Leach in 1988. "I was with Bernard when he died in 1979. It just happened. When I had a stroke he came to see me and I was very fond of him. When he was in hospital at Hayle I used to take him little tiny wild flowers from my garden because he liked to have them near him on his table, but he couldn't see them because he was blind."

"When he was dying Eleanor (his daughter) rang and said would I go and see him with her and pick some flowers from the garden. Bernard was lying on his back on a couch. We started talking about where we were born. I was born in Honolulu. All this talk stirred old memories for Bernard of his first wife and the early days, but very soon he became agitated and the nurse said she would get him into bed. Eleanor and I waited outside. Within a few minutes he had died"

Leach had been at the centre of the pottery world, not only as a potter, but sharing his philosophy, his ideals, his technical knowledge, with great numbers of students, who themselves became thinking and experimental potters.

Some of those students and assistants of Leach set up potteries in and around St Ives and include Bill Marshall, John Bedding, Nic Harrison, Scott Marshall, Jason Wason. Michael Cardew, the first pupil of Bernard Leach in the early twenties, taught his son Seth, who now carries on the Wenford Bridge pottery in Bodmin. Anthony Richards, friend of Leach, taught his son Paul, who is a partner with the painter Richard Ayling in the Porthmeor Gallery, which combines a pottery and gallery and offers

Trevor Corser unpacking the kiln.

Interior with Nude, *Richard Ayling.*

a framing service for artists.

When Richard Ayling came to settle in Penwith there was a period when landscape and seascape were the most important subject matter. He painted on location irrespective of weather conditions to obtain immediacy and freshness in a work. The figure is included to give human contact and scale. Sky is an important element in his work, creating atmosphere and perspective qualities. Figure studies and background are reworked but he still tries to achieve a spontaneous statement as though entered in a diary or notebook. Figures in interiors are now the main subject of his work.

Patrick Hughes studied teacher training in Yorkshire 1959-61 and art at the Institute of Education, London University 1969-70. He taught at several schools, was senior lecturer in painting and drawing at Leeds College of Art 1964-69 and taught at Chelsea School of Art 1970-74. He married second wife Molly Parkin in 1971, though they have since parted.

"My aims are humorous, wide-ranging and inventive. I believe in wearing learning lightly." A series of rainbow paintings in rooms and various unexpected situations created a new use for the hopeful vision of the rainbow and completely mystified one gallery curator, who when receiving work of the rainbow series began to complete

Rainbows, *Patrick Hughes.*

the unwrapping of a rainbow half concealed in manila wrapping paper, not realising this was another variation on the theme of rainbows in unlikely settings.

New Art Centre, Sloane Street

'Cornwall 1945-55' was an exhibition held in Sloane Street which featured the work of 37 artists of St Ives and Newlyn associated with Cornwall. David Brown wrote the introduction: 'The present exhibition contains work in diverse idioms; a unifying factor is that they all mirror in various ways the austere landscape of West Cornwall; the rocks, the ocean and the clear, silvery light of the area which may result from light being reflected off the sea which is never far away. Probably not since an exhibition of paintings from West Cornwall was held at the Whitechapel Art Gallery in 1902 has such a survey as this been seen in London.'[24]

Dr Brown went on to express the hope that this exhibition would lead to more surveys of art produced in Cornwall over the last 100 years. Perhaps this did in fact lead to the more dynamic era of the eighties, when he undertook such a task in writing the catalogue of the St Ives Tate Gallery exhibition in 1985.

In 1983 the New Art Centre decided to devote its exhibitions to works of the modern artists of St Ives,

especially from the period 1945. They claimed to have work available at all times from Frost, Feiler, Hepworth, Heron, Hilton, Lanyon, Wells, Wynter, Mitchell and Mount, most of whom were already showing with the gallery.

1978
Pier Arts Centre, Stromness Orkney

The Pier Arts Centre was opened in 1978. It was the result of a gift of the collection of works of art owned by Margaret Gardiner which, by her wishes, was to be held in trust for the people of Orkney. She was an avid collector of modern British and European art and was a friend of many of the artists whose work she bought. Among the works are those of Lanyon, 'Box Construction'; Nicholson, 'Painted Relief'; Gabo, 'Linear Construction'; Wallis, 'St Ives Harbour', and several Hepworth sculptures. The work of Frost, Heron, Scott, Hilton and Mellis are also included as well as Henry Moore, Picasso, Munch and others.

The brief for designing the gallery and spaces to display the art works was given to Kate Heron (daughter of Patrick Heron) of Axel Burroughs of Levitt Bernstein Associates. The premises were a group of buildings consisting of a 19th century merchant's house, a coal store and some fishermen's sheds.

An Association of Friends was set up, a history of the building published and a catalogue of the collected works printed. It is very much a community based centre.

After a variety of jobs Penn Carwardine moved to St Ives from Taunton to paint full-time and found 'home' where she lives at Edge-O-Cliff, literally. She studied at Hornsey School of Art. Her current work is in watercolour, pastel and mixed media. "My work continues to progress and evolve in accordance with the subject matter, whether landscape, figures or flowers." Her special interest is in colour and the effects of light within confined areas.

Rachael Levine was born in Brighton but moved to St Ives with her family at the age of two. She is entirely self-taught and believes in the power of the subconscious to direct her art. Her subject matter is often a bird or a horse,

Christmas Geese, *Penn Carwardine.*

symbolising freedom and the power to get away, or escape. She is the daughter of the writer Norman Levine and as a child was familiar with the work of her father's friends, the painters, who visited and talked about art and painting, Lanyon, Heron, Frost, Wynter and Francis Bacon. Cassie Flint, sister of Rachael wrote a poem on the death of Francis Bacon, printed in *The Guardian* in May 1992.

In Memory of Francis Bacon
 As a young girl in seaside St Ives,
 With Lanyon and Heron, Wynter and Lowndes,
 Eating at our table or drinking with my dad,
 I grew used to the ways of the painters I knew.
 Then a stranger came, far away, from London.
 Black leather jacket, huge chest, eagle featured
And oh, the softest gentle voice of any man I've known.
 He was old then, always to me he has been old.
 I close my eyes and see his staring,
And that tension, a bird caught in the wrong
 surroundings.
 That over large head and bending nose.
 Waiting to tear the flesh from the bone.
 And that is what he did in those searing, magnificent
 canvases,
 He saw the human state in its anguish and its grace.
 But I remember now his quiet, naïve and generous
 nature;
 He gave my father that black jacket,
 He'd always give we three sisters ten shillings in an
 envelope,
 I thought he must be very rich.
 My mother had an enormous red Le Creuset in their
 rarer days.
 In sunshine, years later, waiting to take my mother to
 be buried
 Red roses came, more roses than my mother had ever
 had before.
 We looked among them for the card, it just said,
 "Love Francis,"
 And I did.

Deep Waters, *Rachael Levine.*

1979
After three years of running at a loss because of lack of support from public funds, the Barbara Hepworth Museum was offered to the Tate Gallery for the nation. The gift was estimated at £500,000. Hepworth's daughters Rachel and Sarah had provided the extra money needed to keep the museum running. The finances were now the responsibility of the Tate. In 1980 at a ceremony in the garden Trewyn studios were officially accepted for the nation by John Nott, MP for St Ives. The Trustees for Dame Barbara were Professor Alan Bowness who, after 22 years at the Courtauld Institute, was appointed Director of Tate Gallery, London in 1979, Sir Norman Reid and David Jenkins. The Chairman of the Tate Trustees, Lord Hutchinson, said the ideal way of showing modern sculpture was in the setting in which it was given life.

The Eighties
Important as the Hepworth, Nicholson, Leach era was to the art colony of St Ives and the art world as a whole, changes were inevitable in their passing and perhaps only in their deaths could the new influx of artists emerge from the giant shadows cast by their presence and reputations.

Painters, sculptors and potters continued to come to St Ives and although it seems unlikely that such a zenith of artistic achievement will be realised by the newcomers, nevertheless, they exist in their own right and create their own successes and achievements and St Ives as an art colony continues.

It has to be said that influential art critics and writers prepared to promote and publicise, and prestigious galleries and public funded bodies prepared to buy works for collections, are also missing, and I think one accepts that the summit has been reached. Nevertheless events were being organised by the artists, exhibitions staged and noticed, articles were being written and a wave of interest washed in with the eighties after the rather dull seventies.

Professor Hodin stated in an article in the local paper in 1980 that he thought St Ives community still contained notable artists. Alan Bowness in his book *Modern European*

Artists at the Penwith Gallery.

St Ives 1986, *Stephen Dove*.

Art published in 1987 wrote, 'In the nature of things, art is the creation of artists, who need to feel that some small originality of vision justifies their existence... they are just as necessary today as they ever were.'

A notable visitor to St Ives in the mid-eighties was Peter Blake, who somehow acquired the Porthmeor studio which had been vacated by Patrick Hughes. Blake had previously visited Cornwall in the fifties with his friend Joe Tilson, then living in a cottage in the village of Nancledra. Both were associated at that time with the Pop Art Movement.

Maurice Sumray said he was somewhat annoyed that Blake had been given a Porthmeor studio and related how he bumped into Blake in St Ives and said in typical forthright manner, "How is it that you as an outsider can get a studio, while I live here and have never been offered one?" Blake apparently was apologetic and understanding and gave up the studio shortly afterwards, having made little use of it and visited infrequently.

Joseph Paul Hodin

Professor Joseph Paul Hodin celebrated his 75th birthday at his home, Cliff Cottage, Carbis Bay, built in 1889. He was author, art historian and art critic and closely associated with St Ives arts community since the end of the war. He was born in Prague and educated at Prague and London University. He attended the Art Academies of Dresden and Berlin and lived for long periods in France, Germany, Belgium and Sweden and spoke five languages. His books on art and literature were published in 10 languages.

His parents were killed by the Nazis. He worked in Sweden during the war for the Czech liberation movement. After the war and on arrival in England he was press attaché to the Norwegian Government in London. In 1945 he came to St Ives with introductions to various artists and wrote biographies of Hepworth, Nicholson, Gabo, Leach, Portway, Milne and other leading figures in the art community.

He became a British subject in 1949 and that same year was appointed Director of Studies and Librarian of the Institute of Contemporary Arts in London. He married a Cornish woman, Doris Pamela Simms, who belonged to a Cornish mining family. They had a son and daughter.

In 1980 Terry Whybrow moved to St Ives to paint full-time. He trained as a furniture designer and was senior designer of a team when he decided to opt out and pursue painting. He had painted from an early age. His works are tonal with the emphases on stillness. This has always been an important factor in his abstract period through to his current work, which utilises recognisable objects, such as spheres and pots, in an abstract context. Earlier influences were very much landscape/seascape and he uses references from that period with importance placed on points of contact with the vertical and horizontal.

After studying at Lancaster, Coventry and Birmingham Polytechnics Stephen Dove came to Cornwall, living first in Zennor in 1976 and then making his home in St Ives with his wife Theresa and their two sons.

His paintings lie in that area that exists between abstraction and figuration. The subject matter of certain paintings may remain quite obvious whilst with others it is less evident and only alluded to. The human form and the landscape are frequent sources referred to directly or hinted at. Because of this varying degree of definition he places greater attention to the paint itself, to colour, tone, shape and space, to convey his feelings as a painter. His influences are the light and the landscape of West Penwith and aspects from the tradition of figurative and abstract art. He held his first solo show at Plymouth Arts Centre in 1980.

More Troubles at the Penwith

The future of the Penwith Galleries was again in doubt following a warning from the Arts Council that it could lose its annual subsidy unless certain conditions were

Painting 1610, *Terry Whybrow*.

met. It is unknown what these conditions were but one must conclude that a lack of willingness to conform was responsible. A criticism levelled at the Penwith was that it was too narrow and too much like a club, the Arts Council envisaged offering the space for touring exhibitions and broadening its outlook. All the provisions for success would seem to have been evident. They now had a valuable permanent collection of works in a newly opened gallery and ongoing exhibitions of contemporary work in improved and enlarged premises.

In 1977, at the request of Sir Norman Reid, Director of the Tate and President of the Penwith, Patrick Heron was asked to draft a historical overview of the Penwith Society. Heron also made a trip to London and persuaded representatives of the Arts Council to visit the galleries. They were suitably impressed with the buildings and exhibitions and raised their grant from £5,000 to £18,000 in 1978. In 1979 there was a promise of a further increase to £22,000 if the Penwith could satisfy the Council's Director that conditions specified by his committee were put in hand. Unfortunately a lack of co-operation with the Arts Council proved the Penwith Gallery's downfall. (The figures are taken from the *St Ives Times & Echo* for December 1979.)

As a result of the withdrawal of the grant the unique collection of works by leading artists, who had lived and worked in St Ives, was dispersed. Owners of the exhibits were asked to remove their work from the gallery for without support it was stated there was no possibility of the Penwith Galleries maintaining the collection without getting heavily into debt for bills in lighting, heating and security arrangements.

Wilhelmina Barns-Graham, a founder member, was shocked and dismayed at the precipitous action taken by the committee and thought that efforts ought to have been made to keep the collection together. "I think the town should have been kept in the picture and all

Farewell to the Tents, *Bob Devereux.*

members of the Society consulted. No one had been informed of the imminent closure. It was an invaluable asset to the town and an attraction to people all over the world." Patrick Heron was absent from St. Ives and at this time his wife, Delia, died suddenly, therefore disabling his ability to oppose the decision. The Gallery's Director, Hugh Scrutton, left after only two years in office.

The collection included a large painting by Christopher Wood, and paintings by B and W Nicholson, Hilton, Wood, Pasmore, Heron, Frost, Lanyon, Feiler, Wynter, Barns-Graham, O'Malley, Wells, Portway, W Nicholson, Conn, Merlyn Evans, Mackenzie, Davie, J Piper, Weschke, Wm Scott, A Garstin, Wallis, Duncan Grant. The sculptors were Gabo, Hepworth, Mitchell, Moore, Mount, Adams, Milne, McWilliam, Wall and the potters Leach, Hamada, Cardew, Pleydell-Bouverie. These artists have been identified from photographs of the gallery in the possession of H C Gilbert.

Surprisingly, having not been consulted over the closure of the new gallery and dispersal of the collection, the Penwith Society members got together to produce a portfolio of 10 silkscreen prints to be sold in aid of funds. Those involved were Conn, Crossley, Tom Cross, Emanuel, Hughes, Maeckelberghe, J and T O'Malley, Lieke Ritman and Walker. The makers of the prints were Kim Tindall and Christine Woodhead who were encouraged and helped by South West Arts.

However, the Penwith Society, despite its past glories, continued to decline through apathy and an unwillingness even to hold annual general meetings. South West Arts withdrew their grant of £5,000 in 1984.

The Salthouse Gallery

The gallery was opened by Bob Devereux and his wife Jenny, a print maker. Several solo shows were given to

Penwith Gallery showing paintings and sculpture of Penwith Collection. H C Gilbert.

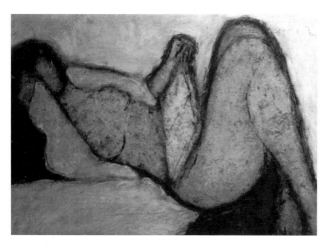

Woman Reading, *John Emanuel.*

local artists, the first of these in 1980 was Roy Walker who, having just learnt to swim, was fascinated by the distortions of figures and shapes under water and produced a series called 'The Deep End'. Other local artists to have solo shows in the next few years were Roy Ray, Yan Kel Feather, Steve Dove, Clare White, Colin T Johnson, Bob Bourne, Charles Howard, Terry Whybrow, Patrick Hayman, Jane and Tony O'Malley, Noel Betowski, Tony Giles, Patrick Hughes, Gill Watkiss, Simon Smith and potters Jon Middlemiss, Christa Maria Herrmann and the sculpture of Max Barrett.

Bob and Jenny Devereux moved to Cornwall in 1965 and to St Ives in 1979 where they had a stall in the Sloop Craft Market before moving to the Salthouse Gallery. He married his second wife Pauline Liu, also a painter, in 1992.

For several years Devereux has been responsible for organising Poetry Festivals with readings from published poets in the Salthouse Gallery. He paints and writes poetry. He has collaborated with musician and composer, Christopher Brown, in writing the librettos for 6 operas and three cantatas. Included in these are 'Seascape', a choral work, 'King Ram', a children's opera performed in Birmingham in 1982 and an opera about the plague village of Eyam in Derbyshire which was commissioned by the Arts Council.

The New Craftsman

This gallery is craft/fine art orientated and shows a selection of paintings, prints, etchings, sculpture and the best in pottery, with such masters as Lucie Rie, Hamada, Hans Coper, Janet and Bernard Leach and Cardew, as well as the work of present day potters. It is jointly owned by Mary Redgrave and Janet Leach. It shows a good selection of the work of the middle generation and present day artists. Only painters and printmakers who live and work in Cornwall are accepted and shown but pottery comes from a wide field. There is a good selection of craftwork in wood, metal, glass and weaving and handcrafted and individually designed jewellery. The New Craftsman has been selected, for the quality of the work shown, by the British Crafts Council.

St Ives Festivals

The eighties were much improved in reporting of events of an artistic nature. A St Ives September Festival was launched and provided for the reintroduction of Open Studios days and several related exhibitions took place, along with music, dance and theatre.

At the St Ives September Festival 1981 a piece of music, commissioned by Brian Smart, son of Borlase Smart, was composed by Christopher Brown with libretto written by Bob Devereux. 'Seascape' was a celebration of the life and work of Borlase Smart. The concert was performed at the Guildhall with choirs and brass ensemble and soprano Wendy Eathorne and baritone John Barrow. An accompanying exhibition at the Penwith Gallery showed drawings, letters and photographs of Smart's working life from earliest days as a boy in Plymouth, when in 1896 he entered and won a drawing competition, to the Second World War and his death in 1947. Roy Ray and Bob Devereux presented an evening of slides, prose and poetry in the form of a Borlase Smart biography. Several of his paintings were on view loaned by individuals and the Town Council.

For a Festival to mark 'Maritime England Year 1982', the sculptor Max Barrett was commissioned by the organiser, Robert Etherington, to carve a suitable piece of sculpture from a 30 cwt slab of Delabole slate. He was to be seen working daily in the parish churchyard on his creation which he called 'Gentle Wave'. The finished sculpture took four months to complete. It now rests at the complex at Land's End.

In 1983 Roy Ray mounted an exhibition of the work of painter John Park at the Penwith Gallery. He requested the loan of pictures, of which it was known there were many, from local people. Park had lived most of his life in the town and was fondly remembered. He had built his reputation painting scenes of the harbour and streets of Downalong.

Largely self-taught, John Emanuel served an apprenticeship in signwriting. He started to paint in 1962. His early work was abstract and concerned with elements of the figure in the landscape, with paint heavily applied to obtain a varied surface texture. The paintings are based on drawings of the figure, both male and female, drawn from life. There are elements of the Cornish landscape in his oil paintings, expressed through texture and tone. The more recent watercolour work is less ambiguous. He moved to Cornwall in 1964 and to St Ives in 1983, where he has a Porthmeor Studio.

The graphic designer, Colin Orchard, worked as a layout artist with *The Times,* and for 10 years was art director for Letraset International and has worked as a freelance graphic designer since 1972. His interest in painting developed after reading Bernard Dunstan's *Paintings in Progress.* "It was an insight into his working methods and his link with a tradition of painting which goes back to Sickert and Vuillard. This was my starting point."

He came to St Ives in 1983 with his wife Celia, who is a quiltmaker, and pursued his long interest in painting in a

more concentrated way. His work is mainly of figures in interiors. They are small intimate paintings. He held his first solo show at the Porthmeor Gallery in 1990. He works in a studio built in his garden at Ayr Manor. When the Tate Gallery of the West became a reality he designed the logo for the promotional literature.

Painter and sculptor, Peter Ward, was a pattern maker with Vickers Armstrong and after studying art became an Art Lecturer in Surrey and Cornwall. He first lived in St Ives from 1962-65 and held his first solo show at St Peter's Studio, Back Road West. This earlier formative period, and the landscape in and around St Ives, influences his present work. After an absence of 18 years teaching art, he and his wife Lesley, a quiltmaker, returned to St Ives in 1983 to paint and sculpt. He has a Penwith studio.

Peter Ward was commissioned to produce a sculpture for the new library block of the College of Maritime Studies in Hampshire in 1988. The library was part of a £3.5 million programme designed to extend the college's resources and technological service to the National and International Martime Industry. The county architect said the work of art enhanced an attractive building and praised Mr Ward for his design and expertise in sculpting from metallic materials.

1984
Whistler Week

Whistler Week was celebrated in 1984, sponsored by the Tregenna Castle Hotel, who exhibited photographs by Andrew Lanyon and held a Victorian Evening and Tea Dance. It was 100 years since Whistler had visited the town with his pupils, Walter Sickert and Mortimer Menpes. Roy Ray gave a lecture at the Arts Club, Whistler and St Ives, illustrated with slides and held an Artists Lunch at the School of Painting. Maps of the studios and art galleries were printed for Artists Show Day and music complemented the visual events.

A late Victorian, Garlick Barnes, aged 93, exhibited her work at the Salthouse Gallery. She was born in London in

Morning Sunlight, Barbara Hepworth Museum. *Colin Orchard.*

1891 and showed an early talent for painting, but it was after her four children were off her hands that she was finally able to devote her time to painting. She studied at the Sidney Cooper School of Art in Canterbury and Heatherley's School of Fine Art, where Walter Sickert taught. In 1936 she became a pupil of Sickert and her work was influenced by him at that time. She exhibited with Sickert at Margate. At the outbreak of the Second World War she moved to St Ives.

Garlick Barnes' twin sons, John and William, opened the Barnes Museum of Cinematography in 1964 in Fore Street. It was an important centre for film study and represented an historical record of the development of the cinema. The brothers began making movies at the age of 12 and won a prize for a documentary on the Cornish fishing industry. The museum closed in 1986 after 23 years.

Continuing the theme, Henry Gilbert at the Wills Lane Gallery mounted a show of work, 'Four Nicholsons', beginning with an eminent Victorian, Sir William Nicholson, accompanied by his son Ben, Ben's first wife Winifred and her daughter Kate. There were also small intimate paintings by Rachel Nicholson, the daughter of Barbara Hepworth. This major show was something of a triumph for a small gallery in St Ives but pinpoints the importance of the town in the art world.

A major retrospective of the work of Maurice Sumray was held at the Penwith Galleries and although he had painted from the thirties when he was an engraver, in the fifties he ceased painting and destroyed most of the works in his possession, being plagued by doubts about the validity of the whole process of painting. He is still the sceptical censor, confronting the canvas and staring back at the creatures he has conjured out of a need to express the

St Ives Elements, *Peter Ward.*

Maurice Sumray with his painting Little White Dove.

melancholy he feels for the sad quietness of humanity.

In one exhibition where he stood contemplating his own work two women, not knowing they were standing next to the artist, commented that they didn't understand the picture. "Neither do I," he said, in typical humorous and dismissive fashion, "It's rubbish, and I should know because I painted it."

A Alvarez, in the introduction to Sumray's catalogue wrote, 'He is a classical painter who works doggedly, often reluctantly, but with persistent intellectual control to create pictures of great formal beauty and peace.'

The Contemporaries
The first publication to appear on the present day painters in St Ives was Marion Whybrow's *Twenty Painters St Ives*. It began as a series of articles written for the local paper and developed into a book which gave a brief description of each painter, with a photograph of the artist against a background of their work. The layout of the book was designed by Colin Orchard with a foreword by Frank Ruhrmund, writer and art critic. All the painters featured lived in Downalong, the one-time home of net lofts and fish cellars, now mostly converted to studios. This conservation area, just off the harbour, is a haven of narrow lanes of cobbled streets and granite cottages.

Following on from painters, she produced *Potters In Their Place* giving details of 16 local potters, with a foreword by John Halkes, then director of Newlyn Orion Gallery. *Forms and Faces* depicts the work of 23 sculptors in SW Cornwall, with a foreword taken from Barbara Hepworth's autobiography.

The next book, in 1985, concentrated on one artist and was called *Bryan Pearce A Private View*, with a foreword by Henry Gilbert and launched at his gallery by Professor Charles Thomas, Director of the Institute of Cornish Studies. The book gave an insight into the working life of the painter. Whybrow, a former teacher, drew on her knowledge of Bryan Pearce through a 7 year period of helping him to improve his reading skills and increase his memory and understanding of what he was reading. He had suffered brain damage in childhood and from a seemingly hopeless situation had carved out a career in painting. The first book on the Pearce family was written by Ruth Jones, *The Path of the Son*.

The Local Historian
Cyril Noall, born in St Ives, writer, local historian and journalist, died in 1984. He was the recorder of the lives of people of St Ives, documenting events which affected the men, women and children in the town in which they were born and how they survived. He was curator of St Ives museum for many years.

Noall was noted as the major historian after John Hobson Matthews of the late 19th century. During the last 25 years of his life Noall had written many books of the area, *The Story of St Ives, The Book of St Ives, Yesterday's Town, A Book of Penzance, The Story of Hayle.* He had produced books on mining, fishing, lifeboat service, Cornish shipwrecks and rescues.

For nearly 30 years he had contributed articles to the *St Ives Times and Echo* and other newspapers and magazines. He was elected a Bard of the Cornish Gorsedd in recognition of his work as a historian. The Royal Institute of Cornwall awarded him the Jenner Medal for his work in the field of literature.

Recognition for Tony O'Malley
This year proved one of the turning points in the career of a painter who for years had worked solidly pursuing his painting with a quiet integrity. The Irish Arts Council, North and South, launched a major retrospective exhibition of the work of their compatriot, Tony O'Malley, which opened at the Ulster Museum, Belfast and travelled to the Douglas Hyde Gallery, Trinity College, Dublin and the Crawford Gallery, Cork. The show featured 150 paintings retrospective to 1945; an observable record of the painter's life from figurative and landscape elements, to the abstract and spiritual awareness inherent in the paintings of the South of Ireland and Cornwall. Brian Fallon, art critic of the *Irish Times*, wrote a biography of Tony O'Malley as a catalogue.

Tony O'Malley in his studio corner, 1986.

Two years previously O'Malley was awarded the Douglas Hyde Gold Medal for a painting which was chosen from a national exhibition, Shortly afterwards he was honoured by being elected to the Irish 'Aosdana' by a Gaelic Council which recognises the work of creative artists in poetry, music and painting.

Also at this time O'Malley's work was chosen for 'Six Artists From Ireland', a European touring exhibition which visited Copenhagen, Stockholm, Brussels, Stuttgart, Rome, Athens and Rotterdam. The show travelled for two years. Other awards followed on from this recognition. He was chosen by the *Guardian* Art Critic and the Irish/American Cultural Society to receive awards for his paintings.

Having settled into a fishing community Christine Anne Micklethwaite is influenced by the life of the fishermen and the beauty of the harbour. "I try to produce the solidity and reality of a landscape by over-working of paint to reach an optimum state which exists as a whole space." .

She completed her art training at Falmouth Art School, BA(Hons) Fine Art. She works directly from life. "I find the paintings, whilst influenced by differing weather conditions, are constantly changing and rarely static." Wishing to extend her experience she visited a fishing community in Thailand where she spent two winters reproducing the brilliant colours and light of a warmer and lusher climate.

A frequent visitor to Cornwall over many years, Audrey Knight decided to make her home in St Ives after gaining a BA degree in Fine Art, as a mature student, from the Central School of Art and Design. As well as painting, she often ventures into printmaking. Her paintings have been exhibited in many local galleries and were shown in the Christie's Inaugural 1984 'Pick of New Graduate Art'.

Untitled, *Audrey Knight.*

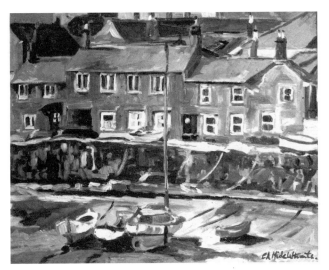

Cottages, Beach and Boats, *Christine Micklethwaite.*

1985
St Ives at the Tate Gallery

An exhibition devoted to St Ives painters from 1939-64 took place at the Tate in a never-before-seen show of the major artists of a small town in an international art gallery. Dr David Brown, Assistant Keeper of the Modern Collection of the Tate, in consultation with Alan Bowness, Director, selected all the works, which centred around the foremost artists of St Ives.

The catalogue for this show was of the period St Ives 1939-64, 25 Years of Painting, Sculpture and Pottery. It provided important biographical details of 50 of the artists, a chronology of minute details, a plentiful supply of colour plates, a foreword by Alan Bowness and a personal memoir by David Lewis.

Visiting the Tate Gallery at the Private View was like walking the streets of St Ives, greeting all the familiar faces, as well as noting the paintings of familiar artists. Celebrated as these artists were, it was important to establish that St Ives art did not pass away with the passing of an era, it simply made way for the next generation.

Meanwhile, back in St Ives, celebrations were taking place under the umbrella of St Ives Heritage Week sponsored by the Tregenna Castle Hotel to mark the 100 years of art

Dr David Brown at St Ives Documentary Exhibition, 1985.

history in the town. Co-ordinated by Beryl James, it was opened by Gerald Priestland, who also lectured at the Parish Church and launched Marion Whybrow's new book *Potters In Their Place* at the Arts Club. Whybrow's play, based on the early artists' colony, *Just Minutes,* was performed at the Penwith Gallery by Arts Club members.

Roy Ray mounted a documentary exhibition held in the Crypt under the Gallery of St Ives Society of Artists. Michael Jacobs gave a talk on art colonies at the School of Painting on which he had recently written a book, *The Good and Simple Life.* Dr David Brown's slide show featured St Ives 1930-60 and Roy Ray's slides introduced contemporary painters. The following Open Studios Day gave these painters a chance to show their work.

The week ended with Michael Manser, President of the RIBA, as guest speaker at the Tregenna Castle, supported by Robert Poynton, President of the South West Region RIBA and Patrick Heron. Manser, in his speech, said that art and architecture go together and regretted the fact that buildings are not now decorated as they were in the past with paintings, carving and sculpture.

Dr David Brown is no stranger to Cornwall. During the Second World War he worked as a 'Bevin Boy' in tin mining at the East Pool and Agar Mine near Redruth. He studied and qualified in veterinary medicine in Edinburgh between 1947-52 and continued his studies for his doctoral thesis in Africa. He lived for 12 years in Kenya researching into tropical diseases in cattle and published 30 scientific papers on the subject. In Nigeria he extended his knowledge into animal production.

After he qualified as a veterinary surgeon he got hooked on oriental ceramics and began his own studies at Cambridge Fitzwilliam Museum. His interest also spread to paintings and art history and he studied drawings of the old masters such as Dürer, Raphael, Michelangelo and Rembrandt informally in the British Museum before reading art history at the University of East Anglia 1970-73.

He spent 14 months as research assistant in the Scottish National Gallery of Modern Art before moving on in 1974 to the post of Assistant Keeper of the Modern Collection at the Tate Gallery, London, where he remained until his retirement in 1985, after organising the Tate's major show of modern works from Cornwall, *St Ives: 1939-64 Twenty Five Years of Painting, Sculpture and Pottery.*

In the modern field his taste ranges through all forms of art, conceptual, minimal, and all the 'isms' as suffix to art terminology. The one particular artist from Cornwall whose work spoke to him loud and clear was Roger Hilton.

"Life is complicated, therefore art is complicated," said David Brown. "Art enhances life and changes one's view of the world."

Patrick Heron at the Barbican and Newlyn Gallery
Corresponding with his major exhibition at the Barbican Centre, Heron brought a selection of 49 paintings from his home and exhibited them in the Newlyn Gallery. 'From Eagle's Nest Paintings and Drawings 1925-1985' included early childhood drawings and pre-war early works never shown publicly, giving a very personal visual statement to his local audience, but the main theme of the exhibition was his devotion to colour. To accompany this show he gave a talk on his work to people who sat and stood in every available space in the upper gallery.

Heron said his earlier drawings overlapped with the work he was doing now. "One can almost fit them one over another. To see certain works in the company of other works is extraordinary works which span a number of years, but there are these moments in life when you break the mould in some way." Heron regretted that Cézanne did not live to see his influence on so many artists. "Braque, Monet and Picasso were given recognition, but Cézanne knew he was a great painter."

One of Heron's few portraits was of T S Eliot, who became known as a critic and poet. "That fascinated me and is why I set out to paint his portrait. What Eliot stood for in 1910 was a poetry bringing in a kind of colloquial speech, the very essence of trivial conversation. The great opposition in Eliot's mind was the established Georgian poets. He was highly critical of Milton, but after four decades of very free verse he pronounced favourably on the architectonic grandeur of Milton's verse." [25]

Tribute to Denys Val Baker
In August a tribute to the writer Denys Val Baker, who died in 1984, took place at the Penwith Gallery in a celebration of his life and work. Research for the readings, *The Cornish Affair,* was undertaken by Jean Penhaligon, a friend of the Val Baker family for over 25 years. The content of the readings was drawn from some 20 of his books and performed by professional actors.

Val Baker's most valuable contribution to the arts community was his publication of the *Cornish Review,* a magazine which printed articles by the many writers, poets, painters and historians living in the county. Novelists such as Winston Graham, famous for his saga with a Cornish setting, the Poldark novels, and poet/novelist D M Thomas contributed, the poets Jack Clemo, Arthur Caddick, W Sydney Graham, and Charles Causley; playwright Donald Rawe; historians F E Haliday, Charles Thomas, A L Rowse and A K Hamilton Jenkin. Other writers on various subjects were Val Baker himself, Frank Ruhrmund, Des Hannigan and Michael Williams

and from without the county Edna O'Brien, Fay Weldon and Margaret Drabble. Reproductions of various painters adorned the front covers, Jack Pender, Bryan Pearce, Peter Lanyon, Margo Maeckelberghe and many more.

The *Cornish Review* provided an arts history of West Penwith and is now a valuable resource for the art and literary researcher. The first reviews ran for 10 issues. In the spring of 1966 the second *Cornish Review* was born, this time with a supporting grant from the Arts Council. Twenty-seven volumes were published but ceased when the Council withdrew the grant.

A Memorial Fund was set up for Denys, which not only provided a seat on the cliffs overlooking the sea, but launched a writing competition in the West Country. The first winner was a St Ives born writer, Roy Phillips, brother of the painter Gerry Phillips, with his novel *The Saffron Eaters*. In further competitions two short-listed St Ives entries were from Hyman Segal and Harding Laity. Unfortunately the competition only ran for a few years.

1986

St Ives middle generation artists remained in the news with the Tate's Forty Years of Modern Art 1945-85, in which the middle generation figured prominently. The exhibition occupied 22 galleries of the extension opened in 1979, as well as most of the central galleries. Works from abstract expressionism, Pop Art, kinetic art, minimal and conceptual art; all forms of modernism were on show. Rothko and Dubuffet had galleries to themselves.

At this time Dr David Brown began writing articles for the *St Ives Times and Echo*, the first being the centenary of the New English Art Club, of which many early St Ives and Newlyn painters were members. He also wrote on Oscar Kokoschka, Helene Schjerfbeck, Mark Rothko, Gabo, Whistler, Winifred Nicholson — all painters associated with St Ives.

Inspire

Inspire came about after Peter Bassett asked Marion Whybrow to organise a visual arts exhibition for the Three Spires Festival in Truro. She chose the painters, allocated an area of space, but gave the artists the choice of what to show. It was unusual at that time for sculpture and pottery to be included in exhibitions at the Royal County Museum and Art Gallery, but the curator, Les Douch, agreed to make stands available. The painters were David Andrew, Ray Atkins, Jill Chandler, Jenny Croxford, Bernard Evans, Terry Frost, Grace Gardner, Derek Jenkins, Alexander Mackenzie, Daphne McClure, Kathy MacNally, June Miles, John Miller, Jane O'Malley, Tony O'Malley, Bryan Pearce, Stuart Peters, Terry Whybrow, Barbara Wills, Vincent Wilson and Fred Yates. The potters were Seth Cardew, Christa-Maria Herrmann and Mary Rich. The sculptors, Ian Carrick, Theresa Gilder, Denis Mitchell and Paul Mount. Professor Charles Thomas opened the exhibition saying, "We do a lot of things well in Cornwall where the arts are concerned, very few areas of the same size and population can begin to match our record of achievement and

Marion Whybrow with Professor Charles Thomas at the opening of Three Spires Festival Exhibition *with Fred Yates' paintings, 1986.*

excellence." The exhibition ran for a month.

Inspire set out to find venues for groups of artists to exhibit their work outside Cornwall. It took no account of groups or societies. It was founded by four people, Toni Carver, printer and publicity, Colin Orchard, graphic designer, Peter Bassett, treasurer and Marion Whybrow responsible for organising exhibitions and writing the catalogues.

As a result of this first show, Rodney Preece, the Commander of Culdrose air base asked the group to organise an exhibition on the base in the officers' mess. This took place and resulted in paintings by Sheila Oliner and Terry Whybrow being purchased for the officers' dining room at Culdrose.

'Inspire 2' exhibition took place the following year at Truro Museum for the Three Spires Festival and included a further selection of painters, potters and sculptors, which was opened by Lord St Levan of St Michael's Mount. The selection of artists came from Falmouth, Truro, Hayle, Penzance, Newlyn, Zennor and St Ives.

Other exhibitions included more artists and were held at Guildford, the Vivaldi Gallery, East Sheen, the Brunswick Gallery at Shoreham-by-Sea, which then went on to the Terrace Gallery, Worthing. Toni Carver negotiated a Pallant House show at Chichester, Sussex called 'Cornwall in the Eighties'. He then packed the work of 15 artists in his van and drove all night to deliver the work to the gallery.

Writer and art critic Peggy Lewis, who paid yearly visits to St Ives to buy paintings in Cornwall, discussed the possibility of exhibiting works in the USA. By 1988 she had approached various galleries and the first exhibition 'The Cornish Collection' opened at the Artfull Eye Gallery in New Jersey and travelled to several other venues over three years.

Priaulx Rainier

In 1986 Dr Priaulx Rainier, one of the most distinguished composers, died aged 83. She had suffered a heart attack while on holiday with her friend June Opie, in the village of Auverne. Rainier was born in Natal, South Africa of

Sheila Oliner in her studio, 1991.

and quite unlike the subject, Surrealism, taken as her thesis at Utrecht University.

Having worked in London, Paris and Spain with the Katherine Durham Dance Company and as a stylist for a photographer, Ponkle branched out on her own in St

English/Huguenot parents and studied at the College of Music as a violinist. After winning a university scholarship she came to study at the Royal Academy of Music in London. She came to St Ives at the invitation of her friends Nicholson and Hepworth and lived in a small wooden cabin at Tregenna Steps Studio, where she composed her music. In 1942 she was appointed professor of composition at the Academy and in 1953 was elected a Fellow of the RA and Fellow of the Worshipful Company of Musicians, City of London. Her music was broadcast and played by orchestras all over the world. Birthday celebrations for her 80th year took place in St Ives Guildhall with a reception and a concert of her music.

Priaulx Rainier left a self-portrait of Barbara Hepworth to the National Portrait Gallery. Three paintings by Nicholson, two sculptures and three other works by Hepworth and three paintings by Wallis were willed to Kettle's Yard, Cambridge University. A watercolour and large drawing by Agnes Drey were left to the Penwith Society.

Leaving a successful art career in Hampstead Sheila Oliner, painter and printmaker, moved to a cottage in the small and remote village of Zennor in 1985 and works from a studio in St Ives. Her relief printmaking has been influenced by Shiko Munakata. Painting and printmaking are of equal importance in her work. She always works directly from landscape, still life or the figure. "I must have an initial excitement about my subject matter. My work changes as I go along. I work in series. Once I have exploited an area I move on to something else that I find exciting." She has had 15 solo shows, including five in Tokyo. She works in a variety of media, watercolour, oils, linocut, woodcut and intaglio.

Gertrude Starink worked as writer and director of plays and programmes on literature for the Dutch radio between 1969 and 1984. It was whilst visiting St Ives in 1977 to prepare a radio play on Virginia Woolf that she fell in love with the town. Thereafter she paid yearly visits until eventually returning to live in St Ives in 1986 in a cottage overlooking the harbour. She opened a specialist bookshop, The Mirror and the Lamp, where she exhibits her own work. Her paintings are watercolours and gouaches based on patterns derived from Cornish Landscapes or themes taken from literature and music

Harbour Lines II, *1992, Gertrude Starink.*

Ives to pursue her work as a painter. She had travelled extensively in Europe, painting in France, where she studied at William Hayter's School in Paris. She opened her cat gallery in Island Square in 1986, where her subject matter is a series of paintings of her own and local cats. Her cats are composed against a background of St Ives and worked in coloured inks on handmade paper. She also models cats in ceramic and resin for outdoor or indoor display. Ponkle is one of a long line of painters who have made St Ives cats their subject.

1987

Naum Gabo's three dimensional structures were exhibited at the Tate. His work used a variety of materials from plastic, metal to other less known substances with which he liked to experiment. Pieces were sometimes stringed or transparent, giving a feeling of lightness, unlike solid and dense sculpture. David Brown wrote 'This is one of the most beautiful exhibitions held at the

John Wells with background of his work, 1993.

Painting with Blue Oval, *1989. John Wells.*

Tate for some years, marvellously arranged, giving a feeling of space, light and harmony.'

Later in the year 90 paintings of Mark Rothko were exhibited at the Tate. The earliest paintings of the 1930s showed a figurative or mythical element but by the late forties his work evolved towards large areas of one colour, built up of layers of paint, their depth and overall colour encouraging a feeling of contemplation.

London's Tate Gallery was offering some of its finest paintings for permanent display in St Ives if a suitable gallery could be found. The offer was welcomed by tourism chiefs, who said it would be a great attraction and a significant help in boosting the off-peak tourist season. The paintings on offer were those by members of the art colony of St Ives and were valued at £2-3 million.

John Wells' 80th Birthday

Wills Lane Gallery pulled off a coup when it succeeded in paying tribute to one of the most respected painters of the arts community, John Wells. His birthday was celebrated in a fashion most painters would desire, a retrospective exhibition but, as Gillie wrote in an introductory passage to the catalogue, 'He is a private, introspective person who has no interest in seeking publicity and little more in exhibiting his work. He is a thinking man; it is the work that matters to him.'

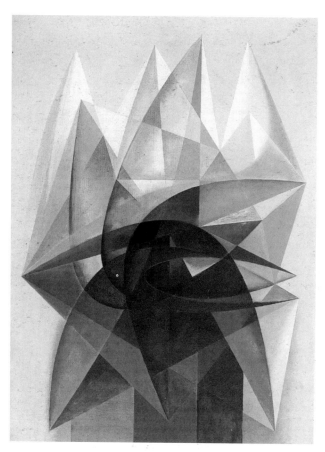

Le Sacré du Printemps, *1947-48, John Wells.*

Louise McClary in her studio, 1991.

Such a promotion of himself was something to be avoided, so it was a considerable achievement for Henry and Joan Gilbert to have persuaded John Wells to exhibit 60 paintings and to meet his many friends at a function designed to pay homage. Many contemporaries, who had been closely associated over the years, turned up to affirm their friendship, Denis Mitchell, William Marshall, Alexander Mackenzie, Paul Mount, Willie Barns-Graham, Patrick Heron, Terry Frost and many more, as well as a goodly crowd of the more recent painters in Cornwall.

The influence of Naum Gabo through the years was shown on the exhibition catalogue entitled 'Homage to Naum Gabo 1948'. Many other Wells paintings were derivatives of constructivist art. In the early years of Wells' career as a painter Gabo wrote this advice, 'If you have done a work which does not satisfy you — go ahead with another — don't stop at that; you can say in one work of art only one thing at a time, you cannot say all and it is always with artists in their younger years, that they express themselves more in a series of work than in a single one.'

Art About St Ives
This book was the joint venture of Henry Gilbert, the initiator of the project, Roy Ray, who wrote the text and Colin Orchard, design and photography. It acted as a guide to sculpture, pottery and paintings in the town, both in public places and in galleries, and gave a brief historical introduction to the art colony and an update on artists living and working in St Ives. Eric Quayle officiated at the book launch at Wills Lane Gallery.

After painting and working part-time in adult education,

Quay, *1992, Noel Betowski.*

188

Noel Betowski left London, where he had studied at the Central School of Art, followed by the University of London Institute of Education, to paint full-time in Cornwall. He was a prize winner of the Constable Centenary Competition incorporating the Camden Annual Show and won an Athena Art Award in the *Sunday Times* watercolour competition at the Mall Galleries.

He was a pupil of David Haughton who introduced him to West Penwith and the outlying areas of this wild peninsula. He finally realised his ambition to live and paint in Cornwall in 1987 when he and his wife Pam, a musician, moved to the area. His work contains both figurative and abstract elements. He is inspired by the local land and seascape of his immediate surroundings.

Penzance born Louise McClary, after studying at Penzance School of Art, worked as head decorator at Troika Pottery in Newlyn but since 1984 has practised as a professional artist. She has run art workshops for children in St Ives and with Newlyn Orion. She feels her paintings express a private language — the dog might represent man, the bird freedom. The crow is a favourite element in her work, which she regards as a strong symbol with many interpretations. She explores relationships, both human and animal.

Her first solo show was 'The Young Unknowns', Waterloo, London in 1989. Recently the Beaux Arts Gallery in Bath has included her in its gallery artists. She moved to St Ives in 1988 and works full-time as a painter in her Porthmeor studio overlooking the Atlantic. Recently she was included in the touring exhibition of women artists in the South West.

Anke Petersen left Germany in 1973 to live in England. She was born in Flensburg, Schleswig Holstein, Germany, where she studied art and taught drawing and painting to children. She studied etching, drawing and painting at Bournemouth and Poole College of Art. She exhibited in eight solo shows and many group shows before moving to St Ives in 1989 where she opened 'Anke's Studio' as a

Cornish Landscape No 18, *Anke Petersen.*

work space and permanent exhibition of her paintings. She says, "The textures and rhythms of shapes and line, matt colour and metallic effects are evoked by the experience of St Ives, the sea and the Cornish landscape." She also writes and illustrates her own poetry.

1988
School of Painting — 50th Anniversary
A week-long celebration at the School of Painting ended with an Arts Ball at the Tregenna Castle Hotel with the theme Artists and Models. The principal, Roy Ray, down on his knees as Toulouse Lautrec, welcomed look-alike artists such as David Hockney, Cézanne, Savador Dali, Holbein, Jackson Pollock etc. Models of the painters ranged from Pre-Raphaelite beauties, Goya ladies of the Spanish Court, Gauguin dusky maidens, Renoir models and dainty Degas ballet dancers, such as Eric Ward, 6ft. 2in. harbour master and coxswain of the lifeboat. Gracing the ballroom were 13 clever spoof paintings in the idiom of an earlier generation of painters, Van Gogh's bandaged ear sprouted a Walkman, and the box of fish fingers on the quay brought Stanhope Forbes' picture 'Fish Sale on a Cornish Beach' up to the minute.

Leon Suddaby Fine Art
'One Hundred Years of Painting in St Ives' was the theme that opened a new prestigious gallery in St Ives on Lifeboat Hill. Leon Suddaby, a specialist in the paintings of the early period of the art colonies of St Ives and Newlyn, nevertheless featured the work of the middle generation and contemporaries.

Leon Suddaby said at the opening, "The town will now be able to appreciate work which is not usually shown in St Ives, the painters who formed the foundation of the arts colony."

The work of Louis Grier, founder member of the Arts Club in 1890, was shown alongside Julius Olsson, with

Shadow Fight, *Louise McClary.*

The Painter and the Subject, *1992, Andrew Lanyon.*

whom he opened a school of painting in 1895. Olsson's seascape was entitled 'Fishing Boats Entering Hayle Harbour'. John Park, a pupil of Olsson, was represented by an impressionist harbour scene and other St Ives painters were Arthur Hayward, Dorothea Sharp, Terrick Williams, Charles Simpson, Leonard Fuller, Marjorie Mostyn and Fred Bottomley.

Representing the middle generation were paintings by Lanyon, Wynter, Heron, Barns-Graham, Segal, Frost, Weschke, Pearce and others. Pots were from Leach, Hamada, Cardew, Marshall and Trevor Corser, with sculpture by Sven Berlin and Max Barrett. Contemporary artists included Fred Yates, Terry Whybrow, Jane and Tony O'Malley, Morwenna Thistlethwaite and a host of other names from all periods, which together amounted to 150 works of art.

One year later Leon Suddaby opened a sister gallery in Chapel Street, Penzance to show his collection of Newlyn painters. Of the 100 paintings shown, the most expensive was 'The Barn' by Stanhope Forbes at £35,000. Elizabeth Forbes' painting 'Violet Girl' was shown alongside her husband's and Tuke, Harris, Fortescue, the Knights and a host of others graced the newly designed art gallery. Exhibitions also featured solo shows by Jack Pender, Joan Gillchrest and John Tunnard. Newlyn artist Ralph Todd, who died in 1932, was featured in an exhibition of 50 works, each of which was mounted in a period frame for the show. These works came from a 90 year old niece of the artist, who was still living in Cornwall.

Together with the St Ives Gallery, these exhibitions provided the most comprehensive and full spectrum of the arts colonies ever before seen in their totality. Unfortunately, both galleries are now closed.

Suddaby introduced Irving Grose, Director of the Belgrave Gallery, to various artists, from whom he bought considerable numbers of paintings. These works were exhibited in several shows at the gallery over a number of years called 'Some of the Moderns'. The St Ives painters were in the majority in each show and included among many Inez Hoyton, Haughton, Heron, Tunnard, Wells, Whybrow, Mackenzie, Frost, Sumray, Clifford Fishwick, Daphne McClure. Jack Pender, Terry Frost and Sven Berlin were given solo shows. Irving Grose wrote in the catalogue introduction to Berlin, 'No ordinary life his — but an epic on a grand scale with Sven, like a Greek hero, struggling with adversity to achieve his goal.' Berlin's exhibition showed his work of the forties and his Cornish connection with his sculpture 'Madonna', paintings of Zennor, drawings of miners at work in Geevor tin mine, and landscapes of a Cornwall that have haunted his lifetime.

1989
A Century of Art in Cornwall
This exhibition celebrated the centenary of Cornwall County Council. Its chairman noted with pride that the County could mount an exhibition of artistic development and achievement, over 100 years and at the highest level, from its own collection. The show featured 105 different artists.

Part One was titled 'An Historical Perspective' and included the work of Stanhope Forbes, Walter Langley, Thomas Cooper Gotch and Laura Knight and other

Piano Series 2, *1992, Ralph Freeman.*

equally famous names and paintings and a smaller number of the St Ives early artists, Park, Olsson and Grier. Moving through the exhibition one encountered 'St Ives: Wallis and the Modern Movement'. Here St Ives came into its own with Nicholson, Hepworth, Heron, Leach, Frost and other notables from the mid-century.

Part Two, 'A Contemporary View', held the works of artists living and working in Cornwall such as Anthony Frost, Michael Finn, Ken Howard, Mary Mabbutt, Margo Maeckelberghe, Jane O'Malley, Leonie Whitton and Fred Yates. This section comprised work by 41 artists 'to reflect the geographical disposition, stylistic variety and sheer professionalism of art in Cornwall now.' John Halkes, organiser, said of his selection he could have chosen other artists of equal standing.

Elizabeth Knowles, who also assisted with the above exhibition, was instrumental in organising an exhibition of the paintings of Christopher Wood, 'The Last Years'. The works were completed in the last two years of his life and comprised 82 paintings and drawings. The show was then scheduled for Sheffield, Swansea and Cambridge. Wood made several trips to Cornwall. His final visit was to Mousehole. He died in a train accident at Salisbury Station.

Peter Lanyon's son Andrew, in 1989, produced a book

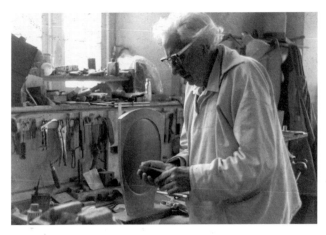

Denis Mitchell in his studio, 1984.

on his father of paintings, constructions, photographs and illustrations gathered from within the family, with accompanying text taken from conversations, lectures, writings and recordings. The book was a limited edition of 500, a collector's book, and contained 50 black and white illustrations and 75 colour plates.

His *St Ives Album,* published in 1979, explored the work of the St Ives photographers at the turn of the century. He is responsible for a number of other books, one of which, *The Rooks of Trelawney,* has a permanent exhibition of camera techniques and historic photographs in the St Ives Museum.

Andrew was born in St Ives and studied at the London School of Film Technique, He is painter, writer and photographer and, like his father, an individualist.

Painter of abstract work in oil and watercolour, composer and jazz musician, Ralph Freeman says his paintings are all about response and trusting the muscular activity of the hand, fed in turn by a subconscious dialogue with the painting. He draws inspiration from the environment and conversely, contemporary modern jazz and paintings of the old masters. Jazz has formed an integral part of his life and relates directly to his work as an artist. "The qualities of improvisation, rhythm, structure and harmony, stimulate the way I express light, colour, form and space."

1990
Wilhelmina Barns-Graham 80th Birthday
A tribute to Wilhelmina Barns-Graham was paid by Frank Ruhrmund, writing in the *St Ives Times,* to her great achievement and total commitment, in 50 years as an artist. She told him she had been blessed in the friends she found in St Ives.

In 1989 the City of Edinburgh Museum and Art Gallery mounted a retrospective exhibition of Barns-Graham's work 1940-89; a welcome if somewhat late recognition. They purchased the painting 'Rocks, St Mary's Isle of Scilly', which illustrated the front cover, for their permanent collection.

In 1992 a surprise birthday celebration was held at the Penwith Gallery for Willie when it seemed as though the whole of St Ives was there to greet her. It was organised by her friend Rowan James, who has managed Willie's affairs for the last few years to enable her to devote her

Blue Drop I, *1978, Wilhelmina Barns-Graham.*

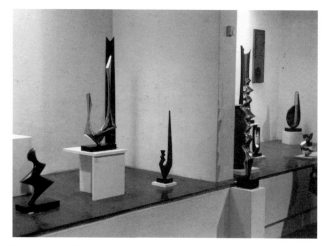

Denis Mitchell's exhibition at Penwith Gallery 1992.

time to painting. Also to honour Willie on her 80th birthday an exhibition of her work from 1963 was shown at Milngavie's Lillie Art Gallery.

One of her greatest pleasures of her 80th year was when the University of St Andrews awarded Barns-Graham an Honorary Degree of Doctor of Letters in recognition of her contribution to art. She received her degree along with 7 other distinguished women. In his laureation address Professor M J Kemp said, 'Anyone encountering her paintings, drawings and reliefs would be right to sense that they are in the presence of one of the most notable Scottish artists of this century.'

1992

Denis Mitchell's 80th Birthday

Also in 1992, an 80th birthday retrospective exhibition was held at the Penwith Gallery to celebrate Denis Mitchell's life's achievement as a sculptor, 'Drawings Painting and Sculpture 1932-1992'. It also provided 'an opportunity for his many friends to pay tribute to a great man.' Patrick Heron as friend and contemporary gave the speech of tribute. John Halkes wrote the introduction to the catalogue and remembered to mention that Jane, Denis's wife, had been a loyal supporter of his work in their 53 years of marriage and was instrumental to any success he had achieved.

Other of Denis's many friends included their own tributes in the catalogue, Willie Barns-Graham wrote, 'There were lively discussions about work and current exhibitions — sometimes heated and often involving local fishermen. Like Bernard Leach he could be a father-figure — wise and philosophical. '

Roger Leigh said, 'Thank you Denis for making so many sculptures that have given me much pleasure. I, and my family, are grateful for your friendship, advice and anecdotes over many years.'

'I first met Denis in the early fifties,' remembered Alexander Mackenzie, 'when St Ives had a marvellous creative feeling and atmosphere. There was a real sense of magic about the place. Denis was the centre of this.'

'To a great friend and teacher,' says Terry Frost, 'sculptor, painter, sage, collector and friend, who in 1951

taught me to carve, make silk screens, to join two pieces of wood together and to never rush when trying to move ten tons of Connemara blue limestone.'

Recalling the days when Breon O'Casey worked as a part-time assistant to Denis Mitchell he said, 'the tedium of polishing bronze was enlivened by the coffee, the stories and the bold plans. And yet the work got done. And I certainly learnt a lot. Every artist should be so lucky.'

Roy Conn met Denis in the late fifties. 'At that time the community spirit was very strong and we would all be in and out of each other's studios and homes most of the time. The studio Denis had at that time was just off Fore Street. From the interior of that marvellous studio emanated a feeling of warmth and conviviality as soon as one entered it.' The weaver Stella Benjamin remembered the Fore Street studio, where she worked with Denis for a year. It was in the heart of what is now known as the Cyril Noall Market.

Penwith Landscape, *Gerald Phillips.*

Sunlight on their Portsides, *Stuart Peters.*

Michael Snow remarked, 'With a keen eye for the humour and irony of life, Denis has always known all the stories that one never finds in the official art histories. Denis's work transmutes his generous spirit and love of life into art. And now he changes age into youth by producing one of his very finest sculptures in his eightieth year!' Sadly Denis died of cancer in March 1993.

Three other St Ives born artists are Gerald Phillips, Stuart Peters and Eric Ward. Gerry Phillips, a self-taught painter, spent 6 years in America, where he first started painting and went to evening classes in San Francisco. He moved to Lake Tahoe and worked at a Casino among art students. They formed the Lake Tahoe Arts Society.

Returning to Britain, he spent some time in Bristol and St Agnes before finally moving back to his home town. He paints his immediate surroundings of sea and harbour in oils or watercolour, and acrylic landscapes in abstract shapes and the vibrant colour of the seasons. His studio is 'The Lamplighter' at Westcotts Quay, which many painters have occupied. He is a keen actor with the Trencrom Revellers and the local Amateur Operatic Society.

Stuart Peters, the second of the contemporary St Ivesians, studied at Camborne Technical College and Birmingham College of Art and Design. He graduated in 1969 with a BA Honours degree. As a boy he attended classes at Leonard Fuller's School of Painting and exhibited in Show Day. He spent some time fishing out of St Ives in the boat *The Girl Renee* before taking up teaching. He taught art at Newquay before his appointment as Head of Art at St Ives Comprehensive School. His work explores all aspects of the harbour and boats — the playground of his childhood. "Painting I feel should be instinctive and free but controlled. Watercolour painting gives me this challenge."

The third St Ives born man is Eric Ward who studied part-time at St Ives School of Painting. He was fortunate to hold a one-man show at Hallam Gallery, London in 1989, having only begun to paint seriously in 1987. His paintings are interior studies with nudes which are worked in oils or acrylics. "Subject matter is a vehicle by which the painting surface may be explored. The use of brush marks, the handling of paint, tone and colour, are the important business of painting."

Eric Ward first showed his interest in painting as a boy when he took lessons at the Painting School run by Leonard Fuller and his work was exhibited in Show Day. As well as finding time to paint he is also the harbour master and coxswain of the St Ives lifeboat.

A Tate Gallery in Cornwall

In 1989 Cornwall County Council agreed to buy the gasworks site overlooking Porthmeor beach from British Gas and to hold it for the purpose of establishing a custom-built Tate Gallery of the West. Of various sites in the town this was considered the most suitable.

A leading modernist architect, Richard Rogers, was appointed to a 6 man panel charged with selecting architects to submit designs for the Tate building. Rogers designed the Lloyds building in London and the Pompidou centre in Paris and closer to home and of an earlier period, two modern houses in Feock, Cornwall. He was one time chairman of the Tate Trustees. Also on the committee were Sir Alan Bowness, director of the Henry Moore Foundation, Nicholas Serota, Director of the Tate and Colin Amery, the architectural critic of the *Financial Times*. £2000 each was paid to five architects selected to submit designs in a national architectural competition in 1990.

Painting from Life, *1992, Eric Ward.*

Terry Frost with his Banner for Tate St Ives, *1992. Painted on Newlyn sail cloth.*

Evans and Shalev, a leading firm of architects with strong St Ives associations, were chosen. Senior partner Eldred Evans has a St Ives home in Barnaloft, which she inherited from her father Merlyn Evans, painter and poet. The partnership is based in London and was founded in 1965. She and David Shalev were responsible for the new Courts of Justice in Truro.

President of the RIBA, Maxwell Hutchinson, with Alan Groves, county architect, and Mike Bradbury, local St Ives architect, visited the site with the architects drawings of the planned building. Maxwell Hutchinson said, "I believe that significant buildings become social and historical markers and that this building will conform to that, not just for St Ives and Cornwall but the country as a whole." Patrick Heron said St Ives was the only provincial town in the world which had given its name to an international art movement in the 20th century. Heron's stained glass window is a major feature in the entrance hall.

Major works of Lanyon, Nicholson, Hepworth, Frost, Barns-Graham, Wells, Heron, Hilton, Wynter and others of the middle generation artists of the 50s and 60s in the Tate Collection, and who worked in Downalong and the Porthmeor studios, would be exhibited in a series of changing shows. It was estimated that the St Ives Tate would attract 75,000 visitors a year (in actuality 100,000 visitors arrived in less than four months).

The Tate of the West had gained momentum with a £250,000 donation from the Henry Moore Foundation. The European Development Fund was right behind the scheme, with the support of other financial bodies and local councils.

Visitors from Japan

Paying a visit to St Ives from Japan were Professor Seiji Oshima, director of the Setagaya Art Museum, Tokyo, his colleague Mr Yoshio Tsubouchi, chairman of the Setagaya Foundation of the arts and M Haruo Suzuki, president of the Association for Corporate Support of Arts. They had come to view the progress of the St Ives Tate Gallery building in which the Japanese arts community had expressed much interest.

Also in the party were Miss Naoko Miyamoto, director of Tokyo Marlborough Gallery and Dr David Brown, formerly of the Tate. Prof. Oshima visited the St Ives 1939-65 exhibition at the Tate in 1985, after which he had asked the help of Dr Brown in staging a like exhibition in Japan in 1989. Shoji Hamada's son, Yoshio Hamada, was also involved. He studied at the Royal College of Art from 1969-72. This was Professor Oshima's first visit to St Ives.

The party, which included Lady Holland, attended a number of private functions, including lunch with Patrick Heron at Eagle's Nest, a visit to the Newlyn studio of Terry Frost, and a party at which a traditional Japanese meal was served by Satchiko at Carn Cobba, Zennor, the home of Eric Quayle the writer. Satchiko, his Japanese wife had been acting as interpreter throughout the day.

STAG — St Ives Tate Action Group

STAG was formed in 1990 with Lady Carol Holland as president, Janet Axten, secretary/co-ordinator and Messrs Toni Carver, Henry Gilbert, Steve Herbert, Jeremy Knight, Roy Ray, Gareth Saunders, Leon Suddaby and Derek White as the first committee. Its aim was to raise £100,000. *St Ives Times and Echo* offered its support for publicity.

David Brown, Seiji Oshima of Setagaya Art Museum, Tokyo and Michael Jacobs at the opening of Tate St Ives.

The first fund-raising event was held at St Ives School of Painting where a lunch was organised for some 50 artists. Richard Carew Pole, chairman of CCC's Steering Committee for the project, outlined its history and hopes for the future.

Ten artists living in St Ives each produced an etching which together formed a varied portfolio. The Artists were Steve Dove, John Emanuel, Michael Foreman, Naomi Frears, Rose Hilton, Sheila Oliner, Bryan Pearce, Roy Ray, Maurice Sumray and Roy Walker. The etchings were limited to an edition of 75 and the sale price was £200. The sale and launch, which took place at Wills Lane Gallery, raised £12,000. Sheila Oliner, who masterminded the project, said "It seems an effective way to make a sum of money and we must have pitched the price just right." Because of the success of this a second portfolio was produced and launched at the Painting School to equal success. Various musical events, shows and lectures in the town also increased funds.

Art Auction 1991 and Wallis Fortnight 1992

By the time of the auction STAG had already raised £70,000 of the £100,000 of its committed target. The auction catalogue contained information about the artists and photographs of their work. Dr David Brown wrote an essay on the history of the art colony in an 80 page commemorative catalogue. David Lay, the auctioneer, and all the members of his staff gave their services free on the day. 250 works of art had been donated, most of them from the artists themselves. The auction raised £27,500. The catalogue, autographed by the artists, raised £100.

Studios Open Day was once again revived and artists received people into their workspace who wished to see a variety of work produced by a large number of painters in a close-knit area.

The Arts Club contribution was to hold a Writers' Day, organised by M Whybrow, when 20 authors with their books, publishers, booksellers, poets, collectors, specialist

St Ives Art Club Writers' Day. Michael Foreman, with Lady Carol Holland, introducing his new book for children Jack's Fantastic Voyage.

book dealers all arrived to meet people. Eric Quayle was on hand to cover book valuations. The official opening was carried out by Lady Carol Holland and a launch with local writer, Alison Symons' book *Tremedda Days*, took place in the morning. In the afternoon Michael Foreman signed copies of his new book *Jack's Fantastic Voyage* and in the evening Tim Hubbard of Radio Cornwall interviewed novelist Jean Stubbs.

At a later date a performance of M Whybrow's play *Back Road West* was part of a St Ives Alfred Wallis Fortnight. Gerry Phillips, local artist and Cornishman, gave a solo performance of Wallis in the last weeks of his painting life in his cottage before entering the workhouse. This was backed up by an Arts Council film on Wallis. Other events included a talk by Edwin Mullins, writer of the book on Wallis, Dr Roger Slack played tapes of interviews with personal acquaintances of Wallis and showed slides of his

8am the last of the workmen depart for home after an all night shift. David Shalev, architect, makes a final inspection.

10.30am the official opening of Tate St Ives. The Prince accompanied by Lord Falmouth the Lord Lieutenant of Cornwall. Left is Nicholas Serota, Director of Tate Gallery London; Sir Richard Carew Pole; Malcolm Veal, Town Clerk; Shirley Beck, Mayor of St Ives; Malcolm Furneaux, Director of Central Services; Councillor Alan Harvey, Chairman of Penwith District Council.

Tate Gallery, St Ives.

'Tate Gallery St Ives will present an annual cycle of displays, based on the Tate gallery's pre-eminent collection of St Ives painting and sculpture dating from about 1925 to 1975. They will be introduced by a simple photographic and textual display in the gallery's entrance "mall" spaces. The changing displays will give a rich picture of the many possible ways of understanding and enjoying modern art in St Ives.'

'As we turn from a typical Ben Nicholson of a still-life before a window with St Ives rooftops, harbour, and in the distance Godrevy lighthouse, and look out at the astonishing view from the gallery restaurant, of St Ives rooftops, harbour, and Godrevy lighthouse beyond, we must be sure to remember everything else that was important to the artist as he arrived at the image.'

'Through the changing displays in St Ives, Liverpool and Millbank, the same major works become visible in different contexts. We can invite speculation on whether the same work looks more or less to do with a given region when seen in different settings. The institution itself creates a "national" gallery in a "regional" setting. In this, the new gallery will pose in a dramatic rhetoric the real challenge of locating art in new contexts.'

One Hundred Years of St Ives as an art colony was splendidly celebrated with the opening of the new Tate Gallery St Ives in 1993.

work, Michael Tooby, new curator of the St. Ives Tate, introduced videos on the painter by art historians and discussed their various approaches to the man and his work.

1993
Opening of the Tate Gallery
Tate Gallery St Ives opened on 23 June 1993 on a glorious sunny day. An army of men worked all night completing the steps and at 8am they departed, leaving a policeman awaiting the arrival of security and the architect, David Shalev, inspecting the finishing touches before the arrival of Prince Charles, Duke of Cornwall.

Prospects for the Future — Michael Tooby, Curator of Tate Gallery, St Ives
'The new gallery in St Ives will operate as an integral part of the Tate Gallery London in common with Tate Gallery Liverpool. Its distinguishing characteristic will be its focus on the modernism associated with St Ives, a clear statement of its underlying aim of presenting and discussing the way in which art relates to a given region.'

'The gallery has to recognise in its audience-building that the audiences must necessarily cross over with other disciplines and interests, not just between art-forms, but with other subjects not immediately connected in the minds of many with modern art, notably archaeology, natural history, and industrial history.'

Michael Tooby, Curator of Tate Gallery, St Ives.

Biographies of Artists 1890-1930s

Robert Weir Allan 1852-1942
Born Glasgow. Painter of landscapes and seascapes in plein-air fashion. Studied at Académie Julian, Paris 1875-81. Moved to London and visited St Ives before the turn of the century. Founder member of NEAC.

Daphne Constance Allen b.1899
Painter and illustrator. Works illustrated in *London News, Tatler, Sketch*. Two books published by Allen and Unwin. Exhibited Dudley Gallery, Piccadilly 1912-15, Burlington Gallery, St Paul's Deanery 1925-27.

Emily Allnutt Exh. 1902-1931
Portrait, miniature and landscape painter. Studied Slade School and Paris. Exhibited at RA, Paris Salon, Liverpool. Member Society of Women Artists.

Sir John William Ashton 1881-1963
Born York 1881 but educated Adelaide and considered an Australian. Landscape and sea painter. Studied under Julius Olsson and Algernon Talmage and at Académie Julian. Member Art Advisory Board purchasing paintings for Australian Government. Pictures in National Galleries of Adelaide and Perth. Exhibited RA 35 times. Knighted 1960. Died Sydney.

Herbert Ivan Babbage 1875-1916
Born Wanganui, New Zealand. Oil and watercolour painter of landscape and seascapes. Before War spent some time painting in Grindelwald and held exhibition of work there. Joined the Devon and Cornwall Light Infantry and died whilst in the Army.

Alfred Charles Bailey b.1883
Born Brighton and studied Brighton School of Art and under Louis Grier in Cornwall. Landscape watercolour painter. Exhibited Goupil Gallery, Redfern and Twenty One Galleries. Atlantic Studio. Lived St Ives 1909-19.

Hurst Balmford b.1871
Born Huddersfield. Oil and watercolour painter of portraits and landscapes. Headmaster Morecambe School of Art. Studied Royal College of Art, Julians, Paris. Exhibited RA 8 times. Beach Studio, St Ives.

John Noble Barlow 1861-1917
Born Manchester. Landscape painter. Studied art Paris, New York, Belgium and Holland. Exhibited Plymouth, Bristol and Liverpool. Exhibited Carnegie Exhibition USA and received gold Medal, also one at Paris Salon 1900. Silver and bronze medals at Exposition Universelle, Paris. Exhibited RA 28 times.

Sir Claude Francis Barry 1883-1970
Educated Harrow. Etcher and landscape painter in oils. Hung 17 times RA. Painted many scenes of Windsor and district. Wife worked landscape and seascape pictures in needlework. Studios at Tregenna Hill and St Leonard's Studio, St Ives.

Frederick Samuel Beaumont b.1861
Born Lockwood, Huddersfield. Portrait, landscape and mural decorations. Studied RA Schools (silver medal) and Julians, Paris. Exhibited RA 15 times. Made 23 decorative panels for P & O Passenger Bureau.

Henry Bishop RA 1868-1939
Born London and studied Slade, Paris, Brussels and Pittsburg. Travelled Middle East. 1933 Chantrey Bequest bought his painting, *Shakespeare's Cliff, Dover*. Elected member of RA 1939. Exhibited RA 66 times. Work in collection of Tate.

Vera Bodilly
Studied St John's Wood Art School under Walenn and won scholarship to RA Schools. In St Ives in the thirties.

Ernest Borough-Johnson 1866
Born Salop. Portrait, figure and landscape, etcher and lithographer. Studied Slade School and Herkomer, Bushey. Professor of Fine Art, Bedford College, London University. Head of Art Chelsea Polytechnic. Teacher of life painting and drawing London School of Art and Byam Shaw School. Hung RA 55 times. Represented in British Museum, South Kensington Museum by drawings and lithographs.

Esther Borough-Johnson Exh. 1896-1940
(*née* George) Born Salop. Studied Birmingham School of Art, Chelsea Art School and Herkomer's, Bushey. Portrait, flower and landscape painter. Honourable mention Paris Salon. Exhibited RA 27 times. Married Ernest Borough-Johnson (q.v.).

George Fagan Bradshaw DSO, RN, b.1887
Born Belfast. Taught Charles Simpson's Painting School, St Ives. Painter of ships. Lived at Ship Studio, Norway Lane, St Ives. Married to painter Kathleen Marion.

Sir Frank Brangwyn 1867-1956
Born Bruges, Belgium. Painter and etcher. Studied under William Morris. Elected RA 1919. Member of most painting societies. Won many international awards and honours. Major retrospective 1924. Knighted 1941.

Sir John Alfred Arnesby Brown 1866-1955
Born Nottingham. Landscape painter in oils. Studied Nottingham School of Art and under Herkomer at Bushey. Painter of large landscapes. RA 1915. Knighted 1938. Exhibited 139 times RA. Three paintings purchased by Chantrey Bequest.

Mia Arnesby Brown d.1931
(*née* Edwards) wife of J Alfred Arnesby Brown (q.v.). Born Monmouthshire. Portrait and figure painter. Studied with Professor Herkomer at Bushey. Showed 36 times RA.

Alfred J Warne Browne d.1915
Landscape and marine painter. Lived St Ives with his wife Edith at Barnoon Terrace. Exhibited RA 20 times.

Reginald Grange Brundrit 1883-1960
Born Liverpool. Studied Slade. Landscapes chiefly in oils. Elected RA 1938, exhibited 38 times. Paintings, *Fresh Air Stubbs,* 1938 and *Nutwith Common, Masham* 1940 purchased by the Chantrey Bequest.

Charles David Jones Bryant l883-1937
Born NSW, Australia. Marine painter. Studied under Julius Olsson. Official artist attached to Australian Imperial Forces on Western Front, 1917. Commissioned to paint American Fleet in Sydney Harbour to be presented to Washington. Exhibited RA 15 times. National Art Gallery of New South Wales owns painting *Low Tide at St Ives.*

William Cave-Day 1862-1924
Born Dewsbury, Yorkshire. Domestic, figure and seascape painter. Studied painting and modelling Paris and Herkomer School. Spent much of his life at Knaresborough but last 5 years in Carbis Bay. Hung RA 10 times.

Minnie Agnes Cohen b.1864
Born Eccles. Studied RA Schools and Paris under Benjamin Constant. Painter and pencil/pastel artist. Exhibited RA 16 times, Paris Salon, Rotterdam and Europe. Two portraits in National Portrait Gallery. Signs M Agnes Cohen, M A C or M A Cohen.

Edith Marion Collier 1885-1964
Born Wanganui, New Zealand. Came to St Ives to study under New Zealand painter, Frances Hodgkins (q.v.) 1914-15 and revisited St Ives 1920 and '21. Also knew NZ painter Herbert Ivan Babbage (q.v.). Associate Society of Women Artists. Hung RA 3 times.

Frank T. Copnall 1870-1949
Born Ryde, Isle of Wight. Educated Ryde and Finsbury Park Colleges. Member Liverpool Academy and London Portrait Society. Portrait painter. Exh. 1894-1937. Hung RA 52 times. Represented in Liverpool and Birkenhead permanent collections.

Theresa Norah Copnall 1882-1972
(*née* Butchart) Born Haughton-le-Skern. Studied Slade School, Herkomer School and Brussels. Portrait and flower studies. Showed RA 7 times. Married Frank T Copnall (q.v.).

Garstin Cox 1892-1933
Born Camborne. Landscape painter, studied Camborne School of Art and under Noble Barlow. First Academy picture accepted at age of 19. Hung 3 more times RA. Son of William Cox of Camborne, draughtsman and painter.

Percy Robert Craft 1856-1934
Born London. Painter in oil, watercolour and pastel. Married Alice Elizabeth Tidy. Studied University College, London, Slade School under Sir E J Poynter and Professor Legros. Gold and silver medallist. Exhibited RA, Paris Salon, Liverpool, Glasgow, New Gallery. Exhibited RA 39 times.

William Edward Croxford 1852-1926
Born Essex. Arrived St Ives late 1880s and painted scenes of fishermen and harbours throughout Cornwall. Mostly landscape and marine paintings in watercolour. Travelled widely in Europe. Exhibited RA 5 times. Exhibition of his work held in Hayle, 1992.

Cyrus Cuneo 1878-1916
Born San Francisco. Painter and illustrator. Exhibited RA 13 times. Lived at 1 Bowling Green Terrace with wife Nell and son Terence (q.q.v.).

Nell Marion Cuneo Exh. 1893-1940
(*née* Tenison) Born London. Studied Cope's School of Painting, Colarossi's Academy, Paris, Whistler School. Portrait painter and illustrator. Medal for drawing, Paris. Worked for *Sphere, Madam* and *Lady's Pictorial.* Illustrated for many English and American publications. Lived Down-Along House, St Ives. Exhibited RA 11 times.

Terence Cuneo Exh. 1936-39
Son of Nell and Cyrus (q.q.v.). Illustrator and painter of trains for book publications. Lived at The Copper Kettle, St Ives with parents as a young man.

David Davies b.1864
Born Ballarat, Australia. Educated France. Studied art Melbourne and Julians, Paris. Landscape and coastal painter. Won first prizes for landscape and figure. Exhibited RA 6 times, also Paris Salon, Carnegie Institute. Work in Melbourne and Sydney Art Galleries.

Henry E Detmold Exh. 1880-1902
Landscape, figure and marine painter, etcher, aquatint, drypoint artist and watercolour painter. St Ives address 7 Bellair Terrace also 1 Rossetti Studios, Flood Street, London. First success with opening exhibition of the New English Art Club 1886. Exhibited RA 16 times.

Jessica Dismorr 1885-1939
Born Gravesend. Studied Slade and Ecole de la Palette. Contributed illustrations to *Rhythm.* Exhibited Salon d'Automne 1912-14. Joined Rebel Art Centre and exhibited at Vorticist exhibitions London (1915) and New York (l917). Member of London Group and 7 & 5 Society.

Mabel Douglas Exh. 1898-1937
(*née* Bucknall) Miniature portrait painter. Married John Christian Douglas, painter and photographer. Lived at 10 Parc Avenue. Sister Georgina Bainsmith, sculptor and photographer.

Thomas Millie Dow 1848-1919
Born Scotland. Landscapes, allegorical pictures and flower paintings. Decorative painter. One of the 'Glasgow

boys.' Studied Paris, and USA with Abbot Thayer. Wife Florence Pilcher was also a painter. President of St Ives Arts Club. Exhibited widely but not RA.

Lowell Dyer 1856-1939
Born USA. Studied Julians Academy and Venice. Friend of T M Dow (q.v.). Studio in the grounds of Talland House. Lived St Ives from 1889 to his death. Exhibited rarely. Known for panels of angels. Founder member of Arts Club. Had 2 brothers and 3 sisters.

William Eadie Exh. 1880-94
Founder member St Ives Arts Club. Came to St Ives 1888. Described as a domestic painter. Responsible for panels of 12 apostles in St John's In The Fields Church, St Ives. Died London and buried Highgate.

Sir Alfred East RA 1849-1913
Born Kettering. Landscape painter and etcher. Studied Glasgow School of Art and Ecole des Beaux Arts, Paris. President Royal Society of British Artists and Honorary Associate of RIBA. Awarded gold medals for paintings in London, Paris, Munich and Barcelona. Lived at 5 The Terrace, St Ives and in Camden Town, London. Knighted 1910, RA 1913. Exhibited RA on 108 occasions.

Mary Alexandra Eastlake Exh. 1891-1936
(née Bell) Born Canada. Studied Paris and painted portrait, figure and landscapes. Exhibited RA and hung there 17 times and in New York, Chicago and Boston. Represented in National Gallery of Canada. Married Charles Herbert Eastlake (q.v.).

Charles Herbert Eastlake Exh. l889-1927
Landscape painter in oils and watercolour. Studied Antwerp and Paris. Exhibited RA 17 times. Paintings in the gallery collections of Wellington and Christchurch, New Zealand. Illustrations in *Studio* magazine.

Archibald Howard Elphinstone 1865-1936
Landscape and seascape painter. RBA 1905 and exhibited 110 times. Showed RA 11 times. Paintings of St Ives Bay and trawlers.

Frank Lewis Emanuel 1865-1948
Landscape, interiors, black and white artist, architecture in etchings and lithographs. Studied University College, Slade, and Julians, Paris. Special artist with Manchester *Guardian*. Travelled widely. Exhibited RA 38 times. Married Florence Crawford-Evans.

Alice Maud Fanner d.1930
(Mrs Taite). Landscape and marine painter. Studied Slade School and with Julius Olsson at St Ives. Worked in Paris. Teacher of art at Richmond School of Art. Member of Society of Women Artists 1918. Exhibited RA 42 times.

A Romily Fedden 1875-1939
Studied with Professor Herkomer at Bushey School, Julians, Paris. Landscape painter in watercolour. Exhibited Paris Salon, International at Venice, Munich and New York. Travelled and exhibited widely but hung only 3 times RA. Exhibited Walker's Gallery, London 432 times.

Harry Fidler d.1935
Born Telfont, Wilts. Studied Herkomer School, Bushey. Figure, rustic and domestic painter. Exhibited Paris Salon, RA 30 times. Works in *Colour Magazine*. Picture in St Ives Town Museum. Married to Laura (née Clunas), portrait and figure painter. Exhibited RA 11 times. Died 1936.

Mary Florence 1857-1954
(née Sargent) Decorative mural painter and fresco artist. Studied Slade School and Colarossi, Paris. Two works painted 1913 bought by Chantrey Bequest in 1932 – *Suffer Little Children to Come Unto Me* and *Pentecost*. In 1949 the Chantrey Bequest bought *Children at Chess*, painted in 1903. Silver Medal at International Exhibition at San Francisco. Also lived at 21 Cheyne Row, Chelsea.

Harriet Mary Ford Exh. 1890-1908
Born Ontario, Canada. Educated Toronto. Studied St John's School of Art, RA Schools, Paris and Italy. Portrait, figure and decorative painter in oil and watercolour. Represented in collection of National Gallery, Ottawa. One of the earliest members of the Arts Club.

William Banks Fortescue 1855-1924
Figure and landscape painter. Studied art Paris and Venice. Lived Newlyn and Penzance. Exhibited 26 times RA. Lived with wife Mary at Treloyhan Cottage, St Ives.

Euphemia Charlton Fortune b.1885
Born California. Educated St Margaret's Convent, Edinburgh. Studied St John's Wood School of Art and New York. Landscape painter. Silver medallist at San Francisco. Exhibited France, America, Europe. Exhibited RA 4 times.

A. Moulton Foweraker Exh. 1898-1912
Flower and landscape painter. Came to St Ives 1901 and lived in Lelant. Exhibited 52 times with Royal Society of British Artists, of which he was a member.

Frank Proschwitzry Freyburg Exh. 1893-1939
Born 1862. Studied RA Schools and hung there 24 times. Landscape and portrait painter. Married Monica MacIvor (q.v.).

Monica Freyburg
(née MacIvor). Born Persia. Studied Alexandra College, Dublin and Julians, Paris. Portrait, miniature, landscape and figure painter. Exhibited RA 12 times and Paris Salon etc. Illustrated *Wonder Book for Children*. Signs Monica MacIvor.

Edmund G Fuller Exh. 1888-1916
Landscape and figure painter. Published set of pen and ink sketches of houses, streets and scenes in St Ives. Came to St Ives 1892. Exhibited 23 times RA

George Turland Goosey
Retired from architecture to become painter. Painted mostly seascapes. Studio in the Warren now known as Crab Rock. Designed war memorial in St Ives and presented it as gift to the town. Not mentioned in Dictionary of British Painters.

Franz Muller-Gossen 1871-1946
Born Munchen-Gladbach, Germany. Studied Dusseldorf. Landscape and sea painter. Studied with Julius Olsson. Painted France, Italy, Holland, Australia, Japan and USA. Professor of several Academies in Europe. Exhibited widely. Pictures sometimes signed F.M.Gossen.

Thomas Cooper Gotch 1854-1931
Born Kettering. Studied Slade School and Paris. Oil and watercolour painter, pastels and etching. Married Caroline Burland Yates, also a painter. *Alleluia* purchased by Chantrey Bequest 1896. Obtained second and third gold medals at Paris Salon. Lived at 9 Bellair Terrace, St Ives and at Wheal Betsy, Newlyn. Exhibited RA 68 times.

Hugh Gresty 1899-1958
Born Lancashire and studied Lancashire School of Art and Goldsmith's College, London. Showed RA 20 times. Lived at Ship Aground off harbour and had a Porthmeor Studio. Later lived at Carbis Bay.

Louis Reginald James Monro Grier 1864-1920
Born Australia of Irish parents. Educated Toronto and King's College, London. Untrained as artist and gave up work in a bank to paint. Came to England 1884 and began painting en plein air. Founder member St Ives Arts Club. Exhibited RA 11 times. Brother of Sir Edmund Wyly Grier.

Mary Grylls Exh. 1921-37
Studied Crystal Palace School of Art. Figure, flower and landscape painter in watercolour/pen and ink wash. Studied under Norman Garstin in Newlyn. Principal works *The Flower Market, Nice* and *The Courtyard, Godolphin Manor House*. Lived at Ar-Lyn, Lelant.

Arthur Creed Hambly b.1900
Born Newton Abbot. Landscape watercolour painter, etcher and illuminator. Headmaster Camborne and Redruth School of Art. Educated Kelly College, Tavistock. Studied Schools of Art Newton Abbot and Bristol. Exhibited Chicago Society of Etchers. Lived at 30 West End, Redruth.

Alfred Hartley 1855-1933
Born Stocken Pelham, Herts. Founded New Print Society St Ives in 1923. Their first exhibition of 65 works held at Lanham's. Specialised in etching and had studio at Piazza. Studied Royal College and Westminster Schools of Art. Exhibited RA 65 times. Wife Nora flower and domestic painter.

Arthur Hayward b.1889
Born Southport. Studied Warrington School of Art and under Stanhope Forbes. Marine, portrait and figure painter. Exh. 1920-40. Hung 19 times RA. Ran school of painting in St Ives.

Beatrice Pauline Hewitt b.1907
Landscape, portrait painter and teacher. Studied Slade School and Paris. Exhibited Society of Women Artists. Hung 15 times RA.

Frances Hodgkins 1870-1947
Born New Zealand. First came to England when she was 20. Received no formal art training. Spent First World War years in St Ives, ran painting school and occupied 7 Porthmeor studios. Figure, landscape and still life painter. Taught at Colarossi's, Paris and opened watercolour school in France for women students. Hung in RA 5 times. Associate of the Society of Women Artists.

Eleanor Hughes b.1882
Watercolour painter from New Zealand. Studied at Newlyn under Stanhope and Elizabeth Forbes. Married Robert Morson Hughes (q.v.). Lived at Lamorna and Chyangweal, St Buryan. Exhibited RA 37 times.

Robert Morson Hughes 1873-1953
Landscape and seascape painter. Born 1873. Educated Queen Elizabeth Grammar School, Sevenoaks. Studied Lambeth School of Art and South London Technical Art School. Exhibited RA 21 times.

Robert Langley Hutton Exh.1912-17
Painter and colourist. Died of tuberculosis 1919 and buried in Barnoon cemetery. Lived at 5 Porthminster Terrace, St Ives from 1909.

Lucy Kemp-Welch 1869-1958
Born Bournemouth. Painter of horses. Studied at Bushey under Professor Herkomer. Became principal of that school after Herkomer. Two paintings were bought by Chantrey Bequest 1897 and 1917. Exhibited RA 61 times.

Helen Knapping d.1935
Landscape and flower painter in oil and watercolour. Studied in England, France and Belgium. Exhibited Grosvenor Gallery, Royal Academy and Goupil Gallery. Illustrations for children's paper, Christmas cards and other designs. Penwith Studio.

Dame Laura Knight 1877-1970
(*née* Johnson) Born Long Eaton. Landscape, figure and portrait painter. Studied Nottingham School of Art. Elected RA 1936 and exhibited there 112 times. Two paintings bought by Chantrey Bequest. Made a Dame 1929. Member Society of Women Artists 1933. During Second World War official war artist and in 1945 provided visual record of the Nuremburg Trials.

Reginald Guy Kortright Exh.1901-39
Born Clifton, Glos, 1877, son of Sir Cornelius Kortright. Landscape and decorative painter. Educated Newton College, Newton Abbot and also Canada. Landscape and decorative painter. Exhibited RA 33 times.

Clara Bracebridge Lancaster Exh.1924-40
(*née* Manger). Born Hong Kong. Portrait, still life and landscape painter. Studied Brussels, Byam Shaw School and with Algernon Talmage at St Ives.

Sydney Mortimer Laurence 1865-1940
Born USA. Painter of snow scenes and now one of Alaska's foremost artists. Came to St Ives 1889. War artist for *Black and White* magazine 1900. Alexandrina Dupre, his first wife, also a painter.

Richard Hayley Lever 1876-1958
Born Adelaide. Landscape and marine painter. Came to St Ives to study under Julius Olsson. Lived at 14 Carrack Dhu. Exhibited Paris Salon, London and other provincial galleries. Sydney National Art Gallery purchased a St Ives painting 1913. Awarded Carnegie prize 1914.

Thomas Hodgson Liddell 1860-1925
Landscape painter. Travelled widely throughout Britain. Came to St Ives 1914. Elected RBA 1905 and exhibited with them 46 times.

Moffat Peter Lindner 1852-1949
Landscape and marine painter in oil and watercolours. Studied Slade. Awarded medals in Paris and Spain. Member New English Art Club. Exhibited RA 68 times. Augusta Baird, his wife, also a painter. President St Ives Arts Club and St Ives Society of Artists.

Arthur Meade Exh. 1888-1939
Landscape and figure painter. Lived St Ives many years and had Morreps Studio in Lelant. President of Arts Club 1902. Exhibited 63 times RA. Died 1942.

Mary McCrossan 1863-1934
Born Liverpool. Studied Liverpool School of Art and Académie Delecluse, Paris and Julius Olsson. Won medals and scholarship in Liverpool and silver medals and scholarship in Paris. Landscape, figure and flower painter. Hung 22 times RA. Work reproduced in *Studio* and *Colour*. Work in Contemporary Art Society. In 1935 Walker Art Gallery, Liverpool held Memorial Exhibition. Also had studio at 126 Cheyne Walk, Chelsea.

Fred Milner d.1939
Landscape painter. Came to St Ives 1898. Lived at Zareba, Treloyhan Hill with wife Sophia. Exhibited RA 30 times. Buried at Lelant.

Robert James Enraght Moony 1879-1946
Born The Doon, Athlone. Studied Julians, Paris. Painter of imaginative pictures and landscapes in tempera and watercolour. Studied sculpture before painting. Exhibited RA 24 times. Lived at Mount Hawke, Truro.

Alice Moore b.1908
Born Honolulu. Studied Royal College of Needlework, South Kensington. Died late 1980s.

Frank Moore b.1876
Watercolour painter and etcher. Studied University College, London. Exhibited 1910-39. Lived at 1 Draycott Terrace. Worked in Beach Studio.

Theo Moore, Miss Exh.1911-29
Born Birmingham 1879. Landscape painter. Studied Paris, Spenlove School of Art and St Ives with Sir Alfred East and Terrick Williams. Became Principal Cathcart School of Modern Painting.

Charles Greville Morris b.1861
Born Lancashire. Landscape painter. Studied Paris. Came to St Ives some time before 1890. Served on first Committee of St Ives Arts Club, 1890. Exhibited 25 times RA.

Arminell Morshead Exh. 1916-28
Born Tavistock, Devon. Studied Slade School and Royal College of Art. Hon. mention at Paris Salon 1928. Painter in oil and watercolour, etcher of horses. Exhibited Paris Salon, Modern Art section Wembley Exhibition.

Oswald Moser Exh. 1904-40
Born London 1874. Educated at Highgate. Studied St John's Wood Art School. Oil and watercolour painter and black/white illustrator of own stories. Hon. mention at Paris Salon 1907. Silver medal Paris Salon 1922. Exhibited RA 37 times. Six of his pictures at Imperial War Museum.

Armorel Mary Yeo Morton Nance Exh. 1924-29
Sculptor, painter, designer and engraver. Educated King Alfred School, Hampstead. Studied Slade and Royal College of Art, Rome, British School at Athens. Lived at Pentowan, Carbis Bay.

Christopher Richard Wynne Nevinson 1889-1946
Painter in oil and watercolour, etcher and lithographer. Son of writer H.W.Nevinson. Visited Arts Club in 1920s. Member New English Art Club. Studied St John's Wood School, Slade and Julians, Paris. Official artist, World War I. Collections at Tate Gallery, Imperial War Museum, Montreal Contemporary Art Society, Metropolitan New York. 1 Steeles Road Studios. ARA 1939.

Alice Hogarth Nicholson Exh. 1899-1940
Born Manchester. Studied Manchester School of Art and Colarossi's, Paris. Oil and pastel figure artist. Kensington medallist prizewoman. Associate Society of Women Artists. Exhibited RA 7 times. Picture *Idleness* presented to Municipal Art Gallery, West Hartlepool.

Job Nixon 1891-1938
Born Stoke-on-Trent. Studied Slade and Royal College of Art and British School in Rome. Known mainly for his etchings. Taught etching at South Kensington. Hung 36 times RA and in collection at Tate Gallery.

Julius Olsson 1864-1942
Born Islington, London. English mother and Swedish father, a timber merchant. Self-taught painter. President St Ives Arts Club. 1919 President Royal Institute of Oil Painters until his death. *Moonlit Shore* purchased by Chantrey Bequest 1911. Elected RA 1920. Exhibited at RA 175 times.

Will E Osborn 1868-1906
Born Australia. Early member of Arts Club. Harbour scenes comparable with John Park (q.v.). Appears in Arts Club photograph, *Saturday Night 1895*. Died in Chelsea. Falmouth Town Council has *Smeaton's Pier* in their collection.

John Anthony Park 1880-1962
Born Preston. Studied under Julius Olsson (q.v.) and Algernon Talmage (q.v.). Marine and landscape painter. *Snowfalls on Exmoor* purchased by Chantrey Bequest, 1940. Exhibited RA 48 times. Lived most of adult life St Ives but moved to Brixham, 1957. Died in Preston.

William Samuel Parkyn Exh. 1899-1940
Born Blackheath, London 1875. Educated Blackheath and Rochester. Naval, sea and landscape painter. Lived Newquay, The Lizard and St Ives. Miniature painting for the Queen's Dolls House.

James Lynn Pitt d.1922
Occupied White Studio on the cliffs at Porthmeor Beach which was open to the public. Painted views from studio of The Island and Clodgy. Buried in Barnoon Cemetery, St Ives.

Lewis Charles Powles 1860-1942
Educated Christchurch, Oxon. MA 1898. Landscape painter. *The Shipyard* in V & A. Other permanent collections in War Museum, Huddersfield and Hastings.

Ethel Louise Rawlins Exh. 1900-40
Landscape, flower and interior painter. Studied Slade School and Newlyn. Exhibited RA 8 times, illustrations in the *Studio*.

Henry Harewood Robinson Exh. 1884-1904
Figure, landscape and coastal painter. First secretary St Ives Arts Club, 1890. Exhibited 13 times RA. Died 1904.

Maria D.Robinson Exh. 1881-1910
(*née* Webb) Born Northern Ireland. Wife of H. Harewood Robinson (q.v.). Figure, landscape and flower painter. First exhibited RA 1885 with *A Pool in the Rocks. A Volunteer for the Lifeboat* owned by Salford City Art Gallery. Exhibited 13 times RA.

Major George Conrad Roller b.1858
Born Surrey. Educated Westminster School. Studied Lambeth Architectural Museum and Paris. Travelled worldwide. Portrait painter. Sporting advertisement designer to Burberry's for 30 years. Picture restorer at Burlington House for 20 years, and for galleries in America and Continent. Featured in magazines *Graphic, Illustrated London News, Harpers*. Portraits of cricket group in pavilion Kennington Oval. Exhibited RA 3 times.

Frederick Sargent
Resident St Ives and lived at Hawks Point. Painted House of Lords and Commons. Town Council own large painting *Catch of Pilchards, St Ives*.

Louis Augustus Sargent b.1881
Born London of French family. Painter and sculptor. Exh.1906-27. Hung once RA. Wife Katharine Evelyn (*née* Clayton) also a painter. When not in St Ives they shared studios at 2 and 3 King Henry's Road, Hampstead.

Helene Schjerfbeck 1862-1946
Born Finland. Painted and exhibited in France and Italy. Came to St Ives and studied with Adrian Stokes. Painted several pictures in St Ives, *The Old Bakehouse* and *View of St Ives* in 1887. *The Convalescent*, of which there were several studies, won medal at Paris World Fair 1889.

Walter Elmer Schofield 1867-1944
Born Philadelphia. Studied art at Pennsylvania Academy and Julians, Paris. Came to St Ives 1903. Travelled widely. Exhibited in USA. Awarded Carnegie Gold Medal whilst in St Ives. Lived at Godolphin Manor, Cornwall.

Helen Priscilla Seddon Exh. 1930s
Born Shropshire, daughter of New Zealand sheep farmer. Studied art Edinburgh and Paris. Landscape, seascape, and architectural painter in watercolour. Still life in oils. Lived at Morvah Studio St Ives.

Dorothea Sharp 1874-1955
Born Dartford, Kent. Landscape, figure and flower painter. Studied Regent Street Polytechnic and Paris. Member Society of Women Artists. Exhibited 54 times RA. Came to St Ives in 1920s.

Edward E. Simmons Exh. 1881-91
American. Landscape, coastal and figure painter. Joined painting colonies of Paris and Concarneau. Came to St Ives 1885. Exhibited RA 6 times. Member first committee of St Ives Arts Club in 1890. Wife Vesta a painter, and writer.

Charles Sims 1873-1928
Portrait, landscape and decorative painter and illustrator. Studied South Kensington, Julians Paris and RA Schools. RA 1915. *The Fountain* and *Wood Beyond the World* purchased by Chantrey Bequest. Keeper of RA 1920-26, resigned due to mental illness and committed suicide.

Charles Walter Simpson Exh.1907-40
Born Camberley, 1885. Painter of wildlife and Cornish landscape, marine and seabirds. Studied with Lucy Kemp Welch (q.v.) at Bushey and Julians, Paris. Illustrated and wrote several books on animals. Awarded silver medal, Paris Salon 1923 and Olympic medal Paris 1924. Gold medal International Exhibition San Francisco.

Ruth Simpson
(*née* Alison) Portrait painter. Studied Stanhope Forbes School of Painting, Newlyn. Member Society of Women Artists. Tutored in portraiture at St Ives School of Painting with husband Charles (q.v.).

Marcella Smith Exh. 1916-40
Born East Molesey, Surrey. Landscape and flower painter. Studied USA School of Design, Philadelphia and Paris. Member Society of Women Artists. Hung 9 times RA. Died 1964 aged 78.

Francis Algernon Spenlove Spenlove 1897-1981
Born London. The Green Studio, The Wharf, St Ives. (Exh.1920-30) Portrait and figure painter. Sometimes signed Francis Raymond. Lived at Hawks Point. Exhibited Paris Salon, Liverpool and other provincial galleries. Son of Frank Spenlove-Spenlove (1868-1933), born in Stirling. Studied London, Paris and Antwerp. Figure and landscape painter in oil and watercolour. Exhibited RA 79 times.

Margaret Stoddart Exh. 1899-1906
Born New Zealand. Landscape painter. Exhibited with Society of Women Artists. Hung once RA. Exhibited Paris Salon 15 times. Collections in New Zealand Galleries.

Adrian Stokes 1854-1935
Born Southport. Studied RA Schools and Paris. Landscape, portrait, genre, historical and literary painter. Author of *Landscape Painting* 1925. First exhibited RA 1876. 1889 awarded medals at Paris exhibition and Chicago World Fair. First president St Ives Arts Club, 1890. Elected ARA 1910 and RA 1919. Exhibited RA 125 times. Vice President RWS 1932. Member NEA.

Marianne Stokes 1855-1927
Born Marianne Preindlsberger, native of Austria. Portrait, genre and biblical painter. Studied Paris and Munich and painted first Salon picture in Brittany 1884 called *Reflection*. Work in Liverpool Art Gallery. Associate Society of Women Artists. Exhibited at the RA 35 times. Married Adrian Stokes (q.v.). Member NEA.

Alan Gardner Folliott Stokes d.1939
Known as Folliott Stokes. Painter, writer and founder member of Arts Club and long-term resident in St Ives. Painted large landscapes of wild moorland scenes with great rolling skies. Hung RA 4 times. Wrote several books on the natural landscape of West Penwith.

Algernon Talmage 1871-1939
Born Oxford of Cornish mother. Studied painting West London School of Art and with Herkomer at Bushey School. Medallist at Hors Concours, Paris Salon. Elected RA 1929 and exhibited RA 140 times. Member NEA. Work in many public collections. Official war artist.

William Holt Yates Titcomb 1858-1930
Born Cambridge. Landscape, figure and genre painter. Studied South Kensington Schools, Antwerp, Paris and at Herkomer School, Bushey. Member first committee St Ives Arts Club 1890, President 1900. Exhibited RA 42 times. Member NEA. Married to Jessie Ada Morison, genre painter. They lived at Windy Parc, St Ives.

John Henry Titcomb 1862-1952
Brother of W H Y Titcomb (q.v.). Studied Slade School. Landscape painter. Lived in St Ives. President Arts Club 1910.

Annie Walke Exh.1909-40
(*née* Fearon). Sister of painter Hilda Fearon. Educated Cheltenham College. Studied Chelsea School of Art and with Augustus John, Sir Wm. Orpen and Sir Wm. Nicholson. Portrait and figure painter in oils. Exhibited Paris Salon, Goupil Gallery, Pittsburg, Venice and Liverpool. Married Rev Bernard Walke of St Hilary church, Marazion, Cornwall.

Billie Waters Exh. 1925-40
Born Richmond, Surrey 1896. Studied Harvey and Procter School, Newlyn, South Kensington and British Museums. Flower and animal painter and decorative panels. Works illustrated in *Sphere* and *Studio*. Fradgen Studio, Newlyn. Died 1965 aged 70.

Helen Stuart Weir Exh. 1915-40
Born New York. Landscape and still life painter and sculptor. Studied England, Germany and USA. Hung 22 times RA. Related to painter Nina Weir Lewis.

Minnie Whalley
Born Gloucestershire. Educated Cheltenham and Clifton High School. Studied Gloucester School of Art, Central School of Arts and Crafts, Geneva. Oil, watercolour and tempera, embroiderer and pewter worker. Formerly art mistress in Dundee, High School Truro and Penzance.

Miss E J Whineray Exh. 1899-1933
Watercolour painter. Studied Birkenhead and Liverpool School of Art and under Julius Olsson and Arnesby Brown (q.q.v.). When not in St Ives at Heswall, Cheshire.

Arthur White 1865-1953
Born Sheffield. Studied Sheffield School of Art. Landscape and marine painter. Ran school of painting in Sheffield with J G Sykes. One of early arrivals in St Ives. Taught pupils at his house TrePolPen in Street-an-Pol.

Sarah Elizabeth Whitehouse 1854-1933
Early member of Arts Club, along with her three sisters. 1893 awarded bronze medal for painting Académie Delecluse. 1897 awarded first prize £40 for *Interior and Figure* in competition. Exhibited in many provincial art galleries and RA twice.

Mary Frances Agnes Williams Exh.1918-33
Born Whitchurch, Salop. Portrait and landscape painter in oil and watercolour. Educated England and Germany. Studied art Paris. Exhibited Paris Salon. Enys Studio, St Ives.

Terrick Williams 1860-1936
Born Liverpool. Educated Kings College School. Studied Antwerp and Paris. Silver medal Paris Salon 1908, gold medal 1911. Marine and landscape painter. Showed RA 142 times. Member Society of 25 Artists. President Institute of Painters in Watercolours. RA 1933.

William Lionel Wyllie RA 1851-1931
Marine and coastal painter, etcher and writer. Studied Heatherleys and RA Schools. Awarded Turner Gold Medal 1869. RA 1907. *Toil, Glitter, Grime and Wealth on a Flowing Tide* 1883 and *The Battle of the Nile* 1899 purchased by Chantrey Bequest.

Biographies of Artists 1930s-1993

Pat Algar b.1939
Born London. Studied Wimbledon College of Art 1955-59. RA Schools 1959-62. Moved to Nancledra 1964 and St Ives 1975.

Alixe Jean Shearer Armstrong 1894-1984
Born London. Educated Roedean School for Girls. Studied Slade School of Art. Flower and portrait painter in oils. Illustrations in black and white and watercolour. Hung RA 9 times. Studios at 1 Piazza and 9 Porthmeor.

Richard Ayling b.1950
Born Middlesex. Studied Twickenham College of Technology. Came to St Ives 1977. Lives on Trencrom Hill. Opened Porthmeor Gallery with Paul Richards 1990.

John Rankine Barclay 1884-1964
Born Edinburgh. Studied Royal Scottish Academy Schools. Awarded Carnegie travelling scholarship to Spain, France and Netherlands. Woodcut artist. Decorative and mural painter.

Wilhelmina Barns-Graham b.1912
Born Fife, Scotland. Studied Edinburgh College of Art 1932-37. Awarded travelling scholarship to Paris and London. 1939 awarded post-graduate scholarship and studied in Europe. Painter who combines abstract and figurative elements.

Trevor Bell b.1930
Born Leeds. Studied Leeds College of Art 1947-52. Taught part-time Harrogate Art College to 1955 and Ravensbourne, Bradford and Winchester Schools of Art. Became Gregory Fellow at Leeds University. Lives in USA.

Anthony Benjamin b.1931
Born Hampshire. Studied engineering Southall Technical College 1946-49. Studied at Fernand Leger's studio, Paris and Regent Street Polytechnic to 1955, where awarded silver medal for painting. Gained awards to study in France and Italy. 1990 solo exhibition 'Works on Paper' Gimpel Fils, London.

Sven Berlin b.1911
Born Sydenham, London of Swedish father and English mother. Studied engineering Crystal Palace Engineering School. Followed career as Adagio dancer after Zelia Raye School of Dancing. Studied art at Beckenham and Redruth Schools of Art. Painter, sculptor and writer. Came to St Ives 1938.

Noel Betowski b.1952
Born Tilbury, Essex. Studied Central School of Art and Institute of Education, London University. Combined painting and teaching but 1987 moved from London to Cornwall to paint full-time. Opened his own gallery in Penzance.

Sandra Blow b.1925
Born London. Studied St Martin's School of Art 1942-46 and RA Schools 1946-47. Worked in Italy, Spain and France. First solo show 1951. Taught at Royal College of Art 1960. ARA in 1971 and RA 1978.

David Bomberg 1890-1957
Born Birmingham. Studied for City and Guilds at evening classes in London 1905-07 and evening classes at Central School of Art 1908-10, also at Westminster School and Slade. Taught part-time at Polytechnic in London 1934-53. Came to St Ives for a year in 1947.

Dorothy Bordass b.1905
Studied France and Italy. Favoured American Abstract Expressionists. Exhibited in 'Tachiste, Abstract and Meta-visual' exhibition at Redfern Gallery, 1957. Lived at St Ives in 1950s.

Susan Bradbury b.1958
Born Newcastle-upon-Tyne. Studied Newcastle School of Art 1974, Liverpool Polytechnic 1975-77. Falmouth School of Art and Design 1989-93. Came to St Ives 1977. Lives with architect husband at the Count House, once the Leach family home.

Michael Canney b.1923
Born Falmouth, Cornwall. Studied Redruth and Penzance Schools of Art, St Ives School of Painting and Goldsmiths. Served as director of Newlyn Orion Gallery for a number of years.

Penn Carwardine
Born London. Studied Hornsey School of Art. Paints in studio in a house Edge o' Cliff overlooking Porthkidney beach. First solo show Camborne School of Mines 1993.

Jill Chandler b.1942
Born Middlesex. Studied Falmouth School of Art, sculpture and painting at age of 15. St Ives painter Peter Lanyon one of her tutors. Lived at Mevagissey and came to St Ives 1976.

John Charles Clark b.1941
Born London. Studied Woolwich School of Art, Camberwell School of Art and London College of Printing. Winner Sainsbury's 'Images for Today' competition 1982. Teaches part-time St Ives School of Painting.

Ithell Colquhoun 1906-1988
Born Shillong, Assam. Studied Slade School, Paris and Athens. Lived Paris and London in the thirties. Leading member of British Surrealists. Work in Tate Gallery. Retrospective exhibition Newlyn Orion, 1976.

Roy Conn b.1931
Born London. Trained as structural engineer. Mainly

self-taught. Hard-edge painter. Also interested in photography. Moved to St Ives 1958. Works from a Porthmeor Studio.

Jessica Cooper b.1967
Born Clifton, Bristol. Studied Falmouth School of Art 1985-86. Goldsmiths College 1986-89. Lived in Cornwall from age of one year. Set up print workshop for mentally handicapped in Penzance.

Tom Cross b.1931
Born Manchester. Studied Manchester College of Art and Slade. Won Italian and French Government scholarships and travelled and painted in those two countries. Taught painting Reading University. Served as Principal of Falmouth School of Art, Cornwall 1976-87. Author of *Painting the Warmth of the Sun* on artists in Cornwall.

Bob Crossley b.1912
Born Northwich, Cheshire. Started painting when 14. Studied Commercial Art. Worked as printmaker for a number of years. Works from a Porthmeor Studio. Came to St Ives 1959.

Robert Culwick b.1926
Born near London. Studied Kingston College of Art. Moved to St Ives 1967. Influenced by Mark Rothko. Works from studio in his home.

George Dannatt b.1915
Born Blackheath, London. Qualified as surveyor after studying at London University 1935-40 and joined family business. Also studied music and song writing. 1955 became interested in painting.

Alan Davie b.1920
Born Grangemouth, Scotland. Studied Edinburgh College of Art 1937-40. Studied jewellery-making as well as painting. Travelled widely in Europe. 1956-59 was Gregory Fellow at Leeds University. Taught at Central School of Art briefly.

Bob Devereux b.1940
Born Surrey. Studied Kingston College of Art. Lived St Erth 1966. Painted in St Ives since 1973. First gallery in Craft Market, St Ives, opened Salthouse Gallery in 1980. Painter, poet and librettist.

Pauline Liu Devereux
Born Preston, Lancashire. Studied Liverpool College of Art 1969-72. Post graduate degree in embroidery at Manchester 1972/3. Embroidery work has sold at Liberty and in Japan. Lived in St Erth since 1973.

Stephen Dove b.1949
Born Leicester. Studied at Faculty of Art and Design, Lanchester Polytechnic and Coventry and Birmingham Polytechnic. Lived Zennor from 1976 and moved to St Ives 1980. Works in Porthmeor Studio.

Agnes Drey d.1957
Studied painting in France and England with Frances Hodgkins (q.v.). Came to St Ives 1932. Exhibited with Newlyn and St Ives Societies.

Tom Early b.1914
Born South China. Cornish family connections on mother's side. Studied medicine but illness caused him to retire from medicine, after which he took up painting, encouraged by Ben Nicholson.

John Emanuel b.1930
Born Bury, Lancashire. Served apprenticeship as signwriter and decorator. Self-taught figure painter. Moved to Cornwall 1963, lived at Nancledra and Halsetown. St Ives 1976. Works in Porthmeor studio.

Merlyn Evans 1910-1973
Born Wales. Studied Glasgow School of Art and Royal College of Art, also Paris, Berlin, Italy and Copenhagen. Exhibited with Surrealist International Exhibition, 1936. Retrospectives at Whitechapel Art Gallery 1956 and Welsh Arts Council exhibition 1974. Visitor to St Ives over many years. His daughter Eldred Evans, with partner David Shalev, architects for new Tate Gallery, St Ives.

Paul Feiler b.1918
Born Frankfurt. Studied Slade 1936-39. Interned in Canada in 1939. On return to England taught art Eastbourne and Oxford. Head of Painting 1963-75 at West of England College of Art.

Clifford Fishwick b.1923
Born Lancashire. Studied Liverpool School of Art 1940-42. Served in Royal Navy 1942-46. Completed studies at Liverpool. 1947 began teaching at Exeter College of Art and in 1958 appointed principal. First solo exhibition at St George's Gallery, London.

Robert Floyd b.1951
Born Birmingham. Studied at Bournville College of Art and Wolverhampton Polytechnic. Prizewinner International Artists in Water Colour 1981. Opened Trelyon Gallery, St Ives in 1991.

Kathryn Floyd b.1951
Born Newport, Gwent. Studied Newport College of Art and Design. Obtained degree in three-dimensional design at Wolverhampton Polytechnic. Opened enamelling workshop in St Ives.

Michael Foreman b.1938
Born Pakefield, Suffolk. Studied Lowestoft School of Art and Royal College of Art where he won scholarship to USA, 1963. Lives and works London and St Ives. Retrospective Smiths Gallery, London 1989.

John Forrester b.1922
Born Wellington, New Zealand. Lived in St Ives five years from 1953. Later moved to France and Italy.

Naomi Frears
Born Leicestershire. Studied Loughborough Art College 1981-82. Sunderland College of Art 1982-86. Studied sculpture and printmaking.

Colin Freebury b.1946
Born London. Studied Falmouth School of Art. Works in

Penwith Studio and came to St Ives in 1967. Abstract colourist.

Ralph Freeman b.1945
Born London. Studied at St Martins and Harrow Schools of Art. As well as painting and lecturing in art has designed stage sets and murals and worked as a Jazz pianist.

Anthony Frost b.1951
Born St Ives. Educated North Oxfordshire Technical College and School of Art 1967-70. Cardiff College of Art 1970-73. Moved back to Cornwall 1974. Prizewinner Westward Open Competition 1977.

Terry Frost b.1915
Born Leamington Spa, Warwickshire. Studied at evening classes Birmingham Art College. 1946 moved to St Ives and studied at St Ives School of Painting and from 1947-49 at Camberwell School of Art. Taught at Bath Academy of Art and Leeds School of Art. Returned to St Ives 1957 to paint full-time. Abstract painter and colourist.

Leonard John Fuller 1891-1973
Born Dulwich. Studied Clapham School of Art 1908-12 and RA Schools 1912-14. Portrait, figure and still life painter. Opened School of Painting in St Ives 1938. Elected Royal Cambrian Academician 1939.

Marjorie Fuller 1893-1979
(*née* Mostyn) Born Bushey. Daughter of Tom Mostyn, the painter. Studied at St John's Wood Art School and RA Schools. 1915 awarded British Institute Scholarship and silver and bronze medals. Painter of portraits and still life. Ran St Ives School of Painting with her husband.

Naum Gabo 1890-1977
Born Russia with the name of Pevsner. Studied medicine and natural sciences at Munich University 1910 and engineering school 1912. Sculptor and constructivist. Came to Britain 1939 and left for USA 1946.

David Haughton 1924-1990
Born London. Attended Slade School of Art. Taught at Central School of Art. Brought students to paint in St Just in Cornwall each year. Work is of old mine workings, engine houses and miners' cottages.

Malcolm Haylett b.1923
Born Canada. Studied St Martins School of Art, London and Southend College of Art. Taught design and painting Redruth School of Art. Wife Jean studied Higginbottom School of Art, Ashton-under-Lyne. The Hayletts came to St Ives 1947.

Patrick Hayman 1915-1988
Born London. Began painting in New Zealand where lived from 1936-47. Returned to England 1947. Founded and edited magazine *The Painter and Sculptor*.

Adrian Heath 1920-1992
Born Burma. Came to England 1925. Studied at Stanhope Forbes, Newlyn 1938 and attended Slade School 1939. Abstract artist. Taught Bath Academy 1955-76 and University of Reading 1980-85.

Isobel Atterbury Heath 1908-1989
Born Yorkshire. Studied Colarossi's, Montparnasse, Paris and St Ives School of Painting under the Fullers. 1939-45 war artist for Ministry of Information. Lived in St Ives for over 50 years.

Dame Barbara Hepworth 1903-1975
Born Wakefield. Studied Leeds School of Art 1920. Royal College of Art 1921-24. Sculptor in wood, stone, slate, marble, bronze. Moved to St Ives from London 1939. Created CBE in New Year Honours List 1958.

Patrick Heron b.1920
Born at Headingly, Leeds. Studied Slade School of Art part-time 1937-39. Taught Central School of Art 1953-56. Awarded CBE 1977. Hon. D. Litt. Exeter University 1982. Lives at Eagle's Nest, Zennor.

Roger Hilton 1911-1975
Born Northwood, Middlesex. Studied Slade 1929-31 and 1935-36. Also at Académie Ranson, Paris. Taught art at Port Regis Preparatory and Bryanston Schools briefly. Taught Central School of Art 1954-56.

Rose Hilton b.1932
(*née* Phipps) Born Kent. Studied Beckenham Art School 1949-53. Royal College of Art 1954-57. Travelled to Rome on Abbey Scholarship for further study. Taught art in adult education programme. 1959-65 lived in Nancledra and then Botallack Moor.

Marion Grace Hocken 1922-1987
Born Zennor. Studied Redruth School of Art and Brighton School of Art. Gave up painting and became something of a recluse, living in Carbis Bay.

Patrick Hughes b.1939
Born Birmingham. Trained as a teacher Leeds Training College before turning to painting. *Behind the Rainbow, Patrick Hughes Prints 1964-83* published by Paradox Publications.

Elizabeth Keys
Born Northumbria. Studied Sunderland College of Arts and Crafts 1951-55. Royal College of Art 1955-58. 1957 won RCA Life Painting Prize. 1958 won Life Painting Prize. 1958-60 awarded Sir James Knott Travelling Scholarship to Europe.

Brenda King b.1934
Born Cumbria. Studied Lancaster College of Art 1950-54. Royal College of Art 1954-57. Worked as a designer for Liberty before painting full-time. Lived at Port Isaac 1975, Falmouth for 3 years. Came to St Ives 1985. Shown frequently RA.

Jeremy King b.1933
Born Oundle. Studied Lancaster College of Art and London University Institute of Education. Left teaching in 1967 to take up painting and lithography full-time. Came to St Ives 1985.

Audrey Knight b.1927
Born London. Studied Central School of Art and Design

where gained BA in fine art as mature student in 1984 and came to live in St Ives. Works from a studio in her home.

George Lambourn 1900-1977
Born London. Studied Goldsmiths College and RA Schools between 1921-26. Collections Imperial War Museum and Tate Gallery.

Andrew Lanyon b.1947
Born St Ives. Son of Peter Lanyon (q.v.). Studied London School of Film Technique. Received awards from South West Arts and the Elephant Trust. As well as painting and photography he also writes. His latest book is *Peter Lanyon 1918-64*.

Peter Lanyon 1918-1964
Born St Ives. Studied Penzance School of Art 1936-37 and Euston Road School of Art 1938. Lectured for a year Falmouth College of Art and from 1960-64 was visiting lecturer at West of England College of Art. Taught Bath Academy of Art, Corsham 1950-57.

Bernard Howell Leach 1887-1979
Born Hong Kong. Studied Slade School under Henry Tonks and etching at London School of Art under Frank Brangwyn. Studied pottery in Japan and China. 1920 returned to England to set up Leach Pottery with Shoji Hamada. 1961 Hon. D. Litt. Exeter University. Awarded CBE 1962.

Rachael Levine b.1957
Born Brighton. Daughter of writer Norman Levine who moved with his family to St Ives, 1959. Self-taught artist who relies on an intuitive direction for her work.

Alan Lowndes 1921-1978
Born Stockport, Cheshire. Served apprenticeship as decorator. Attended evening classes for painting. Painted full-time from 1948. Moved to St Ives 1959. Work exhibited in Tate Gallery 'St Ives 1939-64' in 1985.

Alexander Mackenzie b.1923
Born Liverpool. Studied Liverpool College of Art. Moved to Cornwall 1951. Taught Plymouth College of Art. Included in 'St Ives 1939-64' exhibition at Tate Gallery 1985.

Margo Maeckelberghe b.1932
Born Penzance. Studied Penzance School of Art and Bath Academy of Art, Corsham 1949-52. Featured in 'Spotlight of an Artist' BBC TV 1977. Many solo shows and exhibitions London and Cornwall. Work in collection of Contemporary Art Society, Keele and Durham Universities and others.

Louise McClary b.1958
Born Penzance. Studied Penzance School of Art and at one time was head decorator at Troika Pottery, Newlyn. Runs art classes for children and has practised as a professional artist since 1984. Occupies a Porthmeor studio.

Daphne McClure
Born Helston. Studied Redruth Art School late forties. Hornsey College of Art early fifties. Landscape painter

tending to abstraction and interested in derelict tin mining sites and towns/harbours of Cornwall.

Kathy McNally b.1950
Born Northampton of Irish parents. Studied Northampton and Byam Shaw Schools of Art. Strong figurative works on paper. Came to St Ives 1973.

Margaret Mellis b.1914
Born Wu-Kung-Fu, China. Studied Edinburgh College of Art 1929-33. Received post-graduate award and travelling scholarship. Studied Paris, Spain and Italy. Fellowship Edinburgh College of Art 1935-37. Attended Euston Road School 1938.

Christine Micklethwaite b.1964
Born Lincolnshire. Studied Barnsleigh College of Art and Design 1982-83. Falmouth School of Art 1983-86. Decided to make her living as a professional artist immediately on leaving college. Lives at Hayle.

June Miles b.1924
Born Dulwich, London. Studied Slade when 17 and West of England College of Art 1946-47. Also taught at the College. Married Paul Feiler (q.v.). Came to Cornwall, St Just, in 1969, married Paul Mount.

Denis Mitchell 1912-1993
Born Middlesex. Worked in commercial art studio. Worked as miner and fisherman in Cornwall. Employed by Barbara Hepworth in her studio for 10 years before making own name as sculptor. Taught Redruth School of Art 1960-67.

Marlow Sewell Moss 1890-1958
Born Richmond, Surrey. Studied St John's Wood School of Art and Slade School of Art. Also studied under Leger and Ozenfant, Paris.

Ben Nicholson 1894-1982
Born Denham, Buckinghamshire. Studied Slade School 1910-11. Travelled in Europe 1911-14. Became president of Seven and Five Society 1926. Awarded Order of Merit 1968. Married artists Winifred Dacre and Barbara Hepworth (q.v.).

Bernard Ninnes 1899-1971
Born Reigate, Surrey. Studied Slade 1927-30. Member of Arts Club and St Ives Society of Artists. Lived at Burthallan Lane in St Ives.

Breon O'Casey b.1928
Born London. Attended Dartington Hall School. Studied painting at Anglo-French Art Centre, London. Came to St Ives as assistant to Denis Mitchell and Barbara Hepworth (q.q.v.).

Sheila Oliner
Born London. Studied City and Guild Schools late forties and Slade early fifties. Also studied printmaking. Leading figure in Penwith Printmakers and teaches at Penzance School of Art. Lives at Zennor.

Jane O'Malley b.1944
Born Canada. Travelled in Europe before coming to St Ives in 1969 where attended the St Ives School of Painting under Leonard Fuller (q.v.). Moved to Ireland 1990.

Tony O'Malley b.1913
Born Callan, Co. Kilkenny, Ireland. Worked for 25 years in a bank. 1955 came to study painting at St Peter's Loft School in St Ives. Five years later moved to the town. 1981 awarded Douglas Hyde Gold Medal by Irish Arts Council. Work included in *St Ives 1939-64* at Tate.

Colin Orchard b.1935
Born Ewell, Surrey. Worked as typographer with *The Times* before becoming freelance graphic designer. Started painting seriously after moving to St Ives.

Victor Pasmore b.1908
Born Surrey. Painter and relief maker. Painted in spare time until financed by Kenneth Clark. Founder member of Euston Road School. Taught Camberwell School of Art 1943-49 and Central School 1949-54. Director University of Newcastle 1954-61. CBE 1959. RA 1983.

Bryan Pearce b.1929
Born St Ives. Studied at St Ives School of Painting under Leonard Fuller (q.v.) and made successful career of painting in spite of suffering brain damage as a child. A genuine naïve painter.

Misome Peile 1907-1989
Born Southsea, Hampshire. Studied art in Rome for a year and St Ives School of Painting under Leonard Fuller (q.v.) 1939-43. Member of Society of Women Artists. Also served as Chairman of Penwith Society.

Jack Pender b.1918
Born Mousehole, Cornwall. Studied Penzance School of Art. Served in Duke of Cornwall's Light Infantry 1939-46. Resumed painting Athens School of Art, and Exeter and West of England College of Art. Taught Plymouth Art School and Royal Naval College, Dartmouth.

Anke Petersen b.1941
Born Flensburg/Schleswig Holstein, Germany, where studied art. Taught drawing and painting to children. Arrived England 1973 and studied etching, drawing, painting Bournemouth and Poole College of Art.

Ponkle b.1934
Born London. Travelled throughout Europe with Katherine Durham Dance Company. Studied painting William Hayter's School, Paris. Opened cat gallery in St Ives.

Douglas Portway 1922-1993
Born South Africa. Studied Johannesburg Art School. Exhibited widely France, Germany, Switzerland, Africa, Holland, Spain and France. Moved to Bristol 1984.

Roy Ray b.1936
Born Feltham, Middlesex. Followed no formal art training but after attending St Ives School of Painting for several years took over as teacher and principal.

William Scott 1913-1989
Born Greenock, Scotland. Studied Belfast College of Art 1928-31 and RA Schools for a year afterwards. Taught Bath Academy of Art, Corsham 1946-56. Artist in residence in Berlin 1963-65. Lived in farmhouse at Coleford, near Bath 1965. Awarded CBE. Retrospective exhibition Tate Gallery 1972. Elected RA 1977.

Anne Hariet Sefton (Fish) Exh.1913-33
Born Bristol. Painter and black and white artist. Studied London and Paris. Lived in the Digey, St Ives for a number of years and known by her painting name of Fish.

Hyman Segal
Born of Russian Jewish parents. Studied St Martin's School of Art aged 12. Worked as freelance commercial artist. Moved to Cornwall and in 1948 took over 10 Porthmeor studio, St Ives, vacated by John Park.

Jennifer Semmens
Born Penzance. Studied Falmouth College of Art and Design and Cheltenham College of Art and Technology. Influenced by William Scott and Alexander Mackenzie (q.q.v.).

Tony Shiels b.1938
Born Salford, Lancashire. Studied Heatherley School of Art, London and briefly in Paris. Founded a Surrealist/ Magical/Imaginative magazine called *Nnidnid*.

Borlase Smart 1881-1947
Born Kingsbridge, Devon. Studied Plymouth School of Art 1897-1900 and Royal College of Art 1900-01. Obtained first class honours in design at South Kensington. Art critic for *Western Morning News* 1902-13. Penwith Society of Arts in Cornwall founded as tribute to him.

Michael Seward Snow b.1930
Born Manchester. Worked as librarian. Moved to St Just 1952. Spent part of each year working in Manchester. Produced paintings, reliefs, sculpture and jewellery. Late sixties appointed lecturer Exeter College of Art. Retired 1985 to paint full-time.

Gertrude Starink b.1947
Born Breda, Netherlands. Read History of Art at Utrecht University and graduated with thesis on Surrealism. Worked for Dutch radio writing and producing plays and literary programmes. Opened a bookshop and gallery in St Ives, *The Mirror and the Lamp*.

Minou Steiner
Born Normandy but grew up in Paris and painted from an early age. Self-taught artist who received no formal training. Came to England 1958 and to St Ives 1961.

Adrian Stokes 1902-1972
Born London. Studied history, philosophy, politics and economics Magdalen College, Oxford 1920-23. Studied art Euston Road School 1937. Became trustee of Tate Gallery 1960-67.

Mary Stork
Born Portsmouth. Studied West of England College of

Art, Bristol 1955-58 and Slade School 1958-61. Arrrived to live in St Just 1961. First married to Jeremy Le Grice.

Maurice Sumray b.1920
Born London. Studied drawing and painting at Toynbee Hall and Sir John Cass College. Worked as engraver. Became member of the Hogarth in Fitzroy Street. Won scholarship to study at Goldsmith's College. His twin brother is also a painter.

Morwenna Thistlethwaite b.1912
Born Kew, Surrey. Mother from a St Ives family. Studied painting Leamington Spa Art College 1938-40. Birmingham College of Art for four years during the war. Came to St Ives 1976. Shown frequently at RA.

Joe Tilson b.1928
Born London. Studied St Martin's School of Art with Auerbach and Kossoff 1949-52. Royal College of Art 1952-55. Awarded Rome Scholarship 1955. John Moore's prize-winner 1957 and 67. Taught at St Martin's School of Art 1958-63 and visiting lecturer Slade and King's College, Durham.

John Tunnard 1900-71
Born Sandy, Bedfordshire. Studied Royal College of Art and played in jazz bands 1919-23. Worked as textile buyer for John Lewis 1928. Taught design part-time at Central School of Arts and Crafts and later at Penzance School of Art. Concentrated on painting after moving to Cornwall.

Roy Walker b.1936
Born Welling, Kent. Studied Gravesend and Central Schools of Art. Painter and etcher and makes three-dimensional objects using whatever material suits the subject. Work in collection of V & A and British Council.

Alfred Wallis 1855-1942
Born Devonport. Went to sea as cabin boy as young child. Later joined fishing boats at Penzance. Took up painting at age of 70 after wife died. Collections at Tate Gallery.

Eric Ward b.1945
Born St Ives. Studied St Ives School of Painting. First one-man show Hallam Gallery, London, two years after beginning to paint seriously.

Peter Ward b.1932
Born London. Worked as pattern maker with Vickers Armstrong. Taught painting Guildford School of Art, Cornwall College, Camborne and West Surrey College of Art and Design. Teaches at St Ives School of Painting.

Billie Waters 1896-1979
Lived and worked in Newlyn from 1926-31 and studied with Ernest Procter. Influenced briefly by Ben Nicholson but is known as a representational painter.

Gill Watkiss b.1938
Studied at South West Essex School of Art. Moved to Cornwall in 1959. Lived for some time at St Just, a village and community which shaped her work. Latest show at New Grafton Gallery, London 1992. Collections at Birmingham University and Vassar College, New York.

John Wells b.1907
Born London. Studied Epsom College and University College Hospital 1916-30 when he qualified as a doctor. Attended evening classes for painting at St Martin's School of Art. Took up painting full-time 1945 after leaving medical practice.

Terry Whybrow b.1932
Born St Pancras, London. Trained in furniture/interior design. Occasional adviser to Dept of Design Research Royal College of Art during the seventies. Moved to St Ives 1980 to paint full-time. Shown at Contemporary Art Fairs since 1989.

Bryan Wynter 1915-1975
Born London. Studied Slade 1938-40. Taught Bath Academy of Art, Corsham 1951-56. Represented in *St Ives 1939-64* Tate Gallery. Work in several public collections.

The St Ives Arts Club
Lists of Artists and Visitors

From the 1890s artists came to St Ives in increasing numbers. Visitors are recorded from London, Australia, New Zealand, USA, Paris, Germany, Dublin, Canada, France, Brittany, Egypt, Norway, Finland, Sweden, Italy, India, China and Japan. *The Weekly Summary* of 1890 was quick to note the American painters in the town:

'Messrs P Dougherty, E Schofield and G Symon are a trio of front rank American artists, who have at different times lived and worked in St Ives; the latter two have become more especially famous for their fine snow studies, whilst Mr Dougherty has devoted himself generally to seascapes and particularly to the study of rhythmic movements of breaking waves on the coast. Karl Schmidt, the young American painter has been working in St Ives for the past two months.'

Artists of St Ives Arts Colony 1883-1900 (all are painters unless otherwise stated)
p = painter; ph = photographer; s = sculptor; w = writer;
m = musician; * see Biography.

ADAMS	C G Beale & Mrs, Porthmeor Studios
ADAMS	W Douglas
ALEXANDER	Mr
*ALLAN	Robert Weir
ALMA-TADEMA	Lawrence Sir
ARMSTRONG	Elizabeth Adela (Mrs Stanhope Forbes) born Canada
*ASHTON	Sir John William (Will) (Australian) – studied Olsson & Talmage
BADCOCK w	William, 9 Belmont Terrace
BAINSMITH s	Georgina (née Bucknall) & Prof G, Fairholme, Barnoon, 9 Bellair Terrace & Shelley Cottage
*BARLOW	John Noble & Mrs Elizabeth, 4 Draycott Terrace, Skidden Hill, Carrack Dhu & Barnoon Terrace
BARTLETT	Charles William
BARTLETT	William Henry
BATLEY	Marguerite E
BELL	Arthur George
BERTRAM	G W
*BISHOP	Henry RA 1939
BLACKDEN	Hugh, Back Road Studio
BLOMEFIELD	Eardley W, 6 The Terrace & 7 Bellair Terrace
BORROW	William H
BOSCH-REITZ	S C, 7 & 20 The Terrace 1890/91
*BRANGWYN	Frank Sir RA 1919
BROMLEY	John Mallard, married S M Wing, 3 Bellair Terrace & Quay House
BROOKE	F William, 1 Barnoon Terrace & Ayr Cottage
BROWNE	Harry E J
*BROWNE	Warne Alfred J & Mrs Edith, 9 Barnoon Terrace
BUTLER	Howard Russell (American), 1 Carrack Dhu
CAMERON	Mary L, 13 Barnoon Terrace
CHADWICK	Emma and Frank (American)
COGILL	Emily
COLLIER	Miss A
COLLIER	Bernard C
CONQUEST	Alfred, 24 The Terrace, 1890
COODE	Miss W K M (ornamental design)
COOPER	Miss F
*CRAFT	Percy Robert & Mrs, 1 Bowling Grn Terrace
CRICK	Montague
CROXFORD	William Edward & Mrs
DANBY	Thomas Hardidge, 26 Bowling Green Terrace & St Andrews St Studio
DAVIDSON	J N Miss, 17 Bellair Terrace
DAVIS	C
DAWSON	Amy
DEACON	Allan & Mrs M K & child, 6 Bellair Terrace & 4 Richmond Terrace
*DETMOLD	Henry Ed, 7 Bellair Terrace
DIXON	
DOBBS p & s	Frank
DOCKER	Edward
DOUGLAS p&ph	John Christian, 10 Park Ave & Skidden Hill Studios
*DOUGLAS	Mabel Maude Mrs (née Bucknall), 10 Park Ave & Skidden Hill Studios
*DOW	Thomas Millie & family, Glasgow, 1 West Place, Ayr Cottage, Porthminster Hotel 1896 and family (7) & Talland House
*DYER	Lowell (American) & Mrs A S, Talland House Studio
*EADIE	William & Mrs Annie Bruce
*EAST	Alfred Sir 1910, RA 1913, Carbis Bay, Lelant & 5 The Terrace
*EASTLAKE	Charles Herbert
*EASTLAKE	Mary Alexandra (née Bell) Mrs C H
*EMANUEL	Frank Lewis, Albany House
EVANS	Wilfred Muir
*FANNER	Alice Maud (Mrs Taite) student Julius Olsson
FAULKNER	Herbert Waldron (American)
FARINA	Baroness and Mr Raffash, 5 Bellair Terrace
FEARON	Miss Hilda (sister of Annie Walke) 1900 occupied The Cabin with F S Coles, Ethel Carrick, Agnes Vyse, Renee Dunn. Studied under Algernon and Gertrude Talmage

*FEDDEN	A Romilly
*FLORENCE	Mary Mrs (née Sargent)
FORBES	Stanhope
*FORD	Harriet Mary (Canadian)
FORDRINIERE	
*FORTESCUE	William Banks & Mrs Mary, Treloyhan Cottage & Malakoff Studio
FOSTER	G Ursula
FOX	Emanuel Phillips (Australian)
*FULLER	Edmund G & Mrs 'Gowna Rock', Clodgy View & St Andrews St Studio
GEOGHEDAN	H T
GILLINGTON	Alice E
GORDON	Dorothy
*GOSSEN	Franz Muller (German), St Ives & Penzance
*GOTCH	Thomas Cooper, 9 Bellair Terrace
GOTCH	Caroline Mrs T C
GREENFIELD	E Latham Mrs
*GRIER	Louis Reginald James Monro (Australian) 25 The Terrace
GRIER	Mina – Mrs L G
GRIER	Edmund Wyly Sir (brother of LRJM)
GRONVOLD	Bernt & Mrs
GROSE	Melicent S
HAYES	Edith Caroline
HEARD	Hugh Percy
HELLWAG	Rudolph (German)
HEMY	Thomas M & family, 2 Bowling Grn (brother Charles Napier)
HERVEY	Leslie Miss
HEYWORTH	Richard
HIND w	C Lewis, 7 Draycott Terrace
HIND	Gertrude Miss
HOBKIRK	Stuart & Mrs, 4 Albany Terrace & Hendra's Hotel
HOEBER	Arthur & Mrs (American), Barnoon Villa
HOOK	James Clarke RA 1860
HORN	Marion F (married Luck)
HORN	Miss K S
HUNT	R Holmes
JAMESON	Middleton Alexander
JEVONS	George Walter, 7 The Terrace
JOLLEY	Martin Gwilt & Mrs, Academy Place & Bowling Grn
KENNEDY	Charles Napier (died in St Ives 1898)
KENNEDY	Lucy (Mrs C N)
KENNEDY	Edward Sherard, Porthmeor Studios
KENNEDY	Florence S
KILLMISTER	C Gordon – painter & architect
KING	Bertha
KING	Edward R
KIRKPATRICK	Lily Miss & sister, 15 The Terrace & 2 Bowling Grn
*KORTRIGHT	Guy, Porthminster & 6 Bellair Terrace
LANYON ph/m	William Herbert, Parc Ave, 16 The Terrace & The Redhouse, Attic Studio
LATHAM	C
*LAURENCE	Sydney Mortimer (American), Ayr House & 7 Bowling Grn
LAURENCE	Alexandrina (née Dupre), Ayr House & Zareba
LEVICK	Richard & Mrs (American) b Philadelphia
*LINDNER	Moffat Peter, Chy-an-Porth & 9 Porthmeor Studios
*LINDNER	Augusta (née Baird-Smith) Mrs M P
LINGWOOD	Edward J & Mrs
LITTLE	Mrs & Miss
LOMAX	John Chadwick, Tregenna Hotel & 20 The Terrace
LUDBY	Helen Colter Miss, 9 Bellair Terrace & The Croft, C Bay
MARSHALL	Herbert
MAYBRIDGE	(wrote study of animal locomotion)
*MEADE	Arthur & Mrs Mabel, Godrevy House & Back Road Studios
MENPES	Mortimer, St Ives 1883/84
MILLER	E J
*MILNER	Fred & Mrs Sophia, Zareba, St Ives & 2 Piazza Studios
MOORE	Henry RA 1893
*MORRIS	Charles Greville
*MOSER	Oswald
MUIRHEAD	Charles, Porthminster & 15 The Terrace
*NICHOLSON	Alice Hogarth
NICHOLLS	Dr J M
NORDGREN	Anna Miss (Finland)
NORMAN	Philip
NORRIS	Hugh L
NORSWORTHY	Harold Milford, 3 Warren View & Lelant
*OLSSON	Julius RA 1920 & Mrs Kathleen, St Ia & 5 Porthmeor Studios
OLSSON w	Carl
*OSBORN	Will E (Australian)
RAINEY	J Hargrove & Mrs
RAINEY	Hazel Miss & Pansie A Imara Miss
REASON	Robert G
RICHARDSON	Agnes E Miss, Hawkes Point, Lelant
RIDDALL	Walter
*ROBINSON	Henry Harewood, 1 Carrack Dhu & Belyars Croft
*ROBINSON	Maria D (née Webb), 1 Carrack Dhu & Belyars Croft
ROGERS	M J Mrs, Pendeen
*ROLLER	George & family, 8 Barnoon Terrace
ROSENBERG	Gertrude Mary Miss, 6 Barnoon Terrace
ROSENKRANTZ	(possibly Baron Arild)
ROUNCEFIELD	E W
RUSSELL	J Elgar, The Warren (next to Arts Club)
*SARGENT	Louis Augustus, 2 Clodgy View & 1 Piazza Studios
SARGENT	Katherine Evelyn (née Clayton), Mrs L A
*SARGENT	Frederick – pictures House of Lords & Commons, Hawks Point
SARGENT	E S Mrs
*SCHJERFBECK	Helene, 8 Bellair Terrace
SEALY	E Miss, The Cabin & Elm Farm
SCOTT	Laurence
SICKERT	Bernard, 1 Bellair Terrace
SICKERT	Oswald, 1 Bellair Terrace
SICKERT	Walter, Barnoon Terrace
*SIMMONS	Edward E (American), 23 The Terrace, 4 & 6 Bellair Terrace
SMITH	Edith Heckstall Mrs
STEELE	F M

STEPHEN w	Sir Leslie & Mrs Julia (Virginia Woolf, Vanessa Bell), Talland House
*STOKES	Adrian RA 1919, 15 The Terrace & Virgin St Studio
*STOKES	Marianne (née Preindlsberger)
*STOKES w & p	Folliott Alan Gardner, 5 Bowling Grn & 13 Tregenna Terrace
SWINSTEAD	Frank Hillyard
SWINSTEAD	George Hillyard
TABOR	G Hugo
THAYER	Abbott H (American), 5 Bellair Terrace
THOMAS	Annie H, St Just 1889
*TITCOMB	William Holt Yates, 6 The Terrace & Windy Parc
TITCOMB	Jessie Ada (née Morrison), 6 The Terrace & Windy Parc
TITCOMB	John Henry, 8 Bellair Terrace
TOLLEMACHE	Hon. Duff & Mrs
UREN	John Clarkson
VERNIER	Emile Louis
VOS	Hubert
*WALKE	Annie (née Fearon)
WATERLOW	Ernest Sir
WEGUELIN	John Reinhard
*WHINERAY	E J Miss – studied under Julius Olsson & Arnesby Brown
WHISTLER	James Abbott Mc Neill, 1 or 14 Barnoon Terrace
WHITEHOUSE	Frances Charlotte (Daisy), St Peters St Studio
*WHITEHOUSE	Sarah Elizabeth, St Peters St Studio
WHITEHOUSE	Mary Jane (Jeannie), St Peters St Studio
WHITEHOUSE	Louisa Caroline (Louie), St Peters St Studio
WIGGINS	Carlton (American), Carrack Dhu
WIGGINS	Grace Mrs C & Miss May, Carrack Dhu
WILK	Maria, 8 Bellair Terrace
WILKINSON	R Ellis & Mrs
*WILLIAMS	Terrick
WING	Selina Marion (Mrs J M Bromley), 8 Bellair Terrace & 6 Draycott
WYNNE	E Kendrick & Miss
ZORN	Anders

Visitors to St Ives 1886-1900

Many painters came to St Ives and were brought to the Arts Club and signed in by a member. There are also artists and people of interest on the 'Visitors List' of the St Ives Weekly Summary.

p = painter; w = writer

	Visitors	Members
1886	w Henry James (novelist)	Tregenna Castle
1889 Summer	p Helene Scherfbeck & Miss Wiik1890	Weekly Summary
	Edmund Gosse (writer & critic) from 29 Delamere Terrace London	Treganna Castle
1890 Aug	p Mr & Mrs Stanhope Forbes	H H Robinson
1890 Aug	p A Stanley	E H Smith
1890 Sept	Rev Griffin MA, Vicar of St John's in Fields	C G Morris
1890 Sept	p Alfred East	Wm Eadie
1890 Sept	p E R Fox – Rochester	W H Y Titcomb
1890 Sept	A Fox – Teddington	W H Y Titcomb
1890 Oct	p Mr & Mrs Tom Hemy	Julius Olsson
1890 Oct	p Charles Muirhead	H Bosch Reitz
1890 Nov	Alex Monro Grier – Canada	G W Grier
1891 Apr	p Miss E Fowler	E W Blomefield
1891 Aug	p Thomas H Bowen – S Australia	Allan Deacon
1891 Oct	p Frank Bodilly – Newlyn	Julius Olsson
1891 Nov	p Maud West	E L Greenfield
1891 Nov	p F W Brooke – Parsham, Suffolk	J C Lomas
1891 Nov	p J W Girdlestone & 2 sons	Mrs Olsson
1892 Mar	Mr & Mrs Victor Olsson	Julius Olsson
1892 Apr	Mr & Mrs Shackleton – Dublin	H H Robinson
1892 Apr	p Mr F Milner – Cheltenham	Julius Olsson
1892 June	p Mr W M Evans	Arthur Meade
1892 Sept	p C H Eastlake	W M Evans
1892 Sept	p Mrs Holman Hunt & Party, 5 The Terrace	Weekly Summary
1893 Mar	p J C Salmon	H J Hebblethwaite
1893 Mar	p Frederick Bishop	C H Eastlake
1893 Apr	p Basil Gotto	Bosch Reitz
1893 Apr	p Edith Fithian	Algernon Talmage
1893 Apr	p Acton Butt	Julius Olsson
1893 May	Agnes B Harvey – gold/silversmith	William Eadie
1893 Sept	p Mr W Bush	William Eadie
1893 Sept	p Mr Dodd	William Eadie
1893 Sept	p Wm Brymer – Canada	C H Eastlake
1893 Sept	p George C Wilmshurst	William Eadie
1893 Oct	p Amy Dawson	Dorothy Gordon
1893 Oct	p Miss Edith Fuller, Croydon	C H Eastlake
1893 Oct	p Tennyson Cole – Melbourne	Louis Grier
1893 Dec	p Percy Wild	H H Robinson
1894 Jan	Fred Shackleton – Dublin	H H Robinson
1894 Feb	Miss Brymer – Canada	Julius Olsson
1894 Mar	Victor Olsson	Julius Olsson
1894 Apr	p Rudolph Cristen	M Douglas
1894 Apr	p Abbot Thayer, American	Weekly Summary
1894 Aug	Viscount Mountmorres – London	Algernon Talmage
1894 Oct	p Miss Childers	Miss Kirkpatrick
1894 Oct	Capt & Mrs Julian – Cairo	Algernon Talmage
1894 Oct	p Mr S H Carr – Penzance	Julius Olsson
1894 Dec	Mrs Butt	Julius Olsson
1895	p Mr & Mrs Howard Russell Butler, N York	Weekly Summary
1895 Jan	C J Webb – Co Antrim, Ireland	H H Robinson
1895 Apr	p Miss Rosenberg	H H Robinson
1895 Aug	p Miss Lucy E Mark	Julius Olsson
1895 Sept	p Miss Alice Maud Fanner – Chiswick	Julius Olsson
1895 Oct	p William Henry Charlton	Julius Olsson
1895 Oct	p F Grifiths Mart – London	Julius Olsson
1895 Oct	p Miss Emily B Bland	Julius Olsson
1895 Oct	p Mr W H Charlton – Northumberland	Julius Olsson

	Visitors	Members
1895 Nov	p Alfred Thornton – Chelsea	Julius Olsson
1895 Nov	p Mr & Mrs T Millie Dow – Talland House	H H Robinson
1895 Nov	p Mr & Mrs Carlton Wiggins & Misses	S M Laurence
1895 Nov	p Miss Baird-Smith – Cheshire	H H Robinson
1896 Jan	C J Hobkirk – Cheltenham	S Hobkirk
1896 Feb	Mrs Robert Olsson – Paris	Julius Olsson
1896 Mar	p Mr E K Wynne – Paris	H H Robinson
1896 June	p Percy Short	Algernon Talmage
1896 Oct	p Sydney Lee & Mrs	Jeanie Whitehouse
1896 Oct	p Richard Jack	Stuart Hobkirk
1896 Oct	p Frank S Dobbs	Miss Wing
1896 Oct	p W Westley Manning	Julius Olsson
1896 Oct	p H Bishop	H H Robinson
1896 Nov	p Henry G Liley	J M Bromley
1896 Nov	p Miss Lil Godfrey – Cheltenham	Louis Grier
1896 Dec	p Rudolph Hellwag	J Elgar Russell
1896 Dec	p Mr & Mrs Fortescue	H H Robinson
1897 Mar	Gustaf Bjorck – Stockholm	Julius Olsson
1897 Mar	p Herbert W Faulkner – New York	C H Eastlake
1897 July	Miss Lathrop – New York	Julius Olsson
1897 Aug	p Bernard Sickert (brother of Walter)	Julius Olsson
1897 Oct	p Miss H O'Donnell	M Fortescue
1897 Nov	Leonard Munn	J Elgar Russell
1897 Dec	p Percy Bovill	W H Y Titcomb
1897 Dec	p Percy Macquoid	Adrian Stokes
1898 Apr	p Edith Petherick	Gertrude Talmage
1898 Oct	p Miss Lily Kirkpatrick & Miss	Thos Millie Dow
1898 Oct	p Mr Von Stetten	Julius Olsson
1898 Oct	Percy Kortright	Louis Grier
1898 Nov	p Andrew B Colley	John C Douglas
1898 Nov	p Mr Formilli	W H Y Titcomb
1898 Dec	Mr & Mrs Leonard Stokes RIBA	Adrian Stokes
1898 Dec	p G Sherwood Hunter	H H Robinson
1899 Jan	p J G Woods – Newbury	J Noble Barlow
1899 Jan	Mrs Atkinson – Johannesburg	F Sargent
1899 Jan	p Alan Deacon & Mrs – Montiquy	H H Robinson
1899 Feb	Mrs W Nicholson	M Arnesby Brown
1899 Mar	p Miss McCrossan – Liverpool	Kathleen Olsson
1899 Mar	Miss Petersen – Stockholm	Louie Whitehouse
1899 Apr	p Walter Riddall	Louis Grier
1899 Apr	Reggie Kortright	Louis Grier
1899 Oct	Sir Montague & Lady Pollock	H H Robinson
1899 Nov	p F Adlam	Louis Grier
1899 Dec	p Mr & Mrs Butler	T Hardidge Danby
1900 Feb	p H E J Browne	P M Feeney
1900 Apr	p M E Postlethwaite	E L Greenfield
1900 July	p Tom Mostyn	J Noble Barlow
1900 July	Lady Mountmorres	Gertrude Talmage
1900 Aug	p Ethel Carrick	Gertrude Talmage
1900 Aug	p Hilda Fearon	Gertrude Talmage

	Visitors	Members
1900 Aug	p Agnes F E Vyse	Gertrude Talmage
1900 Aug	p Fanny Louisa Coles	Gertrude Talmage
1900 Oct	p Avery Lewis (American)	A Romilly Feddon
1900 Oct	Herr F Raupp – Munich	Thos Millie Dow
1900 Oct	p Pearsall W Booth – Dublin	H H Robinson
1900 Oct	p Richard M Stack – Dublin	H H Robinson
1900 Oct	p R Heyworth – London	Julius Olsson
1900 Nov	p R H Lever – Adelaide	Louis Grier
1900 Nov	p A Pazolt – Boston	Louis Grier
1900 Dec	p Philip Wilson Steer – London	Moffat Lindner
1900 Dec	p Professor Frederick Brown – London	Moffat Lindner
1900 Dec	p Frank Coles	Moffat Lindner
1900 Dec	p Esther Stella Sutro	W H Y Titcomb

Artists of St Ives Colony 1901-1910 (all painters unless otherwise stated)

p = painter; ph = photographer; s = sculptor; w = writer; m = musician; * see Biography.

ADAMSON	Travers Muirhead (Australian), 11 Albany Terrace
*BABBAGE	Herbert Ivan (New Zealand)
*BAILEY	Alfred Charles – studied with L Grier – Atlantic Studio, 9 Bellair Terrace
BALL	William (possibly Wilfrid William) & Millicent
BAXTER	Charles H
BEAUMONT	Arthur (American)
BELL	George Henry Frederick
BENSON	Miss
*BROWN	John Alfred Arnesby RA 1915, Sir 1939, Piazza Studios
*BROWN	Mia (née Edwards), Mrs Arnesby Brown
BROWN	John Eccles
*BRUNDRIT	Reginald Grange RA 1938
BRYMER	William (Canadian)
BUDGEN	Frank Spencer Curtis
CAMERON	Donald Lovett & Mrs, Ar Lyn, Lelant
CAMERON	Ivy M Miss
CAMERON	Joy M
CAMPBELL	F M Miss
CARR	Sydney H, 8 Albany Terrace
CARR	Emily Mrs Sydney H – studied with Olsson and Talmage
CARR	Irene Miss (& Vera)
CHADWICK	E L Mrs
CHADWICK	Mrs & William, 23 The Terrace
CHRISTIE	Henry C
COCKERAN	Bertha Miss, The Hutch Studio
COOK	George Edward
COOK	Theodore
*DAVIES	David (Australian) & Mrs, 5 North Terrace
DICKSON	William & Mrs
*DISMORR	Jessica

DOUGHTY	Parke Curtis (American)
DOUGHTY	Paul (American)
DUGGINS	James Edward
EDE	Miss
EDELSTEN	Alice J
EDWARDS	Helen Constance Pym, studied with Algernon Talmage 1906-8
ELLIS w	Havelock
ELLIS w	Edith Mary Mrs
*ELPHINSTONE	Archibald Howard
EVANS	W J
FALKNER	Anne L Miss
FEENEY	Peregrine M
FEWSTER	Muriel
FFENNELL	Miss
FITZHERBERT	H G & Mrs
*FOWERAKER	A Moulton & Mrs, The Headland, C Bay, Rock studio
GIRDLESTONE	John Ward & Mrs, The Nest, Carbis Bay
GOSSE	Mrs Edmund (wife of critic), Pupil of Ford Madox Brown
GUNN	William Archibald & Mrs M, Westcotts Quay Studio
GUYON	Agnes E
HADDON	Arthur Trevor
HAIGH	F L
HANDYSIDE	Mrs (New Zealand)
*HARTLEY	Alfred, 7 Bellair Terrace & 3 Piazza Studio
HARTLEY	Nora Mrs St Peter's Street Studio & 7 Porthmeor Studio
HARVEY	Hilda Mary Miss
HICHENS	Ivan & Mrs J
HIGGINS	Victor
HIGGINS	Miss E
HOPTON	Gwendoline Mary
HUDSON w	William Henry, 30 Bowling Green Terrace & 2 Seaview Terrace
HUNTING	J D
*HUTTON	Robert Langley, 5 Porthminster Terrace
I'ANSON	Miss – pupil of Fred Milner
JACKSON p & s	Caroline, Harbour Studio
JACKSON	Edith M
JARVIS	John Bradford
JONES	Reginald
KEASBY	Henry Turner (American), Malakoff studio & 3 Warren View
KELLY	A G (American)
*KNAPPING	Helen Miss, Porthmeor Road & Harbour Studios
LAMAISON	Evelyn
*LANCASTER	Clara Bracebridge (student of Algernon Talmage)
*LEVER	Richard Hayley (Australian), Top studio, Lanhams & 14 Carrack Dhu
LINTON	Evelyn Lina (née Beckles)
LINTON	William Evans
LLOYD m	William Alexander Charles, St Eia Studio
LLOYD m	Constance P
LLOYD m	George
LLOYD	Miss Maynie
LLOYD	Frank
LLOYD	Mrs Frank
LLUELLYN	Mrs & Miss
LUCK	Marion F (née Horn)
LUMSDAINE	Amy
MACGIBBON	A B
MACKENZIE w	M Compton Knighted 1952 & Mrs & Fay Compton, Riviera House, Hayle
MARRIOTT w	Charles & Mrs Misses Dulcie, Vivien & Basil, The Terrace, 8 Barnoon Terrace
*McCROSSAN	Miss Mary, 7 The Terrace & Piazza Studios
MORISON	Cotter Miss
MORRIS	Miss A R
MORRIS	Miss E F E (sister of A R)
MOTTRAM	Charles Sim & Mrs, 23 Bellair Terrace
NICOLLS	Emily Miss
NORRIS	S Walter & Mrs
NORTHCOTE	Percy & Mrs
OPIE	Miss
OXLAND	Mrs
*PARK	John Anthony – student of Olsson & Talmage – Piazza Studios & 10 Porthmeor Studios
*PARKYN	William Samuel, The Lizard, Lanhams Gallery
PARR	F
PATMORE	Coventry Mrs (wife of poet)
PAZOLT	Alfred J & sister, Seaforth, Parc Avenue & Foreshore Studio
PEARSALL	W Booth
PHILLIPS	A R
*POWLES	Lewis Charles
PRAETORIUS	T Miss – student of Talmage – Albert Place & 6 Richmond Place
PROSCHWITZKY	K Miss
QUICK	F Miss
RAWLINS	V Mrs
REASON	Robert G
REID	John Robertson
ROBERTSON	Tom
ROBINSON	Cayley
RODD	Miss
ROWBOTHAM	Claude H
ROWE	Gertrude Miss
SCHMIDT	Karl (American)
SCHOFIELD	John William
*SCHOFIELD	Walter Elmer (American) & Mrs Muriel, 16 The Terrace & Godolphin Manor
*SEDDON	Helen Priscilla Miss, Crab Rock Studio & Chy Morvah, The Warren
SHIELDS	M A Mrs
SHERRARD w	Robert H
SHERRARD	Miss Florence E
SKINNER	Edgar, Salubrious House & Leach Pottery
SKINNER w	Edith Mrs, Salubrious House
SLATER	Emily Miss – student of Talmage
SMITH	Frances Tysoe Miss & Miss S Freeman (sister), Blue Studio
SNELL	J Herbert (American)
STEER	Philip Wilson
STIRLING	J or I
*STODDART	Margaret O (New Zealand)
STRANG	William

SUTRO	Esther Stella Mrs
SUTTON	Helen Constance Pym (student of A Talmage)
SYMONS	George Gardner – (American)
*TALMAGE	Algernon M RA 1929, 14 Draycott Terrace & Harbour Studio
TALMAGE	Gertrude Mrs A M, Westcotts Quay Studio
TAYLOR	Horace Christopher
THURSTON	John H, 4 Albany Terrace
TOWNSEND	Miss
TOZER	E A
TOZER	Henry E
TRACY	Charles Dunlop
TULLY	Miss (possibly Sydney Strickland)
TURNER	Herbert William John, Trevail Farm & Briar Dene, C Bay
TURVEY	Reginald E G & Mrs F, Wheel Speed, Carbis Bay
ULRICH	Robert
WALPOLE w	Hugh Sir
WALTON	A N
WATKINSON	A
WELBY	Miss
WENDT	William (American)
*WHITE	Arthur, 4 Tre-Pol-Pen & Fern Glen
WHITE m	Joseph (musician), born at Nancledra
WILDE	Elizabeth M
WILKINS-WAITE	Edward
WITT	H
WORDEN	Dorothy
*WYLLIE	William Lionel RA 1907 and Mrs

Visitors 1901-1910

p = painter; w = writer

	Visitors	Members
1901 Jan	p J Will Ashton – Adelaide	Louis Grier
1901 Jan	p Charles Fripp – London	P M Feeney
1901 Feb	w Mrs Havelock Ellis	Lily Kirkpatrick
1901 Feb	p C H Baxter – Liverpool	W H Y Titcomb
1901 Mar	C Hales – New Zealand	D Davies
1901 Apr	Lord Mountmorres – London	A M Talmage
1901 June	W Staples Drown – Providence USA	R G Reason
1901 July	Dr Russell – London	Louis Grier
1901 Aug	Mr & Mrs C Rueter Boston USA	A J Pazolt
1901 Nov	p J Stirling Dyce – Albany Terrace	H H Robinson
1901 Nov	p Agnes E Guyon – Clifton	Julius Olsson
1901 Nov	p Alicia Blakesley – London	John Titcomb
1901 Nov	p J W Ashton – Adelaide	J H Thurston
1901 Nov	p H B Wimbush – Cheltenham	Fred Milner
1901 Nov	p James Wetherall Burgess	Julius Olsson
1901 Nov	p Miss Stoddart – New Zealand	Daisy Whitehouse
1901 Dec	G W Beamish – Ireland	A J Pazolt
1901 Dec	Miss Duckworth – London	H H Robinson
1901 Dec	p Mr & Mrs Adrian Stokes	Moffat Lindner
1902 Apr	Mr Johns – St Ives	Moffat Lindner
1902 Apr	p Norman Wilkinson – London	Guy Kortright
1902 Apr	Capt The Hon Shore – Clevedon	F Milner
1902 Apr	p B Kronstrand – Newlyn	Julius Olsson
1902 Nov	p Herbert Draper – London	Moffat Lindner
1902 Nov	P Cohen – Australia	Stuart Hobkirk
1902 Dec	p Miss McCausland – London	E Taylor
1903 Jan	p A J Black – Lands End	Moffat Lindner
1903 Feb	p A R Seddan – Bristol	J H Thurston
1903 Feb	p James Levin Henry – London	A M Talmage
1903 Feb	Mrs H Lane – America	A M Talmage
1903 Feb	w Mrs & Miss Sackville West, Terrace House	W Summary
1903 Aug	Mrs du Maurier, St Eia	W Summary
1903 Sept	w Mr Meredith, London, 8 Belmont Place	W Summary
1903 Sept	p Mr & Mrs Simpson & fam, Penzance, 15 The Terrace	W Summary
1903 Sept	p Oswald Moser – London	Louis Grier
1904 Feb	p Eric Brown	M A Brown
1904 Feb	p Will Ashton – Paris	Louis Grier
1904 Feb	p Guy Kortright – Canada	Nina Grier
1904 Feb	Mr & Mrs Bailey – New Zealand	T Millie Dow
1904 May	A H Bittleston – Oxford & Cambridge Club	H H Robinson
1904 Nov	p Mr & Mrs Norman Garstin – Penzance	T Millie Dow
1904 Nov	p J A Park – Preston	Julius Olsson
1904 Dec	p Norman Hardy – London	J C Douglas
1904 Dec	p Reginald G Brundrit – Skipton	W H Y Titcomb
1904 Dec	p Reginald Turvey – London	W H Y Titcomb
1904 Dec	Miss Gisborne – Birmingham	E M Wilde
1904 Dec	p Horace C Taylor	T Millie Dow
1905 Jan	p William Cadwalader – Criccieth	Nina Grier
1905 Jan	p Alfred Frederick Wm Hayward, Hants	Arnesby Brown
1905 Feb	p Alfred East – London	A Deacon
1905 Mar	p J Acton Butt – Kings Norton	Emily Slater
1905 Mar	p Eric Brown, Notts (brother)	J Arnesby Brown
1905 Mar	p Miss M Godfrey – Cheltenham	F Milner
1905 Mar	Count Spurri – Finland	C Lewis Hind
1905 Apr	p Arthur S White – Penzance	Emily Slater
1905 May	Miss McNicoll – Montreal	R Holmes Hunt
1905 July	p John A Lomax – London	Fred Milner
1905 Nov	w Fergus Hume	J C Douglas
1905 Nov	Louie B Riggall, Melbourne, Australia	S E Whitehouse
1905 Nov	Gertrude P Carr – Australia	S E Whitehouse
1905 Dec	Calthea Vivian – California USA	S E Whitehouse

	Visitors	Members
1906 Jan	p Alicia Matthews – Tunbridge Wells	D Whitehouse
1906 Feb	H C Pinkerton – Windy Parc	J H Titcomb
1906 Feb	p Charles D Tracy – Shoreham	J C Douglas
1906 Oct	p Morley Roberts – St Ives	Alfred Hartley
1906 Dec	p Claude Barry – Windsor	Fred Milner
1907 Dec	p Harry and Laura Fidler – Salisbury	M K Deacon
1907 Mar	p J D Mackenzie – Newlyn (designer)	S Milner
1907 Apr	p Henry John Hudson – London	John Titcomb
1907 Oct	L P Sherriff – Wanganui, New Zealand	George Sherriff
1907 Oct	p Cecily M Baynes – London	George Sherriff
1907 Nov	p Mr & Mrs Chadwick – France	M K Deacon
1908 Jan	p Alfred East	W B Fortescue
1908 Feb	Mrs Patmore – Herne Bay	E Vallentin
1908 Feb	p Miss Mary Constance – Manchester	Edith Skinner
1908 Feb	p Mr & Mrs Craft – Buckden	W B Fortescue
1908 Apr	w H S Walpole – Epsom	Charles Marriott
1908 Apr	Miss Vernon – Lyceum Club, London	G Bainsmith
1908 June	p Laura Coombs Hills – Boston, Mass, USA	G Bainsmith
1908 June	Miss Lizzie B Hills – Boston, Mass	G Bainsmith
1908 July	Miss A G Kelly – Cambridge, Mass	G Bainsmith
1908 Nov	Joseph McKee – New York	Beale Adams
1908 Dec	p Napier Hemy – Falmouth	Charles Marriott
1908 Dec	w Mrs Havelock Ellis – Carbis Bay	Arnesby Brown
1909 Jan	Gen Rawlins – Scotland	V Rawlins
1909 Jan	p Miss Bright – Fulham Studios	J Olsson
1909 Jan	Mrs Irving – High & Dry	A Meade
1909 Jan	p Horace Taylor – Hampstead	J H Titcomb
1909 Jan	p Charles Napier Hemy – Falmouth	A J Pazolt
1909 Feb	p Wilfrid Arnold Forster – London	J C Douglas
1909 Feb	p Miss Chadwick – Paris	Lowell Dyer
1909 Feb	Vivien Marriott	Charles Marriott
1909 Feb	Dulcie Marriott	Charles Marriott
1909 Feb	Fay McKenzie – Hayle	Charles Marriott
1909 Feb	p Mr & Mrs C Napier Hemy – Falmouth	A J Pazolt
1909 Feb	p Wilfrid Arnold Forster	J C Douglas
1909 Mar	Harry Railton – Johannesburg	W Evans Linton
1909 Mar	Mrs Draymouth – New Zealand	D Whitehouse
1909 Apr	p Larmorna Birch – Lamorna	J Olsson
1909 Apr	H Irving – Paris	C Jackson
1909 July	p R C Orpen – Ireland (brother of Sir Wm), stayed at 15 The Terrace	W Summary

	Visitors	Members
1909 Nov	p Percy Bedford – Derby	Julius Olsson
1909 Nov	p Miss F Campbell – Paris	E Higgins
1909 Nov	p Miss O Urie	T Praetorius
1909 Dec	Count Larisch	T Millie Dow
1909 Dec	Signorine Arnice – Italy (Zennor)	T Millie Dow
1909 Dec	Signor Migliorine – Italy	T Millie Dow
1909 Dec	R Garnet Wolseley – Newlyn	E Higgins
1909 Dec	Mrs Wieke – Australia	I Sawyer
1910 Jan	Ernest John	J Olsson
1910 Feb	p H George – London	C Barry
1910 Feb	p Mrs Roos – London	R L Hutton
1910 Feb	p Norman Garstin	Alfred Hartley
1910 Feb	F Chadwick	A Deacon
1910 Feb	p E Ekengren	K Olsson
1910 Feb	p Miss Griesbuck – Yorkshire	F P Freyberg
1910 Feb	N Barrand – New Zealand	F P Freyberg
1910 Mar	p T C Gotch – Newlyn	M Lindner
1910 Mar	p Miss Ross Mabel Dakin	M D H Robinson
1910 Mar	p Miss A St John Partridge – London	H Knapping
1910 Mar	p Miss Garstin – Penzance	Miss Pilcher
1910 Mar	Baroness Deviki – Paris	Mrs Deacon
1910 Nov	N Menzies Gibb, Christchurch, New Zealand	G Sherriff
1910 Dec	p Guiseppe Guisti – London	Ida Sawyer

1907 April 11th the 'golfing artists' from London are named in the Visitors Book, but without initials: Swinstead, Hudson, Smithers, Nowell, Moser, Wilkinson, Browne, Anderson, Forsyth, Moira.

Artists of St Ives Colony 1911-1920 (all are painters unless otherwise stated)
p = painter; ph = photographer; po = potter; s = sculptor; w = writer; m = musician; st = student * see Biography

ABELL st	Miss Theresa Rion (Mrs Trewhella)
*ALLNUTT	Miss Emily
BARRETT w	Frank Mrs & Misses Lilas & Joan Carthew
*BARRY	Claude Francis, 2 The Terrace, Atlantic House
BARRY	Mrs C F & Miss
*BEAUMONT	Frederick Samuel & Mrs
BENNETT w	Rolf & Mrs
BLASHKI	M Evergood
BOUSFIELD	Agnes A Miss, Terrace House
BOWEN	Sylvia Miss, Rose Cottage, Carbis Bay
BOWER	L Scott Mrs, 3 Barnoon Terrace
BOYD	Penleigh, Harbour Studio
BRITTON	Harry
BROCKBANK	Albert Ernest
BROWNLOW	Charles S
*BRYANT	Charles David Jones (Australian) & Lady, studied under Olsson
BURGESS	Arthur James Wetherall
BURNE	Winifred Miss
CAIRNES	Miss & Mrs
CANNING	Florence Miss
*CAVE-DAY	William, Porthmeor Studios

*COLLIER	Edith Marion (New Zealand), student of Francis Hodgkins
COOK	Nelly E Miss
COOKE	Dorothy Miss
*COPNALL	Frank T
*COPNALL	Theresa Norah
COTTON	J W (American)
COTTON	Marietta C Mrs (American) figure & portrait
*COX	Garstin b Camborne – studied under Noble Barlow
CUTHBERT m	C A Mrs & Mr
DAVENPORT	Ruth (embroidery)
DE SALIS	Princess
DE VISTA	Princess Tula
DODD st	Miss
DODD	Francis – painted portrait of Virginia Woolf
DOUGHERTY	Paul (American)
DOWSON	Russell
DRAPER	Herbert James
ELLIS	Vernon (American)
EVANS m	Walton Miss
EWAN	Frances Miss, 6 Porthmeor Studios
FABRY	Emile Mr (Belgium)
*FIDLER	Harry
FIDLER	Laura Mrs
FITZGERALD	Frederick R
FRANCIS	Raymond
FRAZIER m	Miss Kathleen
*FREYBURG	Frank Proschwitzry, Piazza Studios
*FREYBURG	Monica
GIBSON	Edith
GILL	Winifred A
*GOOSEY	George Turland, architect & painter, & Mrs Tregenna, Hill Studio
GRAHAM	Caroline St C, Chy-an-Drea
GRIEVE	Mackenzie Averil Miss, Island & Fire Station Studios
*GRYLLS	Mary Mrs, The Blue Studio & Ar Lyn, Lelant
GURNEY st	A M Miss
HALL	Ethell
HARKE	E
HARRIS	Miss M M
HATTON	Brian
HENDERSON st	Miss
HENRY	Paul
HENRY	E Grace Mrs
HICHENS	W T died 1st World War
*HODGKINS	Frances (New Zealand), 7 Porthmeor Studios
HURST	Maud D Miss, Market Strand, Harbour
HUTTON	Dorothy
JAMES	Lt Colonel
JAMES	Miss
JUDSON	C Chapel & Mrs & Miss Helen (American)
KEMP-WELCH	Lucy Elizabeth
KENNEDY	George & Mrs (architect), April Cottage (son of C N Kennedy)
KENNEDY w	Margaret Miss, Talland House & Primrose Valley
KING w	Lieut E (RN) & Mrs
KING	Violet Malcolm Mrs
*KNIGHT	Dame Laura
KORNICK	Mrs
LAURIE m	Mrs Maxwell & Mr
LAWRENCE w	David Herbert, Tregarthen, Zennor
LAWRENCE	Frieda Mrs D H
LEWIS	Avery (American)
*LIDDELL	Thomas Hodgson
LINTON	Evelyn L Mrs (née Beckles)
LITTLE	Robert
LITTLEJOHN	J
LONG	Sidney (Australian)
LYONS	Arthur J (American)
MACHON w	M
MACLEAN	Sara Mrs
*MACIVOR	Monica Miss – pupil of Frank Freyburg, whom she married
MANSFIELD w	Katherine, Tregarthen, Zennor
MONTAGUE st	R F Miss, The Cabin
*MOORE	Captain Frank & Edith Annie, 1 Draycott Terrace & Beach Studio
MURRAY w	John Middleton, Tregarthen, Zennor
MORSE m	Stewart Mrs
MOUTONS	R A N
MUNNINGS	E F Mrs
NANCE p & w	Robert Morton & Mrs, Chylason, Carbis Bay
NANCE w	Ernest Morton & Mrs
*NANCE s	Armoral Mary Miss
NEVINSON	Christopher Richard Wynne
NORMAN	de Loria Mrs (American)
NORTON	F Montgomery Mrs
PARTRIDGE	Bernard
PATTISON	George A
PETERS	Charles Rollo (American)
PETRIE p & w	Graham
PHILIPS w	Austin
*PITT	James Lynn, The White Studio, Porthmeor Beach
POLLOCK	Montague Sir
POTTER	W J (American), Piazza Studios
PREECE	Patricia
PYNE	Thomas
RANDALL	Maurice
*RAWLINS	Ethel Louise Miss
RECKELBUS	Mons Louis (honorary member)
REDDIE w	Maura Mrs
RICE	Emily Estelle Mrs, Porthmeor Studios
RICHARDSON	Yarker
ROOKSBY	Bryan
ROSKRUGE	Capt Francis John DSO, OBE, RN, 1 Porthmeor Studios
RUSSELL	J R E
SARAWAK m & w	Her Highness Ranee Margaret
SAWYER	Ida
SEIDENECK	George J (American)
*SHARP	Dorothea Miss
SHONE	S H Mrs, The Hollies, Talland Road & Chy-an-Chy Studio
SHORT	Richard
*SIMPSON	Charles, Walter – St Ives School of Painting, Shore Studio

*SIMPSON	Ruth Mrs Charles W, Loyalty Cottage
*SMART	Capt Borlase & Mrs, The Cabin & Ocean Wave Studio
SMITH	Lennie Miss
*SMITH	Marcella Miss, The Grey Studio & 3 Porthmeor Studio
SMITH	David Murray
SMORENBERG	Dirk (Amsterdam), 14 Ayr Terrace
*SPENLOVE	Francis R, Wharf Studio
STIFFE	Katherine
SUTCLIFFE	J & Mrs
SYMAYS w	N & Mrs (honorary members)
TAYLOR	Edward R (died 1st World War)
TAYLOR w	Earnest
THOMPSON	Betty Miss
TOWERS	Samuel
TOWNSEND	S Miss
TWITE	Barbara Miss
TYLER	E V
VAUGHAN	Dora Miss
VERBECK	Frank (American) children's writer & illustrator
VERBECK w	Hanna Rion Mrs – wrote under H R (American)
WARLEIGH	Nora Miss, Balcony Studio
*WHALLEY	Minnie Miss
WHITE w	Sir Herbert & Lady Thirkell
WHITE st	Milicent Mrs
WHITE	Lady Orr & Dr
*WILLIAMS	Mary Frances Agnes Miss, Norway House & Enys Studio
WILLIAMSON	Anne E, The Cabin
WILSON	May, studied under Arnesby Brown
WILSON	Violet, studied under Arnesby Brown
WILSON	Winifred, studied under Arnesby Brown
WIMPERIS st	Miss
WIMPERIS	Edmund Morison
WOODALL	W M
WRIGLEY	A H Mrs
YABSLEY	James Stephen, Atlantic Studio & Sunrise, Penbeagle
YABSLEY	P

Visitors 1911-1920
p = painter; w = writer

	Visitors	Members
1911 Jan	p Walter Langley	W S Parkyn
1911 Jan	p Mr & Mrs Blashki – New York	J Olsson
1911 Feb	p Norman Garstin	Alfred Hartley
1911 Feb	p Mrs de Loria Norman (18 The Warren)	C D Tracy
1911 Mar	p T C Gotch – Newlyn	Moffat Lindner
1911 Mar	p Miss E Lamaison	Nora Hartley
1911 Mar	p Miss Cadell – Edinburgh	Julius Olsson
1911 Apr	p N F Wilkinson	M Sawyer
1911 Apr	p H Hudson – Kensington	Julius Olsson
1911 Apr	p E W Savory – Bristol	Julius Olsson
1911 Sept	Miss Hancock – Toronto	G E Cutts
1911 Nov	N Menzies Gibb – Christchurch, New Zealand	G Sherriff

	Visitors	Members
1911 Nov	D Davies – India	B Cockeram
1911 Nov	p Morley Roberts – London	Alfred Hartley
1911 Nov	w H Hume Spray – Gloucester	Claude Barry
1911 Dec	p Mrs Northcote – London Art Studio	M M Douglas
1911 Dec	p Walter Langley – British Colombia	J H Titcomb
1911 Dec	p J W Cotton – Chicago	W M Cutts
1911 Dec	p Will Potter – USA	L A Sargent
1911 Dec	p Norman Garstin – Penzance	M H Robinson
1911 Dec	J L Mason – New Zealand	H I Babbage
1911 Dec	Miss Power – Ireland	W S Parkyn
1912 Jan	p Penleigh Boyd – Melbourne	G Sherriff
1912 Jan	Mrs Seidenack – Chicago	G Bainsmith
1912 Jan	p Mary Monkhouse – Disley, Cheshire	A H Nicholson
1912 Jan	p A J W Burgess – London	J H Titcomb
1912 Jan	p W Derrick – Bristol	Julius Olsson
1912 Feb	p Arthur Beaumont – Staten Island, USA	H I Babbage
1912 Feb	p F Beaumont – London	Alfred Hartley
1912 Mar	Mr & Mrs Vallentine – Falmouth	Alfred Hartley
1912 Mar	p Violet (& Esme) Reid – Exmouth	Hayley Lever
1912 Apr	Mrs Robert Grafton – Chicago	M C Cotton
1912 June	p Mrs Sydney Lawrence – Coventry	J Whitehouse
1912 Nov	C Luck – Stockholm	F Milner
1912 Dec	p Sir Alfred East – London	M Lindner
1912 Dec	p Mr & Mrs Potter – USA	E Skinner
1912 Dec	w Mr Austin Phillips	T Millie Dow
1913 Jan	Miss Wilson – New Zealand	J M Bromley
1913 Feb	p Miss Tyra Kleen – Sweden	R L Hutton
1913 Feb	p A F W Hayward – Northwood, Middx	G Sherriff
1913 Apr	p Mrs H Wrigley – Clitheroe	Arthur Meade
1913 Nov	Mr Milbank – Adelaide	H I Babbage
1913 Dec	Signorina Arnice – Zennor	Ida Sawyer
1913 Dec	Mr & Mrs Campbell – Murdoch, Morocco	B Cockeram
1913 Dec	Mrs Arnold Forster (Ka Cox)	D Whitehouse
1914 Jan	Charles G W Roberts – Canada	Nora Hartley
1914 Jan	Misses Wilson (2) – New Zealand	H I Babbage
1914 Mar	p Thomas Hodgson Liddell	F Tysoe Smith
1914 Mar	p Miss Arminell Morshead – Tavistock	R L Hutton
1914 Apr	p Lilian B Whitehead – London	G Bainsmith
1914 Apr	Mr Milbank – Australia	H I Babbage
1914 Apr	Miss Martin – Perth	R L Hutton
1914 Apr	p Ada Galton – Upper Norwood	G Bainsmith
1914 Apr	p Lilian B Whitehead – London	G Bainsmith

	Visitors	Members
1914 Nov	Lady Thirkell White – London	M Laurie
1914 Nov	Mrs Judson – San Francisco	D Hutton
1914 Nov	Mrs Pennell – Burmah	M M Douglas
1914 Nov	Miss Smith – Washington USA	F Milner
1914 Nov	p M Reckelbus – Bruges	A Hartley
1914 Nov	Lt E M King RN – Heligoland	F M Campbell
1914 Nov	p A J W Burgess, Stanley Gdns – London	C A Cuthbert
1914 Nov	p Mr & Mrs Chadwick – New York	F Milner
1914 Dec	Miss Glazier – Bruges	Mrs Moore
1914 Dec	M Durandeau – Nice	C Cockeram
1914 Dec	p K W Earle – Berkhampstead	A Meade
1914 Dec	Mrs D Ogilvy – India	T A Lang
1915 Jan	Mrs Garner Richards – Spain	S E Whitehouse
1915 Jan	Madam Blondieu – Belgium	S E Whitehouse
1915 Jan	Miss Lentayne – Burma	Mary Laurie
1915 Feb	Mrs Godfrey – Australia	B Cockeram
1915 Feb	Princess di Vista – Amsterdam	H R VerBeck
1915 Feb	p Mr & Mrs Smorenburg – Holland	Frank VerBeck
1915 Feb	Mrs Godfrey – Australia	B Cockeram
1915 Mar	Mrs Grau – Australia	G Bainsmith
1915 Mar	Mrs Denistoyn – New Zealand	D Whitehouse
1915 Mar	p C E Stafford – London	E L Rawlins
1915 Mar	Mrs R Lynde – London	Francis Hodgkins
1915 Apr	Sir Stephen & Lady Finney – London	T Millie Dow
1915 Apr	p Miss Helen Sinclair – London	Maura Reddie
1915 Apr	p F Stonelake – Clifton	Evelyn L Linton
1915 Apr	Robert Lightbourne – Bermuda Island	H R Verbeck
1916 Jan	p Mary Epps – Hampstead	Dorothy Hutton
1916 Feb	p Mrs Sydney M Lawrence – Coventry	S E Whitehouse
1917 Jan	p W D Barnett – Chelsea	A C Bailey
1917 Jan	p Mr & Mrs Gill	W B Fortescue
1917 Jan	p Walter Durac Barnett – Chelsea	A C Bailey
1917 Oct	Jeanne & Louis Delune – Paris	Frances Ewan
1917 Oct	p W Collett – Mason	Frances Ewan
1917 Nov	Miss Green & Miss Williams – Paris	S E Whitehouse
1917 Nov	Guy Preece, Wellington, New Zealand	A M Gurney
1918 Feb	Mr & Mrs Chapman – Australia	Edgar Skinner
1918 Feb	p Vernon Ellis – USA	Edgar Skinner
1918 Nov	p Capt & Mrs Borlase Smart	Edgar Skinner
1920 Jan	Mrs Pilkington, Colorado, USA	F Tysoe Smith

	Visitors	Members
1920 Jan	p Charles Edward Brittan	R B Smart
1920 Feb	Mrs A H Plumb – Canada	A M Gurney
1920 Feb	p Mr & Mrs Nevinson – London	Nora Hartley
1920 Feb	p Leslie Kent (pupil of Fred Milner)	Fred Milner
1920 Apr	p W T M Hawkworth, Chelsea	Wm Cave Day

Artists of St Ives Arts Colony 1921-1939 (all are painters unless otherwise stated)
p = painter; s = sculptor; po = potter; w = writer;
m = musician; a = architect; dr = drama; st = student
* see Biography.

ADAMS ph	Gilbert, The Digey
ADAMS ph	Marcus, The Digey
AKERBLADH p & a	Alexander (Sweden)
ALEXANDER	Edith Meta Mrs, Downalong Studio
*ALLEN	Daphne Miss
ALLPORT	Howard
ANDREWS	Edith Lovell, 3 Bellair Terrace
ANDREWS s	Elizabeth Miss
ARMSTRONG	Hugh Wells
ARONSON w	Nancy Miss
BALANCE	Miss Margery H, 1 Albany Terrace & 3 Porthmeor Studios
BALANCE	Percy des Carrieres & Mrs, Grey Studio & 3 Porthmeor Studios
*BALMFORD	Hurst & Mrs, Beach Studio
BARNARD	Lily
BEDDARD m	J C & Mrs
BEFORWARD w	A F
BELL	Gertrude M Miss
BELOHORSKY	J & Eva
BENNER	William Roger
BENNETT m	Barriez
BENT	Roger
BENT	Medora Heather
BIRCH	Lamorna John, Flagstaff Cottage, Lamorna
BLUMBERG	General Sir Herbert KCB & Lady
BODILLY	Mrs Lucy & Arthur, Rosemorran
BODILLY	Vera Barclay Miss
*BOROUGH JOHNSON	Ernest
*BOROUGH JOHNSON	Esther Mrs
BOSCAWEN st	June Miss
BOTTOMLEY	Frederick & Mrs, Dragon Studio, Norway & Salubrious House
BRADON po	Norah, Leach Pottery
BRADSHAW	Lt Commander George, Fagan R N – Ship Studio, Norway Lane
BRADSHAW	Kathleen (née Slater), Ship Studio, Norway Lane
BRAND	Ethel Miss
BRISTOL	J S
BRYANT	Annie Miss
BULLOCK	Caroline
CALDER w	Mrs I
CAMERON st	R P
CAMERON	D M
CAPEL CYNGE w	Hilda & Samuel

CHADWICK	F B & Mrs
CHETWOOD AIKEN	K O
CLARK	J B Miss
CLARK	Averil le Gros Mrs
COCHRANE	Alfred & Mrs, Parc-an-Carne
*COHEN	Minnie Agnes Miss
COOKE s	Norman
CORK	Eliza Mary Miss, Chy Morvah, St Andrews
COURIVES st	Madame
CRESSWELL TAYLOR w	Mrs
CROSS	Eileen, Church Place
CRUTHWELL	C R M P
*CUNEO	Cyrus (American)
*CUNEO	Nell Marion (née Tenison Mrs Cyrus), Downalong Studio, St Ives
*CUNEO	Terence
CURRIE m	Miss & Donald
DALZELL	Alexander C
DARMADY w & dr	B Stewart
DARMADY w & dr	Jessie Mrs & Michael & Elizabeth, The Belyars,
DE BERTOUCH	Baroness
DE GRAY	Walter LLD, FSA (honorary member)
DE MATTOS	Ethel M
DOLTON	V G F Miss
DREY dr	Alice
DREY dr	Jeanne Miss
EDMONDS	Mr & Mrs
ELLIS	J Miss
EMERY	Walter & Mrs & Miss Ruth, Rosebank, Ayr
EVANS dr	Wreford M
EVERARD w	Mrs
EVERARD	C S, Horse Shoe Studio
EVERARD	Dorothy Mrs, Dragon Studio, Norway
FARQUHARSON	John
FORBES DENNIS w	Ernan
FORSTER po	Bernard, Leach Pottery
*FORTUNE	Euphemia Charlton Miss (American)
FOWLER	W H
FRADGLEY	Ellen Miss
FREEMAN	M Winifrede, 7 Bellair Terrace
GLASHEY	E H
GLOVER s	Arthur
GREENE	Alison A & Dr
*GRESTY	Hugh, Ship Aground & Mincarlo Studio
HAMADA po	Shoji, Leach Pottery
*HAMBLY	Arthur Creed
HAMEL m	Marjorie Miss
HARRISON st	Miss
* HAYWARD	Arthur W & Mrs, Treventh, Belliers & Shore Studio
HERON	Tom M, Ocean Breezes
HERRING	Evelyn M
*HEWITT	Pauline Mrs, St Peters Street Studio
HOCKING w	Joseph & Mrs & Miss Carew, Penmare, Hayle
HOLLIDAY m	J C & Mrs
HOLT st	Miss & Mrs Ada H, Blue Bell Studio
HONELL	Mr
HOSKINS st	Miss
*HUGHES	Eleanor
*HUGHES	Robert Morson & Mrs
HUMPHERY	Winifred Miss, Enys Studio
IRWIN	Miss
IRWIN	Harry Greville
ISHIKAWA	Mr
JACKSON	Theresa Miss & Fay, 8 Bowling Green Terrace
JENKIN w	Hamilton A K (BA, B Litt) & Mrs, 7 Draycott Terrace
JENNER w	Henry (Grand Bard of Cornwall) & Mrs K, Hayle
JEWELS	Mary, Mousehole, Penzance
JILLARD	Hilda
JONES	Ray (committed suicide), Down Under Studio
JONSSON	Rolf (Swedish), St Ives School of Painting
JORDAN	J Tiel & Phyllis, Flagstaff Cottage, Lamorna
KERR	Lamorna Mrs
KLEEN	Tyra Miss (Sweden)
LANE	R Tudor (Lady Blumberg)
LANE w	Cecil de Winter Miss
LANYON	G P, St Ives
LANYON	Mary (daughter of W H Lanyon), Godolphin Manor House
LEWIS	Lowry
LIDGEY dr	Monica (married G Cave-Day)
LINDNER	Hope (daughter of Moffat Lindner), Chy-an-Porth
LODGE	Janet Miss
MACVIE	Dr A
MAGNUS dr	Cecil & Mrs
MAGNUS dr	Rose Miss
MALAN st	Col & Mrs
MASON	Thelma
MATHESON w	Greville E, Boskerris Vean, Carbis Bay
MATTHEW w	Paul C & Mrs J N, The Terrace
MATSUBAYASHI po	T, Lanhams & Leach Pottery
McCORMACK w	Joan Miss
McMAHON	P, 9 Bellair Terrace
MEADE	Paul
MEADE dr	Mrs
MILLER	Professor
*MOONY	Robert James Enraght
MOORE	Theo Miss
MORSHEAD	Arminell, Island Square Studio
ORCHARD	A G Miss
PAGE st	E F Miss
PELHAM WEBB w	C
PENNELL m	C S & D, 1 Albany Terrace
PENNINGTON	George F (architect), Gorse Cottage, Carbis Bay
POWELL	Blanche H, Penzance
PROCTOR w	Charles, Primrose Valley
PROCTOR	Sheila Miss
PUGH w	C J (Master of Arts)
PULLING	Edward V
RAYMOND	Francis, The Green Studio
REED m & w	E Mary Mrs
REYNOLDS	H Tangye
REYNOLDS	Reginald F
ROBERTSON st	Miss
ROLLO w	Hon Edith C Mrs, Sun Cottage
RUSSELL	Gyrth

RUTHERFORD	H
SAGAR FENTON	Gay
SCHOFIELD	G M
SEGALLER	Dr D & Mrs
SHELDRICK w	Mr & Mrs
SHONE	R E Captain, Chy-an-Chy Studio & Talland Road
SHONE	Mabel, Chy-an-Chy Studio & Talland Road
SIMPSON	Percy
*SIMS	Charles (committed suicide 1928)
SMITH	Bliss Miss
SMITHELLS p & ph	E, Belliers Studio
SPONG	Walter Brookes
SPRING w	J Lewis
STAYTON w	Marianne Miss
STOCKER	Ethel Miss, Loft Studios & Porthminster Terrace
SULLIVAN	Arthur
SYKES	Arthur, 2 Church Lane, Newlyn, Penzance
SYKES	Dorcie, 2 Church Lane, Newlyn, Penzance
TELLUM	Mary
TEMPLE BIRD	Kathleen
THOMAS w	Herbert & Miss Ilva
THOMSON	J Sophie, Ayr
THOMSON	S Miss
THORNLEY w	Rev Alfred
TREWHELLA	Lilas, Trewyn House
TRUMAN	W Herbert & Mrs, Trezion
TURNER	Dorothy H, Briar Dene, Carbis Bay
UPWARD w	A F
VANE	Hon Kathleen Airini (New Zealander)
VIVIAN	Beatrice
VYVYAN	Christina Miss
WAGNER st	G pupil of John Park
WALSH	Lucy E Mrs, 8 Porthmeor Studios
WALTERS	Edith
WARD	Charlotte Blakeney
WARD	Charles D
WEBB	Dora Elizabeth Miss
*WEIR p & s	Helen Stuart Miss (American)
WEIR-LEWIS	Nina May Mrs
WELCH po	Dorothy
WHITE	Franklin
WHITNALL w	Professor M G & Mrs Mary
WILKINSON	Norman
WILLETT	E Miss (American)
WILLIAMS w & p	Mary Miss, Westcotts Quay Flats
WOOD	J Carew
WOOD	Christopher, The Meadow
WRAGGE	Carl

Visitors 1921-1939

p = painter; w = writer; po = potter

	Visitors	Members
1921 Feb	w Henry Jenner (Bard) – Hayle	B Adams
1921 Feb	Mr Jones – India	M Laurie
1921 Mar	Maria Yelland (singer)	A Lloyd
1921 Aug	po Amy Eliza Krauss – Bristol	Minnie Whalley
1921 Aug	p Elsie M Barling – Broadstairs	Minnie Whalley

	Visitors	Members
1921 Dec	H R H Prince Chu-gli – Peking, China	H Weir-Lewis
1921 Dec	p E M Fraser – Bath	L Dyer
1922 Feb	w Crosbie Garstin	L Dyer
1922 Mar	p W B Spong – New York	R E Magnus
1922 Apr	I K Buchanan – New Zealand	P Balance
1922 Nov	p A H L Elphinstone – London	L Grier
1922 Nov	H P Guiler – New York	J H Titcomb
1922 Nov	p J E Carter – Green Studio	F Moore
1922 Nov	p Miss Lawrence Hart – Lyme Regis	F Tysoe-Smith
1922 Dec	Kawasaki – Tokyo	E Skinner
1922 Dec	Mr Redvers Wall – Durban	N E Cooke
1923 Jan	J W E Berry, Calcutta	P Ballance
1923 Jan	po Matsubyashi – Tokyo – Barnoon End	B H Leach
1923 Jan	Mrs Alexander – India	P Balance
1923 Mar	Miss Rose – Co Down, Ireland	E C Fortune
1923 Mar	p P A Lamb – Hampstead	R B Smart
1923 Apr	p Donald Maxwell – Rochester, Kent	J S Yabsley
1923 Nov	p A Akerbladh – 12 Onslow Studios, Chelsea	E A Moore
1923 Nov	Mrs Luard Wright – Auckland, N Z	D E Webb
1923 Nov	po Michael Cardew – Wimbledon	E Skinner
1924 Jan	p Mrs Annie Bryant – Clyst St Lawrence	F Milner
1924 Feb	p Mr & Mrs Norman Garstin – Penzance	N Grier
1924 Feb	w Crosbie Garstin – Penzance	G F Bradshaw
1924 Feb	Mrs E Vivian – Johannesburg	W H Lanyon
1924 Mar	po Miss Pleydel Bouverie – Halsetown	Bernard Leach
1924 Mar	Roger Wearne Ramsdell – Washington	Borough Johnson
1924 June	p Mr H W Faulkner – USA	E Morton Nance
1924 Oct	Mrs Griggs – Tremedda Farm, Zennor	M Kennedy
1924 Nov	Mrs Carl Chadwick – France	Brooks
1924 Nov	w Henry Jenner – Hayle	Mrs Jenner
1924 Nov	p C C Judson – California	W H Lanyon
1924 Dec	Mrs C Chadwick – Paris	F B Chadwick
1924 Dec	p Enid Jackson – Paris	T Jackson
1924 Dec	p Miss Garstin – Penzance	Margaret Kennedy
1925 Feb	w Crosbie & Mrs Garstin – Lamorna	Margaret Kennedy
1925 Feb	Cecil Hughes – Johannesburg	Lanyon
1924 Feb	Mrs Verran – Vancouver	K Frazier
1925 Mar	po Michael Cardew	Dorothy Turner
1925 Mar	p Mr & Mrs Atherton – Yorkshire	Turvey
1925 Oct	Mrs Lawrence – China	J H Titcomb
1925 Oct	Mrs Wallis Smith – Sidney, N S Wales	Lilian Roskruge
1925 Nov	p W L Wyllie, R A – Portsmouth & Mrs	G E Matheson

Date	Visitors	Members
1925 Dec	Miss Henstis – Toronto	M M Douglas
1925 Dec	w Henry Jenner	F Milner
1926 Jan	p Lamorna Birch	J A Park
1926 Jan	p Stanley Horace Gardiner	J A Park
1926 Jan	BBC Filson Young, London	M Lindner
1926 Jan	po Michael Cardew	Bernard Leach
1926 Jan	po Miss N Braden – Leach Pottery	Bernard Leach
1926 Jan	Miss M A Hall – Art Gallery, Newlyn	M W Freeman
1926 Mar	p Miss Bruford – Liskeard	Roskruge
1926 Apr	p Angela Gloag – London	E Morton Nance
1926 Apr	Juan Carlos Baggit – Buenos Aires	A Thornley
1926 Nov	The Hon Mrs Rollo – London	G Bainsmith
1926 Nov	Miss B Mair – Vancouver	Kathleen A Vane
1926 Nov	p Mrs C Barry – New York, USA	Mr Magnus
1926 Dec	Miss Marshall – Kashmir	K Bradshaw
1927 Jan	Miss Stroeli – Switzerland	M Ballance
1927 Feb	Miss Atkinson – New Zealand	R Morton Nance
1927 Mar	Miss Millet – New York	E M Reed
1927 Mar	p Alexander Sonnis – London	N E Cooke
1927 Mar	p Mr & Mrs Procter – Newlyn	W H Freeman
1927 Mar	p Mrs & Miss Waters – Newlyn	N Cuneo
1927 Apr	w W W Jacobs – Berkhamsted	A K Hamilton Jenkin
1928 Jan	Miss V Beauchamp – London	
1928 Jan	Mr & Mrs Cobb – New York	W H Lanyon
1928 Jan	Miss C L O'Leary – Melbourne	M Jenny-Smith
1928 Feb	w Mr & Mrs Crosbie Garstin – St Buryan	G E Matheson
1928 Feb	Lady Mabel Hall	L Roskruge
1928 Dec	p E W Pulling – Sark, C I	A F G Henderson
1929 Jan	Miro Aubeison – Switzerland	D H Turner
1929 Apr	w Crosbie Garstin & Mrs	A K Hamilton Jenkin
1929 Oct	p Lamorna Birch – Lamorna	J E Carter
1929 Nov	p Miss Ackroyd – Stockport	F Milner
1929 Nov	p Miss Jorgensen – Copenhagen	E S Darmady
1929 Dec	Orr Ewing	C S Pennell
1929 Dec	Miss Carrington – New Zealand	J F Courage
1930 Feb	Mrs Pedder – West Indies	G Bainsmith
1930 Mar	E Ashley – Sydney, Australia	F Turvey
1930 Apr	w Crosbie Garstin & Mrs – Lamorna	Mrs Darmady
1930 Oct	Sir Hugh & Lady Orange – Weybridge	C S Pennell
1930 July	H M Gilmour – Montreal	H G Bainsmith
1930 Dec	Miss Harvey – Porthcurno	G E Matheson
1930 Dec	w Arnold-Forster – Zennor	J Darmady
1931 Apr	p Leslie Kent – Radlett	D M Leach
1931 Nov	Mrs Arnold Forster – Zennor	E M Darmady
1931 Nov	p Mrs Laura Fidler – Andover	M W Freeman
1931 Dec	p John Goodrich Woods – Seaford	F Milner
1931 Dec	p Mrs Annie Bryant – Clyst St Lawrence	F Milner
1932 Jan	Bernard Forster – St Ives	B H Leach
1932 Feb	p Miss Winifred (Wyn) George – Blandford	N E Mathews
1932 Feb	Miss K Coope – Sierra Leone	N Elkin Mathews
1932 Mar	Barbara F Millard – South Africa	David Leach
1932 Mar	Miss T Graham – Leeds	David Leach
1932 Apr	p Terry Cuneo – London	G Cave Day
1932 Apr	Elisabeth Goldsbury – S Africa	W H Lanyon
1932 July	Miss L Cookes – London	D A Leach
1932 Nov	Beatrice Brown – Canada	A L W Day
1932 Dec	po Laurie Cookes – Leach Pottery	Bernard H Leach
1933 Jan	Wilbur Holmes – New York	Margaret Kennedy
1933 Jan	Miss A Peck – Canada	C M Findlay
1933 Jan	Lady White	The President
1933 Apr	p Claude Flight – London	E M Herring
1933 Apr	p Edith Lawrence – London	L M Larking
1933 Apr	p Mr & Mrs Sonnis – London	F Roskruge
1933 Oct	Mr Brownbridge – Nice	W Bottomley
1933 Dec	Lt Col F C Hirst – Zennor	A B Forrester
1934 Jan	po Mr Ishikawa – London	E M Leach
1934 Feb	Miss Orr – Zurich	C M Findlay
1934 Mar	p S J Lamorna Birch – Lamorna	The Club
1934 July	Frances B Sweeney – Montrea	–
1934 Nov	Caroline Storm – Toronto, Canada	H Scott
1935 Feb	p Mr & Mrs B Fishwick – Penryn	D Kendall
1935 Mar	Mr & Mrs Heath – Lamorna	F Bottomley
1935 Mar	p Ernest Peirce – Sancreed	F Bottomley
1935 Apr	p Mr Borlase Smart – St Ives	N E Cooke
1935 Apr	Ti Chai Hwan – Shanghai	J Jackson
1935 Oct	p Guy Kortright – 75 Warwick Gds, London	Mrs Louis Grier
1935 Oct	p A C Dalzell – 21 Warwick Gds, London	Mrs Louis Grier
1935 Oct	V Harkvolah – Finland	M F A Williams
1935 Oct	Joan Vivian – Johannesburg	W H Lanyon
1935 Dec	W D L Filson Young – 28 The Terrace	Mrs F C Matthew
1936 Jan	w A K Hamilton Jenkin – London	Daphne Pearson
1936 Apr	Miss N Byrnes – Limerick	G F Foulds
1936 Nov	p Leonard Richmond – Guildford	Bernard Ninnes
1936 Dec	Hilde Kratke – Vienna	M Cave Day
1938 Dec	Mr & Mrs Downing – St Ives	D A Leach

The New Era 1930-1993 (all are painters unless otherwise stated)
Artists of St Ives colony 1939-70
p = painter; s = sculptor; po = potter; ph = photographer;
m = musician; cr = craft; w = writer * see Biography

ACKROYD	L Miss
ADAMS s	Robert
ANDREWS	Edith Lovell, 2 Bellair Terrace
ANGIER	Donald V
ARMFIELD	Stuart
ARMITAGE	Catherine
*ARMSTRONG	Alixe Jean Shearer, 9 Porthmeor Studios
ARMSTRONG	John
ARNOLD FORSTER	Wilfred & Mrs (Ka Cox), Eagles Nest, Zennor
AUTY	Giles
*BARCLAY	John Rankine, 15 Island Road
BARKER w	George
BARKER	Kit
BARKER	Ilse
BARNES	Garlick, Dwindle Stone, Hellesvean
*BARNS-GRAHAM	Wilhelmina, 1 Barnaloft
BATTERHAM po	Richard, Leach Pottery
BAYLEY	Dorothy, Amalwyn, Nancledra
BELL	Amelia, Tywarnhayle, Burthallon Lane
*BELL	Trevor
*BENJAMIN	Anthony
BENJAMIN cr	Stella, Bellair Terrace
BERESFORD w	John Davys
*BERLIN	Sven, Sven's Tower, Porthgwidden
BLACKLOCK	D B Mrs CBE
BLAND	S Josephne, 7 Boase Street, Newlyn
*BLOW	Sandra
BOOTH s	Christopher
*BOMBERG	David
BOTTOME w	Phyllis
BOURNE	Bob
*BORDASS	Dorothy
BREAKER	Charles, Gernick Field Studio, Newlyn
BROIDO	Michael
BRUFORD	Marjorie Frances (Midge)
BURT s	Laurie
BUTLER	Alice
BUTLER	H J
CADDICK w	Arthur, Nancledra, Penzance
*CANNEY	Michael
CARDEW po	Michael, Bodmin
CARNE	Alec
*CONN	Roy, 1 Porthmeor Studios
*COLQUHOUN	Ithell
COOK	Frederick, T W
COUDRILL	Jonathan
COX	David
CROSSLEY	C, Parc Bean
DALE	Shallett
*DANNATT	George
*DAVIE	Alan
DEAR	Helen
DIGBY	Violet, Studio Cottage, The Bellyars
DORFMAN	Stanley
*DREY	Agnes
DU MAURIER	Jeanne, The Warren
*EARLY	Tom
*EVANS	Merlyn, Piazza
FEATHERSTONE s	Bill
*FEILER	Paul, Old Chapel, Paul, Penzance
*FISHWICK	Clifford
FISHWICK	E J
FISHWICK	Patricia
*FORRESTER	John
FRANK	Peggy
FREEMAN	N H Miss
*FROST	Terry, 8 Quay Street & Gernick Field Studio, Newlyn
*FULLER	Leonard John, St Ives School of Painting
*FULLER	Marjorie (née Mostyn)
GABO	Miriam, Carbis Bay
*GABO	Naum, Carbis Bay
GAPUTYTE	Elena
GARSTIN	Alethea, The Old Poor House, Zennor
GEAR	William
GILLAN	Isobel Joan
GILBERT	Dick
GILCHREST	Joan, Love Lane, Mousehole, Penzance
GRAHAM w	W S
GUTHRIE	Derek
HALLIDAY w	Frank & Nancy, Barnaloft Flats
HAMADA po	Atsuya, Leach Pottery
HAMADA	Shoji, Leach Pottery
HAMBLY	A C
HARRIS	Jeffery
*HAUGHTON	David
*HAYLETT	Malcolm, Westcotts Quay Studio
HAYLETT	Jean, Westcotts Quay Studio
*HAYMAN	Patrick, Westcotts Quay Studio
*HEATH	Adrian
*HEATH	Isobel Atterbury, Custom House Studio
HENDERSON	John
*HEPWORTH	Dame Barbara, Barnoon Hill
*HERON	Patrick, Eagles Nest, Zennor
HILL	Philip Maurice
*HILTON	Roger, Botallack Moor
*HILTON	Rose, Botallack Moor
*HOCKEN	Marion Grace, Meadow Studio
HODIN w	Joseph Paul
HOLMAN	Linden
HOYTON	Edward Bouverie
HOYTON	Inez
ILLSLEY	Brian
ILLSLEY	Leslie
INGHAM	Bryan
IZARD	Eileen, Moor Cottage, Rosewall
JEWELS	Mary, Mousehole, Newlyn
JOHN	Augustus, Mousehole, Newlyn
KENNEDY	Horas, Nancledra, Penzance
KIDNER	Michael
LAMB	Henry V
*LAMBOURN	George
LANG s	Faust, Fauna Studio, The Wharf
LANG s	Wharton, Fauna Studio, The Wharf
LANG	Una, 5 Piazza Studios
*LANYON	Peter, Little Parc Owles, Carbis Bay
LASAR	Charles

LAWRENSON	Dorothy Alicia, 3 Knills Cottages, Trelyon
*LAW	Bob
LAW	Denys, Nantewas, Lamorna
*LEACH po	Bernard, Leach Pottery
LEACH po	David (son of Bernard)
LEACH	Eleanor (daughter of Bernard married Dicon Nance)
LEACH po	Janet (wife of Bernard)
LEACH po	Michael (son of Bernard)
LEIGH s	Roger
LEITCH	Gwen
LEONARD	Charmian, Carncrows Street
LEONARD s	Keith, Carncrows Street
LEVINE w	Norman, Bedford Road
LEWIS w	David
LIVEN	Francis, 6 Porthmeor Studios
LONGMAN	Joanne Pemberton
*LOWNDES	Alan, Halsetown
*MACKENZIE	Alexander, Morrab Road, Penzance
MACKENZIE po	Alix, Leach Pottery
MACKENZIE po	Warren, Leach Pottery
*MAECKELBERGHE	Margo, Roscadghill, Penzance
MARSHALL po	Scott, St Just
MARSHALL po	William, Lelant Pottery
MARTIN s	F R
McWILLIAM s	F E
*MELLIS	Margaret, Little Parc Owles, Carbis Bay
*MILES	June, Nancherrow Studio, St Just
MILLER	John, Sancreed, Penzance
MILNE s	John, Trewyn
MISKIN	Lionel
*MITCHELL s	Denis, Fore Street & Chywoone Hill, Newlyn
MITCHELL	Edith Boyle
MONIER	Robert
MOORE cr	Alice, Lelant
MORRIS cr	Guido
MORT	Marjorie, Maryland, The Lidden, Penzance
*MOSS	Marlow Sewell
MOSS	Moreen, Newlyn Gallery
MOUNT s	Paul, Nancherrow Studio, St Just
MUNCASTER	Claude Sir
MUNNINGS	Alfred J Sir, Lamorna
NANCE cr	Dicon (son of Robert Norton Nance)
NANCE cr	Robin (son of Robert Norton Nance)
NANCE	Phoebe (wife of Robin)
NANCE	Benjamin (son of Dicon)
NARROWAY	William
*NICHOLSON	Ben, 5 Porthmeor Studios & Trezion
NICHOLSON	Kate, Porthwidden Studios
NICHOLSON	Rachel
NICHOLSON	Simon
NICHOLSON	Winifred
*NINNES	Bernard, Hayeswood, Burthallan Lane
NIXON	Job
*O'CASEY	Breon, 3 Porthmeor Studios
*O'MALLEY	Jane, 4 Porthmeor Studios
*O'MALLEY	Tony, 4 Porthmeor Studios
ORGAN	Robert
*PASMORE	Victor
*PEARCE	Bryan, 12 Porthmeor Studios
PEARCE	Mary, Market Place
PEARS	Charles
*PEILE	Misome, 9 Porthmeor Studios
PEIRCE	Ernest, Blue Hills, Ludgvan
*PENDER	Jack, Mousehole
PERRY	R G
PICKARD	Biddy, Clodgy Moor, Paul
PIPER	William F
POPE	Terence
*PORTWAY	Douglas, 8 Porthmeor Studios
PRAED	Michael, Newlyn
PRIDEAUX cr	Vivien
PRITCHETT	Dora G, 3 Reginnis Hill, Mousehole
PROCTER	Dod, Newlyn
PROCTER	Ernest, Newlyn
QUAYLE w	Eric, Zennor
QUICK po	Kenneth, Leach Pottery
RAINIER m	Priaulx
RAINSFORD	Peter, Penwith Studios
READ w	Sir Herbert
REDGRAVE	William, 1 Island Road
REISER	Dolf
RICHARD w	Dorothy
RICHARDS po	Anthony, Cripplesease Pottery
RICHMOND	Leonard
RIDGE	Hugh E, Dragon Studio
ROBERTS	L Staniland, 4 Piazza Studios
ROBINSON	Brian
ROGERS	Cedric
ROSE	Vernon
ROUNTREE	Harry
RUHRMUND w	Frank, Newlyn
RUSSELL w	Dora
RYAN	Adrian
*SCOTT	William
*SEFTON	Ann Hariet (Fish), Digey Studio
*SEGAL	Hyman, 10 Porthmeor Studios
*SHIELS	Tony
SIROTO p	Benny
SLACK cr	Janet
SLACK ph	Dr Roger
*SMART	Robert Borlase, 5 Porthmeor Studios
*SNOW	Michael N Seward
SPOTTISWOOD	Elspeth
*STOKES	Adrian, Little Parc Owles, Carbis Bay
STUBBS w	John Heath
TAAFE	Anthony, Saltings Studio, Porthmeor Road
TAYLOR	Bruce
THOMPSON	Jan
*TILSON	Joe
TODD BROWN	William
TRIBE s	Barbara, The Studio, Sheffield, Paul
*TUNNARD	John
VAL BAKER w	Denys, St Christophers, Porthmeor Road
VAN HEAR	James
WALL s	Brian
*WALLIS	Alfred, Back Road West
*WATERS	Billie, Newlyn
WATTS	Amy Miller
WATTS	John Miller
*WELLS	John, Anchor Studio, Trewarveneth Street, Newlyn
*WESCHKE	Karl, Cape Cornwall, St Just

WHICKER Gwen
WHITE A T, Headlands Hotel, Carbis Bay
WHITE Clare, Arts Club
WHITLOCK J, 12 Porthmeor Studios
WOOD Alan
WOOD Rendle
WORSDELL Guy
WRIGHT w David
*WYNTER Bryan, The Carn, Zennor
YATES Marie

Artists exhibiting in St Ives and living in West Cornwall from the 1970s (all are painters unless otherwise stated)
p = painter; s = sculptor; po = potter; ph = photographer;
cr = craft; w = writer *see Biography

ADEY Sue, Ludgvan
*ALGAR Pat, Rope Walk Studios
AGNEW cr Lindsay, Gulval
AMBROSE John, The Wharf
AMBROSE Ray, Newlyn
ANNEAR Jeremy, Salthouse Gallery
ARMITAGE Catherine
ATKINS Ray, Redruth
ATKINSON cr Ryman, Helston
AVERIL Simon, Helston
AYLING Grace, Porthgwidden Studios
*AYLING Richard, Penwith Studios
BAMFORD po Ginnie, the Craft Market
BARNES cr William, Mousehole
BARRATT s Max, Trencrom Hill, Lelant
BARRY Ray, Newmill
BEALING Nicola
BEDDING po John, St Ives Pottery, Fish Street
BEER David, Rose Lane
BERRY p Bob, Coldharbour Pottery, Towednack
BERRY ph Bob, Coldharbour Pottery, Towednack
BERRIMAN Beth, Coldharbour Pottery, Towednack
BETTS Derrick
*BETOWSKI Noel, Gulval
BISHOP w Patricia, Cockwells
BLAKE Peter, 2 Porthmeor Studios
BOWTELL Catherine, Arts Club
*BRADBURY Susan, Count House Lane, Carbis Bay
BRAMLEY Victor, Nancledra
BRAY Barrie
BRAY Heather
BRENNAN Robert
BROUGH po Alan, Pottery Workshop, Newlyn
BROWN Don
BROWN Jennifer, Chywoone Hill, Newlyn
BUCHANAN po John, Halsetown Pottery
BURLTON Victoria, Kelynack, St Just
BURSTON Trevor, Penzance
BUTLER po Sarah, Street-an-Pol
CANN Sid, Digey Square
CARDEW p Ira, Wenford Bridge Pottery, Bodmin
CARDEW po Seth, Wenford Bridge Pottery, Bodmin
CARRICK s Ian, Falmouth
*CARWARDINE Penn, Edge-o-Cliff Studio, Carbis Bay
CHALWIN Michael, Newlyn, Penzance
*CHANDLER Jill, Rose Lane Studio

CHINN Margaret
*CLARK John Charles, 2 Penwith Studios, Back Rd West
CLARK po Martin, Street-an-Pol
CLARKE Betty, Arts Club
CLARKE Bill, Arts Club
CLARKE cr Norman Stuart, The Glass Gallery, St Erth
CLUTTERBUCK s Stephen, Victoria Place
COLES Ina, Porthmeor Gallery
COLLINGS David, Newlyn
COOK Richard, Newlyn
COOKE Ian, Men-an-Tol Studio, Newbridge
COOKE Yuklin, Men-an-Tol Studio, Newbridge
COOKSON po Delan, St Buryan
*COOPER Jessica, Pendeen
COOPER po Waistel, Barbican Pottery, Battery Road, Penzance
CORSER po Trevor, Leach Pottery
*CROSS Tom, Constantine
*CROSSLEY Bob, 7 Porthmeor Studios
CROXFORD Jenny, Mullion
*CULWICK Robert, Seaview Place
DALGARNO Barbara
DALTON Andrew, Lelant
DALTON Sue, Lelant
DAVIS Cynthia, Phillack, Hayle
DAY Nicholas, Penzance
DEACON Brenda, Halsetown
DEAN Michael
De MAUNY Francois, Praze-an-Beeble, Camborne
*DEVEREUX Bob, Salthouse Gallery
*DEVEREUX Pauline Liu, Salthouse Gallery
DEVEREUX Jenny
DOLAN Patrick
*DOVE Stephen, 4 Porthmeor Studios
DYSON Julian, St Ives
EDWARDS Keith
EDWARDS Marianne
*EMANUEL John, 2 Porthmeor Studios
ENGLISH Keith, Lanhams
EVANS Audrey, Faughan Lane, Newlyn
EVANS Bernard, Faughan Lane, Newlyn
EXWORTH s Ray, Polcrebo Downs
FAULKNER cr Felix, St Erth
FEARNLEY Derek, Halsetown
FEATHER Yankel, Newlyn
FEILER Helen, Penzance
FERGUSON Irene, Trewarveneth Street, Newlyn
FIELDING po Sondra, South Place, St Just
FINN Michael, Nancherrow, St Just
FISHER s Bill, Mousehole
FISHER Susan, Lelant
FLETCHER Mary
*FLOYD Kathryn, Trelyon Gallery
*FLOYD Robert, Trelyon Gallery
*FOREMAN Michael, Trezion
FORSYTH Renate, New Craftsman
FOSTER Tony
FOX Peter, Penzance
FRANK Peggy
*FREARS Naomi, Laity Lane, Carbis Bay
*FREEBURY Colin, Penwith Studios

FREEMAN s	Esther, Falmouth	KELLEY ph	Ann, Bowling Green
*FREEMAN	Ralph, Craft Market Studio	KEMP s	David, St Just
*FROST	Anthony, Rosemergy Cottage, Pendeen	*KING	Brenda, White Studios
FURNESS	Jane, Cornwall Terrace, Penzance	*KING	Jeremy, White Studios
GAMBLE	Peter, Copperhouse, Hayle	KINLEY s	Susan
GARDNER	Grace, Flushing, Falmouth	*KNIGHT	Audrey
GASKELL po	Alice, The Forge, Cape Cornwall	KNOWLES	Stuart, Marazion
GILDER s	Theresa, Clarence Street, Penzance	LANCASTER	Kathie, Wesley Place
GILES	Tony, St Agnes	*LANYON	Andrew, Farmers Meadow, Newlyn
GOLDEN	Lynn, St-Just-in-Roseland, Truro	LANYON	Martin, St Agnes
GOULDEN s	Pamela	LARGE	Roger, Salthouse Gallery
GOUGH	Barbara, Digey Square	LEGRAND	Gwen
GRANT	Donald, Back Road West	LeGRICE	Jeremy, St Buryan
GRAY	Margery	LEAMAN	Bridget, The Lizard
GREEN w	Mary Ann, Hellesveor	LEMAN	Martin, Bellair Terrace
HALL cr	Charles, Hayle	*LEVINE	Rachael, Penwith Studios
HALL cr	Tim, Penzance	LEWIN	Paul, New Craftsman Gallery
HARDY w	Melissa, Women's Library, New Mill	LEWINGTON	Sue, New Craftsman Gallery
HARRIS	Helen, Penryn, Falmouth	LORENS s	Amanda, Alma Place, Penzance
HARRISON po	Nick, Trelowarren Pottery, Helston	MABBUTT	Mary
HART	Jennifer, Gulval	MACLEOD	Donald, Harbour Craft Market
HAWKINS po	Therese, St Erth	MACMIADHACHAIN	Paddy, Salthouse Gallery
HAWKES	Gabrielle, Visions and Journeys, St Just	MARSHALL po	Andrew, Stithians, Truro
HAYES po	Peter, New Craftsman	MARSHALL cr	Peter, St Ives
HEDGES	Russell, Porthmeor Gallery	MARTIN	Mary, Penwith Gallery
HENDERSON SMITH ph	Tom, Visions and Journeys, St Just	MATTESON	Steve
HERRING	John	MATANLE cr	Terry, Portreath
HERRMANN po	Christa-Maria, Borah Studio, Lamorna	MAWDSLEY	Philip
HEWITT	Graham	*McCLARY	Louise, 6 Porthmeor Studios
HEWLETT s	Francis, Falmouth	*McCLURE	Daphne, St Marys Terrace, Penzance
HICKS	June, Sennen	McCLURE	Emma
HICKS	Sheila, Cavell, The Promenade, Penzance	McCLURE	Peter Hugo, Victoria Place, Penzance
HIGGINS	John, Craft Market	McDOWALL	Carole, Penwith Gallery
HIGGINS	Nicola, Craft Market	McINTOSH	Gordon, Wolf-at-the-Door, Penzance
HITCHENS ph	Geoff, Fern Glen Studio	*McNALLY	Kathy, Penwith Studios
HILL	Douglas, Longships Gallery	*MICKLETHWAITE	Christine, Phillack, Hayle
HILL cr	Alan, St Andrews St	MIDDLEMISS po	Jon, Lelant
HOBART	John, Ludgvan	MILES s	Seth, Towednack
HOLLAND	Derek, New Craftsman	MILLAN	Henry, Porthmeor Gallery
HOLLAND	Marjorie, New Craftsman	MILLER	Charlotte, White Studios
HOLMAN	Linden	MILNE cr	Jenni, St Teath, Bodmin
HOWARD	Charles, Leskinnick Terrace, Penzance	NEED cr	George, Craft Market
HOWARD	Ken, Paul Lane, Mousehole	*OLINER	Sheila, Penwith Studios
HUGHES ph	Andy	O'DONNELL	Michael, Marazion
*HUGHES	Patrick, 3 Porthmeor Studios	O'DONNELL cr	Sheelagh, Marazion
HUMMEL cr	Anthony, Newlyn	ORAM	Arthur, Harbour Craft Market
HUNTER	Ian	*ORCHARD	Colin, Ayr Manor House
HUNTER	Elizabeth	ORCHARD cr	Celia, Ayr Manor House
INSOLL	Chris, Portscatho, Nr Truro	ORCHARD	Louise, Ayr Manor House
JACKSON	Kurt, St Just	PAGE	Carol, New Craftsman
JAMES w	Beryl, St Just	PARKIN w	Mollie, 3 Porthmeor Studios
JAMES	Rowan, Barnaloft	PEDLEY	Vivian
JENKINS	Derek, Truro	PEARCE	David
JENKINS	Jennifer, Truro	PERRY po	Greta, Mousehole
JOHN	Caroline	*PETERSEN	Anke, Anke's Studio
JOHNSON	Colin T, New Craftsman	PETERS	Stuart, St Ives Society of Artists
JONES	Robert, Sea Lane, Hayle	PHILIPS	Mary
JUTA	Suzanne, Newlyn Art Gallery	PHILLIPS	Gerald, Lamplighter Studio
KANTARIS	Rachel, Salthouse Gallery	PHILLIPS w	Roy
KANTARIS w	Sylvia, Helston	PIPER	John, Newlyn
KARN	Barbara, Penzance	PISK	Litz
*KEYS	Elizabeth, Victoria Place	PONCKLE	Clark

POOLEY	Simon	TOWNDROW	Roger, Falmouth
PRICE	Trevor, Back Road East	TREZISE	Nigel, Victoria Place
PRIESTLAND w	Gerald	TRINICK po	Katrina, Bodmin
PRIESTLAND ph	Sylvia	TRUSCOTT	John
PROSSER po	Deborah, The Lizard	TUDOR cr	Ruth, Penzance
*RAY	Roy, Porthmeor Studios	TURNER cr	Daphne, Bedford Road
RICH po	Mary, Truro	TURNER cr	Pepe, Bedford Road
RICHARDS po	Paul, Porthmeor Gallery	TYSACK	Michael, Bedford Road
RITMAN	Lieke, Penwith Studios	VIGG	Bob, Botallack, St Just
ROBINSON	Sonia, St Ives Society of Artists	WADDINGTON	Andrew, Truro
ROGERS	Mary	WALKER	Rod, Penzance
ROSE	Stuart	*WALKER	Roy, 3 Porthmeor Studios
ROWE s	Tommy, Newlyn	*WARD	Eric, Ocean View Terrace
ROXBURGH	Annie, White Studios	WARD cr	Lesley, Channel View
SAUNDERS	Elfrida	*WARD	Peter, Penwith Studios
SCOTT	Colin	WARRIOR po	Charmaine, Lelant Downs
*SEMMENS	Jennifer, Penzance	WASON po	Jason, Penzance
SHALATAIN	Jack	*WATKISS	Gill, Morrab Road, Penzance
SIMPSON	Red, Craft Market	WATKISS ph	Reg, Morrab Road, Penzance
SIMPSON cr	Ruth, Craft Market	WATSON cr	Iain Stuart, Atlantic Terrace
SKINNER s	Diane	WEBSTER	John
SMIRNOFF	Alex	WEBSTER	Peter, Falmouth
SPEIGHT	Karen, Hayle	WEST	Sebastian, Crow Studio
SMITH	Simon, St Buryan	WESTBY s	David, Summerhill Studio, Falmouth
STAFFORD	Sheila, Hayle	WHITTINGHAM	Ann, Porthmeor Workshop
*STARINK	Gertrude, St Andrews Street	WHITTON	Leonie, Summerhill Studios, Falmouth
ST CLAIR	Julian, Porthmeor Gallery	WHYBROW w	Marion, Fauna Cottage
STEAD	Angela	*WHYBROW	Terry, Fauna Cottage
*STEINER	Minou, Lelant Downs	WILDING s	Alison, The Lizard
STELLA	Mary, Lanhams Gallery (Yram Allets)	WILES s	Alec, Truro
STEVENSON	Richard Lee, Relubbus	WILKINSON s	Bill, Newlyn
*STORK	Mary, St Just	WILLERS	Ann
STRANG	Michael, Gulval	WILLIAMS	Nic, Rope Walk Studios
STRONG	Mary, Penzance	WILLIAMS s	Ross, Penwith Studios
*SUMRAY	Maurice, St Christophers	WILLIAMS	Tamsin, Porthmeor Gallery
SUTCLIFFE s	Guy, Tregenna Terrace	WILLIS	David, Harbour Craft Market
SUTHERLAND ph	Ron, Back Road West	WILLS	Barbara, New Craftsman
SYMONDS po	David, Hayle	WILSHAW s	Derrick, Falmouth
SYMONDS	Ken, Fore Street, Newlyn	WILSON	Vincent, Penwith Gallery
SYMONS w	Alison	WOOD s	Ron, Mount Hawk, Truro
SYMONS	Judy	WOODRUFF	Patrick
TAYLOR	Marion, White Studios	WRIGHT s	Peter, Stithians, Truro
TAYLOR cr	Noah, Lamorna Smithy	WYNNE JONES	Nancy
TEMPEST	Vicky, Lelant	YATES	Fred, New Craftsman
*THISTLETHWAITE	Morwenna, Victoria Place	YATES cr	Jennifer, Penzance
THOMPSON	Paul	ZIA	Partou, Porthmeor Gallery
TIFFIN	Sheila, St Andrews Street	ZIAR	Rosemary, Penzance

Sources 1890-1900

The Timeless Land – The Creative Spirit in Cornwall, Denys Val Baker, Adams and Dart, Bath, 1973 (first quotation).
1, 35: Historical Sketch of St Ives and District, W Badcock 1896.
2, 4, 6, 26: *From Seven to Seventy, Memories of a Painter and a Yankee*, Edward E Simmons, Garland Pub. 1976.
3: *Whistler A Biography*, Stanley Weintraub, William Collins, l974.
5: *Stanhope and Elizabeth Forbes*, Mrs Lionel Birch, Cassell & Co Ltd.
7: 'Concarneau, Brittany as a Sketching Ground', F L Emanuel, *Studio*, 1894.
8: Volendam as a Sketching Ground, *Studio*, 1900.
9,10,13,34: 'A Painters Club', Louis Grier, *Studio*, 1895.
11: *The Table*, R H Sherrard, 1897.
12: 'The Charm of the Country Town, St. Ives', Frank L Emanuel, illus., R Borlase Smart, *Architectural Review*, July 1920.
14: Excerpt from *Westminster Gazette*.
15: *From St Ives to Land's End*, A G Folliott Stokes, 1908, Greening Pub, 1908.
16: 'A Newlyn Retrospect', Stanhope Forbes, *The Cornish Magazine*, 1898, Ed., Quiller Couch.
17: 'Newlyn v St Ives', Charles Lewis Hind, *Studio*, 1895.
18: Article, Alice Meynell, *Art Journal*, 1884-1890.
19: 'Newlyn as a Sketching Ground', Frank Richards, *Studio*, 1895.
20: *Brangwyn's Pilgrimage, The Life Story of an Artist*, Wm. de Belleroche, Chapman & Hall, London, 1948.
21: *Days in Cornwall*, C Lewis Hind, photos, J C Douglas and W H Lanyon. Methuen & Co Ltd., 1907.
22: *Western Morning News*, 1889.
23: *The Artist*, 1894.
24: *Men and Memories, Recollections of Wm.Rothenstein 1900-1922*, Faber & Faber.
28: *The Standard*, 1898.
29: *An Artist's Life, Autobiography Sir Alfred Munnings*, Museum Press, 1955.
30: *Moments of Being*, Virginia Woolf, Chatto & Windus Ltd. l976.
31: *The Life & Letters of Sir Edmund Gosse*, The Hon. Evan Charteris KC, Wm Heinemann, 1931.
32: *Letters of Virginia Woolf, Vol.1 1888-1912*, Hogarth Press, 1975.
33: *The Mausoleum Book*, Sir Leslie Stephen, Clarendon Press, Permission Oxford University Press.
36: *The Faulls of St Ives*, Lilian M Faull, Headland Printing Co.
38: *A Boy at the Hogarth Press*, Richard Kennedy, Heinemann.
39: Moffat Lindner's personal account of his early work as a painter.
25,27,37,40: St Ives Weekly Summary and Visitors List, 1889-1900.

Sources 1901-1910

41,44,45,46: St Ives Weekly Summary, 1901-10.
42: J A Arnesby Brown, *Studio*, 1900.
43: Letter to Brian Hatton's mother, *Cornish Interlude*.
47: *Richard Hayley Lever*, Previti Gallery, New York, catalogue, 1985.
48: Letter from Sidney Long, 1912.
49: 'Paintings from Cornwall, Memories of Cornwall's Art Colony', Denys Val Baker, *Cornish Review*.
50: Article in *Daily Mail*, Charles Marriott.
51: 'The Work of Mrs. Adrian Stokes', Harriet Ford, *Magazine of Art*, 1890.

52: 'Reform of the Academy Schools', *The Magazine of Art*, 1890.
53: *The Magic of a Line, Autobiography of Laura Knight*, Wm Kimber, London SW1, 1965.
54: *Oil Paint & Greasepaint, Autobiography of Laura Knight*, Ivor Nicholson and Watson, London, 1936.
55: *As I was Going to St Ives*, Leonard Spray.
56, 57: *My Life and Times*, Compton Mackenzie, Octave Four 1907-1914, Chatto & Windus, 1965.
58: *The Land's End*, W H Hudson, J M Dent & Sons, 1923.
59: *From St Ives to Land's End*, Folliott Stokes, 1908.
60: Folliott Stokes' plea for a Cornish Theatre, *The Playgoer*, 1903.
61: *An Artist's Life, Autobiography of Munnings A J*, The Museum Press.
62: Visitors' Book of Mrs Griggs.
63: *My Life and Times*, Compton Mackenzie, Octave Three 1900-1907, Chatto & Windus, 1965.
64,65,66,67: *My Life*, Havelock Ellis, Heinemann, 1940.

Sources 1911-1920

68: 'Garstin Cox', *The Cornish Post*, 1920.
69: 'Poem of Lament', Louis Grier.
70, 72: *St Ives Times*.
71: T M Dow, J.Olsson, M Lindner, Letter to *St Ives Times*, 1915.
73: Edith Ellis, *St Ives Times*, 1916.
74: *Oil Paint and Greasepaint, Autobiography of Laura Knight*, Ivor Nicholson and Watson, London, 1936.
75: *Frances Hodgkins*, Myfanwy Evans, Penguin Modern Painters.
76: 'Paintings of Louis Sargent', Folliott Stokes, *The Studio*, 1919.
77, 78: Letter to *St Ives Times*, Captain Borlase Smart, 1919.
79: Letter to *St Ives Times*, 'Whole Hogger', 1919.
80, 81: 'The Charm of the Country Town, St Ives, Cornwall', Frank L. Emanuel, illus. Borlase Smart, *Architectural Review*, 1920.
82: *Rupert Brooke, A Biography*, Christopher Hassell, Faber & Faber.
83: *The Flight of the Mind, Letters of Virginia Woolf 1888-1912*, The Hogarth Press.

Sources 1921-1930

84: 'Charles Marriott, The Newlyn School', *St Ives Times*, 1922.
85: *Studio*, 1922.
86: 'Show Day', *St Ives Times*, 1927.
87: Letter from Headmaster to *St Ives Times*, 1920.
88, 103: Article, D I Sedding, *St Ives Times*, 1921.
89: 'Art Needlework', *St Ives Times*, 1925.
90: Dorothea Sharp, 1923.
91: *Dorothea Sharp*, P G Konody.
92: *Marcella Smith*, P G Konody.
93: 'Margaret Stoddart, A Woman and Art', *The Sun*, Australia.
94: 'The Charm of the Country Town, St Ives, Cornwall', Frank L Emanuel, illus. Borlase Smart, *Architectural Review*, 1920.
95: Letter to *St Ives Times*, Mrs Ka Arnold Forster.
96: *The Question of Things Happening Vol 2, The Letters of Virginia Woolf 1912-1922*, The Hogarth Press.
97,98,99: Letters of Charles Greville Matheson.
100: 'Phantom Party', M A H, *St Ives Times*, 1924.
101: Christmas Number, *St Ives Times*, 1925.
102: Retrospective Exhibition St Ives Society, May 1927.
104: 'Lanham's Exhibition', D I Sedding, *St Ives Times*, 1922.
105: 'Diamond Jubilee of Lanham's 1929', *St Ives Times*.
106: Solicitor's Document, Arts Club building.

Other sources

Interviews with local people; *St Ives Times* 1889-1930; Minutes of St Ives Arts Club 1890-1930; St Ives Arts Club Suggestions Book; *The Dictionary of British Artists 1880-1940,* Antique Collectors' Club; *Britain's Art Colony by The Sea,* Denys Val Baker, George Ronald, London 1959; 'School of St Ives', Harold Begbie, *The Morning Post,* 1898; *W H Y Titcomb, Artist of Many Parts,* David Tovey; 'Some Notable Women Painters', *Magazine of Art,* 1895; *Whistler As I Knew Him,* Walter Menpes; *A Brush With Life,* Norman Wilkinson; *Women's Works* (catalogue), Jane Sellars, Walker Art Gallery, Liverpool; *The Origin & the First Two Years of the New English Art Club,* William James Laidlay; 'Julius Olsson', Folliott Stokes, *Studio* 1910; 'Summertime in St Ives', William Henry Bartlett, *Art Journal,* 1897; 'Anders Zorn, His Life and Work', Dr Karl Asplund, *Studio;* 'The Work of Thomas Millie Dow', Norman Garstin, *Studio,* 1897; *Who's Who in Art,* 1929; *Biography of Hugh Walpole,* Rupert Hart-Davis, Macmillan, London, 1952; 'Algernon Talmage', *Studio,* 1907; *W Elmer Schofield, Proud Painter of Modest Lands,* Valerie Livingston; 'A Century on the Towans', History of West Cornwall Golf Club; *Brian Hatton 1887-1916,* Celia Davis, Pub. Terence Dalton; The ladies magazine *Eve;* 'Edith Collier in Retrospect', Janet Paul, Sarjeant Gallery N.Z.; 'Charles Simpson's School of Painting', *St Ives Times,* 1920; *Broadsides from Bohemia,* Arthur Caddick; *Cornish Chelsea,* Vera Hemmens, 1923; *Paintings from Cornwall,* Denys Val Baker, The Cornish Library; Denis Mitchell — Interview with Radio Cornwall, Tim Hubbard, 1988; *Good Morning & Good Night,* Ranee Margaret of Sarawak, Constable & Co London, 1935; *A View From Land's End,* Denys Val Baker; *Visitors to Cornwall,* Ida Procter; *The Good and Simple Life,* Michael Jacobs, Phaidon.

NEW ERA

Sources 1930-1993

1: Barbara Hepworth, A M Hammacher, Thames & Hudson, 1987.
2: *Peter Lanyon,* Andrew Lanyon.
3: Excerpt from *The Spectator,* November, 1945.
4: Letter from Peter Lanyon to *St Ives Times,* August, 1945.
5: Letter from Borlase Smart to *St Ives Times,* September 1946.
6: Review of the Crypt Exhibition, *St Ives Times,* 1946.
7: *The Changing Forms of Art,* Patrick Heron, Georges Braque.
8: Review of Patrick Heron exhibition at Downings Bookshop, *St Ives Times,* 1947.
9: Obituary of Borlase Smart, Leonard Fuller, *St Ives Times,* 1947.
10: Letter to *St Ives Times* from David Cox, 1949.
11: Review of First Exhibition of Penwith Society of Arts, *St Ives Times,* 1949.
12: *The Changing Forms of Art,* Patrick Heron, Peter Lanyon, 1955.
13: Letter to *St Ives Times* from Hyman Segal, 1950.
14: Review of Exhibition Penwith Society of Arts, Patrick Heron, *St Ives Times,* 1950.
15: Report of Misome Peile's visit to Trewyn Studio.
16: Letter to *St Ives Times* from Peter Lanyon, 1955.
17: Nicholson Retrospective at the Tate, 1955.
18: Letter to *St Ives Times* from Peter Lanyon, 1956.
19: Review of Penwith Society Exhibition, 1958.
20: Review of American Painters, Patrick Heron, *Studio International,* December, 1966.
21: Review of Exhibition of Tony O'Malley at the Sail Loft, 1962.
22: Introduction to catalogue of exhibition of Bryan Pearce at Falmouth, Jim Ede.
23: *St Ives Times* report of Terry Frost's departure from St Ives, 1963.
24: 'Cornwall 1945-55', Exhibition at New Art Centre, Sloane Street. David Brown's introduction to catalogue.
25: Excerpts from Patrick Heron's talk at Newlyn Gallery in 1985 taken from Marion Whybrow's shorthand notes.

Other Sources

'St Ives 1939-64, 25 Years of Painting, Sculpture and Pottery', Tate Gallery catalogue, 1985; *Paintings From Cornwall,* Denys Val Baker, pub. The Cornish Library, 16 Morrab Place, Penzance; 'Painting & Sculpture of a Decade 1954-64', Tate Gallery Catalogue; *About Rothko,* Dore Ashton, Oxford University Press, New York, 1983; 'John Tunnard 1900-1971', The Arts Council Exhibition catalogue; 'Roger Hilton, Night Letters & Selected Drawings', Newlyn Orion Galleries; *Bryan Pearce, A Private View,* Marion Whybrow, St Ives Printing & Publishing Co, 1985; *Potters In Their Place,* Marion Whybrow, St Ives Printing & Publishing Co; *Twenty Painters St Ives,* Marion Whybrow, St Ives Printing & Publishing Co; *Patrick Heron: The Development of a Painter,* Ronald Alley, Studio International, 1967; *Ben Nicholson,* Jeremy Lewison, Phaidon 1991; *A Century of Art in Cornwall 1889-1989,* Cornwall County Council; *The St Ives Years, Essays on the Growth of an Artistic Phenomenon,* Peter Davies, the Wimborne Bookshop, Dorset; *Britain's Art Colony by the Sea,* Denys Val Baker, George Ronald 1959; 'On Patrick Heron's Striped Paintings', Retrospective Exhibition, 1957-66, Alan Bowness, Museum of Modern Art, Oxford; Peter Lanyon Arts Council Exhibition catalogue, 1968; Wilhelmina Barns-Graham Retrospective 1940-1989, City of Edinburgh Museums & Art Galleries; 'Paintings Sculpture & Prints, Modern Art in the United States', Tate Gallery 1956, The Arts Council; 'The New American Painting', Tate Gallery catalogue, 1959; Cornwall 1945-1955, New Art Centre, Sloane Street, 1977; 'Alexander Mackenzie', Newlyn Art Gallery catalogue, 1980; *Peter Lanyon, His Painting,* Andrew Causey with introduction, Naum Gabo, Aidan Ellis; *Patrick Heron* — introduction, Vivien Knight pub. John Taylor in association with Lund Humphries, 1988; 'The British Influence on New York', Patrick Heron, *Arts Guardian* Oct. 10, 11, 12, 1974; *The Fine & Decorative Art Collection of Britain & Ireland,* written and ed. Jeannie Chapel & Charlotte Gere, Weidenfeld & Nicholson; *Unknown Colour, Paintings, Letters, Writings,* Winifred Nicholson, ed. Andrew Nicholson, Faber & Faber, 1987; *Painting the Warmth of the Sun,* Tom Cross, Alison Hodge, 1984; 'British Art & the Modern Movement 1930-40' an exhibition at National Museum of Wales, Cardiff, 1982, Introduction, Alan Bowness; Auction of Fine & Applied Art, Catalogue St Ives Tate Action Group; *Dictionary of British Art Vol.VI 20th Century Painters & Sculptors,* Frances Spalding, Antique Collectors' Club, 1990; *Contemporary Artists,* St James Press, 1977; *The Phaidon Companion to Art and Artists in the British Isles,* Michael Jacobs and Malcolm Warner; *British Art since 1900,* Frances Spalding, Thames & Hudson, 1986; *Contemporary British Artists,* compiled & pub. Bergstrom & Boyle Books, London, 1979; *Modern British Painting 1900-1980,* Alan Windsor, Scolar Press; *Modern European Art,* Alan Bowness, pub. World of Art, 1967.

Index